DAVID O. McKAY LIBRARY
RICKS COLLEGE
REXBURG, IDAHO 83460-0405

WITHDRAWN

P9-DUH-715

DAVID O. McKAY LIBRARY
BYU-IDAHO

NICHOLAS & ALEXANDRA

Nicholas & Alexandra Exhibition

A Broughton Masterpiece Presentation

NICHOLAS & ALEXANDRA

The Last Imperial Family of Tsarist Russia

From the State Hermitage Museum
and the State Archive of the Russian Federation

Booth-Clibborn Editions Harry N. Abrams, Inc., Publishers

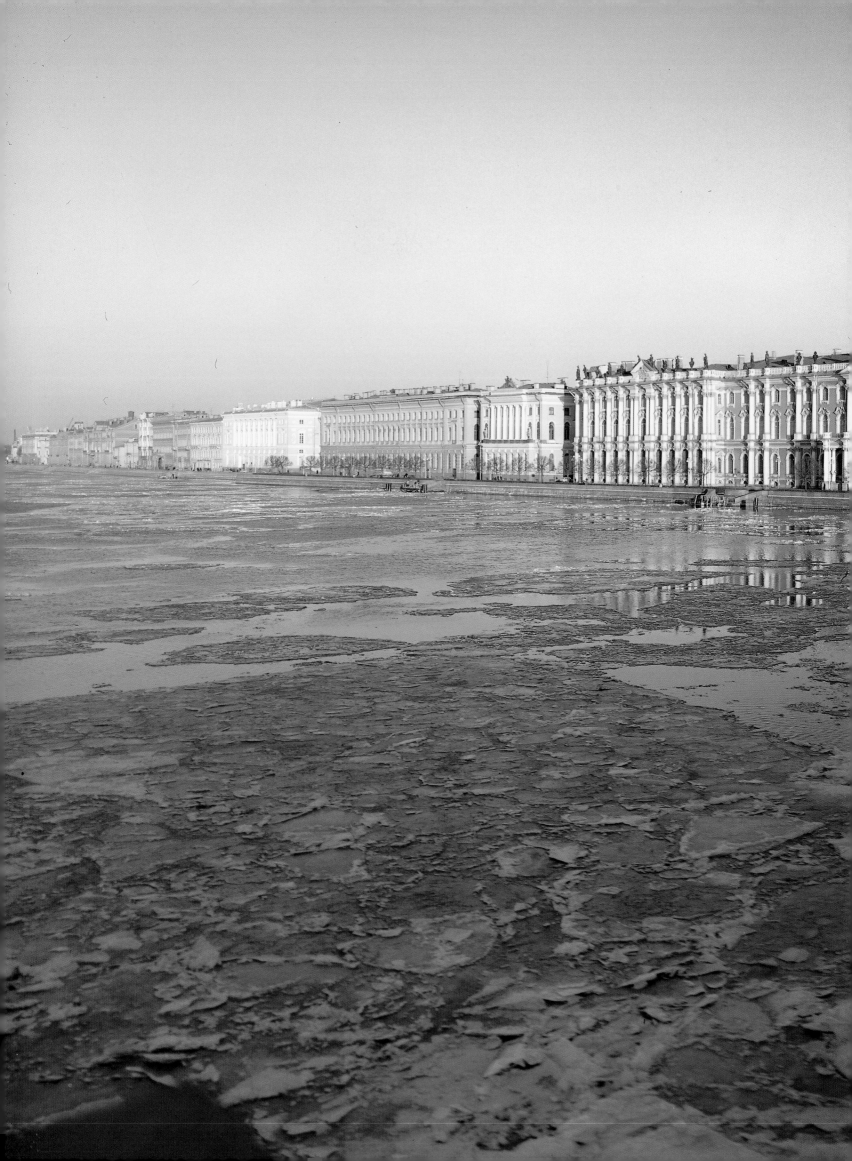

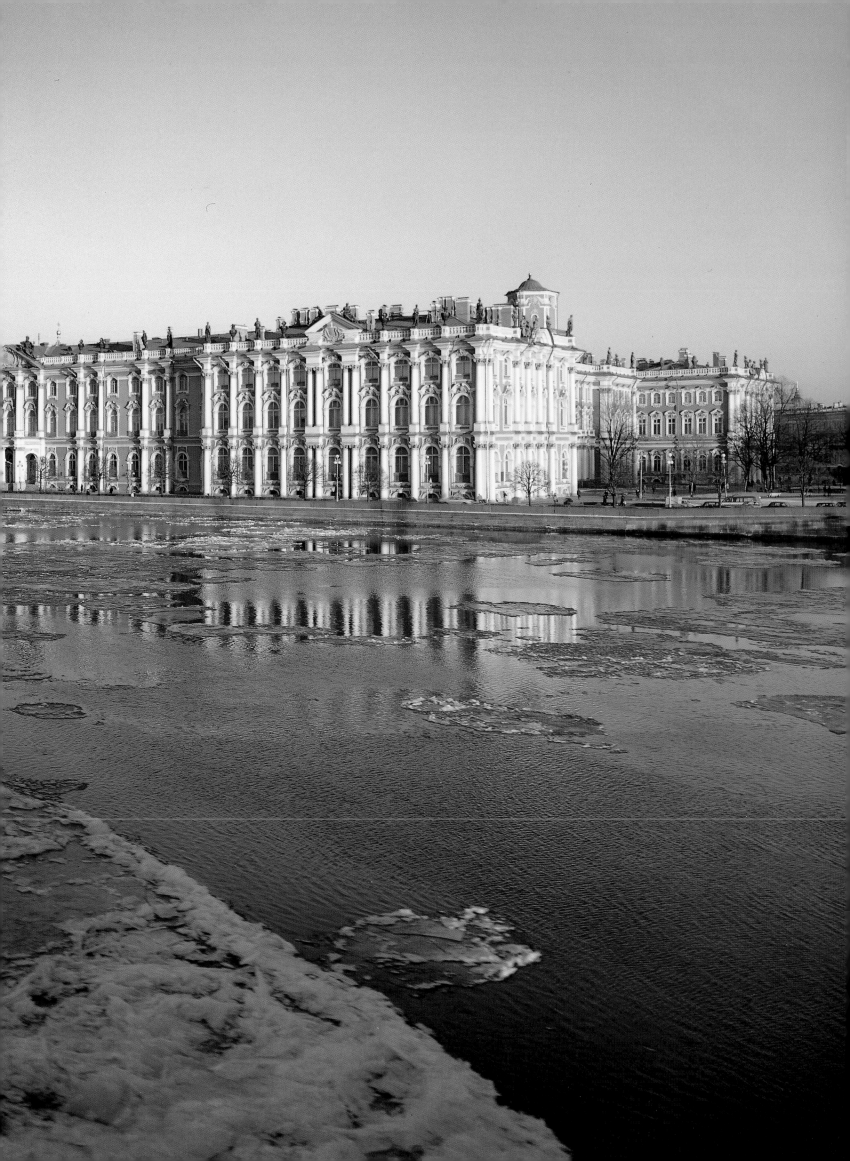

Managing Editor: Mark Sutcliffe
Editor: Robert Timms
Design: Angus Hyland, Imke Himstedt, Pentagram Design
and Esther Mildenberger
Translation: Frank Althaus, Darya Lakha
Photography: Yury Molodkovets, Vladimir Terebenin and
Leonard Heifets (State Hermitage); V. S. Glebov (State Archive)

See page 8 for full details of contributors

© The State Hermitage Museum, St. Petersburg 1998
© The State Archive of the Russian Federation, Moscow 1998
© The State Palace Museum, Tsarskoe Selo 1998
© FORBES Magazine Collection, New York 1998
© Broughton International, Inc. 1998
© Booth-Clibborn Editions 1998

Extract (p. 269) from *Nicholas and Alexandra* by Robert Massie,
reproduced by kind permission of Victor Gollancz Ltd.
Front cover: Emperor Nicholas II with Empress
Alexandra Feodorovna and their children, Livadia, 1914 (State
Archive of the Russian Federation).
Back cover: Burial site of the imperial family's remains, near
Ekaterinburg (Alexander Zemlianichenko — AP).
Previous spread: View of the State Hermitage Museum and
the river Neva.

Library of Congress Cataloging-in-Publication Data

Nicholas and Alexandra: the last imperial family of Tsarist
Russia / by George Vilinbakhov ... [et al.] ;
introductions by Mikhail Piotrovsky and Sergei Mironenko.
 p. cm.
"Catalogue of the exhibition 'Nicholas and Alexandra',
State Hermitage, State Archive of the Russian Federation.
(Opening of the exhibition 1st August 1998, Wilmington USA)"—CIP p. 1.
Includes index.
ISBN 0-8109-3687-9 (hardcover) / ISBN 0-8109-2768-3 (BOMC pbk.)
1. Nicholas II, Emperor of Russia, 1868-1918—Exhibitions. 2. Nicholas II,
Emperor of Russia, 1868-1918—Family—Exhibitions. 3. Russia—Kings and
rulers—Exhibitions. 4. Russia—History—Nicholas II, 1894-1917—
Exhibitions. 5. Nicholas II, Emperor of Russia, 1868-1918—Portraits—
Exhibitions. 6. Nicholas II, Emperor of Russia, 1868-1918—Family—
Portraits—Exhibitions. 7. Russia—Kings and rulers—Portraits—
Exhibitions. 8. Art objects, Russian—Exhibitions. I. Vilinbakhov, G.
(Georgiĭ) II. Gosudarstvennyĭ Ėrmitazh (Russia) III. Gosudarstvennyĭ
arkhiv Rossiĭskoĭ Federatsii.
DK258.N476 1998
947.08'3'092—dc21 98-27383

First published in 1998 by Booth-Clibborn Editions
12 Percy Street, London W1P 9FB
United Kingdom
www.booth-clibborn-editions.co.uk
info@internos.co.uk

Published in North America in 1998 by
Harry N. Abrams, Inc.
100 Fifth Avenue
New York, N.Y. 10011
www.abramsbooks.com

All rights reserved. No part of the contents of this book may be
reproduced without the written permission of the publishers.

Printed and bound in South Korea

Tobolsk

Pokrovskoe

Ekaterinburg

R U S S I A N E M P I R E

St Petersburg

Kostroma

Sarov

Moscow

Mogilev

ranovitchi

Kiev

Livadia

MAP OF EUROPE IN 1913

NICHOLAS AND ALEXANDRA

The State Hermitage is numbered among the very greatest museums, and is rightly called a treasure-house of world art. The museum contains a priceless and varied collection of humankind's artistic and cultural creations, from ancient times to the present day. Works by artists from western Europe, America and the Far East stand alongside a vast collection of Russian works of art. The latter have provided several major exhibitions celebrating different periods of Russia's cultural history. Significant among these was the exhibition dedicated to the era of Catherine the Great, which was shown in three major American cities between 1991 and 1993 — Memphis, Los Angeles and Dallas — and then at the State Hermitage in 1993.

'Nicholas and Alexandra', a major new exhibition about the last Russian tsar, Nicholas II, and his wife, Alexandra Feodorovna, will also be displayed in several cities in the United States. It celebrates a period of Russia's past no less tragic than it was artistically significant: the turn of the twentieth century. The exhibition does not attempt to cover all the various aspects of Russian history and culture of this time. Its theme is limited to an account of the life of the last emperor, his family and his circle. It tells the story of the relationship between Nicholas and Alexandra and their tragic deaths, and illustrates various aspects of society at one of the most splendid imperial courts in Europe.

The exhibition's organisers have attempted to portray the life of Nicholas II and his court from two different standpoints. First, the exhibition highlights the enormous human and social tragedy of Nicholas, Alexandra and their family: their loneliness after the birth of their haemophiliac son, whose incurable illness they tried to hide for so long; and their failure to understand the social conditions of the country, which led to such a dramatic and tragic conclusion. Second, the exhibition illustrates the traditional ceremony and magnificence of the imperial court, the brilliance of its parades and receptions and the luxury of its court balls.

Thus, for example, in January 1915, not long before the end of the tsar's reign, the French ambassador to Russia, Maurice Paléologue, attended a New Year's reception for the diplomatic corps at Tsarskoe Selo. He wrote, 'The ceremony was as magnificent as ever: a display of wealth, splendour, majesty and brilliance for which the Russian court has no equal.'[1] Yet almost at the same time, Nicholas wrote in a letter to his wife, 'I feel very strong, but very lonely.' 'I was in the woods today — how quiet it was; you could forget everything — all this unpleasantness and human vanity ...'[2]

This fascinating period of history, on the cusp of two centuries, is superbly illustrated through the Hermitage's works of art. The richness of the museum's collection from this era has provided more than 500 pieces for the exhibition; prominent among them are the works of Russian artists and foreign artists living in Russia, but the exhibition also includes works by European and Oriental masters presented to the Russian tsar as gifts to decorate various royal residences. This wealth of objects is hardly surprising, since the buildings of the State Hermitage include the Winter Palace — formerly the main residence of the Russian emperors — where the finest works commissioned for the court were kept.

The State Archive of the Russian Federation, as one of the organisers of the exhibition, has provided around 240 exhibits including unknown and previously unpublished documents, photographs and drawings of members of the royal family, as well as letters between Nicholas and Alexandra. These archive documents provide a wonderful chronicle not only of the whole period, but also of the daily life of the tsar's family, culminating in detailed accounts of their tragic deaths.

The State Palace Museum at Tsarskoe Selo has also participated in this exhibition. It is well known that Tsarskoe Selo was the last and favourite residence of Nicholas II and his family, and provided a temporary refuge after the tsar's abdication. It was here, especially after the 1905 revolution, that they spent the majority of their time. Here, too, as at the State Hermitage, the private possessions of the imperial family have been preserved to the present day, alongside numerous works of art from the period.

It should be noted that most of the exhibits have spent several decades in storage and have been on public display only once before — at an exhibition at the Hermitage in 1994, also entitled 'Nicholas and Alexandra'. The current exhibition in the United States provides a unique opportunity, therefore, to enjoy this remarkable period in Russian culture; like the Golden Age of Catherine the Great, the early twentieth century was known as the Silver Age of Russian poetry and literature, and the term has subsequently come to be applied to all aspects of Russian art at the turn of the century.

Among the most interesting works of art are the commemorative items belonging to the royal family which decorated the imperial residences in St. Petersburg and at Tsarskoe Selo and Peterhof. Numerous paintings, watercolours, engravings and sculptures, along with a whole range of photographs, provide portraits of the members of the royal family and their circle. They also

portray the most important events in the life of Nicholas and Alexandra: their wedding, the coronation, court celebrations, balls and masquerades. In addition, the exhibition provides a dazzling picture of St. Petersburg — at the time the capital of Russia and one of the most beautiful cities in the world. Among the exhibits are formal portraits of Alexander III, Nicholas II, Alexandra Feodorovna and several other members of the family. They tell the story of a little-known period in the history of Russian art. Of particular interest are the works of such artists as I. N. Kramskoi, B. M. Kustodiev, K. E. and A. V. Makovsky, N. E. Sverchkov, N. M. Bogdanov-Belsky and — a particular favourite at court — E. K. Liphart. Among the lesser-known artists on display are N. Bekker, N. K. Bodarevsky, A. A. Karelin, I. A. Tiurin, A. M. Leontovsky and F. S. Zhuravlev. Equally interesting are the works of the Austrian artist H. von Angeli and the Dane, L. Tuksen, who were commissioned by the court to paint several portraits and scenes from the life of the royal family, such as the coronation and the wedding of Nicholas II (nos. 27, 28). Also included are the marvellous sculptures (nos. 130–133) by M. M. Antokolsky, L. A. Bernstamm and M. A. Chizhov, which provide a complete picture of the development of Russian sculpture at the turn of the twentieth century.

The vast watercolour panorama by P. Y. Piasetsky, *The Coronation of Nicholas II* (no. 62), has never before been exhibited in full, either in Russia or abroad. This exhibition provides the first ever opportunity to view its total length of 58 metres, comprising various views of Moscow as well as the coronation celebrations of 1896, beginning with Nicholas II's triumphal entry into the city and ending with the military parade on Khodynka Field. Here, too, is a scene of the public holiday on Khodynka Field that took place on 18 May 1896 and which ended so tragically when over a thousand people were crushed to death as they waited for the traditional presentation of royal gifts. This last event is also represented in various photographs from the time (nos. 469–71).

The exhibition includes the wonderful etched portraits of the imperial family by M. V. Rundaltsov (nos. 76–81), whose works are some of the forgotten masterpieces of Russian graphic art of the turn of the century. No less interesting is the portrait in pastels of Grigory Rasputin (no. 61), painted by E. N. Klokacheva, which seems visually to confirm all the oral accounts of the famous *staretz*, or monk.

Nicholas II was extremely interested in photography, and took endless pictures of his family, which he and his family personally stuck into albums. A large number of these are preserved in the State Archive of the Russian Federation, and three of the albums are included here (nos. 520, 521, 534). The exhibition also includes photographs by such well-known photographers as K. Bergamasco, C. de Hahn, I. G. Nostitz and K. Schultz; their portraits of the royal family and contemporary events provide a photographic account of the reign of Nicholas II.

The world of applied and decorative art is also richly represented, for all the finest craftsmen, factories and firms were commissioned by the royal court for decorating the various royal palaces. Suppliers to the Imperial Court included the Imperial Porcelain and Glass factories and the famous stone-carving factories at Peterhof, Ekaterinburg and Kolyvan, as well as the illustrious jewellery firms of Fabergé, Ovchinnikov and Khlebnikov. These masterpieces of applied art include gold and silver articles with precious stones, as well as Fabergé's wonderful miniature copy of the imperial regalia (no. 208). The exhibition contains porcelain and glass both from St. Petersburg manufactories, including vases decorated with Russian semi-precious stones (malachite, lapis lazuli, marble and various types of jasper and porphyry), and from a number of leading western European makers.

The Russian Orthodox Church played an important role in the life of the state, and this is reflected in the richness of vestments ornamented with gold embroidery and pearl brocade, as well as religious articles made of gold and silver, such as icons in frames, bible covers, patens and folding icon cases.

The royal family's opulent wardrobe was kept at the Hermitage and at Tsarskoe Selo. The exhibition includes various regimental uniforms belonging to Nicholas II and his son Alexei, and court dresses and ball gowns that belonged to the Dowager Empress Maria Feodorovna, Alexandra Feodorovna and the tsar's daughters. The dresses and uniforms of court officials, including those of ladies-in-waiting, maids of honour, senators, chamberlains, court guards, servants and footmen, provide a colourful array of court apparel. The costumes that belonged to the Tsarevich Alexei are particularly touching, while some of the most interesting costumes are those that were preserved from the famous last masked ball held in the Winter Palace in 1903 (nos. 372–6, 394).

A wonderful selection of ball gowns and accoutrements used by Empress Alexandra Feodorovna and her ladies-in-waiting at various events in the Winter Palace and other royal residences is set out at the exhibition to recreate an imaginary scene from a ball.

However, it was not only the ladies that presented a dazzling spectacle on such occasions; the men, too, were a sight to behold, especially those in military, parade or ball uniforms, brightly coloured with gold and silver embroidery, and with an abundance of ribbons and diamond-studded medals. Many of these uniforms are shown here. It is worth noting that almost all the members of the royal family had military rank, and Nicholas himself was a colonel. Unfortunately, the jewellery that decorated ladies' dresses and gentlemen's uniforms has not been preserved, but it is easy to imagine the magnificent effect they would have created, and which so impressed foreigners at court receptions and balls.

Fine examples of furniture from the royal palaces are represented by such pieces as the small lady's table made from several different types of wood (no. 274). The work of the famous court supplier N. F. Svirsky, it probably belonged to Empress Maria Feodorovna, Nicholas II's mother. The exhibition recreates various parts of the private rooms of Nicholas and Alexandra, including Alexandra's study with her desk (no. 275), and her sitting-room with a sofa (no. 282) designed specially for the Lower Dacha at Peterhof by the famous architect F. Melzer. The music room has also been recreated with the grand piano (no. 285) decorated by E. K. Liphart, which was commissioned by Nicholas II as a present for his wife (Alexandra Feodorovna is known to have played the piano and sung well). Two other pieces are particularly notable: the throne (no. 273) commissioned by Paul I at the end of the eighteenth century; and a carriage (no. 284) commissioned by Catherine the Great, also from the eighteenth century. It was in this carriage that Alexandra Feodorovna travelled to the coronation in Moscow in 1896.

Various gifts presented to the imperial court by the governments of western Europe and the Far East include the marvellous china service (no. 235) made at the Berlin Porcelain Factory as a wedding present from Emperor Wilhelm II to Nicholas II; and tapestries from the famous series *The Seasons* (no. 303), woven at the Gobelins Manufactory in 1910–13 and presented by President Poincaré of France during his visit to Russia in 1914. Artefacts acquired by Nicholas II in 1890–1, when, as tsarevich, he made a journey to India, China, Japan, Siam and other neighbouring countries, are especially interesting.

Finally, many original documents and contemporary photographs tell the tragic story of the events of the night of 17 July 1918 when, by order of the Bolshevik Government, the whole of the tsar's family was shot in Ekaterinburg (nos. 579–639).

The turn of the twentieth century, the final chapter in the history of the Russian autocracy, is a period still in the historian's domain. Gradually, as more and more archive material is uncovered, it is becoming possible to re-examine individual events of the time, although any conclusive assessment of the period and its leading figures remains the work of the future.

Nevertheless, there is no doubt that while the fate of the last Russian emperor was tragic, his reign was also one of the most tragic and bloody in Russian history. It began in 1894, when, with the unexpected death of his father Alexander III, Nicholas became emperor. His coronation is associated with the terrible events on Khodynka Field, or 'Bloody Saturday' as it became known (see pp. 286–7), after which Nicholas himself became known as 'Bloody Nicholas'. It ended with the savage murder of his family on 17 July 1918 at the Ipatiev House in Ekaterinburg.

In 1917 the historian S. P. Melgunov wrote, 'The reign of Nicholas II is undoubtedly one of the most bloody in history. Khodynka, two blood-soaked wars, two revolutions, and in between disorder and pogroms ending with merciless revenge carried out under the slogans: "Take no prisoners"; "Do not pity your leaders".'[3]

Nor should we forget 'Bloody Sunday' in 1905, when thousands of unarmed protesters were shot on their way to a meeting with the tsar in the Winter Palace; or the terrible execution of workers on the river Lena in 1912. These and other tragic events towards the end of Nicholas's reign undoubtedly led to the collapse of autocracy and drove Russia into what historians have called the 'cycle of unending woes'.

Although Nicholas II was at once a tragic and fateful figure for Russia, numerous memoirs and archive materials describe him as an educated man who was pleasant to talk to: 'I believe him to be the most charming man in Europe,' wrote one of his contemporaries.[4] He was a man of modest habits in his private life, deeply religious, but entirely unsuited to the office thrust upon him after the death of his father Alexander III.

Nicholas himself understood his predicament from the very beginning. On 31 December 1894, after his accession to the throne, he noted in his diary: ' ... the very worst thing has happened to me, the very thing I have been dreading all my life.'[5] These words echo those of the Old Testament, 'For the horrible thing that I feared has befallen me: that which I dreaded has come to pass.' Nicholas II's sister, Grand Duchess Olga Alexandrovna, recalled after the Revolution how the young emperor had sobbed on the death of his father, repeating that he 'didn't know what would become of us all, that he was completely unprepared to rule'. 'And this was entirely my father's fault,' Olga Alexandrovna continued, 'for he never allowed the heir to participate in affairs of state ... And what a terrible price was paid for this mistake.'[6]

The same theme runs through the memoirs of Grand Duke Alexander Mikhailovich, who, as the emperor's uncle and childhood friend, knew the man's character well. Alexander Mikhailovich believed that Alexander III's death was a terrible catastrophe, as a result of which 'a sixth of the world's surface' was entrusted 'into the trembling hands of a confused young man'. Later he wrote that the new tsar had all the qualities required of an ordinary citizen, but which were fatal in a monarch. 'If Nicholas II had been born amongst mere mortals, he would have lived a contented life, encouraged by his

superiors and respected by his equals. He was an ideal family man whose word was his bond ... It was not his fault that fate forged from these positive characteristics a bloody instrument of destruction ...'[7]

The French ambassador Maurice Paléologue, who had many meetings with the tsar over several years towards the end of his reign, was an astute observer of the imperial court: 'I don't know who it was who said that Caesar had every vice but not a single defect. Nicholas II had not a single vice, but the very worst defect for an autocratic monarch — lack of personality. His will was either ignored, misled or suppressed ...'[8]

Gentle by nature, weak-willed and lacking in self-confidence, Nicholas II often changed his decisions and decrees. He did not even have the necessary authority within the extended imperial family; throughout his reign his relationship with the grand dukes and their families gradually deteriorated. As a family man beyond reproach, he preferred the company of his wife and children to affairs of state. He was burdened less by solitude than by his duties as monarch, his official receptions and public appearances. Thus, for example, in February 1917 he wrote to his wife from General Headquarters: 'My mind is at rest here — no ministers and no tiresome questions.'[9] These were the words of the commander-in-chief — a monarch who was responsible for the conduct of the war and the welfare of the state.

Furthermore, as was noted by many of those who knew him, Nicholas was a fatalist, who seemed mystically resigned to his fate. 'He is weak,' said Maria Pavlovna, wife of Nicholas's uncle Grand Duke Vladimir Alexandrovich, and one of the most influential women at court. 'He is a fatalist. When things go wrong, instead of making a decision one way or another, he convinces himself that it is what God has decreed, and so submits himself to God's will!'[10]

'Nicholas II, Tsar of All Rus, supreme commander of fifteen million Russian soldiers, with all the zeal of a supine peasant, chose as his motto "God's Will Be Done,"' wrote Grand Duke Alexander Mikhailovich in his memoirs. '"Nicky, who taught you to yield to God's will in this way? You call it Christianity, but it sounds more like Mohammedan fatalism." "Everything is willed by God," replied Nicky deliberately. "I was born on 6 May, the day dedicated to Job the Long-Suffering. I am ready to accept my fate." These were his final words. Words of warning had no effect on him whatsoever. He went to his death believing that it was God's will — influenced by the example of Job in the Bible: "There was a man in the land of Uz, whose name was Job; and that man was perfect and upright, and one that feared God, and eschewed evil." In everything he did Nicholas II pursued this ideal ... he forgot that he was a monarch.'[11]

The appraisal of Nicholas by the publisher A. Surovin, although caustic, is nonetheless astute: 'Alexander III reined in a Russian thoroughbred. Nicholas II harnessed a nag. He rides around but has no idea where he's going. Perhaps one day he might end up somewhere!'[12]

Nonetheless, the tragedy of the emperor's life in purely human terms should not be forgotten. His only son and heir, Alexei, was afflicted by the terrible illness of haemophilia, which undoubtedly affected Nicholas's actions and played a significant role in the history of Russia. The artist A. N. Benois remembered how he heard the cannon salute that greeted the long-awaited birth of the heir to the throne, on 30 July 1904: like 'millions of my fellow countrymen,' he thought, 'God willing ... let the future sovereign be closer to the ideal of a monarch than his father, who, for all his human qualities and for all his charm had by this time already ceased to be worthy of the love and faith of his subjects. But fate had prepared a terrible, tragic answer to our hopes. The young boy born that day, before dying a martyr's death, was to be the innocent cause of years of unending suffering to his parents. For it was through Alexei's illness that a fateful shadow was cast over the lives of his mother and father: that of Rasputin, the *staretz* who by some magical gift was able to stop the bleeding from which the young boy suffered. And what a bright, happy day that was!'[13]

Pierre Gilliard, tutor to the young tsarevich, who remained with the imperial family almost until the very end, wrote: 'The illness of the heir to the throne dominated the last years of Nicholas II's reign; this illness alone explained all his actions ...'[14]

Nicholas II's wife, Alexandra Feodorovna, whom he loved to the end of his days and to whose will he almost invariably submitted without question, also played a crucial role both in the life of her family and in the fate of Russia. Originally from a small dukedom in Germany called Hesse-Darmstadt, the young Princess Alice of Hesse converted to Orthodoxy on her marriage and took the name Alexandra Feodorovna (she was known as Alix within the family). Everyone was struck by her extreme beauty. M. P. Bok, the daughter of former prime minister P. A. Stolypin, recalled, 'How I admired the young empress, stunningly beautiful in her pale dress, sparkling with diamonds. She was an enchantress from a fairy-tale ... here was true beauty — a Russian tsarina with looks that were worthy of her high position.'[15]

Nicholas II's cousin, Grand Duke Gavril Konstantinovich, describing the procession marking Epiphany on 6 January 1914, observed: 'Alexandra Feodorovna was the very picture of beauty: she was tall, and held her head slightly to one side. There was something sad in her smile ... It was rare to meet such a combination of beauty, breeding and delicate manners.'[16]

Alexandra was a loving wife and a wonderful — though tormented — mother. Nevertheless, as A. A. Mosolov, head of the Ministry of Court, commented: 'Something within her prevented her from becoming a real empress, which was a particular shame since her strong character could have been a great support to the tsar. Alas, the empress's vision was far narrower even than the tsar's, and her influence only served to harm him.' Grand Duchess Elizaveta Feodorovna, on the other hand,

the sister of the empress and wife of Grand Duke Sergei Alexandrovich, 'really became a Russian, after several years spent among Russian souls and Russian habits'. By contrast, Alexandra Feodorovna, 'although she loved Russia, to the very end of her reign ... was unable to understand the Russian soul, and could not inspire the same affection in others as could her sister ...'[17]

Reserved by nature, severe and withdrawn in her dealings with others, Alexandra Feodorovna was happy only when she was with her family. She liked neither court life nor St. Petersburg society. Only in the first years of her marriage did she regularly attend court balls and receptions for the aristocracy; thereafter she gradually began to withdraw from society. She had little idea of how to conduct smalltalk, she could not smile at will or say some kind, flattering but meaningless words. It was not long before she had turned the court against her, as Grand Duke Alexander Mikhailovich describes: 'Ill at ease within the intricate circles of St. Petersburg society, the young empress made mistakes that, while insignificant in themselves, were viewed as terrible crimes by high society. This frightened her and created the extraordinary tension between her and those around her.'[18] Nicholas II took these attitudes to the empress to heart, and very quickly relations between the court and society became severely strained.

The empress's character was observed by the young page B. V. Gerois while serving in the Winter Palace at the time of Nicholas and Alexandra's wedding (he later became major-general of the General Staff): 'At last she arrived with her sister Grand Duchess Elizaveta Feodorovna, who was an absolutely exceptional beauty. Alexandra Feodorovna was beautiful and majestic, too, and resembled her sister closely, but still she took second place. We met them at the doors to the carriage and helped them get out. The bride offered her hand for us to kiss, but with an awkward and embarrassed gesture. A sense of unease was thus the first thing you noticed on meeting the young empress, and this impression she never managed to dispel. She was so obviously nervous of conversation, and at moments when she needed to show some social graces or a charming smile, her face would become suffused with little red spots and she would look intensely serious. Her wonderful eyes promised kindness, but instead of a bright spark, they contained only the cold embers of a dampened fire. There was certainly purity and loftiness in this look, but loftiness is always dangerous: it is akin to pride and can quickly lead to alienation.'[19]

The empress's reserve and her dislike of court life became particularly apparent after the birth of her incurably ill son. The long-awaited heir to the throne was born in 1904, after ten years of marriage and the birth of four daughters in succession. 'Oh God! What a disappointment! A fourth daughter!', wrote Nicholas's sister Grand Duchess Xenia Alexandrovna in her diaries. For Nicholas it was more than a disappointment: four times he had looked forward to a son, and now his hopes were to be dashed by Alexei's haemophilia. By this time

Alexandra Feodorovna was already an ill woman: she had a weak heart, a nervous condition, frequent hysterics and weak legs that prevented her from accompanying her husband and children on their frequent walks. The birth of her sick son only served to plunge her further into despair. She was a mother who knew that she was the cause of her son's illness (the disease being passed down the female line, in this case from Alexandra's grandmother Queen Victoria of England, who passed it on to many of her descendants). She was a mother who heard the cries of her son and saw his suffering, but was unable to do anything about it. Her life was one of unceasing torment and anxiety.

Alexandra gave up believing in conventional doctors, whose remedies provided little relief for her son. Instead she turned to the mysterious *staretz* Grigory Rasputin, who many believed had psychic gifts and who seemed able — even from a distance — to stop the flow of blood from the young tsarevich and end his suffering. This explains the unique power Rasputin had over the empress and, through her, over Nicholas himself. The requests — or, rather, demands — of the *staretz* were met unconditionally. Thus the terrible shadow of Rasputin was cast over Russia.

Seeing the suffering of both his son and his wife, Nicholas II sanctioned Rasputin's visits to Tsarskoe Selo. P. A. Stolypin, according to his daughter, took every opportunity to warn the tsar about Rasputin, but received this reply: 'I agree with you, Piotr Arkadyevich, but better ten Rasputins than one hysterical empress.' Stolypin comments: 'And of course this was the whole point. The empress was ill, seriously so; she believed that Rasputin was the only man on the face of the earth who could help the heir, and it was beyond the strength of mortal man to convince her otherwise. Indeed it was difficult to communicate with her at all ...'[20]

Nicholas's reaction to the situation — and the great love he had for Alexandra — was markedly different from that taken by his great-grandfather, Nicholas I: 'My great-grandfather,' wrote M. P. Bok, 'was for some reason presented to Nikolai Pavlovich [Nicholas I], who asked him, "How is your wife's health?" "Quite well, thank you, your highness, only her nerves give her constant trouble." "Nerves?" exclaimed the Emperor. "The Empress also used to have trouble with her nerves, but I told her to stop it, and she doesn't have any trouble any more!"'[21]

In the words of the Minister of Finance V. N. Kokovtsev, one of the features of the empress's outlook was 'her belief that after three centuries the Russian autocracy was at once unshakeable, indestructible and immutable. She adopted this attitude along with her religiosity, and increasingly it became her political dogma. In her political beliefs the empress was more absolute than the sovereign. She was undoubtedly the inspiration behind the idea of strong or, as they used to say at the time, "firm" leadership; it was as if she provided the emperor with the basis and justification for all his views ...'[22]

It is enough to read Alexandra Feodorovna's letters to her husband to understand that she exercised extraordinary influence over all his actions. Particularly revealing are the letters written during the First World War, at that most difficult moment in Russia's history, when Nicholas was at General Headquarters in Mogilev. A constant refrain throughout Alexandra's letters is the absolute autocracy of the Tsar. 'Do not forget that you are and must remain the autocratic emperor! We are not yet ready for a constitutional monarchy,'[23] she wrote on 17 June 1915, when the question of the introduction of a constitutional monarchy was a pressing concern.

Alexandra had little understanding of what was going on in the country as a whole, and was entirely under the influence of Rasputin and his clique. In her letters that refer to the opinion of 'our friend' (as she called Rasputin), she would demand the appointment of new ministers and the dismissal of those she did not like. Nicholas II could not refuse her and the result was a farcical period of ministerial leap-frog, when practically all the members of the government changed. It should be said that unlike his forebears Catherine II and Alexander II, Nicholas II was unable (or unwilling) to surround himself with intelligent and creative people who might have been able to help him change the course of history. People like S. Y. Witte, P. A. Stolypin, V. I. Kokovtsev and S. D. Sazonov did not remain in their positions long enough, leaving for a variety of reasons. On Rasputin's recommendation they were replaced by comparatively undistinguished and reactionary figures such as I. L. Goremykin, A. F. Trepov, B. V. Shturmer and N. D. Golitsyn.

'Our friend has asked that you close down the Duma,' wrote Alexandra Feodorovna on 14 December 1916, when the monarchy was on the brink of collapse. 'Be Peter the Great, be Ivan the Terrible, be Emperor Paul — smash the lot of them. Do not laugh ... I desperately want to see you act like this with those who are trying to control you. Show them the fist, prove yourself a sovereign; you are the autocrat — and they should not dare forget it.'[24] The hopes of the empress, however, were to be disappointed. Nicholas II — weak-willed and not possessed of a great mind — was not the man to halt the flow of events and strengthen autocratic power. The empress's persistence, in the words of the Minister of Foreign Affairs S. D. Sazonov, was the result of her 'morbid psyche and the fact that she was ... but a weapon in the hands of those shameless people who hid behind her.'[25]

The emperor was head of the large Romanov family, which by 1913 had more than 60 members. Even the majority of the grand dukes realised the necessity of reform and the limiting of absolute power. It was on this matter that the well-known historian and uncle of the emperor, Grand Duke Nikolai Mikhailovich, addressed Nicholas: 'You are on the eve of a new time of troubles; indeed, I would go further — a period when attempts are likely to be made on your life. Believe me, if I put pressure on you to free yourself from the fetters that surround you [the influence of Alexandra Feodorovna], it is only because

of my hope and desire that you should save yourself from the most serious and irreparable consequences.' Grand Duke Alexander Mikhailovich expressed similar sentiments, with equally little result: 'Some force in the country is dragging you, and with you Russia, towards inevitable destruction. Unless you heed the voices of those who know the state in which Russia finds herself, and who advise you to take whatever measures are necessary to lead us away from chaos, the result will be utter despair.'[26]

But Alexandra Feodorovna's influence over her husband did not wane and she continued to stir him on to take a firm line: 'Show them that you are in charge ... The time has passed for humility and mildness, now yours must be a reign of power and strong will! They [the grand dukes] must be taught to obey ... Why do they hate me so?'[27]

'From the very beginning [the empress] misunderstood the situation,' wrote the English ambassador George Buchanan. 'By persuading the emperor to steer the ship of state on a course fraught with difficulties, while the political waters were rising to dangerous heights ... she became the cause of his destruction ... If his wife had been a more far-sighted, more perceptive woman, and if she had understood that such a regime was an anachronism in the 20th century, the history of his reign might have been very different.'[28]

Nicholas II's genuine belief that he was predestined to be autocrat of Russia, that he was anointed by God, meant that he was determined never to give way to anyone. At the same time he was almost slavish in his submission to his wife, who in turn was under the influence of Rasputin and his reactionary group at court (known as the 'camarilla'). In the words of Grand Duke Alexander Mikhailovich, Nicholas II 'was heading towards the abyss, believing that such was the will of God'[29].

However, all the tragic circumstances surrounding the life of the royal family and 'the tragic events in Russian life that rapidly enveloped the reign of Nicholas II could not pierce the thick armour of royal custom, and scarcely affected its strict and measured flow.'[30] Official life at court followed its traditional course, notable as always for its magnificence and luxury.

'Although extremely modest and simple in his private life,' wrote Grand Duke Alexander Mikhailovich, 'the tsar had to ... accede to the demands of etiquette. As ruler of a sixth of the earth's surface he could only receive his guests in an atmosphere of extravagant splendour.' And this, of course, was what most struck foreign diplomats and those with access to court. Describing one of the balls at the Winter Palace, Alexander Mikhailovich continued: 'The immense halls lined with gold-framed mirrors were full to bursting with dignitaries, court officials, foreign diplomats, Guards officers and Eastern potentates. Their dazzling uniforms embroidered with gold and silver provided a sumptuous background for the court dresses and jewels of their ladies. Cavalrymen and Guardsmen in hats with the emblem of the imperial eagle, and Cossacks of His Highness's Convoy in red coats lined the stairway

and the entrance to the Nicholas Hall ... Suddenly the crowd fell silent and the master of ceremonies appeared. He struck the floor three times with his rod to announce the arrival of the royal cortège. The mighty doors of the Heraldic Hall [in fact the Concert Hall] swung open and the sovereign and his wife appeared on the threshold with members of their family and retinue.'[31]

The French ambassador Maurice Paléologue recalls a reception held to mark the visit of the French President Poincaré to St. Petersburg in July 1914: 'At half past seven the ceremonial dinner began in the hall of Empress Elizaveta [in the Great Palace at Tsarskoe Selo]. Such was the magnificence of the uniforms, the richness of the liveries, and the splendour of the attire, such, indeed, was the dazzle and pomp of the whole mighty spectacle, that there was not a single court in all the world to match it. I shall remember the almost blinding radiance of the gems worn by the ladies for a long time to come. This fantastic array of diamonds, pearls, rubies, sapphires, emeralds, topaz and beryl created a vision of light and colour.'[32]

Of course, this was no more than an outsider's view of the Russian court, which had existed in its traditional ceremonial form since the eighteenth century and had remained virtually unchanged throughout the next 200 years. At the same time the court adopted quite readily the innovations of the twentieth century: the telephone, telegraph, cinema, automobiles, electricity and so on.

The compulsory court costumes, particularly the so-called Russian or 'uniform' dresses worn by ladies at balls and receptions were already strictly regimented under Nicholas I in 1834. Their form remained almost unchanged until 1917. Similarly, the uniforms for court dignitaries invited to official ceremonies as well as for court servants, chamberlains, footmen and other officials, were an integral part of the ritual of court life. Also strictly regimented was the circle of people that participated in grand, as well as more informal, excursions by the royal family. On these occasions the royal family would process from their private rooms into the parade halls or to church, and everyone would know exactly with whom and behind whom to walk. Such strictly regimented ceremony also applied to more substantial excursions and other official events: visits to regimental celebrations, especially for those regiments headed by members of the royal family; visits to exhibitions; and the laying of foundations for new churches.

Visits to the Great Church of the Winter Palace on religious festivals (such as Easter and Christmas) were particularly ceremonial occasions. Grand Duke Gavril Konstantinovich, son of Grand Duke Konstantin Nikolaevich, the well-known poet 'KR', wrote in his memoirs about the last of the great excursions at the Winter Palace, which took place on 6 January 1914. Nicholas II and Alexandra Feodorovna came out of their private rooms into the Malachite Hall, and processed to the Great Church (through the Malachite, Nicholas and Heraldic Halls). 'A large screen divided the church. The sovereign, empress and members of the royal family stood behind the screen, everyone else in front. There was no room behind the screen for my brothers and me, since we were the most junior members of the family, so we stood in front alongside the Leuchtenburg and Oldenburg regiments. Two choirs sang, and at the end of the mass the sovereign and empress kissed the cross carried by Metropolitan Vladimir.'[33]

Nicholas and Alexandra were extremely religious; numerous icons hung in their private rooms in all the royal palaces. They were placed on special screens or hung from the walls, and were decorated with Easter eggs on ribbons. As Y. P. Denisov recalls, 'the emperor's carriage in the royal train contained a whole chapel with icons, both large and small, and other religious items ... [the emperor] never missed a single church service.'[34] Alexandra's religious fervour is well documented; she would spend hours on her knees in prayer for the health of her son and family.

Each royal palace had its own self-contained court church, while the Winter Palace, the principal royal residence, had two — the 'Small Church', named after the Feast of the Purification, and the 'Great Church', named after the Saviour Not-Made-With-Hands. The latter was designed by B. F. Rastrelli, and after the fire of 1837 was rebuilt almost without alteration by the architect V. P. Stasov. The church was remarkably elegant, with a dazzling gilded interior centred on a wonderful carved iconostasis.

The Russian monarch was *de facto* head of the Orthodox Church; for this reason the most important religious services were held in the Great Church of the imperial residence. In terms of the wealth of its church interiors, the splendour of its robes and the gem-studded gold and silver of church paraphernalia, the Orthodox Church was no less magnificent than the court itself. Religious services were usually accompanied by singing from the court choir, or occasionally the metropolitan's choir. In the words of M. Paléologue, during the service 'marvellous singing resounded, now deep and powerful, now tender and ethereal. It seemed to reflect better than any words the boundless aspirations of Orthodox mysticism and Slavic sensibilities.'[35]

In the years that followed 1910, however, the luxury and splendour of the Russian court and its church services had begun to wane — mostly because of the war, but also due to the fact that from 1905, the imperial family lived at Tsarskoe Selo, and only came to the Winter Palace to mark special occasions or religious holidays. As M. P. Bok recalled, 'There were no more receptions at court during those years, so I only know of the wonderful balls at the Winter and Anichkov Palaces from accounts of the older generation.'[36]

By way of an epilogue we should return once more to the words of the French ambassador M. Paléologue, who recalled how, a few days after the abdication of Nicholas II (on 2 March 1917), he was walking in the Summer Gardens in St. Petersburg. There he met one of the 'Ethiopians [palace servants] who had so often led me to

the emperor's study. The good-hearted Negro was
dressed in civilian clothes, and was looking very sad ...
he had tears in his eyes ... At that moment when a whole
political and social system was collapsing, he represented
for me the lost world of royal lux· y, the beauty and
splendour of the ceremonial that had been established
under Elizaveta and Catherine the Great — indeed, all
the charm summoned up by those words that now had so
little significance: the Russian court.'[37]

G. N. Komelova

Notes

1 M. Paléologue, *Imperial Russia on the Eve of the Revolution*, Moscow, 1991, p. 146.

2 E. Radzinsky, *The Last Tsar: The Life and Death of Nicholas II*, New York, 1992, pp. 174–5.

3 M. Iroshnikov, L. Protsai, Y. Shelaev, *Nicholas II: The Last Russian Emperor*, St. Petersburg, 1992, p. 504.

4 Grand Duke Alexander Mikhailovich, *Memoirs*, Paris, 1980, p. 178.

5 Diaries of Nicholas II, Moscow, 1991, p. 56.

6 J. Vorres, *The Last Grand Duchess: Her Imperial Highness Grand Duchess Olga Alexandrovna*, London, 1985, p. 67.

7 Grand Duke Alexander Mikhailovich, *Memoirs*, Paris, pp. 174–5.

8 M. Paléologue, *Imperial Russia on the Eve of the Revolution*, Moscow, 1991, p. 391.

9 E. Radzinsky, *The Last Tsar: The Life and Death of Nicholas II*, New York, 1992, p. 176.

10 M. Paléologue, *Imperial Russia on the Eve of the Revolution*, Moscow, 1991, pp. 354–5.

11 Grand Duke Alexander Mikhailovich, *Memoirs*, Paris, pp. 185–6.

12 A. Suvorin, Diary, Moscow, 1992, p. 264.

13 A. N. Benois, *My Recollections*, vol. iv, Moscow, 1980, p. 410.

14 P. Gilliard, *The Tragic Fate of the Russian Imperial Family*, Paris, 1921, p. 14.

15 M. P. Bok, *Recollections of my Father, P. A. Stolypin*, Moscow, 1990, p. 264.

16 Grand Duke Gavril Konstantinovich, *In the Marble Palace: A Chronicle of Our Family*, St. Petersburg, 1993, p. 142.

17 A. A. Mosolov, *At the Court of the Last Emperor*, St. Petersburg, 1992, p. 33.

18 Grand Duke Alexander Mikhailovich, *Memoirs*, Paris, p. 170.

19 B. V. Gerois, *Recollections of My Life*, vol. i, Paris, 1969, pp. 36–7.

20 M. P. Bok, *Recollections of My Father, P. A. Stolypin*, p. 331.

21 M. P. Bok, *ibid*, p. 99.

22 V. N. Kokovtsev, *Recollections of My Past, 1911–19*, Moscow, 1991, pp. 412–3.

23 E. Radzinsky, *The Last Tsar: The Life and Death of Nicholas II*, New York, 1992, pp. 145.

24 E. Radzinsky, *ibid*, pp. 150, 161.

25 S. D. Sazonov, *Memoirs*, Moscow, 1991, p. 367.

26 E. Radzinsky, *The Last Tsar: The Life and Death of Nicholas II*, New York, 1992, p. 158.

27 E Radzinsky, *ibid*, p. 159.

28 G. Buchanan, *Memoirs of a Diplomat*, Moscow, 1881, p. 216.

29 Grand Duke Alexander Mikhailovich, *Memoirs*, Paris, p. 186.

30 Diaries of Emperor Nicholas II, 1890–1906, Paris, 1980 (introduction).

31 Grand Duke Alexander Mikhailovich, *Memoirs*, Paris, pp. 161–2.

32 M. Paléologue, *Imperial Russia on the Eve of the Revolution*, Moscow, 1991, p. 133.

33 Grand Duke Gavril Konstantinovich, *In the Marble Palace: A Chronicle of Our Family*, St. Petersburg, 1993, p. 143.

34 Y. P. Denisov, 'My Recollections of Emperor Nicholas II and Grand Duke Mikhail Alexandrovich'; *Anthology of Russia Abroad*, Moscow, 1991, p. 363.

35 M. Paléologue, *Imperial Russia on the Eve of the Revolution*, Moscow, 1991, p. 264.

36 M. P. Bok, *Recollections of my Father, P. A. Stolypin*, Moscow, 1990, p. 333.

37 M. Paléologue, *Imperial Russia on the Eve of the Revolution*, Moscow, 1991, pp. 461–2.

THE PRIVATE ROOMS OF THE
IMPERIAL FAMILY IN THE WINTER PALACE

The Russian royal family had several residences in and around St. Petersburg. Before becoming tsar, Nicholas lived in the palace at Gatchina and in the Anichkov Palace on Nevsky Prospect in St. Petersburg itself. As a bachelor he occupied four rooms in the Anichkov Palace, but after his marriage to Alexandra Feodorovna these rooms were supplemented by two further apartments, one of which was located in the Winter Palace.

After the unexpected death of Emperor Alexander III at Livadia in the Crimea, it was suggested that Nicholas and his bride should occupy the rooms of the former tsar on the third floor of the Winter Palace. Instead they were provided with apartments on the second floor of the north-western wing with windows overlooking the river Neva and the Admiralty.

According to contemporary accounts, Alexandra Feodorovna's elder sister Elizaveta, wife of Grand Duke Sergei Alexandrovich, organised the selection of these rooms for the tsar and tsarina. With the help of her lady-in-waiting Vasilchikova and General Speransky, Elizaveta chose fourteen rooms on the *bel étage* as well as the first floor of the children's wing. It was also Elizaveta who approved the architect Alexander Feodorovich Krasovsky's plans and sketches for the décor of the royal family's new home.

A. F. Krasovsky (1848–1918) was a well-known St. Petersburg architect and had designed numerous buildings in the city. In 1891 he was appointed Technical Officer of the Court Authority, a position which in effect meant that he was the chief architect at the Winter Palace. He was responsible for much of the renovation work in the buildings of the Hermitage and the Winter Palace. He chose two architects to assist him — N. I. Kramskoi and S. A. Danini — and he also enlisted the help of three artists for the sketches: E. Gruzhevsky, N. Kozlov and D. Kryzhanovsky.

As was the custom in the second half of the 19th century, Krasovsky's designs were based on the drawings of well-known architects from the past. For example, one of the sources for Krasovsky's designs was the work of the 18th century English architects Robert and James Adam. Simulations of their ornamental engravings were made by the artist V. Korenev and draft sketches, including copies of decorations, were presented to Grand Duchess Elizaveta Feodorovna, who then introduced her own changes to the proposals.

Having commissioned plans for the décor, it was decided that the architect N. V. Nabokov, who had earlier created the interiors of the royal yacht *Polar Star* and the tsar's foreign train, should also be responsible for furnishing the royal apartment. Nabokov produced an album of sketches suggesting a range of furniture, vases and light fittings for the rooms.[1] Many of the pages still show the comments made by Elizaveta Feodorovna.

Initially, the royal couple took an interest in the furnishing of their 'flat', as the tsar himself called their rooms. In December 1894 Nicholas and his wife considered materials and furnishings and selected items from their Japanese, Chinese and Indian collections. 'The three of us spent a long time discussing with Speransky,' the tsar wrote in his diary, 'and we finally chose patterns for materials, chintzes and carpets for our rooms in the Winter Palace.'[2] Discussions with Elizaveta Feodorovna continued into the spring and summer, until finally, on 8 November 1895, Nicholas wrote in his diary: 'Went to the Winter where we looked at our rooms with Ella — nearly finished.'[3]

On 30 December 1895 Nicholas II and Alexandra Feodorovna — Alix to her family — left their beloved Alexander Palace in Tsarskoe Selo and headed for St. Petersburg. Nicholas records in his diary: 'From the station at Peter we went straight to our new rooms in the Winter. Prayers were said in the library and all the rooms, both ours and the children's, were sprinkled with holy water. After two hours' work I felt settled and had found a place for all my things ... Read a lot. We dined together. Read some more in the evening. Had a lovely swim in our amazing piscine [swimming pool].' The following day's entry reads: 'We both slept wonderfully in our new home. The sun shone delightfully into my study as I worked in the morning.' On the same day Nicholas went to the Anichkov Palace where, 'We went through our old rooms and collected all our pictures and photographs and anything else left, to take to the Winter. We spent the afternoon in our rooms sorting everything out.'[4]

The royal family passed New Year 1896 settling into their home in the Winter Palace. 'Spent a very pleasant time lounging in the bath and after coffee set about these blasted telegrams,' writes Nicholas. 'The walk-about began at 11.00. This was the first time we had done the New Year's parade together. Alix, thank God, was splendid, putting up with the lunch, the diplomatic reception, the *bezmen* (greeting by proffering her hand) not only of the ladies but also the Council of State, the Senate, the Court and the Retinues. We christened our dining-room with a family breakfast ... Had lunch together and then spent the whole evening hanging up icons in the new icon-case.'[5]

Nicholas established a routine; he received official announcements in the library, where he would also spend the evenings in conversation with those closest to him — his mother, his sister Xenia and her husband Grand Duke Alexander Mikhailovich. During their free time Nicholas II

and his wife would hang photographs in the rooms and arrange souvenirs from foreign travels.

After the January balls, the royal couple continued to decorate their own rooms. Many items were brought from the *serviznaya* (dinner-service store-room) at the Anichkov Palace. By now the billiard room had been fitted with a billiard table, and was christened with a game between N. D. Obolensky, the tsar's brother Mikhail and his sister Xenia's husband. The children's wing on the first floor was renovated at the same time as the *bel étage*, with direct access from Alexandra's rooms to the children's quarters via a connecting staircase. Here hung photographs of Nicholas and Alexandra with their daughter Olga, taken by Pasetti.

The royal couple gradually got used to the necessity of holding grand receptions and balls at the Winter Palace, from which they could escape to their comfortable family nest. Prince S. M. Volkonsky gives a particularly colourful description of the atmosphere at court during those years: 'Who can remember those concert balls? In the doorways between the Concert Hall, where the dancing took place, a nd the Arabian Hall, where the card players gathered, there always sat old ladies-in-waiting, watching, talking, reminiscing and gossiping: faded beauty bedecked with jewels, and esteemed old age with badges of distinction. I always felt that in this part of the Arabian Hall the floor was on fire. Next to the door leading to the dancing in the Concert Hall was another door through to the Malachite Hall, where the royal family took their tea. And this threshold, partitioned off by a glass door, was always a hubbub of agitation, curiosity, even fear. People either sat or slid about in a great hurry. The adjutant or maid of honour would slip past, or the footman would come flying in with a flourishing feather atop his *shako*. At the same time the card-tables were full: epaulettes, bald patches, bare shoulders long past the first flush of youth, Ribbons of St. Andrew and breast medals.'[6]

From the end of the 1890s up until 1904 Nicholas and his family spent the time between autumn and spring at the Winter Palace. Towards the end of the tsar's reign, amidst escalating political and familial difficulties, the royal family chose to make Tsarskoe Selo their permanent residence, although they still visited the Winter Palace for ceremonies and receptions.

After the revolution in 1917, until 1926, Nicholas II's rooms and the other royal apartments at the Winter Palace were transformed into the so-called 'Historical Rooms' of the Museum of the Revolution, where they served as an illustration of the life of the royal family.

In 1926 the former royal rooms became part of the State Hermitage, now one of the world's greatest museums.

Unfortunately, when the rooms began to be used for exhibitions, the original interiors were destroyed, as they were thought to have no artistic value. Only the library and dining-room retain their original features, and the other rooms only show traces of their former décor. However, the rare photographs from the Hermitage collection, as well as archive documents, drawings and plans in this exhibition give an accurate picture of the original architectural and artistic design of the private apartments.

The royal living quarters began with the Malachite Hall, where the family had breakfast and held minor receptions; here, too, courtiers awaited the appearance of the royal couple from their private rooms on ceremonial occasions. In appearance the Malachite Hall has remained unchanged since its creation by the architect A. P. Briullov in 1839.

The Empire Room (no. 103), a drawing-room leading off the Malachite Hall, was so called because it was decorated in the classical style. The lower part of the walls was faced with short wooden panels decorated with gilt rosettes and palm fronds; the upper walls were covered with light silk fabric decorated with stylised palmettes. The finish of the wall panels, the gilt doors and the suite of furniture was the work of the famous firm of N. F. Svirsky. N. V. Nabokov also designed lamps, vases on tripods and furniture for this room. All the furniture was painted white and decorated with relief ornamentation in the empire style with matching upholstery. The upright back of the sofa was divided into three sections, each of which was framed with an ornament of acanthus leaves to reflect the décor of the walls. The overall character of the interior was complemented by bronze chandeliers, various lamps and a vase on a tripod of crystal and bronze made at the Imperial Glass Factory. Only the painting on the ceiling in this room has been preserved to the present day.

The second drawing-room had two different names — the Silver Drawing-Room or the Louis XVI Drawing-Room (no. 104). It too boasts a ceiling painting, by N. A. Alexandrov, with floral garlands typical of the Louis XVI style, and is framed by a cornice by the sculptor P. S. Kozlov. The basic decoration of the room was the work of N. F. Svirsky's firm. Walls were faced with silk fabric and silver fretwork garlands, echoing the gilt décor of the doors which lent the room the title 'silver'.

N. V. Nabokov designed the sofa, armchair, chairs, grand piano and round table with ornamented legs for this room, and, as with the other rooms, he designed the cornices around the windows and the curtains. Svirsky's factory produced the furniture suite based on Nabokov's sketches which included a low sofa notable for its complex curved back decorated with carvings of garlands and bows.

Like the sofa, the chairs of this suite were covered with silk. A large French tapestry with a mythological subject hung behind the grand piano; the grand piano (no. 285), decorated by E. K. Liphart, was a gift from Alexandra Feodorovna to her husband. White marble fireplaces complemented the gentle colour scheme of the room — the work of G. Botte's workshop, based on sketches by Krasovsky. P. Lambin also took part in the decoration of the room by providing paintings contained in panels above the doorways. In addition to the furniture designed by Nabokov, it appears from photographs that the Silver Drawing-Room also contained furniture from the old Winter Palace collections: a red wood secretaire by the French master J. A. Risener and a half-cupboard commode with panels made at the Wedgwood factory at the end of the 18th century. On top of the tables and mantelpieces stood items made of glass, porcelain and precious stones from imperial factories.

The Silver Drawing-Room also contained several glass vases from E. Gallé's workshop, with silver mounts made by craftsmen from the world-renowned jewellers' firm Fabergé. As is well known, the tsarina adored these works; the royal family frequently commissioned pieces including unique, ornately decorated Easter eggs, silver services and other smaller souvenirs. One of the employees of the firm, F. Birbaum, noted that Alexandra Feodorovna always accompanied her commissions with sketches, and would fix the value of the piece in advance. 'It was technically and artistically impossible to create the pieces in the sketches,' he wrote, 'so we would have to resort to various ruses: modifications would be explained by the stupidity of the craftsman, or we would say that the sketch had been lost, etc. As far as the price was concerned, in order not to provoke her displeasure, the pieces would be valued in accordance with her prices. Since all these items were practically worthless, the small loss incurred in their making would be made up for when we received commissions for serious works.'[7]

The third room in the exhibition was originally intended as another sitting-room, but later became Alexandra's study (no. 105). Here was kept the desk on display in the exhibition (nos. 116, 275). Lit by four windows, this corner study was designed in the Rococo style. In accordance with the strict, sometimes ascetic tastes of the tsar's wife, the walls of the study had neither gilt decoration nor extravagant stucco: the wall fabric was golden-yellow in tone and had a delicate design of rosettes on a criss-cross background.

The focus of this room was the white marble fireplace, designed by A. F. Krasovsky and built at G. Botte's workshop. Above the mantelpiece hangs a wooden frame whose rocaille flourishes border a series of mirrors. The painting on the ceiling in the form of floral garlands was the work of N. A. Alexandrov.

The furniture in Alexandra's sitting-room and study was influenced by two different styles: Louis XV and Jacobean. A sofa, a canapé, deep armchairs, tables and jardinière-screens in the sitting-room were built in the Louis XV style. Evidence suggests that the furniture for the study only began to be collected in August 1895. The most unusual of the pieces was the sofa that had a shelf and was decorated with mirrors in intricate rocaille frames.

Photographs from 1917 show a number of paintings on the walls of the study, including portraits of the tsarina's parents, the well-known portrait of Nicholas II by V. A. Serov, and portraits of Maria Feodorovna and Elizaveta Alexeevna. There is a writing desk and a needlework basket, revealing Alexandra's interests, whilst the sofa shelf holds vases and statuettes as well as pieces from a tea service.

Beneath the windows of Alexandra Feodorovna's study, the architect built a small raised platform with parquet flooring and steps; from here the royal couple often admired the view over the Neva. In his diary entry for 4 April 1896 Nicholas II wrote, 'After coffee sat at Alix's corner window and watched an excellent flow of ice.' It is also still possible to see the distinctive autograph of Alexandra Feodorovna scratched with a diamond ring onto the pane of one of the study windows on 17 March 1902.

The royal couple's bedroom (nos. 106–107) adjoined the study. From the original decoration of the bedroom Krasovsky retained the columns that separated off the alcove and the corresponding pilasters on the walls. English cretonne was specially ordered for the walls. Stretched out on frames of Karelian birch, the material decorated the upper section of the walls. The lower part of the walls was faced with Karelian birch, set in rectangular panels culminating in a shelf. Thus the architect combined a classical composition with a favourite Russian resource, Karelian birch.

Elizaveta Feodorovna took special care over the sketches for the bedroom furniture, striving for a sense of stylistic unity throughout the room. The suite of furniture designed by Nabokov was also made of Karelian birch and covered in the same material as the walls. The carved designs of wreaths, ribbons and arrows decorating the bedhead and bedside table echo the Louis XVI style. Yet the whole decorative design of the interior, including the white marble fireplace with its caryatids and relief frieze, is closer to the traditions of Russian classicism. The fireplace was built at Botte's workshop, and the sculpted design of the cornice and the architrave was the work of the firm of Svirsky. In addition to a bed and a pillow basket, the alcove also contained a large case containing icons, hinged icons and Easter eggs. There were also icons on the wall and the shelf — another indication of the extreme religiosity of the royal family.

Portraits of Nicholas II and the children hung on the walls of the bedroom, while on the screen hung a watercolour portrait of Marie-Antoinette and the 'Female Heads'. In front of the screen that separated off the alcove stood some soft armchairs and a small settee, along with children's furniture and a small round table. This part of the room was probably intended for conversations between the parents and their children before they were sent off to their own quarters.

The boudoir next door (no. 108) completed the private apartments of the tsarina, which also included sitting-rooms, studies and a bedroom. Alexandra Feodorovna's boudoir was one of the most elegantly decorated of all the rooms.

The walls were faced with pale lilac striped silk, the tsarina's favourite colour, whilst the ceiling was decorated with paintings of wreaths, and floral garlands incorporating the monogram *AΦ* [AF], created by N. A. Alexandrov. Floral garlands and wreaths were also used in the decoration of the white fireplace and the mirror frames and in the ornamentation of the furniture. The tsarina used to put favourite family photographs and small porcelain vases of flowers on the closet, bookcase and round table. Portraits of the children hung on the walls and a parquet of valuable woods, created by the well-known St. Petersburg factory of N. Tarasov, covered the floor.

In papers held in the archives the tsarina refers to the bathroom as 'the pool', although it did not house a pool. Designed by F. Melzer of the Krasovsky furniture factory, the bathroom walls were lined with tall wooden panels, which, along with the doors, window frames and window sashes, were made of Turkish pine. The door that led from the bathroom to the staircase was mirrored on one side and made of cypress wood on the other; the seat of the lavatory in the bathroom was also made of cypress wood.

Above the wooden facing and the small closets were patterned tiles, provided by Cosse & Dure, suppliers to the Imperial Court, who also produced the Dresden tiles for the bath itself. Floral chintz was draped from the top of the walls. Fortunately much of the décor in the bathroom has been preserved, although now the room also contains display cabinets filled with exhibits from the museum.

Emperor Nicholas II's rooms were situated behind Alexandra Feodorovna's boudoir; they consisted of a study, a corridor, a dressing-room, a library, a billiard room and a reception room.

Nicholas II's study (nos. 109–111) was made up of two inter-connecting rooms, joined by three arches; the room was decorated in the gothic style, very popular at the time. Wood was the main decorative material: wall panels were faced with oak, as were the arches, pilasters and ceiling beams. Shields were installed on the walls between the pilasters; they were covered with canvas and faced with lacquered putty, which was then polished and tinted to the colour of wood. The centrepiece of the study was a ceramic fireplace situated in the pier between the arches; it was decorated with the gryphons of the Romanovs and winding columns.

The door from Nicholas II's study into the corridor room was decorated with an applied metal ornament, recalling the doors in ancient castles. Metal hinges and handles were created at the workshops of Karl Winkler, where two large chandeliers, one candelabra and two cast iron sconces were also manufactured. A large sofa with a tall back and shelf, and leather armchairs with carved backs complemented the gothic style. The simple writing desk with its discreet ornament reveals the frugal tastes of the study's owner, while the piano recalls the tsar's love of music — Nicholas II used to enjoy going to the opera and liked to play duets on the piano with his wife.

For the first time in the Winter Palace it was decided that, in addition to a normal bath, a swimming pool should be built in the emperor's rooms. The construction was carried out by Botte's workshop to a design by Krasovsky. An iron tank was installed into a recess in the floor with concrete walls and a bottom of natural white marble slabs. Eight marble steps led down into the pool. The walls of the room were faced with marble and decorated with 20 pilasters, and the floor surrounding the pool was covered with polished marble decorated with an *à-la-grecque* frieze (with meander ornamentation). F. Melzer's workshop prepared the window frames and sashes of birch wood, while the door was made of birch and lemon wood. P. S. Kozlov decorated the ceiling with a carved ornament of meanders, rosettes and stars in square frames.

Nicholas wanted the walls of the bathroom to be decorated with pictures of naval scenes; the artist P. Lambin, however, was not able to complete the commission on time. The night before the tsar's arrival the architect Krasovsky invited two other decorators to join in; the architect told them, 'Take some white card, think up some imaginary scenes and then paint some seascapes by morning; they can be glued temporarily to the walls.' 'It was already evening,' recalled one of the artists. 'We had to work all night. The pictures had to be made to fit the six ledges, using whatever colours we could find in the workshop. In order to keep ourselves awake we drew pictures of a bottle of vodka, some tea and snacks. Having eaten and drunk in advance, we began to paint scenes of the sea as our imagination led us. By morning the pictures were ready.'[8]

General Speransky, architect and head of the Court Administration, was satisfied with the work and delighted by the artists' fantasies. The scenes were placed on the walls and, thanks to the ingenuity of the architect and the creativity of the artists, the royal inspection went off without a hitch. Later, Lambin's seascapes were installed in Nicholas II's bathroom as intended.

Nicholas II's library (no. 112) is one of the most interesting of Krasovsky's creations. Like the study, the room was decorated in the gothic style, with a carved walnut ornament in a recessed ceiling. The architectural details of the decoration are reminiscent of English gothic monuments. Lancet arches, quatrefoil rosettes and trefoils can be seen on all the elements of the interior. Intricate transoms cover window frames, and the design of the banister and the balustrade around the upper gallery are all inspired by the gothic style. The interior was remarkable for its colour, a result of the dark red stamped leather and gilt paper, which complemented the wood of the doors. Small platforms with oak parquet were built next to the windows of the library, supporting small benches and reading desks. The windows gave out onto magnificent views of the gardens, the Admiralty and the banks of the Neva. At the heart of the library stood the fireplace, designed by Krasovsky. It was finished with coats of arms and other decorative ornaments. The hearth stone, the rear iron plate with the Arms of State in relief, and the trivet were all the work of the factory of F. San-Galli.

The furniture in the library included not only bookshelves, but also large tables, chairs and armchairs. Nabokov made several sketches for tables to be decorated

with the gothic ornament known as 'linen pleats'. These designs, from the album entitled *Sketches for Furniture and Other Decorations for the Rooms of their Royal Highnesses in the Winter Palace*, were approved on 24 August 1895. Nabokov's designs for the chairs were particularly unusual: their backs consisted of a circular cut-out with a mounted cross and ornaments in the form of gothic arches.

From the library one enters the billiard room (no. 113) which was decorated in the classical style. White marble porticoes with Corinthian pilasters framed doors of red wood. The classical appearance of the billiard room was accentuated by the parquet of rare woods, formerly in the Pompeii Dining-Room in the Winter Palace. The repair and finish of the parquet was carried out by Tarasov's workshop. P. S. Kozlov was responsible for the detailed decoration of the door porticoes, the fireplace and the ceiling. Archive photographs show a large billiard table, a leather sofa, Nicholas II's favourite landscapes and various Japanese vases, which stood on the mantelpiece and the shelves.

Beyond the billiard room is the reception room, known as the 'Nicholas II's Reception Room for Ministers' (no. 114). Here, too, the architect used variations of the classical style. All the walls were covered with fabric which served as a backdrop for the paintings of G. Becker, including *The Coronation of Emperor Alexander III and Empress Maria Feodorovna*, dated 1888 (no. 2) and *The Anointing of Emperor Alexander III and Maria Feodorovna*. The leather chairs and armchairs suited the formal purpose of the room, although even here, the tsar put small closets, tables, a screen and other works by eastern craftsmen obtained during his travels in 1890–1. A pair of elephant tusks, the work of Siamese artists, stood next to the fireplace. These pieces gave the room a special flavour: not only was it a chamber for official activities (the reception of ministers), it was also used as one of the royal family's domestic rooms.

The corridor room that shut off the Tsar's quarters led away from the parade halls of the palace to the so-called 'Saltykov Staircase', which served as an official entrance to the royal family's rooms. Designed by N. I. Kramskoi, the staircase walls were decorated with tapestries. Eastern and European vases stood on corbels and marble pedestals.

In addition to the rooms of Nicholas II's private quarters already mentioned, Krasovsky also designed the interior of the Small Dining-Room (no. 115), also known as the 'White Dining-Room'. Here he created another variation of the Rococo, or Louis XV style. For reasons of hygiene, the architect rejected the custom of covering the walls with material; nor did he use the gilt décor traditional for this style. The walls were divided up into large panels which contained tapestries in carved frames with a Rococo ornament of flourishes and shells. Three of the tapestries, representing Asia, Africa and America were part of a series entitled *The Countries of the World*; they were made in St. Petersburg in 1745–7. They portray symbolic female figures set among fantastic animals and plants. Above the fireplace hung *The Swans*, a fine example of Russian applied art of the mid 18th century.

The 18th century English crystal chandelier in the Small Dining-Room was among the original decorations. It contained a cylindrical musical mechanism that played a variety of melodies. Light reflected off its many crystal pendants to fill the whole room. The decoration of the room was the work of craftsmen from the Svirsky factory who prepared panels of lime wood, carved frames for the tapestries and carved the ornamentation on the doors.

The moulding on the walls and ceiling, which contributed to the overall character of the interior, was carried out by P. S. Kozlov. The specially designed parquet flooring was the work of N. Tarasov's factory and the Rococo marble fireplace was supplied by the Botte workshop. Even such decorative details as the window latches and door handles were specially made in the Louis XV style at A. Moran's bronze foundry.

N. V. Nabokov also participated in the furnishing of the Small Dining-Room; he designed the chairs, the dining tables and side tables, as well as the glass display cabinets for the crystal collection. While his chair designs were accepted, the designs for the tables were simplified; on one of the sketches a comment from the architect has been preserved: 'Commission a simple expanding table without a leg under the middle leaf.' Today a table from a later period stands in the middle of the room. Although Nabokov's designs for the glass cabinets were approved, their look was changed somewhat during construction. Practically all of Nabokov's designs contain the printed seal: 'Supplier to the Court of His Highness, N. F. Svirsky. St. Petersburg'.

In his design of the interior of Nicholas II's private apartments in the Winter Palace, A. F. Krasovsky showed himself to be a considerable authority on historical styles. He used examples of artistic interior design that were highly appropriate for the end of the last century, a transitional period in art between the eclectic and the modern.

T. A. Petrova, T. A. Malinina

Notes

1 *Painting on Furniture and Other Decoration in the Rooms of Nicholas II* (album): Russian State Historical Archive (archive 489, list 2, file 509).

2 Diaries of Nicholas II, 1991, p. 59.

3 *Ibid.*, p. 112.

4 *Ibid.*, p. 120; inventory of items from the Anichkov Palace kept in the State Archive of the Russian Federation (archive 601, list 1, file 1706).

5 Diaries of Nicholas II, 1991, p. 121.

6 Prince Sergei Volkonsky, *Memoirs*, vol. ii, Moscow, 1992, p. 115.

7 Notes of François Birbaum, 1919, in *Fabergé: Court Jeweller*, State Hermitage, ex. cat., 1993, p. 453.

8 A. M. Gromov, *Recollections over 50 years*, 1929; manuscript in the Central Library of the State Hermitage, p. 15.

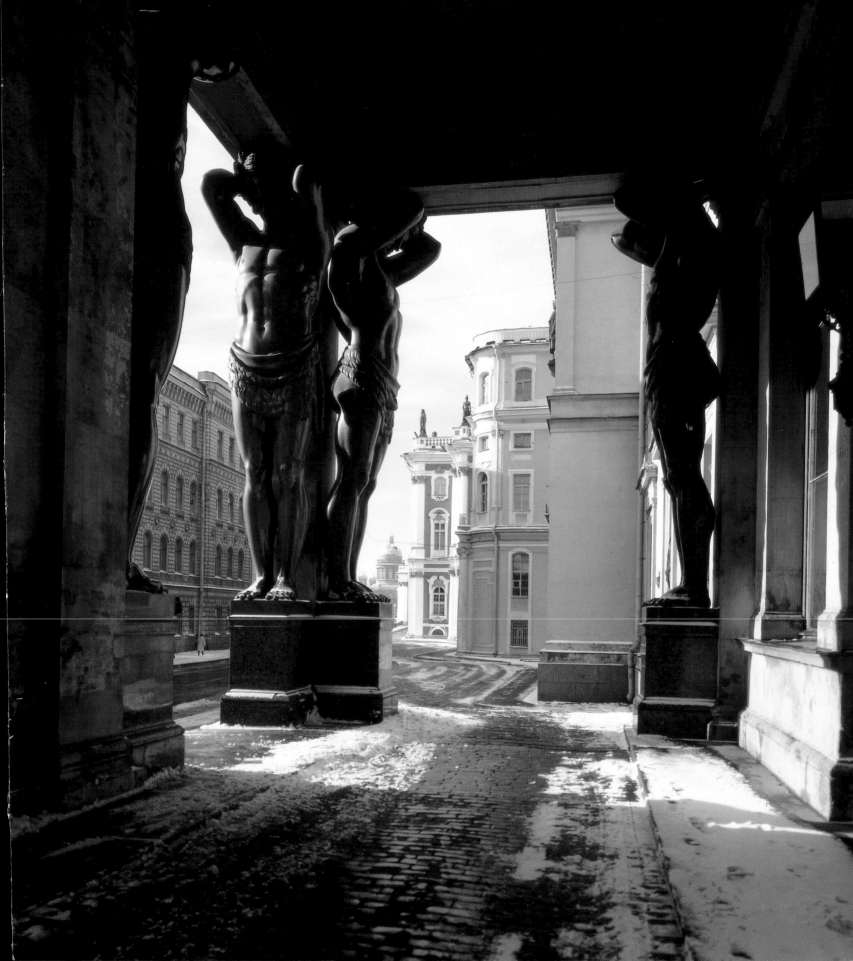

THE STATE HERMITAGE
MUSEUM

Paintings

HEINRICH VON ANGELI

1840–1925

Austrian artist, portraitist.

Studied at the Academies of Art in Vienna and Düsseldorf from 1854 to 1856. Travelled in Belgium and Holland, visited Paris and Berlin in 1863, and Italy in 1871. Member of the Berlin and Munich Academies of Art. Professor at the Viennese Academy of Art from 1876. Undertook numerous royal commissions in Vienna, London and other European cities.

1 Portrait of Grand Duchess Maria Feodorovna, 1874

Signed and dated bottom left: *H.V. Angeli. 1874*
Oil on canvas, 127 × 89 cm
Provenance: Acquired from the Anichkov Palace in St. Petersburg in 1932. ГЭ-6975
Previous Exhibitions: St. Petersburg, 1994, Cat. 1
Literature: Prakhov, 1903, pl. 45; Schmid, 1906, vol. ii, p. 290;
Hermitage, 1981, p. 223; Asvarishch, 1988, No. 249

Angeli was invited to Russia in 1874 to work on portraits of members of the royal family. His first work, a portrait of Maria Feodorovna, was completed at the Livadia Palace (the royal family's residence in the Crimea); Maria Feodorovna gave the portrait to her husband for Christmas in 1875. Angeli later painted a number of portraits based on sketches he had completed at Livadia: in 1875 a portrait of Empress Maria Alexandrovna, wife of Alexander II (of which two versions are now in the Hermitage), and in 1876 a portrait of Alexander II himself (also at the Hermitage). In the 1870s Angeli was at the height of his popularity in Europe. His portraits were much admired and he received commissions from the most eminent patrons in Vienna, Berlin and London. In January 1874 Alexander II's daughter, Grand Duchess Maria Alexandrovna, married Prince Alfred, Duke of Edinburgh, in St. Petersburg. One of the presents the couple received was a portrait of the Crown Prince of Prussia and his wife painted by Angeli. BA

GEORGES BECKER

1845–1909

French artist, historical painter, portraitist.

Born in Paris, studied under G. L. Gérôme. Made his debut at the Paris Salon of 1868. During the 1880s worked in Moscow on his painting *The Coronation of Emperor Alexander III and Empress Maria Feodorovna*.

2 The Coronation of Emperor Alexander III and Empress Maria Feodorovna, 1888

Signed bottom left: *Georges Becker*
Oil on canvas, 108 × 156 cm
Provenance: Acquired from the State Museum of Ethnography of the USSR in 1941. ЭРЖ-1637
Previous Exhibitions: Aarhus, 1990, Cat. 2; St. Petersburg, 1994, Cat. 2

The Coronation of Alexander III and Empress Maria Feodorovna took place on 15 May 1883, a year and a half after the tragic death of Emperor Alexander II. The ceremony took place on a special dais erected in the middle of the Uspensky Cathedral and reached by twelve steps. Two thrones were placed on top of the dais. The emperor's throne was that of Tsar Mikhail Feodorovich, known as the 'Persian Throne'; it was decorated with rubies, sapphires, emeralds and turquoises. The empress's throne, which had belonged to Tsar Alexei Mikhailovich and which was known as the 'Diamond Chair', was studded with large diamonds, pearls and other precious stones.

The artist has captured the culminating moment of the coronation, as Alexander III and Maria Feodorovna rise from their thrones. Their ermine robes are decorated with gold embroidered eagles, and they wear diamond crowns and the diamond insignia of the Order of St. Andrew the First-Called. The emperor takes the imperial sceptre from the hands of Metropolitan Isidor as a symbol of power. He wears the uniform of a general with aiguillettes of an adjutant-general; the chain of the Order of St. Andrew the First-Called hangs on his chest, and he wears the ribbon of the Order of St. Vladimir across his shoulder. Maria Feodorovna wears a white brocade dress with the ribbon of the Order of St. Catherine. Behind the emperor stand his assistants, Grand Dukes Vladimir and Alexei Alexandrovich, and behind the empress Grand Duke Sergei Alexandrovich and the Danish Prince Valdemar. The Commander of the Horse-Guards Regiment, General N. N. Shipov, stands between the thrones with a drawn broadsword and a helmet in his left hand. On the steps below stand the Horse-Guardsmen, also with drawn broadswords. Adjutants-General Count D. A. Milutin and Prince V. A. Menshikov stand on the upper steps, the former with the sword of state, the latter with the banner of state. Members of the royal family stand on top of the platform; among them the Tsarevich Nikolai Alexandrovich, Grand Duke Georgy and Grand Duchess Xenia stand to the right of Maria Feodorovna. Field Marshals Grand Duke Nikolai Nikolaevich and Grand Duke Mikhail Nikolaevich hold Marshals' staffs. The ceremony was attended by numerous heads of state from European countries as well as members of governments and ambassadors of Eastern and Western powers. To the left of the sovereign stand the ministers and members of the Council of State, military and state dignitaries in parade uniforms and dresses, each corresponding to their rank and title. Twelve hierarchs of the Russian Orthodox Church took part in the ceremony. They are dressed in golden vestments, with Metropolitan Isidor of St. Petersburg at their head.

The ceremony of the coronation was followed by the holy liturgy, the anointing, and the procession of the emperor to the altar for the Eucharist. At the end of the prayers the choir sang 'Many Years' three times, after which the imperial couple left the cathedral. They emerged to the sound of gun salutes and the ringing of church bells throughout Moscow. AP

I

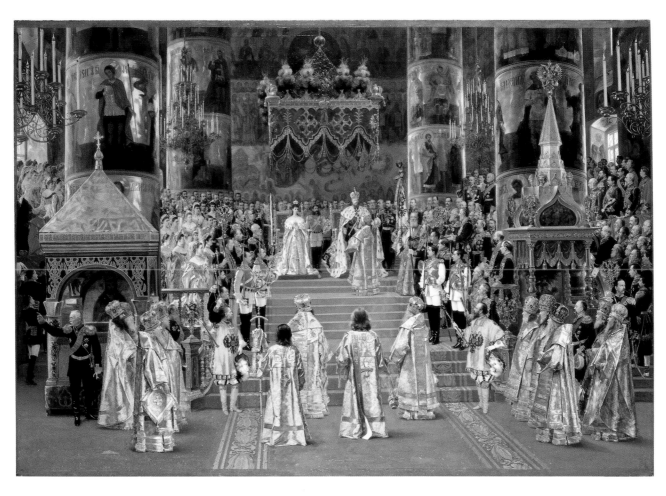

2

NIKOLAI BEKKER

Russian artist of the first half of the 20th century.

3 Portrait of Prince F. F. Yusupov,
Count Sumarokov-Elston, 1914

Signed and dated below: *Н. Беккеръ 1914 г. Кореизъ* [Koreiz]
Oil on canvas, 70.2 × 50.8 cm
Provenance: Acquired from the State Museum of Ethnography of the USSR in 1941;
previously in the collection of the princes Yusupov in St. Petersburg. ЭРЖ-264
Previous Exhibition: St. Petersburg, 1994, Cat. 3

Prince Felix Felixovich Sumarokov-Elston (1856–1928) was
educated at the Corps des Pages, and from 1876 he served as
cornet in the Odessa Lancers Regiment. In 1879 he was seconded
to the Horse-Guards Regiment, which he commanded from 1904
to 1908. In 1905 he was promoted to the rank of major-general
and was appointed to the emperor's retinue, an event recorded
in Nicholas II's diary. After his marriage to lady-in-waiting Z. N.
Yusupova, whose family had no male heirs, Sumarokov-Elston
was given permission to adopt the name of Prince Yusupov.
He is portrayed in the uniform of the Horse-Guards Regiment
as adjutant-general of His Imperial Highness's Retinue. AP

NIKOLAI PETROVICH BOGDANOV-BELSKY

1868–1945
Russian illustrator, portraitist and genre painter.
Studied at the icon-painting workshops of the Trinity St. Sergei Monastery,
and then at the Moscow Institute for Painting, Sculpture and Architecture
under V. E. Makovsky, V. D. Polenov and I. M. Pryanishnikov. Between 1884
and 1889 studied at the Academy of Arts; awarded the Silver Medal. After 1895
studied under I. E. Repin and later in Paris. In 1890 joined the Association
of Travelling Art Exhibitions. Member of the Academy of Arts from 1903 and
Fellow from 1914. Exhibited in Paris and New York.

4 Portrait of Adjutant-General P. P. Gesse, 1904

Signed and dated bottom right: *Богдановъ-Бельский. 1904 г.*
Oil on canvas, 167 × 112.5 cm
Provenance: Acquired from the State Museum of Ethnography of the USSR in 1941.
ЭРЖ-1741
Previous Exhibition: St. Petersburg, 1994, Cat. 5

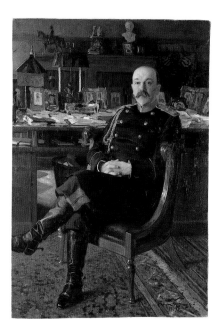

Piotr Pavlovich Gesse (1846–1905) was the younger son of
Adjutant-General and Governor of Kiev P. I. Gesse. He served
during the Russo-Turkish War of 1877–8. Alexander III
appointed Gesse commander of the Combined Guards and
Infantry Regiment, a post he held from 1884 to 1888. In 1896
he became Court Commandant, charged with providing personal
protection for Emperor Nicholas II. The regimental commander
and officers of the Emperor's Guard were housed in barracks
by the Commandant's Entrance at the Winter Palace. Gesse
is portrayed in his study at the Winter Palace. AP

NIKOLAI KORNILEVICH BODAREVSKY

1850–1921
Russian artist, portraitist, genre painter, and historical illustrator.
Studied at the Academy of Arts between 1869 and 1873. Awarded the title of
First Class Artist in 1875. From 1880 took part in exhibitions of the Association
of Travelling Art Exhibitions. Academician from 1908. Had his own exhibition
in St. Petersburg in 1913.

5 Portrait of Empress Alexandra Feodorovna, 1907

Signed and dated bottom left: *Н. Бодаревскій. 1907. Царское Село* [Tsarskoe Selo]
Oil on canvas, 268 × 135 cm
Provenance: Acquired from Pavlovsk Palace Museum in 1959. ЕД-635-Х
Previous Exhibitions: St. Petersburg, 1994, Cat. 6
From the State Palace Museum, Tsarskoe Selo

Alexandra Feodorovna (1872–1918) was born Alice-Victoria-
Helena-Louisa-Beatrice, Princess of Hesse-Darmstadt, daughter
of Grand Duke Ludwig IV and Grand Duchess Alice. She spent
her childhood at the court of her grandmother, Queen Victoria
of England. She graduated from Heidelberg University with a
degree in philosophy. She first visited Russia at the age of twelve
for the wedding of her elder sister Grand Duchess Elizaveta
Feodorovna, and the young princess made a deep impression
on the heir to the Russian throne. Despite the initial objections
of his parents, Nikolai Alexandrovich gained their consent to
the marriage, and the engagement was announced in the spring

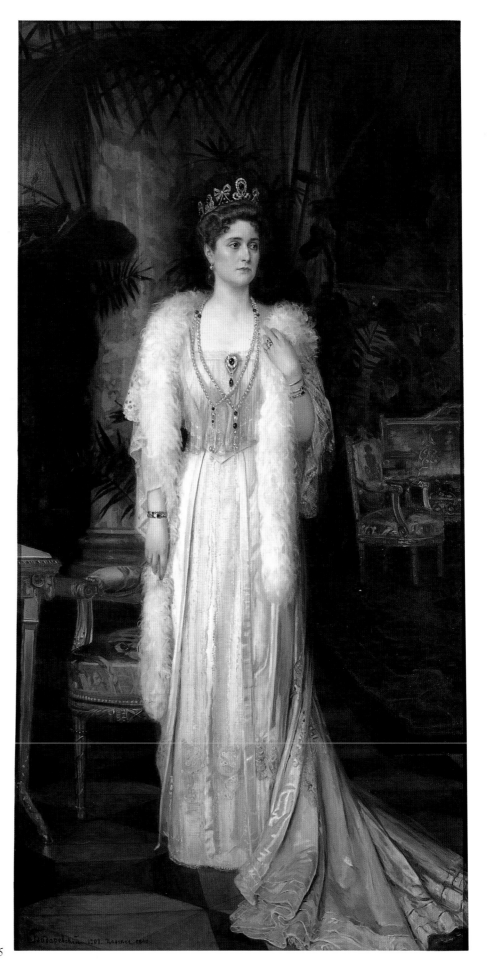

5

of 1894. In autumn of the same year, after Emperor Alexander III fell seriously ill, Alice was summoned urgently to Russia. Notwithstanding the period of mourning after his death, the wedding of Alice and Nicholas II took place on 14 November; the Princess of Hesse became Empress of Russia. After converting to Russian Orthodoxy, she took the name Alexandra Feodorovna. A year and a half later the coronation took place in the Uspensky Cathedral of the Moscow Kremlin. Pierre Gilliard, French tutor to the royal children, wrote in his memoirs, '[Alexandra] had to get used to her position in Europe's most resplendent court, a place rife with the intrigues and rivalries of its competing circles ... Little wonder that she felt herself ill prepared for her new responsibilities.' (Gilliard, 1921, p. 47.) Those at court considered the young empress beautiful but cold: 'When she saw that she was misunderstood, it was not long before she withdrew into herself. Her natural pride was wounded and increasingly she avoided celebrations and receptions, which she found an intolerable burden. She was overcome with a sense of constraint and estrangement.' (Gilliard, 1921, p. 48.)

The birth of her children and the care they demanded helped the empress in her solitude. Olga was born in 1895, Tatiana in 1897, Maria in 1899, and Anastasia in 1901. 'Nicholas II was an extraordinarily tender and loving father: he lived for his children and was proud of them ... The emperor did not simply love his wife — he was in love with her, even to the extent of feeling jealous of those things, pastimes and people that dragged her attention away from him.' (Mosolov, 1992, pp. 78, 79.) When the long-awaited heir to the throne, Alexei, was born on 12 August 1904, the joy of the family was complete. It soon emerged, however, that he suffered from haemophilia. The empress, fearing for the life of her son, began to find solace in religion. Her religiosity sometimes verged on mysticism, and soon religious wanderers and charlatans began to appear at court. Among them was Rasputin, who was destined to play a tragic role in the lives of the last of the Romanovs. Society could not excuse his influence on the empress. Her beloved sister, Grand Duchess Elizaveta Feodorovna, tried to open the empress's eyes to the true nature of the *staretz* (monk) but was met with a cool rebuff. Nevertheless, even someone as critical of the royal family as A. F. Koni, the well-known lawyer and chief procurator of the Senate, could not bring himself to be too critical of the empress. He understood her maternal instincts, and he blamed the influence of Rasputin on 'the servility and loutish intrigues of those at court, for his was but the cunning echo of their own lust.' (Koni, 1989, p. 114.)

The imperial family's main residence was at Tsarskoe Selo; they spent their summers at Peterhof, in the discreet palace called Alexandria. According to the memoirs of M. P. Bok, daughter of P. A. Stolypin, the palace was reminiscent of the dwelling of a fairly wealthy landowner. Receptions at the Winter Palace were rare, but without exception all who attended noticed that the empress, although strikingly beautiful in her diamond-studded dresses, found her social duties quite distressing. A. F. Koni, describing a reception in the George Hall of the First State Duma, comments: 'Alexandra Feodorovna wore her usual frosty look, with that bitter, dissatisfied turn of her mouth.' (Koni, 1989, p. 103.)

Of all that was said about Alexandra, there could be no doubting her strength of feeling for her family: 'Princess Alice of Hesse, who became Russian Empress three weeks after the sovereign's accession to the throne, was Nicholas II's closest friend and faithful spouse throughout her life, in good times and bad. Their marriage was unfailingly happy, and the family life of the sovereign was darkened only by the illnesses of his children. The emperor's wife, who shared her husband's view of the world entirely, rarely involved herself in the affairs of state until the final difficult years of his reign.' (Oldenburg, 1897, p. 45.) LB

6 Portrait of Empress Alexandra Feodorovna, 1907

Signed and dated bottom left: *Н. Бодаревский. 1907 г. Царское Село 15 мая* [Tsarskoe Selo, 15 May 1907]
Oil on canvas, 67 × 49.5 cm
Provenance: Acquired from the State Museum of Ethnography of the USSR in 1941. ЭРЖ-647
Previous Exhibition: St. Petersburg, 1994, Cat. 7.
AP

NARKIZ NIKOLAEVICH BUNIN

1856–1912

Russian artist, water-colourist, military painter, genre painter. Part-time student at the Academy of Arts between 1881 and 1887. Lecturer at the Academy of Arts from 1891. Exhibition dedicated to Bunin's work in St. Petersburg in 1913.

7 Sentinel of the Life-Guard Horse Regiment in the Winter Palace, 1889

Signed and dated bottom left: *Н. Бунинъ 1889 г.*
Oil on canvas, 35.4 × 25.4 cm
Provenance: Acquired from the Leningrad Artillery Museum in 1951. ЭРЖ-774
Previous Exhibitions: Paris, 1989, Cat. 224; Aarhus, 1990, Cat. 5; St. Petersburg, 1994, Cat. 10

In his cycle 'A Soldier's Sonnets', Grand Duke Konstantin Konstantinovich dedicates one of his poems to the sentinel:

Taken from the plough, yesterday's dweller of the fields,
Now you are a private standing guard,
Vigilant, a symbol of patience,
Unwavering, powerful and strong of spirit,
Let winged messenger stand before you
And command you to leave your post —
You would not heed: only your sovereign
By whose word you stand here, sentinel ...
(K. Romanov, 1991, p. 155.)

The sentinel is portrayed in the so-called 'court uniform' of the Life-Guard Horse Regiment. AP

8 Emperor Nicholas II Presenting the Colour to the 145th Novocherkassk Infantry Regiment, 1900

Signed and dated bottom left: *Н. Бунинъ 1900 г.*
Oil on canvas, 75.5 × 116.5 cm
Provenance: Acquired from the Leningrad Artillery Museum in 1951. Эзн.-пр. 963

The Novocherkassk Infantry Regiment was formed in 1796. At the time of the coronation of Nicholas II, the commander-in-chief

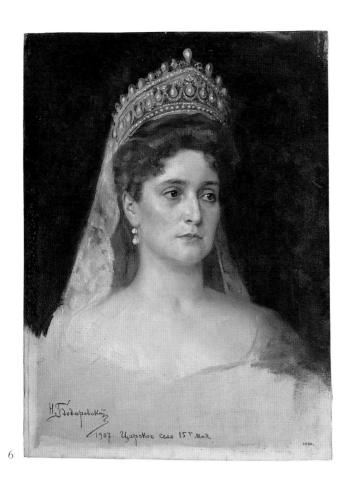

6

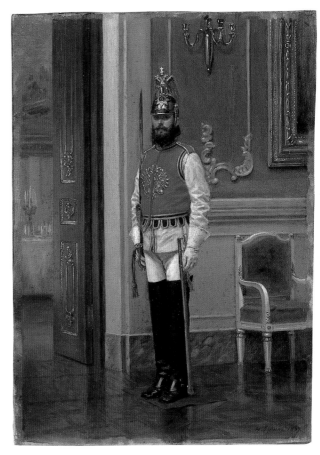

7

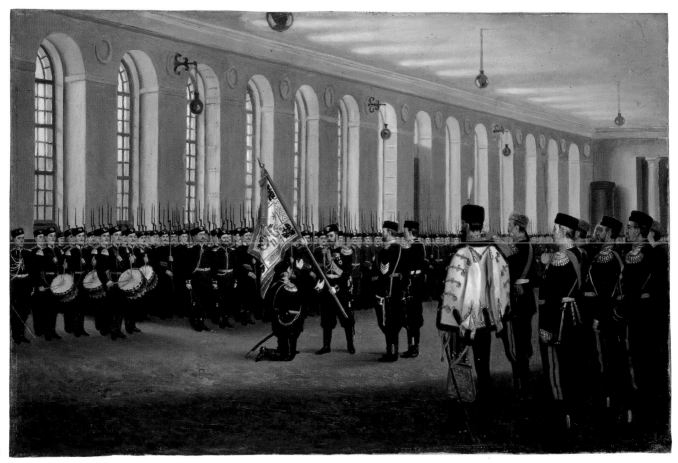

8

was still officially considered to be his father, Emperor Alexander III. In 1900 a new colour was adopted, with an image of the Saviour Not-Made-with-Hands.

The history of the regiment dates from 1796, when the Tomsk Musketeers Regiment was formed from the Ekaterinburg and Semipalatinsk Field Battalions. In 1863 two of the battalions of the Tomsk Musketeers Regiment formed the Novocherkassk Infantry Regiment. From 1866 the commander-in-chief of the regiment was Grand Duke Alexander Alexandrovich, later heir to the throne and then Emperor Alexander III. On the occasion of the regiment's centenery on 29 November 1896, Nicholas presented the regiment with a celebratory Colour of St. George bearing the following inscription: *For the pacification of Transylvania in 1849 and for Sevastopol in 1854 and 1855*, and the centenary dates *1796–1896*.

Nicholas II is portrayed handing over the colour to the regimental commander (colours were usually kept in the War Gallery of the Winter Palace). The Novocherkassk Regiment was quartered on the Vyborg Side in St. Petersburg, a place marked today by Novocherkassky Prospect. GV

LOUISE-ÉLISABETH VIGÉE-LEBRUN
1755–1842
French artist and portrait painter.
Studied in Paris under her father L. Vigée, J.-B. Greuze, J. Vernet, and G. F. Doyen. Worked in Paris, Italy, Austria, Germany, England, Sweden, and in Russia from 1795 to 1801. A member of the Paris, St. Petersburg and other European Academies.

9 Portrait of Grand Duchess Elizaveta Alexeevna, 1798

Oil on canvas, 80 × 65 cm
Provenance: Painted by commission of Grand Duchess Elizaveta Alexeevna in 1798; kept at the Winter Palace until 1918 . ГЭ-7615
Previous Exhibition: Tokyo, 1994, No. 49
Literature: *Souvenirs de Mme Louise-Élisabeth Vigée-Lebrun*, 1835, vol. ii, p. 300; Dussieux, 1856, No. 909; Vrangel, 1911, pp. 25, 76; Nolhac, 1912, p. 199; Reau, 1924, p. 298; Nicolenco, 1967, pp. 98,.109–10, Nos. 32a, 32b, 32d, 32e; Nemilova, 1975, p. 440; Nemilova, 1982, No. 90; Nemilova, 1985, No. 323

Grand Duchess Elizaveta Alexeevna (1779–1826) was born Princess Louisa-Maria-Augusta, the third daughter of Carl Ludwig, Margrave of Baden. In 1793 she married the heir to the Russian throne, Grand Duke Alexander Pavlovich, later Emperor Alexander I (from 1801).

This portrait was commissioned by Elizaveta Alexeevna as a gift for her mother, Amalia, Margravine of Baden. However, it remained at the Winter Palace and at the turn of the 20th century hung in the private study of Empress Alexandra Feodorovna. ED

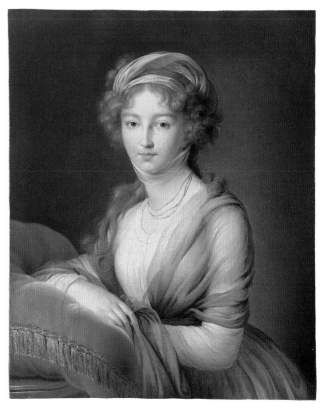

9

P. VOSNOVSKY
Russian artist of the first half of the 20th century.

10 Portrait of Grand Duke Vladimir Alexandrovich, 1903

Signed and dated right side: *П. Восновский 1903*
Oil on canvas, 72 × 89 cm
Provenance: Acquired from Pavlovsk Palace Museum in 1959; previously at Gatchina Palace. ЕД-312-Х
Previous Exhibition: St. Petersburg, 1994, Cat. 11
From the State Palace Museum, Tsarskoe Selo.

Grand Duke Vladimir Alexandrovich (1847–1909) was the third son of Alexander II and uncle of Nicholas II. He was general of the infantry, adjutant-general, commander-in-chief of the Military Guard and the St. Petersburg Military District from 1884 to 1905, a member of the Council of State, senator, honorary member of the Academy of Sciences and president of the Academy of Arts.

'Handsome, well-built ... with a voice that reached to the furthest recesses of the clubs he frequented, a great lover of hunting and unparalleled gourmet (he possessed a rare collection of menus with his own observations made immediately after each meal), Vladimir Alexandrovich was a man of undeniable authority. No one ever dared to disagree with him, and it was only in private conversation that the grand duke allowed himself to be gainsaid. As president of the Academy of Arts he was a dedicated patron of all the arts and often received talented artists at his palace. In the presence of Vladimir Alexandrovich Nicholas II was overcome with a timidity that almost made him ill.' (Mosolov, 1992, p. 125.)

Grand Duke Vladimir is here portrayed in the uniform of an adjutant-general of His Imperial Majesty's Retinue. LB

10

FIRS SERGEEVICH ZHURAVLEV

1836–1901

Russian painter, portraitist and genre painter.
Studied at the Academy of Arts from 1855 to 1863. Left the Academy along with twelve other students in 1863. Academician from 1874. Exhibited with the Association of Travelling Art Exhibitions, as well as in Paris and Philadelphia.

11 Portrait of Empress Maria Alexandrovna, 1870s

Signed bottom left: Ф. Журавлевъ
Oil on canvas, 78.8 cm × 66 cm (oval)
Provenance: Acquired from the State Museum of Ethnography of the USSR in 1941. ЭРЖ-637
Previous Exhibitions: Aarhus, 1990, Cat. 8; St. Petersburg, 1994, Cat. 13

Maria Alexandrovna (1824–80) was born Maximiliana-Wilhelmina-Augusta-Sophia-Maria, the daughter of Grand Duke Ludwig II and Grand Duchess Wilhelmina-Louisa of Hesse-Darmstadt. Having lost her mother at the age of nine, she and her brother were brought up by a governess at the castle of Jugendheim near Darmstadt. In 1841 the princess came to St. Petersburg and converted to Orthodoxy, taking the name Maria Alexandrovna. On 14 April 1841 she married the heir to the throne (the future Alexander II), and in 1855 Maria Alexandrovna became empress. Following the example set by Maria Feodorovna, wife of Paul I, Maria Alexandrovna was patron of numerous charitable organisations in Russia, including the Red Cross. On her initiative schools were set up in various towns around the country, as well as church schools for girls. The frailty of her health meant that Maria Alexandrovna spent her last years in virtual solitude and took little part in court life.
AP

ANDREI ANDREEVICH KARELIN

1866–after 1911

Russian painter and portraitist.
Studied at the Academy of Arts from 1883 to 1885. Honorary lecturer at the Academy from 1892.

12 Portrait of Metropolitan Antony, 1911

Oil on canvas, 140 × 108.5 cm
Provenance: Acquired from the State Museum of Ethnography of the USSR in 1941; formerly held in the Archives of the Alexander Nevsky Monastery. ЭРЖ-701
Previous Exhibition: St. Petersburg, 1994, Cat. 14

Antony (1846–1912), metropolitan of St. Petersburg and Ladoga, was born Alexander Vasilievich Vadkovsky. He was educated at the Tambov Holy Seminary and the Kazan Church Academy, from where he graduated in 1870, and where he remained a lecturer. He took holy orders in 1883, and was later appointed archimandrite of the Monastery of St. John in Kazan. In 1887 he became rector of the St. Petersburg Church Academy and was elected to the bishopric. He became bishop of Vyborg and, in the same year, was appointed head of the newly formed Finland Eparchy [Diocese]. From 1898 he was metropolitan of St. Petersburg and Ladoga. In 1900 he was the first to be elected to the Holy Synod and in 1906 was chosen as a member of the Council of State. Metropolitan Antony was made a Doctor of Theology for his various academic achievements. AP

11

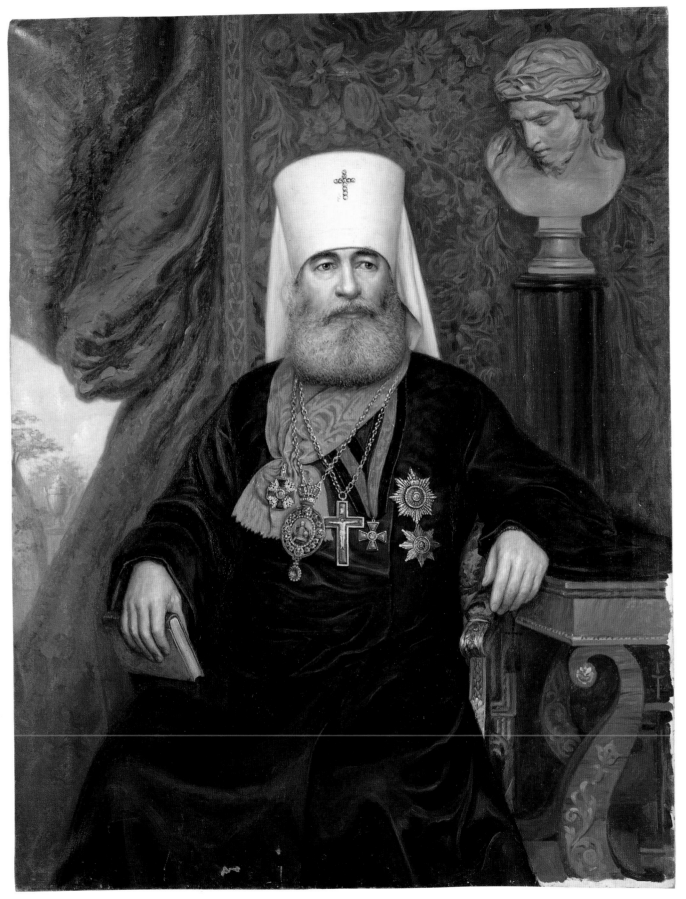

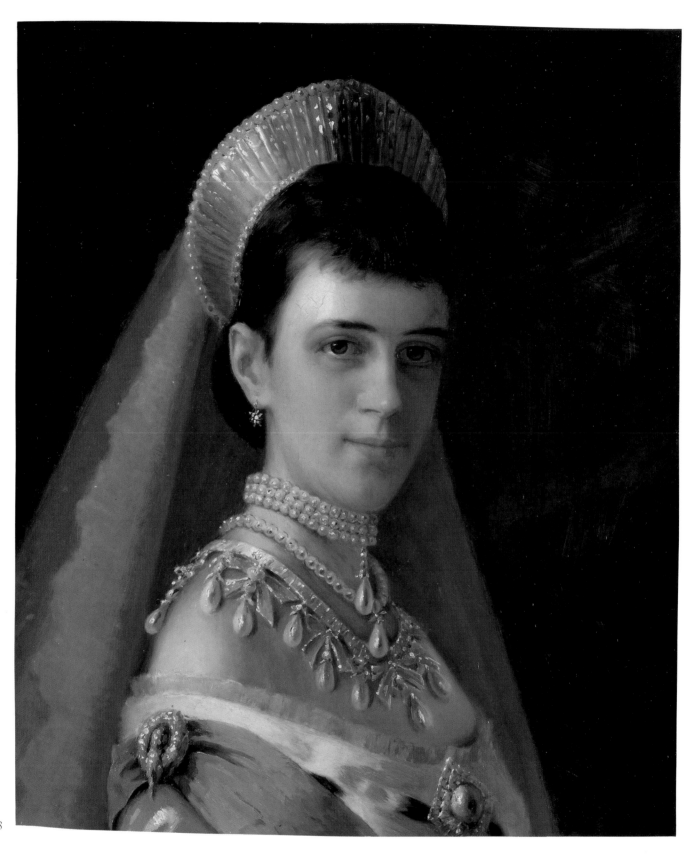

13

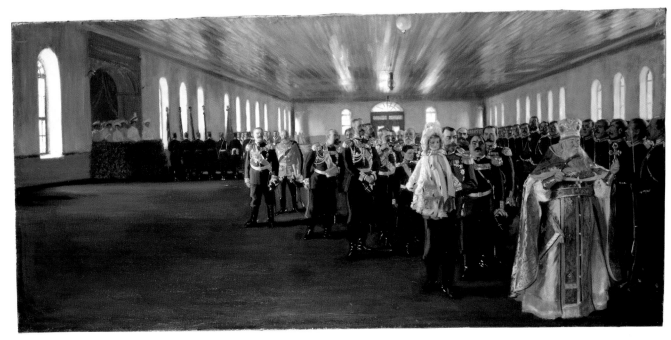

14

IVAN NIKOLAEVICH KRAMSKOI

1837–87

Russian painter, draughtsman, portraitist and genre painter.
Studied at the Academy of Arts under A. T. Markov. Left the Academy with
twelve fellow students in 1863 to form an artists' cooperative. In 1871 was one
of the founders of the Association of Travelling Art Exhibitions. Took part
in the World Fair in Paris in 1871. In 1883 attended the coronation of Emperor
Alexander III in the Uspensky Cathedral in Moscow. His sketches formed
the basis of an album celebrating the event.

13 Portrait of Empress Maria Feodorovna in a pearl head-dress,
1880s

Oil on canvas, 55 × 47 cm
Provenance: From the original Hermitage collection. ЭРЖ-2777
Previous Exhibitions: Paris, 1989, Cat. 238; Aarhus, 1990, Cat. 10; St. Petersburg,
1994, Cat. 15

'The initial impression of the Dowager Empress was one of
wonderment at how such a tiny figure could constitute such royal
majesty. Affectionate, kind and simple in her manner, Maria
Feodorovna was an empress from top to bottom; she combined
her sense of majesty with such goodness that she was adored
by all who were close to her.' (Bok, 1990, p. 212.) AP

BORIS MIKHAILOVICH KUSTODIEV

1878–1927

Russian painter, draughtsman, stage designer and portraitist.
Studied under I. E. Repin at the Academy of Arts from 1896 to 1903; took part
in sketches of portraits for Repin's painting *Council of State*. Member of the
Union of Russian Artists from 1907 and Academician from 1909. In 1911 joined
the group of artists known as the 'World of Art'. His self-portrait of 1912 hangs
in the Uffizi Gallery in Florence.

14 Church Parade of the Life-Guard Finland Regiment, 1906

Signed bottom left: Б. Кустодиевъ
Oil on canvas, 80.5 × 169 cm
Provenance: Acquired from the State Museum of Ethnography of the USSR in 1941.
ЭРЖ-163
Previous Exhibition: St. Petersburg, 1994, Cat. 16

The Life-Guard Finland Regiment was formed under Alexander I
in December 1806. The regiment served in the wars against
France of 1807 and 1812, in the campaigns of 1813 and 1814,
and in the Turkish campaign of 1877–8. The Finland Regiment
received special recognition for its performances in battle: the
Regimental Colour of St. George, silver trumpets, cap badges
and so forth. On 30 July 1904, the day on which Grand Duke
Alexei Nikolaevich was born, Emperor Nicholas II sent the
following telegram to the regiment: 'God has sent us a son and
heir, and the loyal Finland regiment a new commander-in-chief.
I send you my heartiest congratulations.'

The painting portrays the ceremonial presentation of the new
commander-in-chief to the Finland regiment, which took place
in the Great Riding School at Tsarskoe Selo on 12 December
1905. Present were Emperor Nicholas II, Grand Dukes Nikolai
Nikolaevich (the younger), Mikhail Alexandrovich, Dmitry
Pavlovich, Empress Alexandra Feodorovna, the grand duchesses
and other members of the royal family. The commander of
the regiment, Major-General P. M. Samgin, stands alongside
Nicholas II. The service was conducted by the presbyter of
the military and naval clergy, A. A. Zhelobovsky. Nicholas II
is carrying the tsarevich in his arms.

The following description of the event comes from the diary of
Nicholas II: 'Monday 12 December. A religious ceremony took
place at 10:30 in the exercise ring: present were the first company
of the Corps des Pages, the Finland Regiment and a platoon
of the Volynsky Regiment. Alexei also took part and behaved
himself very well. When the priest sprinkled holy water on the
men, I took Alexei in my arms and walked along the front rank.
It was the first time that the Finns and their commander-in-chief
had met each other.' (Diaries of Nicholas II, 1991, p. 244.) AP

ERNST KARLOVICH LIPHART
1847–1932

Russian painter, draughtsman, engraver.

Lived in Italy and studied under F. von Lenbach from 1863 to 1873; in 1873 studied under J. Lefèvre; exhibited at the Paris salons. Came to St. Petersburg in 1886 and taught at the Drawing School of the Society for the Promotion of the Arts until 1895. Academician from 1893. Appointed Fellow of the Academy of Arts in 1902, and from 1906 worked as a curator at the Hermitage. Discovered Leonardo's *Benois Madonna*, which the museum acquired with his assistance in 1914.

15 Portrait of Emperor Nicholas II, 1890s

Signed bottom right: *Липгартъ*
Oil on canvas, 292 × 153 cm
Provenance: Acquired from Pavlovsk Palace Museum in 1959. ЕД-626-Х
Previous Exhibition: St. Petersburg, 1994, Cat. 19
From the State Palace Museum, Tsarskoe Selo

Nicholas II (1868–1918) was the eldest son of Emperor Alexander III. After a general legal and military education, he gained practical experience of military affairs when he served in the Life-Guard Preobrazhensky and Hussar regiments, and took part in drills and parades in Krasnoe Selo. He reached the rank of colonel of the Russian Army, a title he retained until the end of his life.

As heir to the throne, Nicholas had little involvement in the affairs of state, although he was chairman of the Committee for the Construction of the Great Siberian Railroad. Only in 1893 was he allowed to attend sessions of the Council of State and the Committee of Ministers.

On the death of Alexander III in 1894 Nicholas acceded to the Russian throne. His coronation as Emperor Nicholas II took place on 14 May 1896 in the Uspensky Cathedral of the Moscow Kremlin. Emperor at the age of 26, Nicholas did not have enough experience of affairs of state, nor did he know how to treat his subjects. Indeed, as was noted by those who knew him well, his character was not yet fully formed: 'By nature Nicholas II was extremely shy. He did not like to argue, partly through a lack of self-confidence, and partly through a fear that he might be proved wrong or that others would perceive the error of his opinions. He realised that he was incapable of defending his own point of view, and found the idea of this quite demeaning.' (Mosolov, 1992, p. 72.) Almost all his contemporaries agreed that 'Emperor Nicholas — and even his enemies admitted this — had enormous personal charm.' (Oldenburg, 1991, p. 38.)

V. N. Kokovstev, who occupied various posts in government from 1896, was often in close contact with Nicholas II. This is how he described him in a letter to the French ambassador M. Paléologue: 'The emperor is sensible, intelligent and hard-working. His ideas are for the most part healthy. He has a heightened sense of his own role, and a deep awareness of his duties. He has not, however, been well enough educated, and he often finds himself confronted by tasks that require knowledge beyond the bounds of his own comprehension. He is ignorant of people, of business and of life. His mistrust of himself and others means that he is extremely wary of excellence. As a result he is surrounded only by mediocrity. He is also very religious, but in a narrow and superstitious way that makes him extremely jealous of his supreme power, since it was given him by God.' (Paléologue, 1991, p.351.)

No less interesting is this opinion of the Russian sovereign, expressed by Prince Heinrich of Prussia, brother of Kaiser Wilhelm II: 'The tsar is benevolent, pleasant to talk to, but not as pliant as is often thought. He knows what he wants and gives way to no one. There is humanity in him, but he has no desire to give up his absolute power. He is a free thinker on religious matters, although never publicly expresses disagreement with the Orthodox Church. He is a fine soldier.' (Oldenburg, 1991, p. 211.)

Ceremonial portraits of the ruling monarch were traditionally painted to hang in imperial palaces and buildings of state. Nicholas II is here portrayed in the uniform of a colonel of the Life-Guard Hussar Regiment, with the insignia of aide-de-camp.
LB

16 Portrait of Grand Duke Mikhail Nikolaevich, 1913

Signed bottom right: *Липгартъ*
Oil on canvas, 133.5 × 98.5 cm
Provenance: Acquired from the State Museum Fund in 1947. ЭРЖ-644
Previous Exhibition: St. Petersburg, 1994, Cat. 21

Grand Duke Mikhail Nikolaevich (1832–1909) was the fourth son of Nicholas I and great-uncle of Nicholas II. He was a field marshal-general, head of the artillery and chairman of the Council of State. He served in the Crimean War of 1854–6. During the defence of Sevastopol he held the Mount of Malakhovka with his brother Grand Duke Nikolai Nikolaevich. In 1862 he was appointed governor-general of the Caucasus and commander-in-chief of the Caucasian army. On completion of his term of office in 1881 he returned to St. Petersburg. He was an honorary member of the Military Staff Academy, the Russian Geographical Society and the Academy of Military Medicine, and served as commander-in-chief of several regiments. Sergei Witte, whose father worked for the civil service under the governor-general of the Caucasus, knew Grand Duke Mikhail

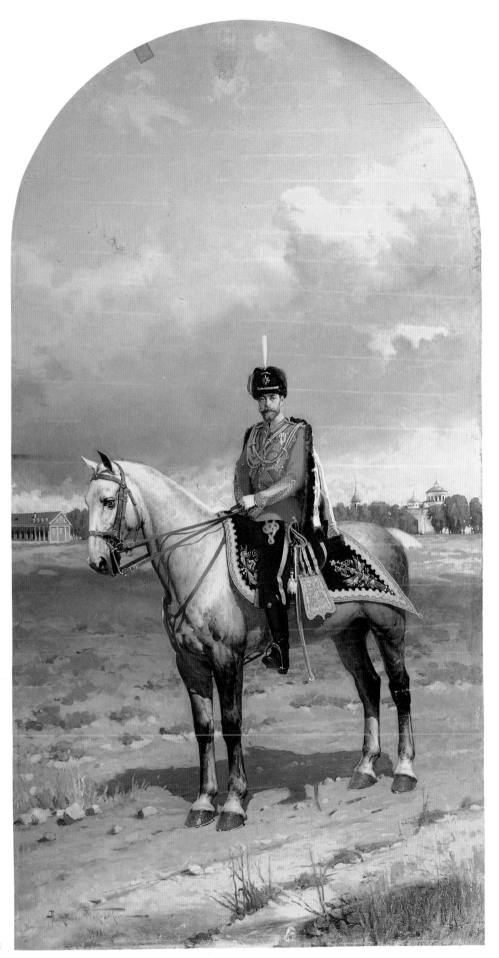

19

20

21

KONSTANTIN EGOROVICH MAKOVSKY

1839–1915

Russian artist, portraitist and historical painter.
Studied at the Moscow Institute of Painting, Sculpture and Architecture under M. I. Scotti, S. K. Zarianko and V. A. Tropinin. Entered the Academy of Arts in 1858. Exhibited at Academy exhibitions. Left the Academy in 1863 along with I. N. Kramskoi. Later joined the Association of Travelling Art Exhibitions. Travelled to Egypt and Syria; exhibited in London, Paris, Vienna, Berlin and Antwerp.

19 Portrait of Grand Duchess Maria Nikolaevna, 1905

Signed bottom right: *C. Makowsky*
Oil on canvas, 133 × 84 cm
Provenance: Acquired from the State Museum of Ethnography of the USSR in 1941. ЭРЖ-1473
Previous Exhibitions: Aarhus, 1990, Cat. 15; St. Petersburg, 1994, Cat. 24

Grand Duchess Maria Nikolaevna (1899–1918) was the third daughter of Emperor Nicholas II and Alexandra Feodorovna.

The four daughters of the imperial family were great friends, and they all loved and looked after their brother, the Tsarevich Alexei. Everyone's darling, however, was Maria Nikolaevna: 'She was a beauty; strong for her age, she sparkled with colour and good health. She had wonderful big grey eyes. Her tastes were simple, and she was full of warmth and kindness. Her sisters sometimes took advantage of this, calling her "Le bon gros Toutou". The nickname referred to her sweet nature and the slightly clumsy way in which she always obliged others ... At 18 Maria Nikolaevna was the tallest, strongest and most lovely of them all. She drew well. Of all the sisters she was the most unaffected and the most cordial. Like Olga Nikolaevna she loved her father most of all. Out of affection for her simplicity and kindness her family all called her Mashka.'
(Gilliard, 1921, p. 172.)

Maria's teacher K. M. Bitner expressed similar sentiments: 'Maria Nikolaevna was a most beautiful girl; typically Russian, kind-hearted, cheerful and level-headed. She was happy to talk to anyone, particularly those of humble background, with whom she always found common ground. She was very strong ... she had a special talent for drawing and needlework.'
(Buranov, Khrustalev, 1992, pp. 156, 226.) AP

ALEXANDER FEODOROVICH PERSHAKOV

1843–?

Russian painter and portraitist.
Studied at the Academy of Arts from 1864. Awarded the title of visiting artist in 1876.

20 Portrait of P. S. Vannovsky, Late 19th century

Signed bottom left: *A. Першаковъ*
Oil on canvas, 116 × 82.5 cm
Provenance: Acquired from the State Museum of Ethnography of the USSR in 1941. ЭРЖ-253
Previous Exhibition: St. Petersburg, 1994, Cat. 25

Piotr Semeonovich Vannovsky (1822–1904) was a public figure during the reign of three emperors: Alexander II, Alexander III and Nicholas II. He graduated from the Moscow Military School in 1840 and joined the Life-Guard Finland regiment. He served in the Eastern War and the Siege of Silistria. After seventeen years of active service he was appointed head of the Infantry School. In 1861 he was promoted to major-general and appointed director of the Pavlovsk Military School. He attained the rank of lieutenant-general in 1868. He served in the Russo-Turkish War, and in 1880 became War Minister. Sergei Witte wrote of Vannovsky, '[he] was a particular favourite of Alexander III, who summoned him from his training duties in Kiev ... Vannovsky made his way on personality alone: he had little education, was uncultured, but determined and fiercely loyal to the sovereign. He was a man who followed the rules, and was occasionally irritable. In any event it must be admitted that he kept the War Ministry in good order.' (Witte, 1990, p. 304.)

After his coronation, Nicholas II thanked Vannovsky for his long service. In a special commendation he paid tribute to his sturdy and straightforward character, and awarded him the Order of St. Andrew the First-Called. After 60 years of service Vannovsky left the military in 1898 to become a member of the Council of State. In 1901 he was appointed Minister of Education but resigned from the post in 1902 due to ill-health.

Vannovsky is portrayed in the uniform of an adjutant-general of His Imperial Majesty's Retinue. AP

21 Portrait of Admiral E. I. Alexeev, Late 19th century

Signed bottom right: *A. Першаковъ*
Oil on canvas, 89 × 57.5 cm
Provenance: Acquired from the State Museum of Ethnography of the USSR in 1941. ЭРЖ-40
Previous Exhibitions: St. Petersburg, 1994, Cat. 25; Hamburg, 1995, p. 42; Kaliningrad, 1996, Cat. 25

Evgeny Ivanovich Alexeev (1843–1918) was an admiral, adjutant-general and member of the Council of State. He studied at the Naval Academy from 1856 to 1863, and graduated with the rank of naval cadet. From 1863 to 1867 he took part in a round-the-world expedition on board the corvette *The Varangian*. He later spent several years on board various ships in the Mediterranean and Atlantic oceans and visited America and Africa. Between 1880 and 1883 he completed his second round-the-world voyage on board the cruiser *Africa*. On his return he was posted to France where he was promoted to captain, first class, and took command of the French-built cruiser *Admiral Kornilov*. In 1891 Alexeev was promoted to rear-admiral, and in 1895 he was appointed head of the Pacific Ocean Squadron. He became vice-admiral and senior flag-officer of the Black Sea Fleet in 1897. From 1899 Alexeev's activities were confined to the Far East, where he became commander of the Pacific Fleet. Promoted to adjutant-general in 1901, from 1903 to 1905 he served as the tsar's representative in the Far East. At the beginning of the Russo-Japanese War he was supreme commander of land and sea forces, a post he held until his retirement in October 1905. Nicholas II valued the services of Alexeev highly, and in 1905 appointed him a member of the Council of State, retaining the title of adjutant-general. AP

Vladimir Alexandrovich Poyarkov

1869–?

Russian artist, historical painter, portraitist.

Studied at the Academy of Arts from 1891 to 1897; awarded the title of
Artist in 1898.

22 Portrait of Court Grenadier M. Kulakov, 1915

Signed and dated bottom left: *Писалъ Поярковъ. 1915*
Oil on canvas, 79.5 × 55.5 cm
Provenance: Acquired from the Leningrad Artillery Museum in 1951; previously
in the collection of Grand Duke Nikolai Mikhailovich. ЭРЖ-775
Previous Exhibition: St. Petersburg, 1994, Cat. 26
Literature: Glinka, 1988, No. 127

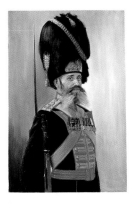

The Company of Court Grenadiers, or Honorary Guard of
the Winter Palace, was established in 1827 from soldiers and
non-commissioned officers of guards' regiments honoured for
their participation in the 1812 Patriotic War and the campaigns
of 1813–14. The special uniform of the company's officers was
decorated with golden chevrons, so that they became known
in St. Petersburg as the 'golden company'. The regiment was
disbanded in 1921.

Kulakov is shown in parade uniform, with medals including
the Order of St. George, second, third and fourth degree. AP

23 Portrait of the Colour Bearer of the Company of Court Grenadiers, 1915

Signed and dated bottom right: *В. Поярковъ 1915*
Oil on canvas, 99.5 × 64.3 cm
Provenance: Acquired from the Leningrad Artillery Museum in 1951. Эзн.-пр. 961
Previous Exhibition: St. Petersburg, 1994, Cat. 27

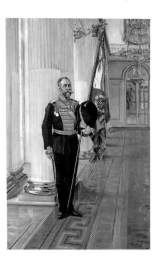

A special banner was awarded to the Company of Court
Grenadiers in 1830. The flag was richly embroidered with gold
thread and bore the inscription 'To commemorate the heroic
deeds of the Russian Guards'. The colour bearer is here portrayed
standing in the George Hall of the Winter Palace.

The company's banner was normally kept in the War Gallery
of the Winter Palace, along with the banners and standards of
other sections of the St. Petersburg garrison. GVV

Nikolai Semeonovich Samokish

1860–1944

Russian artist, war painter and portraitist.

Studied at the Academy of Arts from 1879 to 1885; stipendiary student at the
Academy from 1885 to 1888; joined the army as an artist in 1887; academician
from 1890; teacher of the military painting class at the Academy of Arts from
1912; professor and fellow of the Academy of Arts from 1913.

24 Portrait of Grand Duke Nikolai Nikolaevich (the Younger) on Horseback, After 1910

Signed bottom right: *Н. Самокишъ*
Oil on canvas, 67.5 × 55.5 cm
Provenance: Acquired from the Leningrad Artillery Museum in 1951. Эзн.-пр. 1036
Previous Exhibition: St. Petersburg, 1994, Cat. 28

Grand Duke Nikolai Nikolaevich is portrayed in field dress with
the insignia of the Order of St. George and the Military Medal of
France. In the background is a Cossack carrying the grand duke's
standard. This type of standard was introduced in 1827 for use
on board ship, and later extended to dry land. The image of the
grand duke in this portrait corresponds precisely to a description
of him on manoeuvres at Krasnoe Selo by Prince V. S. Trubetskoi,
officer in His Majesty's Life-Guard Cuirassier Regiment: 'The
grand duke arrived in a huge grey automobile and stopped some
distance from the regiments in a pre-arranged spot. Here he was
met by his orderlies, who held a noble thoroughbred by the bridle,
and by a Cossack with a large colourful flag. The grand duke
made a tremendous impression on horseback. Although a huge
man, with immensely long legs, he sat in the wonderful, almost
flirtatious, way of a cavalier of the old school. His posture set
him off so well against his mount that man and horse seemed to
become one harmonious, indivisible whole. Nikolai Nikolaevich
was a guardsman from head to toe, to the very marrow of his
bones. And yet there was no other guardsman quite like him.
Many officers tried to copy his manners, but he was inimitable.
At this time his prestige was unrivalled. Everyone trembled
before him, and it was not an easy thing to impress him in
training.' (Trubetskoi, 1991, pp. 150–1.) GV

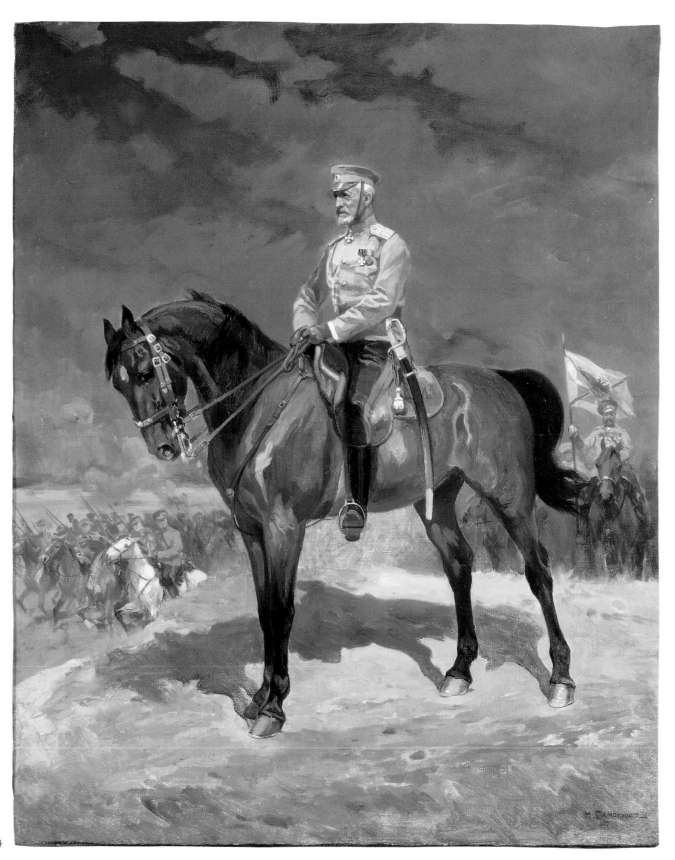

NIKOLAI EGOROVICH SVERCHKOV
1811–98

Russian painter, portraitist and sculptor.

Studied at the Academy of Arts from 1827 to 1829. Worked at the Ministry of Internal Affairs for nine years. Awarded the title of Free Artist in 1839; academician from 1852 and professor from 1855.

25 Portrait of Emperor Alexander III, 1881

Signed and dated bottom left: *Н. Сверчковъ*
Oil on canvas, 260 × 150 cm
Provenance: Acquired from Pavlovsk Palace Museum in 1959; ЕД-625-Х
Previous Exhibition: St. Petersburg, 1994, Cat. 29
From the State Palace Museum, Tsarskoe Selo

During a visit to the Maryinsky Theatre, the artist A. N. Benois first caught sight of Emperor Alexander III: 'I was struck by the size of the man; though cumbersome and heavy, he was still a mighty figure. Up until then I had felt from looking at official portraits of the sovereign that there was something of the *muzhik* [Russian peasant] about him, which I did not like at all (one such portrait hung in the assembly hall of the Fiscal institute, another in the great hall of the City Duma). And the sovereign's dress in these pictures seemed to me downright ugly, especially in comparison to the elegant appearance of his father and grandfather. The new military uniform introduced at the very beginning of his reign, with its pretensions towards national character, its sullen simplicity and, worst of all, its ghastly boots with trousers tucked into them, all offended my artistic sensibilities. But as soon as I saw his impressive features face to face, all this was forgotten. The look in his bright eyes made a particular impression on me. As he passed where I was standing, he raised his head for a second, and to this day I can remember what I felt as our eyes met. It was a look as cold as steel, in which there was something threatening, even frightening, and it struck me like a blow. The tsar's gaze! The look of a man who stood above all others, but who carried a monstrous burden and who every minute of the day must fear for his life and the life of those closest to him. In later years I came into contact with the emperor on several occasions, and I felt not the slightest bit timid. In more ordinary circumstances Alexander III could be at once kind, simple and even almost … homely.' (Benois, 1980, vols. i–iii, pp. 591, 592.)

Alexander III is portrayed in the uniform of a general of the Life-Guard Hussar Regiment. LB

IVAN TROFIMOVICH TRIFONOV
Russian artist of the turn of the 20th century.

Studied at the St. Petersburg School of Drawing and the Academy of Arts from 1866; awarded two junior silver medals and the title of Superior Artist.

26 Portrait of Grand Duke Georgy Alexandrovich,
Late 19th century

Signed on the right: *И. Трифонов*
Oil on canvas, 87 × 74 cm
Provenance: Acquired from Pavlovsk Palace Museum in 1959. ЕД-434-Х
Previous Exhibition: St. Petersburg, 1994, Cat. 30
From the State Palace Museum, Tsarskoe Selo

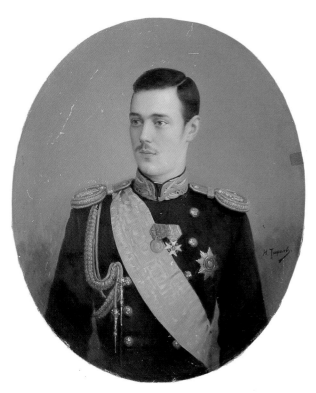

Grand Duke Georgy Alexandrovich (1871–99) was the third son of Alexander III and brother of Nicholas II. After Nicholas II's accession to the throne Georgy Alexandrovich became tsarevich and heir to the throne from 1894 to 1899. He was chief of the Life-Guard Ataman and 93rd Irkutsk Regiments, and honorary chairman of the Russian Astronomical Society. He died from tuberculosis at the age of 28 on his private estate of Abas-Tuman in the Caucasus. He is portrayed in the uniform of aide-de-camp of the fleet. LB

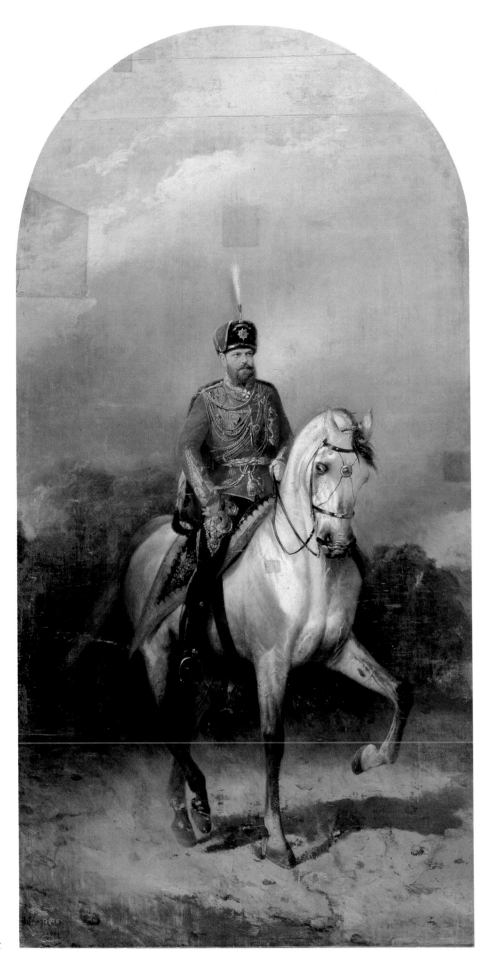

LAURITS REGNER TUXEN

1853–1927

Danish artist, historical and genre painter, portraitist, sculptor.
Studied at the Copenhagen Academy of Arts under C. Drachman and V. Kin,
then in Paris under L. Bonnat. Visited Italy, England, Egypt and Palestine
in 1883. Taught at the School of Artistic Studies in Copenhagen from 1882
to 1906; professor of the Copenhagen Academy of Arts from 1909 to 1915.
Court artist at the Danish Court.

27 The Wedding of Emperor Nicholas II and Empress Alexandra Feodorovna, 1895

Signed and dated bottom left: *L. Tuxen, 1895*
Oil on canvas, 65.5 × 87.5 cm
Provenance: Acquired from the Anichkov Palace in St. Petersburg in 1918. ГЭ-6229
Previous Exhibitions: Aarhus, 1990, Cat. 22a; St. Petersburg, 1994, Cat. 31
Literature: Svanholm, 1990, pp. 94–101, No. 484a

The marriage of Nicholas and Alexandra took place shortly after
the death of Alexander III, on 14 November 1894, Empress
Maria Feodorovna's birthday; the state of mourning was lifted
for that one day. This painting is a preparatory work for a larger
picture (169.5 x 139.5 cm) now hanging at Buckingham Palace
in London. The features of those portrayed are not always clear,
and it is sometimes necessary to guess who is who. Nicholas II
and Alexandra Feodorovna stand in the centre. Against the wall
in the background, to the right of the window, stands King
Christian IX of Denmark, Nicholas II's grandfather. Further to
the right are the Dowager Empress Maria Feodorovna and two of
her daughters, Grand Duchesses Olga and Xenia. According to
contemporary accounts rather fewer guests attended the wedding
ceremony than are portrayed in Tuxen's picture.

'The sovereign appeared [from the Malachite Hall] in the uniform
of the Life-Guard Hussar Regiment, of which, as heir to the
throne, he was a squadron commander ... he was followed by
a number of grand dukes. The group processed towards the main
church at the palace; as they entered, the imperial choir burst
into song from both sides. The sovereign stood in the middle,
flanked by the attendant grand dukes. Bobrovsky stood behind
the tsar, carrying his beaver-fur Hussars hat with its long white
plume. The guests — not a large number, for the church was
small — gathered in all their finery and formed a corridor down
which the bride processed. This procession, marked in the
Christian faith by its measured solemnity, is often the most
moving part of the wedding ceremony. On this occasion it was
also a magnificent spectacle. Everything sparkled in the electric
light, which lent the whole scene an even stronger sense of
theatre. The betrothed couple stood side by side and approached
the lectern. The wedding ceremony began. Behind the sovereign
and his future wife their attendants stood at the ready. As the
choir sang 'Isaiah Rejoice!', the cortège began to process round
the lectern three times. It was a difficult manoeuvre indeed:
the best man had to walk holding the crown above the head of
the tall empress, while her page had to carry her endless train,
guiding it carefully between the chandeliers with their burning
candles.' (Geroit, 1970, vol. i, pp. 39, 40.)

On 16 May 1895 Nicholas II wrote in his diary: 'After breakfast
I sat for an hour while Tuxen drew me for our wedding.' (Diaries
of Nicholas II, 1991, pp. 79-80.) AB

28 The Coronation of Emperor Nicholas II and Empress Alexandra Feodorovna, 1898

Signed and dated bottom left: *L. Tuxen. 1898*
Oil on canvas, 66 × 87.5 cm
Provenance: Acquired from the State Museum of Ethnography of the USSR in 1941.
ЭРЖ-1638
Previous Exhibitions: Aarhus, 1990, Cat. 22; St. Petersburg, 1994, Cat. 32

The coronation of Nicholas II and Alexandra Feodorovna took
place in the Uspensky Cathedral of the Moscow Kremlin on
14 May 1896. The ceremony was a tremendous state occasion.
It marked the recognition of the power of the monarch over
Russia and the blessing of that power by the church.

The Uspensky Cathedral was renovated for the event. The lower
part of the columns that supported the cupolas were draped in
crimson velvet and a dais was erected between the columns.
Three thrones were placed on top of the dais: the throne of Ivan
III for the emperor, made of ivory and brought to Russia from
Byzantium by Sophia Paleolog; for the empress the throne of
Mikhail Feodorovich, studded with massive rubies, sapphires and
other precious stones, and presented to Ivan the Terrible by the
Shah of Persia; and for the Dowager Empress Maria Feodorovna
the throne of Alexei Mikhailovich, made in Persia. The latter
was decorated with 876 diamonds and 1,223 rubies, pearls and
turquoises. Behind the seated emperor and empress stood their
assistants, Grand Dukes Mikhail Alexandrovich, Vladimir
Alexandrovich, Sergei Alexandrovich and Pavel Alexandrovich;
then came other members of the imperial family, foreign princes,
senior military and state figures, representatives of the gentry,
ladies-in-waiting, maids of honour and other dignitaries.

Among those portrayed are Olga Konstantinovna, Queen of the
Hellenes; Prince Heinrich of Prussia, brother of Kaiser Wilhelm
II; the Duke of Connaught, son of the Queen of England;
Prince Victor Emmanuel, heir to the Italian throne; the Greek
Prince Constantine; Prince Ferdinand of Bulgaria; and Prince
Ferdinand, heir to the Romanian throne.

Horse-guardsmen and heralds stand on the steps leading up to
the dais. At the foot of the stairs stand the senior clergy, including
the metropolitans: Pallady of St. Petersburg, Sergy of Moscow
and Ioanniky of Kiev. The picture records the moment when
Metropolitan Pallady of St. Petersburg invites Nicholas II to
read 'The Symbol of Faith'. Thereafter everything proceeded
according to ritual. The emperor put on the imperial purple, the
chain of the Order of St. Andrew the First-Called, and the crown.
Now standing, he took the orb and sceptre from his assistants,
while the three metropolitans and other members of the clergy
read the liturgy. At the conclusion of the ceremony Nicholas II
and Alexandra Feodorovna removed their crowns and received
the annunciation. The church bells rang out and a 101-gun salute
spread the news to the thousands gathered in the square outside
the cathedral and on the streets of Moscow: the coronation
ceremony was complete. 'From this moment he [Nicholas II] felt
himself anointed by God; the coronation ceremony was ... a
moment of great significance for him. From childhood he had felt
himself betrothed to Russia; now it was as if he had been joined
to her in wedlock.' (Oldenburg, 1991, p. 58.) AP

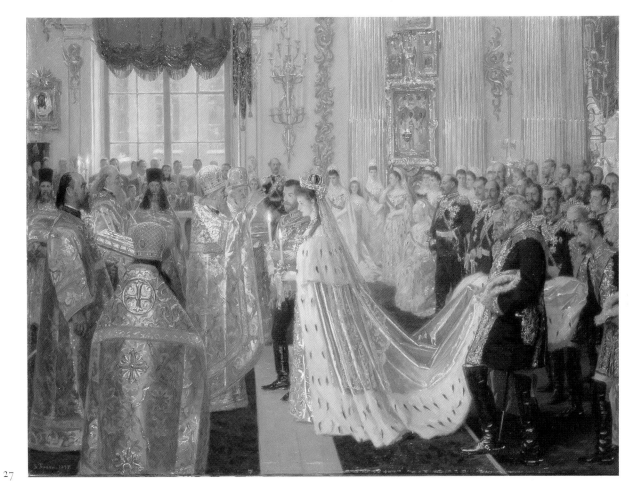

27

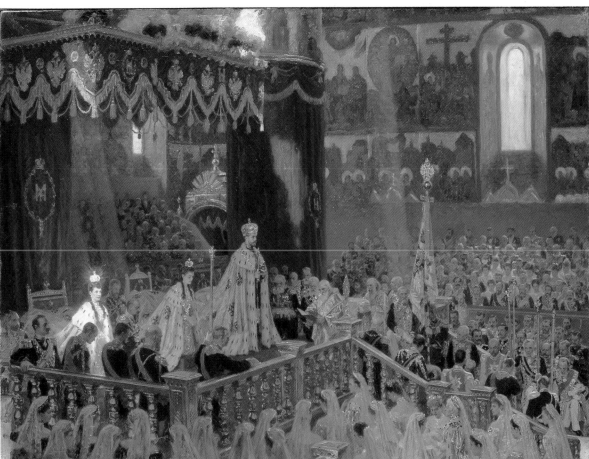

28

Ivan Alexeevich Tiurin

1824–1904

Russian painter.

Part-time student at the Academy of Arts from 1845 to 1850. Awarded the title of Free Artist in 1850. Academician from 1885.

29 Portrait of Emperor Alexander III, 1890

Signed and dated bottom right: *И. Тюрин. 1980*
Oil on canvas, 210 × 170 cm
Provenance: Acquired from Pavlovsk Palace Museum in 1959. ЕД-624-Х
Previous Exhibition: St. Petersburg, 1994, Cat. 33
From the State Palace Museum, Tsarskoe Selo

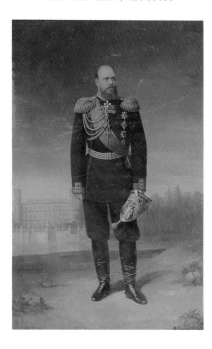

Alexander III (1845–94) was the second son of Emperor Alexander II and heir to the throne from 1865. After the tragic death of his father on 1 March 1881 he was proclaimed emperor; his coronation took place in Moscow on 15 May 1883.

During Alexander's reign the royal family lived solely at Gatchina Palace, which was why the emperor was often called 'the prisoner of Gatchina'. He is portrayed in the uniform of a general of the Life-Guard Pavlovsk Regiment with the insignia of adjutant-general. Gatchina can be seen in the background. LB

François Flameng

1856–1923

French artist, portraitist, historical painter and graphic artist.

Studied in Paris under his father L. Flameng, A. Cabanelle and J. P. Lorance. Exhibited at the Paris Salon from 1873 to 1922. Professor at the Paris School of Fine Arts from 1905. Also worked in England, America and Russia.

30 Portrait of Princess Z. N. Yusupova, 1894

Signed and dated at the base of the column: *François Flameng, 1894*
Oil on canvas, 125.5 × 94 cm
Provenance: Acquired from the State Museum of Ethnography of the USSR in 1941; previously in the private collection of the Yusupovs in St. Petersburg. ЭРЖ-1371
Previous Exhibitions: Aarhus, 1990, Cat. 23; St. Petersburg, 1994, Cat. 34

Zinaida Nikolaevna Yusupova (1861–1939) was the daughter of the steward of the royal household and deputy director of the public library, N. B. Yusupov. Married to Count F. F. Sumarokov-Elston in 1882, she was the mother of Nikolai (killed in a duel in 1908) and Felix (who married Nicholas II's niece, Irina, and played a leading role in the murder of Rasputin). Zinaida Nikolaevna was close to the court; she was especially friendly with Grand Duchess Elizaveta Feodorovna and Empress Maria Feodorovna, as well as with Alexandra Feodorovna, the young bride of the emperor.

The Yusupov family was one of the oldest in Russia. Their enormous wealth enabled them to acquire some wonderful and rare pieces of jewellery. The family jewels included the Polar Star diamond, the diadem of the Queen of Naples, the ear-rings of Marie-Antoinette, and one of the famous Peregrine pearls that had once belonged to King Philip II of Spain. This is the pearl Zinaida Yusupova is wearing on a long necklace in the portrait by Flameng. AP

Vasily Pavlovich Khudoyarov

1831–92

Russian artist, portraitist, genre and landscape painter.

Studied at the Academy of Arts from late 1850s to 1863. Awarded the title of Artist (third class) in 1865.

31 Portrait of Grand Duke Alexander Alexandrovich as Heir to the Throne, Late 1870s – early 1880s (p. 55)

Signature scratched left side: *В. Худояровъ*
Oil on canvas, 88.2 × 75 cm (oval)
Provenance: Acquired from the State Museum of Ethnography of the USSR in 1941. ЭРЖ-646
Previous Exhibitions: Aarhus, 1990, Cat. 17; St. Petersburg, 1994, Cat. 35

During the reign of Alexander II the heir to the throne was his eldest son, Grand Duke Nikolai Alexandrovich. After the death of Nikolai Alexandrovich in Nice in 1865, Grand Duke Alexander Alexandrovich became heir to the throne at the age of 20. Alexander II began to familiarise his second son with affairs of state, appointing him Ataman of the Cossack forces, Chancellor of Helsingfors University, and later a member of the Council of State. During the Russo-Turkish War of 1877–8 he commanded the Rushchuksky detachment.

Alexander is portrayed in the uniform of the Life-Guard Ataman Regiment with the insignia of adjutant-general. AP

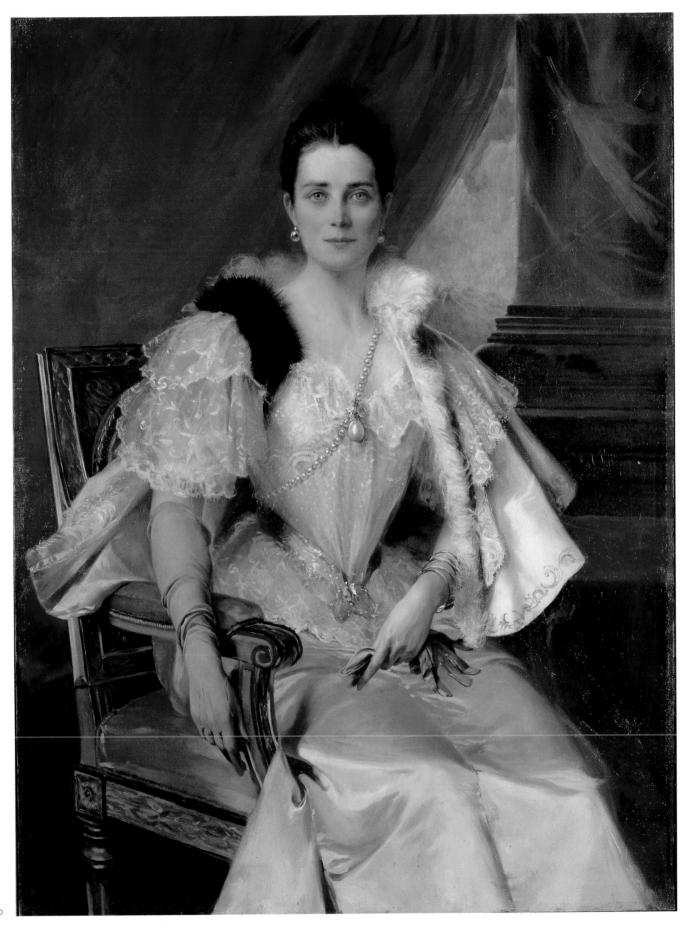

VICTOR KARLOVICH SHTEMBER

1863–after 1917
Russian artist.
Initially studied at the modern school of the Evangelical Lutheran Church of St. Michael in Moscow. Part-time student at the Academy of Arts from 1881 to 1883. Studied at the Paris Academy under A. V. Bouguereau and Robert-Fleury. Exhibited at the Paris Salon from 1888, and at Academy and other exhibitions in Russia. One of the founders of the Society of Artists in 1903.

32 Portrait of S. M. Raevskaya, 1907

Oil on canvas, 143 × 115 cm
Provenance: Acquired from the State Museum of Ethnography of the USSR in 1941; previously in the private collection of the Raevsky family. ЭРЖ-1395
Previous Exhibition: St. Petersburg, 1994, Cat. 36

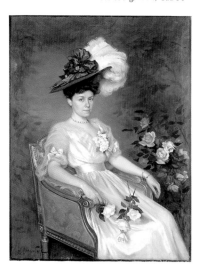

Sophia Mikhailovna Raevskaya was the daughter of Major-General M. N. Raevsky; she was lady-in-waiting to the empress and sister of P. M. Raevsky. AP

33 Portrait of Count D. A. Sheremetev, Cornet of the Horse-Guards Regiment, 1909

Signed and dated bottom left: *В. Штемберъ. 1909*
Oil on canvas, 134.5 × 89.5 cm
Provenance: Acquired from the State Museum of Ethnography of the USSR in 1941. ЭРЖ-261
Previous Exhibition: St. Petersburg, 1994, Cat. 37

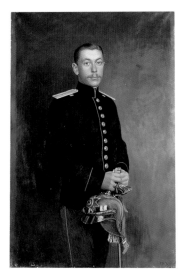

Dmitry Alexandrovich Sheremetev (1885–?) was the son of A. D. Sheremetev. He studied at the Third St. Petersburg High School and in 1906 joined the Horse-Guards Regiment as a volunteer. In 1907 he was promoted to the rank of cornet in the Pskov Dragoons Regiment and was seconded to the Horse-Guards Regiment. In 1908 he married Countess D. A. Bobrinskaya, a lady-in-waiting and daughter of A. A. Bobrinsky, steward at the imperial court.

Sheremetev is portrayed in the uniform of the Horse-Guards Regiment. AP

34 Portrait of Baroness D. E. Grevenits, 1912

Dated bottom left: *1912*; signed right: *В. Штемберъ*
Oil on canvas, 156.5 × 115 cm
Provenance: Acquired from the State Museum of Ethnography of the USSR in 1941; previously in the Collection of M. K. Golitsyna. ЭРЖ-1794

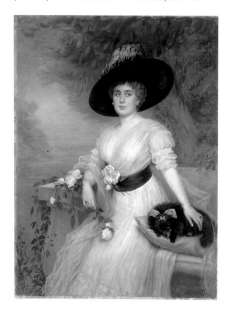

Darya Evgenevna Leuchtemberg-Beauharnais (1870–1937) was the daughter of the Romanov prince Evgeny Maximilianovich, 5th Duke of Leuchtemberg and Count Beauharnais, and his first wife Darya Konstantinovna Opochinina. Darya Evgenevna's ancestors included some of the most eminent names in Russia, France and Bavaria. Her grandmother was Nicholas I's daughter, Grand Duchess Maria Nikolaevna, who owned the Maryinsky Palace in St. Petersburg where Darya was born and brought up. Her great-grandfather was Eugène Beauharnais, son of Empress Josephine, and other ancestors were related to the royal house of Bavaria. On her mother's side she was the granddaughter of Field-Marshal M. I. Kutuzov. Darya Evgenevna was renowned as a great beauty, and together with her stepmother, Zinaida Dmitrievna Beauharnais, dazzled high society at balls in St. Petersburg. She married Prince L. M. Kochubei in 1893, and after divorcing him married Baron V. E. Grevenits in 1912. The portrait by Shtember was painted at this time. In 1917 Darya Evgenevna set off for the Russian–Austrian Front with a detachment of nurses that she had established with her own money. On her return to Russia after the revolution she worked at the World Literature Publishers with Maxim Gorky. From 1924 she worked at the State Public Library in St. Petersburg. She died in 1937. AP

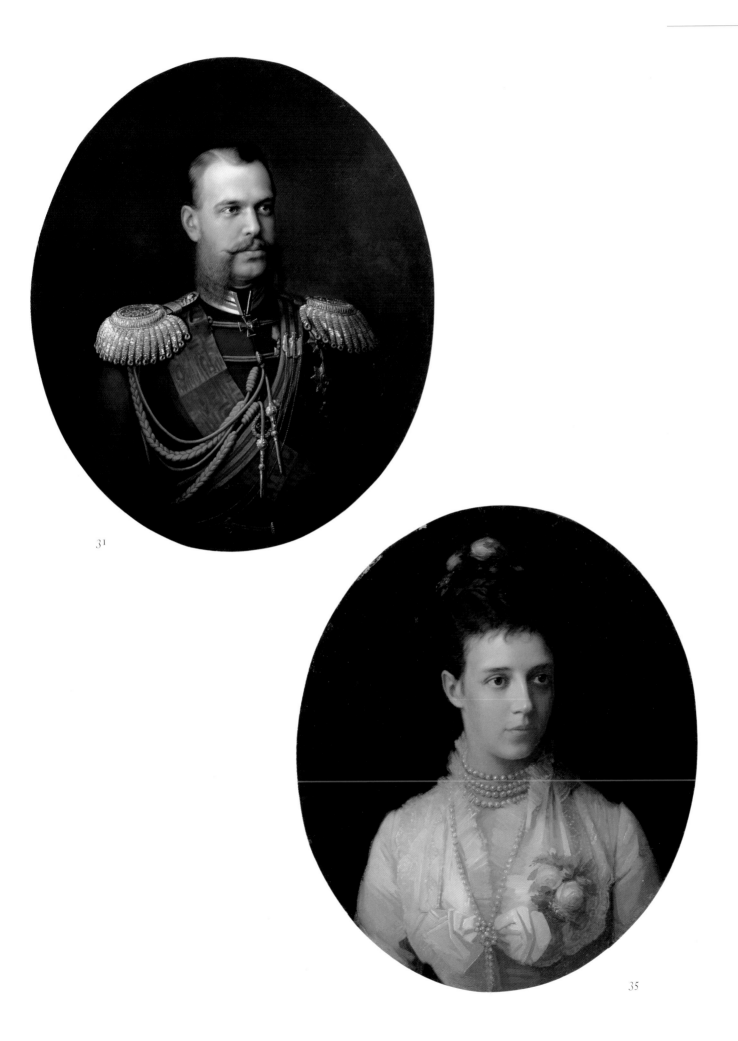

31

35

35 Portrait of Grand Duchess Maria Feodorovna, 1870s

Unknown artist of the second half of the 19th century
Oil on canvas, 62 × 54 cm
Provenance: Acquired from the State Museum of Ethnography of the USSR in 1941.
ЭРЖ-2778
Previous Exhibitions: Paris, 1989, Cat. 238; Aarhus, 1990, Cat. 17;
St. Petersburg, 1994, Cat. 38

Maria Feodorovna (1847–1928) was born Maria-Sophia-Frederica-Dagmar, youngest daughter of King Christian IX and Queen Louisa of Denmark. In 1864 she became engaged to Grand Duke Nikolai Alexandrovich, heir to the Russian throne. A year after his death in 1865 she married his brother, Grand Duke Alexander Alexandrovich, who became Emperor Alexander III in 1881. She converted to Orthodoxy and took the name Maria Feodorovna.

After the death of Alexander III in 1894 and the accession to the throne of Nicholas II, Maria Feodorovna lived mostly at the Anichkov Palace. However, she continued to participate in court life and occupied herself with many charitable works, including the Empress Maria Society, which was named after her. After the abdication of Nicholas II and his brother Mikhail Alexandrovich in 1917, she left for the Crimea together with her daughters Olga and Xenia, and Xenia's husband, Grand Duke Alexander Mikhailovich. She later fled to Denmark, where she lived until her death. AP

36 Portrait of Emperor Alexander II, 1888

Unknown artist of the second half of the 19th century (Monogram: В. Г. [VG])
Monogrammed and dated right: В. Г. 1888
Oil on canvas, 85 × 71 cm
Provenance: Acquired from the State Museum of Ethnography of the USSR in 1941;
previously at the Fountain House of the Sheremetev family in St. Petersburg.
ЭРЖ-633
Previous Exhibitions: Aarhus, 1990, Cat. 17; St. Petersburg, 1994, Cat. 39

Alexander II (1818–81) was the eldest son of Emperor Nicholas I and grandfather of Nicholas II. As heir to the throne he was tutored by V. A. Zhukovsky and K. K. Merder, a captain in the Life-Guard Izmailovsky Regiment. Among his other teachers was M. M. Speransky, who taught him law.

At the age of 16 the tsarevich undertook a seven-month journey through Russia. As a result of his acquaintance with political exiles in Siberia he asked his father to alleviate their hardship. In 1840 he travelled abroad with the aim of finding himself a bride. He chose the Princess of Hesse-Darmstadt who, prior to their wedding in 1841, converted to Orthodoxy and took the name Maria Alexandrovna. One of Maria Alexandrovna's ladies-in-waiting was the observant and sharp-witted A. F. Tiutcheva. She knew the court and its inhabitants well, and she described the emperor thus: 'He was a good-looking man, with a certain fullness of figure that he later lost. His features were correct but a little flabby and ill-defined. He had large blue eyes but his look was not very inspired — in short, his face was inexpressive and on occasion even unattractive, particularly when he felt that he needed to appear solemn and majestic in public ... However, when the grand duke was among his family or closest friends he was his true self, and his face would light up with kindness, cordiality and a tender smile that made him quite attractive. When he was still heir to the throne this latter look was predominant; later, when he became emperor, he always felt himself obliged to adopt an expression of impressive severity. The two sides to his facial expression reflected in large measure the duality of his nature and his fate. His strongest quality was his heart, at once kind, ardent and philanthropic; it was this that attracted him to all that was generous and good, and prompted everything great that was achieved in his reign. His mind was too narrow and uneducated to enable him to grasp the full significance of those reforms that made his reign one of the most glorious and wonderful episodes in the history of our country.' (Tiutcheva, 1990, pp. 22, 23.)

When he acceded to the throne in 1855, the thirty-seven-year-old Alexander Nikolaevich was already prepared for dealing with the affairs of state. During his father's lifetime he had been inducted into the highest state bodies in the land, such as the Senate, the Synod, the Committee of Ministers and the Council of State. The early part of his reign was overshadowed by the Crimean War of 1854–6; together with his brothers Nikolai and Mikhail he visited the Crimea in order to express his gratitude to the defenders of Sevastopol. And it was only after the conclusion of the war, on 26 August 1856, that his coronation as Emperor Alexander II took place.

The greatest achievement of Alexander's reign was undoubtedly the emancipation of the serfs which resulted from the publication of the 'Manifesto of 19 February 1861'; not without reason was Alexander II known as the liberator-tsar. Other significant reforms of his reign included the 'Zemstvo Statute' of 1864 and the 'Municipal Statute' of 1870, which established the right of self-governance for provinces, districts and towns. Several advances were made in internal and foreign policy: Russia obtained new territories, particularly in the East, and war was successfully waged against the Turks in 1877–8. The emperor himself saw military action, and after the seizure of Plevna and the defeat of the Turks at Shipka, he led the victory procession of the Russian forces into Sofia. Several attempts were made on Alexander II's life after 1866. On 1 March 1881, the last of these, on the banks of the Catherine Canal, was successful.

The emperor is portrayed in the greatcoat and cap of the Horse-Guards Regiment. AP

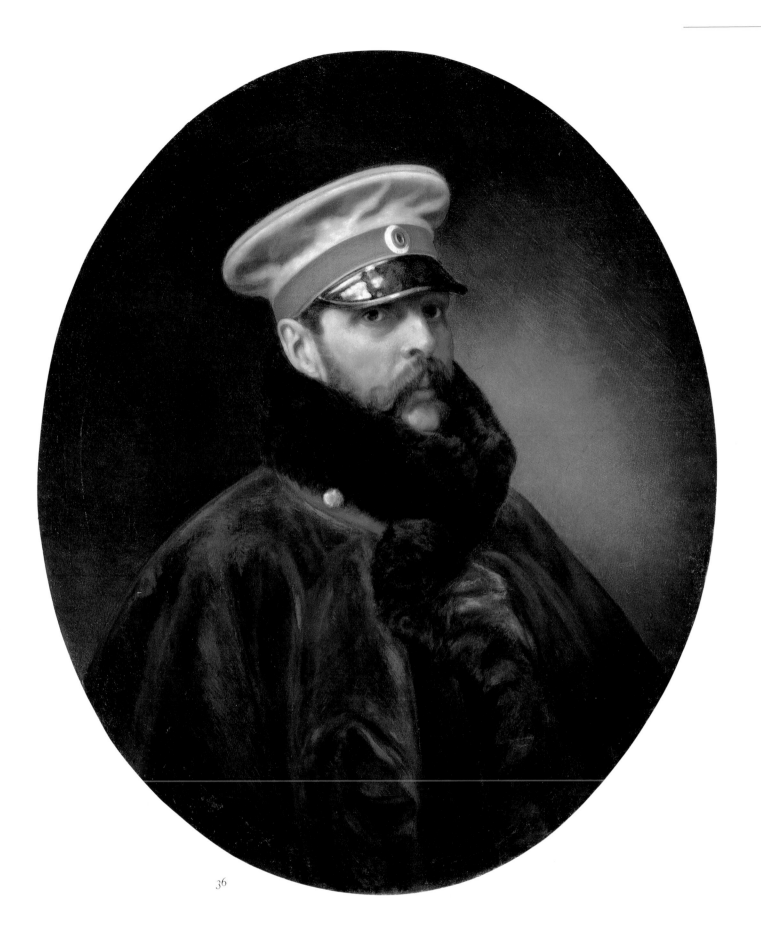

36

37 Portrait of King Christian IX of Denmark

Unknown Danish (?) artist of the second half of the 19th century
Oil on canvas, 218 x 140 cm
Provenance: Acquired from the State Museum Fund in 1948;
previously at the Anichkov Palace in St. Petersburg. ГЭ-9413
Previous Exhibition: St. Petersburg, 1994, Cat. 40

Christian IX (1818–1906) was king of Denmark from 1863.
He married Princess Louise, niece of King Christian VIII of
Denmark, in 1842. Three of his children became royalty: Princess
Alexandra became Queen of England; Prince Wilhelm became
King George I of Greece; and Princess Dagmar became Empress
Maria Feodorovna of Russia. His grandson Karl became King
Khogen of Sweden. As a result, Christian IX became known
as 'the father-in-law of Europe'.

The families of Alexander III and Nicholas II were frequent
visitors to their relatives in Denmark. AB

ALEXEI IVANOVICH KORZUKHIN

1835-94
Russian artist, genre painter and portraitist.
Entered the Academy of Arts in 1858; awarded the junior gold medal for a
painting of 1861. Left the Academy in 1863 along with twelve others under I.N.
Kramskoi to form an artists' co-operative. Exhibited at Academy exhibitions.
Academician from 1868. Also painted religious pictures for churches,
particularly the Cathedral of Christ the Saviour in Moscow.

38 Portrait of Grand Duke Alexei Alexandrovich, 1889

Signed bottom right: *А. Корзухинъ 1889*
Oil on canvas, 133 x 99 cm
Provenance: Acquired from Pavlovsk Palace Museum in 1959. ЕД-558-Х
From the State Palace Museum, Tsarskoe Selo

Grand Duke Alexei Alexandrovich (1850–1908) was the fourth
son of Emperor Alexander II. From an early age he was trained
to serve in the navy: his tutor was Adjutant-General Admiral
K. N. Posiet, under whose command he undertook a round-the-
world voyage aboard a frigate. During the Russo-Turkish War
of 1877–8 he served as head of naval command on the Danube.
From 1880 he was an adjutant-general; he served as commander
of the fleet and head of the Naval Department from 1880 to
1905, and from 1883 was an admiral and member of the Council
of State.

'Grand Duke Alexei Alexandrovich always had a reputation
as the most attractive member of the royal family, although
his colossal weight was a significant barrier to his success with
the ladies. A man of refinement from head to toe ... whom ladies
loved to cosset, Alexei Alexandrovich was a great traveller.
The very idea of spending a year without visiting Paris would
have made him tender his resignation. He worked in the civil
service and showed the same complete lack of enthusiasm when
appointed admiral of the Russian Imperial Fleet. It would be
hard to imagine a more modest comprehension of naval affairs
than that shown by this admiral of a mighty power. At the
merest reference to current reforms in the navy a fearful grimace

would spread across his charming face.' (Grand Duke Alexander
Mikhailovich, 1991, p. 115.)

'Grand Duke Alexei Alexandrovich was the favourite brother of
Alexander III and therefore had considerable influence. He was
in all respects a worthy and excellent man, but a man who had
no ideas concerning the state — or indeed any serious ideas at all.
He was attracted to a comfortable and pleasant private life rather
than to the life of a public figure.' (Witte, 1960, vol. 1, p. 310.)

Russian society considered Grand Duke Alexei one of the main
culprits in the rout of the Russian fleet in the Russo-Japanese
War. After his squadron's annihilation at Tsushima he renounced
the title and powers of adjutant-general, and in 1905 he retired.
He spent his last years in Paris.

Grand Duke Alexei is portrayed in the uniform of an aide-de-
camp in His Imperial Majesty's Retinue. LB

39 Portrait of Admiral A. I. Rusin, Early 20th century

Unknown artist of the turn of the century
Oil on canvas, 91 x 78 cm
Provenance: Acquired from the State Museum of Ethnography of the USSR in 1941.
ЭРЖ-42
Previous Exhibition: Kaliningrad, 1996

Alexander Ivanovich Rusin (1861–1956) studied at the Naval
School from 1878 to 1881. He later graduated from the
hydrographic department and the artillery officers' class of the
Nikolaevsky Naval Academy. From 1899 to 1904 he was Russian
military and naval attaché in Japan. In 1905 he took on the
responsibilities of head of the naval campaign office and
commander-in-chief of land and sea forces in the Far East.
In 1908 he became head of the Nikolaevsky Naval Academy and
director of the Naval College. He took part in naval exercises
around Europe and the Mediterranean. From 1914 he was head
of the Naval General Staff and in 1916 became Head of the Naval
Staff at the headquarters of Supreme Command. He emigrated
after 1917 and died in Morocco. Rusin was chairman of the
association of Russian naval organisations overseas, and was
awarded numerous Russian and foreign decorations. AP

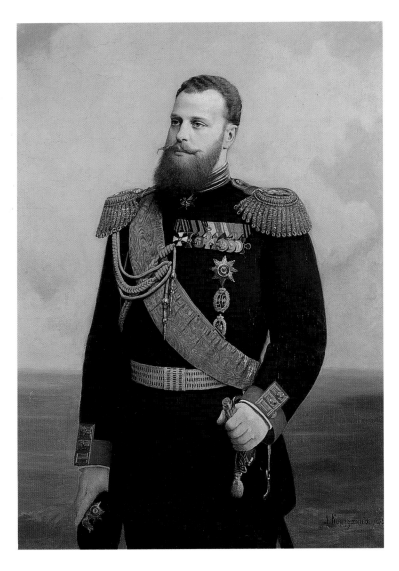

38

37

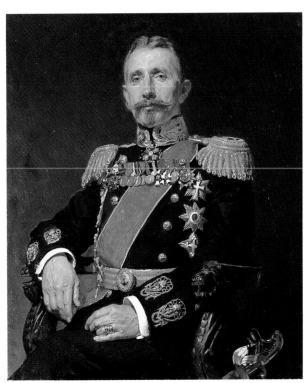

39

Icons

MIKHAIL IVANOVICH DIKAREV

Icon-painter of the second half of the 19th and early 20th centuries.

Born and worked in the village of Mstera in Vladimir province; painted icons and other church art. Founded an icon-painting workshop in Moscow. Restored icons and frescoes of the cathedrals in the Moscow Kremlin. Was an expert in ancient Russian icon-painting and had a large icon collection.

40 The Venerable Nikon, 1900

Signed and dated below: *Писалъ М.И. Дикаревъ 1900 г.*
Egg tempera on wood, 31 × 25.3 cm
Provenance: Acquired from the State Museum of Ethnography of the USSR in 1959; previously at the Marble Palace in St. Petersburg. ЭРЖ-2515
Previous Exhibitions: Leningrad, 1990, Cat. 220; St. Petersburg, 1994, Cat. 43

Nikon is one of the saints of the Russian Orthodox Church. He studied under St. Sergei of Radonezh, the founder of the Trinity St. Sergei Monastery near Moscow, and after St. Sergei's death became Father Superior of the monastery. The Venerable Nikon restored the monastery after its destruction by the Tartar horde in 1408. AP

A. I. TSEPKOV

Mstera icon-painter of the late 19th and early 20th centuries.

41 St. Nicholas the Miracle-Worker and St. Tsarina Alexandra, 1898

Signed and dated bottom right: *Иконописец слободы Мстеры А.И. Цепковъ 1898 roga* [Mstera icon-painter A. I. Tsepkov, 1898]
Egg tempera on wood, gilt, 31.3 × 26.8 cm
Provenance: Acquired from the collection of the Uspensky family in 1953. ЭРЖ-2285
Previous Exhibitions: Leningrad, 1990, Cat. 166; St. Petersburg, 1994, Cat. 44

The icon portrays the name saints of Emperor Nicholas II and Empress Alexandra Feodorovna. AP

OSIP SEMEONOVICH CHIRIKOV

?–1903

Mstera icon-painter with workshop in Moscow.

Like M. I. Dikarev, a talented icon-painter able to reproduce the styles of various ancient Russian schools of icon-painting: those of Novgorod, Stroganov and Moscow. Undertook several commissions for the royal court. Restorer and collector of icons.

42 The Exaltation of the Cross of Our Lord

Signed bottom right: *Писалъ Чириковъ*
Egg tempera on wood, 31.2 × 26.2 cm
Provenance: Acquired from the State Museum Fund in 1959; previously at the Marble Palace in St. Petersburg. ЭРЖ-2525
Previous Exhibitions: Leningrad, 1990, Cat. 211; St. Petersburg, 1994, Cat. 45

The Exaltation of the Cross of Our Lord was one of a number of icons painted by O. S. Chirikov and M. I. Dikarev for the Marble Palace in St. Petersburg, which belonged to Grand Duke Konstantin Konstantinovich. AP

43 The Moscow Metropolitans, Chosen Saints Piotr, Ioan, Philip and Alexy, late 19th – early 20th century

Unknown icon-painter of the turn of the century
Oil on wood, metal frame, 36 × 30 cm
Provenance: Acquired from the Museum of the History of Religion in Leningrad in 1956. ЭРЖ-2422
Previous Exhibition: St. Petersburg, 1994, Cat. 46

In ancient Rus, before the introduction of the patriarchate in 1589, the ecclesiastical hierarchy was led by the metropolitan, known as the Metropolitan of Moscow and All Rus. The seat of the metropolitan was originally in Kiev, then in Vladimir and from the 14th century in Moscow. The metropolitans led the Orthodox Church and also exercised considerable influence over the political life of the state. Piotr, Ioan, Philip and Alexy were particularly revered in Rus and were canonised after their death.

Piotr became metropolitan in 1305. During the internecine battles between the princes of Tver and Moscow he took the latter's side and thus helped to strengthen the Moscow principality with Ivan Kalita at its head. He died in 1326. Alexy became metropolitan of All Rus in 1353. He visited the Golden Horde twice, and won several concessions from the Khan, including permission for the clergy not to pay tribute money. It was through the authority and actions of Alexy that Prince Dmitry was able to become Great Prince of Moscow in 1359. Alexy did not live to see the victory of Dmitry at the battle of Kulikova, dying in 1378. Ioan was elected metropolitan in 1448 by the council of Russian bishops. He governed the principality in the absence of Prince Vasily Vasilievich Tiomny. In his 'educational epistles' he wrote about state governance and the importance of the well-being of the state. He died in 1461. Philip belonged to the noble line of the Kolychevs. After taking holy orders he entered the Solovetsky Monastery, which during his period as Father Superior became one of the richest and most significant monasteries of the North. In 1568 Philip criticised Ivan the Terrible and his actions; he was subsequently removed from office and banished back to the Solovetsky Monastery. He was strangled by Malyuta Skuratov in 1569. It has been suggested that the heir to the Russian throne, Tsarevich Alexei Nikolaevich, was named after Metropolitan Alexy; another story has it that Nicholas II named his son after Tsar Alexei Mikhailovich, whom he greatly admired. AP

40

41

42

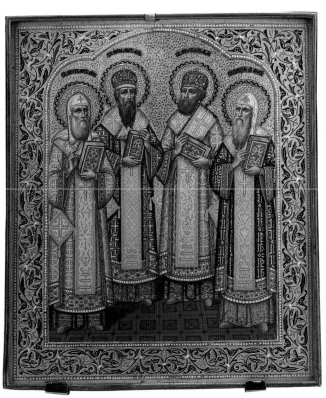

43

44 St. Serafim of Sarov, Early 20th century

Unknown icon painter of the turn of the century
Egg tempera on wood, 31 × 26.5 cm
Provenance: Acquired from the State Museum of Ethnography of the
USSR in 1941. ЭРЖ-3136
Previous Exhibition: St. Petersburg, 1994, Cat. 47

Serafim was a monk and hermit who lived in a wood near
Sarov; he acted as confessor to the nuns of the Diveev
Convent and preached the cult of the Mother of God. He was
reputed to have powers of healing from illness and infertility,
and pilgrims — particularly women — flocked to him. He
died in 1833, and after his relics were recovered he was
canonised in 1903, in large part on the insistence of Empress
Alexandra Feodorovna.

'On 17 July the sovereign arrived at Sarov Monastery for the
bearing of the remains of St. Serafim of Sarov ... he was very
interested in the figure of the venerable Serafim ... and spent
large sums on decorating his dwelling and on preparing the
shrine for the relics of the saint, as well as on organising a
celebration to mark the occasion ... Talk of the celebrations
spread all over Russia ... pilgrims and the sick began to gather
in Sarov. By the evening of 17 July many important people
had arrived: the sovereign, both empresses, Grand Dukes
Sergei Alexandrovich, Nikolai Nikolaevich, Piotr Nikolaevich
and other members of the royal family, Metropolitan Antony
of St. Petersburg and bishops from Nizhegorod, Kazan and
Tambov ... On the third day of festivities, after the liturgy,
Archbishop Dmitry of Kazan said in his sermon: "This
solitary abode of an ascetic has become a populous town." '
(Oldenburg, 1991, pp. 207, 208.)

During the celebrations the emperor went on foot into the
monastery where Serafim would retire to pray. Later that
evening, after prayers in the cathedral, the emperor and the
grand dukes carried the coffin containing the relics of the
saint to the Zosimo-Savvatiev Church, while the empress and
some of her ladies-in-waiting bathed in the healing spa waters.

St. Serafim of Sarov was one of the saints most revered by the
royal family, and an icon portraying Serafim hung in Nicholas
II's office. AP

45 St. Alexander Nevsky and St. Nicholas the Miracle-Worker, Late 19th century

St. Petersburg; unknown icon-painter of the turn of the century
Reverse side upholstered in velvet with an inscription in metal letters:
Екатерина Засецкая [Ekaterina Zasetskaya – probably the name of the donor]
Double-doored wooden casing with inside upholstered in velvet and silk.
Paint on wood; *oklad* [frame] decorated with metal thread, sequins, beads, pearls,
embroidery, velvet. Casing: wood, velvet, silk.
Icon: 45 × 35 cm; casing: 55.5 × 46 cm
Provenance: Acquired from the State Museum of Ethnography of the USSR in
1941; previously at the Winter Palace. ЭРЖ-9663
Previous Exhibition: St. Petersburg, 1994, Cat. 223

The icon portrays two of the best known and most revered of
all the saints of Russia: Alexander Nevsky was the patron
saint of soldiers, and Nicholas the Miracle-Worker the patron
saint of seamen. It is rare to find them both portrayed in the
same icon. It is likely that this icon, intended as a gift for the
royal family, was one of those known as 'family icons', that is,
painted on commission and combining the patron saints of
various emperors of Russia of the 19th and 20th centuries.

The icon is set in a gold embroidered *oklad*, or frame.
Embroidered frames were generally made in monasteries. The
traditional gold thread used in this icon was commonly used
to decorate costumes, items of church furniture and the
interiors of town houses. The thread was then embellished
with pearls, coloured stones, glass or sequins. In the flickering
light of icon-lamps and candles the gold embroidered casing of
the icon was particularly striking. EM

46 Processional Cross

Unknown artist of the second half of the 19th century
Egg tempera on wood, 86 × 70.5 cm; handle length 101 cm
Provenance: Acquired from the private collection of the Uspensky family in 1980.
ЭРЖ-2871
Previous Exhibition: St. Petersburg, 1994, Cat. 48

The processional cross was an essential feature of the religious
ceremony known as the Procession of the Cross. This was a
procession that took place around a church or to a holy place
on such feast days as Easter, the Baptism of Christ, the
Sanctification of the Water, or other special occasions of
national or religious significance. AP

44

45

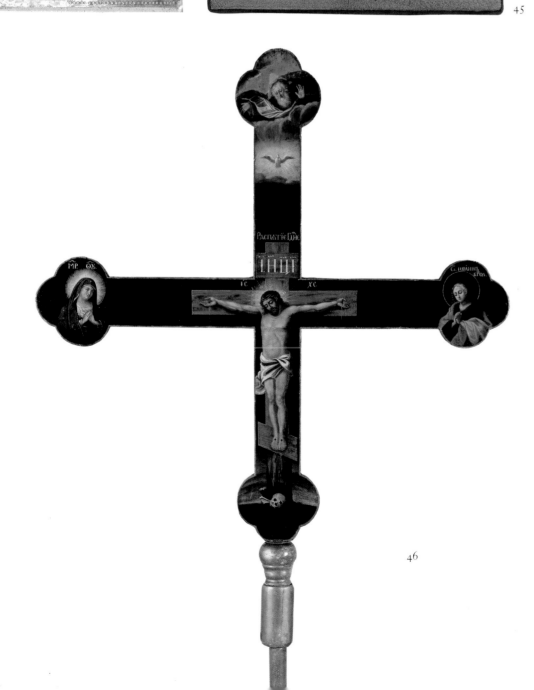

46

Watercolours, Drawings, and Engravings

ALBERT NIKOLAEVICH BENOIS

1852–1936

Russian artist, painter, watercolourist and landscape painter. Eldest son of the architect N. L. Benois; graduated from the Academy of Arts in 1877. Studied watercolours under L. O. Premazzi; famed for his watercolours and landscapes. Academician from 1884 and teacher of the watercolour class at the Academy of Arts from 1885. Lived in Paris from 1924.

47 Five Views of St. Petersburg, 1880

St. Isaac's Cathedral (centre)
Church of the Life-Guard Chasseur Regiment
Church of St. Nicholas the Miracle-Worker on the Little Neva
Church of the Transfiguration of Christ on Koltovskaya embankment
Parish Church on the Banks of the Neva

Watercolour of St. Isaac's Cathedral signed bottom right: *Альбертъ Бенуа*
Watercolour on paper, card, 34.5 × 50 cm; 50.7 × 64.2 cm with passe-partout
Provenance: Acquired from the Library of Emperor Alexander II in the Winter Palace in 1927. ЭРР-8148-8152
Previous Exhibitions: Aarhus,1990, Cat. 26; St. Petersburg, 1994, Cat. 49

A series of views of St. Petersburg was commissioned in honour of the silver jubilee of Emperor Alexander II. These included watercolours depicting the most significant events of the emperor's reign and pictures celebrating various innovations in St. Petersburg town life, including new transport and communications and, above all, the numerous buildings built or restored over the period: palaces, cathedrals, theatres, and educational establishments, as well as hospitals, stations, markets and so on. The series was presented to Alexander II by the State Duma on 19 February 1880. GP

48 Five Views of St. Petersburg, 1880

Maryinsky Theatre (centre)
Maly Theatre on the Fontanka
Cinizelli's Circus
St. Petersburg Yacht Club
Zoological Gardens

Watercolour of the zoo signed and dated bottom right: *Альбертъ Бенуа, 1880*
Watercolour on paper, card, 34.7 × 50.5 cm; 50.1 × 64.3 cm with passe-partout
Provenance: Acquired from the Library of Emperor Alexander II in the Winter Palace in 1927. ЭРР-8189-8193. Sheet from the same series as no. 47
Previous Exhibitions: Aarhus,1990, Cat. 27; St. Petersburg, 1994, Cat. 50
GP

47

48

49

LEONTY NIKOLAEVICH BENOIS

1856–1928

Russian architect.

Son of the architect N. L. Benois. Graduated from the Academy of Arts in 1879. Academician from 1885. Designer of many famous buildings in St. Petersburg; taught at the Drawing School of the Society for the Promotion of the Arts and at the Institute of Civil Engineering. One of the directors of the department of architecture at the Higher Institute of Art of the Academy of Arts from 1893; rector of the Academy of Arts from 1903 to 1906 and from 1911 to 1917; Professor Emeritus of Art from 1928.

49 Five Views of St. Petersburg, 1880

Nicholas I Memorial (centre)
Palace of Grand Duke Nikolai Nikolaevich
Palace of Grand Duke Mikhail Nikolaevich
Palace of Grand Duke Vladimir Alexandrovich
Museum of Carriages at the Court Stables

Signed and dated bottom centre of the sheet: *Леонтий Бенуа. 1880*
Watercolour on paper, card, 34 × 49.5 cm; 50.8 × 64.3 cm with passe-partout
Provenance: Acquired from the Library of Emperor Alexander II in the Winter Palace in 1927. ЭPP-8141-8145. Sheet from the same series as no. 47
Previous Exhibitions: Aarhus, 1990, Cat. 29; St. Petersburg, 1994, Cat. 51
GP

KAREL (CARL) OSIPOVICH BROZH

1836–1901

Czech artist, portrait, genre and landscape painter, illustrator.
Studied at the Academy of Fine Arts in Prague; worked in St. Petersburg
from 1858. Drawings commissioned by several St. Petersburg magazines
including *The World of Illustration*, where he was head of the arts
department.

50 Court Ball in the St. Nicholas Hall of the Winter Palace,

Late 1880s

Signed bottom right: *К. Брожъ*
Pencil and ink on card, 41 x 63.8 cm
Provenance: Acquired from the State Museum of Ethnography of the USSR in
1941; originally in the Alexander III Memorial Gallery opened in the Russian
Museum in St. Petersburg in 1898. ЭРР-6000
Previous Exhibitions: Aarhus, 1990, Cat. 33; St. Petersburg, 1994, Cat. 53

Emperor Alexander II stands to the left of the picture,
conversing with a foreign diplomat; on the right stands
Empress Maria Feodorovna, and next to her the Chief
Marshal of the Court, presenting the ladies to the empress.
In the centre of the picture stands the Tsarevich Nikolai
Alexandrovich; next to him is Grand Duchess Maria
Pavlovna, the wife of Grand Duke Vladimir Alexandrovich.

The 'stern and elegant' Grand Duke Vladimir Alexandrovich
can be seen to the right of the emperor, while behind the
tsarevich stands Grand Duke Alexei Alexandrovich,
'generally recognised as the rake of the family and idolised
by the beauties of Washington'. Grand Duke Konstantin
Nikolaevich stands behind Grand Duchess Maria Pavlovna,
chatting to a lady; behind them can be seen Grand Duke
Pavel Alexandrovich, 'the most handsome and most
democratically-minded' of the tsar's brothers, and Sergei
Alexandrovich, 'a snob, who irritated everyone with the ennui
and scorn written so clearly on his young face'. (Extracts from
the memoirs of Grand Duke Alexander Mikhailovich, 1991,
pp. 38, 199.)

'The first ball of the season was usually held in the St.
Nicholas Hall for 3,000 guests ... Only one ball a year was
held in the Hall, attended exclusively by those who belonged
to the top four classes of society (according to the table of
rankings) ... Also included on the guest-list were foreign
diplomats and their families, the most senior officers in the
guards' regiments with their wives and daughters, some
young officers invited as 'dancers' and a few others invited
specially by their royal highnesses ... It was like a scene from a
fairy-tale: January; a harsh frost. All three buildings of the
palace are lit up. The carriages draw up one after the other.
Officers, oblivious to the cold, ride up in sleighs, their horses
bedecked in blue ... Silhouetted against the light, ladies tiptoe
nervously from their carriage to the entrance. Here a glimpse
of the lively and the gracious, there the mighty figures of aged
aunts and grandmothers. Fur in abundance — ermine, silver
fox ... Heads are bare, for the married ladies wear tiaras while
the young girls wear flowers in their hair.' (Mosolov, 1992, pp.
196, 197.)

'The immense halls lined with gold-framed mirrors were full
to bursting with dignitaries, court officials, foreign diplomats,
Guards' officers and Eastern potentates. Their dazzling
uniforms embroidered with gold and silver provided a
sumptuous background for the court dresses and jewels of
their ladies. The halls were decorated with countless palms
and tropical plants from the imperial orangeries. It was an
almost magical scene as the blinding light of the massive
chandeliers reflected in the mirrors. And as you looked at the
teeming St. Nicholas Hall you could almost forget the bustle
of the twentieth century and find yourself once more in the
golden age of the reign of Catherine the Great. And suddenly
the crowd would fall silent and the master of ceremonies
would appear. Striking the floor three times with his rod, he
would announce the arrival of the royal cortège. The mighty
doors of the Heraldic Hall would swing open and the
sovereign and his wife would appear standing on the threshold
with members of their family and retinue. The emperor
always opened the ball with a polonaise, after which the
general dancing began.' (Grand Duke Alexander
Mikhailovich, 1991, p. 135.) GP

51 The Wedding of Grand Duchess Xenia Alexandrovna and Grand Duke Alexander Mikhailovich on 25 June 1894 in the Church of the Great Palace at Peterhof, 1894

Signed bottom right: *К. Брожъ*
Ink pen and brush on card, 38.5 x 58.4 cm
Provenance: Acquired from the State Museum of Ethnography of the USSR in
1941; originally in the Alexander III Memorial Gallery opened in the Russian
Museum in St. Petersburg in 1898. ЭРР-5999
Previous Exhibitions: Aarhus, 1990, Cat. 32; St. Petersburg, 1994, Cat. 52

On the left of the picture stands Grand Duke Alexander
Mikhailovich; next to him is Grand Duchess Xenia
Alexandrovna, who is receiving her wedding ring from
the priest. On a carpet to the right stand members of the
imperial family: the parents of the bride, Emperor
Alexander III and Empress Maria Feodorovna, to their left
Olga Konstantinovna, Queen of the Hellenes, and to their
right the bride's sister and brother, Grand Duchess Olga
Alexandrovna and the Tsarevich Nikolai Alexandrovich.

Grand Duke Alexander Mikhailovich left the following record
of this event: 'Our wedding was to take place in the very same
church of the Great Palace at Peterhof where I had made my
oath of allegiance on reaching my majority. I had chosen the
church because of my superstitious mistrust of the capital.
The empress herself oversaw the ceremonial dressing of the
bride along with the most senior of her ladies-in-waiting and
attendants. Xenia's hair was arranged in long ringlets and a
jewelled crown was attached to her head in some complicated
fashion. I remember that she was wearing the same silver
dress worn by my sister Anastasia Mikhailovna and all the
grand duchesses on their wedding day. I also recall the
dazzling crown on her head, several strings of pearls about
her neck and a number of diamond ornaments on her breast.
At last I was allowed to see the bride and the procession
began. The emperor himself led Xenia to the altar. I followed
arm-in-arm with the empress while the rest of the royal family
came behind us in order of seniority. Misha and Olga,
Xenia's younger brother and sister, winked at me, and it was
all I could do to stop myself laughing. I was told later that

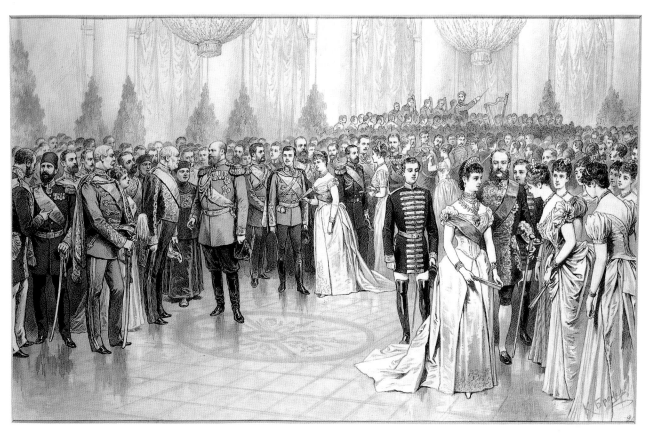

50

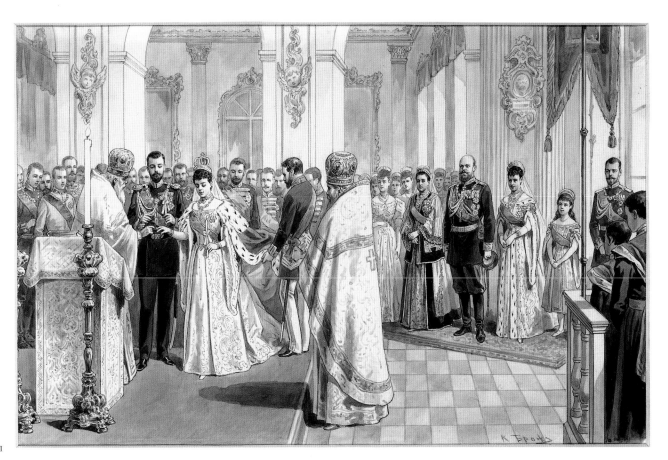

51

"the choir sang divinely." My mind was too firmly fixed on the forthcoming honeymoon in Ai-Todor to notice the church service or the singing of the court choristers.' (Grand Duke Alexander Mikhailovich, 1991, pp. 109, 110.) GP

52 The Burial Service of Alexander III in the St. Peter and St. Paul Cathedral in St. Petersburg, 1894

Ink pen and brush, white wash on card, 35 × 52.7 cm; 51 × 70 cm with passe-partout
Provenance: Acquired from the State Museum of Ethnography of the USSR in 1941; originally in the Alexander III Memorial Gallery opened in the Russian Museum in St. Petersburg in 1898. ЭPP-6004
Previous Exhibition: Aarhus, 1990, Cat. 34

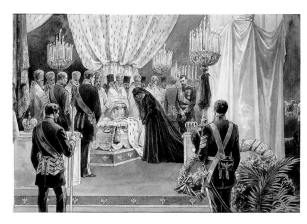

From the diary of Nicholas II, 7 November 1894: 'Once again we have had to relive those hours of grief and misery that befell us on 20 October. The service began at ten-thirty, followed by the burial of dear, never-to-be-forgotten Papa!' (Diaries of Nicholas II, 1991, p. 46.)

Maria Feodorovna is shown in the centre of the picture by the coffin, with Nicholas II behind her. 'It was impossible not to cry as we watched our dear empress lean over the body of her beloved for the last time. How quiet she was — how meek, how humble. I saw not a single tear in the eyes of the new sovereign: his grief was too deep. He cried on the day of his father's death, and has not been able to cry since.' (Diary of Grand Duke Konstantin Konstantinovich, State Archive of the Russian Federation.) GP

M. Zhukovsky
Russian artist of the second half of the 19th century.

53 Portrait of Doctor P.A. Badmaev, 1880s

Signed bottom left: *М. Жуковскій*
Pencil, watercolour on card, 33.5 × 26 cm; 53 × 43 cm with passe-partout. ЭPP-9219

Piotr Alexandrovich Badmaev (1851–1920) was a Buriat, christened Dzhamsaran. A godson of Alexander III, he was a well-known doctor and expert on Tibetan medicine; he translated a treatise on the subject. He went to school in Irkutsk and then to St. Petersburg University. From 1875 he worked in the Asian Department of the Ministry of

Foreign Affairs. At the same time he practised medicine in St. Petersburg, Mongolia and Tibet: his patients included several members of the royal family and of St. Petersburg high society. He taught Mongolian at St. Petersburg University from 1890. During the reign of the last tsar Badmaev was a well-known figure and an acquaintance of Rasputin. He was a Councillor of State from 1893. GP

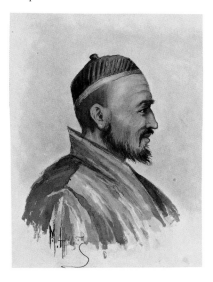

Mikhail Alexandrovich Zichy (Mihàly Zichy)
1827–1906
Artist, draughtsman and lithographer; genre painter, war artist, portraitist and illustrator.
Studied in Budapest and Vienna and in St. Petersburg from 1847. Academician at the St. Petersburg Academy of Arts from 1858. Court painter for Alexander II from 1859 and later for Alexander III and Nicholas II. Author of numerous drawings and watercolours of scenes from life at court under three Russian emperors.

The Death of Alexander III at Livadia:
A series of eleven drawings and watercolours (of which six are shown here), dated 1895 and based on sketches drawn from life. Originally in the Anichkov Palace.

54 The Deceased Alexander III in his Chair with Empress Maria Feodorovna alongside, 1895

Inscription at the top: *Совершишася! 20 окт. 1894* [It is finished! 20 October 1894] Signed and dated bottom right: *Zichy 95.*
Watercolour, pencil, white wash on grey paper; 23.5 × 30.5 cm; 34 × 41.5 cm with passe-partout. ЭPP-8020
Previous Exhibition: Aarhus, 1990, Cat. 40
GP

55 Alexander III on his Deathbed, Surrounded by Angels and a Weeping Youth Symbolising the Romanov Dynasty, 1895

Inscription bottom left: *Ливадія 20 окт. 1894.* [Livadia. 20 October 1894] Signed and dated bottom right: *Zichy 95*
Watercolour, pencil, white wash on grey paper; 23.5 × 31 cm; 34 × 41.5 cm with passe-partout. ЭPP-8022
Previous Exhibition: Aarhus, 1990, Cat. 41

54

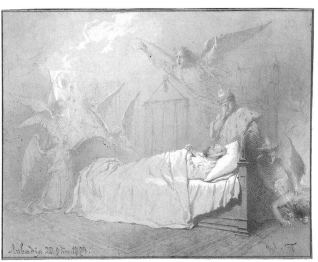

55

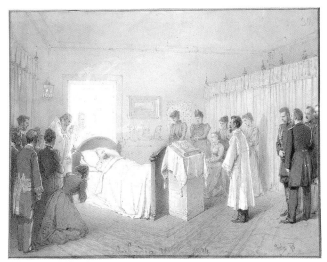

56

57

58

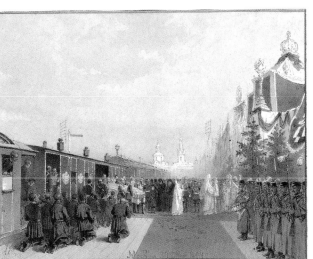

59

'My God, My God! What a day! The Lord has summoned our adored, dearest, beloved Papa. My head is spinning — I do not want to believe it — a terrible event that had seemed unthinkable until now ... A saint has died! God help us over these difficult days! Poor dear Mama.' (Diaries of Nicholas II; entry for 20 October 1894; 1991, p. 43.)

'Everyone who was present at the death of Alexander III — relatives, doctors, courtiers and servants — realised that our country had lost the buttress that was preventing Russia from sliding into the abyss. No one knew this better than Nicky, and for the first and last time in my life I saw tears in his blue eyes. He took me by the hand and led me down to his room. We embraced and wept together. He seemed unable to collect his thoughts. He realised that he was now emperor and the fearful burden of power weighed heavily on him. "Sandro, what shall I do?" he exclaimed pathetically. "What will become of Russia? I am not ready to be tsar! I can't rule an empire. I don't even know how to talk to ministers." ' (Grand Duke Alexander Mikhailovich, 1992, pp. 140, 141.) GP

56 Requiem for Alexander III in his Bedroom in the Small Palace at Livadia, 1895

Inscription bottom centre: *Ливадія 20 окт. 1894.* [Livadia. 20 October 1894]
Signed and dated bottom right: *Zichy 95*
Watercolour, pencil, white wash on grey paper, 23.9 × 30.9 cm; 34 × 41.5 cm with passe-partout. ЭPP-8028

'After breakfast the requiem mass was said, and again at 9 o'clock. The expression on dear Papa's face was wonderful — he was smiling, exactly as if he wanted to laugh!' (Diaries of Nicholas II; entry for 21 October 1894; 1991, p. 43.) GP

57 Alexander III's Body Being Carried Out of the Small Palace at Livadia, 1895

Inscription bottom right: *Ливадія 20 окт. 1894.* [Livadia. 20 October 1894]
Signed and dated bottom left: *Zichy 95*
Watercolour, pencil, gouache on grey paper, 23.5 × 30.5 cm; 34 × 41.5 cm with passe-partout. ЭPP-8021
Previous Exhibition: Aarhus, 1990, Cat. 42

'At half past six we began the painful ceremony of transporting the body of dear Papa in his coffin to the large church. Cossacks bore the coffin on a bier ... We returned to an empty house, exhausted in our hearts! How heavy is the burden that God has sent us!' (Diaries of Nicholas II; entry for 25 October 1894; 1991, p. 44.) GP

58 Alexander III's Coffin Being Carried Down the Gangway in Sevastopol, 1895

Inscription bottom left: *Севастополь 27 окт. 1894* [Sevastopol. 27 October 1894]
Signed and dated bottom right: *Zichy 95*
Watercolour, pencil, white wash on grey paper, 23.8 × 30.9 cm; 34 × 41.5 cm with passe-partout. ЭPP-8029

'Arrived at the pier at half past four. After mooring, the oarsmen carried the coffin to the carriage and the funeral train set off 20 minutes before us with a full escort (from the Preobrazhensky and Horse-Guards regiments) ... Left Sevastopol at 5.20. Got out at Simferopol station and went to the funeral carriage for a requiem mass.' (Diaries of Nicholas II; entry for 27 October 1894; 1991, p. 44.) GP

59 Alexander III's Coffin Being Carried Out of the Funeral Train in Moscow, 1895

Inscription bottom centre: *Москва 30 окт. 1894* [Moscow. 30 October 1894]
Signed and dated bottom left: *Zichy 95*
Watercolour, pencil, gouache, white wash on grey paper, 23.8 × 30.3 cm; 34 × 41.5 cm with passe-partout. ЭPP-8030

'Boarded the funeral train at 9.30 and travelled in it all the way to Moscow. Uncle Sergei, Ella and Uncle Misha met us on the platform. We carried the coffin to the hearse. The streets were lined with troops and thousands of people — the orderliness was amazing.' (Diaries of Nicholas II; entry for 30 October 1894; 1991, p. 45.) GP

DMITRI NIKOLAEVICH KARDOVSKY

1866–1943

Russian painter, draughtsman, genre painter, illustrator, stage designer and teacher.

Graduated from the law faculty at Moscow University in 1891 and at the same time attended the school of the architect A. O. Gunst. Studied at the Academy of Arts under P. P. Chistyakov and I. E. Repin from 1891 to 1901, and at the Ashbe School in Munich between 1896 and 1900. Awarded the title of Artist in 1902. Teacher at I. E. Repin's workshop from 1903; professor and director of the workshop after 1907; fellow of the Academy of Arts from 1911.

60 Ball at the Assembly Hall of the Nobility in St. Petersburg, 1915

Signed and dated bottom right: *Д. Кардовскій, 1915*
Watercolour, gouache, white wash on paper glued on canvas, 89 × 133 cm
Provenance: Acquired from the State Museum of Ethnography of the USSR in 1941; originally in the Winter Palace. ЭPP-5990

The grand ball at the Assembly Hall of the Nobility was held on 23 February 1913 during the festivities celebrating three hundred years of the Romanov dynasty. On 19 February, the eve of the festivities, the royal family had arrived in St. Petersburg from Tsarskoe Selo.

Empress Alexandra Feodorovna can be seen in the centre of the picture, in the royal box; to the left, by a column, is the Dowager Empress Maria Feodorovna, and between them, wearing the Order of St. Catherine, is Grand Duchess Maria Pavlovna. Grand Duchess Victoria Feodorovna is to the left of Maria Feodorovna, with a column behind her. Behind the ladies, standing right to left at the back of the box, are: Emperor Nicholas II, Grand Dukes Nikolai Nikolaevich (the younger), Piotr Nikolaevich and Boris Vladimirovich. Grand Duchess Olga Nikolaevna, the tsar's eldest daughter, can be seen waltzing in the foreground among a group of court ladies, dignitaries, generals and officers.

'Saturday 23rd February. At nine o'clock we got ready and took Olga with us to the ball at the Assembly Hall of the Nobility. Saltykov brought us the bread and salt in the Great

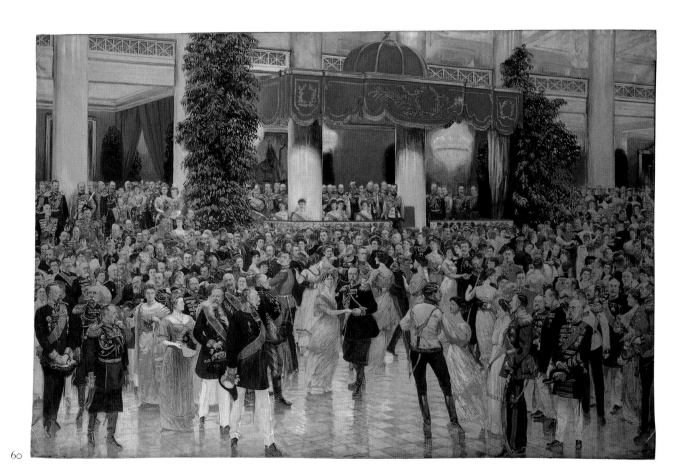

60

Hall; then they played a new cantata. After that we danced the Polka and then the dancing began. Olga danced a lot. Alix was the first to go, then Mama left, and finally Olga and I at 11.40. A splendid gathering and a beautiful ball.' (Diaries of Nicholas II, 1991, pp. 384, 385.) GP

ELENA NIKANDROVNA KLOKACHEVA

1871–after 1915
Russian artist, genre and portrait painter.
Daughter of a rear-admiral, studied at the Academy of Arts from 1891 to 1901; awarded the title of Artist in 1901. Lived and worked in St. Petersburg.

61 Portrait of G. E. Rasputin, 1914

Signed and dated bottom right: *E. Клокачева, июнь [1]914*
Coloured pencil, pastel on grey card, 81.5 × 56 cm
Provenance: Acquired from the Museum of the Revolution in 1954. ЭРР-5432
Previous Exhibition: St. Petersburg, 1994, Cat. 56

Grigory Efimovich Rasputin (1869–1916) was a well-known *staretz* [monk, or spiritual advisor] and a popular figure at the court of Emperor Nicholas II and Empress Alexandra Feodorovna. He was born to a family of prosperous peasants

in the Tobolsk region. A clairvoyant, he also practised hypnosis. He travelled widely around Russia's monasteries, where he befriended members of various sects and built up a reputation as a *staretz* and a soothsayer. He came to St. Petersburg in 1905 and through the rector of the St. Petersburg Religious Academy was introduced to Grand Duke Nikolai Nikolaevich (the younger). The grand duke's wife introduced Rasputin to the royal family and he began to visit the palace at Tsarskoe Selo. Rasputin had an extraordinary influence over Empress Alexandra Feodorovna, her daughters and even Nicholas II himself, for the simple reason that he seemed able to relieve the suffering of the Tsarevich, Alexei Nikolaevich.

His influence at court was especially strong during the war years. From 1914–16 he was the empress's only advisor in matters of state government. Ministers and senior state officials were appointed on his advice, a situation that gave rise to much protest at all levels of society, including at court and within the Romanov family itself. Rasputin was murdered on the night of 18 December 1916 at the Yusupovs' palace in St. Petersburg; among those who conspired to kill him were Prince F. F. Yusupov, V. M. Purishkevich, a member of the State Duma, and Grand Duke Dmitri Pavlovich. M. Paléologue, the French ambassador, described Rasputin's

features in his memoirs: 'Dark hair, long and unkempt, a thick black beard, high forehead, nose wide and prominent, fleshy mouth. But the whole expression of the face was concentrated in his eyes: blue, the colour of flax, with a strange gleam, deep and seductive. His gaze was at once penetrating and caressing, open and cunning, direct and distant. And when his speech became animated, his pupils seemed to give off an almost magnetic force.' (Paléologue, 1991, p. 162.)

'Rasputin's personality gripped the imagination of the whole civilised world. Serious historians and credulous romantics have dedicated volumes to the role the uneducated peasant played in the downfall of Russia. The "truth" about Rasputin is really quite simple. In addition to his innate courtesy, there was another side to the tsar's character, no less defining: he was an ideal husband and a loving father, who wanted to have a son. And herein lay the secret of Rasputin's powers. When it became clear that the boy suffered from haemophilia, the sovereign aged ten years overnight. He tried to find respite in endless work, but the empress was unwilling to give in to her fate. She spoke endlessly of the ignorance of doctors and clearly had more faith in charlatans ... So it was that the ground was prepared for the appearance of a miracle worker ... as far as the empress was concerned, she believed that the *staretz* saved her son from death. The sovereign despised Rasputin and was opposed to his visits to the palace.' (Grand Duke Alexander Mikhailovich,1991, pp. 151, 152.)

'However, giving in to the empress's entreaties, [the emperor] came to terms with the *staretz*'s visits and his influence over the empress, for, as he once explained to P. A. Stolypin: "Better ten Rasputins than one hysterical empress." ' (Bok, 1991, p.332.)

' "My dear Count!" Nicholas II once said to Minister at Court V. B. Fredericks, when he had decided to tell him what he thought of Rasputin. "You and I have often spoken of Rasputin, and I know everything that you have to say about him ... But let us be friends, and talk no more of it" ... Those less influential than Fredericks were simply removed from office for the slightest show of disrespect to the *staretz*.' (Mosolov, 1992, p.11.)

This is a rare example of a portrait of Rasputin, whose face is known principally from photographs. GP

PAVEL YAKOVLEVICH PIASETSKY
1843–1919

Russian explorer, artist, honorary part-time fellow of the Academy of Arts, fellow of the Russian Geographical Society, doctor of medicine, writer.

Graduated from the medical faculty of Moscow University in 1871; worked as a doctor at a clinic in St. Petersburg from 1873, at the same time studying under professor P. P. Chistyakov at the Academy of Arts. Also studied geography, ethnography and anthropology. From 1874 — the year he first visited China — Piasetsky completed numerous drawings from life. He used them as sketches for his own 'geographical observations'; these were rolls of panoramic watercolours up to 100 metres long, mounted onto fabric for durability and convenience. Among Piasetsky's unique creations were the panorama of the Great Siberian Road (1897–1903) in nine rolls; panoramas of China (1874), Mongolia (1875), Bulgaria during the Russo-Turkish War (1877–8), Central Asia and the Trans-Caspian Railway (1891–2), Turkmenia and Persia (1895), Japan and the Sea of Japan (1903), the Far Eastern Peninsula and Port Arthur (1904). The artist also accompanied Emperor Nicholas II on his travels and painted the panorama of Moscow (1896–1900) during the days of the coronation festivities, as well as views of Paris (1896), London (1897) and France (1901) during visits by the imperial couple. The artist exhibited his panoramas in the Winter Palace, at public readings in St. Petersburg and at the World Exhibition in Paris in 1900. He was awarded the gold medal of the Russian Geographical Society and the French Légion d'honneur.

62 Panorama of Moscow During the Coronation of Nicholas II, 1896–1900

Watercolour on paper glued onto fabric, 58.5 × 0.418 m
Provenance: Acquired from the Central Geographical Museum in St. Petersburg. ЭPP-591
Previous Exhibitions: Bonn, 1993, No. 24, p. 251; St. Petersburg, 1994, Cat. 57

The panorama depicts the main events of the coronation festivities, beginning with the arrival of the royal train in Moscow on 6 May 1896, and ending with the farewell parade on Khodynka Field on 26 May. Scenes in the panorama portray events in the order in which they took place. The first scene [not illustrated] shows the imperial train and the specially decorated platform at Smolensk Station; this is followed by views of the Palace at Petrovskoe where Nicholas and Alexandra spent three days before their return to Moscow, which took place on 9 May 1896.

'9 May — the day of our arrival in Moscow. The weather was marvellous. At 2.30 precisely the procession set off. I rode on Norma. Mama sat in the first gold coach, Alix in the second, also on her own. There is little to say about the welcome, except that it was full of pomp and joy, as only Moscow knows how. The view of the troops was magnificent!' (Diaries of Nicholas II, 1991, p. 143.)

The artist depicts the ceremonial procession [p. 75, top right] with Nicholas on horseback at the head followed by a dazzling cortège, as they make their way down Peterburgskoe Chaussée, through the Tver Gate and down Tverskaya Street to the Kremlin. All along the route the brightly decorated streets are lined with troops and crowds of well-wishers. After reaching Red Square the cortège completed its procession inside the Kremlin.

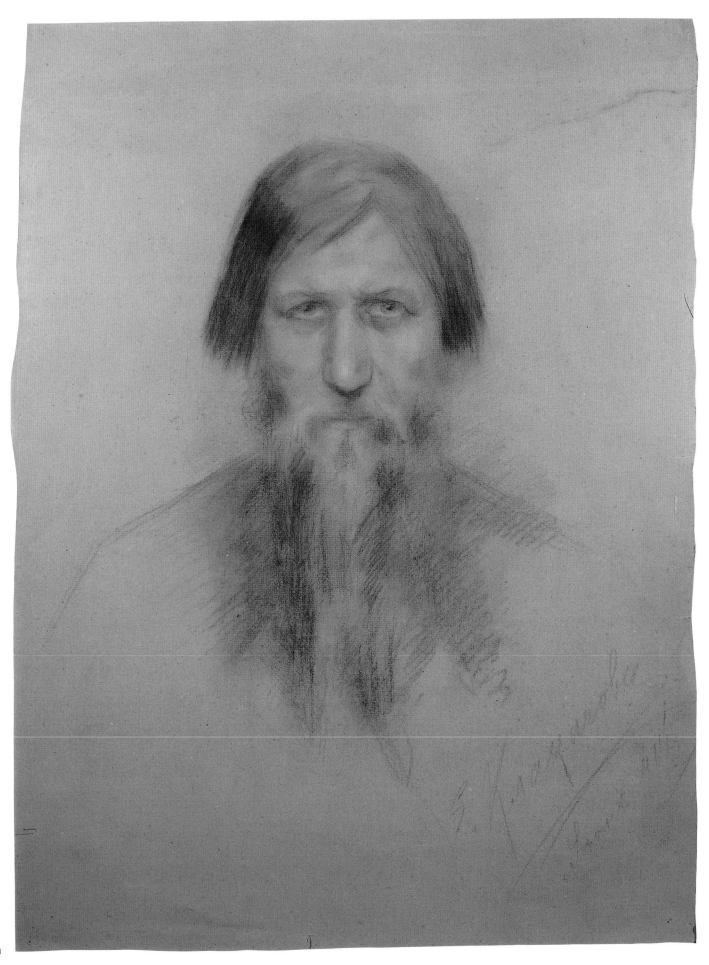

In the next part of the panorama the artist turns his attention away from the events of the coronation; instead, views of Moscow's embankments open up before the spectator: first looking south across the river from the Kremlin towards the Zamoskvoreche District, and then looking north towards the Kremlin from the opposite bank of the river, with views of the Cathedral of Christ the Saviour, the Great Kremlin Palace, the Kremlin Cathedrals, the Bell-Tower of Ivan the Great and other buildings inside the Kremlin.

Further on the artist returns to the events of the coronation: heralds are depicted on Red Square announcing the day of the coronation; Cathedral Square and the interior of the Uspensky Cathedral are pictured on the day of the coronation, 14 May 1896; this is followed by views of the royal procession, the Archangel and Annunciation Cathedrals and the imperial couple's appearance on the Red Porch to bow to the people.

'Tuesday 14 May. A great, solemn day, but spiritually a difficult one for Alix, Mama and me. On our feet from 8 in the morning; the procession began at 10.30. The weather, thank goodness, was still excellent, and the Red Porch a marvellous sight. Everything happened in the Uspensky Cathedral, and although it all seemed like a dream I know I shall never forget it for as long as I live!!! We got back at half past one. At 3 o'clock we repeated the procession to dinner in the Palace of Facets. At 4 everything reached an entirely satisfactory conclusion; my soul was overflowing with gratitude to God, and I was ready to drop!!!' (Diaries of Nicholas II, 1991, p. 143.)

'Wonderful spring days, the historical city all decked out in flags, the sound of bells from sixteen hundred belfries, crowds of people shouting "hurrah!", the young empress dazzling all with her beauty, the ruling heads of Europe in their golden carriages — no strict command could have provoked more enthusiasm among the crowd than did this scene that greeted our eyes.' (Grand Duke Alexander Mikhailovich, 1991, p. 142.)

The scenes that follow [not illustrated] show the deserted interiors of the Terem and Great Kremlin Palace, from which it is clear that the artist was not present at a number of the celebrations. Thus the chambers of the Terem Palace and the Vladimir, Catherine, Alexander and George halls in the Great Kremlin Palace, as well as the main staircase, are shown without any of the participants. Further scenes show the ceremonial arrival of the royal couple in the Throne Room of St. Andrew on 15 May 1896, where they accepted the congratulations of the clergy, state institutions, nobility, and regional and town councils; also depicted is the grand ball held in the Assembly Hall of the Moscow Nobility, which took place on 21 May 1896.

'Tuesday 21 May. At 10.45 went to the ball at the Nobles' Assembly; it was terrifically hot.' (Diaries of Nicholas II, 1991, p.146.)

Piasetsky's detailed depiction of the festive illuminations in Moscow on 9 May is of particular interest. Multi-coloured electric lights lined the Kremlin walls, the cathedrals and a number of important architectural sites around the city; at the same time the projectors that lit up the Moscow sky were a remarkable technical achievement. Vast sums were spent on setting up the illuminations, and several of Moscow's finest artists, engineers and builders took part in their organisation.

'At 9.00 we went out onto the top balcony from where Alix lit the illuminations on the Ivan the Great Bell-Tower; then in turn the Kremlin towers and walls lit up, as well as the opposite bank of the river and the Zamoskvoreche District.' (Ibid. p. 145.)

The last two events shown in the panorama [not illustrated] are the public walkabout near the Tsar's Pavilion which took place after the catastrophe on Khodynka Field on 18 May, and the military parade in the same place on 26 May. 'According to the programme of events the distribution of gifts to the people was to take place at 11 o'clock on the morning of the third day of coronation festivities. A pale dawn lit up the pyramids of tin beakers decorated with imperial eagles, which were set out on specially constructed wooden scaffolds. It took only a second for the Cossacks to be crushed, as the crowd charged forward ... Five thousand people were killed, even more injured and maimed. At three in the afternoon we went to Khodynka; en route we passed carts piled high with corpses. That evening Nicholas II went to a grand ball given by the French Ambassador.' (Grand Duke Alexander Mikhailovich, 1991, p.143.)

'Saturday 18 May. We lunched at 12.30 and then Alix and I set off for Khodynka for this sad "national" celebration. There was nothing much going on there: we looked out of the pavilion onto a huge crowd surrounding the stage where an orchestra kept playing the national anthem and "Be Glorified!". We dined at Mama's at 8 o'clock. Went to Montebello's ball. It was beautifully done, but the heat was unbearable. We left after supper at 2 o'clock.' (Diaries of Nicholas II, 1991, p. 146.)

'Sunday 26 May. At 11 o'clock got onto my horse, Alix in the charabanc with Missy and Ducky, and set off to review the troops who were lined up 300 paces away from the pavilion opposite Petrovskoe. The parade was magnificent in every respect, and I was delighted that the troops put on such a fine show in front of the foreign visitors. Returned to Petrovskoe and had lunch; afterwards we bid farewell to the foreign delegations. At 7 o'clock there was a big dinner for the Moscow authorities and representatives of various estates ... Got changed, set off for the station and said goodbye to Mama; she left for Gatchina while we set out in the opposite direction.' (Ibid. p. 147.)

Piasetsky's panorama is a unique testament: at once an interesting record of historical events and a distinctive work of art. It was first exhibited at the World Exhibition in Paris in 1900. GP

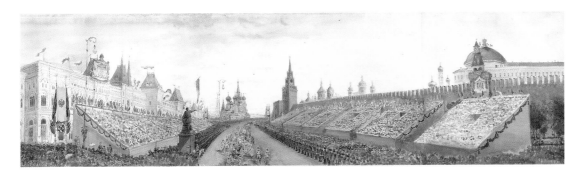

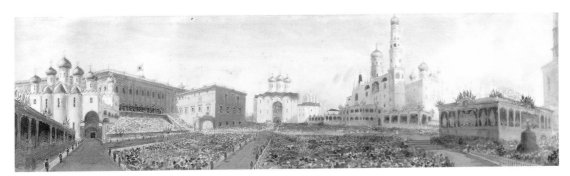

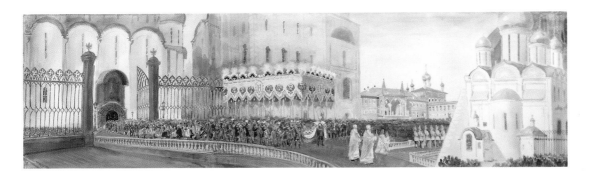

Rudolf Feodorovich (Ferdinandovich) Frentz

1831–1918

German painter and draughtsman.

Born in Berlin, studied at the Berlin Academy of Arts; after graduation in 1859 came to St. Petersburg. Was part of the retinue of Grand Duke Nikolai Nikolaevich, whom he accompanied on trips around Russia, drawing and painting. Also accompanied Grand Duke Vladimir Alexandrovich on hunting trips and painted hunting scenes for him. Spent several years in the retinue of Grand Duke Nikolai Alexandrovich (later Nicholas II); drew pictures of military manoeuvres and many hunting scenes for him. Took part in exhibitions of the Association of Travelling Art Exhibitions; also exhibited in Paris, Philadelphia and Berlin.

63 Record of the Imperial Hunt for 1896

An inscription in red ink in the centre of the scene records the hunting bag; inscription below: *И. Д. Начальника Императорской Охоты Свиты Вашего Величества Генералъ-Маіоръ Князь Голицынъ* [Head of the Imperial Hunt of Your Highness's Retinue Major-General Prince Golitsyn]
Signed bottom right: *Р. Френцъ*
Watercolour and ink on paper glued on card, 50 × 33.5 cm
Provenance: Acquired from the Library of Nicholas II in the Winter Palace. ЭPP-8366
Previous Exhibitions: Riihimäki, 1991, No 58; Hørsholm, 1996, No. 67

'The hottest day so far ... Set off for Gatchina at one; didn't go as far as the station, got off at the meadows and walked to the new grouse mating-ground. Bagged two grouse at sunrise. Got back to Tsarskoe at 5.15 in the rain.' (Diaries of Nicholas II; entry for 18 April 1896; 1991, p. 139.) Nicholas II always gave a brief but precise account of the day's bag in his diary. It appears from his notes that he mostly hunted birds and small animals.

These decorative records of the hunting bag probably sum up the results for the whole season. GP

64 Record of the Imperial Hunt for 1899,

10 November 1899

An inscription in red ink in the centre of the scene records the hunting bag; inscription bottom right: *Начальникъ Императорской Охоты Егермейстер Генералъ-Лейтенантъ Князь Голицынъ* [Head of the Imperial Hunt Lieutenant-General Prince Golitsyn]
Signed bottom left: *Р. Френцъ*
Watercolour and ink on card, 50 × 33.8 cm
Provenance: Acquired from the Library of Nicholas II in the Winter Palace. ЭPP-8368
Previous Exhibitions: Riihimäki, 1991, No. 59; The Danish Museum of Hunting and Forestry, 1996, No 68

'Got up at 5.30, had coffee with dear Alix and set off for Kipen in the troika with Girsh [surgeon]. The hunt was jolly and successful: 760 kills with thirteen guns. I bagged 58 — 1 grey-hen, 1 grey partridge and 56 hares ... The hunt ended up at Ropshinskaya Church, from where I headed back to Tsarskoe in my old "Siberian" carriage with Gustav.' (Diaries of Nicholas II; entry for 30 October 1896; 1991, p. 177.) GP

65 Record of the Imperial Hunt for 1900

An inscription in brown ink in the centre of the scene records the hunting bag; signed bottom left: *Р. Френцъ*; inscription centre: *Начальникъ Императорской Охоты Егермейстер Генералъ-Лейтенантъ Князь Голицынъ* [Head of the Imperial Hunt Lieutenant-General Prince Golitsyn]
Watercolour and ink on grey paper glued on card, 48 × 31.5 cm
Provenance: Acquired from the Library of Nicholas II in the Winter Palace. ЭPP-8369
Previous Exhibitions: Riihimäki, 1991, No. 60; Hørsholm, 1996, No. 69
GP

66 Record of the Imperial Hunt for 1902

An inscription in red ink in the centre left of the scene records the hunting bag; signed bottom right: *Р. Френцъ*; inscription left: *Начальникъ Императорской Охоты Егермейстер Генералъ-Адъютант Князь Голицынъ* [Head of the Imperial Hunt Adjutant-General Prince Golitsyn]
Watercolour, white wash, pencil and ink on grey paper glued on card, 49 × 32.5 cm
Provenance: Acquired from the Library of Nicholas II in the Winter Palace. ЭPP-8371
Previous Exhibitions: Riihimäki, 1991, No. 61; Hørsholm, 1996, No. 70

'Tuesday 20 April: Went to the mating-ground near Gatchina at one in the morning — killed two grouse.'
'Thursday 22 April: Went to the same mating-ground, got lucky this time and bagged five grouse ...'
'Tuesday 27 April: Went to a different grouse mating-ground at night. Weather warm and windy. Killed two grouse and got back by 5 o'clock ...' (Diaries of Nicholas II; entries for 20, 22, 27 April 1904; 1991, pp. 205, 206.)

Later diaries from 1905 and 1906 contain numerous references to hunts at the grouse mating-ground, and also descriptions of shoots in Finnish skerries.

'At 8.45 set off in the motor for Nastolovo with Fredericks, Orlov and Drentelen. Weather misty and warm. The drive began at Piuduzi and then along both sides of Ropshinskoe Chaussée. Breakfast in a tent ... Total bag: 286. I bagged 21: a pheasant, 4 grey-hen, a woodcock, two grey partridge and 13 hares.' (Diaries of Nicholas II; entry for 28 September 1906; 1991, p. 336.) GP

63

64

65

66

67 Record of the Imperial Hunt for 1908

An inscription in brown ink in the centre of the page and in the left corner records the hunting bag; signed left side: *P. Френцъ*; inscription bottom left: *Генералъ-Адъютантъ Князь Голицынъ* [Adjutant-General Prince Golitsyn.]
Watercolour, pencil and ink on paper glued on card, 48.7 × 32 cm
Provenance: Acquired from the Library of Nicholas II in the Winter Palace. ЭPP-8374
Previous Exhibitions: Riihimäki, 1991, No. 62; Hørsholm, 1996, No. 71

In the winter and spring of 1907–8 Nicholas II frequently went hunting, usually in the area around St. Petersburg.

'Went to Peterhof at 12.30 for a shoot in the Znamensky pheasant drive. Total bag: 620; I bagged: 116 pheasants, 2 grey partridge and 1 white hare, total 119.' (Diaries of Nicholas II; entry for 25 January 1908; 1991, p. 351.) GP

68 Record of the Imperial Hunt for 1911

An inscription in brown ink in the right-hand corner records the hunting bag; signed left: *P. Френцъ*; inscription below: *Начальникъ Императорской Охоты Генералъ-Адъютантъ Князь Голицынъ* [Head of the Imperial Hunt Adjutant-General Prince Golitsyn]
Watercolour, pencil and ink on paper glued on card, 52 × 33.4 cm
Provenance: Acquired from the Library of Nicholas II in the Winter Palace. ЭPP-8377
Previous Exhibitions: Riihimäki, 1991, No. 64, p.28; Hørsholm, 1996, No. 73

The emperor himself is depicted shooting pheasants in the winter of 1911, probably around Gatchina, near St. Petersburg. GP

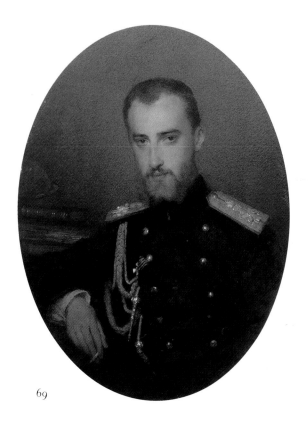

69

MARIA VASILIEVNA ETLINGER (ERISTOVA)
?–1934
Russian artist, portraitist, painter and draughtsman.
Studied under I. E. Repin and M. A. Zichy; completed artistic education in Paris. Honorary part-time student at the Academy of Arts. Lived in St. Petersburg and Tbilisi. Painted numerous portraits of members of high society and the intelligentsia in St. Petersburg and Tbilisi. Exhibited under the pseudonym 'Mary'.

69 Portrait of Grand Duke Nikolai Mikhailovich, 1882

Signed and dated right: *Mary, 1882*
Watercolour, coloured pencil, pencil and pastel on paper, 56.5 × 43 cm (oval)
Provenance: Acquired from the State Museum of Ethnography of the USSR in 1941; originally in the palace of Grand Duke Mikhail Nikolaevich in St. Petersburg. ЭPP-5225

This portrait originally formed part of a panel of a large screen along with portraits of the other children of Grand Duke Mikhail Nikolaevich. The screen consisted of seven panels; an oval portrait of each of the seven children of Grand Duke Mikhail Nikolaevich was mounted in each. The screen was commissioned for Mikhail Nikolaevich's palace in St. Petersburg in memory of his time as governor of the Caucasus between 1863 and 1882.

Grand Duke Nikolai Mikhailovich (1859–1919) was the eldest son of Field Marshal Grand Duke Mikhail Nikolaevich. He was a grandson of Emperor Nicholas I and an uncle of Nicholas II. He began his career in the military, reaching the rank of lieutenant in 1876. He served in the Russo-Turkish War of 1877–8 and was awarded the Order of St. George, 4th Class, for bravery. He became aide-de-camp in 1879. Until 1881 he served in the Caucasus, and afterwards in the Horse-Guards Regiment. He was promoted to colonel in 1892 and major-general and commander of the Horse-Guards in 1896. He reached the rank of lieutenant-general in 1901 and by the time he left the military in 1903 he was adjutant-general.

Grand Duke Nikolai Mikhailovich was a well-known historian and art historian, and corresponded with L. N. Tolstoy. He was the author of a number of studies of the reign of Alexander I, as well as works on Russian diplomacy, genealogy and the history of portrait painting in Russia. He was chairman of the Russian Historical Society from 1909 to 1917, president of the Russian Geographical Society and an Honorary Fellow of the Imperial Academy of Arts. He was considered the leader of the so-called Grand Dukes' *fronde*, the group that was critical of Nicholas II and, especially, of Alexandra Feodorovna. He was known in the family as the 'Red Duke' for his liberal views and for his criticism of Nicholas II's policies, particularly during the time of Rasputin's influence at court. He believed in limiting the power of the autocracy and welcomed the February Revolution. However, the grand duke's optimism after the February Revolution quickly vanished, as is shown by his conversation with the French Ambassador M. Paléologue. When asked about his gloomy demeanour, the grand duke replied, 'I cannot forget that I am a doomed man.' Grand Duke Nikolai Mikhailovich was shot by the Bolsheviks in the Peter and Paul Fortress in 1919, despite petitions for his

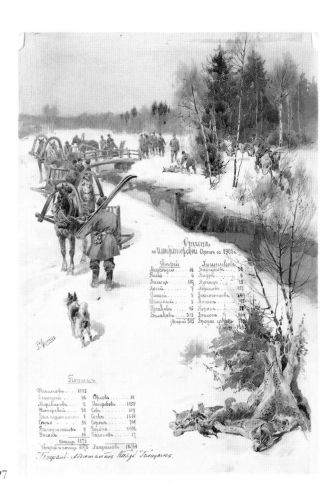

67

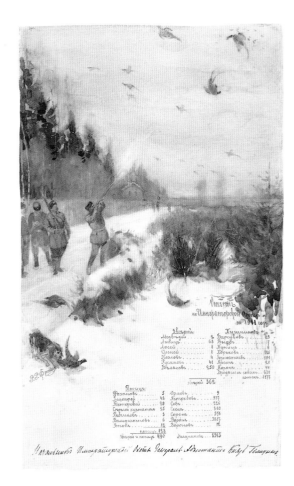

68

release from Maxim Gorky and the Academy of Sciences. 'Nikolai Mikhailovich was a distinguished, intelligent man, remarkable for his love of intrigues. In the Yacht Club, where he liked to hold forth, the caustic criticism of the grand duke contributed in no small measure to the downfall of the regime. His damning sarcasm percolated through society, encouraging unhealthy opposition to the power of the tsar. He was one of the main initiators of the collective letter written by the grand dukes which caused such dissension in the royal family. Banished to his property in the south of Russia, he was not in St. Petersburg when the revolution erupted.' (Mosolov, 1992, p.146.)

'Nikolai Mikhailovich was more critic and *frondeur* than conspirator; he was too fond of epigrammatic thrusts in the salon. He was not in the least a man to make risky attacks.' (Paléologue, 1991, p. 32.)

Nikolai Mikhailovich's brother, the intelligent and educated Grand Duke Alexander Mikhailovich, was particularly sorry that it was his brother's unhappy fate to have a talent unrecognised by society: 'My elder brother Nikolai Mikhailovich was undoubtedly the most "radical" and most gifted member of the family. He was elected a member of the Academie Française ... His sharp mind, European views, innate goodness and understanding of the opinions of foreigners, allied to great patience and a genuine love of peace would have earned him admiration and respect in any of the world's capitals.' (Grand Duke Alexander Mikhailovich, 1991, pp. 123, 124.)

Nikolai Mikhailovich is portrayed in the frock-coat of the Life-Guard Horse-Grenadiers Regiment with the insignia of aide-de-camp. GP

70 Portrait of Grand Duke Alexander Mikhailovich
as a Young Man, 1882

Signed and dated right: *Mary, 1882*
Watercolour, coloured pencil, pencil and pastel on paper, 57 × 43.5 cm (oval)
Provenance: Acquired from the State Museum of Ethnography of the USSR in
1941; originally in the palace of Grand Duke Mikhail Nikolaevich in St. Petersburg.
ЭPP-5229
Previous Exhibition: St. Petersburg, 1994, Cat. 59

Grand Duke Alexander Mikhailovich (1866–1933) was the son
of Field Marshal Grand Duke Mikhail Nikolaevich. He was a
grandson of Emperor Nicholas I and an uncle of Nicholas II.
In 1894 he married Nicholas II's sister, Grand Duchess Xenia
Alexandrovna.

He began his service in the navy as midshipman in 1885. He
became aide-de-camp in 1886 and briefly retired from the
navy between 1896 and 1899. In 1900 he was promoted to
captain, first rank, and in 1902 led a forestry concession on
the river Yalu in Korea. In 1902 he was promoted to the
rank of rear-admiral and was appointed minister in charge of
the Russian merchant navy. He retired in 1906 and went
abroad with his family. In 1908 he organised the first Russian
Flying School outside Paris and in spring 1909 his students
made the first ever flights in St. Petersburg. In autumn 1909
he established the Russian School of Aviation outside
Sevastopol. During the First World War he commanded the
air force on the southern front and then became supreme
commander of the Russian Air Force. In 1918 he emigrated to
France from the Crimea; he later lived in the USA.

In his memoirs Alexander Mikhailovich wrote: 'Good sense
and logic should have meant that I went to Naval College.
Established tradition, however, dictated that grand dukes
could not be educated alongside the sons of mere mortals, so I
was taught at home ... The theory I studied at home was
supplemented by visits to warships and docks. Every summer
I spent three months on board a cruiser alongside cadets and
midshipmen from the Naval College.' (Grand Duke Alexander
Mikhailovich, 1991, pp. 66–8.)

This portrait of the grand duke was painted at the time of the
naval studies described above. GP

ALOISE GUSTAV (ALOIZY PETROVICH) ROCKSTUHL

1798–1877

Russian miniaturist, watercolourist, portraitist and
draughtsman.

Studied at the Academy of Arts from 1832 to 1835; student of miniature
painting from 1840, court artist after 1864 and professor at the Academy of
Arts from 1864. Often worked on commissions from court. Apart from
miniature portraits, completed a large number of drawings of exhibits in
the museum of the Arsenal at Tsarskoe Selo.

71 Portrait of the Tsarevich, Grand Duke
Nikolai Alexandrovich, as a One-Year-Old Child, 1869

Signed and dated along left side of oval: *1869 Рокштуль*
Inscription on the reverse: *portrait de Monseigneur le Grand Duc Nicolai
Alexandrovich, peint en 1869 par le peintre de Sa Majesté L'Empereur A. de
Rockstuhl chevalier* [portrait of His Royal Highness the Grand Duke Nikolai
Alexandrovich, painted in 1869 by His Majesty the Emperor's artist A. de
Rockstuhl, knight]
Watercolour and gouache on ivory, 11 × 9 cm (oval)
Provenance: Acquired from the State Museum of Ethnography of the USSR in
1941; originally in the Anichkov Palace in St. Petersburg. ЭPP-45
Previous Exhibition: St. Petersburg, 1994, Cat. 60
GP

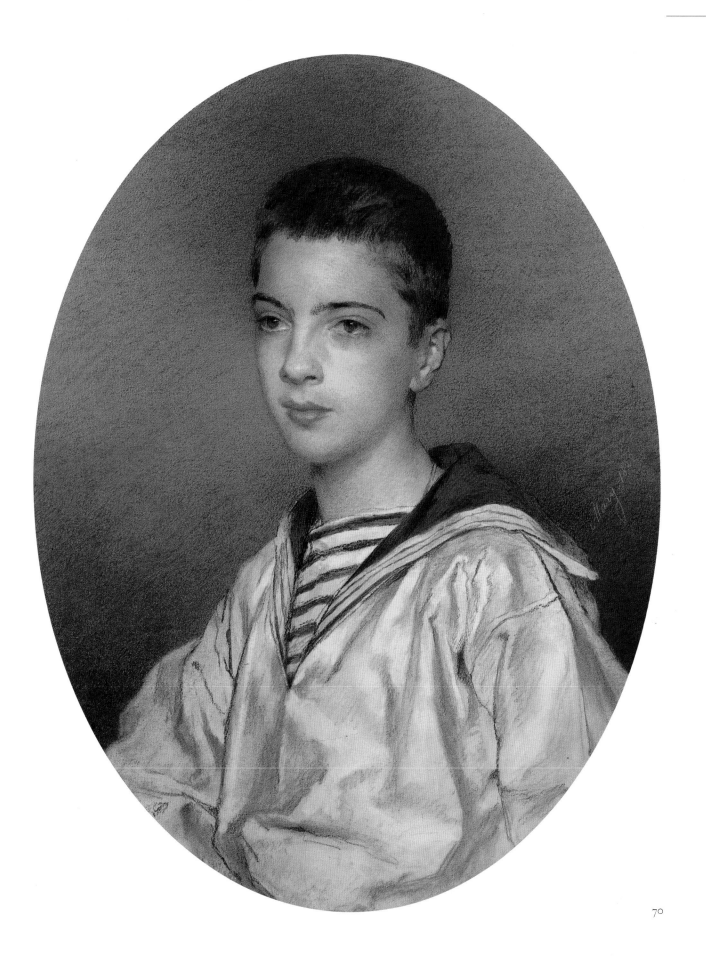

R. de San Gallo
Italian miniaturist of the turn of the 20th century.

72 Portrait of Count F. F. Sumarokov-Elston, 1900s

Signed along left side of oval: *R. de San Gallo*
Watercolour and gouache on ivory, 9.4 x 7 cm (oval)
Provenance: Acquired from the State Museum of Ethnography of the USSR in 1941; originally in the palace of the Yusupov family in St. Petersburg. ЭPP-61
Previous Exhibition: St. Petersburg, 1994, Cat. 61
Literature: Komelova, Printseva, 1986, p. 298, Cat. 99

Count Felix Felixovich Sumarokov-Elston (1887–1967) was the son of Count F. F. Sumarokov-Elston (the elder) and Princess Z. N. Yusupova; in 1908 he became Prince Yusupov.

Yusupov married Irina Alexandrovna, niece of Nicholas II, in 1914, and served in the Horse-Guards Regiment. He was one of the organisers and participants in the murder of Rasputin in 1916, after which he was exiled to his property in Kursk province. He later went abroad, where he was joined by his wife. After the revolution the Yusupovs lost practically all their wealth; with what remained they bought an inexpensive building in Paris and set up a hat shop.

'This morning, at 9 o'clock exactly, Prince Yusupov paid me a visit,' wrote V. M. Purishkevich in his diary for 21 November 1915 (as the plot against Rasputin began to develop). 'He was a young man of about 30, dressed in uniform — apparently an officer. I was much taken with his appearance: there was a sense of refinement and breeding about him, and in particular a spiritual fortitude. He was evidently a man of strong will and character, qualities not frequently met in Russian people, especially those of aristocratic origin.' GP

73 Portrait of Emperor Nicholas II, *c. 1913*

Unknown artist of the early 20th century
Enamel and paint on silver, 8.7 x 7 cm (oval)
Provenance: Acquired from the State Depository of Art Treasures in 1951. ЭPO-8882
Previous Exhibition: St. Petersburg, 1994, Cat. 63

This miniature of Nicholas II was probably intended as part of a presentation book or anniversary album to mark the 300th anniversary celebrations of the Romanov dynasty.

Nicholas is portrayed in the uniform of a colonel in the Life-Guard Keksholm Regiment with the insignia of aide-de-camp in His Imperial Highness's Retinue. GP

I. Bondarenko
Artist of the turn of the 20th century.

74 Deed Marking the Presentation of Text-Books on the History of Russia to the Tsarevich Alexei Nikolaevich from the Society for the Promotion of Religion, Morality and Patriotism in the Education of Children

In a frame with floral ornament containing a view of the Moscow Kremlin and a picture of the Tsarevich Alexei in ancient Russian dress writing in an exercise-book.
Waxed paper, manuscript in ink and watercolour, gouache, Indian ink, bronze paint, metallic gilt thread suspended from seal, 40 x 107 cm. КП 107-68/2

Beneath the text are the autographs of Princess Sofia Golitsyna, chair of the society, the Bishop of Serpukhovsk, the Moscow suffragan Anastasy, the State Inspector of Schools, G. Markov, and others. GM

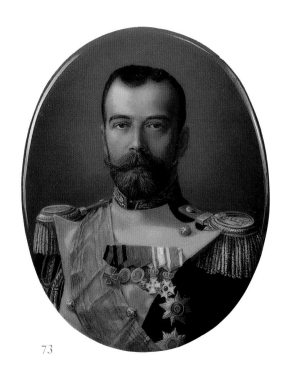

73

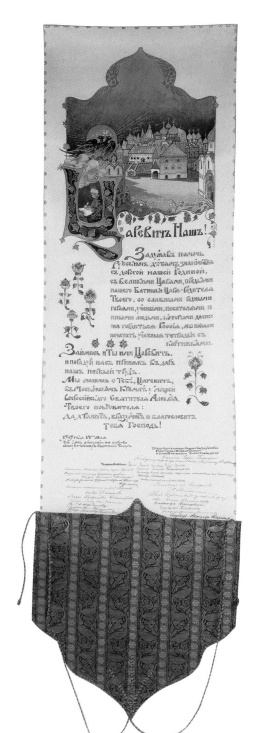

74

FERNAND DESMOULIN

1853–?

French painter and engraver.

Worked in St. Petersburg at the turn of the 20th century; made engravings based on his own and others' originals: portraits, cityscapes, various events. Made a number of portraits of members of the royal family.

75 Coronation Portrait of Emperor Nicholas II, 1896

Signed bottom left: *F. Desmoulin*
Etching, 58.5 × 44.3 cm; 80 × 56.1 cm
Provenance: From the original Hermitage Collection. ЭРГ-33635
Previous Exhibition: St. Petersburg, 1994, Cat. 64

Nicholas is portrayed in the uniform of the Life-Guard Preobrazhensky Regiment, wearing an ermine mantle and a diamond chain of the Order of St. Andrew the First-Called. He is shown with the symbols of royal power: the crown, orb and sceptre. GM

MIKHAIL VIKTOROVICH RUNDALTSOV

1871–1935

Russian portraitist and engraver.

Part-time student at the Baron A. L. Stieglitz School of Technical Drawing. Academician from 1905. Engraver for the firm of Fabergé. Emigrated to America in 1920 and then moved to France; died in Paris. Undertook a large number of portraits of Russian cultural figures as well as members of the imperial household. Worked principally in etching.

76 Portrait of Grand Duke Vladimir Alexandrovich, 1902

Subject's signature beneath the etching: *Владимиръ*.
Signed and dated by the artist bottom right: *Мих. Рундальцовъ 1902*
Etching, 59 × 44.5 cm; 81 × 61 cm
Provenance: Acquired from the Leningrad Artillery Museum in 1951. ЭРГ-33982
Previous Exhibition: St. Petersburg, 1994, Cat. 65

Grand Duke Vladimir Alexandrovich (1847–1909) was the third son of Alexander II and uncle of Nicholas II. He was a general in the infantry, adjutant-general, member of the Council of State, senator, president of the Academy of Arts and honorary fellow of the Academy of Sciences. He commanded the Guards Academy during the war of 1877–8, and later became commander of the Guards in the St. Petersburg military district. He married Grand Duchess Maria Pavlovna, who was born Countess Mecklenburg-Shverein; their marriage bore three sons and a daughter — Alexander, Kyril, Andrei and Elena. Their second son Kyril Vladimirovich (1876–1938) emigrated and was declared the sole rightful heir to the Russian throne. By a decree of 31 August 1924 he proclaimed his eldest son, Vladimir Kyrilovich (1917–92), tsarevich and heir.

'Grand Duke Vladimir Alexandrovich ... was a man of undoubted artistic talent. He drew, was interested in ballet, and was the first to finance the overseas ballet tours of S. P. Diaghilev. He collected ancient icons, visited Paris twice a year and loved to hold elaborate receptions at his wonderful palace in Tsarskoe Selo. Although a kind man by nature, his somewhat extravagant character meant that he sometimes gave the impression of being unapproachable. Anyone meeting Grand Duke Vladimir for the first time would be struck by the abruptness and booming voice of this Russian *grand seigneur*. He was particularly disdainful of the young grand dukes. It was impossible to talk to him of anything other than art or the subtleties of French cuisine ... Because of his position and age he was commander of the Guards Academy; he viewed these military duties, however, as little more than a hindrance to his love of the arts.' (Grand Duke Alexander Mikhailovich, 1991, p. 114.)

Grand Duke Vladimir Alexandrovich is portrayed in the uniform of adjutant-general in His Imperial Highness's Retinue. GM

77 Portrait of Grand Duke Mikhail Alexandrovich, 1914–16

Signed below: *Михаилъ* [Mikhail] and *гр. Рундальцовъ* [engraved by Rundaltsov]
Etching, 56 × 47 cm; 89 × 62 cm
Provenance: From the original Hermitage Collection. ЭРГ-16711
Previous Exhibition: St. Petersburg, 1994, Cat. 71

Grand Duke Mikhail Alexandrovich (1878–1918) was the third son of Alexander III, brother of Nicholas II and a lieutenant-general. After the death of his brother Grand Duke Georgy Alexandrovich in 1899, and before the birth of Nicholas II's son Alexei in 1904, he was the heir to the Russian throne. He served in the Guards from 1898 to 1911. During the First World War he led the Indigenous Cossack Mounted Division, and was later in charge of the Second Cavalry Corps.

Mikhail Alexandrovich was Alexander III's favourite son. Although Alexander was well-known for being strict with all his children, he always forgave Mikhail his indiscretions. Mikhail married a commoner, N.S. Wulfert, in a ceremony in Vienna in 1912 that was kept secret from Nicholas II. After the marriage Mikhail Alexandrovich was banished from court and forbidden to enter Russia. With the outbreak of war with Germany in 1914 he was allowed to return to St. Petersburg with his wife. On their return, Mikhail Alexandrovich's wife received the title of Countess Brassova (it was as Count Brassov that Mikhail Alexandrovich had earlier travelled around Europe). According to the French Ambassador M. Paléologue, 'Through [his wife] the grand duke grew closer to the Socialist Revolutionaries of the left, and so began the idea of removing Nicholas from the throne in favour of Mikhail.' (Paléologue, 1991, p. 134.)

According to the initial draft of his abdication document, Emperor Nicholas II relinquished the throne in favour of his son Alexei, with Mikhail Alexandrovich acting as regent until he reached his majority. On 2 March 1917, however, a delegation from the Committee of the State Duma — V.V. Shulgin and A.I. Guchkov — came to see Nicholas, and he gave them a telegram with the following text to be dispatched to the Tauride Palace: 'Today at 3 o'clock in the afternoon I took the decision to abdicate; this decision remains unchanged. I had initially intended to pass on the throne to my son Alexei; on reflection, however, I have changed this decision, and now abdicate on both my own and my son's

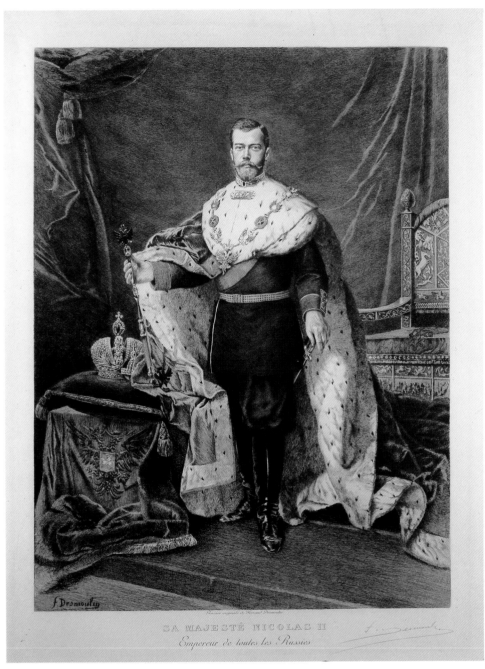

SA MAJESTÉ NICOLAS II
Empereur de toutes les Russies

75

76

77

behalf in favour of my brother Mikhail.' (Danilov, 1924, p. 236.)

Grand Duke Mikhail Alexandrovich is portrayed in the uniform of the Life-Guard Mounted Artillery Brigade. GM

78 Portrait of Empress Alexandra Feodorovna, 1905

Signed and dated right: *М. Рундальцовъ 1905*
Etching, 62.5 × 47.5 cm; 96 × 67.5 cm
Provenance: From the original Hermitage Collection. ЭРГ-16871
Previous Exhibition: St. Petersburg, 1994, Cat. 66

'The empress looked particularly fine at this time,' wrote Pierre Gilliard in his diary in the autumn of 1905. 'Tall, strong, with marvellous posture. But this was nothing compared to the look in her grey-blue eyes — strikingly alive, and seeming to reflect every emotion of her vigorous soul.' (Gilliard, 1921, p. 17.)

79 Portrait of the Tsarevich Alexei Nikolaevich with Remarque-Portraits of his Elder Sisters Grand Duchesses Olga, Tatiana, Maria and Anastasia, 1911

Signed and dated bottom right: *Мих. Рундальцовъ 1911*
Dry-point, 46.5 × 33.8 cm; 53 × 36.2 cm
Provenance: From the original Hermitage Collection. ЭРГ-28932
Previous Exhibition: St. Petersburg, 1994, Cat. 67

'Alexei Nikolaevich was at the heart of this close-knit family — all their hopes and affections were invested in him,' wrote his tutor, Gilliard. 'His sisters adored him and he was the apple of his parents' eye. When he was healthy, it was as if the whole palace had been transformed; he was the sunlight that lit up everything and everyone around him. Naturally gifted, he would have developed quite normally had it not been for his illness. Every crisis needed a week, sometimes even a month, of rest; if the bleeding was particularly severe he would be left in a general state of anaemia and was often forbidden any kind of stressful activity for a long time ... The grand duchesses were delightful — vigorous and healthy. It would have been hard to find four sisters more different in character and yet so close to each other. Their friendship, however, did not affect their individuality: indeed, it united them despite the difference in their temperaments. The first letters of their names spelt the name *Otma*, and they would use this signature when making presents or sending letters written by one of them on behalf of all four.' (Gilliard, 1921, pp. 65-8.)

N. A. Sokolov, who observed the royal family in the months before their execution in 1918, wrote: 'Alexei Nikolaevich was an intelligent, observant, receptive boy. He was affectionate and cheerful. He was inclined to be lazy and had no great liking for his books ... He obeyed only his father ... His illness took a terrible toll on him.' (Sokolov, 1991.) GM

80 Portrait of Nicholas II with a Remarque-Portrait of the Tsarevich Alexei Nikolaevich, 1913

From an original painting by V. A. Serov
Signed and dated bottom left: *М. Рундальцовъ 1913*
Watercolour and ink, etching, 28.2 × 21.5 cm; 52 × 37.5 cm
Provenance: From the original Hermitage Collection. ЭРГ-28931
Previous Exhibitions: Aarhus, 1990, Cat. 59; St. Petersburg, 1994, Cat. 69

The portrait by V. A. Serov, which hung in the private room of Alexandra Feodorovna in the Winter Palace, was considered by many contemporaries to be the best portrait of the emperor. Y. P. Danilov, who spent many years serving on the general staff, wrote in his memoirs that many of the pictures of Nicholas II bore little resemblance to him. He explained the difficulty of catching the emperor's likeness as follows: 'Nicholas II had a complex character: few got to the heart of it, and few could describe it ... I think that Serov's portrait of him — "The Sovereign in a Military Jacket" — was the best likeness. The emperor had a modest, rounded beard, flecked with red. He had grey-green eyes, remarkable for their impenetrability, which meant that he always hid what he was thinking from those with whom he spoke. This impression may have been caused by the emperor's habit of never looking anyone in the eye for a long time. He would gaze into the distance as he spoke to you, looking over your shoulder, or else he would eye you up and down, never fixing his gaze. In all his gestures and movements the emperor was considered, even slow. This was part of his character: those who knew him well said that the sovereign never hurried but nor was he ever late.' (Danilov, 1924, p. 212.)

Alexander Benois gives an interesting account of how V.A. Serov painted his portrait of Nicholas II 'in a grey jacket' in 1900: 'During the sittings, which took place in the sovereign's private apartments, an intimacy grew up between the artist and the monarch. It expressed itself in their broad exchange of views and in the way that Serov instructed Nicholas II in various aspects of art. Generally it seemed that the emperor was more comfortable in the company of the direct, absolutely sincere Serov, than in the society of those who somehow or other offended his pride, or in whose company he was unable to overcome his natural shyness. Unfortunately, however, when Serov completed the work, an unpleasant scene arose. When the artist felt that the portrait was complete, Nicholas II wanted to show it to the empress; she, however, was used to the smooth finish of modish foreign artists like F. A. Kaulbach and F. Flameng. When she saw the picture for the first time, she announced in English in front of the artist: "But the portrait is not finished!" This cut our friend to the quick, and since he still had his palette and brush in his hands, he offered them to the empress with the words: "Then finish it yourself." ' (Benois, 1990, vols. iii–iv, p. 376.)

In 1959, shortly before her death in Canada, Grand Duchess Olga Alexandrovna reminisced about the coloured engraving of her brother Nicholas II, based on Serov's original: 'I am so glad to have it. It is one of the best portraits ever painted of Nicky.' (Vorres, 1985, p. 216.) Nicholas is portrayed in a jacket of the Life-Guard Preobrazhensky Regiment. GM

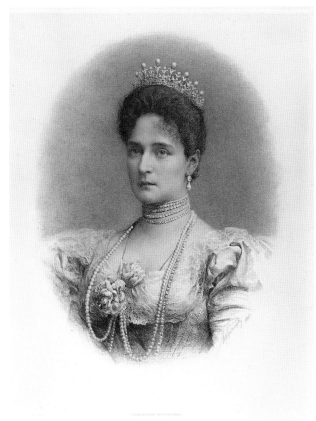

78

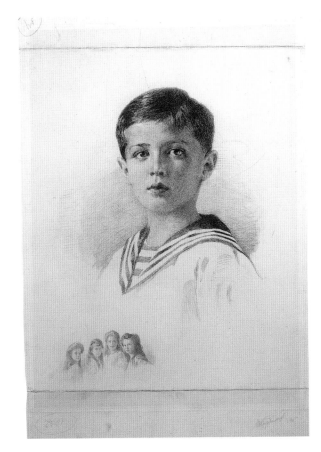

79

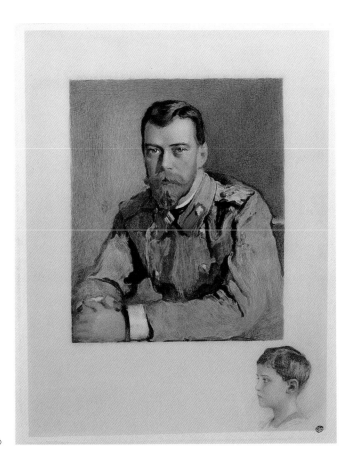

80

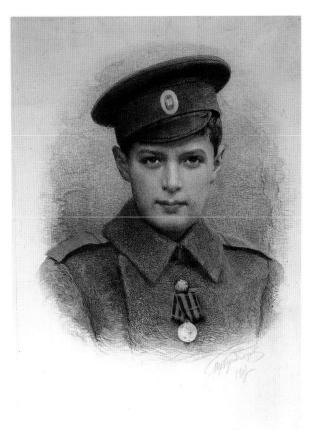

81

81 Portrait of Tsarevich Alexei Nikolaevich, 1917

Signed and dated below: *Михаилъ Рундальцовъ 1917*
Etching, watercolour, 42.7 × 34 cm; 71.5 × 62 cm
Provenance: Acquired from the Leningrad Artillery Museum in 1951. ЭРГ-33981
Previous Exhibition: St. Petersburg, 1994, Cat. 69

At birth the tsarevich was given the rank of lieutenant. He was commander-in-chief of several army and guards regiments, and during the First World War he accompanied his father on many of his journeys with the serving army, for which he was awarded the Silver Medal of St. George, 4th Class.

On 6 October 1915 Nicholas II wrote to his wife: '[Alexei's] presence gives light and life to us all — foreigners included. It is awfully nice to sleep alongside him; we pray together every evening as soon as we get on the train ... he was terribly excited about the review, following behind me and standing there all the time as the troops marched past — it was wonderful ...' (Letters of Nicholas and Alexandra Romanov, vol. iii, p. 384.)

Alexei is portrayed in a soldier's greatcoat with the epaulettes of a lance-corporal and the Medal of St. George, 4th Class. GM

KARL ANTON SCHULTZ

1831–84

Lithographer and photographer.

Produced lithographs from his own and others' originals; landscape artist and portraitist. Worked in the same genres as a photographer.

82 Portrait of Grand Duke Mikhail Nikolaevich

Lithograph, 45 × 37 cm
Provenance: From the original Hermitage Collection. ЭРГ-10055
Previous Exhibition: St. Petersburg, 1994, Cat. 73

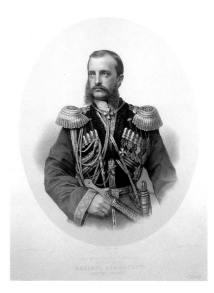

Grand Duke Mikhail Nikolaevich is portrayed in the uniform of His Imperial Majesty's Own Convoy with the insignia of adjutant-general. GM

83 Portrait of Grand Duke Alexei Alexandrovich, 1880s

From a photograph by C. Bergamasco
Lithograph, 45 × 37 cm; 79.5 × 56.5 cm
Provenance: From the Original Hermitage Collection. ЭРГ-32773
Previous Exhibition: St. Petersburg, 1994, Cat. 74

'Not particularly interested in anything that did not involve women, food or drink, [Alexei Alexandrovich] contrived a splendid ruse for holding meetings of the Admiralty Council: he invited all the councillors to his palace. This carefree existence was tainted by tragedy, however: despite the obvious signs of an imminent war with Japan, the admiral continued his revelries until one morning he woke up to discover that our fleet had been routed in battle by the modern Mikado dreadnoughts. The grand duke resigned after this and died soon after.' (Grand Duke Alexander Mikhailovich, 1991, pp. 115, 116.)

Grand Duke Alexei Alexandrovich is portrayed in the uniform of the Guards Ship's Company with the insignia of aide-de-camp. GM

84 Portrait of Empress Maria Feodorovna, 1880s

Unknown lithographer of the turn of the 20th century
From an original by F. Flameng
Below lithograph: *François Flameng*
Lithograph, colour print, 62.8 × 37.2 cm; 77 × 51 cm
Provenance: From the Original Hermitage Collection. ЭРГ-28933
Previous Exhibitions: Aarhus, 1990, Cat. 55; St. Petersburg, 1994, Cat. 74
GM

ERNST KARLOVICH LIPHART

1847–1932

85 Menu of the Dinner Held on 23 May 1896 in the Moscow Kremlin to Celebrate the Coronation of Nicholas II, 1896

Signed bottom right: *Липгартъ*
Chrome lithograph, 34.5 × 24.5 cm
Provenance: From the original Hermitage Collection. ЭРГ-10628/7
Previous Exhibition: St. Petersburg, 1994, Cat. 76

The day of the coronation began with a visit by the imperial couple to the Moscow City Duma and a gala reception given by representatives of the Great Powers. At 9 o'clock in the

evening a ball was held in the Alexander Hall of the Great Kremlin Palace.

'At twelve o'clock their royal highnesses went with all their most senior royal guests into the inner chambers, where tea was served in the main drawing-room. The ladies-in-waiting and foreign ambassadors and their wives were invited to join their majesties there. At dinner the empress sat at high table in the centre; the Prince of Naples sat on her right and the Prince of Denmark on her left. The other Russian and foreign dignitaries sat at the same table. All the other guests took their seats in the George Hall, the Palace of Facets, the Gold Hall and in the dining-room on Boyar's Square, as well as in tents set up next to the Church of the Saviour by the Forest. 2,229 guests dined.' (The Coronation Book, 1889, vol. ii, p. 368.) GM

86 Menu of the Dinner held on 25 May 1896 in the Moscow Kremlin to Celebrate the Coronation of Nicholas II, 1896

Signed bottom right: *Липгартъ*
Chrome lithograph, 34.5 × 24.5 cm
Provenance: From the original Hermitage Collection. ЭРФт-10628/8
Previous Exhibition: St. Petersburg, 1994, Cat. 77

'On the morning of 25 May, the birthday of Empress Alexandra Feodorovna, a service was held in the Church of the Birth of the Blessed Virgin in the Great Kremlin Palace ... At seven o'clock a gala dinner was held in the George Hall of the Great Kremlin Palace and on Boyar's Square. Guests included members of the royal family, foreign royalty, ambassadors, envoys and their wives, foreign military figures, members of the Council of State and Senators ... The emperor's table was laid for 96 guests and decorated with a priceless dinner service and a whole carpet of live flowers. Their imperial majesties sat at the table alongside Russian and foreign royal guests and senior foreign diplomats and their wives. There were about 700 guests altogether, who sat at enormous tables set out all about the hall. During the meal artists from the Imperial Russian Opera gave a splendid concert from the gallery.' (The Coronation Book, 1889, vol. i, p. 376, 377.) GM

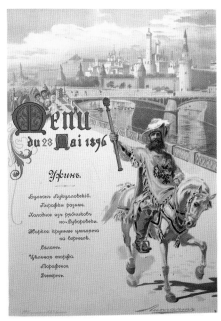

85

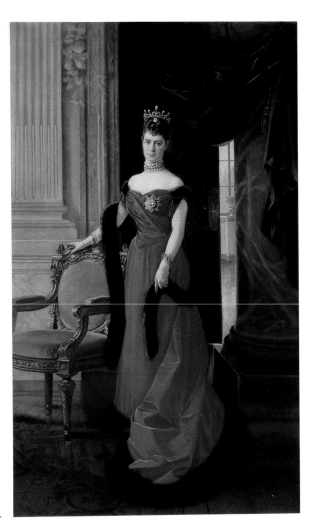

84

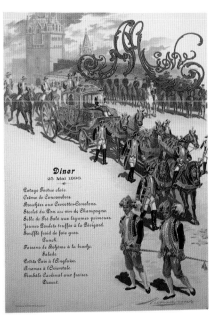

86

Photographs

KARL BERGAMASCO

1830–96

St. Petersburg photographer.

Took many portraits, including members of the royal family. Owned a studio at 12 Nevsky Prospect.

87 Portrait of Grand Duke Konstantin Konstantinovich, 1875

Signed and dated in ink at bottom of passe-partout: *Константин фрегатъ Светлана. 26 июня 1875 г.* [Konstantin. Frigate *Svetlana*, 26 June 1875] and *Ch. Bergamasco. St. Petersbourg*
Mounted photograph, 12.5 × 9.5 cm; 14 × 10 cm
Provenance: Acquired from the State Museum of Ethnography of the USSR in 1941; previously at the Marble Palace in St. Petersburg. ЭРЖ-26888
Previous Exhibitions: Leningrad, 1991, Cat. 26; St. Petersburg, 1994, Cat. 78

Grand Duke Konstantin Konstantinovich (1858–1915) was the second son of Grand Duke Konstantin Nikolaevich; he was a grandson of Nicholas I and uncle of Nicholas II.

Commander-in-chief of the 15th Tiflis Grenadiers Regiment from birth, he enlisted in the Life-Guard Izmailovsky Regiment, with whom he saw active service. From 1880 to 1890 he was head of the central administration of all military academies in Russia. While serving in the Izmailovsky Regiment he organised the 'Izmailovsky events' — evenings dedicated to contemporary Russian literature.

From an early age Konstantin Konstantinovich was expected by his father to join the navy. He took part in naval exercises on board training ships from the age of 12. At 16 he was promoted to the rank of midshipman and in June 1875 he set off on a long voyage on board the frigate *Svetlana* under the command of Grand Duke Alexei Alexandrovich. Russian sailors visited ports in the Baltic and Mediterranean Seas, as well as some ports in the Northern United States, where the American President held a ceremonial reception in their honour.

Konstantin Konstantinovich became president of the Academy of Sciences in 1889. In the same year he headed the Committee for the Celebration of the Centenary of the Birth of A. S. Pushkin. On the centenary itself a cantata was played at the Academy of Sciences; composed by A. K. Glazunov, it was set to words by the grand duke. He wrote plays and was the author of several collections of poetry (under the pseudonym K. R.). Glazunov and Tchaikovsky set many of his verses to music. The grand duke was himself a musician of considerable ability, and he took part in amateur productions on the stage of the Hermitage Theatre. He also completed the first and best Russian translation of Shakespeare's *Hamlet*. In the photograph he is shown in the uniform of a midshipman during his time on board the frigate *Svetlana* in 1875. TP

88 Portrait of Princess E. N. Obolenskaya, 1890

Trademark of the Bergamasco studio on the reverse of the photograph with an inscription in pencil: *Кн. Е. Н. Оболенская* [Princess E. N. Obolenskaya]
Mounted photograph, 20.8 × 10.5 cm
Provenance: Acquired from the State Museum of Ethnography of the USSR in 1941. ЭРФт-27078
Previous Exhibition: Leningrad, 1991, Cat. 28

Princess E. N. Obolenskaya, born Princess Mengrelskaya, was the wife of Major-General Prince A. D. Obolensky. She was lady-in-waiting to Empress Alexandra Feodorovna. She is portrayed here in court dress. TP

KARL KARLOVICH BULLA

1853–1929

St. Petersburg photographer.

Worked from the 1880s until summer 1917, when he emigrated from Russia. Had studios at numbers 48 and 54 Nevsky Prospect as well as on Sadovaya Street. Took numerous photographs for Russian newspapers and magazines.

89 Nevsky Prospect by Gostiny Dvor, 1890s

Stamp of the studio on the reverse: *Фотографъ К. Булла Спб., Невский пр., 48* [Photographer K. K. Bulla, 48 Nevsky Prospect, St. Petersburg] and *St. Petersburg, Newsky pr., 48.*
Photograph, 24.2 × 37 cm
Provenance: Acquired from the State Museum of Ethnography of the USSR in 1941. ЭРФт-31
Previous Exhibition: Leningrad, 1991, Cat. 208

Gostiny Dvor was built between 1761 and 1785 from designs by J.-B. Vallin de la Mothe. In 1880 it was rebuilt to a design by Albert Benois (this is how it appears in Bulla's photograph). The tower of the State Duma was built between 1799 and 1804 by the architect D. Ferrari. TP

90 Warsaw Station in St Petersburg, 1890s

Stamp of the studio on the reverse: *Фотографъ К. Булла Спб., Невский пр., 48* [Photographer K. K. Bulla, 48 Nevsky Prospect, St. Petersburg] and *Photograph C. O. Bulla St. Petersburg, Newsky pr., 48.*
Photograph, 20.5 × 27.6 cm
Provenance: Acquired from the State Museum of Ethnography of the USSR in 1941. ЭРФт-5
Previous Exhibition: Leningrad, 1991, Cat. 205

Warsaw Station was built between 1857 and 1860 to a design by the architect P. O. Salmonovich. TP

91 The Winter Palace from the Neva, 1890s

Stamp of the studio on the reverse: *Фотографъ К. Булла Спб., Невский пр., 48* [Photographer K. K. Bulla, 48 Nevsky Prospect, St. Petersburg] and *Photograph C. O. Bulla St. Petersburg, Newsky pr., 48.*
Photograph, 24.3 × 36.3 cm
Provenance: Acquired from the State Museum of Ethnography of the USSR in 1941. ЭРФт-176
Previous Exhibition: Leningrad, 1991, Cat. 215

The Winter Palace was built between 1754 and 1762 to designs by the architect B. F. Rastrelli. After a fire it was restored in 1838–9 by the architects V. P. Stasov and A. P. Briullov. The balconies of the living quarters on the second and third floors are visible in Bulla's photograph; these have not survived to the present day. The optical telegraph tower was built in the 1830s. Light signals were sent from St. Petersburg to Tsarskoe Selo, Gatchina, Kronstadt, Wilno (Vilnius) and Warsaw. A jetty stretched out in front of the Winter Palace; porphyry vases, a gift from the King of Sweden, stood here from 1851 alongside bronze lions on granite pedestals. In the 1870s the vases were moved to the jetty by Petrovsky (Senate) Square. In 1914 the lions were installed by the military pavilion of the Admiralty, where they stand to this day. TP

92 The Winter Palace from the Alexander Gardens, 1900s

Stamp of the studio on the reverse: *Фотографія К. К. Булла Спб., Невский пр., № 48. Телефон № 1700* [Photographer K. K. Bulla, 48 Nevsky Prospect, St. Petersburg. Telephone 1700] and *Photograph C. O. Bulla St-Petersburg, Newsky pr., 48.*
Photograph, 24.5 x 36 cm
Provenance: Acquired from the State Museum of Ethnography of the USSR in 1941. ЭРФт-175

From 1896 to 1901 a garden was designed by the botanist R. Kufaldt in front of the west façade of the Winter Palace. Open-work metal railings were mounted on a granite socle around the gardens. Designed by the architect R. F. Meltser, these were later dismantled in the 1920s. A track for horse-drawn trams, opened in the 1860s, linked the Winter Palace to the Admiralty. TP

93 A Sitting of the State Duma, 1900s

Trademark of the studio of K. K. Bulla on the passe-partout
Photograph, 22 x 28.4 cm; 26.2 x 36.5 cm
Provenance: Acquired from the State Museum of Ethnography of the USSR in 1941. ЭРФт-2889

Sittings of the State Duma, the highest state institution in Russia, took place from 1906 until July 1917 in the Tauride Palace (built to a design by the architect I. E. Starov between 1783 and 1789). TP

94 The Opening of the Tram Line in St. Petersburg, 1907

Stamp of the studio on the reverse: *Фотографъ К. К. Булла Спб., Невский пр., 54* [Photographer K. K. Bulla, 54 Nevsky Prospect, St. Petersburg] and *St.Petersburg, Newsky pr., 54.*
Inscription in pencil: *Die elektrische Trambahn-Verbindung in St. Petersburg* [The electric tram line connection in St. Petersburg]
Photograph, 16.2 x 22 cm
Provenance: Acquired from the State Museum of Ethnography of the USSR in 1941. ЭРФт-216

Regular travel on trams in St. Petersburg began in 1907. The first line ran from Palace Square across the Nicholas Bridge to Vasilevsky Island. TP

95 Unveiling of the Memorial to Alexander III on Znamenskaya Square, 1909

Photograph, 20.2 x 27.6 cm
Provenance: Acquired from the State Museum of Ethnography of the USSR in 1941. ЭРФт-164

The memorial to Alexander III was designed by the sculptor P. P. Trubetskoi; it was planned and built between 1889 and 1909. Members of the royal family and their retinues, as well as representatives of the clergy and the military, attended the memorial's unveiling on 23 May 1909. TP

96 View of the Left Bank of the Neva from the Nicholas Embankment, 1900s

Stamp of the studio on the reverse: *Фотографъ К. К. Булла Спб., Невский пр., 54* [Photographer K. K. Bulla, 54 Nevsky Prospect, St. Petersburg] and *Photograph C. O. Bulla.*
Photograph, 21.8 x 29 cm
Provenance: Acquired from the State Museum of Ethnography of the USSR in 1941. ЭРФт-41

The Annunciation Bridge (called the Nicholas Bridge from 1855) was St. Petersburg's first metal bridge. Designed by S. Kerbedz, it was built between 1843 and 1850; the railings were built to a design by A. P. Briullov. The chapel on the bridge was designed by A. I. Stakenschneider and was constructed in the 1850s. TP

97 Public Promenade along the Obvodny Canal, 1890s

Stamp of the studio on the reverse: *Фотографъ К. К. Булла Спб., Невский пр., 48* [Photographer K. K. Bulla, 48 Nevsky Project, St. Petersburg] and *Photograph C. O. Bulla St. Petersburg, Newsky pr., 48*
Photograph, 20.5 x 27.7 cm
Provenance: Acquired from the State Museum of Ethnography of the USSR in 1941. ЭРФт-186

The Obvodny Canal was lined with kiosks, a photo studio and an open theatre where cinefilms were shown. TP

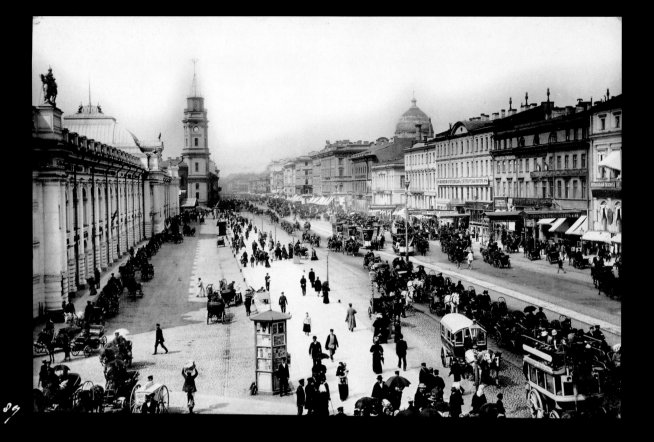

89

83

88

90

Константинъ Фрегатъ Свѣтлана

CH. BERGAMASCO S.ᵗ PETERSBOURG

16 Iюня 1875.

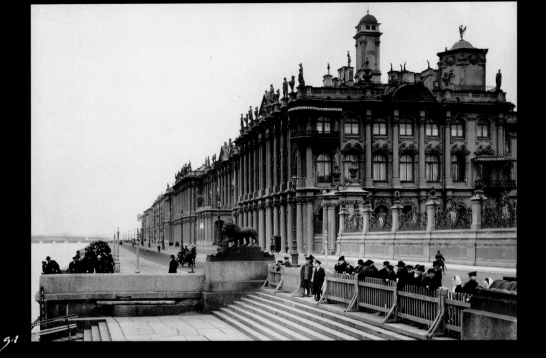

91

92

93

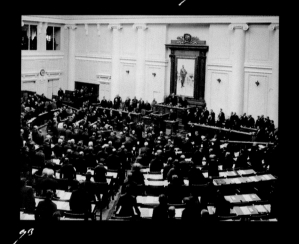

92

93

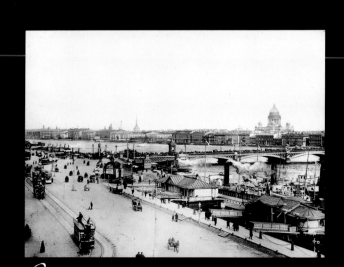

98 The Opening of the Peter the Great (Bolsheokhtinsky)
Bridge, 1911

Photograph, 23.6 × 29.6 cm
Provenance: Acquired from the State Museum of Ethnography of the USSR in 1941.
ЭРФт-130

The Peter the Great bridge, built between 1908 and 1911, was
designed by the engineer G. G. Krivoshein and the architect
V. A. Alyshkov; the architect L. N. Benois was also involved
in the project.

E. WESTLY
Photographer to Grand Duke Mikhail Nikolaevich.
Worked in St. Petersburg under the name E. Westly and Co.

99 Portrait of an Unknown Lady in Court Dress, 1880s

Signed on passe-partout: *E. Westly and Co. St. Petersbourg*
Mounted photograph, 20.5 × 9.7 cm
Provenance: Acquired from the State Museum of Ethnography of the USSR in 1941.
ЭРФт-27068
TP

C. E. DE HAHN & CO.
Photographic firm, working at the turn of the 20th century.
Photographers to the court of His Majesty.

100 The Throne Speech of Emperor Nicholas II at the Opening
of the State Duma in the Winter Palace on 27 April 1906

Inscription on passe-partout, bottom right: *Фот. Двора Его Величества Ф. Ганъ и Ко
Царское Село* [Photographers to the Court of His Majesty, de Hahn & Co., Tsarskoe
Selo]
Inscription centre: *Тронная речь Государя Императора Николая II въ день
торжественнаго открытия государственного Совета и Государственной Думы
Въ Императорскомъ Зимнем дворцъ дня 27 апреля 1906 г.* [Throne speech of t
he Sovereign Emperor Nicholas II at the ceremonial opening of the Council of State
and the State Duma at the Imperial Winter Palace 27 April 1906]
Mounted photograph, 27.3 × 37.1 cm; 43.7 × 55.7 cm
Provenance: Acquired from the State Museum of Ethnography of the USSR in 1941.
ЭРФт-26766
Previous Exhibition: St. Petersburg, 1994, Cat. 79

A celebratory reception was held in the St. George Hall of the
Winter Palace for the members of the Duma. General A. A.
Mosolov recalls the event: 'The procession to the Throne Room
began in the inner chambers; the most senior state figures
processed in front of the emperor, carrying the regalia: the banner
and, on red velvet cushions, the seal, sceptre, orb and diamond-
studded crown. They were escorted by palace grenadiers in their
tall fur hats and full dress uniform. The members of the Duma
stood on the right-hand side of the Throne Room with the
senators in front of them; to the left stood members of the
Council of State, senior courtiers and ministers. The sovereign
and both empresses remained in the middle of the room with
other members of the royal family. The regalia was carried up
onto the dais and placed on red benches on either side of the
throne; the throne itself was half covered by the royal mantle.
Then the lectern was brought in, and the emperor was sprinkled
with holy water by the metropolitan of St. Petersburg. The
prayers began. Then the empresses and the other royals processed

past the sovereign up to the dais, on the left side of the throne.
The tsar waited alone in the centre of the hall until the empresses
had taken their seats. Then, with measured step, he approached
the throne and sat down. He was handed the Throne Speech
which he began to read in a loud and clear voice. After
the speech he descended the steps and the procession out of the
Throne Room began, following the same procedure as before,
although without the regalia.' (Mosolov, 1992, pp. 181, 182.)

After the tsar's Throne Speech the members of the Duma left
the Winter Palace for the Tauride Palace, where the first sitting
of the State Duma took place. TP

CARL SONNE
Danish court photographer; worked in Copenhagen.

101 Portrait of the Crown Princes with Tsarevich
Alexei Nikolaevich, 1904

Signed bottom of the passe-partout: *Carl Sonne, Kjobenhavn. Hoffotograf.*
On the reverse the trademark of the studio and inscription in ink: *Крон-принцы,
присутствовавшие при крещении нацледн. цесарев. В. К. Алексея Николаевича* [The
Crown Princes attending the Christening of Tsarevich Grand Duke Alexei Nikolaevich]
Mounted photograph, 15 × 10.3 cm; 16.5 × 10.7 cm
Provenance: Acquired from the State Museum of Ethnography of the USSR in 1941;
previously at the Winter Palace. ЭРФт-29198

'The momentous day of our dear son's christening. Bright and
warm in the morning. By 9.30 gold carriages had drawn up in
front of the house along the sea-front, and the road was lined with
a platoon of the Convoy, Hussars and Atamans. The procession
began at 9.55 ... I set off for the Great Palace with Misha
[Nicholas II's brother, Grand Duke Mikhail Alexandrovich].
The christening began at 11 ... Mama and Uncle Alexei were
the main godparents. After the mass there was a reception of
diplomats and then a large lunch.' (Diaries of Nicholas II; entry
for 11 August 1904; 1991, p. 224.)

Those present at the christening of Tsarevich Alexei included
Prince Christian, the heir to the Danish throne (in the centre
of the photograph with the infant in his arms), Prince Ludwig
of Battenburg (husband of Victoria of Hesse, Alexandra
Feodorovna's sister) and the Prussian Prince Heinrich-Albert
Wilhelm (married to Irina of Hesse, another of Alexandra
Feodorovna's sisters). The latter two are thought to be pictured
here alongside Prince Christian. TP

102 Tsarevich Nikolai Alexandrovich at Winter Manoeuvres, 1894

Photograph by Lieutenant Kolzakov
Signed bottom of passe-partout: *17 марта 1894 г., Зимний маневръ, Сним. Поручика Колзакова* [Winter manoeuvres, 17 March 1894, photographed by Lieutenant Kolzakov]
Mounted photograph, 20.5 × 26.5 cm; 24.6 × 30.3 cm
Provenance: From the original Hermitage Collection; previously in Nicholas II's rooms in the Anichkov Palace and then at the Winter Palace. ЭРФт-29206

Winter manoeuvres were often held at Krasnoe Selo. The heir to the throne is in the uniform of a colonel of the Life-Guard Preobrazhensky Regiment.

Nicholas II personally chose this photograph to be moved from his rooms at the Anichkov Palace to his new quarters at the Winter Palace. TP

KARL KARLOVICH KUBESH

St. Petersburg photographer of the turn of the 20th century.
Photographed the interiors of palaces and residences.

The following photographs of Nicholas II's apartments in the Winter Palace were taken in 1917, principally between March and August. The interiors were designed by the architect A. F. Krasovsky in 1894–5 in time for the wedding of the heir to the throne to Princess Alice of Hesse, the future Empress Alexandra Feodorovna.

103 The Empire (White) Drawing-Room, 1917

Inscription in pencil on the reverse: *Зимн. Дв. Половина Ал. Фед. Белая гост. F-567* [Quarters of Alexandra Feodorovna, Winter Palace. White Drawing-Room]
Photograph, 20.5 × 9.7 cm
Provenance: Acquired from the State Museum of Ethnography of the USSR in 1941. ЭРФт-21226
TP

104 The Silver Drawing-Room ('Louis XVI'), 1917

Inscription in pencil on the reverse: *Зиммего Дв. Половина Ал. Ф. Серебряная Гостиная. F-561* [Quarters of Alexandra Feodorovna, Winter Palace. Silver Drawing-Room]
Photograph, 16.9 × 22.4 cm
Provenance: Acquired from the State Museum of Ethnography of the USSR in 1941. ЭРФт-21221
TP

105 Empress Alexandra Feodorovna's Study/Sitting-Room, 1917

Inscription in pencil on the reverse: *Зимн. Дв. Рабочий Кабинет Ал. Ф. F-564* [Study of Alexandra Feodorovna, Winter Palace]
Photograph, 17 × 22.4 cm
Provenance: Acquired from the State Museum of Ethnography of the USSR in 1941. ЭРФт-21224
Previous Exhibition: Leningrad, 1991, Cat. 283
TP

106 Bedroom, 1917

Inscription in pencil on the reverse: *Зимн. Дв. Спальня Н II и Ал. Ф. F-559* [Bedroom of Nicholas II and Alexandra Feodorovna, Winter Palace]
Photograph, 16.8 × 22.4 cm
Provenance: Acquired from the State Museum of Ethnography of the USSR in 1941. ЭРФт-21219
TP

107 Bedroom, 1917

Inscription in pencil on the reverse: *Зимн. Дв. Спальня Н II и Ал. Ф. F-560* [Bedroom of Nicholas II and Alexandra Feodorovna, Winter Palace]
Photograph, 16.8 × 22.5 cm
Provenance: Acquired from the State Museum of Ethnography of the USSR in 1941. ЭРФт-21220
Previous Exhibition: Leningrad, 1991, Cat. 282
TP

108 Empress Alexandra Feodorovna's Boudoir, 1917

Inscription in pencil on the reverse: *Зимн. Дв. Половина Ал. Ф. Сиреневый будуар F-557* [Quarters of Alexandra Feodorovna, Winter Palace. Lilac Boudoir]
Photograph, 16.5 × 22.3 cm
Provenance: Acquired from the State Museum of Ethnography of the USSR in 1941. ЭРФт-21217
TP

109 Emperor Nicholas II's Study, 1917

Inscription in pencil on the reverse: *Зимн. Дв. Кабинет Ник.II 2-я половина F-553* [Study of Nicholas II, Winter Palace]
Photograph, 22.5 × 16.6 cm
Provenance: Acquired from the State Museum of Ethnography of the USSR in 1941. ЭРФт-21213
TP

110 Nicholas II's Study, 1917

Inscription in pencil on the reverse: *Зимн. Дв. Кабинет Ник.II F-554* [Study of Nicholas II, Winter Palace]
Photograph, 22.5 × 16.7 cm
Provenance: Acquired from the State Museum of Ethnography of the USSR in 1941. ЭРФт-21214
TP

111 Desk in Nicholas II's Study, 1917

Inscription in pencil on the reverse: *Зимн. Дв. Кабинет Ник. II F-555* [Study of Nicholas II, Winter Palace]
Photograph, 22.5 × 16.8 cm
Provenance: Acquired from the State Museum of Ethnography of the USSR in 1941. ЭРФт-21215
TP

112 Nicholas II's Library, 1917

Inscription in pencil on the reverse: *Зимнего Дв. Библиотека Н II F-547* [Library of Nicholas II, Winter Palace]
Photograph, 16.7 × 22.3 cm
Provenance: Acquired from the State Museum of Ethnography of the USSR in 1941. ЭРФт-21208
TP

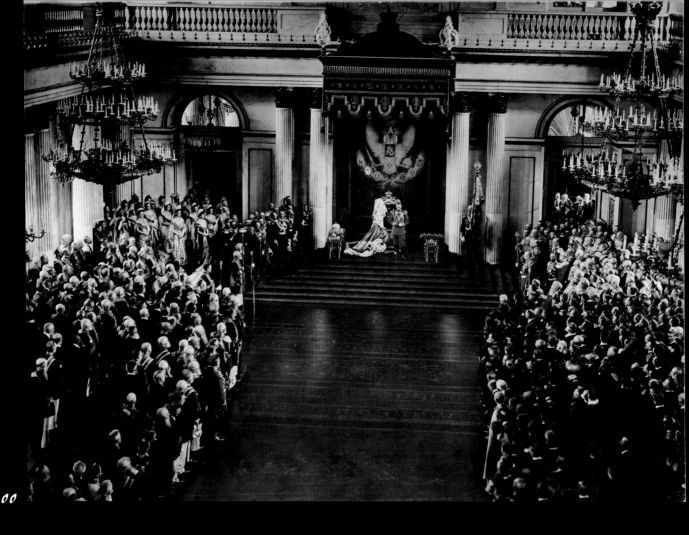

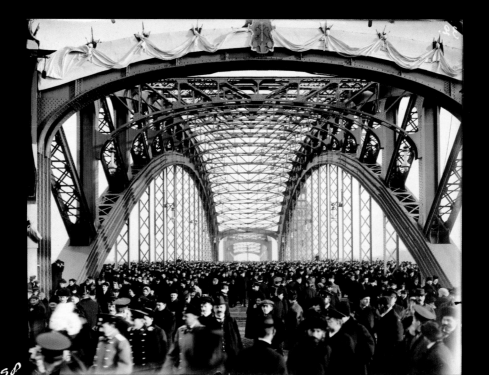

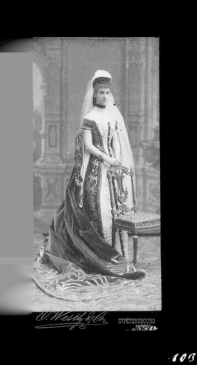

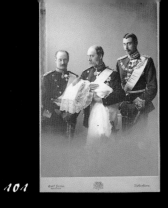

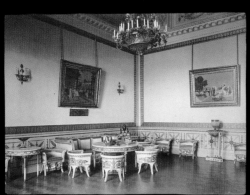

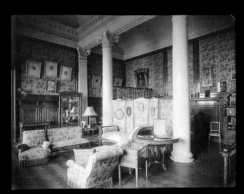

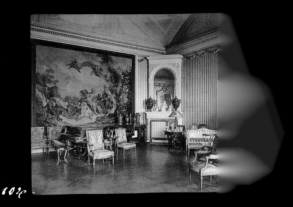

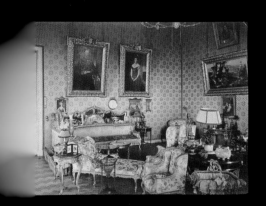

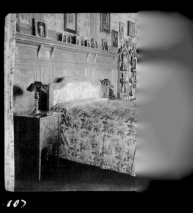

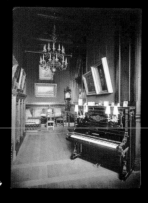

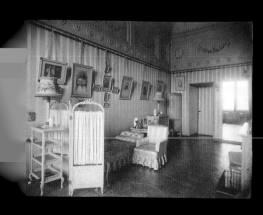

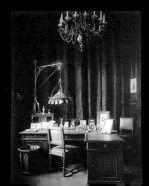

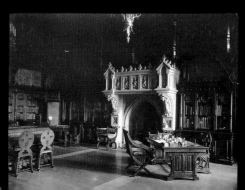

113 Nicholas II's Billiard Room, 1917

Inscription in pencil on the reverse: *Зимнего Дв. Биллиардная Н II F-545* [Billiard Room of Nicholas II, Winter Palace]
Photograph, 16.5 × 22.6 cm
Provenance: Acquired from the State Museum of Ethnography of the USSR in 1941.
ЭРФт-21206
TP

114 Nicholas II's Reception Room, 1917

Inscription in pencil on the reverse: *Зимн. Дв. Приемная министров Н II F-544* [Reception Room for ministers, Winter Palace]
Photograph, 16.8 × 22.4 cm
Provenance: Acquired from the State Museum of Ethnography of the USSR in 1941.
ЭРФт-21205
TP

115 The Small Dining-Room in the Quarters of Nicholas II and Alexandra Feodorovna, 1917

Inscription in pencil on the reverse: *Зимн. Дв. Половина А. Ф. Малая стол. F-572* [Quarters of Alexandra Feodorovna, Winter Palace. Small Dining-Room]
Photograph, 22.5 × 16.8 cm
Provenance: Acquired from the State Museum of Ethnography of the USSR in 1941.
ЭРФт-21230
TP

116 Desk from Alexandra Feodorovna's Study, 1917

Inscription in pencil on the reverse: *Зимн. Дв. Рабочий Кабин. Ал.Ф. F-565* [Study of Alexandra Feodorovna, Winter Palace]
Photograph, 22.5 × 16.7 cm
Provenance: Acquired from the State Museum of Ethnography of the USSR in 1941.
ЭРФт-21225
TP

SERGEI LVOVICH LEVITSKY

1819-98
Graduate of the Legal Faculty of Moscow University.

First interested in early forms of photography in 1839. Studied photography from 1844 to 1849 in Rome and Paris. Opened first Russian daguerreotype studio in 1849 at 3 Kazan Street and a photo studio at 30 Moika Embankment and 28 Nevsky Prospect. From 1871 worked with his son, L. S. Levitsky.

117 Portrait of the Tsarevich, Grand Duke Nikolai Alexandrovich (future Nicholas II), 1892

Autograph and date in ink at the bottom: *Николай. 1892* [Nicholas, 1892]
Photograph, 14.5 × 10.3 cm
Provenance: Acquired from the State Museum of Ethnography of the USSR in 1941.
ЭРФт-30307
Previous Exhibition: St. Petersburg, 1994, Cat. 80

A. N. Benois recorded a visit made by the royal family to an exhibition of watercolours in 1892: 'The Tsarevich, our future sovereign, made a rather less favourable impression. To start with, he had an uninspiring, even simple-minded look. The uniform of the Preobrazhensky Regiment ill became him and all agreed that he looked as if he was "playing soldiers". He seemed small alongside his father, and his gestures were notable for that false familiarity which people often adopt when they are among unfamiliar people and wish to disguise their discomfort. He turned rather too abruptly, clicked his heels in a strange manner, and had an irritating habit of running his finger along the row

of buttons on his coat. It was all too clear that the Tsarevich was bored, and that he had absolutely no interest in these thoroughly tedious pictures and the dull fellows who had come to trade in them. Let it not be thought, however, that this was the result of the extreme refinement of his tastes ... He walked behind his father, looking from side to side rather than at the paintings, and said absolutely nothing to the artists themselves ... No doubt his parents had forced him to accompany them, and he had agreed to come along only because he was used to obeying them, or because there was nothing more diverting to occupy him at that particular time. Nikolai Alexandrovich scarcely made a better impression on the streets, when he went for his daily ride in a sled or *droshky*. He could sometimes be seen wearing the uniform of the Hussars, but even this made him look no better; indeed, there was something rather puerile and false about the uncomfortable way he wore his fur hat with its very tall plume. These impressions did little to convince people that their future sovereign would be a true leader.' (Benois, 1980, vols. i–iii, pp. 697, 698.)

Nikolai Alexandrovich is portrayed in the uniform of the Life-Guard Ataman Regiment, with the insignia of aide-de-camp.
TP

B. P. MISHCHENKO
Photographer working in Tiflis at the turn of the 20th century.

118 Portrait of Grand Duke Georgy Alexandrovich, 1892

Impressed signature below photograph: *Б. Мищенко, Тифлис*
On the reverse: trademark of B. P. Mishchenko's studio in Tiflis.
Mounted photograph, 14.5 × 11 cm; 16 × 11 cm
Provenance: Acquired from the State Museum of Ethnography of the USSR in 1941; previously in the State Museum Fund. ЭРФт-26887
Previous Exhibition: St. Petersburg, 1994, Cat. 81

Through poor health Grand Duke Georgy Alexandrovich had to spend most of his time at Abas-Tuman, his property in the Caucasus. One of his contemporaries, S. P. Bartenev, visited the grand duke in the winter of 1892 and described their meeting thus: 'He wore a fur naval jacket and tall boots. From the healthy, slightly tanned colour of his face you could scarce imagine the reason for his presence in this distant, wild gorge in the Caucasus. Only the slight look of melancholy in his eyes and his light cough revealed his illness.' (S. P. Bartenev, 1909, vol. iii, ed. 2, pp. 340–6.) Before he left Abas-Tuman, Bartenev made a sketch of the palace then under construction, and Grand Duke Georgy Alexandrovich gave him a signed photographic portrait of himself. The photograph of Georgy Alexandrovich in the Hermitage collection has the same date, 1892, and it is possible that it was taken from the same negative.

Georgy Alexandrovich is portrayed in the uniform of aide-de-camp of the Guards Ship's Company. TP

IVAN GRIGORIEVICH NOSTITZ

1824–1905

Landscape and portrait photographer, working in St. Petersburg and Moscow.

The counts Nostitz were descended from Saxon noblemen. Adjutant-General Count G. I. Nostitz, the photographer's father, joined the Russian army in 1801. I. G. Nostitz graduated from the Corps des Pages in 1841, joined the Life-Guard Horse Regiment as a cornet and served in the Caucasus. Retired as lieutenant-general in 1873 and settled in Moscow. Began taking photographs in the 1840s. Took many views and panoramas of St. Petersburg, Moscow and their surroundings. An album, *The Photographs of Count Nostitz*, was published in Vienna in 1896.

119 Nevsky Prospect near Gostiny Dvor, 1870s

Impressed trademark below: *Гр. Ностицъ*
Inscription in ink on passe-partout bottom right: *Е. И. В*ᵘ *Наследнику Цесаревичу*
[To His Imperial Highness The Tsarevich]
Mounted photograph, 25.6 × 36.7 cm; 48.8 × 66.8 cm
Provenance: From the original Hermitage Collection. ЭРФт-30113
Previous Exhibition: St. Petersburg, 1994, Cat. 82
Literature: O. Tiunina, 1991, pp. 35–8
TP

120 Nevsky Prospect near the Anichkov Palace, 1870s

Impressed trademark on bottom right corner of photograph: *Гр. Ностицъ*
Inscription in ink on bottom of passe-partout: *Е. И. В*ᵘ *Наследнику Цесаревичу*
[To His Imperial Highness The Tsarevich]
Mounted photograph, 25.6 × 33 cm; 48.3 × 67 cm
Provenance: From the original Hermitage Collection; previously in Nicholas II's rooms in the Anichkov Palace. ЭРФт-30122
Previous Exhibition: Leningrad, 1991, Cat. 243

The Anichkov Palace was built between 1741 and 1754 by the architects M. G. Zemtsov, G. D. Dmitriev and B. F. Rastrelli. It was rebuilt in the 1770s by I. E. Starov (the photograph shows some features of the palace that no longer exist: the bell-tower and the church cupolas). The 'Study' building was built between 1803 and 1806 by G. Quarenghi.

The equine sculptures, cast from a model by the sculptor P. K. Klodt, were mounted on the bridge in the 1840s. TP

ALEXANDER ALEXANDROVICH PASETTI

Owned a studio at 24 Nevsky Prospect.

Took many photographic views and portraits.

121 Kazan Cathedral on Nevsky Prospect during a visit by Empress Maria Feodorovna, 1883

Trademark of the studio on bottom of passe-partout: *Photographe A.Pasetti/Persp. de Nevsky No 24.*
Inscription in ink on top of mount: *Императрица Марія Феодоровна въ Казанском Соборе. 1883* [Empress Maria Feodorovna in Kazan Cathedral, 1883]
Mounted photograph, 26.5 × 38.3 cm; 47.7 × 62.7 cm
Provenance: Acquired from the State Museum of Ethnography of the USSR. ЭРФт-30122
Previous Exhibition: Leningrad, 1991, Cat. 244

Kazan Cathedral was built between 1801 and 1811 to a design by the architect A. N. Voronikhin. TP

R. PROROKOV

122 Group Photograph including Tsarevich Nikolai Alexandrovich in Chita, 1891

Signed on bottom of passe-partout: *Р. Пророковъ, Чита Заб. Обл.*
Mounted photograph, 16.5 × 22.8 cm; 24.5 × 32.5 cm
Provenance: From the original Hermitage Collection; previously in Nicholas II's rooms in the Winter Palace. ЭРФт-29721

The Tsarevich Nikolai Alexandrovich returned from his travels of 1890–1 through Siberia. In Chita he was photographed with a group of artillery officers from the Cossack detachment of the Baikal Troops. TP

E. E. UKHTOMSKY

123 Group Photograph including Tsarevich Nikolai Alexandrovich during his Travels to the Far East, 1891

Mounted photograph, 11.5 × 16.8 cm
Provenance: From the original Hermitage Collection; previously in Nicholas II's rooms in the Winter Palace. ЭРФт-29719

This photograph is thought to have been taken by Prince E. E. Ukhtomsky, editor of the newspaper *Sankt-Peterburgskie Vedomosti*, who was a member of the retinue accompanying the tsarevich on his travels. Nikolai Alexandrovich (second from right) is pictured with a bandaged head. This was the result of a wound he received on 29 April 1891 in the Japanese town of Otzu, after a policeman struck him on the head with a sabre. He was not seriously injured. The emperor of Japan visited him, and remained in Kyoto until he had completely recovered; the emperor then accompanied Nikolai Alexandrovich to the docks at Kobe, where the Tsarevich boarded the frigate *Pamyat Azova* to continue his travels. TP

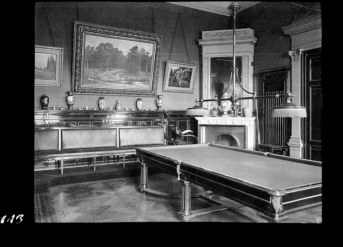

113

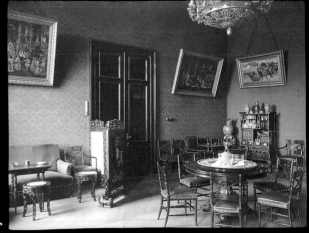

114

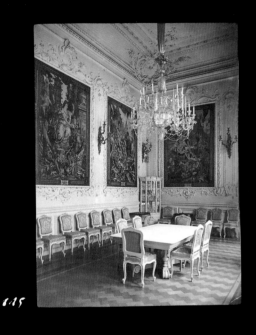

115

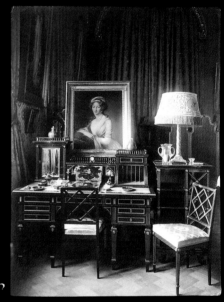

116

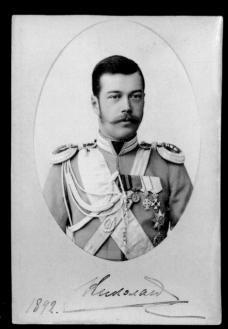

117

118

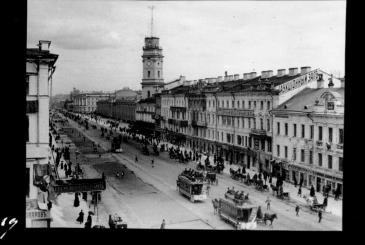

119

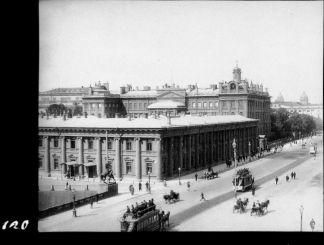

120

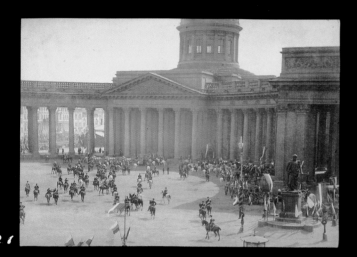

121

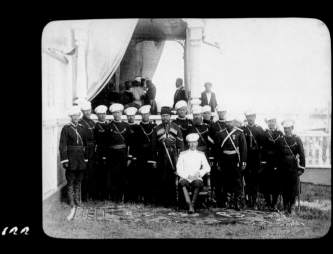

122

123

KARL ANDREEVICH FISHER

Owned a photographic studio at 11 Kuznetsky Most in Moscow.
Also took photographs in St. Petersburg.

124 Portrait of Grand Duchess Elizaveta Feodorovna
from a Portrait by G. Kaulbach, 1900s

Inscription in ink on passe-partout: *На память о совместной работе. Москва 1904/5 Елисавета.* [In memory of our joint work. Moscow 1904/5 Elizaveta]
Mounted photograph, 17 cm (circular); 36.2 × 30.2 cm
Provenance: Acquired from the State Museum of Ethnography of the USSR in 1941.
ЭРФт-29262

Grand Duchess Elizaveta Feodorovna (1864–1918) was born
Princess of Hesse-Darmstadt, daughter of Grand Duke Ludwig
IV of Hesse. Elder sister of Empress Alexandra Feodorovna, on
3 June 1884 she married Grand Duke Sergei Alexandrovich, son
of Alexander II. She had an artistic education at home, and was
a talented amateur painter. She lived in St. Petersburg until 1891
and then moved to Moscow when Sergei Alexandrovich was
appointed governor-general of the city. After the death of her
husband (killed by Kalyaev, a terrorist, in 1905) she retired from
court life. She founded the Charitable Order of Martha and Mary
and became the order's mother superior. The order earned an
excellent reputation, with the best doctors in the town working
there. In-patients and out-patients were treated free of charge,
while Elizaveta Feodorovna herself tended the sick and assisted
during operations. The breadth of her charitable works was
remarkable. She was arrested after the revolution in April 1918,
and was killed on the night of 18 July in Alapaevsk, in the Urals.
She was buried in Jerusalem and canonised by the Orthodox
Church.

'Rare beauty, a fine mind, a delicate sense of humour, the
patience of an angel and a noble heart — such were the qualities
of this remarkable woman. It was terrible that a woman of her
qualities should have joined her fate to a man like Uncle Sergei.
From the very moment she arrived in St. Petersburg from her
native Hesse-Darmstadt everyone fell in love with "Aunt Ella".
Whenever we spent an evening in her company, and recalled her
eyes, the colour in her face, her laughter and her ability to make
all those around her feel at ease, we would despair at the thought
of her impending engagement. I would have given ten years of
my life not to see her go down the aisle with arrogant Sergei ...
She was too proud to complain and lived nearly twenty years
with him. It was pure charity — not a pose nor a posture — that
made her visit her husband's murderer in his Moscow prison cell
before his execution. Her subsequent entry into a monastery, her
heroic if unsuccessful attempts to control the tsarina, and, finally,
her martyrdom at the hands of the Bolsheviks — all combine
to give solid grounds for her canonisation. No more noble woman
has left her mark in the bloody pages of Russian history.' (Grand
Duke Alexander Mikhailovich, 1991, pp. 137, 138.)

Maurice Paléologue, French ambassador to the Russian court,
remembered her thus: 'Grand Duchess Elizaveta Feodorovna,
sister of the empress and widow of Grand Duke Sergei
Alexandrovich, was a strange creature, whose whole life was
a series of riddles. Born in Darmstadt on 1 November 1864, she
had already blossomed into a charming, beautiful young woman
when, at the age of 20, she married Alexander II's fourth son.

I remember having lunch with her in Paris a few years later, in
about 1891. I can see her now as she was then: tall and strong,
with bright eyes, deep and sincere, a delicate mouth, gentle
features and a thin, straight nose. The outline of her figure was
at once harmonious and well-defined, and there was a bewitching
rhythm in all her movements. Her conversation revealed the
very best kind of female mind: truthful, serious and full of hidden
goodness.' (Paléologue, 1991.) TP

KARL ANTON SCHULTZ

Lithographer, landscape and portrait photographer.
Worked in Derpt, Riga and St. Petersburg from 1860 to 1880. Created a series
of panoramic photographs of the squares and embankments of St. Petersburg,
and of its suburban parks.

125 St. Isaac's Square from the Maryinsky Palace, 1870s

Signed bottom right: *Фот. К. Шульца въ Дерптъ.* [Photographer K. Schultz in Derpt]
Mounted photograph, 28.5 × 46.4 cm; 43.5 × 58.6 cm
Provenance: From the original Hermitage Collection. ЭРФт-30126
Previous Exhibition: St. Petersburg, 1994, Cat. 83
TP

126 Panorama of Senate Square and the Alexander
Gardens, 1870s

Mounted photograph, 29.3 × 46.3 cm; 46.3 × 58.6 cm
Provenance: From the original Hermitage Collection; previously in Empress Maria
Feodorovna's rooms at the Anichkov Palace. ЭРФт-30126
Previous Exhibition: Leningrad, 1991, Cat. 256

The Senate building was designed by C. I. Rossi and built
between 1828 and 1834; the memorial to Peter the Great on
Senate Square was designed by E. M. Falconet and erected
between 1768 and 1782, while the Admiralty building was built
by A. D. Zakharov between 1806 and 1823. The Alexander
Gardens were created in 1872–4 to a design by the botanist
E. L. Regel. TP

UNKNOWN PHOTOGRAPHER

Of the turn of the 20th century

127 Emperor Nicholas II with a Group out Hunting, 1890s

Photograph, 29.5 × 23.2 cm
Provenance: Acquired from the Winter Palace. ЭРФт-29214

This photograph is thought to have been taken in September
1896 during a visit by Nicholas II to Scotland, where he went
hunting with his wife's relatives — 'Uncle Bertie', the future
King Edward VII and son of Queen Victoria, and 'Uncle Arthur',
Prince Arthur-Wilhelm of Connaught, also Queen Victoria's son.
TP

128 Portrait of P. A. Stolypin, 1900s

Inscription below: *Председ. Совѣта Министровъ и Министръ Внутр. Дѣлъ
П. А. Столыпинъ* [Chairman of the Council of Ministers and Minister of the Interior
P. A. Stolypin]
Photograph, 13.8 × 8.5 cm
Provenance: Acquired from the State Museum of Ethnography of the USSR in 1941.
ЭРФт-26857
Previous Exhibition: St. Petersburg, 1994, Cat. 84

Piotr Arkadevich Stolypin (1862–1911) was Minister of the
Interior and Chairman of the Council of Ministers from 1906
to 1911. Born of an old noble family, his ancestors included
the poet M. Yu. Lermontov, while his parents counted
N. V. Gogol and L. N. Tolstoy among their friends. His father,
a major-general in the Emperor's Retinue, served in the Crimea
during the Russo-Turkish War of 1877–8.

After graduating from the Physics and Mathematics Faculty at
St. Petersburg University, P. A. Stolypin served in the Ministry
of the Interior and the Ministry of State Property. He later
proved himself an energetic administrator when he worked as
Marshal of the Kovno nobility and then as governor of Grodno
(1902) and Saratov (1903–6). His organisational abilities were
recognised by contemporaries at all levels. When he was elected
to the post of Chairman of the Council of Ministers, Stolypin
instituted several reforms in the fields of agriculture and local
self-government, although he was only partially successful in
the former. Stolypin's policies were aimed at improving state
structures in Russia while maintaining and strengthening
autocratic rule.

'Circumstances have conspired to raise me up — if only for one
moment! But I want to use this moment fully and as much as
my strength, understanding and feelings will allow me, for the
good of the people and the country that I love, as it was loved
in ancient times,' he wrote to L. N. Tolstoy in October 1907.
(Zyrianov, 1992, p. 69.) Stolypin's political course, however,
found little support. The reforms he promoted had opponents
at all levels of society. He had enemies in the State Duma and
the Council of State. Terrorists queued up to make attempts
on his life and eventually he was killed in Kiev in 1911 by
D. Bodrov, an *Okhranka* (Secret Police) agent. TP

THE BOISSON AND EGGLER WORKSHOP

The photographic studio belonging to F. G. Boisson and F. O. Eggler was
situated at 24 Nevsky Prospect. Numerous portraits of the St. Petersburg
aristocracy, including the royal family, were created here.

129 Portrait of the Tsarevich, Grand Duke
Alexei Nikolaevich, 1910–12

Autograph in ink on bottom of passe-partout: *Алексѣй* [Alexei]
Part of an impression of the studio trademark: *Boissonas et …*
Mounted photograph, 19.4 × 9.7 cm; 24.7 × 12.8 cm
Provenance: Acquired from the State Museum of Ethnography of the USSR in 1941.
ЭРФт-30311
Previous Exhibition: St. Petersburg, 1994, Cat. 85

'Alexei Nikolaevich was then nine and a half years old. He was
quite tall for his age, with a long thin oval face and gentle
features, wonderful light chestnut hair with tinges of bronze,
and big grey-blue eyes like his mother's. He lived life as fully as
he was able, like any playful, lively boy … He was very modest
in his tastes. He had a lively mind and strong opinions, and was
also very thoughtful. At first I took him for a small, capricious
creature, but then I discovered a good-hearted child, loving by
nature and sensitive to the suffering of others because he had
already suffered much himself.' (Gilliard, 1991, pp. 39, 40.)

Alexei Nikolaevich is portrayed in the uniform of the Imperial
Infantry Regiment, to which all male members of the Romanov
family belonged. TP

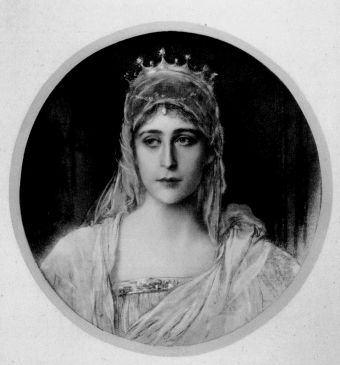

На память о совместной
работѣ. Москва 4 0ч/5 —
Елисавета

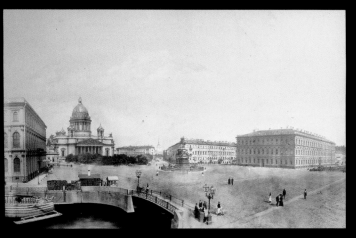

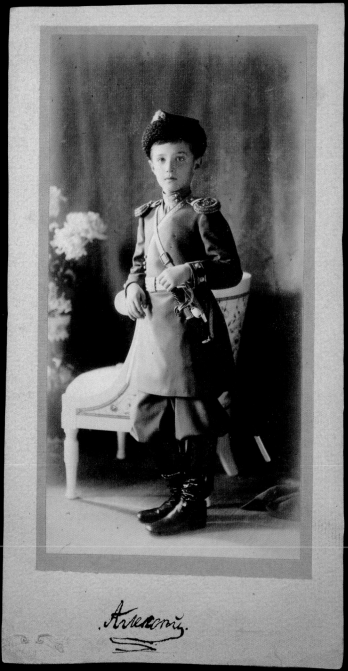

Алексѣй.

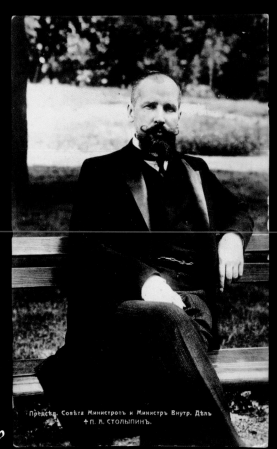

Предсѣд. Совѣта Министровъ и Министръ Внутр. Дѣлъ
✝ П. А. СТОЛЫПИНЪ.

MARK MATVEEVICH ANTOKOLSKY

1843–1902

Russian sculptor.

Studied at the Academy of Arts under N.S. Pimenov and I.I. Reimer; academician from 1871. Took part in the first exhibition of the Association of Travelling Art Exhibitions. His work is dominated by historical themes. Creator of numerous monuments, including the statue of Peter I (1873), casts of which can be seen at Peterhof, Taganrog and Arkhangelsk. Awarded the gold medal and the Légion d'honneur at the World Exhibition in Paris in 1878. Professor of Sculpture at the St. Petersburg Academy of Arts from 1880. Member of the Paris, Berlin and Urbino Academies.

130 Portrait of Empress Maria Feodorovna, c. 1887

Marble, 81 × 55 × 38 cm
Provenance: From the original Hermitage Collection; originally in the private rooms of Emperor Alexander III. ЭРСк-64
Previous Exhibitions: Aarhus, 1990, Cat. 62; St. Petersburg, 1994, Cat. 86

'I must say,' A. N. Benois recalled, 'I was quite enchanted by the empress: even her lack of height, her slight lisp and far from perfect Russian speech could not detract from the bewitching effect she had on me. Quite the contrary — her slight speech defect and all too obvious embarrassment was touching; certainly it was hardly regal, and yet it warmed me to her. The empress always dressed modestly, without any modish affectation; only the rouge on her face (which even her black veil could not hide) hinted at her well-known coquetry — *das ewig Weibliche* [the ever-feminine]. There was also nothing regal about the relations between the empress and her husband. It was obvious to all that they were still full of the tender feelings that had burnt brightly a quarter of a century previously. This was also charming, and evident in the way that as they went round the exhibition the tsar turned to his wife on several occasions to draw her attention to something that he liked.' (Benois, 1980, vols. i–iii, p. 697; the account refers to 1892, when Benois showed the royal family around an exhibition of watercolours.) LT

131 Portrait of A.A. Polovtsov, 1887 (p.108)

Signed on the back: *Antokolsky*
Marble, 72 × 53 × 37 cm
Provenance: Acquired from Baron Stieglitz's School of Technical Drawing in 1919. ЭРСк-204
Previous Exhibition: St. Petersburg, 1994, Cat. 87
Literature: State Russian Museum Catalogue, 1988, p. 25; Kuznetsova, 1989, p. 25

Alexander Alexandrovich Polovtsov (1832–1909) graduated from the School of Jurisprudence; he served in the Senate from 1851 and became a Councillor of State in 1865. In 1866–7 he was chief procurator of the Senate, and a senator from 1876. In 1861 he married I. M. Iyuneva, the seventeen-year-old ward of the banker A. L. Stieglitz. The marriage made him one of the richest men in Russia, and had a considerable influence on his career and position in high society. After his wife's death Polovtsov inherited a vast fortune which he had spent by the end of his life. Polovtsov's private receptions were graced by members of the imperial family and the highest court nobility. Between 1883 and 1892 he was Secretary of State under Alexander III. In 1905–6 he took part in discussions about the formation of the State Duma and the reorganisation of the Senate into the upper house. The Central School of Technical Drawing was set up with his help, and in 1866 he founded and then later chaired the Russian Historical Society. He also published the Russian Dictionary of Biography with his own money. From 1859 he kept a diary, a document of considerable historical value. Throughout his life A. A. Polovtsov was a close friend of Grand Duke Vladimir Alexandrovich, and was constantly in the company of Emperor Alexander III and members of his family. LT

LEOPOLD ADOLFOVICH BERNSTAMM (LEOPOLD-BERNARD LEIBBER)

1859–1939

Russian sculptor.

Studied at D.I. Jensen's workshop in St. Petersburg, then at the Drawing School of the Society for the Promotion of the Arts. Part-time student at the Academy of Arts from 1879 to 1881; continued education in Rome and Florence under A. Rivalti in 1883–4. Lived in France from 1885 perfecting his skills under M.-L. Mercier. Exhibited annually at the Paris Salon from 1887; principal artist at the A. Greven Museum of Wax Figures in Paris from 1890. Knight of the Légion d'honneur in 1891 and commander in 1908.

132 Portrait of Emperor Nicholas II, 1897 (p.108)

Sèvres Porcelain Manufactory
Stamped on the back of the shoulder, top left corner: *Sèvres 1897*
On the bottom right corner of the overcoat: *L. Bernstamm*
Biscuit (unglazed ceramic), 46 × 38 × 21 cm
Provenance: Acquired from the State Museum Fund in the 1920s; previously at the Winter Palace. ЭРСк-236
Previous Exhibition: St. Petersburg, 1994, Cat. 88
Literature: Librovich, 1913, pp. 309–15; Tezi, 1909, pp. 8–10; Severukhin, 1993, pp. 246–59

'Wednesday 20 September, 1895 ... After breakfast spent more than an hour sitting for Bernstamm, who's been recommended by Bogoliubov.' 'Thursday 21 September. Sat for the sculptor again.' (Diaries of Nicholas II, 1991, pp. 103, 104.)

'At the beginning of 1896 the sculptor was invited to Tsarskoe Selo, where he completed busts of several members of the tsar's family in less than three weeks ... the marble busts of the royal couple served as an excellent model for mass-produced works and for a long time had the sovereign's approval.' (Severukhin, 1993, p. 252.)

Busts of the imperial couple were commissioned from the Sèvres Porcelain Manufactory after their visit to Paris in 1896. 'On 23 September the emperor and empress arrived at Cherbourg with Grand Duchess Olga (who was 10 months old). There they were met by President Félix Faure, and so began the "Russian Week", which finished on 27 September with a "Shalonsky Parade".' On the third day of the festivities, 'On the way to Versailles the royal couple visited the famed Porcelain Manufactory at Sèvres ... Their royal highnesses were accompanied by the president ... On behalf of the French government Rimbaud presented their royal highnesses with a vase of new porcelain, considered to be the most beautiful example of current techniques ... The emperor and empress then approached a table on which lay all the pieces to be presented to their royal highnesses: busts of the Emperor Paul, Alexander I, Catherine II, a group representing Russia and France, portraits of their highnesses and many others ... The royal party left the factory at 4 o'clock. The town was splendidly decorated: the two triumphal arches on the Rue St. Pierre displayed the inscription "1716 — Peter the Great. 1896 — Nicholas II." Two artillery batteries were scarcely able to restrain the vast crowd. There was a ten gun salute ... Parisian society was gripped by genuine admiration ... few indeed were the Frenchmen who did not give way to real enthusiasm for the emperor and for Russia over these days.' (The newspaper *Temps*, quoted by Oldenburg, 1991, pp. 66, 67.)

'I know of no one who, when introduced to the tsar for the first time, was not charmed by him; he charmed everyone with his warmth, his manners and, in particular, his great good-breeding — for I have never in all my life met a man more cultivated in his manner than our emperor ... Nicholas II was at once the most humble of tsars and the proudest of military colonels.' (Witte, 1960, vol. ii, p. 80; vol. iii, p. 260.) Nicholas is portrayed in the uniform of the Life-Guard Preobrazhensky Regiment. LT

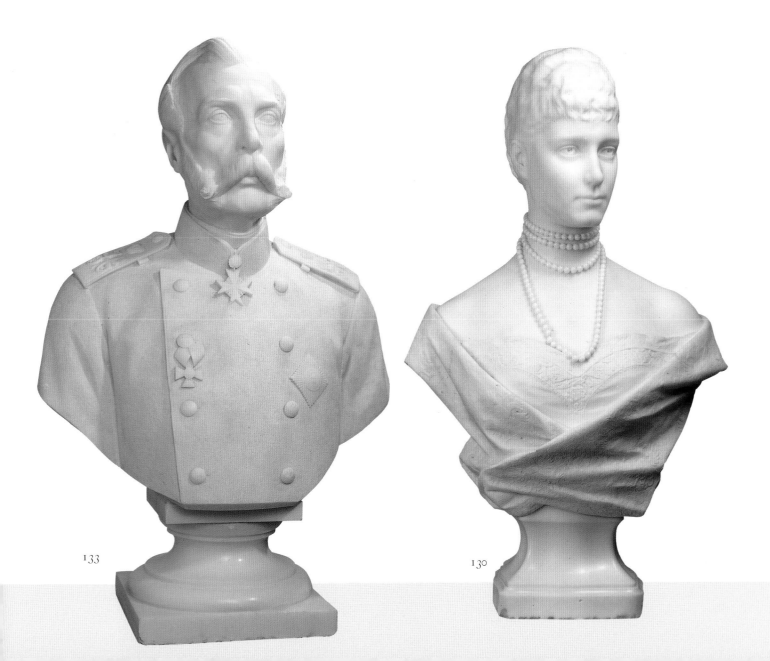

133

130

MATVEI AFANASIEVICH CHIZHOV

1838–1916

Russian sculptor.

Worked in his father's stonemason's workshop in Moscow as a child. Studied at the Stroganov school, the School of Drawing and Sculpture from 1851, and under N. S. Pimenov and A. R. Bok at the Academy of Arts from 1863 to 1867. Continued training in Italy in 1868 and was appointed academician in 1878. Awarded the gold medal, third class for a series of works at the World Exhibition in Paris (1878). Fellow of the Academy of Arts from 1893 and taught at the Stieglitz School of Technical Drawing. Sculpture restorer at the Hermitage. Participated in the creation of the Novgorod sculptural monument entitled 'Russia's Millennium' (1862) and the statue of Catherine the Great in St. Petersburg (1873).

133 Portrait of Emperor Alexander II, 1881

Signed and dated on the back: *М. Чижовъ 1881*
Marble, 85 × 55 × 30 cm
Provenance: From the original Hermitage Collection. ЭРСк-243
Previous Exhibitions: St. Petersburg, 1994, Cat. 91; St. Petersburg, 1997, Cat. 55

'The sovereign was extremely tall, well-proportioned and with a majestic, lively bearing. He had big blue eyes, and there was an angelic kindness and gentleness that shone within them which was also visible on his lips with their scarcely noticeable but ever-present smile. His face was oval and lightly tanned, framed with thick dark side-burns and a big handlebar moustache. The monuments representing great Russia that were erected in his honour bear the most striking resemblance to him. This man really was the 'Tsar-Bogatyr', the 'Sun King', who should have lived to a hundred for Russia's sake, but who on 1 March 1881 was suddenly no more ...' (Captain V. Donetsky, 1898, vol. ii, pp. 473, 474.) LT

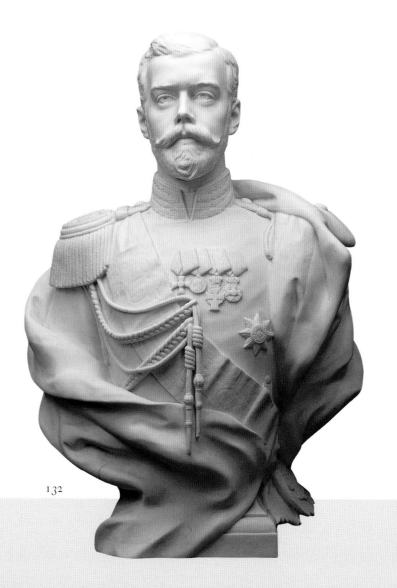

132

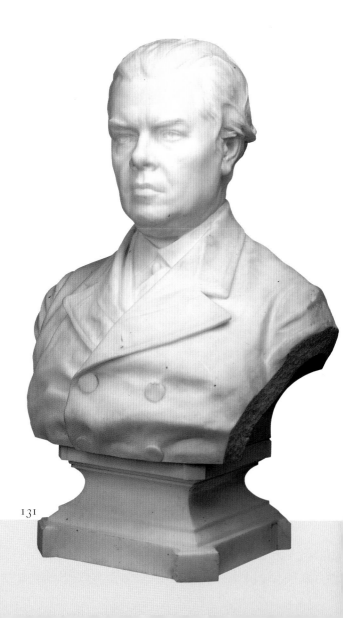

131

EDOUARD DROUOT
1859–1906

134 Devotion (The French Fireman), 1891

France, Paris
Inscription on helmet: *Sapeurs pompiers de cellier* [underground firemen]
Signed bottom right on the back of the base: *E. DROUOT*
Inscription on shield: *LE DEVOUEMENT PAR DROUOT MEDAILLE AU SALON*
['Devotion' by Drouot, salon medal]
Inscription on gilded bronze plate attached to the marble base: *Hommage de l'Union Departementale des Sapeurs Pompiers de l'Oise à sa Majesté Nicolas II Empereur de Russie. 1901.* [Gift of the Oise union of firemen to His Majesty Nicholas II, emperor of Russia. 1901]
Bronze, golden-brown patina
Height 45 cm
Provenance: Acquired from the Winter Palace in 1902. Н. ск. 507
Previous Exhibition: St. Petersburg, 1994, Cat. 320

This statuette was presented to Tsar Nicholas II by French firemen during his visit to France in 1901. NKK

LUCIEN FALISE
1839–97

Lucien Falise came from a family of jewellers and silversmiths; he also worked using the technique of sectioned enamel; collaborated with Emile Gallé.

135 Allegory of Peace, 1896

France, Paris
Signed and dated on cross-section of base: *Falise orf. 1896*
Inscription on the laurel wreath: *PAX PORTIBUS, A. S. M./NICOLAS II/EMPEREUR DE TOUTES LES RUSSIES/LA VILLE DE PARIS.* [Bearer of Peace. To His Majesty Nicholas II, emperor of all the Russias, from the city of Paris]
Silver; casting, engraving, partial gilding.
Height 60 cm
Provenance: Acquired from the Central Museum Fund Repository in 1956; previously at the Alexander Palace in Tsarskoe Selo until 1941. Э-17253
Previous Exhibitions: Leningrad, 1974, Cat. 67; St. Petersburg, 1994, Cat. 321
Literature: Yakovlev, 1928, p. 74

Lucien Falise has portrayed the 'Allegory of Peace' in the form of Minerva. His treatment reveals elements of the influence of Salon art and Art Nouveau. As is shown by the inscription, the figure was presented to Nicholas II by the city of Paris, probably on the occasion of his accession to the throne in 1896.

134

135

Orders and Medals

Anton Feodorovich Vasyutinsky
1858–1935
Russian medallist.
Completed studies at the Academy of Arts in St. Petersburg in 1888, winning a gold medal; granted an overseas scholarship. Lived and worked for five years in Paris, exhibited at the Salons of 1891 and 1892. Senior medallist of the St. Petersburg mint from 1893.

136 Souvenir Medal of the Wedding of Emperor Nicholas II and Princess Alice of Hesse on 14 November 1894, struck 1896

Obverse side: head-and-shoulders images of the newly-weds
Inscription on the medal: *14 ноября 1894* [14 November 1894]
Circular text: *В ПАМЯТЬ БРАКОСОЧЕТАНИЯ ИМПЕРАТОРА НИКОЛАЯ II С ПРИНЦЕССОЙ АЛИСОЙ ГЕССЕНСКОЙ* [To commemorate the wedding of Emperor Nicholas II and Princess Alice of Hesse]
Reverse side: interior scene of wedding. Lower right: *B* [V]
Silver, engraving. *Diam.* 70 mm
Provenance: Acquired from the St. Petersburg mint in 1896. PM-4605
Previous Exhibition: St. Petersburg, 1994, Cat. 92
Literature: Smirnov, No. 1088
ES

137 Great Coronation Medal of Emperor Nicholas II, 1896

Obverse side: profiles of Nicholas II and Alexandra Feodorovna
Signed lower right: *A BAC-KИ* [A. Vasyutinsky]
Circular text: *ИМПЕРАТОРЪ НИКОЛАЙ II. ИМПЕРАТРИЦА АЛЕКСАНДРА ФЕДОРОВНА: КОРОНОВАНЫ 1896 В МОСКВЕ* [Emperor Nicholas II and Empress Alexandra Feodorovna. Crowned in Moscow 1896]
Reverse side: image of the state coat of arms
Around the top: *СЪ НАМИ БОГЪ* [God is with us]
Silver, engraving. *Diam.* 10 mm.
Provenance: Acquired from the St. Petersburg mint in 1896. PM-4651
Previous Exhibitions: St. Petersburg, 1994, Cat. 93
Literature: Smirnov, No. 1101; Coronation Album, vol. ii, pp. 52–8

Coronation medals were first struck in Russia for the coronation of Catherine I in 1724. They were made of gold and silver in several sizes and were awarded in accordance with the Table of Ranks to those who had taken part in the triumphal ceremony. On the emergence of the imperial couple from the Uspensky Cathedral of the Moscow Kremlin, so-called crown tokens would traditionally be distributed to the people in the square. For the coronation of Nicholas II and Alexandra Feodorovna, five thousand medals and over thirty thousand tokens were struck. The souvenir medal of the wedding of Nicholas II and Alexandra Feodorovna (no. 136) was produced at the same time as the coronation medal in 1896, and was presented to members of the imperial family and dignitaries during the coronation celebrations.

On 30 January 1896, Nicholas II wrote in his diary: 'The first sitting was held, at which I was sketched and sculpted from all sides at once, by Repin, Antokolsky and Vasyutinsky. It lasted more than an hour — what a bore!' (Diaries of Nicholas II, 1991, p. 62.) ES

Avgust Franz Zhakar
Late 19th–early 20th century.
Russian engraver of French origin.
Lived and worked in St. Petersburg from the 1890s; in 1907 opened a private studio for the production of artistic medals. Brought in well-known sculptors and medallists to work with him (I. Ginsburg, M. Dillon, G. Malyshev). The Zhakar workshop ceased production in 1917.

138 One-Sided Medal with a Portrait of Tsarevich Alexei Nikolaevich, 1908

Head-and-shoulders image of the heir in a fur *papakha* (hat)
Signed and dated bottom left: *A ЖАКАР. 1908*
Circular text: *ЕГО ИМПЕРАТОРСКОЕ ВЕЛИЧЕСТВО НАСЛЕДНИКЪ ЦЕСАРЕВИЧ ВЕЛИКИЙ КНЯЗЬ АЛЕКСЕЙ НИКОЛАЕВИЧЬ* [His Imperial Highness the Heir Apparent and Tsarevich Grand Duke Alexei Nikolaevich]
Silver, engraving. *Diam.* 56 mm
Provenance: Acquired from the original Hermitage Collection. PM-5835
Previous Exhibition: St. Petersburg, 1994, Cat. 95

Grand Duke Alexei Nikolaevich (1904–18) was the son of Nicholas II. He suffered from haemophilia, the hereditary disease of the House of Hesse. He was shot in Ekaterinburg with the rest of his family on the night of 16–17 July 1918.

N. A. Sokolov, who observed the tsar's family during the last months before their murder in 1918, wrote: 'Alexei Nikolaevich was a clever boy, observant, receptive, kind-hearted, full of the joys of life. He was rather lazy and had no great liking for his books … He obeyed only his father … The illness left a severe mark on him.' (Sokolov, 1991). ES

137

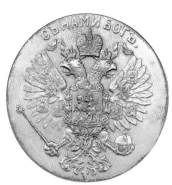

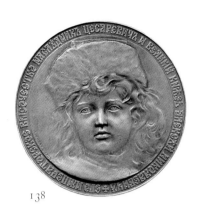

138

139

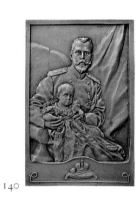

140

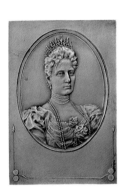

141

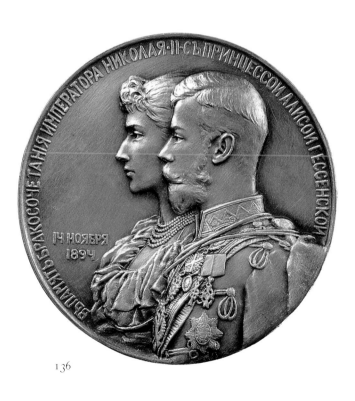

136

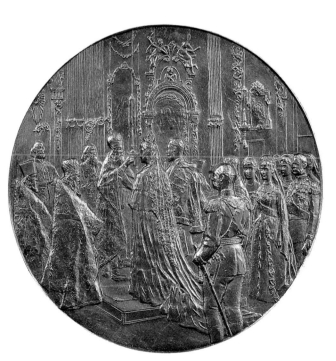

Daniel Jean-Baptiste Dupuis
1849–99
French medallist, sculptor and painter.

139 Souvenir Medal of the Opening of the Alexander III Bridge in Paris, 1900

Obverse side: three figures representing Peace, Russia and France under drapes with an image of the head of Alexander III
Inscriptions: *ALEXANDRE III* and *PAX*
Signed on the right edge: *DANIEL-DUPUIS*. Below is an engraved four-line verse.
Reverse side: image of the Seine in the form of a recumbent nymph against a background of the Alexander III Bridge
On the right: cupid, holding a scroll with an inscription in French: *7-me octobre 1896* [7 October 1896]
Below: *ЕГО ВЕЛИЧЕСТВО НИКОЛАЙ II ИМПЕРАТОР ВСЕРОССИЙСКИЙ ЕЕ ВЕЛИЧЕСТВО ИМПЕРАТРИЦА АЛЕКСАНДРА ФЕДОРОВНА, ФЕЛИКС ФОР – ПРЕЗИДЕНТ ФРАНЦУЗСКОЙ РЕСПУБЛИКИ ЗАЛОЖИЛИ В ПАРИЖЕ ПЕРВЫЙ КАМЕНЬ МОСТА АЛЕКСАНДРА III М. ЕТАН ПРЕЗИДЕНТ СОВЕТА МИНИСТРОВ, А. БУШЕ – МИНИСТР КОММЕРЦИИ А. ПИКАР – ГЕНЕРАЛЬНЫЙ КОМИССАР ВСЕМИРНОЙ ВЫСТАВКИ.* [His Highness Nicholas II Emperor of All Russia, Her Highness Empress Alexandra Feodorovna and Félix Faure President of the French Republic Laid the First Stone of the Alexander III Bridge in Paris. M. Etaing – President of the Council of Ministers, A. Boucher – Minister of Commerce, A. Picard – General Commissioner of the World Exhibition]
Silver, engraving. *Diam.* 70 mm
Provenance: Acquired from the Paris Mint in 1906. PM-3832
Previous Exhibition: St. Petersburg, 1994, Cat. 96
Literature: Catalogue de la Monnaie, p. 170; Marx, pl. 9, No. 2; Description of Medals, p. 141, No. 32

This medal commemorating the opening in Paris of a bridge devoted to the memory of Alexander III is at the same time a souvenir of Nicholas and Alexandra's visit to the city in the autumn of 1896. Nicholas himself possessed a copy of this medal in gold, but its present whereabouts are not known. ES

Awes-Münze (A. Werner & Sons)
Beginning of 20th century.

140 One-Sided Plaque with Portrait of Nicholas II and Tsarevich Alexei, 1906

Copper, engraving. 62 × 91 mm
Provenance: Acquired from the firm Awes-Münze in 1907. PM-7130
Previous Exhibition: St. Petersburg, 1994, Cat. 97
Literature: Iroshnikov, p. 314; Awes-Münze, pl. 74, No. 10553

At the turn of the 20th century it became fashionable to display on tables and mantelpieces portrait medallions and plaques reproducing photographs or engravings. In 1906, the firm Awes-Münze issued eight portrait plaques with Russian subjects. Two of them were devoted to the Russian imperial family. The original for this plaque showing Nicholas II was a family photograph of 1905; that for the portrait of Alexandra Feodorovna (no. 141) was an etching by M.V. Rundaltsov of 1905. ES

141 One-Sided Plaque with Portrait of Empress Alexandra Feodorovna, 1906

Bronze, engraving. 62 × 81 mm
Provenance: Acquired from the firm Awes-Münze in 1901. PM-7131
Previous Exhibition: St. Petersburg, 1994, Cat. 98
Literature: Awes-Münze, pl.74, No. 10553
ES

142 Chain of the Order of St. Andrew the First-Called, 1856

Marks: 72 (assay), *Keibel, WK*; triangular mark with St. Petersburg coat of arms and year *1856*; double-headed eagle emblem denoting suppliers to the court
Gold, enamel, stamping, casting, hot enamel, engraving, mounting. 55 × 1060 mm
The chain consists of 17 large links interconnected by flat oval rings; three compositions are repeated in the chain: the double-headed eagle with the Moscow coat of arms on its breast, a round shield in blue enamel with the monogram of Peter I under a crown, overlaying trophies, and a round radial shield in red enamel overlaid by a blue St. Andrew's Cross and the letters *SARP* (Sanctus Andreas Russiae Patronus) on the ends of the cross.
Provenance: Acquired from the State Museum Fund. B3-1384
Previous Exhibition: St. Petersburg, 1994, Cat. 268
Literature: Zamyslovsky, Petrov, 1891, pp. 6–8; Hazelton, 1932, pp. 10–16; Spassky 1963, pp. 110–11; Kuznetsov, 1985, pp. 24–34; Werlich, 1985, pp. 265, 268; Durov, 1993, pp. 10–19
MD

143 Badge of the Order of St. Andrew the First-Called, 1861

Marks: on loop of crown 56 (assay); St. Petersburg coat of arms in a circle; emblem denoting supplier to court; WK (Wilhelm Keibel); WK and double-headed eagle on the cross
Gold, enamel, stamping, engraving, hot enamel, mounting. 63 × 82 mm
Badge in the form of a gold double-headed eagle covered in black enamel, overlaid by the image of a saltire with the figure of the crucified apostle. On the ends of the cross, the gold letters: *SARP* (Sanctus Andreas Russiae Patronus). The heads of the eagle are crowned by two small crowns, and the entire badge by a large Imperial crown with blue ribbons. On the back, on the breast of the eagle in the form of a necklace, a cartouche of white enamel with the motto of the order: *ЗА ВЂРУ И ВЂРНОСТЬ* [For Faith and Loyalty].
Provenance: Acquired from the Chapter of Orders in 1863 as part of a collection of Russian orders for preservation in the museum. B3-93
Previous Exhibition: St. Petersburg, 1994, Cat. 269
MD

144 Star of the Order of St. Andrew the First-Called, Mid 19th century

Marks: 84 (assay); St. Petersburg coat of arms in circle; *Keibel*
Silver, gold, enamel, stamping, engraving, gilding, enamelling, mounting. 82 × 83 mm
Eight-pointed radial star, in the centre of which is a round medallion with an overlaid image of a double-headed eagle with the St. Andrew's Cross on its breast. At the edge, in overlaid gold letters against a field of blue enamel is written the Order's motto: *ЗА ВЂРУ И ВЂРНОСТЬ* [For Faith and Loyalty].
The star has a pin fixing with hooks on the gilded reverse side.
Provenance: Acquired from the State Museum Fund. B3-1320
Previous Exhibition: St. Petersburg, 1994, Cat. 270

The Order of St. Andrew the First-Called — the first and highest Russian order — was inaugurated by Peter I at the end of the 1690s. Its statute, compiled with Peter's participation in 1720, was not confirmed, but all its provisions were observed until the statute of 1797 was compiled. The order had a limited number of Russian knights and was restricted to people of the highest ranks. Like all the highest European orders, it was not divided into degrees and was the only order in Russia to have an order chain, which was worn on ceremonial occasions.

The badge of the order (no. 143) was made up of a saltire, or St. Andrew's Cross, with an image of the crucified apostle, overlaying a double-headed eagle. The badge hung from a pale-blue ribbon over the right shoulder and rested on the left hip. As a mark of special favour, under the statute of 1797, the badge was allowed to be decorated with diamonds. At the end of the 19th century diamond badges were issued from the Cabinet of His Imperial Majesty, but their cost was recovered from the ministry or department in which the recipient served.

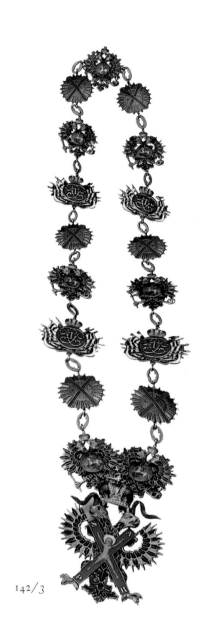

142/3

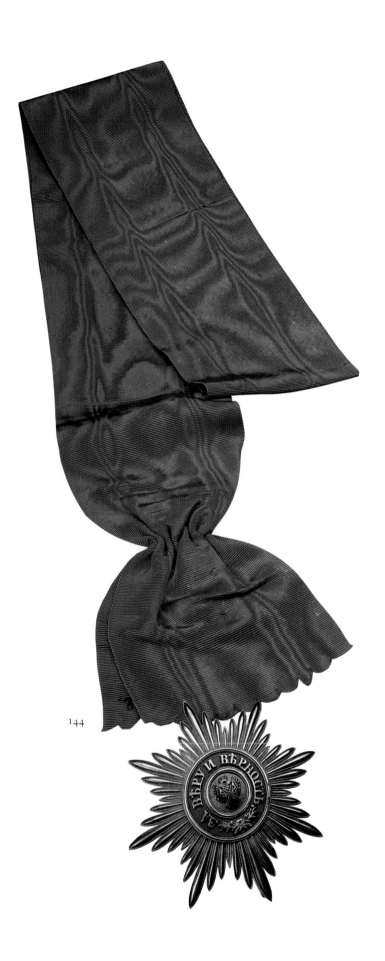

144

The eight-point star was attached to the breast on the left side. In the centre of the star is an image of the St. Andrew's Cross (overlaid, from the end of the 18th century, on the breast of a double-headed eagle), encircled by the order's motto, 'For Faith and Loyalty'. The stars were originally embroidered in sequins and metal thread, but in the 18th century they were gradually replaced by metal ones.

The knights of the order wore a special costume on ceremonial occasions. It consisted of a green velvet cloak lined in white silk, with a star embroidered on the left side, a white topcoat with a cross embroidered on the breast, and a black hat with black and white feathers and a St. Andrew's Cross of narrow ribbon.

The first knight of the order was General-Admiral Feodor Alexeevich Golovin, an outstanding soldier and diplomat of Peter's time. Peter himself received the award from Golovin in 1703 for the capture of two Swedish ships in the Neva estuary. The knights of this supreme Russian order included P. A. Rumiantsev, A. V. Suvorov, G. A. Potemkin, P. I. Bagration, M. I. Kutuzov and many others renowned for military or civilian feats. Under Paul's statute of 1797, all grand dukes were awarded the Order of St. Andrew the First-Called at their christening, and grand dukes of royal blood when they came of age. The award was only intended for persons of the rank of full general (or an equivalent civilian rank).

From 1855 the image of crossed swords was introduced for all orders awarded for military services. It was placed on the star and on the badge. On the badge of the Order of St. Andrew the First-Called, the swords appeared under the large crown above the heads of the eagle. MD

145 Badge of the Order of St. Alexander Nevsky, Late 19th century

Marks: 56 (assay); St. Petersburg coat of arms in an oval
Gold, enamel, stamping, engraving, painting on enamel, enamelling, mounting
48 × 73 mm (with eyelet and ring)
Badge in the form of a cross with equal arms in red enamel. In the centre, a round medallion with an image of St. Alexander Nevsky on a white horse; above him, emerging from clouds, a hand with a wreath; gold double-headed eagles between the arms of the cross. On the back of the medallion, on a field of white enamel, the monogram: SA (Sanctus Alexander) under a prince's crown.
Provenance: Acquired from the former Gallery of Treasures of the Winter Palace. ИЗ-318
Previous Exhibition: St. Petersburg, 1994, Cat. 271
Literature: Zamyslovsky, Petrov, 1891, pp. 9–10; Hazelton, 1932, pp. 23–6; Spassky, 1963, pp. 112, 115; Kuznetsov, 1985, pp. 39–43; Werlich, 1985, p. 267; Durov, 1993, pp. 22–33
MD

146 Star of the Order of St. Alexander Nevsky, Mid 19th century

Marks: 84 (assay); Keibel; St. Petersburg coat of arms in a circle
Silver, enamel, gilt, stamping, engraving, gilding, enamelling, mounting. 88 × 88 mm
Eight-point radial star. In the centre of the medallion, on a white enamel field, the order's motto: ЗА ТРУДЫ И ОТЕЧЕСТВО [For Labours and the Fatherland]; at the bottom, two laurel wreaths with a crown between them. Fixed by a pin and hook and gilded on the back.
Provenance: Acquired from the State Repository of Treasures of the USSR Ministry of Finance. ИО-1434
Previous Exhibition: St. Petersburg, 1994, Cat. 271

After the transfer of the relics of St. Alexander Nevsky from Vladimir to St. Petersburg in 1724, Peter I decided to inaugurate an order devoted to the memory of the prince who defeated the

Swedes. The order was intended to be awarded for military feats. Peter's sudden death in January 1725 meant that he did not live to see the inauguration. Nevertheless, on 21 May of the same year, at the time of the marriage of Tsarina Anna Petrovna to the Duke of Holstein, the first badges of this order were distributed. They had probably been made earlier, quite possibly while Peter was still alive. The order's robes were established in 1735 by Empress Anna Ioannovna, but its statute not until 1797, under Paul I. The order had no degrees. Its badge (no. 145), a red enamel cross with an image of the prince on horseback, was worn on the right hip on a red ribbon over the left shoulder. The star bears the monogram of St. Alexander and the Latin letters SA under a prince's crown, encircled by the order's motto 'For Labours and the Fatherland'. On ceremonial occasions, the knights wore the order's costume. This consisted of a red velvet cloak with a white lining, and a large star of the order embroidered on the left; a white topcoat with gold braid and an upright cross in the centre; and a black hat with a black and white feather and a cross made from the order's ribbon. The order was awarded to persons who had reached a rank not lower than lieutenant-general or the civilian rank of privy councillor.

Since the order was an award for both military and civilian services, from 1855 badges awarded for military feats received an addition in the form of crossed swords. Diamond badges of the order and matching diamond-encrusted swords were awarded as a special form of recognition. The knights of this order included many of renown: A. D. Menshikov, A. I. Repnin, Ya. V. Brus, P. A. Rumiantsev, A. P. Gannibal, G. A. Potemkin, A. G. and G. G. Orlov, A. V. Suvorov (and earlier, his father V. I. Suvorov), M. I. Kutuzov, F. F. Ushakov, D. S. Dokhturov, M. A. Miloradovich, N. N. Raevsky; and among the civilians: K. G. Razumovsky, president of the Academy of Sciences, I.I. Betskoi, president of the Academy of Arts, and I. I. Shuvalov, one of the founders of Moscow University. MD

147 Star of the Military Order of the Great Martyr and Victor St. George, Mid 19th century

Marks: 884 (assay); Keibel; St. Petersburg coat of arms in a circle
Silver, enamel, stamping, engraving, gilding, enamelling, mounting. 87 × 87 mm
Four-point radial star, in the centre of which, on a yellow enamel field, is the overlaid monogram: СГ (St. George), and circular inscription: ЗА СЛУЖБУ И ХРАБРОСТЬ [For Service and Bravery]. Fixed by a pin with hook.
Provenance: Acquired from the State Repository of Treasures of the USSR Ministry of Finance in 1951. ИО-1436
Previous Exhibition: St. Petersburg, 1994, Cat. 273
Literature: Zamyslovsky, Petrov, 1891, pp. 20–2; Hazelton, 1932, pp. 35–41; Spassky, 1963, pp. 115, 116; Kuznetsov, 1985, pp. 44–61; Werlich, 1985, pp. 268, 269; Durov, 1993, pp. 36–51
MD

148 Badge of the Military Order of the Great Martyr and Victor St. George, Second half of 19th century

Gold, enamel, engraving, enamelling, painting on enamel, mounting
47 × 51 mm (with eyelet)
Cross with equal arms in white enamel with gold border. In the centre, in a gold frame, is a pink enamel medallion with an image of St. George killing a dragon with a spear. On the back of the medallion, on a field of white enamel, the monogram СГ (St. George) is inscribed in black enamel.
Provenance: Acquired from the State Museum Fund. В3-1130
Previous Exhibition: St. Petersburg, 1994, Cat. 273
MD

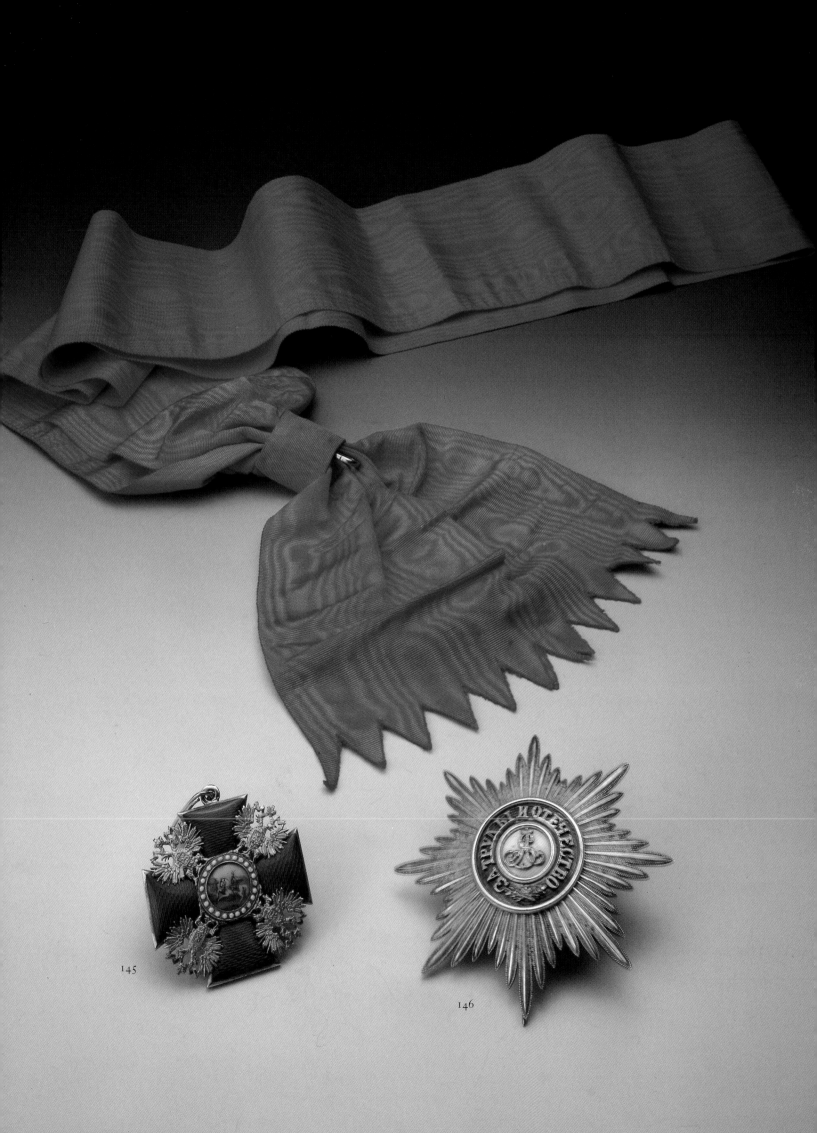

145

146

149 Badge of Distinction of the Military Order for Soldiers and Non-Commissioned Officers (George Cross 1st Degree), After 1913

Gold, engraving. 33 × 53 mm (with eyelet and ring)
Gold cross with equal arms, with double relief border round the edge. In the centre, encircled by a convex border, a medallion with an image of St. George on horseback killing a dragon, and the monogram: *СГ* (St. George). On the back, on the arms of the cross: *No. 15-470*; at the bottom: *1 степ* [1st degree].
Provenance: Acquired from the State Repository of Treasures of the USSR Ministry of Finance in 1951. A3-2374
Previous Exhibition: St. Petersburg, 1994, Cat. 275
Literature: Zamyslovsky, Petrov, 1891, pp. 19, 20; Hazelton, 1932, pp. 45, 46; Spassky, 1963, p. 116; Kuznetsov, 1985, p. 157; Durov, 1993, pp. 54–60
M.D.

150 Badge of Distinction of the Military Order for Soldiers and Non-Commissioned Officers, 4th Degree

Silver, engraving. 34 × 41 mm (with eyelet)
On the back: *No. 173038*
Provenance: Acquired from Moscow Regional Finance Department. ИО-22830
Previous Exhibition: St. Petersburg, 1994, Cat. 276

The Military Order of the Great Martyr and Victor St. George was inaugurated on 26 November 1789. The statute issued the next day defined it as an award for specific military feats. The order was divided into four classes or degrees, which made it much more democratic than the orders of Peter's time. Any officer who distinguished himself on the field of battle could be given this award; furthermore, the lowest, 4th degree, was a reward for 25 years' service in officer ranks in the army or 18 sea voyages in the navy. The granting of the highest degree of the order was extremely rare: apart from the founder of the order herself, Catherine II, eight men were given this award in the 18th century (and only 25 over the entire history of the order's existence). The award of any degree of the order conferred the right to hereditary nobility and numerous other privileges. The badge of the order (no. 148) was a cross with equal arms in white enamel with an image of St. George on horseback, killing a dragon. The 1st degree badge was worn on the left hip on a ribbon consisting of three black and two yellow stripes, placed over the right shoulder under the caftan, or tunic. A gold rectangular star accompanied the 1st and 2nd degree badges and was attached to the left breast. 1st and 2nd degree crosses differed in size and were worn on the neck, and the cross of the lowest degree in a buttonhole. A costume for knights of the order was only introduced in 1833.

In 1807 the Badge of Distinction of the Military Order for Soldiers and Non-Commissioned Officers (no. 149) was introduced as an award for the lower ranks of the army. This was a cross engraved in silver, its shape and images similar to those of the badge of the order. The service number of the recipient was printed on the back, on the arms of the cross. The award was accompanied by the following privileges: exclusion from corporal punishment, a wages supplement, and the retention of NCO rank when transferred from the army regiments to the guards. In 1856, the Badge of Distinction was divided into four degrees: gold crosses for 1st and 2nd, silver for 3rd and 4th. Each degree was numbered separately. In 1913 a new charter for this award was issued: it was given the name of the George Cross, and the numbering by degrees was started again from the beginning. The cross was worn on a ribbon in the colours of the order. MD

151 Badge of the Order of St. Vladimir, 2nd Degree, 1850s

Marks: *56* (assay); and year mark *18*
Gold, enamel, engraving, enamelling, painting on enamel, mounting
45 × 68 mm (with eyelet and ring)
Cross with equal arms in red enamel with a black border. Central round medallion with an image on a black field of a prince's mantle under a prince's crown; on the mantle the letters: *C* and *B* (*SV* – St. Vladimir). On the back of the medallion, the date of the founding of the order: *22 сентября 1782 года* [22 September 1782].
Ribbon with two black and one red stripes
Provenance: Acquired from the Expert Purchasing Commission of the State Hermitage in 1967. В3-1210
Previous Exhibition: St. Petersburg, 1994, Cat. 277
Literature: Zamyslovsky, Petrov, 1891, pp. 22–4; Hazelton, 1932, pp. 50–7; Spassky, 1963, p. 117; Werlich, 1985, p. 269; Kuznetsov, 1985, pp. 69–75; Durov, 1993, pp. 90–103
MD

152 Star of the Order of St. Vladimir, Second half of 19th century

Marks: *84* (assay); *Keibel*; St. Petersburg coat of arms
Silver, enamel, stamping, engraving, enamelling, gilding, mounting
87 × 87 mm
Eight-point radial star. In the centre, in a circle of black enamel, is a gold cross, in the corners of which are the letters *СРКВ* (St. Vladimir, Prince of Apostle Status); in a circle on a red enamel field, in overlaid letters, the order's motto: *ПОЛЬЗА, ЧЕСТЬ И СЛАВА* [Good, Honour and Glory]. Fixing: screw with wing nut.
Provenance: Acquired from the State Repository of Treasures in 1951. ИО-1437
Previous Exhibition: St. Petersburg, 1994, Cat. 278
Literature: see no. 151

The Order of St. Vladimir, Prince of Apostle Status, was inaugurated by Catherine II on 22 September 1782 to mark the 20th anniversary of her coronation. Like the previously inaugurated Military Order of St. George, the new order was also divided into four degrees, and was intended to be awarded both to civilian and military persons for diligent service. The fourth degree of the order was awarded for 35 years of exemplary service; the recipients had the right to hereditary nobility. An annual pension was awarded to knights of the order, but each knight had to contribute a certain sum for charitable purposes. The badge of the order (no. 151) was attached to a ribbon consisting of one red and two black stripes; the 1st degree badge was worn at the hip on a ribbon over the right shoulder, 2nd and 3rd degree badges were worn on the neck and 4th degree in the buttonhole. The order did not have an accompanying costume. The star, attached to the clothing on the left breast, went with the 1st and 2nd degree badges. MD

153 Badge of the Order of St. Anne, 2nd Degree, Second half of 19th century

Marks: *56* (assay); St. Petersburg coat of arms in an oval; under enamel a double-headed eagle denoting supplier to the court
Gold, enamel, engraving, enamelling, painting on enamel, mounting
44 × 68 mm (with eyelet and ring)
Cross with equal arms in red enamel. Between the arms of the cross, plant ornament. In the central medallion, an image of St. Anne in the desert. On the back, on a medallion of white enamel, a monogram of the letters *AJPF* [Amantibus Justitiam Pietatem Fidem – loving truth, piety and fidelity].
Red neck ribbon with thin yellow stripes at the edge
Provenance: Acquired from the former Gallery of Treasures of the Winter Palace in 1938. В3-483
Previous Exhibition: St. Petersburg, 1994, Cat. 279
Literature: Zamyslovsky, Petrov, 1891, pp. 10–15; Hazelton, 1932, pp. 58–67; Spassky, 1963, pp. 119–29; Kuznetsov, 1985, pp. 76–84; Werlich, 1985, pp. 269, 270; Durov, 1993, pp. 106–19
MD

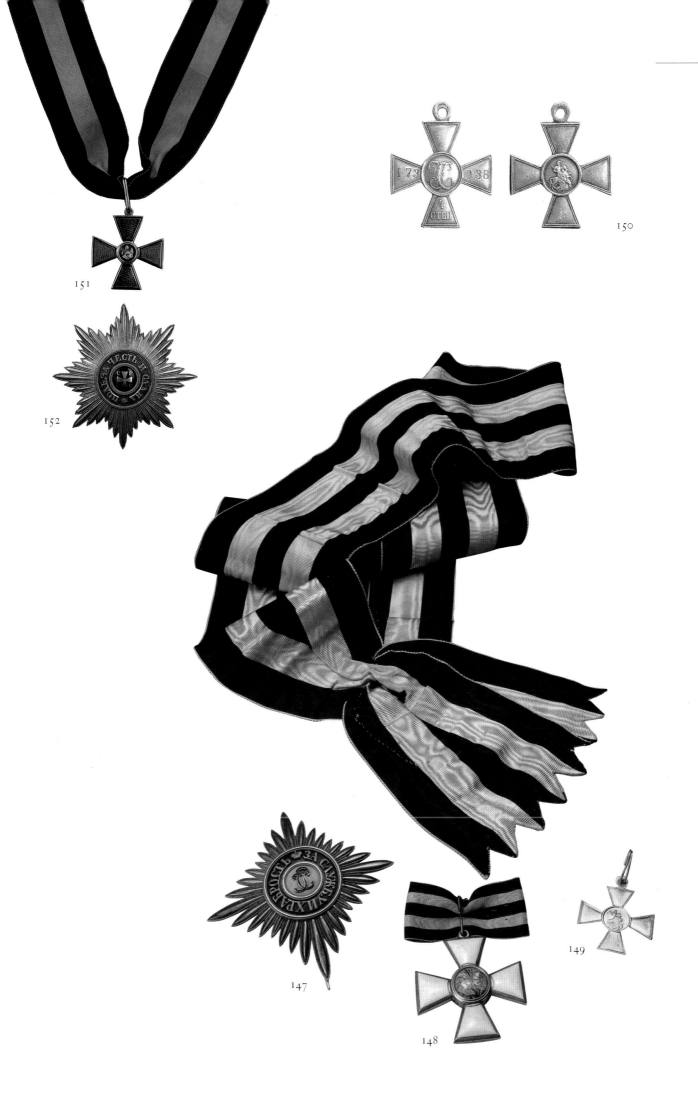

154 Star of the Order of St. Anne, Mid 19th century

Marks: *84* (assay); St. Petersburg coat of arms; *Keibel*; double-headed eagle
Silver, enamel, gilt, stamping, engraving, gilding, casting, enamelling, mounting
89 × 89 mm
Eight-point radial star with a round medallion in the centre containing a red enamel cross on a gold background. The order's motto runs around the cross: *AMAN JUST PIET FID* [loving truth, piety and fidelity]. At the top of the cross, two angels support a crown. On the back are the marks. Fixing: pin with hook.
Provenance: Acquired from the State Museum Fund. ИО-24364
Previous Exhibition: St. Petersburg, 1994, Cat. 280
Literature: see no. 153

The Order of St. Anne was inaugurated in 1735 by Karl Friedrich, Duke of Schleswig-Holstein, in memory of his wife Anna Petrovna, daughter of Peter I, who died in 1728. The order's motto consisted of words chosen to correspond to the initial letters of the name and ancestry of Anna Petrovna — AIPF (Anna, Imperatoris Petri Filia: Anna, daughter of Emperor Peter). The order has one degree and a limited number of knights — 15 including the founders. In 1742, Peter Ulrich, the son of Anna Petrovna and Karl Friedrich, arrived in Russia and was soon proclaimed heir to the Russian throne (he reigned as Peter III). The order of St. Anne, of which he was the Grand Master, 'dedicated itself to the Empire of All the Russias'. Under Paul I, in accordance with the manifesto on Russian orders issued on 5 April 1797, the order was divided into three degrees and was integrated into the system of Russian orders. In 1815 a fourth degree was added. The badge of the first three degrees was a cross with equal arms of red enamel with an image of St. Anne in the centre. The fourth degree badge (which had been the 3rd degree before 1815) was a red enamel cross in a gold circle under a crown; it was attached to the sheath of a sword or dagger. When the order was awarded for military feats, the inscription *За храбрость* [For bravery] was engraved on the hilt. The star, which was attached to the right breast, went with the 1st degree badge. This was attached to a broad red shoulder ribbon with narrow yellow piping, worn over the left shoulder. The 2nd degree badge was worn on the neck, that of the 3rd degree in the buttonhole. Awards of the order were made on 3 February — the order's festival. The order owned the Church of Simeon the Receiver of God and Anne the Prophetess, situated in St. Petersburg's 'foundry' quarter. MD

155 Set of Ten Orders and Medals, After 1915

Gold, silver, bronze, enamel, stamping, engraving, hot enamel, mounting. 170 × 97 mm
10 awards (4 orders and 6 medals):
1. Badge of the Order of St. Vladimir 4th Degree. Gold, enamel. 34 × 46 mm
2. France, Croix de Guerre with swords. Inaugurated 8 April 1915. Bronze. 36 × 46 mm
3. Medal commemorating the coronation of Emperor Alexander III. Inaugurated 4 May 1884. Gilded bronze. *Diam*. 29 mm
4. Medal commemorating the reign of Alexander III. Inaugurated 17 March 1896. Silver. *Diam*. 27 mm
5. Medal commemorating the Bicentenary of the victory at Poltava. Inaugurated 27 June 1909. Gilded bronze. *Diam*. 27 mm
6. Medal commemorating the Centenary of the Patriotic War of 1812. Inaugurated 26 August 1912. Gilded bronze. *Diam*. 27 mm
7. Medal commemorating the Tercentenary of the Reign of the House of Romanov. Inaugurated 12 March 1913. Gilded bronze. *Diam*. 28 mm
This medal is turned with the reverse side outward, as the obverse side bears a portrait of Nicholas II.
8. Medal commemorating the Bicentenary of the Battle of Gangut. Inaugurated 12 June 1914. Gilded bronze. *Diam*. 27 mm
9. Denmark Badge of the Order of Daneborg (the Danish flag). Inaugurated 1219, re-established in 1617. Silver. 27 × 57 mm
10. Greece, Badge of the Order of the Saviour. Inaugurated 1833. Gold, silver, enamel. 33 × 55 mm
Provenance: Acquired from the former Gallery of Treasures of the Winter Palace in 1938. В3-319
Previous Exhibition: St. Petersburg, 1994, Cat. 281
Literature: Sheveleva, 1962, pp. 88, 89, 99, 100–2; Spassky, 1963, pp. 54, 93, 94, 117

This set of orders belonged to Nicholas II. The Badge of the Danish Order of Daneborg and the Greek Badge of the Order of the Saviour are explained by Nicholas's close ties of kinship to the Danish and Greek ruling houses: his mother, Maria Feodorovna, was a Danish princess; his second cousin, Olga Konstantinovna, was Queen of Greece. MD

156 Hereditary Chest Badge, Inaugurated 18 February 1913

Awarded to those offering their imperial majesties personal congratulations as true subjects on the occasion of the Tercentenary of the reign of the House of Romanov during the anniversary celebrations of 21–24 February 1913

On the badge: *84* (assay); *ВА*; *kokoshnik* (woman's headdress) with the badge of the St. Petersburg hallmark office; on the washer: *ВА* and *ЭДУАРДЪ* [VA and Edouard]
Silver, stamping, engraving, mounting, gilding. 41 × 51 mm
The badge is in the form of an oxidised open-work emblem of the Romanov boyars, crowned with the imperial crown and encircled by a gilded laurel wreath, on the ribbon of which at the bottom are the dates: *1613-1913*. Fixing: screw with washer and wing nut.
Provenance: Acquired from the former collection of the counts Bobrinsky. ИО-1338
Previous Exhibition: St. Petersburg, 1994, Cat. 282
Literature: Andolenko, Werlich 1972, p. 163, No. 551

The badge was intended for persons of both sexes who brought congratulations to their imperial majesties on the occasion of the 300th anniversary of Romanov rule, both personally and as part of deputations. Recipients of the badge had the right to have their forename, patronymic and surname engraved on the back. The badge was worn on the right breast, below stars but above other badges. The right to wear the badge was hereditary and passed to the eldest direct male descendant; this was confirmed by a special certificate. MD

157 Badge of the Life-Guard Preobrazhensky Regiment, Inaugurated 25 June 1909

Marks: *84* (assay); St. Petersburg; *Э. Кортманъ, А. Г.* [E. Kortman, A. G.]; *kokoshnik* on the wing nut
Silver, enamel, stamping, engraving, mounting, enamelling, gilding. 51 × 44 mm
St. Andrew's Cross, covered in blue enamel on a guilloche background with a gold rim and gold cross bearing an enamel image of St. Andrew the First-Called. In the upper part, between the arms of the cross, a tsar's crown with an eyelet; at the sides and below between the arms of the cross, gold double-headed eagles. On the back of the badge is the motto of the order of St. Andrew the First-Called: *ЗА ВЬРУ И ВЬРНОСТЬ* [For Faith and Loyalty]. Fixing: Screw with washer and wing nut
Provenance: Acquired from the former collection of Epanchin. ИО-1346
Previous Exhibition: St. Petersburg, 1994, Cat. 283
Literature: Andolenko, 1966, p. 81; Sheveleva, 1993, p. 8; Andolenko, Werlich, 1972, p. 20, No. 2

The design of the Preobrazhensky badge faithfully repeats the design of the original badge of the Order of St. Andrew the First-Called, which Peter I is reputed to have created personally. This explains why the order's motto is on the back, and why the crown has a ring at the top. MD

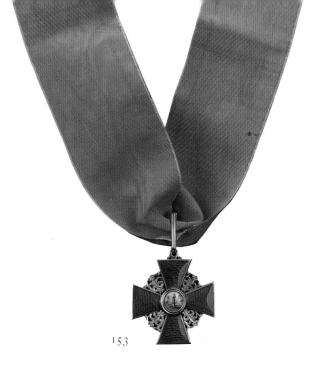

153

154

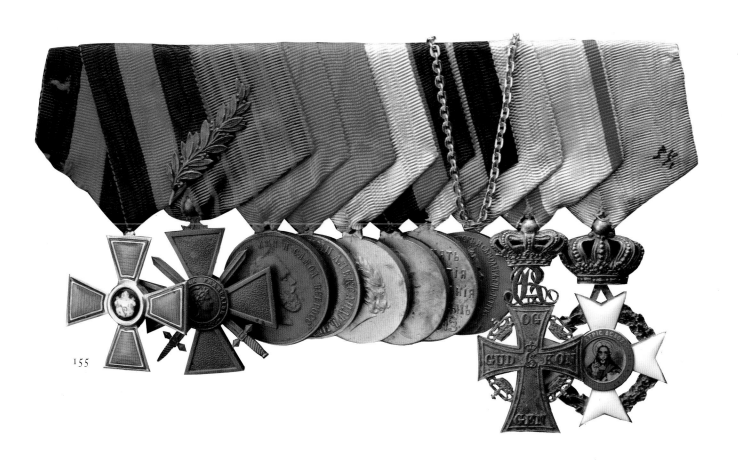

155

158 Badge of the Life-Guard Semeonov Regiment,
Inaugurated 11 July 1908

Bronze, stamping, mounting, enamelling, silvering. 46 × 48 mm
Badge in the form of a palmate five-leaf cross of white enamel with a silver border.
The cross is overlaid with a silver sword with a gilded handle, the blade pointing
upward. The cross and type of sword are analogous to the images on Peter's banners.
Fixing: Screw with washer and wing nut.
Provenance: Acquired from the former collection of Epanchin. ИО-1348
Previous Exhibition: St. Petersburg, 1994, Cat. 284
Literature: Andolenko, 1966, p. 61; Sheveleva, 1993, p. 9; Andolenko, Werlich, 1972,
p. 20, No. 3
MD

159 Badge of the Life-Guard Izmailovsky Regiment,
Inaugurated 15 March 1910

Bronze, stamping, engraving, mounting, gilding, enamelling.
50 × 35 mm
Badge in the form of the monogram of Empress Anna Ioannovna – a gold letter 'A'
intertwined with two obliquely crossed letters covered in blue enamel, crowned with
the imperial crown with two scrolls of red ribbon projecting from under it. There is
red enamel in the interstices of the crown, and its ornament is in blue and red enamel.
In the centre is the monogram of the commander-in-chief of the regiment *H II*
[Nicholas II] under a crown. At the bottom, the year the regiment was formed: *1730*
in gold inset numbers. Fixing: screw filed down.
Provenance: Acquired from the State Historical Museum in 1956. ИО-3258
Previous Exhibition: St. Petersburg, 1994, Cat. 285
Literature: Andolenko, 1966, p. 61; Sheveleva, 1993, p. 9; Andolenko, Werlich, 1972,
p. 20, No. 4

The Izmailovsky regiment was formed in 1730, during the reign
of Empress Anna Ioannovna, by Colonel Khrushchov in Moscow
from people selected from the Ukrainian land militia. The
regiment took part in the capture of Ochakova in 1737, in the
Patriotic War of 1812, in the Battle of Kulm in 1813 and in the
battles for Gorny Dubnyak in 1887. The regiment was
commanded by Anna Ioannovna, Elizaveta Petrovna, Peter III,
Catherine II, Paul I, Grand Dukes Konstantin and Nikolai
Pavlovich, Nicholas I, Alexander II, Alexander III and Nicholas
II. MD

160 Badge of the 4th Life-Guard Rifle Regiment of the Imperial
Family, Inaugurated 1854 (the year the regiment was formed)

Gilded bronze, stamping, engraving, gilding. 43 × 43 mm
Four-arm cross. In the centre, the monogram of Nicholas I; on the arms of the cross:
За Вѣру и Царя [For Faith and the Tsar]. Fixing: Screw with washer and wing nut.
Provenance: Acquired from the former collection of the counts Stroganov. ИО-1322
Previous Exhibition: St. Petersburg, 1994, Cat. 286
Literature: Andolenko, 1966, p. 66; Andolenko, Werlich, 1972, p. 23, No. 17

The regiment's badge repeats the design of the militia cross of the
time of Nicholas I, which in turn originates from the badge of the
St. Petersburg militia of the period of the Patriotic War of 1812,
which was originally headed by M. I. Kutuzov. It is considered
that the idea and design of the badge were his, which is why it
was called the Kutuzov badge. The regimental badge, like that of
the militia, was worn on the cap. MD

161 Badge of His Majesty's Life-Guard Ural Cossack Squadron
of the Combined Cossack Regiment, Inaugurated 20 June 1909

On the washer: *КП* and *Э. Кортманъ* [KP and E. Kortman]
Silver, enamel, casting, engraving, hot enamel. 32 × 50 mm.
Badge in the form of a silver oak-leaf wreath, on which crossed black ataman marks
with gold decoration are overlaid. Above the marks, the monogram of Nicholas II
under a crown in silver. In the upper part of the badge, a silver double-headed eagle
with spread wings and with a Maltese cross in white enamel on its breast. In the
centre of the cross, a red escutcheon with the monogram of Paul I. In the lower part,
a bow of crimson ribbon with the dates: *1798–5 сент–1898* [1798–5 September–
1898]. Fixing: screw with washer and wing nut.
Provenance: Acquired from the Ministry of Finance. ИО-21252
Previous Exhibition: St. Petersburg, 1994, Cat. 287
Literature: Andolenko, 1966, p. 68; Sheveleva, 1993, p. 15; Werlich, 1972, p. 25,
No. 24

This badge belonged to the Tsarevich Alexei Nikolaevich. MD

162 Badge of His Imperial Majesty the Tsarevich's
4th Battery of the Life-Guard Horse Artillery

On the badge: *84* (assay) and *КП* [KP]; on the washer: *Э. Кортманъ* [E. Kortman]
Silver, chasing, mounting. 37 × 47 mm
The badge constitutes the Latin letter C in gold, signifying the number 100, on which is
set the abbreviated name of the regiment: *4. Н. Ц. Гв. К. Б.* The letter/number frames a
St. Nicholas double-headed eagle with outstretched wings and crowned by a single
imperial crown. The eagle holds in its claws two crossed cannon barrels; on its breast
is the monogram of Nicholas II beneath a crown; and on its wings the dates *1812-
1912*. Fixing: Fastened by a screw, wing-nut and washer
Provenance: Acquired from the State Historical Museum in 1956. Ba-1120
Previous Exhibition: St. Petersburg, 1994, Cat. 288
Literature: Andolenko, 1966, p. 74; Andolenko, Werlich, 1972, p. 29, No. 39
MD

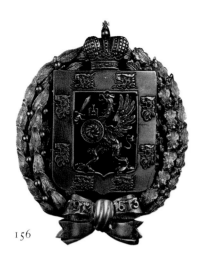

156

157

159

158

160

163 Badge of His Imperial Majesty's Own Convoy,

Inaugurated 20 June 1909 to commemorate the centenary of the 1st
and 2nd Kuban Companies of the Convoy

Gold, stamping, casting, engraving, polishing, mounting. 26 × 41 mm
Badge in the form of an oxidised shield with a double relief gold border; between the
borders, 13 gold rivets. On the shield is an oblique sword, blade upward; in the top
left corner the imperial crown; in the bottom right, *100 л.* [100 years]
Provenance: Acquired from the personal collections of the imperial family. Вз-1115
Previous Exhibition: St. Petersburg, 1994, Cat. 289
Literature: Andolenko, 1966, p. 80; Sheveleva, 1993, p. 20; Andolenko, Werlich, 1972,
p. 34, No. 57

A draft design for this badge was made by Empress Alexandra
Feodorovna. MD

164 Badge of the 148th Caspian Infantry Regiment of Her
Imperial Highness Grand Duchess Anastasia Nikolaevna

Bronze, enamel, stamping, engraving, hot enamel, gilding, mounting. 40 × 40 mm
Badge in the form of a black enamel cross with a gold border, on the arms of which
are the dates *1811–1911*, and at the bottom, the number of the regiment: *148*. The
cross is overlaid with an image of the Nicholas double-headed eagle, crowned with a
single crown, with the Moscow badge on its breast, and holding a wreath and feathers
in its claws.
Provenance: Acquired from the Museum of the Revolution. ИО-3507
Previous Exhibition: St. Petersburg, 1994, Cat. 290
Literature: Andolenko, 1966, p. 146; Sheveleva, 1993, p. 45

The 148th Caspian Infantry regiment, which was formed in 1863
from part of the Odessa Infantry Regiment, had all the honours
and seniority (i.e. date of formation) of the Odessa Regiment. The
commander-in-chief of the regiment was Anastasia Nikolaevna,
Nicholas II's youngest daughter. MD

165 Badge of the 3rd Elizavetgrad Hussar Regiment of Her
Imperial Highness Grand Duchess Olga Nikolaevna,

Inaugurated 1912

Gold, stamping, engraving, enamelling, mounting. 45 × 28 mm
Badge of white enamel in the form of a Hussar's helmet with gold braid and cord; in
the middle the initials of the commander of the regiment: *O.H.* [ON in Slavonic
entwined lettering] under the imperial crown. The helmet is topped by a Nicholas
eagle, holding feathers and a wreath in its claws.
Provenance: Acquired from the State Repository of Treasures in 1951.
Previous Exhibition: St. Petersburg, 1994, Cat. 291
Literature: Andolenko, 1966, p. 178; Sheveleva, 1993, p. 59; Andolenko, Werlich,
1972, p. 122, No. 402

Chest or regimental badges played an important part in Russian
military heraldry. The early chest badges (such as, for example,
the badge for the higher ranks of the 1st Grenadier Companies of
the Life-Guard Preobrazhensky and Semeonov Regiments of
1827) were at the same time badges of differentiation, indicating
membership of a military unit or of a certain category of
servicemen, as well as badges of distinction. For this reason they
were entered in service records.

The individual instances of the inauguration of badges at the end
of the 19th century and early years of the 20th century were
connected with anniversaries of the military colleges (Pavlovsk
Military College in 1898, Corps des Pages in 1902, Naval Cadet
Corps in 1900). Most of the badges were inaugurated between
1907 and 1914. Although some of them remained purely
anniversary badges, the majority were exclusively corporate
badges, differentiating one military unit from another.
Undoubtedly their appearance resulted from changes in military
costume, during which many distinguishing features of
regiments, particularly on working and field uniforms, were lost.
The War Ministry issued regulations and orders establishing the
rules for wearing the badges, which from 1911 were subdivided
into 'regimental' and 'chest' (i.e. all other than regimental)
badges. The first regimental badges appeared in the army
infantry in 1907 and were of two sorts — for officers and for
soldiers. The former were made of silver (or were silvered), and
were enamelled; the latter were usually bronze and without
enamel. By the beginning of the First World War, almost all
regiments had regimental badges and their designs were approved
at the highest level. As a rule, the right to wear a badge was
confirmed by a certificate signed by the unit commander.

The emblematic content of the badges was very varied: primarily
it recounted the military past of the unit, but also symbolically
represented the entire military history of Russia. In the majority
of cases, the badge designs were created by the officers of the
regiment, but sometimes they were done by the grand dukes
serving in the particular units or who had been their
commanders-in-chief. For example, the badge for the units of
His Imperial Majesty's Own Convoy was created from a design
by Empress Alexandra Feodorovna herself. The time of Peter the
Great was reflected in the badges of the senior regiments — the
Preobrazhensky and Semeonov regiments. MD

161

162

163

165

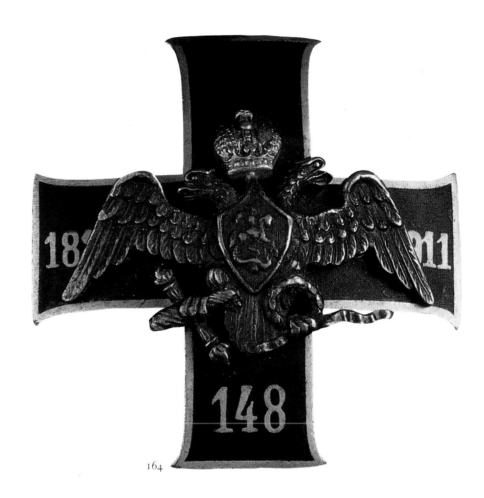

164

Weapons

166 Set of Three Miniature Firearms, 1897

Izhevsk

The barrels and other metal parts are of polished and burnished steel; on the breech of the barrels is the inscription *Ижевский Оружейный завод 1897* [Izhevsk Weapons Factory 1897] and the monogram *H II* [Nicholas II] under a crown inlaid in gold. The stocks and shoulder pieces are of polished wood. The case is covered in pale leather and is lined with silk and velvet. On the outside of the lid, imprinted in gold, is the inscription: *Его Императорскому Величеству, Отцу и благодетелю Верноподданные ижевские оружейники в память изготовления на ижевских заводах полумиллиона 3х. л. винтовок. Март 1897* [To his Imperial Majesty Emperor Nikolai Alexandrovich, Father and Benefactor, from his loyal Izhevsk armourers, to commemorate the production of half a million rifles at the Izhevsk factories. March 1897].
Length 30 cm, barrel 17 cm; 32 cm, barrel 19 cm; 30 cm, barrel 17.5 cm
Provenance: Not established. The set is recorded in the inventory documents of the museum from 1936. З.О. 5479, 5479a, 5480
Previous Exhibitions: Finland, 1992, Cat. 2; St. Petersburg, 1994, Cat. 295
Literature: Tarasiuk, 1971, pp. 502–4

The set of firearms consists of three working models, reproducing in quarter scale the Russian rifle of the 1891 pattern, designed by S. I. Mosin. One is a copy of the infantry version; the second of the dragoon version; and the third of the Cossack version. In spite of their miniature dimensions, the models exactly reproduce the originals in all details and with extraordinary precision. The set was made to mark the production by the Izhevsk works of the first five hundred thousand of these famous rifles. The set was presented to Nicholas II by the Izhevsk armourers in March 1897. YM

167 Cuirassier Officer's Broadsword (*Palash*), Late 19th-early 20th century

Germany, Solingen (blade); St. Petersburg, workshop of P. Fokin.
Steel, leather, metallic thread, forging, burnishing, gilding, engraving
Blade of damask steel, single-edged, with two broad fullers in the lower part and one broad fuller in the upper part, decorated on both sides by burnishing and ornament inlaid in gilded brass along the edges of the blade. Bears the inscription: *ЕДУ НЕ СВИЩУ* [I arrive without a sound] (on one side), *А НАЕДУ НЕ СПУЩУ* [I shall let none pass] (on the other). On the burnished heel on one side is depicted the mark of P. Fokin's shop, the officers' accoutrements shop. Fokin worked in St. Petersburg from 1850 to 1915. On the other side is the inscription: *DAMASC*. The handle is of wood, covered in leather; the sheath is of gilded bronze with three knuckle bows. The hilt cup has the inlaid inscription: *П. ФОКИН* [P. Fokin] and the Russian coat of arms. The scabbard is steel.
Length overall 111.5 cm, *length* of blade 95 cm
Provenance: Probably acquired from the collection of Count S. D. Sheremetev in 1930. З. О. 2135
YE

168 Officer's Sabre (*Klych*) of the 1st Astrakhan Cossack Regiment, which belonged to the Tsarevich Alexei Nikolaevich, 1913

St. Petersburg, workshop of Shaf & Sons
The blade is highly curved, with three narrow fullers, and is damascened. On the right of the heel is the workshop mark and the inscription: *Обожаемому Августейшему атаману всех казачьих войск* [To the most respected, most august ataman of all Cossack troops]. On the left, on the body of the blade: *Астраханский казачий полк* [Astrakhan Cossack regiment]. The inscriptions are inlaid in gold. The hilt consists of a handle of white bone, a crosspiece with fairing and decoration in the form of buds, spine and head stamped in the form of a lion's head. It has a gold chain instead of a knuckle bow. All the metal parts are gilded. The scabbard is of wood, covered in pale brown leather. The scabbard facing is steel, the ring clamps are in the form of rosettes and the rings are of gilded bronze.
Length overall: 95 cm, *length* of scabbard 85 cm
Provenance: Acquired from the State Museum Fund for palaces near Leningrad in 1960, before 1941 it was in the Alexander Palace of Tsarskoe Selo. ЕД-1116-III
Previous Exhibition: St. Petersburg, 1994, Cat. 306
From the State Palace Museum, Tsarskoe Selo

The sabre was presented by the officers of the 1st Astrakhan Cossack regiment to the Tsarevich Alexei Nikolaevich in 1913. GV

169 Cossack Officer's Sabre (*Klych*) of the Life-Guard Don Cossack Battery, 1913

St. Petersburg, workshop of Shaf & Sons
The blade is highly curved, damascened, with three narrow fullers. At the heel on the right is the workshop mark. At the left on the body of the blade, the monogram: *H II* [Nicholas II] under a crown and the inscription: *Л. гв. Донская батарея 1913 г.* [Life-Guard Don Battery 1913]. All the inscriptions are in gold inlay. The handle is covered in black patent leather bound round with twisted gilded wire. The back and head are of gilded bronze. The curved knuckle bow passes into a crosspiece with a fairing. On the head is the chased monogram *H II* under a crown in a wreath of laurel branches. The scabbard is of wood, covered in black patent leather. The mouth and facing of the scabbard, the crest and the ring clamps are gilded.
Length overall 95 cm, *length* of scabbard 85 cm
Provenance: Acquired from the State Museum Fund for palaces near Leningrad in 1960; before 1941 it was in the Alexander Palace of Tsarskoe Selo. ЕД-1160-III
Previous Exhibition: St. Petersburg, Cat. 305
From the State Palace Museum, Tsarskoe Selo

The sabre was presented by the officers of the Don Cossack battery to its commander-in-chief, Nicholas II, in 1913. GV

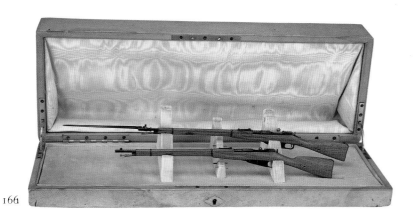

161

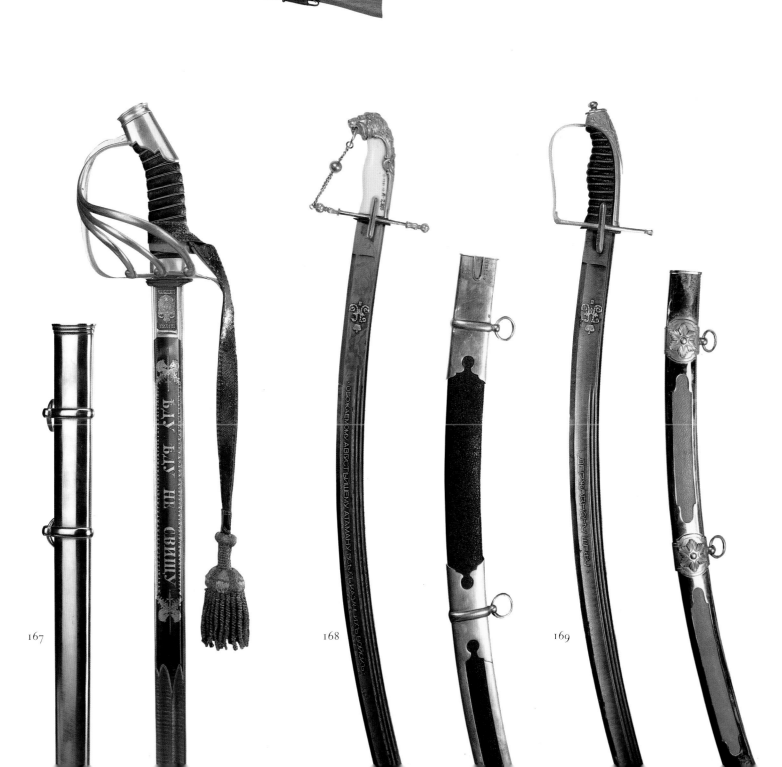

167 168 169

Precious Objects

170 Presentation Dish and Salt Cellar, 1896

Kiev, factory of I. A. Marshak
Marks: *И. А. Маршакъ* [I. A. Marshak]; *С. О. 1896* [S. O. 1896]; *Кiев* [Kiev]
On dish: *отъ Върноподданнаго кiевскаго дворянства* [from the loyal nobility of Kiev];
monogram *H II A* [Nicholas II Alexandrovich]; *августа 1896* [August 1896]
On salt cellar: *Работа Иосифа Маршака Въ Кiев?* [work of Iosif Marshak in Kiev]
The set is decorated with a silver double-headed eagle, a figure of the Archangel
Michael and pseudo-Byzantine ornament.
Labradorite, silver, moulding, repoussé, gilding, carving
Dish: 54.5 × 54.5 × 5 cm; salt cellar: 16.5 × 14 × 14 cm
Provenance: Acquired from the State Museum of Ethnography of the USSR in 1941;
previously in the Diamond Store of the Winter Palace. ЭPO-5428, 3922 a, 6
Previous Exhibitions: Aarhus, 1990, Cat. 73; St. Petersburg, 1994, Cat. 99

In 1878 Iosif Abramovich Marshak founded a gold and silver
artefacts factory in Kiev (extant until 1917). From 1904 he also
owned a shop.

The lid of the salt cellar is crowned with a figure of the Archangel
Michael, the crest of Kiev. The dish and salt cellar were presented
by a delegation of the Kiev aristocracy during Nicholas II's visit
to Kiev on the occasion of the dedication of St. Vladimir's
Cathedral. ко

171 Presentation Dish, 1913

Moscow, workshop of N. F. Strulev
Marks: *HC* [NS: the workshop]; *В. УШТЕРЕР* [V. Ushterer: Moscow assay office]; *84*
On dish: *Его императорскому величеству Государю Императору Николаю
Александровичу отъ древл стольнаго града Владимiра 16 мая 1913 г.* [To His
Imperial Majesty Emperor Nikolai Alexandrovich from the ancient captial city of
Vladimir, 16 May 1913.]
The wooden dish is decorated on the upper side with silver images of the Cap of
Monomakh and a sceptre and orb, and the dates *1813–1913*. There are also inlaid
enamels that show views of the city of Vladimir. In the centre of the dish is the crest
of Vladimir.
Wood, silver, almandine, chrysolites, enamelling, repoussé, painting on enamel
52.5 × 53.5 × 5 cm
Provenance: Acquired in 1956; previously at the Alexander Palace in Tsarskoe Selo.
ЭPO-8679
Previous Exhibition: St. Petersburg, 1994, Cat. 100

Nikolai Feodorovich Strulev owned a silversmith workshop in
Moscow from 1883 to 1910.

The celebrations for the 300th anniversary of the Romanov
dynasty began in St. Petersburg on 20 February 1913 and
continued until the end of May. On 15 May the imperial family
set off on a trip around the old Russian towns with links to the
establishment of the Russian state. The emperor and his family
visited Vladimir, Suzdal, Nizhny Novgorod, Kostroma,
Yaroslavl, Rostov Veliky and Pereslavl. On 24 May they entered
Moscow, where the celebrations were concluded. In every town
the inhabitants welcomed their exalted guests with great
enthusiasm and presented them with bread and salt on dishes

covered with embroidered napkins and other gifts. This dish
was presented by the inhabitants of Vladimir on 16 May 1913.
It is decorated with images of the ancient Vladimir cathedrals of
St. Dmitry and the Uspensky and also the building of the City
Duma. ко

172 Presentation Dish, 1903

Moscow, firm of K. E. Bolin
Marks: *BOLIN; KL* [Master K. Linke]; *ИЛ* [assay inspector Ivan Lebedkin]; *84*
Lilies are carved on the border of the dish. The silver monogram of Emperor
Nicholas II lies under the imperial crown. A silver ribbon is inscribed with
*Его Императорскому величеству государю Императору Николаю II отъ Донского
дворянства 16 августа 1904 г.* [To His Imperial Highness Emperor Nicholas II from
the Don nobility, 16 August 1904]. The state crest is in the centre of the dish.
Wood, silver, carving, moulding, repoussé, gilding
70 × 70 cm
Provenance: Acquired from the State Museum of Ethnography of the USSR in 1941;
previously in the Diamond Store of the Winter Palace. ЭPO-5429
Previous Exhibitions: Stockholm, 1996, p. 107; Stockholm, 1997, Cat. 176

The dish was presented to Nicholas II by a deputation of the
Don aristocracy in a Cossack settlement close to Novocherkassk
on 16 August 1904, where there was a review of the armed forces
before they departed for the Russo-Japanese war.

The Bolin jewellery firm (1796–1916) was based in St. Petersburg
from 1839, and was a supplier to the court of His Imperial
Majesty. A branch of the firm opened in Stockholm in 1816, and
in Moscow in 1852. ко

173 Presentation Dish, 1891

Sakhalin Island. Master unknown
On underside of central applied element, fragmentary inscriptions: *Работа сскатрож
Влад... Алек... нова 1891 года* [Work of convicts. Vlad ... Alex ... nova, 1891]
Carved on underside of dish: *№ 120 5 ф 33 1/4 золот* [No. 120, 5 lb, 33¼ gold]
Applied silver decoration on the dish includes emblems of justice, crafts, arable farming
and mining. There are also applied silver state crests and the inscription: *Островъ,
Сахалин, 1891, года* [Sakhalin Island, 1891]. In the centre of the dish, on a silver mantle
under a crown, is the monogram *HA* [Nikolai Alexandrovich].
Wood, silver, repoussé, engraving, enamelling
45 × 45 cm
Provenance: Acquired from the State Museum of Ethnography of the USSR in 1941;
previously in the Diamond Store of the Winter Palace. ЭPO-5426
Previous Exhibition: St. Petersburg, 1894, Cat. 1252

The dish was presented to the Tsarevich Nikolai Alexandrovich
by exiles in Sakhalin, on his way back from his round-the-world
voyage to the East in 1890–1. ко

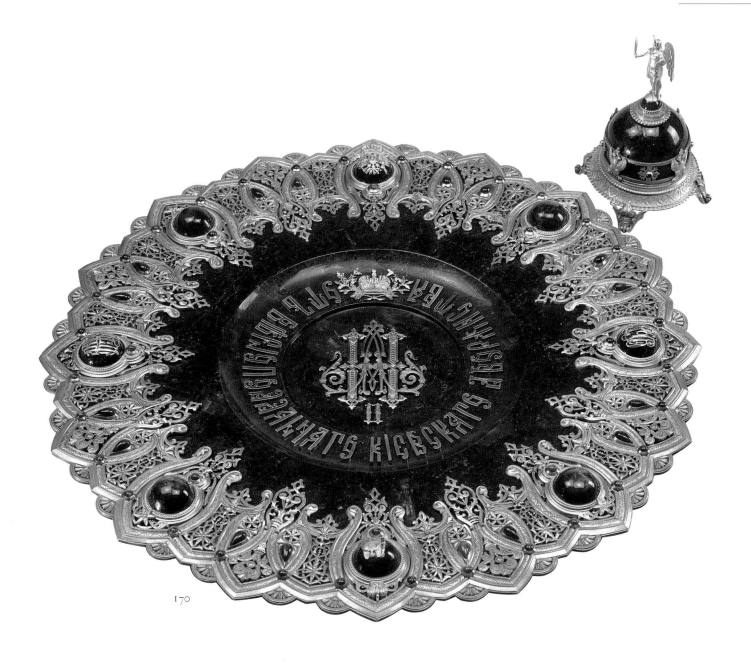

170

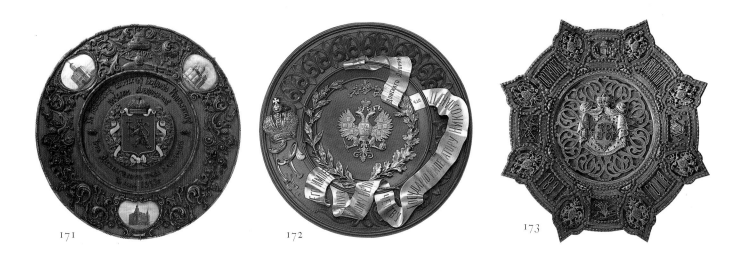

171

172

173

174 Presentation Dish, 1903

St. Petersburg, Master E.A. Kortman
Marks: ЭК [Master E. Kortman]; ЯЛ [Assay inspector Ya. Liapunov]; 1896-1903
Inscription on the dish: Рабочие Невского судостроительного и механического завода 14 августа 1903 года [Workers of the Nevsky shipbuilding and mechanical factory, 14 August 1903]
The state crest is at the top of the dish. At the bottom is a silver plaque engraved with an image of the cruiser Zhemchug. In the centre of the dish is the imperial monogram Н II А [Nicholas II Alexandrovich].
Wood, silver, enamelling, engraving
51 × 49 cm
Provenance: Acquired from the State Museum of Ethnography of the USSR in 1941; previously in the Diamond Store of the Winter Palace. ЭРО-5423
Previous Exhibitions: Hamburg, 1996, Cat. 47; St. Petersburg, 1996, Cat. 206

Edward Ivanovich Kortman owned an engraving and guilloche workshop, as well as a silver and gold workshop in St. Petersburg, at 34 Nevsky Prospect. The workshop produced presentation dishes, addresses, blotting-pads, albums and various types of medals.

The dish was presented to Emperor Nicholas II on the occasion of the Zhemchug's launch. During the Russo-Japanese war of 1904-5 the cruiser took part in the battle of Tsushima. During the First World War it was part of an Allied squadron and escorted merchant ships in the Indian ocean. The cruiser was sunk on 15 October 1914. ко

175 Presentation Salt Cellar, 1890

Moscow, Master P. Ovchinnikov
Marks: П Овчинниковъ [P. Ovchinnikov — master] under crest; А.О./1890 [assay master]; Москвы [Moscow]; 84 [assay]
On the base: ЕГО ИМПЕРАТОРСКОМУ ВЫСОЧЕСТВУ ГОСУДАРЮ НАСЛѢДНИКУ ЦЕСАРЕВИЧУ ВЕЛИКОМУ КНЯЗЮ НИКОЛАЮ АЛЕКСАНДРОВИЧУ от акционернаго общества Б?лор?цкихъ Железнод?лательныхъ заводовъ Пашковых 1891 г. № 335/Ф 3В 1/4з [To His Imperial Highness, Heir to the Throne Grand Duke Nikolai Alexandrovich, from joint-stock company, Beloretsky Pashkov Factories, 1891. No. 335/F 3V 1/4z]. The lid is crowned by a double-headed eagle.
Wood, silver, moulding, carving, repoussé, gilding.
18.5 × 15 × 15 cm
Provenance: Acquired from the State Museum of Ethnography of the USSR in 1941; previously at the Winter Palace. ЭРО-4998 а, б
Previous Exhibitions: St. Petersburg, 1894, Cat. 1119; St. Petersburg, 1994, Cat. 101

Pavel Akimovich Ovchinnikov (1830–88) established a factory in Moscow in 1853, with a branch and a shop in St. Petersburg. It produced numerous table services, vases, presentation dishes, salt-cellars and church plates, decorated with niello, enamel, engraving and repoussé work. From 1885 it was a supplier to the imperial court, and participated in numerous Russian and foreign exhibitions, where its products were awarded high honours. Following the death of P. A. Ovchinnikov, his sons Mikhail and Alexander took over the firm, which existed until 1917.

In 1890–1, in order to complete his education, the Tsarevich Nikolai Alexandrovich undertook a round-the-world voyage to the Far East. This salt cellar was presented to him by Myasnikov, the owner of the Beloretsky Factories, when he was returning from Vladivostok to St. Petersburg via Siberia and the Urals. In the Urals, he visited the Beloretsky Metallurgical Factory close to the city of Verkhneuralsk in the province of Orienburg. The factory was established in 1762 and was one of the oldest metallurgical factories in the Urals. ко

176 Teapot, Sugar Bowl and Cream Jug, Early 20th century

Moscow, Sixth Moscow Jewellers' Artel
Marks: 6МА [Sixth Moscow Artel]; 84 [assay]
The surface of this set is covered with stylised floral ornament in polychrome enamel on metal beading.
Silver, mother of pearl, enamelling, gilding, moulding, beading
Teapot: 11.5 × 18 × 10 cm
Sugar bowl: 11.5 × 17 × 10 cm
Cream jug: 8.3 × 13.5 × 7.5 cm
Provenance: Acquired from the Expert Purchasing Committee of the State Hermitage in 1969. ЭРО-8978, 8979, 8980
Previous Exhibitions: Leningrad, 1981, Cat. 511; St. Petersburg, 1994, Cat. 103
Literature: Russian Enamel, 1987, No. 166

In the early 20th century individual jewellers joined together to form artels (or collectives) to be able to compete with the big firms. There were 20 such artels in all. The Sixth Moscow Jewellers' Artel was established in 1908 and it existed until 1917. Its craftsmen's pieces — usually tea sets, powder boxes and cigar cases — were distinguished by their elegant work and superb quality of enamel. ко

177 Cavalry Guard Helmet, c. 1903

St. Petersburg, firm of Grachev Brothers
Marks: БР. ГРАЧЕВЫ [Grachev Brothers] under crest; 84 [assay]. Inside helmet: Кавалергардскому Ея Величества Государыни Императрицы Марии Феодоровны полку Отъ Великого Князя Андрея Владимировича - 1879 2/V 1904 [To Her Majesty Empress Maria Feodorovna's Cavalry Guard Regiment from Grand Duke Andrei Vladimirovich, 2 May 1879-1904]
Silver, enamelling, moulding, repoussé, engraving.
29.5 × 32 × 19.2 cm
Provenance: Acquired from the State Valuables Depository in 1951. ЭРО-7732
Previous Exhibitions: Leningrad, 1981, Cat. 509; St. Petersburg, 1994, Cat. 106

In the imperial family it was traditional for grand dukes to become commanders-in-chief or officers of guards regiments at birth. Grand Duke Andrei Vladimirovich (1879–1956), son of Grand Duke Vladimir Alexandrovich and cousin of Emperor Nicholas II, was enlisted on 2 May 1879 into the Cavalry Guards. The helmet was presented to the regiment by Andrei Vladimirovich on the 25th anniversary of his enlistment.

In the early 1860s the founder of the Grachev firm, Gavril Petrovich Grachev (1840–73), had a shop in St. Petersburg's 'Silver Row'. In 1866 he opened a workshop producing silver items. Following his death in 1873, his sons, Mikhail, Semeon and Grigory, carried on the business and expanded it; from the 1870s they executed numerous commissions for the imperial family and the courts of the grand dukes. The firm's goods competed successfully with the leading firms of Ovchinnikov, Khlebnikov and Fabergé. In 1892 Grachev Brothers became suppliers to the court of His Imperial Majesty. The firm's goods were exhibited at Russian and international exhibitions, where they won prestigious awards. ко

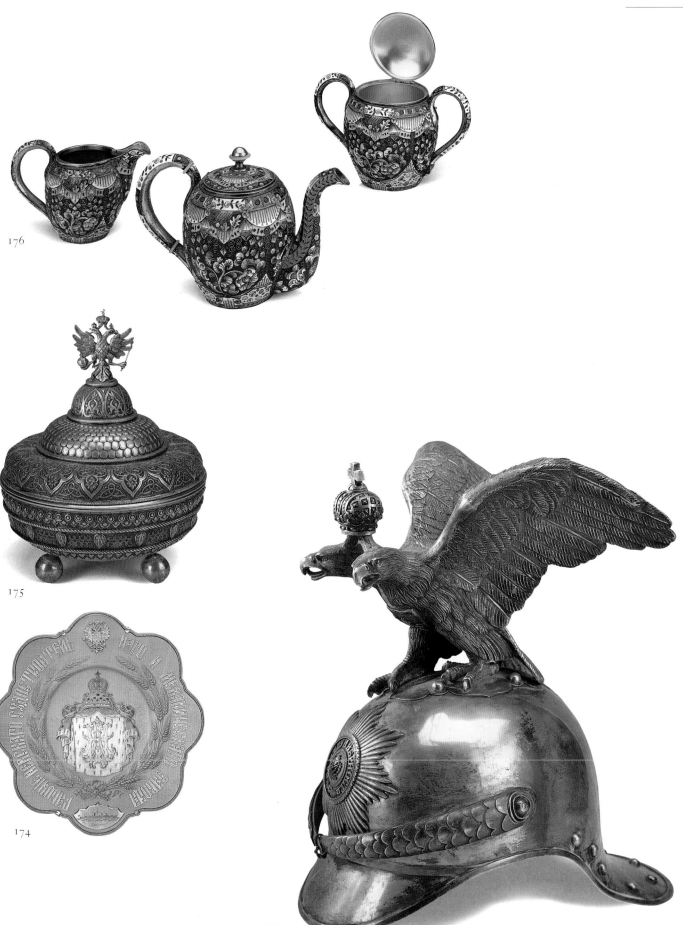

176

175

174

177

178 Scent Bottle, 1900s

St. Petersburg, firm of Fabergé. Master M. E. Perkhin
Marks: *МП* [M. Perkhin]; *ФАБЕРЖЕ* [Fabergé]; 56 [assay]
The bottle is covered with pink enamel over carved ground.
Coloured gold, enamel, rose-cut diamonds, carving
4.5 × 2 × 1 cm
Provenance: Acquired from the Expert Purchasing Committee of the State Hermitage
in 1982. ЭРО-9328
Previous Exhibitions: Limoges, 1988, Cat. 53; Zurich, 1989, Cat. 110; Aarhus, 1990,
Cat. 85; St. Petersburg, 1994, Cat. 107
Literature: Russian Enamel, 1987, No. 151

Mikhail Evlampievich Perkhin (1860–1903) was one of the
leading craftsmen in the firm of Fabergé. In 1884 he was awarded
the title of 'master craftsman'. From 1886 he was the firm's head
jeweller, and one of the major producers of Easter eggs for the
imperial court.

Fabergé is one of the world's most famous names in jewellery. Its
founder, Gustav Fabergé (1814–93), opened a jeweller's workshop
on Bolshaya Morskaya Street in St. Petersburg in 1842. His
successor, Karl Piotr Fabergé (1846–1920), considerably
expanded his father's business. He brought together the finest
master jewellers of the capital at the St. Petersburg branch of the
firm, such as: Erik Kolin, August Holmström, Mikhail Perkhin,
Henryk Wigström and Yuly Rappoport. In 1885 Fabergé was
awarded the title of supplier to the court of His Imperial Majesty.
In 1887 he opened the firm's Moscow branch, followed by shops
in Kiev, Odessa and London.

Karl Fabergé was the imperial family's favourite jeweller. From
the 1860s the firm carried out numerous orders for the court:
cigar cases, cufflinks, brooches, rings. Emperor Alexander III
ordered presents from Fabergé for his wife and children, including
the famous Easter eggs with surprise contents and a magnificent
table service for the heir to the throne. Empress Maria
Feodorovna received Fabergé personally and often ordered
presents for her relatives from the firm's craftsmen. The English
Queen Alexandra (Maria Feodorovna's sister) facilitated the
opening of the firm's London branch and often visited the shop
herself.

Emperor Nicholas II and Alexandra Feodorovna also thought
highly of Karl Fabergé's talents. The firm made diplomatic gifts,
presents for the birth of children both in the royal family and the
families of the grand dukes, as well as jewellery for weddings.
Presents from Fabergé were a part of life for the House of
Romanov from cradle to grave.

Jewellery made by the craftsmen of Fabergé was repeatedly
exhibited at Russian and foreign exhibitions, where it always won
prestigious awards. At the World Fair in Paris in 1900, for
example, Fabergé won the Grand Prix for a copy of the imperial
regalia (no. 208). The firm existed in Russia until 1917. LZ

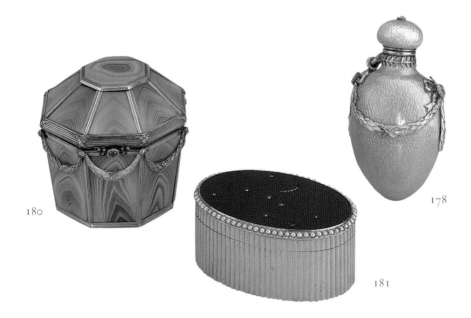

180

181

178

179 Tea Service, 1910s

St. Petersburg, workshop of A. S. Bragin
Marks: *АБ* [A. Bragin]; *84* [assay]
The service consists of a water heater with spirit lamp, a sugar bowl, tea pot,
cream jug and slop-basin.
Silver, wood, gilding, moulding, repoussé, engraving, fluting
Water heater: 40.5 × 24 × 24 cm
Sugar bowl: 13.5 × 15 × 12 cm
Teapot: 17 × 20.5 × 12 cm
Cream jug: 16.2 × 12.5 × 8 cm
Slop-basin: 8.5 × 18 × 18 cm
Provenance: Acquired from the State Museum of Ethnography of the USSR in 1941;
previously in Princess P. N. Shakhovskaya's collection.
ЭРО-4990, 4991, 4992, 4993, 4994
Previous Exhibition: St. Petersburg, 1994, Cat. 99

Andrei Stepanovich Bragin was master of silver work from 1852.
In the early 20th century he owned a silversmith workshop. LZ

180 Toiletries Box, 1900s

St. Petersburg, firm of Fabergé. Master H. Wigström
Marks: *HW* [H. Wigström]; *ФАБЕРЖЕ* [Fabergé]; *AP* [assay inspector]; *56* [assay]
An octagonal, agate box, decorated with garlands of coloured gold.
Agate, rose-cut diamonds, rubies, gold, moulding, repoussé.
4.5 × 4.7 × 4.7 cm
Provenance: Acquired from the Expert Purchasing Committee of the State Hermitage
in 1982. ЭРО-9322
Previous Exhibitions: Munich, 1986, Cat. 260; Zurich, 1989, Cat. 16; Aarhus, 1990,
Cat. 84; St. Petersburg, 1994, Cat. 108

H. E. Wigström (1862–1923) was a craftsman at the firm of
Fabergé; from 1903 he was senior jeweller. Famous for his unique
enamel work, he produced several Easter eggs for the imperial
court. LZ

181 Toiletries Box, Early 20th century

St. Petersburg, firm of Fabergé. Master M. E. Perkhin
Marks: *МП* [M. Perkhin]; *ФАБЕРЖЕ* [Fabergé]; *56* [assay]; *7234* [index number]
An oval, gold box with lapis lazuli inset.
Gold, lapis lazuli, rose-cut diamonds, pearls, moulding, repoussé, carving
2.1 × 5.3 × 3.5 cm
Provenance: Acquired from the Expert Purchasing Committee of the State Hermitage
in 1984. ЭРО-9406
Previous Exhibitions: Munich, 1986, Cat. 257; Zurich, 1989, Cat. 9, pl. 5; Aarhus,
1990, Cat. 83; Stockholm, 1997, Cat. 92
KO

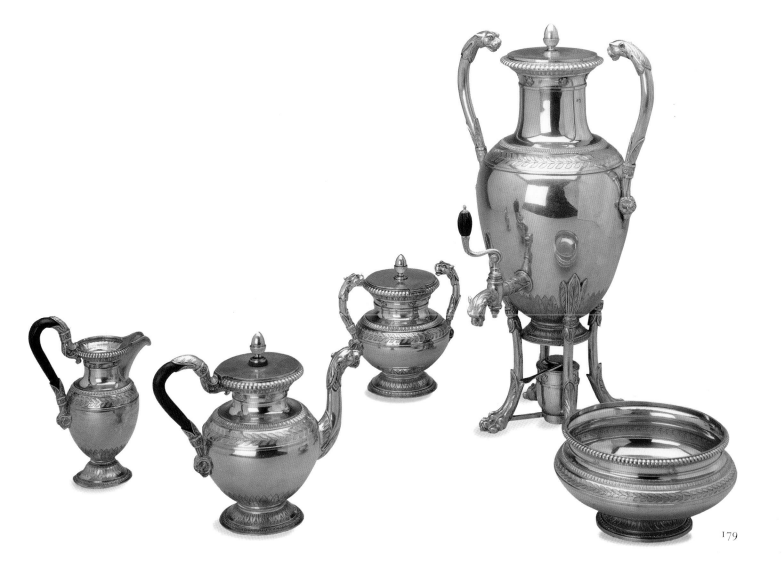

179

182 Photograph Frame, 1890s

St. Petersburg, firm of Fabergé. Master J. V. Aarne
Marks: *B.A.* [V. Aarne]; *ФАБЕРЖЕ* [Fabergé]; *86* [assay]; *58942* [index number]
The frame is in gilded silver, decorated with enamel, and stands on a wooden column.
Wood, gilding, enamelling
16.7 × 5.8 × 5.2 cm
Provenance: Acquired from the State Museum of Ethnography of the USSR in 1941; previously at the palace of Grand Duchess Xenia Alexandrovna in St. Petersburg. ЭРО-6751
Previous Exhibitions: Zurich, 1989, Cat. 88; Aarhus, 1990, Cat. 81; St. Petersburg, 1993, Cat. 64; Paris, 1993, Cat. 64; London, 1994, Cat. 64; Stockholm, 1997, Cat. 118

The photograph shows Grand Duchess Irina Alexandrovna (1895–1970), daughter of Grand Duke Alexander Mikhailovich (1866–1933) and Grand Duchess Xenia Alexandrovna (1875–1960), granddaughter of Emperor Alexander III and niece of Emperor Nicholas II; in 1914 she married Prince Felix Felixovich Yusupov (1887–1967).

Johann Victor Aarne (1863–1934) worked in the firm of Fabergé between 1880 and 1890. From 1891 he owned his own workshop, which he sold in 1904 to Ya. Armfeldt. ко

183 Jug in the Form of a Beaver, Late 19th century

St. Petersburg, firm of Fabergé. Master Yu. A. Rappoport
Marks: *IP* [Yuly Rappoport]; *ФАБЕРЖЕ* [Fabergé]; *88* [assay]
Silver, moulding, repoussé, gilding
23.2 × 15.6 × 25 cm
Provenance: Acquired from the State Museum Fund in 1924. ЭРО-5001
Previous Exhibitions: Leningrad, 1961, Cat. 501; Cologne, 1981–2, Cat. 98; Munich, 1986–7, Cat. 73; Zurich, 1989, Cat. 163, pl. 5; Leningrad, 1990, Cat. 66; Ekaterinburg, 1995, Cat. 296; Stockholm, 1997, Cat. 164

Yuly Alexandrovich Rappoport (1864–1918) achieved fame as a master silversmith at the firm of Fabergé from 1883. He specialised in animal figures. ко

184 Watercolour Frame, c. 1906

St. Petersburg, firm of Fabergé. Master H. Wigström
Marks: *HW* [H. Wigström]; *ФАБЕРЖЕ* [Fabergé]; *AP* [assay inspector]
At top of frame dates and monogram: *1894; 1906; MO*
At bottom inscription: *Михаилу Александровичу Остроградскому на добрую память* [To Mikhail Alexandrovich Ostrogradsky with best wishes]
The frame is decorated with a bow and its surface is covered with enamel.
Gold, diamonds, enamelling, wood, ivory
12.5 × 13.5 cm
Provenance: Acquired from the State Museum of Ethnography of the USSR in 1941; previously in the Art Department of the State Russian Museum. ЭРО-6137
Previous Exhibitions: Leningrad, 1974, Cat. 39; Leningrad, 1981, Cat. 186; St. Petersburg, 1993, Cat. 256; Paris, 1993, Cat. 256; London, 1994, Cat. 256; Stockholm, 1997, Cat. 130

Mikhail Alexandrovich Ostrogradsky was a senior civil servant and manager of the insurance section of the administration of the Ministry of the Interior. From 1908 to 1910 he was an assistant of the Minister for Trade and Industry.

The frame contains a watercolour (late 1880s) depicting Chernyshev Bridge on the left and the building of the Ministry of the Interior and Finance on the right. GP

185 Photograph Frame, 1890s

St. Petersburg, firm of Fabergé. Master M. E. Perkhin
Marks: *М.П.* [M. Perkhin]; *ФАБЕРЖЕ* [Fabergé]; *88* [assay]; *58806* [index number]
Inscription on reverse: *Отъ Ники и Аликс 25 м. 1898 г.* [From Nicky and Alix, 25 May 1898]
This gilded silver, rectangular frame is decorated with enamel and crowned with a laurel leaf and ribbons.
Silver, gilding, enamelling, ivory
14.3 × 7 × 1 cm
Provenance: Acquired from the State Museum of Ethnography of the USSR in 1941; previously at the palace of Grand Duchess Xenia Alexandrovna in St. Petersburg. ЭРО-6761
Previous Exhibitions: Munich, 1986, Cat. 259; Limoges, 1988, Cat. 48; Helsinki, 1990, Cat. 10; Aarhus, 1990, Cat. 80; St. Petersburg, 1993, Cat. 16; Paris, 1993, Cat. 16; London, 1994, Cat. 16; Stockholm, 1997, Cat. 115
Literature: Russian Enamel, 1987, No. 149

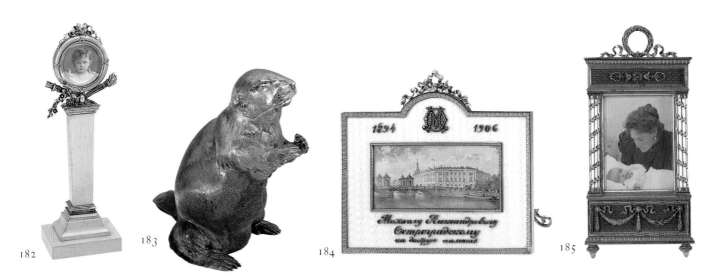

182 183 184 185

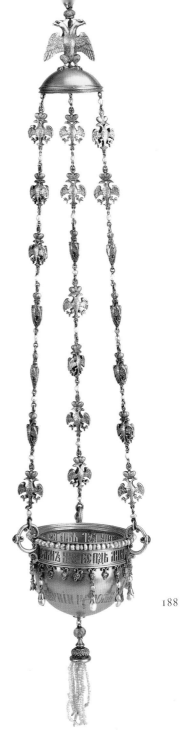

This frame contains a photograph of Empress Alexandra Feodorovna (1872–1918) with her daughter Tatiana (1897–1918).

The frame and photograph were presented by the imperial couple to the emperor's sister, Grand Duchess Xenia Alexandrovna. ко

186 Cigarette Box, 1890s

St. Petersburg, firm of Fabergé. Master M. E. Perkhin
Marks: *М.П.* [M. Perkhin]; *ФАБЕРЖЕ* [Fabergé]; *56* [assay]
The steel, rectangular cigarette box has applied decorations of embossed gold with floral shoots.
Steel, gold, repoussé
2.1 x 9.8 x 6.2 cm
Provenance: Acquired in 1956; previously at Gatchina Palace. ЭРО-8657
Previous Exhibitions: St. Petersburg, 1993, Cat. 6; Paris, 1993, Cat. 6; London, 1994, Cat. 6; Stockholm, 1997, Cat. 97
LZ

187 Photograph Frame, 1896–1907

Moscow, firm of Fabergé
Marks: *К. ФАБЕРЖЕ* [K. Fabergé] under a double-headed eagle;
15307 [index number]
This gilded silver frame is in the form of a round leaf. The stem is finished with a sapphire cabochon.
Silver, gilding, sapphire
6.5 x 6.2 cm
Provenance: Acquired from the State Museum of Ethnography of the USSR in 1941; previously in the collection of the counts Sheremetev in St. Petersburg. ЭРО-6750
Previous Exhibitions: St. Petersburg, 1993, Cat. 236; Paris, 1993, Cat. 236; London, 1994, Cat. 236; Stockholm, 1997, Cat. 121

The child in this photograph is most probably Count Boris Petrovich Sheremetev (born 1901). LZ

188 Icon-Lamp, 1890s

St. Petersburg, firm of Fabergé. Master M. E. Perkhin
Marks: *М.П.* [M. Perkhin]; *ФАБЕРЖЕ* [Fabergé]; *88* [assay]
Carved inscription in Slavonic script on side: *САМЪ ЖЕ ГОСПОДЬ МИРА ДА ДАСТЬ НАМЪ ВСЕГДА ВО ВСЯКОМЪ ОБРАЗЕ* [May the Lord grant you peace in every way]. Carved inscription on body: *ОТЪ ДВОРЯНОКЪ КУРСКО… ГУБЕРНИИ 14 НОЯБРЯ 1894 Г.* [From the nobility of Kursk province, 14 November 1894].
Silver, gilding, rose-cut diamonds, emeralds, sapphires, rubies, pearls, moulding, carving, engraving
9.5 x 9.5 x 9.5 cm; *length* of chain 30 cm
Provenance: Acquired in 1956; previously at the Alexander Palace in Tsarskoe Selo. ЭРО-8809

The icon-lamp hangs from chains linked by double-headed eagles and is richly decorated with precious stones. It was a gift for the wedding of Emperor Nicholas II and Empress Alexandra Feodorovna. LZ

189 Small Nephrite Box, 1890s

St. Petersburg, firm of Fabergé. Master M. E. Perkhin
Marks: *М.П.* [M. Perkhin]; *ФАБЕРЖЕ* [Fabergé]; *56* [assay]
Nephrite, gold, diamonds, enamelling
4.3 x 8.3 x 8.3 cm
Provenance: Acquired from the State Museum Fund in 1996. ЭРО-10059
LZ

188

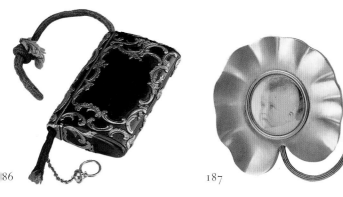

86 187

190 Small Box of Rose Quartz, 1910s

St. Petersburg, firm of Fabergé. Master H. Wigström
Marks: *HW* [H. Wigström]; *ФАБЕРЖЕ* [Fabergé]
Rose quartz, gold, diamonds, enamelling
1.9 × 2.2 × 2.2 cm
Provenance: Acquired from the State Museum Fund in 1996. ЭPO-10060
LZ

191 Table Clock, 1910s

St. Petersburg, workshop of I. S. Britsyn
Marks: *ИБ* [I. Britsyn]; *88* [assay]
Silver, ivory, enamelling, moulding, guilloche-work, engraving
The front of the triangular clock is covered with crimson enamel over guilloche ground; the face is of blue enamel.
9.3 × 9.4 × 2 cm
Provenance: Acquired from the Expert Purchasing Commission of the State Hermitage in 1988. ЭPO-9575
Previous Exhibitions: Limoges, 1988, Cat. 58; St. Petersburg, 1994, Cat. 117

Ivan Savelevich Britsyn (1870–1951) was a St. Petersburg master silversmith. In 1903 he was awarded the title of master craftsman and in the same year opened his own workshop. He was one of the finest enamel craftsmen in St. Petersburg. LZ

192 Icon: The Faithful St. Alexander Nevsky, St. Titus the Miracle-Worker and the Holy Martyr Policarpus, 1879

Moscow. Icon: painted by V. V. Vasiliev; frame: factory of P. A. Ovchinnikov
Marks: *П. Овчинниковъ* [P. Ovchinnikov] under double-headed eagle; *ИК/1879* [unknown assay master]; *84* [assay]
Plaque on frame with inscription: *Сооруженъ усердiемъ и поднесенъ Государю Императору Александру II – И. Ф. Козьминымъ, О. Г. Самсоновой, В. А. Гостеевымъ, П. А. Овчинниковымъ, М. И. Фуковой, Д. А. Петровымъ, М. А. и А. А. Александровыми, Е. И. Сивохинымъ, Академикомъ В. В. Васильевымъ и Колеж. Совет. З. И. Дехтяревымъ* [made with diligence and presented to Emperor Alexander II by I. F. Kozmin, O. G. Samsonova, V. A. Gosteev, P. A. Ovchinnikov, M. I. Fukova, D. A. Petrov, M. A. and A. A. Alexandrov, Academician V. V. Vasiliev and Councillor Z. I. Dekhtiarev]
Wood, tempera, silver, diamonds, pearls, enamelling, beading, repoussé, engraving, fluting, gilding
128 × 85 cm
Provenance: Acquired in 1922 from the Great Church of the Winter Palace where it had been kept since the time of its presentation in 1879. ЭPO-7252
Previous Exhibition: St. Petersburg, 1994, Cat. 118
Literature: K. A. Orlova, 1986, p. 88; Russian Enamel, 1987, No. 128

Vasily Vasilievich Vasiliev (1829–94) was a part-time student at the Academy of Arts. In 1851 he was awarded the title of artist of Historical and Portrait Painting. In 1858 he was made an academician of Byzantine-style painting for his icon *The Mother of God and the Holy Infant.*

This icon of the three saints was presented to Emperor Alexander II to mark his deliverance from an attempt on his life by the terrorist A.K. Soloviev on 2 April 1879. Alexander Nevsky is the patron saint of Alexander II; 2 April is the day the Orthodox Church honours the memory of Sts. Titus and Policarpus. St. Titus (9th century), a holy worker of miracles, monk and ascetic, was famed for his meekness and kindness to all. Policarpus (4th century) was a holy martyr who suffered martyrdom in Alexandria under the Roman Emperor Maximian, ruler of Syria and Egypt and famous for his campaigns against the Christians.

Since its presentation the icon was kept in the Great Church of the Winter Palace (the Church of the Saviour Not-Made-by-Hands). A depiction of the icon may be seen in L. Tuxen's *The Wedding of Emperor Nicholas II and Empress Alexandra Feodorovna* (no. 27). KO

193 Three-Part Folding Icon: Bogoliubskaya Mother of God (centre); Sts. Alexander Nevsky and Mary Magdalene (sides), 1882

Moscow, factory of I. P. Khlebnikov
Marks: *ИХ* [I. Khlebnikov]; *84* [assay]
On silver plaque on reverse: *Дворянство Владимирской губернии* [nobility of Vladimir province]
Wood, silver, tempera, repoussé, polychrome enamelling, beading
54 × 49.2 cm
Provenance: Acquired in 1956; previously at Gatchina Palace. ЭPO-8837
Previous Exhibitions: Limoges, 1988, Cat. 32; Aarhus, 1990, Cat. 95; St. Petersburg, 1994, Cat. 119
Literature: Coronation of Alexander III, 1883, p. 289

Ivan Petrovich Khlebnikov (1818–81) was a Merchant of the First Guild, and from 1849 had a silver goods shop in Moscow. In 1867 he founded a factory in St. Petersburg, which was later transferred to Moscow. From 1873 the factory's craftsmen participated in Russian and international exhibitions, where their work won gold medals, and in 1873 Khlebnikov himself became a supplier to the court of His Imperial Majesty. After his death the factory was managed successfully by his sons, finally closing in 1918.

This folding icon was presented to Alexander III and Empress Maria Feodorovna on the day of their coronation, 14 May 1883. 'The general view of the whole presentation of deputations was most picturesque and noteworthy. The representatives were moved by the most unfeigned and sincere of feelings ... Most of them were carrying bread and salt on dishes of precious materials

190

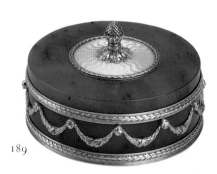

189

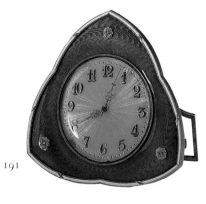

191

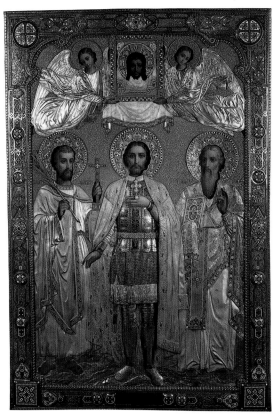

192

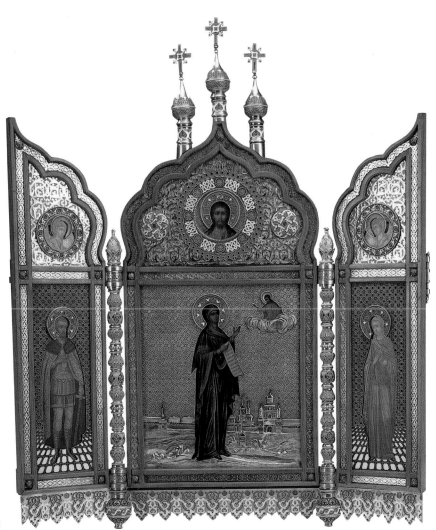

193

and many of them had icons. Two deputations presented albums, and two more (Kolomna and Kharkov) gave intricately decorated chests (an ancient custom). One of the Asian deputations had a device for drinking koumiss [fermented mare's milk]. Two were carrying precious swords. There were so many items presented that they were placed on the window sills for lack of space on the tables. And, of all of them, the most distinguished for its elegance was the expensive folding icon with images of the Bogoliubskaya Mother of God, Alexander Nevsky and Mary Magdalene, in the form of a precise copy of the Cathedral of the Intercession, built in Vladimir by Prince Andrei Bogoliubsky. The folding icon was presented by the Vladimir nobility and is one of Khlebnikov's finest works.' (*In Memory of the Holy Coronation of the Sovereign Emperor Alexander III and the Sovereign Empress Maria Feodorovna*, St. Petersburg, 1883, p. 269.) KO

194 Icon: The Faithful St. Alexander Nevsky, Early 20th century

Moscow, P. I. Olovianishnikov and Sons Ltd. Master K. I. Konov
Marks: *KK* [K. Konov]; *84* [assay].
Wood, silver, tempera, gilding, repoussé, fluting
31.5 × 20.3 cm
Provenance: Acquired in 1956; previously at the Alexander Palace in Tsarskoe Selo. ЭРО-8750
Previous Exhibition: St. Petersburg, 1994, Cat. 120

Kuzma Ivanovich Konov was a master silversmith in Moscow from 1891 to 1917, working for P. I. Olovianishnikov and Sons Ltd.

Alexander Yaroslavich (1220–63), Great Prince of Vladimir and Prince of Novgorod and Tver, was a general and diplomat. In 1240 he inflicted a crushing defeat on Swedish forces on the river Neva, for which he was awarded the title 'Nevsky'. In the mid 16th century he was canonised by the Orthodox Church and — as patron saint of St. Petersburg — is one of Russia's most revered warrior saints. LZ

195 Icon: Ioasaf of Belgorod, 1911

Moscow. Icon-painter: K. Emelianov; frame: factory of I. P. Khlebnikov
Marks: *ХЛЕБНИКОВЪ* [Khlebnikov] under crest; *84* [assay]
Bottom right: *писалъ К. Емельяновъ 1911* [painted by K. Emelianov, 1911]
Wood, oil, mica, brocade, silver, filigree
31 × 26.6 cm
Provenance: Acquired in 1956; previously at the Alexander Palace in Tsarskoe Selo. ЭРО-8761
Previous Exhibition: St. Petersburg, 1994, Cat. 121

St. Ioasaf (Gorlenko) (1705–54) was bishop of Belgorod and Kharkov from 1748. He is shown against the background of the Holy Trinity Monastery in Belgorod, with an image of Christ in the upper left. The lower section of the frame contains St. Ioasaf's holy relics.

The icon was painted for the celebrations marking the official canonisation of Ioasaf of Belgorod, which took place in September 1911. KO

196 Two-Part Icon: The Chosen Saints, 1912

Moscow, workshop of D. L. Smirnov
Marks: *Д. СМИРНОВЪ* [D. Smirnov]; *84* [assay]
In blue enamel on two plaques on the front are the words from a prayer of gratitude to Emperor Nicholas II; on a silver plaque on the reverse, the inscription: *ЕГО ИМПЕРАТОРСКОМУ ВЕЛИЧЕСТВУ ГОСУДАРЮ ИМПЕРАТОРУ НИКОЛАЮ АЛЕКСАНДРОВИЧУ МОЛИТВЕННОЕ ПРИНОШЕНИЕ МОСКОВСКОГО МАСТЕРА СЕРЕБРЯН. ИЗДЕЛИ… Д. СМИРНОВА 29 МАЯ 1912 Г.* [To His Imperial Majesty Emperor Nikolai Alexandrovich a gift of prayer from Moscow master of silver work D. Smirnov, 29 May 1912]
Wood, silver, chrysolites, tempera, enamelling, gilding, moulding, repoussé, fluting
24.8 × 18.7 cm
Provenance: Acquired in 1956; previously at the Alexander Palace in Tsarskoe Selo. ЭРО-8751
Previous Exhibition: St. Petersburg, 1994, Cat. 122

The icon of the chosen saints was presented by master silversmith Smirnov on 29 May 1912 while the imperial family was in Moscow. The upper part of the icon depicts the patrons and intercessors of the imperial children: the saints Mary Magdalene, Princess Olga, Metropolitan Alexy, Tatiana and Anastasia. The lower section depicts the patron saints of the emperor and empress: St. Nicholas the Miracle-Worker and the St. Tsarina Alexandra.

In late May 1912 the imperial family set out for Moscow for the unveiling of a monument to Alexander III. The monument was built to the design of the sculptor A. M. Opekushin and was erected on the square in front of the Cathedral of Christ the Saviour. The colossal figure of the emperor on a throne in full coronation regalia was almost 10 metres tall. The ceremonial dedication of the monument took place on 30 May 1912 in the presence of Emperor Nicholas II, Empress Maria Feodorovna, Empress Alexandra Feodorovna, Tsarevich Alexei Nikolaevich, the grand duchesses Olga, Tatiana, Maria and Anastasia, and the senior Russian clergy. LZ

197 Icon: The Feodorovskaya Mother of God with attendant Sts. Michael, Tsarina Alexandra, Metropolitan Alexy, and Nicholas the Miracle-Worker, 1913

Moscow. Icon: painted by V. P. Gurianov; frame: workshop of D. L. Smirnov
Marks: *Д. СМИРНОВЪ* [D. Smirnov]
Bottom right: *1913 ГОД ПИСАЛЪ СЕ… ОБРАЗЪ В.П. ГУРЬАНОВЪ* [V. P. Gurianov painted this icon in 1913]
Wood, silk, silver, tempera, enamelling, beading
35.5 × 31.2 cm
Provenance: Acquired from the State Museum Fund of Palaces near Leningrad in 1956; previously at the Alexander Palace in Tsarskoe Selo. ЭРО-8753
Previous Exhibitions: Leningrad, 1990, Cat. 227; St. Petersburg, 1994, Cat. 123

Vasily Pavlovich Gurianov was an icon-painter with a large workshop in Moscow; he was also a supplier to the court of His Imperial Majesty. Gurianov created icons for many cathedrals and churches in Russia, including churches in the village of Feodorovskoe at Tsarskoe Selo. Dmitry Lukich Smirnov owned a silver workshop in Moscow from 1883, and fulfilled a number of commissions for V. P. Gurianov's icon-painting workshop.

The Feodorovskaya Mother of God icon was highly revered by the Romanov family. According to tradition, the original icon was found in 1239 by Vasily Kvashnya, Prince of Kostroma, while out hunting. The name was taken from the place it was first found, in the Church of St. Feodor Stratilates in Kostroma. Its present location is unknown.

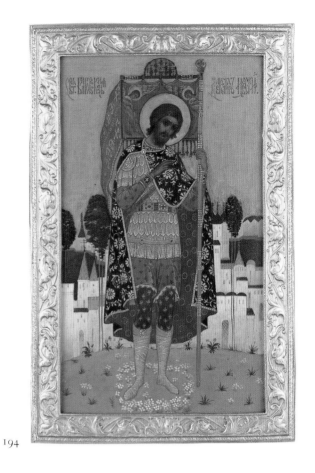

194

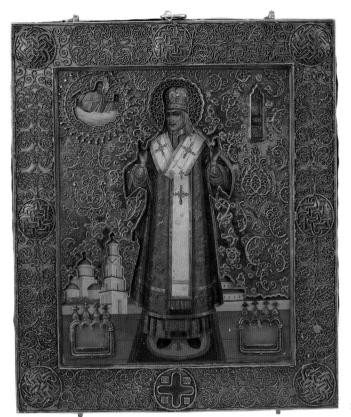

195

196

197

Sts. Michael, Alexandra, Alexy and Nicholas are depicted against the background of the Uspensky Cathedral in the Kremlin, where all the tsars of the Romanov dynasty were crowned. St. Michael was the patron saint of the first Romanov tsar, Mikhail Feodorovich; Sts. Tsarina Alexandra and Nicholas the Miracle-Worker were the patron saints of the ruling royal couple; and the holy Metropolitan Alexy was the heavenly defender and intercessor of the heir to the throne, Tsarevich Alexei. This group of saints thus symbolised the legitimacy and continuity of succession of Romanov rule. The icon was commissioned for the 300th anniversary of the house of Romanov, which was sumptuously celebrated in 1913. LZ

198 Altar Gospels, 1893

Moscow, factory of F. A. Ovchinnikov
Marks: Ф. ОВЧИННИКОВЪ [F. Ovchinnikov]; 84 [assay]
On the front, enamel plaques with images of the four evangelists and scenes of the Resurrection; on the reverse, a Crucifixion and the instruments of the Passion
Paper, printing, silver, enamelling, beadwork, gilding, painting on enamel
10 × 47.3 × 36.5 cm
Provenance: Acquired from the State Museum of Ethnography of the USSR in 1941. ЭРО-5705
Previous Exhibitions: Aarhus, 1990, Cat. 96; St. Petersburg, 1994, Cat. 124

Feodor Alexeevich Ovchinnikov owned a gold, silver and bronze factory, which he founded in Moscow in 1881. The factory principally produced articles for church use. Following the death of F. A. Ovchinnikov, it was bought from his heirs by the sons of P. A. Ovchinnikov, who were suppliers to the court of His Imperial Majesty. KO

199 Altar Gospels, 1911

Moscow, P. I. Olovianishnikov and Sons Ltd. Master K. I. Konov
Marks: О.С.ей [Olovianishnikov and Sons]; 84 [assay]
On the front cover, images of Christ with attendant figures and gathering of Russian orthodox saints; in filigree gilded silver frame with a silver filigree cross on the reverse.
Paper, velvet, silver, amethysts, gilding, filigree
6.2 × 19 × 15 cm
Provenance: Acquired in 1956; previously at the Alexander Palace in Tsarskoe Selo. ЭРО-8827
Previous Exhibition: St. Petersburg, 1994, Cat. 125

In late August 1911 Emperor Nicholas II arrived in Kiev. On 30 August he attended the dedication of a monument to his grandfather Emperor Alexander II, erected in honour of the 50th anniversary of the emancipation of the serfs. On the same day Nicholas II visited the Kievo-Pecherskaya Monastery, where the monks presented him with these Gospels. LZ

200 Cross, 1912

Moscow, P.I. Olovianishnikov and Sons Ltd. Master K.I. Konov
Marks: Т-ВО ОЛОВЯНИШНИКОВА О.С.ей [Olovianishnikov and Sons Ltd]; 84 [assay]
Inscription: ДАРЪ БЕССАРАБСКОГО ДУХОВЕНСТВА КИШИНЕВСКОМУ КАФЕДРАЛЬНОМУ СОБОРУ ВЪ 1912 Г. В ПАМЯТЬ СТОЛЕТИЯ ПРИСОЕДИНЕНИЯ БЕССАРАБИИ К РОССИИ [Gift of the Bessarabian clergy to Kishinev Cathedral in 1912, to commemorate the 100th anniversary of the union of Bessarabia and Russia]
Wood, tempera, mica, aquamarine, amethysts, rhodonite, silver, enamelling, beading, moulding, carving
38 × 18.3 × 2 cm
Provenance: Acquired from the State Valuables Depository in 1951. ЭРО-7729
Previous Exhibitions: Aarhus, 1990, Cat. 101; St. Petersburg, 1994, Cat. 126

This magnificent cross, produced at the jewellery factory of P. I. Olovianishnikov and Sons to a design by S. Vashkov, was presented by the Bessarabian clergy to Kishinev Cathedral in 1912.

After the Russo-Turkish war of 1806–12, under the terms of the Treaty of Bucharest, the territory of Bessarabia was annexed to the Russian empire. On 16 May 1912, the 100th anniversary of that event was celebrated in Kishinev. LZ

201 Chalice and Paten, 1901

Moscow, workshop of A. I. Kuzmichev
Marks: AK [A. Kuzmichev]; 58 [assay]
On base of chalice: Сей сосудъ с приборомъ из золота пожертвованъ в Зосимову пустынь наместникомъ Троице-Сергиевой Лавры Архимандритомъ Павломъ 1901 года 25-го декабря [This gold vessel and paten was given to the Zosimov monastery by the head of the Troitse-Sergiev monastery Archimendrite Pavel, 25 December 1901]
On the cup of the chalice, images of the Deisus and Christ Pantocrator, and a liturgical inscription. On the base of the paten, images of the Magi bearing gifts to the infant Jesus; on the side, liturgical inscription.
Gold, diamonds, rubies, emeralds, moulding, repoussé, carving, engraving
Chalice: 30.5 × 14.3 × 19.9 cm; paten: 11.5 × 21.5 × 21.5 cm
Provenance: Acquired from the State Valuables Depository in 1951. ЭРО-8187, 8188
Previous Exhibitions: Leningrad, 1981, Cat. 557, 554; Aarhus, 1990, Cat. 100 (chalice); St. Petersburg, 1994, Cat. 127

Antip Ivanovich Kuzmichev was the owner of a gold, silver and bronze artefacts factory, which he founded in Moscow in 1856. LZ

202 Censer, Early 20th century

St. Petersburg, workshop of A. N. Sokolov
Marks: AC [A. Sokolov]; 84 [assay]
Silver, gilding, moulding, filigree, fluting
Spherical base surmounted by a cross on three legs; surface covered with filigree casing.
23.5 × 9.5 × 9.5 cm; length of chain 66 cm
Provenance: Acquired from the State Museum of Ethnography of the USSR in 1941. ЭРО-5666
Previous Exhibition: St. Petersburg, 1994, Cat. 128

Alexander Nikolaevich Sokolov was a master silversmith in St. Petersburg from 1850. In 1867 he became a Merchant of the Second Guild and the owner of a silver and bronze artefacts workshop, located in Leshtukov Lane in St. Petersburg. In the 1880s he had a bronze artefacts shop on Nevsky Prospect. Sokolov's workshop was well known until the early 20th century.

The censer is made in the style of traditional Russian jewellery work of the 17th century. LZ

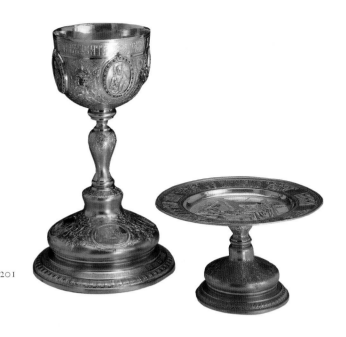

201

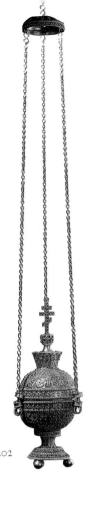

202

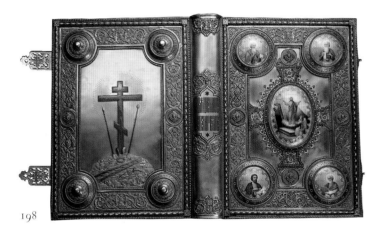

198

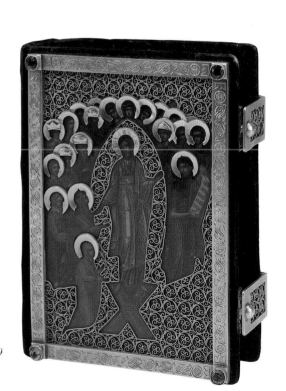

199

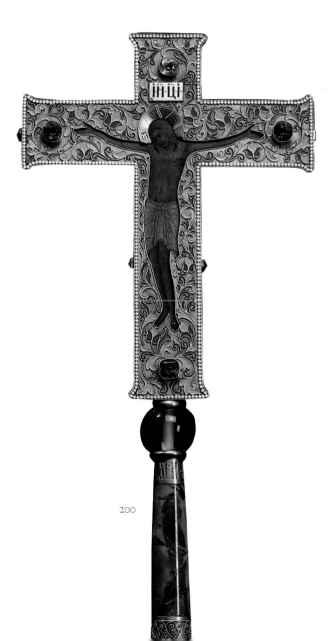

200

203 Icon Lamp, 1890s

Moscow, workshop of N. V. Alexeev. Master A. A. Alexandrov
Marks: *HA* [N. Alexeev]; *AA* [A. Alexandrov]; *88* [assay]
Silver, enamelling, gilding, carving, fluting
11 × 11 × 11 cm; *length* of chain 95 cm
Provenance: Acquired from the State Museum of Ethnography of the USSR in 1941.
ЭРО-5663
Previous Exhibitions: Leningrad, 1981, Cat. 496; Aarhus, 1990, Cat. 99; St. Petersburg, 1994, Cat. 129

Andrei Andreevich Alexandrov was a master silversmith and niello craftsman in Moscow from 1879 to 1917. Nikolai Vasilievich Alexeev owned a silver and enamel workshop in Moscow which existed from the 1880s to the 1900s. He exhibited his enamel work at the Industry and Arts Exhibition in 1896 in Nizhny Novgorod. LZ

204 Easter Egg, 1910s

Moscow, Stroganov School of Technical Drawing
Marks: *ИСУ* [metal workshops of Stroganov school]; *84* [assay]
Suspended wooden egg in silver filigree case with tassel of mother-of-pearl beads. Crowned with a double-headed eagle. On the body, four oval medallions with images of Christ, the Virgin Mary, John the Baptist and the Crucifixion.
Wood, silver, mother-of-pearl, metal, tempera, moulding, repoussé
20.8 × 11 × 11 cm
Provenance: Acquired in 1956; previously at the Alexander Palace in Tsarskoe Selo.
ЭРО-8811
Previous Exhibition: St. Petersburg, 1994, Cat. 130

In the early 20th century a special metal workshop was set up at the Stroganov school, with its own trademark.

According to tradition, the custom of giving coloured eggs at Easter goes back to Mary Magdalene, who presented a red egg to the Roman emperor Tiberius as a sign of the resurrection of Christ. Subsequently, Easter eggs symbolising the resurrection of Christ were made of the most varied materials: gold, silver, semi-precious stones, porcelain, glass, papier-mâché, and wood. Large Easter eggs were hung beneath the most revered icons in church. LZ

205 Easter Egg, Early 20th century

Moscow, Stroganov School of Technical Drawing
Marks: *ИСУ* [metal workshops of Stroganov school]
Suspended egg, crowned with a double-headed eagle. On the body, oval medallions with repoussé images of St. George and the Ascension of Christ
Silver, gilding, repoussé
26 × 15 × 15 cm
Provenance: Acquired in 1956; previously at the Alexander Palace in Tsarskoe Selo.
ЭРО-8812
Previous Exhibition: St. Petersburg, 1994, Cat. 131

LZ

206 Steel Hammer with Ivory Handle, 1896

France, Paris. Master Lucien Falise
On side faces of hammer: *PAS ROBVR*; on handle the letters *RF* (République Française);
N (Nicolas)
Signed: *L. Falise of Paris*
Gold, steel, ivory; carving, gilding
Length 33.6 cm
Provenance: Donated by Nicholas II to the Hermitage Museum on 20 January 1902.
Э-4746
Previous Exhibitions: Paris, World Fair, 1900, p. 50-1, ill. 45; Leningrad, 1974, Cat. 68; St. Petersburg, 1994, Cat. 322

The hammer was a gift from the President of the Republic of France, Félix Faure, to Emperor Nicholas II at the laying of the foundation stone of the Alexander III bridge in Paris on 4 October 1896.

An additional hammer and a gold trowel with an ivory handle were made for the same ceremony, both bearing inscriptions explaining their purpose. All of the items were exhibited at the 1900 World Fair in Paris. ML

207 Celebratory Address, 1896

France, E. Bastanier. Active during the second half of the 19th century
Inscription at bottom: *E. Bestanier, 1896.* On title page of the address: *A LEUR MAJESTES IMPERIALES L'EMPEREUR NICOLAS II L'IMPERATRICE ALEXANDRA FEODOROVNA Au moment où la Russie toute entière fête avec tant d'éclat et d'amour le Couronnement et le Sacre de Leurs MAJESTES IMPERIALES la Colonie française de St. Petersbourg solicite humblement la permission de joindre ses voeux a ceux que forme le peuple Russie pour la grandeur et la prospérité du règne de SA MAJESTE L'EMPEREUR NICOLAS II et de déposer aux pieds de Leurs MAJESTES IMPERIALES l'expression de ses hommages les plus respecteux.* [To Their Imperial Majesties Emperor Nicholas II and Empress Alexandra Feodorovna. At this time when all Russia is celebrating with such magnificence and such love the coronation of Their Imperial Majesties, the French colony in St. Petersburg humbly begs permission to join with the Russian people in wishing His Majesty Emperor Nicholas II greatness and prosperity in his reign, and to place at the feet of Their Imperial Majesties the expression of their most sincere respect]
In leather binding, with gold monogram under an imperial crown, consisting of the interwoven initials of Nicholas II and Alexandra Feodorovna.
45 × 32.5 cm
Provenance: From the original Winter Palace Collection. Э-9703
Previous Exhibition: St. Petersburg, 1994, Cat. 323

This celebratory address with the monograms of Nicholas II and Alexandra Feodorovna was presented to the tsar during his coronation in 1896 on behalf of the French inhabitants of St. Petersburg. It consists of 18 pages, each of which bears the names of 30 members of the French colony of St. Petersburg. The front cover is decorated with applied metal relief work painted in enamel with images of two female figures symbolising Russia and France. OK

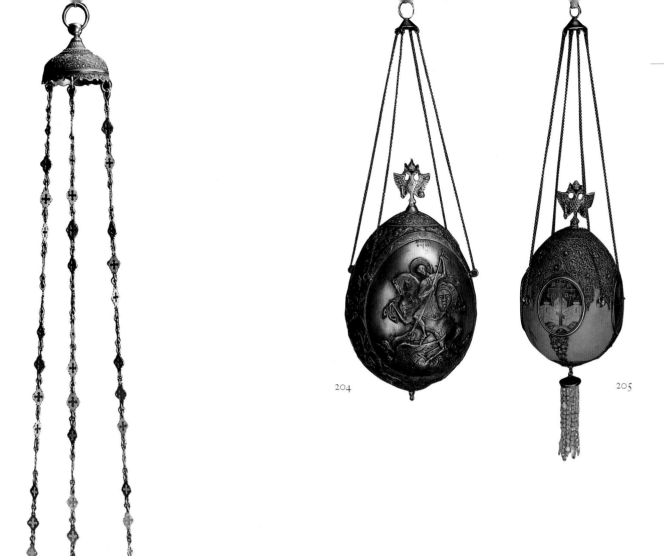

203

204

205

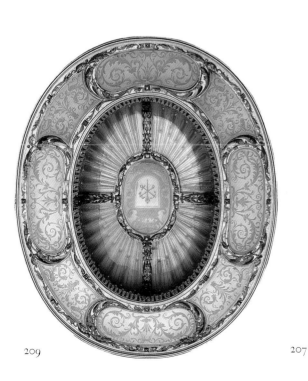

209

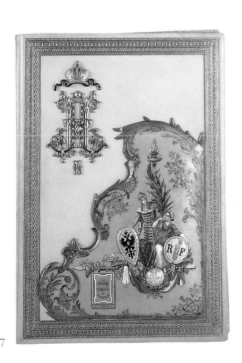

207

208 Miniature Copy of Imperial Regalia, 1899–1900

St. Petersburg, firm of Fabergé. Masters Yuly Rappoport, August Holmström
Marks of the firm of Fabergé, master Yuly Rappoport, St. Petersburg 1899–1900; *88*
[assay]
Gold, silver, platinum, diamonds, oxides, pearls, sapphires, velvet, rose quartzite
On base of large crown: *К. Фаберже* [K. Fabergé]
Crowns: (large) 7.3 × 5.4 cm, (small) 3.8 × 2.9 cm; orb: 3.8 × 4.4 cm; sceptre: 15.8 cm
Provenance: Acquired in 1901 after the World Fair of 1900 in Paris. Э-4745
Previous Exhibitions: Memphis, 1991–2, p. 135; St. Petersburg, 1993, Cat. 113; St.
Petersburg, 1994, Cat. 116
Literature: Liven, 1901, p. 154; Harlow, 1997, p. 179–80

Yuly Alexandrovich Rappoport (1864–1916) was famous from
1883 as a master silversmith, working in the firm of Fabergé.
August Wilhelm Holmström (1829–1903) was also a master
craftsman at Fabergé, specialising in jewellery items.

Copies of the imperial regalia were made for the 1900 World Fair
in Paris and soon afterwards they were purchased by Nicholas II.
Since 1901 they have been kept in the Hermitage; in 1911 they
were transferred to the museum's new Jewellery Gallery. The
following year the court jeweller Agathon Fabergé described the
work as follows: 'A large crown consisting of 1,083 diamonds and
245 uncut rose diamonds. A small crown made of 180 diamonds
and 1,204 uncut rose diamonds. Orb: 65 diamonds and 654 uncut
rose diamonds. Sceptre: single diamond and 125 uncut rose
diamonds.' OK

209 Dish with the Crest of St. Petersburg, 1896

St. Petersburg, firm of Fabergé. Master Mikhail Perkhin
Marks of St. Petersburg, firm of Fabergé, master M. Perkhin; *88* [assay]
On the reverse an inscription: *От дворянства С. Петербургской губернии 1896*
[from the nobility of St. Petersburg province, 1896]
Silver, diamonds, rock crystal, enamelling, engraving, gilding
40 × 34 cm
Provenance: Acquired from the Diamond Store of the Winter Palace on 15 June
1922. Э-6388
Previous Exhibitions: Lugano, 1986, Cat. 118; Munich, 1987, Cat. 282; Zurich, 1989,
Cat. 22; Leningrad, 1989, Cat. 42; St. Petersburg, 1993, Cat. 111; Paris, 1993, Cat. 111;
London, 1994, Cat. 111
Literature: Lopato, 1984, pp. 43–9

The dish was presented by the nobility of St. Petersburg on the
occasion of Nicholas II's coronation on 14 May 1896. In making
the dish, Mikhail Perkhin drew on late Renaissance examples of
jewellery made of rock crystal. There is a similar dish in the
Kunsthistorisches Museum in Vienna. OK

210 Small Gold Box with Enamel and Precious Stones, 1890s

St. Petersburg, firm of Fabergé. Master Mikhail Perkhin
Marks of the firm of Fabergé, master Mikhail Perkhin, St. Petersburg; *56* [assay];
47449 [index number]
Gold, enamelling, diamonds, rubies, sapphire
2.8 × 2.3 × 2.2 cm
Provenance: Transferred from Grand Duke Alexei Alexandrovich's collection in St.
Petersburg in 1908. Э-307
Previous Exhibitions: Leningrad, 1989, Cat. 52; St. Petersburg, 1993, Cat. 66; Paris,
1993, Cat. 66; London, 1994, Cat. 66; Stockholm, 1997, Cat. 86

Mounted in the lid of this small box is a rectangular sapphire,
faceted along its edges and decorated with a gold floral
application of diamonds and rubies. The sides are coated in
thick white enamel with decorations of flowers composed of ruby
cabochons.

Until 1908 the box was in the collection of Grand Duke Alexei
Alexandrovich (1850–1908), the fourth son of Alexander II, and
the favourite brother of Alexander III. He was commander of the
fleet and head of the Naval department (1881–1905). In the
transfer listing of the grand duke's collection the box is described
thus: 'No. 31. Gold bonbonnière, white enamel in the Indian
style, with pale sapphire, encrusted with gold, made by Fabergé.
600 roubles.' OK

211 Kovsh-Cup in the Form of an Elephant's Head,
Early 20th century

St. Petersburg, firm of Fabergé
Obsidian, rose-cut diamonds, carving
4.5 × 9.1 × 5.5 cm
Provenance: Acquired from the State Valuables Depository in 1951. Э-17154
Previous Exhibitions: Lugano, 1986, Cat. 129; Munich, 1986-7, Cat. 261; Zurich, 1989,
Cat. 160; Stockholm, 1997, Cat. 162
LY

211 212

212 Box in the Form of a Shell, Late 19th century

St. Petersburg, firm of Fabergé. Master Mikhail Perkhin
Marks of St. Petersburg, the firm of Fabergé, master M. Perkhin; *58* [assay]
Nephrite, gold, rose diamonds, rubies, carving, repoussé
6.3 × 6.1 × 3.0 cm
Provenance: Acquired from the State Valuables Depository in 1951. Э-17151
Previous Exhibitions: Lugano, 1986, Cat. 122; Leningrad, 1989, Cat. 50; Stockholm,
1997, Cat. 84
LY

213 Box in the Form of a Tub, Late 19th century

St. Petersburg, firm of Fabergé
Nephrite, gold, rose-cut diamonds, carving
2.8 × 7.1 × 5.2 cm
Provenance: Acquired from the State Valuables Depository in 1951. Э-17152
Previous Exhibitions: Lugano, 1986, Cat. 128; Zurich, 1989, Cat. 26; Stockholm, 1997,
Cat. 171
LY

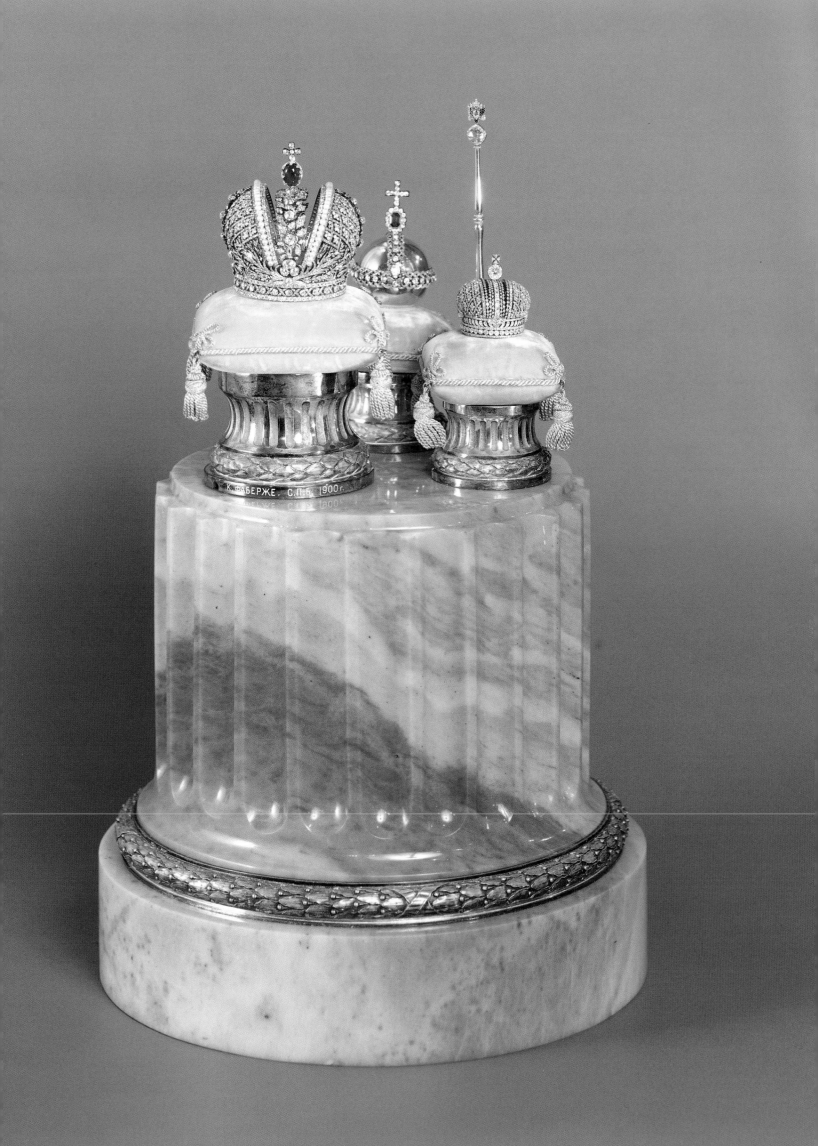

214 Compass, Early 20th century

St. Petersburg, firm of Fabergé. Master Mikhail Perkhin
Marks of the firm of Fabergé, master M. Perkhin; 56 [assay]
Gold, rose-cut diamonds, enamelling, repoussé, guilloche-work
Diam. 3.7 cm, *length* 3.7 cm
Provenance: Acquired from the State Valuables Depository in 1951. Э-17145
Previous Exhibitions: Munich, 1986–7, Cat. 492; Zurich, 1989, Cat. 110; Stockholm, 1997, Cat. 153
LY

215 Box in the Form of a Fan, Late 19th century

St. Petersburg, firm of Fabergé. Master Mikhail Perkhin
Marks of St. Petersburg, firm of Fabergé, master M. Perkhin; 72 [assay]
Gold, enamelling, rose-cut diamonds, rock crystal, guilloche-work
Height 1.2 cm, *length* 1.2 cm
Provenance: Acquired from the State Valuables Depository in 1951. Э-15729
Previous Exhibitions: Munich, 1986–7, Cat. 507A; Zurich, 1989, Cat. 8; Leningrad, 1989, Cat. 49; Stockholm, 1997, Cat. 84
Literature: Lopato, 1984, p. 49
LY

216 Small Display-Case, 1900s

St. Petersburg, firm of Fabergé. Master Mikhail Perkhin
Marks of St. Petersburg, the firm of Fabergé, master M. Perkhin; 56 [assay]
Agate, gold, moulding, repoussé, engraving
7.5 × 4.9 × 7.0 cm
Provenance: Acquired from the Expert Purchasing Commission in 1948. Э-15603
Previous Exhibitions: Lugano, 1986, Cat. 127; Munich, 1986–7, Cat. 256; Zurich, 1989, Cat. 11; Leningrad, 1989, Cat. 44; Stockholm, 1997, Cat. 154
Literature: Lopato, 1984, pp. 43–9
LY

217 Vase for Flowers, 1800s

St. Petersburg, firm of Fabergé. Master Yuly Rappoport
Marks of St. Petersburg, the firm of Fabergé, master Yu. Rappoport
Smoke-coloured quartz, silver, carving, moulding, repoussé, gilding
Height 37 cm
Provenance: Acquired from the Winter Palace Collection in 1931. Э-17576
Previous Exhibitions: Leningrad, 1974, Cat. 23; Lugano, 1986, Cat. 120; Munich, 1986–7, Cat. 281; Zurich, 1989, Cat. 33; Leningrad, 1989, Cat. 65; St. Petersburg, 1993 Cat. 55; Paris, 1993, Cat. 55; London, 1994, Cat. 55
Literature: Lopato, 1984, p. 44
LY

217 218 219

218 Bilberry Twig in a Vase, 1880s

St. Petersburg, firm of Fabergé
Gold, nephrite, lapis lazuli, rock crystal, moulding, carving, repoussé
Height 14.2 cm
Provenance: Acquired from the collection of A. K. Rudanovsky in St. Petersburg in 1919. Э-14893
Previous Exhibitions: Leningrad, 1974, Cat. 21; Lugano, 1986, Cat. 117; Munich, 1986–7, Cat. 390; Zurich, 1989, Cat. 188; Stockholm, 1997, Cat. 16

This piece is very similar to the Whortleberry Twig in a Vase, made of chalcedony, which is ascribed to Fabergé and is in the Cleveland Art Museum. LY

219 Orchid in a Vase, 1900s

France, Paris
Mark: *Paris 1847–1919* (head of an eagle)
Gold, diamonds, coloured enamelling, jasper, rock crystal, moulding, carving
Height 17.5 cm
Provenance: Acquired from the collection of A.K. Rudanovsky in St. Petersburg in 1919. Э-14892
Previous Exhibitions: Leningrad, 1974, Cat. 47; Lugano, 1986, Cat. 154

Table decorations in the form of bouquets and separately standing flowers in little vases of rock crystal were popular in the late 19th century. Many well-known jewellery firms, such as Fabergé and Cartier, executed orders for such items, using small and precious stones in combination with gold and coloured enamel. In the 1900s jewellery artefacts with similar enamel work were produced by the firm Duval et le Turc. LY

220 Pair of Candelabra in the Form of a Bird on a Stand, Late 19th century

Thailand, Bangkok
Silver, gilding, engraving, niello
Height 45 cm
Provenance: From the private apartments of Nicholas II at the Winter Palace. ИС-313, 314
Previous Exhibitions: St. Petersburg, 1894, Cat. 196; St. Petersburg, 1994, Cat. 337; St. Petersburg, 1997, Cat. 121

The two candelabra were brought back by the Tsarevich Nikolai Alexandrovich from his trip to the Far East in 1890–1. They were presented to him among other gifts (including no. 221) by King Rama the Fifth, Chulalongkorn, when the tsarevich visited Siam. Made specially for the Russian heir's visit, the candelabra combine a typically European high candlestick form with the Siamese tradition of incorporating the figures of birds in the design. OD

221 Table Decoration, Late 19th century

Thailand, Bangkok
Silver, gilding, engraving, niello
Height 45 cm
Provenance: From the private apartments of Nicholas II at the Winter Palace. ИС-315
Previous Exhibitions: St. Petersburg, 1894, Cat. 197; St. Petersburg, 1994, Cat. 338;
St. Petersburg, 1997, Cat. 122

The table decoration was presented to Nicholas at the same time
as the candelbra (no. 220). Three birds support two cups, one set
on top of the other. In Siam, where social rank was strictly
observed, vessels of this shape and decoration were used only by
the immediate heirs to the throne. They were used as trays for
betel leaves, since the tradition of chewing betel leaves was an
important part of everyday life. This traditional vessel, like the
candelbra, corresponds to an accustomed European form, in this
case the centrepiece. The two-tier octagonal pedestal is decorated
on four of its sides with state emblems surmounted by crowns: on
two sides with Russian state emblems and crowns, on the other
two with Siamese. OD

222 Set of Hair-Pins and Ear-rings, Second half of 19th century

China, Qing dynasty (1644–1911)
Brass, silver, gilding, semi-precious stones, pearls, glass, beads, kingfisher feathers
Height 14 cm; 12 cm; 10 cm; *ear-rings* 7 cm
Provenance: Acquired from the Ethnography Department of the State Russian
Museum; previously in the Museum of the Society for the Promotion of the Arts.
ΛM-671, 672, 674, 682 a, 6
Previous Exhibition: St. Petersburg, 1994, Cat. 358

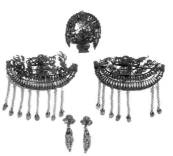

The set of hair-pins and ear-rings was brought back to Russia by
the Tsarevich Nikolai Alexandrovich from his journey to the Far
East in 1890–1. In the curiosity shops and market stalls of Hong
Kong the traveller's attention was caught by local decorative
artefacts: hair-pins, bracelets, brooches. 'The most original are
the apparently enamelled items, which turn out to be covered
with coloured powder with the feathers of birds of paradise glued
onto the surface.' (Ukhtomsky, vol. iv, p. 189.) Kingfisher
feathers were highly valued in China, and are known to have been
used as tribute since the time of the T'ang dynasty (618–906).
During the Qing dynasty, decorations made of feathers were
commonly worn by women of both the noble estates and the
middle classes. Finely trimmed turquoise, blue and green
kingfisher feathers were glued onto the gilded surface of an
artefact and supplemented with stones and beads to create
traditional symbolic ornaments. Strings of pearl beads with rose
quartz or glass that jangled when the wearer moved were used to
drive away evil spirits. These ear-rings are in the form of a 'hand
of Buddha' citrus fruit suspended from a lotus flower. MLM

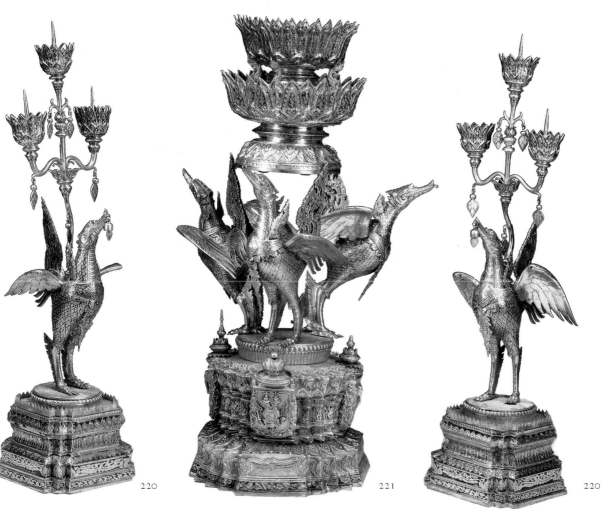

220 221 220

Porcelain and Faience

223 Two Pieces from the 'New-Style Coat of Arms' Service, 1882–1914

St. Petersburg, Imperial Porcelain Factory
Plate: coat of arms on the border; underglaze green mark: *A III 1888*,
beneath a crown.
Porcelain, overglaze painting. 3 × 23.5 cm. ЭРФ-1373
Cup and saucer: underglaze green mark: *H II 1909 1910*, beneath a crown.
Porcelain, overglaze painting.
5.8 × 11.2 × 9.5 cm; 2.8 × 14.1 cm. ЭРФ-8450 a, 6
Provenance: plate: from the original Winter Palace Collection; cup and saucer:
acquired from the State Hermitage Expert Purchasing Commission in 1985.
Previous Exhibition: St. Petersburg, 1994, Cat. 133

The service was ordered for the coronation of Emperor Alexander
III in 1882 and consisted of 19,000 pieces. The order was later
repeated for the coronation of Emperor Nicholas II and the size
of the service significantly increased (47,000 pieces). The tsar's
table at the coronation banquet was traditionally laid with the
gold service, while the service with the coat of arms was intended
for the numerous guests. This service was added to right up until
the First World War and apparently was used for grand banquets
held at the court. The new coat of arms was introduced in 1856.
TVK

224 Vase with Dark Red Polychrome Glaze, 1889

St. Petersburg, Imperial Porcelain Factory
Glaze maker: K. F. Klever
Porcelain, high-temperature fired 'ox-blood' glaze
Underglaze green mark, stencilled: *A III 89* beneath a crown.
26.3 × 18 cm
Provenance: from the Winter Palace. ЭРФ-8501
Previous Exhibition: St. Petersburg, 1994, Cat. 136
TVK

225 Cup and Saucer with Ornamental Painting, 1890–2

St. Petersburg, Imperial Porcelain Factory
Designed by I. A. Monighetti, 1871
Porcelain, underglaze polychrome painting, gilding, silver
Underglaze green marks, stencilled interwoven monogram: *A III 90*;
below, hand-painted in gold: *1892*
Cup: 8 × 12 × 10 cm; saucer: 2.3 × 16.5 cm
Provenance: Acquired from the State Museum of Ethnography of the USSR in 1941;
previously at Gatchina Palace. ЭРФ-2939 a, 6
Previous Exhibition: St. Petersburg, 1994, Cat. 139
Literature: Nikiforova, 1973, No. 131

In 1871 the architect I. A. Monighetti (1819–78) designed the
interior décor, equipment and utensils for the imperial yacht
Derzhava, including glass and porcelain services which were made
at the Imperial Porcelain and Glass Factories. The painted design
included interwoven ropes and anchors. The pieces
designed by Monighetti were subsequently painted with other
ornamental compositions. The cup, in the Russian style much
favoured by Emperor Alexander III, was painted in imitation of
the decoration of 16th and 17th century enamels and was for the
personal use of the imperial family at Gatchina Palace. TVK

226 Vase depicting a Heron among Marsh Plants and Irises, 1892

St. Petersburg, Imperial Porcelain Factory
Sketch and painting: K. F. Liisberg
Porcelain, relief, underglaze painting, polychrome.
Underglaze green mark, stencilled interwoven monogram: *A III* beneath a crown;
below, hand-painted in gold: *1892*
31 × 18.5 cm
Provenance: Acquired from the State Museum of Ethnography of the USSR in 1941;
previously at Gatchina Palace. ЭРФ-5358
Previous Exhibitions: Leningrad, 1974, Cat. 97; St. Petersburg, 1994, Cat. 140
Literature: Kudryavtseva, 1985, p. 127
TVK

227 Two Pieces from the Raphael Ceremonial Dinner and Dessert
Services from Tsarskoe Selo Palace, 1883–1903

St. Petersburg, Imperial Porcelain Factory
Porcelain, overglaze painting, polychrome, gilding on mastic
Shallow hors-d'oeuvre plate with grisaille depiction of Venus and Cupid in the centre,
framed by grotesque ornaments and garland (right).
Marks: underglaze green, stencilled monogram: *A II* beneath a crown; red with gold,
hand-painted interwoven monogram: *A III 1885* beneath a crown.
2.3 × 21.2 cm. ЭРФ-6978
Shallow cake plate with grisaille depiction of a woman in a veil, framed by grotesque
ornaments and landscapes in reserved panel (left).
Marks: underglaze green, stencilled monogram: *A II* beneath a crown; red with gold,
hand-painted interwoven monogram: *A III* beneath a crown; below, hand-painted in
gold: *1884*.
1.9 × 17.4 cm. ЭРФ-8711
Provenance: from the Winter Palace.
Previous Exhibition: St. Petersburg, 1994, Cat. 141
Literature: Wolf, 1906, pp. 270, 271, 292, 293; Kudryavtseva, 1982, pp. 21–30

The Raphael Service, the most significant formal service from
the late 19th and early 20th centuries, was commissioned in 1883
for Tsarskoe Selo Palace. The design was developed under the
direction of the head of the painting workshops of the Imperial
Factory — Leonard Leonardovich Schaufelberger. Emperor
Alexander III personally supervised the making of the service
and made his own corrections to the design.

The decoration includes ornamental and allegorical compositions
based on motifs from Raphael's loggias. The colourful pattern
almost covers the entire white background. The decorative motifs
are constantly varied while preserving the overall design. Items
of the service were presented to the emperor on completion every
year as Christmas gifts. In all, the service took 20 years to
produce. In 1903 the service of a total of 50 covers was completed
and put in the palace store-rooms. TVK

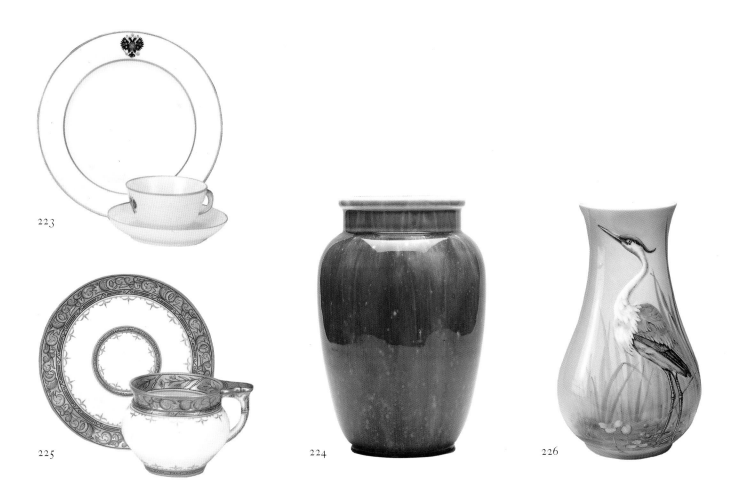

223

225

224

226

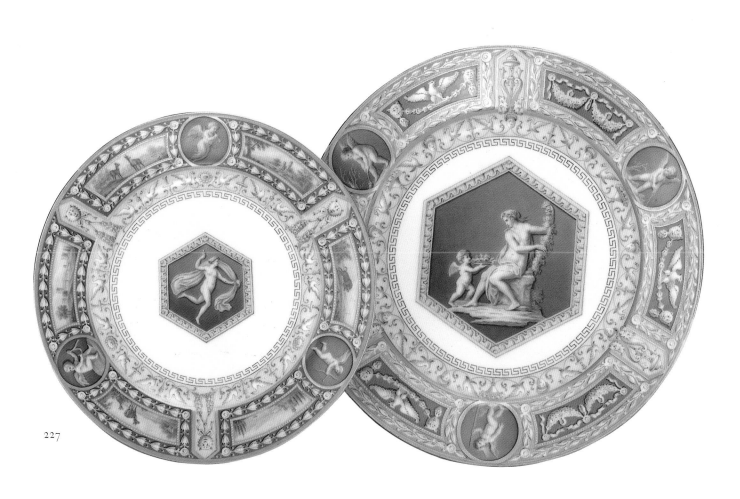

227

228 Three Pieces from the Alexandra Turquoise Service, 1899–1904

St. Petersburg, Imperial Porcelain Factory
Porcelain, coloured glaze, overglaze painting, polychrome, gilding, guilloche.
·Shallow dessert plate with wreaths on a turquoise background and a garland framing a picture of a girl in blue (right).
Underglaze green mark, stencilled monogram: *H II 1899* beneath a crown.
2.4 × 22.3 cm. ЭРФ-8704
Shallow cake plate with garlands of oak leaves and birds in insets on a turquoise background (centre).
Underglaze green mark, stencilled monogram: *H II 1900* beneath a crown.
1.8 × 13.5 cm. ЭРФ-6357
Dessert bowl with wreaths on a turquoise background and garlands, framing a picture of Cupid (left).
Underglaze green mark, stencilled monogram: *H II 1903* beneath a crown.
5 × 21.5 cm. ЭРФ-6359
Provenance: Acquired from the State Museum of Ethnography of the USSR in 1941; previously in the Marshal of the Court's section of the Winter Palace.
Previous Exhibition: St. Petersburg, 1994, Cat. 142
Literature: Wolf, 1906, p. 314, illus. pp. 481, 482; Kudryavtseva, 1982, pp. 27-9

In the Winter Palace, as in other imperial residences, services intended for everyday use and for ceremonial occasions were kept in the store-rooms. One of the last ceremonial services to be commissioned was the Alexandra Service, named after Empress Alexandra Feodorovna, who ordered it for the Winter Palace in 1899. The second appellation 'turquoise' refers to the decoration, which was designed in imitation of the famous Sèvres porcelain with a colourful design on an intense turquoise background.

The later ceremonial services for the palace had many fewer pieces compared with the banqueting services of earlier years (for example, the famous Arabesque Service included about sixty different pieces). According to workers in the Marshal of the Court's department, many pieces were no longer used, with dishes and sauce-boats being replaced by silver. Accordingly when new services were commissioned they had many fewer pieces. The Alexandra Turquoise Service had only 1,290 plates of five different types. In 1903, 36 dessert bowls of two different types were added to it. When other items were needed for serving at ceremonial banquets, they were supplemented by silver from the Winter Palace store-rooms. TVK

229 Vase depicting a Lake in Finland, 1903–9

St. Petersburg, Imperial Porcelain Factory
Sketch and painting: G. D. Zimin
Porcelain, underglaze painting, polychrome
31 × 24.5 cm
Provenance: Acquired from the State Hermitage Expert Purchasing Commission in 1987. ЭРФ-8559
Previous Exhibition: St. Petersburg, 1994, Cat. 144

Grigory Dmitrievich Zimin (1875–1958) was one of the Imperial Porcelain Factory's best underglaze painters. In 1886–8 he studied at the Technical Drawing School of Baron A. L. Stieglitz. In 1902 he graduated from the school of the Society for the Promotion of the Arts. He learned to paint on glass in the studios of the Imperial Glass Works; in 1886 he was taken on as a pupil at the painting studio of the Imperial Porcelain Factory where, in 1886, he was appointed painter specialising in underglaze painting on porcelain. Zimin worked from his own sketches and was considered one of the factory's best artists.

Vases made using polychrome underglaze painting in the style of Danish porcelain were not usually mass-produced. Two copies were made, one for presentation to the court, one for the Imperial Porcelain Factory museum. TVK

230 Baluster Vase depicting a Crane and Flowering Branches, 1911

St. Petersburg, Imperial Porcelain Factory
Sketch and painting: E. Gagen-Torn
Porcelain, underglaze polychrome painting
Underglaze green mark, stencilled monogram: *H II 1911*, beneath a crown.
42.6 × 16.7 cm
Provenance: from the Winter Palace. ЭРФ-8496
Previous Exhibition: St. Petersburg, 1994, Cat. 145

Elena Gagen-Torn studied at the Technical Drawing School of Baron Stieglitz in the early 1900s. In about 1910 she went to work as a painter at the Imperial Porcelain Factory, specialising in underglaze painting on porcelain. TVK

231 Figures from the 'Peoples of Russia' Series, 1907–17

St. Petersburg, Imperial Porcelain Factory
Creator of the models: P. P. Kamensky; Painting: M. I. Gertsak
Porcelain, overglaze painting, polychrome, gilding, silver
Sart (Uzbek man)
Green mark on bisque, stencilled monogram *H II 1911* beneath a crown. Facsimile impressed on paste: *П. Каменскій* [P. Kamensky] *1910*; hand-written: *АЛ* [AL]
Inscription impressed on paste by hand: *Сартъ* [Sart].
Kamensky's model was introduced at the Imperial Porcelain Factory on 22 November 1910; the 1911 model was moulded by A. Lukin.
Height 38.8 cm. ЭРФ-3702
Georgian woman
Underglaze green mark, stencilled monogram: *H II* beneath a crown. Facsimile impressed on paste: *П. Каменскій* [P. Kamensky] *1910*; hand-written: *КЗ* [KZ]
Inscription impressed on paste by hand: *Грузинка* [Georgian woman]
Kamensky's model was introduced at the Imperial Porcelain Factory on 20 August 1912; the 1912-16 model was moulded by K. Zakharov.
Height 39.6 cm. ЭРФ-3716
Provenance: from the Winter Palace.
Previous Exhibition: St. Petersburg, 1994, Cat. 147
Literature: Nikiforova, 1973, illus. p. 132; Kudryavtseva, 1986, pp. 97-107

Pavel Pavlovich Kamensky (1858–1922) studied at the Academy of Arts from 1874 to 1885. From 1886 he taught drawing at the Imperial Theatre School, and from 1888 was sculptor for the Directorate of Imperial Theatres and head of the properties studio. One of his finest sculptures, his statue of Ophelia in

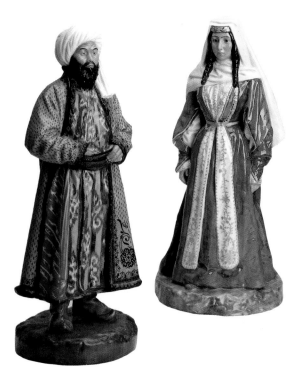

231

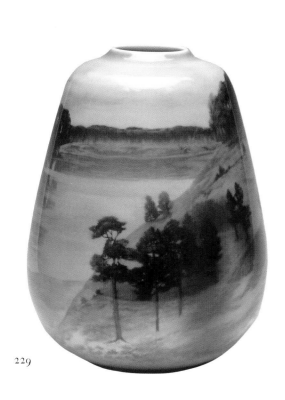

229

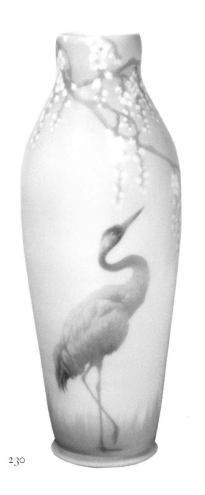

230

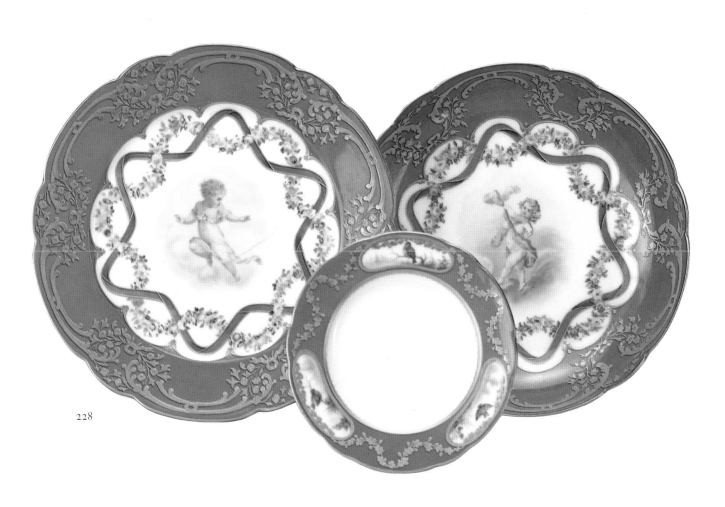

228

terracotta and biscuit, was made at the Imperial Porcelain Factory in 1891, and between 1901 and 1914 Kamensky created over 100 porcelain figures for the 'Peoples of Russia' series.

One of the traditional themes in sculpture and painting on porcelain at the Imperial Factory was the portrayal of the various nationalities that inhabited Russia. The last and biggest series of sculptural figures of the peoples of Russia was made between 1907 and 1917, after Kamensky's models. It included about 150 male and female figures in fine national costumes. The main aim was to create an accurate and detailed portrayal of the differences in appearance and dress of the various nationalities. The artists used exhibits and mannequins from the Peter the Great Museum of Anthropology and Ethnography and the Ethnographic Department at the Russian Museum of Emperor Alexander III. Doctor of Philology V. V. Radlov oversaw the accuracy of the portrayals. At the same time as the large pieces that were presented to the court, half-size copies of the sculptures were made as gifts. TVK

232 Souvenir Beaker for the Coronation of Emperor Nicholas II and Empress Alexandra Feodorovna, c. 1896

Tver, factory of M. S. Kuznetsov Ltd
Mark stamped on paste: *М. С. Кузнецова* [M. S. Kuznetsov]; *1878 15* [model numbers].
Decorated with the Moscow coat of arms in relief depicting St. George on horseback killing the dragon with his lance. Inscription above: *На память священного коронованiя* [In memory of the holy coronation]. To the sides, the monograms *H II* and *A* crowned with the imperial crown, and garlands of oak and laurel leaves.
Faience, coloured glaze
11.7 × 9 cm
Provenance: Acquired from the State Museum of Ethnography in 1941. ЭРФ-6482

The beaker was among a number of souvenirs made as gifts to be distributed among the people on Khodynka Field on 18 May 1896 during the coronation celebrations in Moscow. TVK

233 Vase depicting a Coiled Snake on a Blue Background, 1890

Copenhagen, Royal Porcelain Manufactory
Painting by A.-E. Krog (1856–1931)
Blue underglaze mark: three waves, monogram of A. Krog.
Porcelain, underglaze painting
Height 35.5 cm
Provenance: Acquired from the State Museum Fund in 1937; originally bought by Alexander III in Denmark in 1891. Inventory No. 25005
Previous Exhibitions: Leningrad, 1974, Cat. 81, p. 32; St. Petersburg, 1994, Cat. 324
Literature: Russian State Historical Archive, collection 465, catalogue 13, file 166; Hayden, 1913, pl. LXVII

The vase's motif, a snake entwined around the body of the vessel, seems also to define the actual shape of the piece; this was an artistic device characteristic of followers of the modernist style. The designer was A.-E. Krog, the famous Danish artist, architect, ceramicist and graphic artist. From 1885 to 1916 Krog was artistic director of Copenhagen's Royal Porcelain Manufactory while continuing to work as a painter on porcelain and as a designer.

The vase is from the collection of Alexander III, who acquired it from the Royal Porcelain Manufactory during a trip to Denmark in 1891. LL

232

233

234 Vase with Palace Buildings, 1891

Copenhagen, Royal Porcelain Manufactory
Blue underglaze mark: three waves
Bottom right corner of medallions with view of palaces: *O*
In medallions on body of vase: *9 de Nover 1866* and *9 de Nover 1891*
Lid decorated with a sculptural group of putto figures holding a shield bearing a monogram with the letters *M* and *A* beneath a crown. On the stem of the vase: monogram of Christian IX beneath a crown.
Porcelain, overglaze painting, gilding
Height 80 cm
Provenance: from the original Winter Palace collection; previously in the Anichkov Palace in St. Petersburg. Inventory No. 14463
Previous Exhibition: St. Petersburg, 1994, Cat. 326

The vase was made on the occasion of the silver wedding anniversary of Emperor Alexander III and Empress Maria Feodorovna (whose initials are reproduced on the oval shield on the lid of the vase). On the sides of the vase are depicted the Anichkov Palace (where Tsarevich Alexander was born and lived while heir to the throne), and one of the four buildings of Amalienborg (the royal residence in Copenhagen), the Levetsaus Palace. The inscriptions on the side panels, '9 November 1866' and '9 November 1891', refer to the dates of the wedding and the 25th wedding anniversary respectively. The monogram of King Christian IX of Denmark (the father of the Russian Empress) on the stem of the vase suggests that the vase was a personal gift from him. Its form repeats an earlier vase with the monogram of Christian IX which was probably presented by the King of Denmark on the occasion of Alexander's marriage to his daughter.
LL

235 Dinner and Dessert Services with Table Decoration, 1894

Germany, Berlin Porcelain Manufactory
Mark on all pieces: sceptre (blue underglaze), orb with the letters *KPM* (red overglaze).
Porcelain, overglaze painting, gilding
Shallow plate: *diam.* 25.5 cm; Inv. no. 19289. Hors d'oeuvre plate: *diam.* 21.6 cm; Inv. no. 19283. Sauce-boat on saucer: *height* 9.5 cm; *length* 25.2 cm; Inv. no. 19909. Oval bowl with lid: *height* 23.8 cm; *length* 42.2 cm; Inv. no. 19927. Plate for oval bowl: *length* 46 cm; Inv. no. 19931. Vase with the initials of Emperor Nicholas II and Empress Alexandra: *A.H. II height* 72 cm; *diam.* 58 cm; Inv. no. 19960. Fruit bowl: *height* 18 cm; *diam.* 23.1 cm; Inv. no. 19940. Five-candle candelabra: *height* 65 cm; Inv. no. 24839. Boy-Mercury with mask: *height* 15.6 cm, Inv. no. 19948.
Provenance: Acquired from the Hermitage Table-Service Store-Room in 1922.
Previous Exhibitions: Leningrad, 1974, Cat.116; St. Petersburg, 1994, Cat. 215-27

This large six-person dinner and dessert service, including candelabra and table decorations as well as plates and dishes, was given by the German Emperor Wilhelm II on the occasion of the wedding of Nicholas II and Princess Alice of Hesse, which took place on 14 [26] November 1894 in St. Petersburg.

For transportation to Russia, the service was packed in Berlin in 11 boxes weighing approximately two tons in total. Part of the service was delivered to St. Petersburg in time for the wedding; the remaining pieces arrived on 10 February 1895. In Emperor Nicholas II's diary there is an entry for 29 January [11 February] 1895: 'We went to look at the beautiful service sent by Wilhelm with his Marshal of the Court, Ehlovstein, for our wedding...' (Diaries of Emperor Nicholas II, Moscow, 1991, p. 62.)

The service was made in the retrospective third rococo style. Dating from the 18th century, the relief decoration

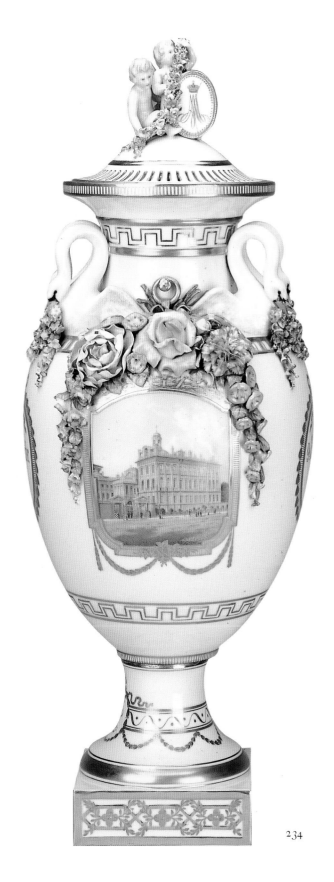

234

('Reliefzierat') is accompanied by flowers painted in the pale tones fashionable in porcelain decoration at the end of the 19th century. The figures for the table decoration were based on 18th century models. The service was used in the palace right up until 1917 and for this reason was not transferred from the table-service store-rooms of the Winter Palace to the Porcelain Room in the Hermitage when it was set up in 1910. NK

236 Vase with Double-Headed Eagle (Russian State Crest), 1896

France, Sèvres Porcelain Manufactory
Manufacturer's mark: black underglaze: S.96. Painter's mark: black overglaze.
Porcelain, overglaze painting, gilding
Height 82.5 cm
Provenance: Transferred from the Winter Palace in 1922. Inv. No. 21129
Previous Exhibition: St. Petersburg, 1994, Cat. 329

Judging by the date of manufacture, this vase may have been presented to Emperor Nicholas II and Empress Alexandra Feodorovna when they paid an official visit to France during the so-called 'Russian Week' (5–10 October 1896). Alternatively the gift may have been presented later by the President of France during his visit to St. Petersburg with a French naval squadron in August 1897. NK

237 Elephant with a Three-Tiered Pagoda on its Back, 1880s

Japan, Satsuma workshops
Faience, polychrome overglaze painting, gilding
Height 42.2 cm
Provenance: Transferred from the Winter Palace in the early 1930s. ЯК-1007
Previous Exhibitions: St. Petersburg, 1894, Cat. 453; Nagasaki, 1990, p. 45; St. Petersburg, 'Nicholas and Alexandra', 1994, Cat. 347; St. Petersburg, 'Oriental Porcelain', 1994, p. 36; St. Petersburg, 1995, Cat. 57

The figure of the elephant is hollow inside, the pagoda serving as a lid. Around the lid are figures of boys sitting on the cloth painted in the so-called brocade style. One of them is holding a scroll with the words 'painted by Togo Juusei from Gekumei-san village (Tamakiyama), Hioki (Hioke) district, Navashiroshin locality, Satsuma province' (translation M.V. Uspensky). The elephant was acquired by Tsarevich Nikolai Alexandrovich on 5 May 1891 in Kagoshima during his trip to Japan. TA

238 Hotei, Late 1880s

Japan, Satsuma workshops
Faience, polychrome painting and painting in gold on ivory-coloured glaze.
Base of figure unglazed; round opening in centre.
Height 19.4 cm
Provenance: From the private rooms of Nicholas II in the Winter Palace; brought back by Tsarevich Nikolai Alexandrovich from his trip to the Orient in 1890-1. ЯК- 984
Previous Exhibitions: St. Petersburg, 1894, Cat. 456; St. Petersburg, 1994, Cat. 346

One of the 'seven deities of fortune', Hotei is depicted according to the classic representation of him as a fat man holding a bag with the figure of a *karako* (Chinese boy). TA

239 Vessel with a Dragon and Pearls among Clouds, Second half of the 19th century

China, Jingdezhen (Jiangxi province)
On bottom: mark of the Guanxu period (1875-1908)
Porcelain, painting in gold on brilliant black glaze.
Height 38 cm
Provenance: From the private rooms of Nicholas II in the Winter Palace; brought back by Tsarevich Nikolai Alexandrovich from his trip to the Orient in 1890-1. ЛК-1200
Previous exhibitions: St. Petersburg, 1894, Cat. 289; St. Petersburg, 1994, Cat. 356
TA

240 Vessel with a Dragon and Pearls among Clouds, Second half of the 19th century

China, Jingdezhen (Jiangxi province)
On bottom: mark of the Qianlong period (1736-95)
Porcelain, painting in gold on brilliant black glaze.
Height 36 cm
Provenance: From the private rooms of Nicholas II in the Winter Palace; brought back by Tsarevich Nikolai Alexandrovich from his trip to the Orient in 1890-1. ЛК-1201
Previous Exhibition: St. Petersburg, 1994, Cat. 357
TA

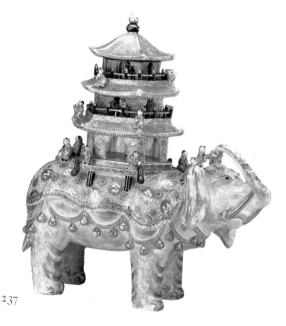

237

238

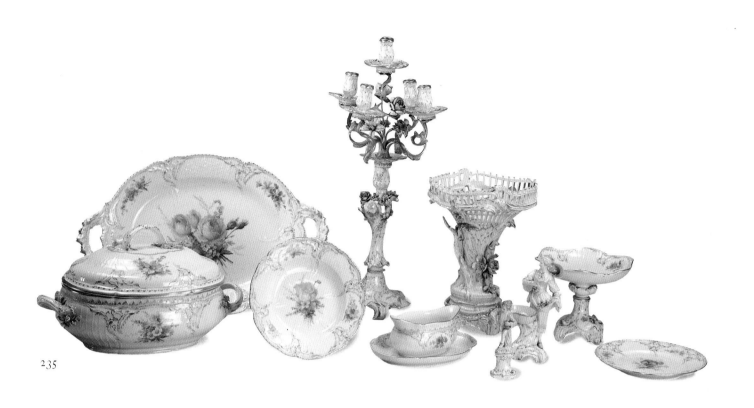

235

236

239

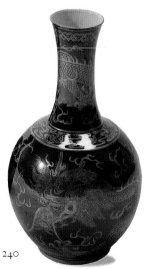

240

Glass

241 Three goblets, Late 19th century

St. Petersburg, Imperial Glass Factory
Master: Lavr Orlovsky
With engraved monogram H II A [Nicholas II Alexandrovich] and
double-headed eagle.
Colourless crystal, engraved, ground, painted, gilding.
16.7 × 7.3 × 7.3 cm. ЭPC-1131
20 × 9.1 × 9.1 cm. ЭPC-3029
20 × 9.1 × 9.1 cm. ЭPC-3030
Provenance: Acquired from the State Museum Fund in 1948.
Previous Exhibition: St. Petersburg, 1994, Cat. 152.

Lavr Orlovsky was one of the leading masters of the Imperial
Glass Factory at the turn of the 20th century.

The goblets were created in imitation of glasses which were in use
in the 18th century. From the time of Peter the Great goblets and
shtofs (decanters) were decorated with allegorical compositions,
portraits and monograms of Russian emperors and empresses.
In 1767 Empress Catherine II 'was pleased to order' from St.
Petersburg glass factories 150 crystal goblets with her monogram
beneath a crown. These goblets were used at banquets and on
days marking different orders. During the reign of Emperor
Paul I only gilt glassware was permitted at the royal table. Under
Nicholas II the Imperial Glass Factory continued to produce
goblets with the emperor's monogram, which were designated
for use on the most formal occasions. TM

242 Goblet, 1910s

St. Petersburg, Imperial Glass Factory
Master: Lavr Orlovsky
With engraved monogram H II A [Nicholas II Alexandrovich] beneath a crown in a
cartouche; a fountain with a balustrade and flowers.
Colourless crystal, engraved, ground.
31.5 × 14 × 14 cm
Provenance: Acquired from the Museum of the Stieglitz School of Technical Drawing
in 1921. ЭPC-2421
Previous Exhibition: St. Petersburg, 1994, Cat. 153.
TM

243 Vase with Yellow Water-Lily Motif, 1896

St. Petersburg, Imperial Glass Factory
From a design by I. I. Murinov
Mark engraved on the base: H II beneath a crown and the date 1896
Smoke-coloured crystal, engraved, ground.
24 × 17.7 × 17.7 cm
Provenance: Acquired from The State Museum of Ethnography of the USSR in 1941;
previously at Gatchina Palace. ЭPC-1722 a, б
Previous Exhibition: St. Petersburg, 1994, Cat. 154.

Ivan Ivanovich Murinov (1843–1901) worked at the Imperial
Glass Factory from 1855. From 1873 to 1890 he headed the
painting workshop. From 1894 until 13 August 1901 he directed
the main artistic workshops of the factory.

At Christmas 1896 this vase was given to the Dowager Empress
Maria Feodorovna, and she kept it in her rooms at Gatchina
Palace. In the inventory of glassware delivered that year to
Empress Maria Feodorovna there were 40 items (vases,
decanters, bottles, glasses, jars, wine-glasses) to a value of about
7,000 roubles; this included the yellow water-lily vase with a lid,
valued at 300 roubles. TM

244 Vase with Tulip Motif, 1898

St. Petersburg, Imperial Glass Factory
From a design accredited to K. Krasovsky
Mark engraved on the base: H II beneath a crown and the date 1898
Two-layered (colourless and turquoise-blue) crystal, engraved, ground.
30 × 20 × 20 cm
Provenance: Acquired from the private rooms of Empress Alexandra Feodorovna in
the Winter Palace in 1931. ЭPC-2430
Previous Exhibitions: Leningrad, 1974, Cat. 201; St. Petersburg, 1994, Cat. 155.

The Tulip vase adorned the Silver Drawing-Room of Empress
Alexandra Feodorovna in the Winter Palace. Together with its
pair, it can be seen in one of the photographs (no. 104) of the
private rooms of the Romanovs in the north-west wing of the
Winter Palace. TM

245 Vase with Iris Motif, 1900

St. Petersburg, Imperial Glass Factory
Master: A. Zotov, from a design accredited to K. Krasovsky
Mark engraved on the base: H II beneath a crown and the date 1900
Two-layered (matt lilac and purple-violet) crystal, engraved, ground.
30.5 × 19.5 × 19.5 cm
Provenance: Acquired from the private rooms of Empress Alexandra Feodorovna
in the Winter Palace in 1931. ЭPC-2432
Previous Exhibitions: Leningrad, 1974, Cat. 202; St. Petersburg, 1994, Cat. 156.

Konstantin Nikolaevich Krasovsky worked at the Imperial Glass
Factory from the 1850s, first as a painter and then, from 1866, as
a master.

The Iris vase adorned the boudoir of Empress Alexandra
Feodorovna in the Winter Palace. The empress loved pink and
lilac shades, which were selected not only for her dresses, but were
also used in upholstery and interior decoration. For this reason,
the artists gave preference to lilac and deep violet colours in their
vase designs, thus creating new problems for the factory's
technicians. In order to achieve violet tones of any depth, they
began at this time to use a combination of gold and cobalt,
instead of using manganese peroxide, the method generally
accepted in the glass industry. TM

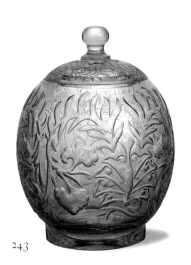

243

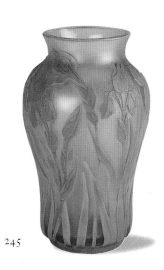

244

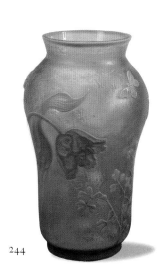

245

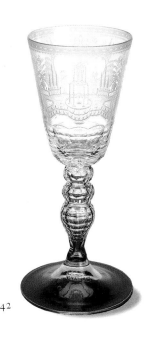

242

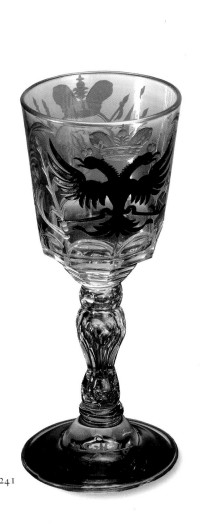

241

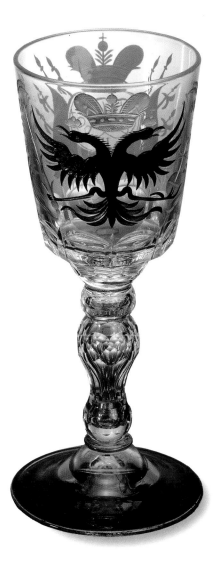

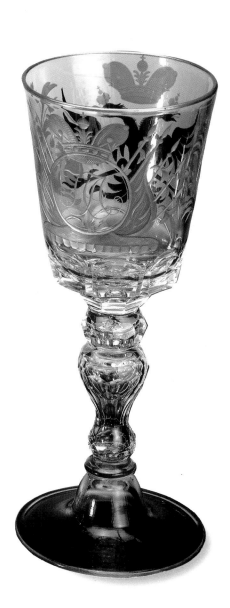

246 Vase with Wild Grapes Motif, 1901

St. Petersburg, Imperial Glass Factory
Master: T. Kozlov, from a design by K. Krasovsky
Mark engraved on the base: *H II* beneath a crown and the date *1901*
Two-layered (matt and 'gold' ruby) crystal, engraved, ground.
32.8 × 16.1 × 16.1 cm
Provenance: Acquired from the State Museum of Ethnography of the USSR in 1941.
ЭРС-1656
Previous Exhibition: St. Petersburg, 1994, Cat. 157

'Once a year there took place what was known as the "presentation": all the products which had accumulated during the year — decorative porcelain and glassware — were shown or, so to speak, "surrendered" to the tsar. But at the factory they began preparing for this a long time in advance and it created quite a fuss. The items earmarked for the presentation were brought into the director's office and displayed on a huge table, and here the final selection was made. Two copies were made of many of the goods to guarantee quality and, at the final examination, the director would smash the lesser of the two with his own hands, using an ordinary hammer which you would use to hammer nails. To this day I cannot forget that crude instrument in the director's well-groomed hand, and the tinkling sound of those valuable vases smashing. Everything intended for the palace had to be unique; duplicates were not permitted. After the final selection, the carefully packed products were loaded onto wagons from the palace, and livery coachmen with long horsewhips set off for Tsarskoe Selo. There, in the Alexander Palace where Nicholas II usually lived, the items were laid out in rooms specially set aside, and the factory director, who would have arrived in good time, rigged out in his court outfit, would await the royal entrance. The tsar would usually appear with his whole family, accompanied by several attendants. The tour would be accompanied by a discussion of the merits of the items on display, and it was here that you had to catch which way the wind was blowing, for this was all there was in the way of instructions for the future, and the factory's programme for the next year was based on it. It was Empress Alexandra Feodorovna who dictated taste in the tsar's family, and the sharp drop in the artistic level of the factory's output at the beginning of the 20th century should to a significant extent be put down to her.'
(Kachalov, 1959, p. 273.) TM

247 Vase with Azalea Motif, 1901

St. Petersburg, Imperial Glass Factory
Master: D. P. Lukin, from a design by B. Reinhardt
Mark engraved on the base: *H II* beneath a crown and the date *1901*
Three-layered (smoky green, green and white) crystal, engraved, ground.
27.5 × 12 × 12 cm
Provenance: Acquired from the private rooms of Empress Alexandra Feodorovna in the Winter Palace in 1931. ЭРС-2427
Previous Exhibitions: Leningrad, 1974, Cat. 204; Leningrad, 1989, Cat. 185; St. Petersburg, 1994, Cat. 158

Empress Alexandra Feodorovna was particularly fond of vases made from three-layered glass 'by Gallé's method' (the French artist Emile Gallé). It is possible that Alexandra saw D. P. Lukin's work on the Azalea vase, which was made in 1901. On 17 November 1901 she visited the Imperial Porcelain and Glass factories:

'At 11.25 Her Royal Highness Empress Alexandra Feodorovna, accompanied by her august sister Grand Duchess Elizaveta

Feodorovna ... visited the imperial factories, where Her Majesty the Empress and Their Highnesses were greeted by the head gentleman of the bedchamber Baron Wolf and the factory administration. Baron Wolf had the honour of presenting the Sovereign Empress and the Grand Duchesses with splendid bouquets of flowers. Her Majesty went on to the museum, where the Sovereign Empress and the Grand Duchesses entered their names in the book for royal personages. Then the Sovereign Empress looked at the painting studio and the White Chamber studio. In the former Her Majesty stopped to look at the work of almost all the artists and paid particular attention to a service which had been made by order of Her Majesty, who expressed her pleasure at its fine execution and in many cases was pleased to indicate what shades, background and form the products should have. Her Majesty showed great interest in the manufacture at various benches of articles from three-layered, multicoloured crystal, which requires skilled craftmanship.'
(*Rossiya* newspaper, 1901, No. 922.) TM

248 Vase with Begonia Motif, 1910

St. Petersburg, Imperial Glass Factory
Master: N. Semeonov from his own design
Mark engraved on the base: *H II* beneath a crown and the date *1910*
Two-layered (dark pink and brown-red) crystal, engraved, ground
20.5 × 15 × 15 cm
Provenance: Acquired from The State Museum of Ethnography of the USSR in 1941. ЭРС-2076
Previous Exhibitions: Leningrad, 1989, Cat. 1933; St. Petersburg, 1994, Cat. 159

The vase is cylindrical in form, which Empress Alexandra Feodorovna particularly liked, and finished in her favourite combination of colours. A surviving document from the factory archives reads: 'When articles from the Imperial Factories were presented, Her Royal Highness Empress Alexandra Feodorovna was pleased to give the following instructions for glass production: to produce flower vases without making the neck too narrow; to reduce the production of tall vases; to create several glass flower vases in a completely rounded form.' TM

249 Vase with Hop-Plant Motif, 1908

St. Petersburg, Imperial Glass Factory
Unknown master
Mark engraved on the base: *H II* beneath a crown and the date *1908*
Colourless crystal, engraved, ground
21.7 × 23.2 × 23.2 cm
Provenance: Acquired from The State Museum of Ethnography of the USSR in 1941. ЭРС-1660
Previous Exhibitions: Leningrad, 1974, Cat. 297; St. Petersburg, 1994, Cat. 160
TM

250 Vase with 'Tsar's Crown' Flower Motif, 1911

St. Petersburg, Imperial Glass Factory
Master: P. Marintsev, from a design by P. Krasnovsky
Mark engraved on the base: *H II* beneath a crown and the date *1911*
Colourless crystal, engraved.
43 × 19 × 19 cm
Provenance: Acquired from the State Museum Fund in 1929; previously in the Anichkov Palace. ЭРС-2592
Previous Exhibitions: Leningrad, 1974, Cat. 209; Leningrad, 1989, Cat. 194; St. Petersburg, 1994, Cat. 161

Piotr Ivanovich Krasnovsky (1871–?) worked at the Imperial Glass Factory from the 1890s as a designer in the art studio. He was still working at the factory in 1914.

'Our factory was frequently visited by high-ranking dignitaries of various ranks. Accompanying them around the workshop was an unpleasant duty, as the tone in which these people addressed mere mortals was not always bearable, and the employees of the factory tried to shift the responsibility of guide onto Andrei Ionich [the senior master]. Knowing his own worth, Andrei Ionich showed visitors around the factory and gave extensive explanations; as the guests were not very demanding, both sides were perfectly happy with each other. The visits usually ended with the following trick: at Ionich's bidding one of the workers would blow a huge glass sphere, which would burst with an ear-splitting crack. The visitors would jump in surprise, whereupon Ionich would say: "A salute in your honour", after which he would be given a 20-kopeck piece and the guests would depart, absolutely delighted by the rich experience.' (Kachalov, 1959, p. 270.) TM

251 Vase with a Portrait of Empress Maria Feodorovna and the Heir to the Throne, Tsarevich Nikolai Alexandrovich, 1870s

St. Petersburg
Glass, painting, gilding.
Height 40 cm
Provenance: Acquired from the State Hermitage Expert Purchasing Commission in 1994. ЭРC-3448

The portrait on the vase was based on a well-known photograph from 1870 by S. L. Levitsky. The vase is made from 'golden ruby' glass, which contained real gold, and glassware made from this material was particularly highly valued. It is possible that the portrait of Empress Maria Feodorovna with the heir to the throne was produced for presentation to the royal couple. TM

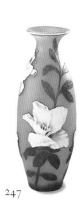

246

247

248

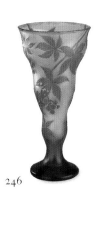

249

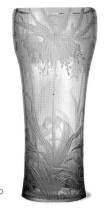

250

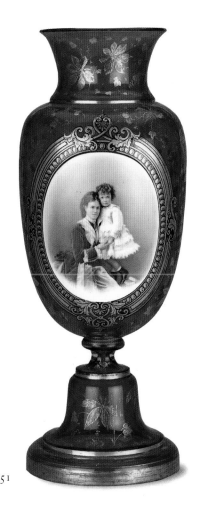

251

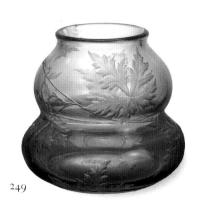

Metal Items

252 Ornamented Samovar, 1896

Tula, 'Heirs of Vasily Stepanovich Batashev' Samovar factory
Factory stamp: *Наследники Василия Степановича Баташова* [Heirs of Vasily
Stepanovich Batashev]
With monogram *H II A* beneath an imperial crown; lid depicts medals received by the
factory at the All-Russian exhibitions of 1870 and 1892.
Copper, ivory, gilding, chasing, moulding, engraving. 54 × 40 × 43 cm
Provenance: Acquired from The State Museum of Ethnography of the USSR in 1941.
ЭPM-2275
Previous Exhibitions: Leningrad, 1976, Cat. 46; St. Petersburg, 1994, Cat. 162

Nicholas II's monogram and the date 1896, as well as medallions
containing portraits of emperors Alexander II and Alexander III,
suggest that this magnificently decorated samovar with gilded
acanthus branches and white flowers in ivory was intended for
presentation to Nicholas II on the occasion of his coronation in
1896. MM

253 Candelabra, Date unknown

Russia. Master craftsman P. Chizhov.
Made for nine candles in the form of a glass column with bronze capitals on a
rectangular base; chased stamp on plinth: *П. Чижовъ* [P. Chizhov]
Bronze, glass, gilding, chasing, engraving. 105 × 52.5 cm
Provenance: Acquired from the Expert Purchasing Committee of the State Hermitage
in 1955. ЭPM-5621, 5622
Previous Exhibitions: Leningrad, 1975, Cat. 269; St. Petersburg, 1994, Cat. 163

The pedestal of each candelabrum is decorated with medallions
containing a portrait of Napoleon and a double portrait of Grand
Duke Alexander Nikolaevich (the future Emperor Alexander
II) and his wife, Grand Duchess Maria Alexandrovna. The
combination of depictions suggests that the candelabra
originated from the collection of Maximilian, Duke of
Leuchtenberg. IS

254 Bust of Nicholas I, Mid 19th century (p. 170)

St. Petersburg
Patinated and gilded bronze, granite. 17.8 × 7.8 × 5 cm
Provenance: Acquired from the State Museum of Ethnography of the USSR in 1941.
ЭPM-4560

A small desk-top bust of Nicholas I would often be found on
writing desks in Russian interior design of the second half of the
19th century. A similar bust to this one stood on the writing
desk in Nicholas II's study in the early 20th century. IS

255 Table lamp, 19th century (p. 169)

England, Wedgwood
Mark on the porcelain: *WEDGWOOD*
Gilded bronze, porcelain, silk. 70 × 35 × 22 cm
Provenance: Acquired from the imperial family's private rooms in the Winter Palace.
ЭPM-4207

This lamp with Wedgwood porcelain was manufactured in the
first half of the 19th century for use with candles. However, it
seems likely that during the installation of electricity in the
imperial residences under Alexander III and Nicholas II, the
lamp was altered to work with electricity, and was used in the
living rooms at the Winter Palace. IS

256 Table lamp, 1903 (p. 170)

St. Petersburg Electrical Fittings Factory
Brass, silver plate, silk
47.5 × 21.5 cm; shade: 18 × 24 cm
Provenance: Acquired from the imperial family's private rooms in the Winter Palace.
ЭPM-4208

Established in 1898, the St. Petersburg Electrical Fittings
Factory specialised in lighting appliances. The then dominant
art nouveau style of the period, with its smooth flowing lines and
stylised plant motifs, left its mark on almost all the work done
there. At the turn of the century the factory's products enjoyed
unfailing success both in ordinary homes in St. Petersburg and in
the palaces of the nobility. IS

257 Candlesticks, About 1825 (p. 169)

St. Petersburg
Gilded bronze
15.8 × 9.3 cm
Provenance: Acquired from the State Museum of Ethnography of the USSR in 1941;
until 1977 in the Koksharov collection. ЭPM-45, 46

Candlesticks of this type were widely used during the era of
Alexander I and Nicholas I. Similar candlesticks were to be found
in the living quarters of the last Russian emperor as well. IS

258 Candelabra, 1820s

St. Petersburg
Made for eight candles in the form of a fluted column holding a sphere crowned with
the figure of winged Glory.
Gilded bronze. 120.5 × 48 cm
Provenance: Acquired from the State Museum of Ethnography of the USSR in 1941;
until 1917 in the Myatlev collection in St. Petersburg. ЭPM-161, 162
IS

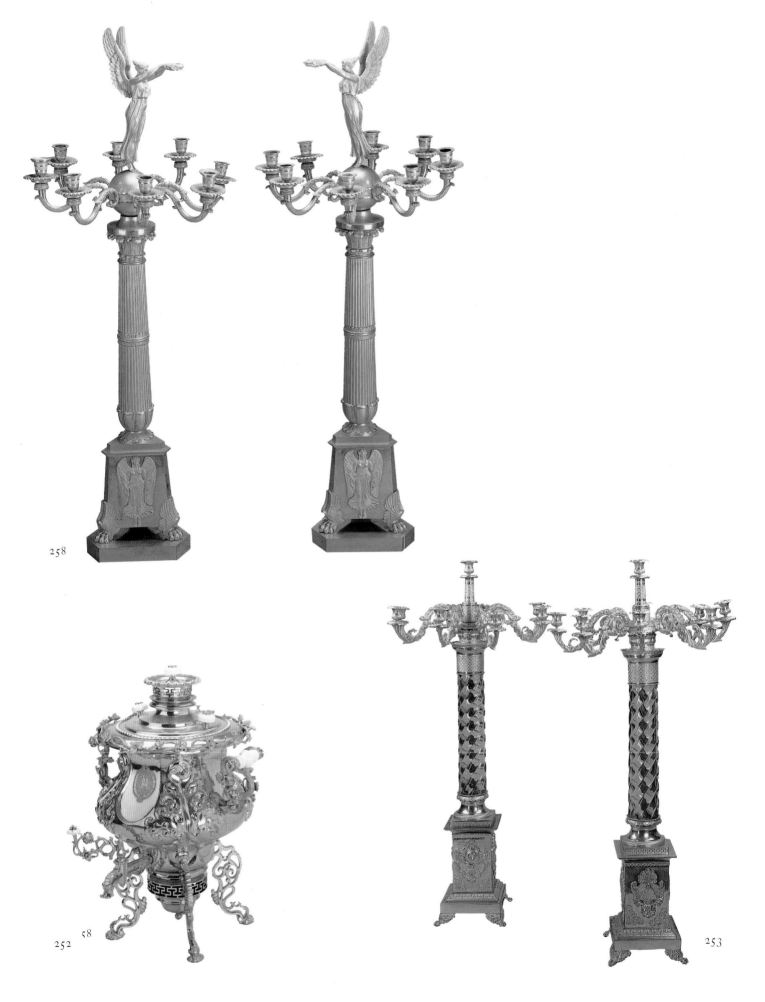

258

252

58

253

259 Vase, 18th century

China, Qing dynasty (1644–1911)
Bronze
Height 75 cm, *opening* 26 cm
Provenance: Acquired from the private rooms of Nicholas II in the Winter Palace in 1930. ΛM-156
Previous Exhibitions: St. Petersburg, 1894, Cat. 355; St. Petersburg, 1994, Cat. 361
Literature: Menshikova, 1995

The vase was brought back by Tsarevich Nikolai Alexandrovich from a journey to the Orient in 1890–1. While in China, it was decided to change the tsarevich's itinerary to shorten his stay; as a result a proposed meeting in Tianjin between Nikolai Alexandrovich and Li Hunjan, the emperor's vice-regent, did not take place. Li Hunjan sent this vase as a gift to the tsarevich as a sign of respect. Traditional Chinese archaic relief ornamentation in the form of the face of the monster 'Tao-che' is reminiscent of the ancient bronze sacrificial vessels of the 2nd and 1st centuries BC. Similar vessels were produced later to decorate altars, temples and palaces; as in ancient times, bronze remained a valuable material. MLM

260 Pair of Vases in the form of 'Moon Flasks', Early 19th century

China, Qing dynasty (1644–1911)
Bronze, cloisonné, gilding. *Height* 28 cm, *diam.* 24 cm
Provenance: Acquired from the private rooms of Nicholas II in the Winter Palace. ΛM-575, 576
Previous Exhibition: St. Petersburg, 1994, Cat. 350
Literature: Menshikova, 1995

The vases were brought to Russia and presented by Li Hungchang on the occasion of Nicholas II's coronation in 1896. The ornamentation includes bats, the Chinese characters 'fu' [happiness], 'zhou' [longevity], an endless chain, garlands of gems, flowers, and 'jui' finials — all linked with wishes of longevity, happiness and prosperity. The background enamel is yellow, being a colour only emperors were allowed to use and wear. MLM

261 Fire-Guard with Two Cranes, Late 18th – early 19th centuries

Cranes: China, Qing dynasty (1644–1911)
Cloisonné, bronze, gilding
Guard: Russia, second half of 19th century
Bronze, painting, gilding.
Height of cranes and base 150 cm, *length* of guard 196 cm
Provenance: Acquired from the State Museum Fund in 1928; previously in the Anichkov Palace in St. Petersburg. ΛM-643 (1–3)
Literature: Prakhov, 1903; Menshikova, 1995

A photograph of the fire-guard has survived showing it standing in front of the fireplace in the second hall of 'My Museum' in the Anichkov Palace for which it was specially made. As tsarevich, Alexander III had been interested in cloisonné and he possessed one of the best collections of enamel work in St. Petersburg. Work from China, Japan and Russia adorned the ceremonial and private chambers, as well as the staircase, in the Anichkov Palace.

Pairs of cloisonné Manchurian white cranes decorated throne rooms in Qing-dynasty China. The birds symbolised longevity and, arranged around the throne, represented the wish that the dynasty should endure for 10,000 years. A similar pair of white enamel cranes was brought to Nicholas II's coronation in 1896 as a gift from the Emperor Guanxu (1875–1908) by his ambassador Li Hunjan. MLM

262 Table decoration, End of 18th – early 19th centuries

China, Qing dynasty (1644–1911)
Made in the form of an elephant under a saddle-cloth with a vase on its back containing two ornaments in the form of a 'musical' stone with silk tassels.
Bronze, cloisonné, gilding, jade, silk. *Height* 37 cm
Provenance: Acquired from The State Museum Fund in 1928; previously in Alexander III's rooms in the Anichkov Palace in St. Petersburg. M-549 a, 6, в
Previous Exhibition: St. Petersburg, 1994, Cat. 354

In China, the elephant symbolised stability and prosperity. Elephant vases contained various good-luck charms, including five kinds of cereal to ensure a good harvest in a peaceful country (the Chinese word for vase — *bin* — is a homonym of the word meaning 'peace'). Pairs of white elephants adorned the entrances to the reception halls of imperial palaces, standing symmetrically near the throne. MLM

263 Basin with Two Figures, 1736–95

China, Qing dynasty (1644–1911). From the Summer Palace of Yuanmingyuan
Mark and date of Qianlong (1736–95)
Bronze, cloisonné, gilding
Height 41 cm, *length* of basin 80 cm
Provenance: Acquired from the State Museum Fund in 1928; previously in Alexander III's rooms in the Anichkov Palace in St. Petersburg (used for flowers). ΛM-499
Previous Exhibition: St. Petersburg, 1994, Cat. 359

The ornamented basin is borne by two male figures, standing on one knee, dressed in robes with lotus decoration and turbans. The sides of the box outside and inside are decorated in turquoise and multicoloured enamel. The decoration, known as 'one hundred flowers', symbolises prosperity and luck. A mark on the base comprising four Chinese characters shows the years of rule of Qianlong (1736–95). One of the best examples of 18th century Chinese cloisonné, the basin appears to originate from the Summer Palace of the emperors of Yuanmingyuan, which was built in the 18th century in the 'European' style. When the court moved to this palace in the summer the cloisonné workshop also moved there. An ice-box similarly decorated with the same figures is in the Victoria and Albert Museum in London, and it is probable that the two pieces were originally displayed together. In 1861, during the suppression of the Taipin uprising in China by European forces, the palace of Yuanmingyuan was robbed and destroyed. Russians were not involved in the action but items from the palace went to private collections and museums, and were also auctioned or brought back to Russia by Russians serving in China. It is possible that the magnificent workmanship of the basin persuaded Alexander III to purchase it for his cloisonné collection. MLM

263

259

260

262

261

Wood and Other Materials

264 Easter Egg, Second half of 19th century

Lukutin factory near Moscow
Inside on one of the halves: *Отъ московскихъ старообрядцев преемляющих Священство* [From Moscow Old Believers taking to the Priesthood].
In two sections, decorated with miniatures: Descent into Hell, and Prince Vladimir holding a cross.
Papier-mâché, oil, painting, gilding, lacquer
16 × 10.5 × 10.5 cm
Provenance: Acquired from The State Museum of Ethnography of the USSR in 1941.
ЭРРз-125 a, 6
Previous Exhibitions: Aarhus, 1990, Cat. 8; St. Petersburg, 1994, Cat. 166;
St. Petersburg, 1995, pp. 98–9
Literature: Ukhanova, 1963, fig. 84; Ukhanova, 1983, pp. 109–23; Ukhanova, 1995, pp.
157, 160
IU

265 Easter Egg, Second half of 19th century

Lukutin factory near Moscow
Inside on one of the halves: *Христос Воскресе* [Christ has Risen].
In two sections, decorated with miniatures: the Resurrection, and the Cathedral of Christ the Saviour in Moscow.
Papier-mâché, oil, gilding, painting, lacquer
11.5 × 7.5 × 7.5 cm
Provenance: Acquired from the State Museum of Ethnography of the USSR in 1941;
previously in the Anichkov Palace in St. Petersburg. ЭРРз-109 a, 6
Previous Exhibitions: Aarhus, 1990, Cat. 8; St. Petersburg, 1994, Cat. 165

Easter eggs made of papier-mâché with festive decorations, silk ribbons, tassels and metal rims were made for hanging on icons, the iconostasis and icon cases in churches and domestic chapels. Painted Easter eggs made of papier-mâché were popular and were even taken to court. Eggs were decorated with bouquets of flowers, different gilts, sometimes ornamental enamel rims and every kind of holy subject dedicated to the Resurrection as well as famous architectural monuments such as the Moscow Kremlin, the Cathedral of Christ the Saviour, and the Trinity St. Sergei Monastery.

Easter egg painting involved craftsmen such as S. M. Matveev from Lukutin, as well as icon-painters from Palekh and Mstera, the ancient villages which had retained Russian folk-art traditions. Among icon-painters from Mstera who established themselves in Moscow during the second half of the 19th century were O. S. Chirikov and M. I. Dikarev who decorated eggs for the Lukutin factory and made samples of Easter eggs for china eggs to be painted at the Imperial Porcelain Works. The method of painting miniatures on the lacquer surface of circular halves of papier-mâché eggs was similar to icon-painting but technically more complex. IU

266 Decorative Ornament in the form of the Russian Imperial Coat of Arms, Late 19th – early 20th centuries

St. Petersburg
Double-headed eagle with the orb and sceptre and the figure of St. George the Victor on the shield.
Wood, open carving, relief, lacquer
68 × 54 cm
Provenance: Acquired from the State Museum of Ethnography of the USSR in 1941.
ЭРД-2236

Russian Imperial coats of arms were made from a wide range of materials including wood, often carved, painted or gilded. Wooden double-headed eagles were usually used as decoration for special festivals and ceremonies; they decorated the tsar's thrones, canopies and hangings. They also adorned meeting rooms or special repositories for state treasures such as the Heraldic Room of the State Senate. IU

267 Decorative Ornaments in the form of Double-Headed Eagles, Late 19th – early 20th centuries

St. Petersburg
Double-headed eagles under crowns with winding ribbons; on their breasts: the monogram *H II*.
Wood, carving, painting, gilding
80 × 28 × 33 cm
Provenance: Acquired from the State Museum of Ethnography of the USSR in 1941;
previously in the Senate in St. Petersburg. ЭРД-2306 a, 6

These ornaments are examples of the ancient Russian craft of wood-carving. The technique reached its height with the decorative relief carving created by Russian masters to adorn cathedrals, palaces and private residences around the country. The figure of the double-headed eagle was already widespread as a wood-carving motif in the 17th century; the tradition was still popular with craftsmen at the end of the 19th century. IU

268 Picnic Hamper, Late 19th – early 20th centuries

Germany/Russia
Reed, metal braid work (German silver), stamping, engraving, linen, glass, faience, leather
Basket 72 × 35 × 18 cm; box 20.5 × 14 × 9.5 cm; length of forks: 21.5 cm; length of knives: 21 cm; length of spoons: 18 cm; length of teaspoons: 14 cm; diam. of plates: 18 cm; height of tins: 6.5–10.5 cm; height of glasses: 8.5–10.5 cm; thermos flask: 40.5 × 11 cm
Provenance: Acquired from the State Museum of Ethnography of the USSR in 1941.
ЭРРз-1012–1041, 1044–1048

Special baskets were normally taken on picnics, containing all the items required for a meal: teapots, spirit lamps, plates, spoons, forks and knives. This cane hamper is reminiscent of a rectangular suitcase; it contains a set of 36 items stored in special holders for four people. This type of hamper was used by members of the imperial family. To judge from the stamps on the individual metal items they were made in Germany. IU

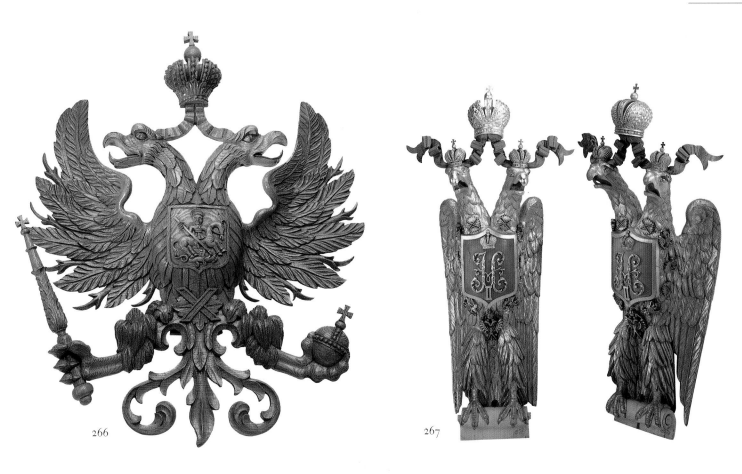

266

267

264

265

268

269 Child's Board Game 'War in Europe', 1914

Russia, Vilna. Printers D. Kreines and Sh. Kovalsky
Cardboard, colour printing, metal
30.5 × 22.5 × 2.5 cm (box)
Provenance: Acquired from the State Museum of Ethnography of the USSR in 1941;
previously in the Alexander Palace, Tsarskoe Selo. КП-1616–1624

The game, which belonged to Tsarevich Alexei, consists of a
special box with a picture on the lid of mounted soldiers and
burning huts, the rules of the game and 54 different pieces
(hospital train, firing cannon, soldiers etc.), 32 of which stand on
circular metal bases. The set also includes 32 spare bases. IU

270 Game of Lotto with Animal Pictures, 1903

Russia, Riga. Printers Kalinin and Deigman
Cardboard, colour printing
28.5 × 28.5 × 3.5 cm (box), 18 × 24.5 cm (boards)
Provenance: Acquired from The State Museum of Ethnography of the USSR in 1941;
previously in the Alexander Palace, Tsarskoe Selo. КП-2123–2140

The game consists of a special box with a picture on the lid of a
horse and foal in its stall, a set of rules, six boards and 71 pieces.
Also included are round metal counters in a transparent bag. IU

271 Carved Frame in the form of an Icon-Case, 19th century

Southern India, accredited to Tamil Nadu
Wood, carving
57 × 29 cm
Provenance: Acquired from the Royal Property Directorate in 1930. ИС-248
Previous Exhibitions: St. Petersburg, 1894, Cat. 146; St. Petersburg, 1994, Cat.
343

271

This intricately carved frame was brought from India by
Tsarevich Nikolai Alexandrovich during his journey to the Far
East. The frame is finished in the shape of a portal framed by two
columns with an arched embrasure and pediment above. On top
of the pediment is a border of *makar toran* — in the form of two
makars (fantastic aquatic creatures with elephants' trunks),
facing each other and joined by a magnificent garland of flowers
protruding from their open trunks. The same decorative motif
adorns the arched embrasure. The presence of such elements
confirms the southern Indian origin of the frame. The treatment
of the four-armed female figure with a third eye in her forehead,
possibly the wife of Shiva Durga, is distinctive: she sits above
the arch flanked by two elephants. The seated pose is treated
similarly, appearing for the first time on seals of the Proto-Indian
civilisation (3,000 BC), and then in reliefs of the South Indian
temple of Makhabalipuram (7th century) which also points to a
southern Indian origin for the frame.

An engraved portrait of Nicholas II, which has not survived, was
inserted into the frame. OD

272 Chess Set, Second half of 19th century

China, Guandung province
Board: wood, black and gold two-tone lacquer painting
Chess pieces: painted and white ivory
Height of pieces: 4.6–11.6 cm
Provenance: Acquired from Ethnography Department of the Russian Museum;
previously brought back by Tsarevich Nikolai Alexandrovich from his trip to the
Far East in 1890–1. Pieces: ΛH-966–997; board ΛH-998
Previous Exhibitions: St. Petersburg, 1894, Cat. 500; St. Petersburg, 1994, Cat. 360

This chess set was brought back by Tsarevich Nikolai
Alexandrovich from his trip to the Far East in 1890–1. The
tsarevich saw the chess sets and fans in shops in Guangzhou and
Hong Kong in March 1891, but this set was probably purchased
by him in Japan and exhibited in the Japanese section of the
1894 exhibition.

Chess sets were manufactured in China specially for export. Such
sets were purchased by European and Russian aristocrats and
were to be found in many well-to-do households. The board is
decorated with genre scenes in two-tone gold lacquer on black.
The sides and interior of the board are decorated with butterflies,
flowers and jewels. The box, like the chess board, is decorated
with painted spikenards. Each chess piece is cut from a single
piece of ivory. MLM

270

269

272

Furniture

273 Throne and Footstool, 1797

St. Petersburg, Workshop of H. Meier
Wood, velvet, gilding, carvings, embroidered with silver-gilt thread
Throne: 183 × 87 × 104 cm; footstool: 22 × 84 × 58 cm
Provenance: Acquired from the Winter Palace. ЭРМ6-110/1, 2

The throne is a copy of a silver gilded throne made by the
craftsman N. Clausen in London in 1731–2 and now in the
Hermitage Museum. At the behest of Paul I, the architect
V. Brenna had the court workshop of H. Meier make six copies of
the Clausen throne. The copies were placed in the throne room
of all the palaces in which Paul I stayed. Three have survived
to the present day, two in the Moscow Armoury and one in the
Hermitage Museum. This throne used to be in the throne room of
Maria Feodorovna, Paul I's wife. It was then kept permanently
at the Winter Palace where it was used until 1917. NG

274 Lady's Table, 1885–9

St. Petersburg, Factory of N. F. Svirsky
Maple, birch, oak, walnut, pear, tortoiseshell, ivory, metal, bronze, leather, velvet, silk,
inlay work, etching, gilding, casting
15.5 × 141 × 61 cm
Provenance: Acquired from the Expert Purchasing Commission of the State
Hermitage Museum in 1989. ЭРМ6-1828
Previous Exhibition: St. Petersburg, 1994, Cat. 168

From 1880 to the early 1900s Nikolai Feodorovich Svirsky
owned a factory making furniture, parquet flooring and joinery
in St. Petersburg; he also had a shop in the city. He was a regular
supplier to the court of His Imperial Highness. His factory made
the furniture for the Winter and Anichkov palaces, and the
Alexander Palace in Tsarskoe Selo. Craftsmen working for N. F.
Svirsky fitted out the imperial yacht *Polar Star*, the naval ships
Ilyin, *Rurik* and *Petropavlovsk*, the imperial broad-gauge train for
travelling around Russia, and many houses and palaces of the St.
Petersburg nobility.

This table served both as a writing desk and as a table for
needlework. The surface is covered with inlaid compositions and
ornamentation. On the inner face of the drawer a small copper
has survived with the engraved profile of Alexander III, a medal
inscribed *От города Санкт-Петербурга* [From the City of St.
Petersburg] and the inscription: *N. Svirsky, St. Petersbourg*.
The desk was most likely exhibited at the 1889 World Exhibition
in Paris where N. F. Svirsky's products were awarded a gold
medal for the quality of their inlay work. NG

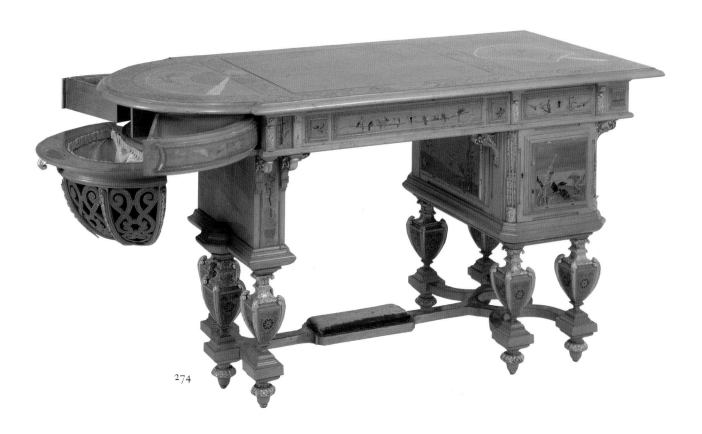

274

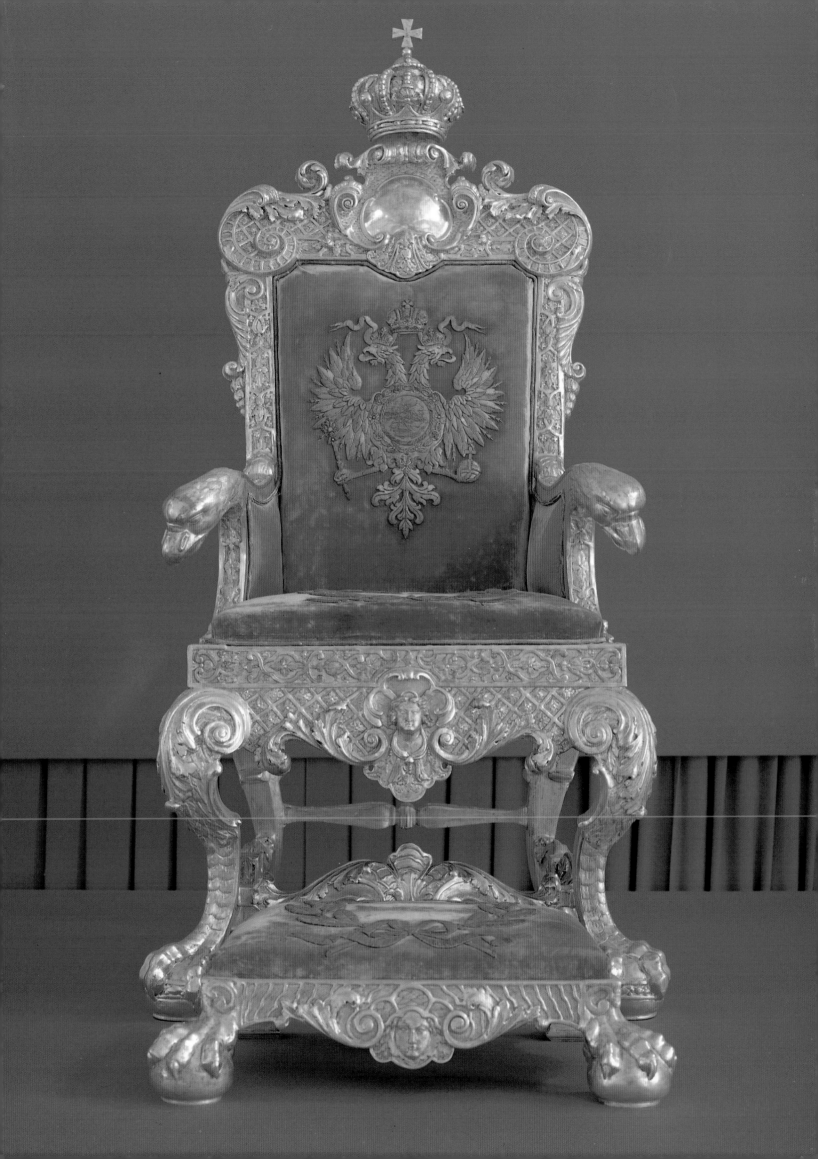

275 Desk from the Sitting-Room of Empress Alexandra Feodorovna, 1890–1900

St. Petersburg, Factory of N. F. Svirsky
Mahogany, amaranthus, metal, leather
139 × 142 × 84 cm
Provenance: Acquired from the Winter Palace. ЭРМ6-1343
Previous Exhibitions: Aarhus, 1990, Cat. 182; St. Petersburg, 1994, Cat. 169

This desk, which belonged to Empress Alexandra Feodorovna, is shown together with its chair in a 1917 photograph by K. K. Kubesh of the empress's sitting-room (no. 105). The desk is in the Jacobean style with decorative metal brackets in the form of rosettes and corrugated mounts. Furniture of this type first appeared at the end of the 1790s and regained its popularity under Alexander III and Nicholas II. One room would often combine examples of the earlier originals with later imitations.
NG

276 Chair, 1890s

St. Petersburg
Mahogany, metal, silk (new upholstery)
84 × 44 × 47.5 cm
Provenance: Acquired from the house of the counts Bobrinsky in St. Petersburg. ЭРМ6-84
Previous Exhibitions: Aarhus, 1990, Cat. 182; St. Petersburg, 1994, Cat. 170
NG

277 Pedestal Set of Shelves, Early 20th century

Russia
Mahogany, bronze
118 × 30 × 30 cm
Provenance: Acquired from the Expert Purchasing Commission of the State Hermitage Museum in 1985. ЭРМ6-1779
NG

278 Writing Desk in the form of a Lectern, 1894–6 (p. 171)

St. Petersburg, Factory of N. F. Svirsky
From the Library of Emperor Nicholas II in the Winter Palace.
Walnut, leather, carving
114 × 84 × 86 cm
ЭРМ6-1321
NG

279 Armchair, 1894–6 (p. 171)

St. Petersburg, Factory of N. F. Svirsky
From the Library of Emperor Nicholas II in the Winter Palace.
Walnut, carving
85 × 80 × 50 cm
ЭРМ6-1319
NG

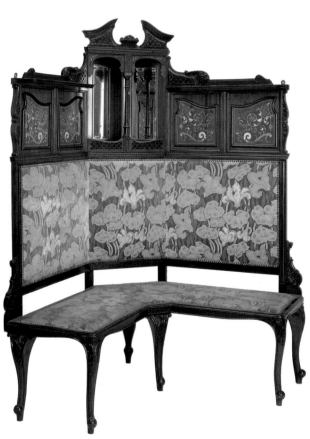

282

283

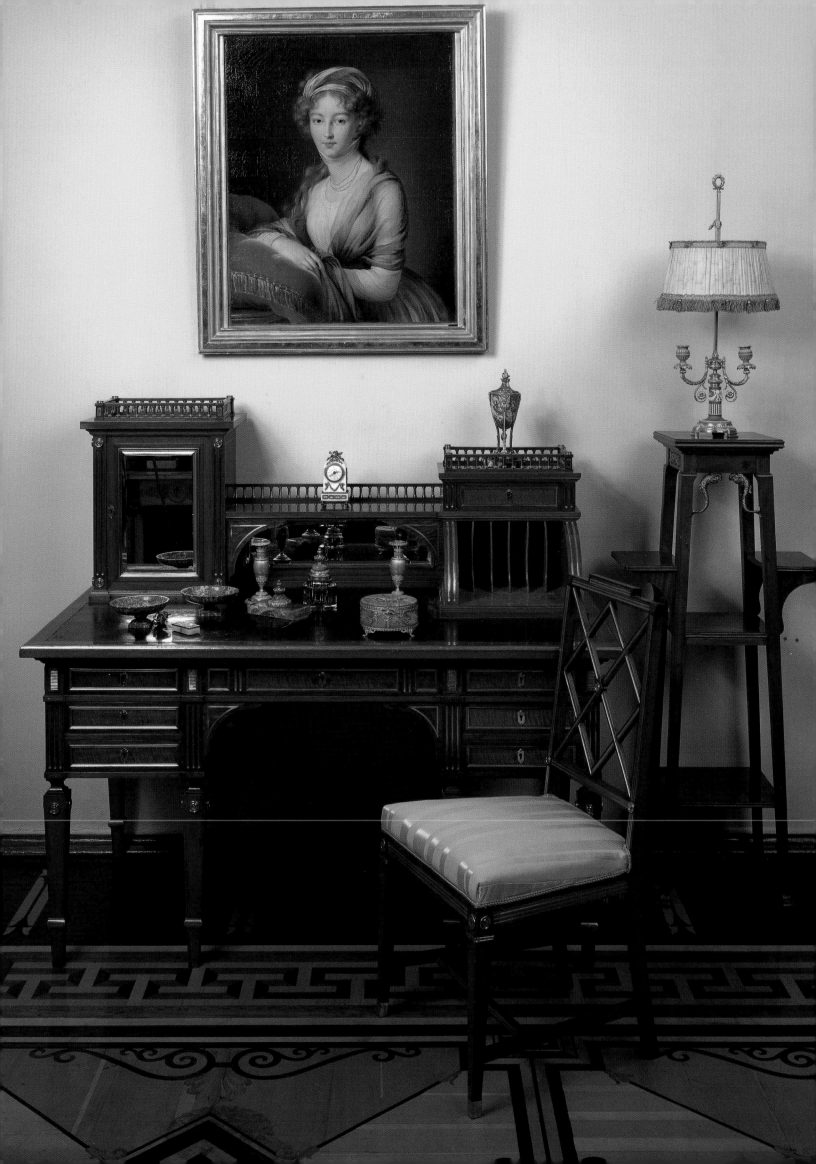

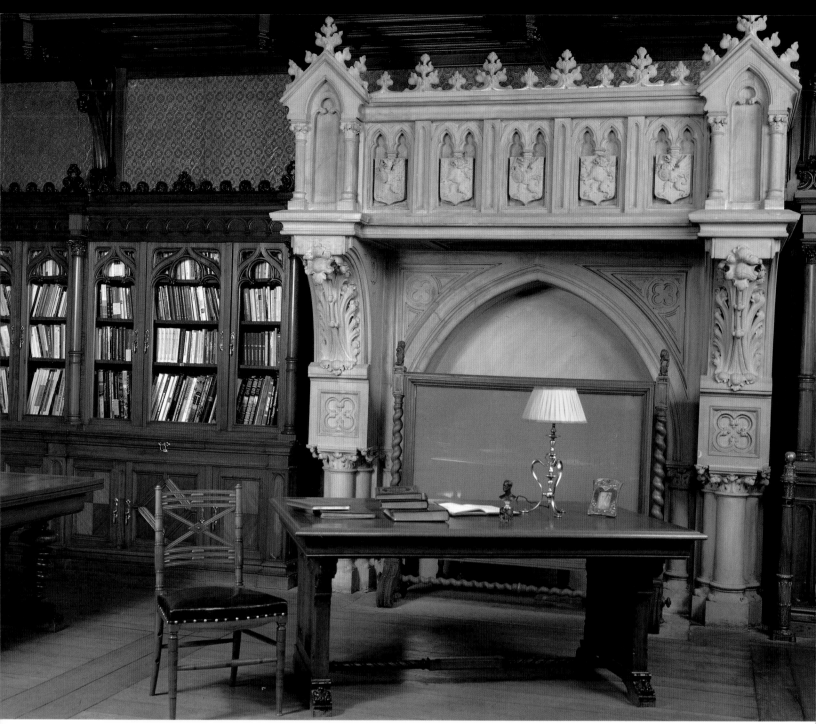

280 Table, 1894–6

St. Petersburg, Factory of N. F. Svirsky
From the Library of Emperor Nicholas II in the Winter Palace.
Walnut, carving
75 × 170 × 106.5 cm
ЭРМб-1323

The plan for the decoration of Nicholas II's library in the Winter
Palace was drawn up by the architect A. F. Krasovsky. Urgency
dictated that furniture was commissioned from two famous court
suppliers, N. F. Svirsky and F. F. Melzer. The fitted walnut
bookcases and furniture decorated with details reflecting
medieval motifs were made at Svirsky's factory. NG

281 Chair, 1894–6

St. Petersburg, Factory of F. F. Melzer
From Nicholas II's Reception Room in the Winter Palace.
Mahogany, leather
84 × 44 × 47.5 cm
Provenance: Acquired from the Winter Palace. ЭРМб-1421

The chair can be seen in K. K. Kubesh's photograph (no. 114) of
the reception room in Nicholas II's quarters at the Winter Palace.
NG

282 High-Backed Corner Divan, End of 19th century (p.168)

St. Petersburg, Factory of F. F. Melzer
Walnut, ivory, mirrorwork, velvet, inlay
175 × 141 × 43 cm
Provenance: Acquired from the Lower Palace at Alexandria at Peterhof in 1933.
Э-3572
Previous Exhibitions: Leningrad, 1974, Cat. 265; St. Petersburg, 1994, Cat. 171

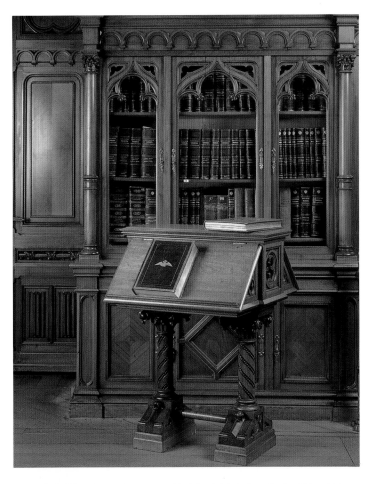

278

279

Friedrich (Feodor) Melzer and his brother Robert owned a furniture factory in St. Petersburg, which was a supplier to the court of His Imperial Highness.

In 1895 the architect A. O. Tomishko built the Lower Palace or Lower Dacha in the park of Alexandria at Peterhof. It was created for Nicholas II and his family and became their favourite place to stay. The palace's furnishings were chosen from designs by Melzer, and included this corner divan with a high back and mirror niche, edged in green velvet with a cyclamen design. Melzer also furnished Olga's rooms in the dacha at Peterhof. Nicholas II, Alexandra Feodorovna and their daughters were photographed on this very divan. Alongside the divan in the photograph can be seen the mahogany armchair (no. 287) also manufactured by Melzer and now in the Hermitage collection. TR

283 Bookcase, 1860s (p. 168)

Denmark, Copenhagen. Master J. Lund
Ebony, silver, semi-precious stones, tortoiseshell, inlay, mosaic
230 × 140.6 × 56 cm
Provenance: Acquired from the Winter Palace after 1917; previously in the Anichkov Palace in St. Petersburg. Э-6381
Previous Exhibitions: St. Petersburg, 1994, Cat. 172; St. Petersburg, 1996, Cat. 461
Literature: Jenvold, 1992, p. 35

Jorg Lund worked in the second half of the 19th century. The bookcase was built in Denmark as a gift for Princess Maria Sophia Frederica Dagmar on her wedding to the Russian heir, the future Tsar Alexander III. The top of the case is decorated with a medallion with the monogram of Sophia Dagmar. The bookcase with books in rich bindings was sent by sea to St. Petersburg in 1866 together with the princess's dowry.

It was decorated with overlay made of semi-precious stones, tortoiseshell inlay and mosaic inserts, as well as silver busts of famous Danes such as the writers Holberg and Ohlenschluger, the sculptor Torvaldsen, and the physicist Oersted. TP

284 Carriage, 1793

St. Petersburg, Royal Stables workshops. Master craftsman J. K. Buckendahl
Oak, ash, birch, lime, iron, steel, copper, brass, bronze, silver, gold, velvet, silk, canvas, leather, glass
512 × 207 × 270 cm
Provenance: Acquired from the Toy Museum in Moscow in 1929; previously in the Royal Stables Museum in St. Petersburg, Inventory No. 683
Previous Exhibitions: St. Petersburg, 1993, pp. 435–7; Washington, 1993, pp. 435–7; St. Petersburg, 1994, Cat. 174
Literature: The Royal Stables Museum, 1891, No. 3; Kreisel, 1927, p. 117, pl. 29b; Chernyshev 1989, pp. 82, 87

This carriage was built in 1793 for Empress Catherine II in the workshops of the Royal Stables in St. Petersburg. The master coachbuilder Johann Konrad Buckendahl supervised its building, evidently to his design. Right up until the beginning of the 20th century, the carriage was always used on special ceremonial occasions, including the coronation of Russian emperors in 1825 and 1856 in Moscow. In 1896 Alexandra Feodorovna rode in it to the coronation of her husband, Emperor Nicholas II.

A model of the carriage was placed in an Easter egg (no. 397) which Nicholas II presented to his wife for Easter in 1897 to celebrate her accession to the Russian throne. The egg was made by craftsmen from the firm of Fabergé — the jewellers Mikhail Perkhin and Henrik Wigström; the model of the carriage was made by Georg Stein. Stein spent more than a year working on the model and for that reason visited the Royal Stables Museum in St. Petersburg where the original was kept. VC

285 Grand Piano, 1898

St. Petersburg. Mechanism by the firm of A. M. Schroeder (No. 17003); decoration by E. K. Liphart; bronze by C. Bertault; carving by S. Volkovyssky
On the lid top right: Липгарт [Liphart] 1898
Wood, gilded bronze, painting, carving
277 × 156 × 100 cm
Provenance: Acquired from the Music Department of the Hermitage in 1940. Э-6280
Previous Exhibitions: St. Petersburg, 1994, Cat. 173; St. Petersburg, 1996, Cat. 460

This grand piano was a gift to Empress Alexandra Feodorovna from her husband. Its decoration was entrusted to one of the

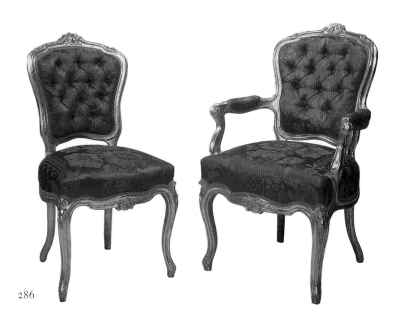

286

287

most famous St. Petersburg artists of the time, Ernest Karlovich Liphart, who covered the finished instrument with paintings on the theme of the myth of Orpheus. In his memoirs he wrote that he had painted 100 figures depicting the entire legend of Orpheus. TS

286 Armchair and Chair, 1853

St. Petersburg. To a design by Yu. A. Bosse
Wood, silk (contemporary upholstery), carving, gilding
Armchair: 100 × 56 × 65 cm; chair: 92 × 50 × 48 cm
Provenance: Acquired from the Winter Palace in 1996. Э-3885, 3887
Previous Exhibition: St. Petersburg, 1996, Cat. 505–7
Literature: Sokolova, 1973, pp. 24, 249

These chairs belong to an ensemble made for the boudoir of Empress Maria Alexandrovna, the grandmother of Nicholas II. The luxurious interior and arrangement of the various pieces of furniture have been preserved to the present day. TS

287 Armchair with Rounded Back, End of 19th century

St. Petersburg, Factory of Melzer
Mahogany, velvet
81 × 55 × 45 cm
Provenance: Acquired from the Lower Palace at Alexandria at Peterhof in 1933.
Э-3866
Previous Exhibition: Leningrad, 1974, Cat. 265
TR

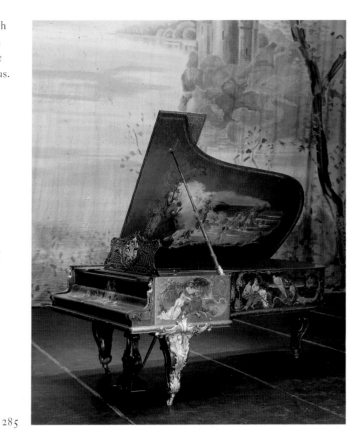

285

284

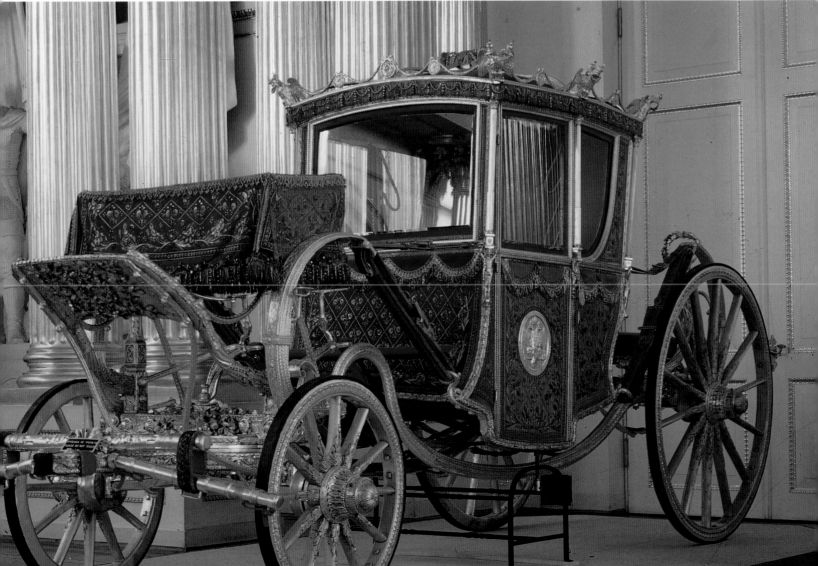

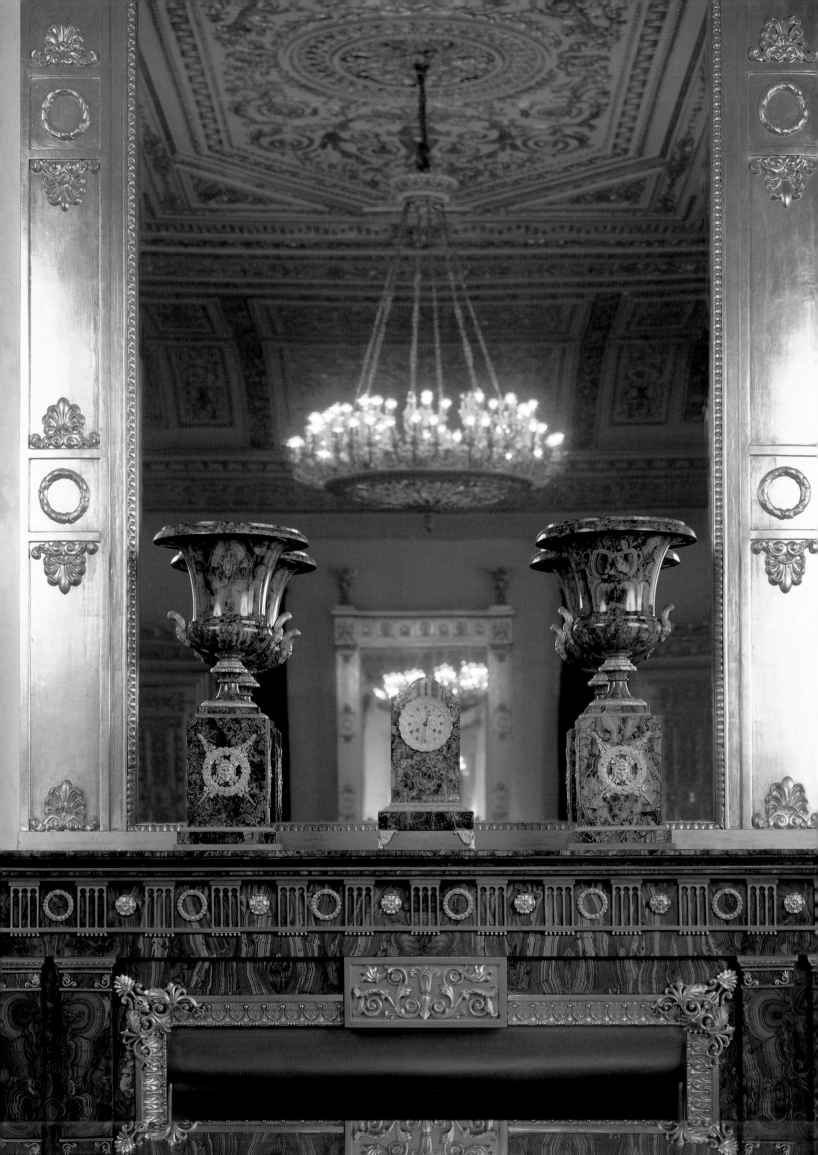

Tapestries

303 *The Seasons* Series, 1910–13

Paris, Gobelins Manufactory
From cartoons by Jules Chéret (1836–1932)
Provenance: Acquired from the Winter Palace in 1924
Previous Exhibitions: Leningrad, 1974, Cat. 270–3; St. Petersburg, 1994, Cat. 333–6
Literature: Guiffrey, 1911, No. 252; Kuhn, 1905–6, p. 11; Jarry, 1968, p. 306; N. Biriukova, 1974, Nos. 46–9

This series was produced from cartoons by Jules Chéret, the famous artist and creator of designs and cartoons for tapestries. It is an interesting example of early 20th century tapestry weaving, containing features of art noveau. The series was recreated several times at the Gobelins Manufactory and was complemented by upholstery for a suite of furniture. There is an identical series at the State Furniture Archive in Paris. The Hermitage tapestries were brought to the Winter Palace as a gift from the French president Raymond Poincaré during his visit to Russia in 1914.

Winter: Holly, 1911–13 (top left)

Weavers: Thuaire and Claude
Bottom right, woven at the border: *Chéret 1910*; on the right edge the manufactory's mark: *RF/S*, the date: *1911–1913* and the weavers' signatures: *C. H. Thuaire, L. Claude*
Wool, silk, 8 warp threads per cm; 280 × 170 cm
T-15595

On the reverse side is the Gobelins ribbon with the mark: *Manufacture Nationale des Gobelins. N 625. D'après J. Chéret. Les Houx (réplique)* [Gobelins State Manufactory, No. 625, from J. Chéret. Holly (replica)]. N B

Spring: Roses, 1911–13 (top right)

Weavers: Chevalier and Cuneo
Bottom right, signature woven: *Chéret*; on the bottom edge the mark: *RF/S*, the date: *1911–1913* and the weavers' signatures: *Chevalier, Cuneo*
Wool, silk, 8 warp threads per cm; 280 × 175 cm
T-15592

On the reverse side is the Gobelins ribbon with the mark: *Manufacture Nationale des Gobelins. N 637. Les Roses (réplique). D'après le modèle de J. Chéret* [Gobelins State Manufactory, No. 637. Roses (replica), from cartoon by J. Chéret]. N B

Summer: Corn, 1911–12 (bottom left)

Weavers: Gauzy, Gagnot, Deluzenu
Bottom right, at the border, the signature: *Chéret*; on the right edge the mark: *RF/S*, the date: *1911–1913* and the weavers' signatures: *H. Gauzy, G. Gagnot, E. Deluzenu*
Wool, silk, 8 warp threads per cm; 278 × 172 cm
T-15593

On the reverse side is the Gobelins ribbon with the mark: *Manufacture Nationale des Gobelins. N 621. Les Blés (réplique). D'après J. Chéret* [Gobelins State Manufactory, No. 621. Corn (replica), from J. Chéret]. N B

Autumn: Grape-Vines, 1912–14 (bottom right)

Weavers: Boucher, Gonnet, Claude, Laurent
Bottom right, signature: *Chéret*; on the edge the mark: *RF/S*, the date: *1912–1914* and the weavers' signatures: *H. Boucher, Gonnet, Claude, F. Laurent*
Wool, silk, 8 warp threads per cm; 275 × 170 cm
T-15594

On the reverse side is the Gobelins ribbon with the mark: *Manufacture Nationale des Gobelins. N 657. Les Pampres (réplique). D'après J. Chéret* [Gobelins State Manufactory, No. 657. Grape-vines (replica), from J. Chéret]. N B

304 *Goddaughter of the Fairies* Tapestry, 1876–89

France, Gobelins Manufactory, workshop of E. Flament and F. Munier
Bottom left: *Mazerolle 1876*, in the left corner at the edge: *P. V. Galland invi 1879 Frd Flament Fs Munier*. At the edge is embroidered: *Gobelins RF 1888*. In the centre of the bottom border on a cartouche: *Filleule des Fées*; in the centre of the upper border is the Russian crest with the legend: *С Нами Бог* [God be with us]. At the corners, cartouches with the Gobelins Manufactory mark
Wool, silk, gilt thread
435 × 735 cm
Provenance: Acquired from the Winter Palace in 1924. T-15551
Previous Exhibition: St. Petersburg, 1996, Cat. 781
Literature: Fenaille, 1923, pp. 161, 162; Guiffrey, 1911, p. 78; Biriukova, 1974, No. 45

The cartoon was ordered by A. J. Mazerolle in 1874 for one of the halls of the Elysée Palace and was exhibited at the Paris Salon of 1876. The sketch for the border was done by P. V. Galland. After the work was completed in 1889, the tapestry was exhibited at the International Exhibition in Paris, but it was not selected for the Elysée Palace. In 1895 it was designated as a coronation present for Nicholas II, after which the Russian crest was woven in and embroidered on the upper border. The composition reflects the tradition of easel painting, which was a peculiarity of tapestry weaving of the 19th century. The border is composed in the 17th century style. N B

301 Cabinet with 'Arabesque' Mosaic Panel, 1886–8

Peterhof, Imperial Lapidary Factory. From designs by N. V. Nabokov and L. Leriche (panel). Masters: A. V. Shutov (carpentry), A. Ya. Sokolov (bronze), A. Kakovin and assistants, R. Pestu (mosaic)
Oriental plane wood, ormolu, Florentine mosaic (lapis lazuli, chalcedony, jasper, amazonite)
148 × 72 × 40 cm
Provenance: Acquired from the Directorate of the Russian Gem Trust in 1941; previously, from 1893 to 1924, in the Anichkov Palace in St. Petersburg. ЭРМ6-454
Previous Exhibition: St. Petersburg, 1994, Cat. 183
Literature: Fersman, Vlodavets, 1921, pp. 25, 29; Belitskaya, 1983, pp. 58, 59

By order of Alexander III and Maria Feodorovna, the Peterhof Lapidary Factory made three identical cabinets with mosaic panels for the Anichkov Palace in St. Petersburg from 1886 to 1892. In 1941 two of them were transferred to the Hermitage, the third to the A.V. Shchusev State Architecture Museum in Moscow (currently in the A. E. Fersman Mineralogical Museum). In 1893 the cabinet was exhibited at the International Columbus Exhibition in Chicago. LT

302 Gilded Wooden Table with Malachite Top, 1830s

Table top: Ekaterinburg Lapidary Factory, 1836–7
Base: St. Petersburg, late 1830s
Wood, serpentine, malachite, engraving, gilding
Height 80 cm; *diam.* of top 71.5 cm
Provenance: Acquired from the Winter Palace. Э-3575
Literature: Semeonov, 1987, vol. ii, p. 129

The technique of setting mosaics of malachite is one of the most remarkable aspects of the work of the Ekaterinburg Lapidary Factory. The decision not to work with the usual single-piece materials was based on the structure of the material, as much as for economic reasons. In the finest articles produced at the factory, the pieces of facing stone created a distinctive rhythm that contributed to an overall decorative effect, and this can be seen particularly clearly in the articles designated for the imperial court.

This table (its pair is also in the museum) was made from a design by the architect I. I. Galberg (1778–1836). The serpentine boards set with malachite were made in the Urals at the Ekaterinburg Lapidary Factory. It can be gleaned from archive sources that the work on lining the two boards which make up the base of the table tops was begun on 11 October 1836. Tagil malachite was obtained from the Demidov manufacturers. In September 1837 the finished table tops were sent to the capital; they cost 3,975 roubles and 65 kopecks. The carved, gilt bases were made in St. Petersburg, evidently shortly after the table tops had arrived in the capital. NM

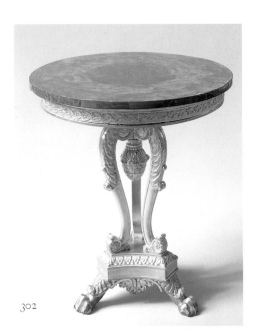

302

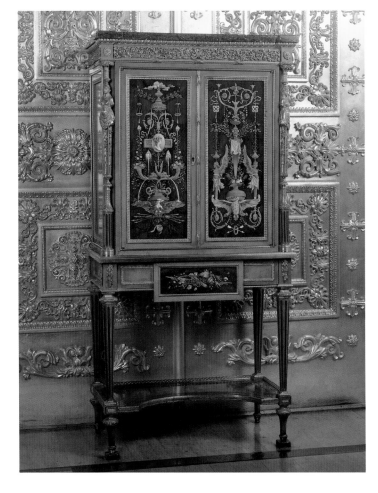

301

297 Vase in the form of an Amphora, Mid 19th century

St. Petersburg
Loop-shaped handles with two-faced masks and swans' heads; ormolu heraldic figures on the body: cupids with a lyre and trumpeting figures of Glory.
Marble, ormolu, engraving
60.7 × 24.5 × 23.3 cm
Provenance: Acquired from the State Hermitage Expert Purchasing Commission in 1949; previously in the Benckendorf family. ЭРКм-557
Previous Exhibition: St. Petersburg, 1994, Cat. 175

This vase is reputed to come from the former private rooms of lady-in-waiting Elizaveta Andreevna Benckendorf, on the third floor of the Winter Palace. Born Elizaveta Zakharzhevskaya, she married Count A. Kh. Benckendorf and was lady-in-waiting to Empress Alexandra Feodorovna (wife of Nicholas I) from 1839 to 1858. LT

298 Scaphoid Vase with Lid, 1900s

Peterhof, Imperial Lapidary Factory. Mounting: workshop of K. Bok
Mark on the mounting: *KB*
Mounted in silver with open-work meander on the body, handles and stem.
Lapis lazuli, silver, engraving, etching
13 × 23 × 8.8 cm
Provenance: Acquired from the State Museum of Ethnography of the USSR in 1941; previously at the Winter Palace, among the personal effects of Empress Maria Feodorovna. ЭРКм-395 a, б
Previous Exhibitions: Delhi, 1984, Cat. 92; Sofia, 1984, Cat. 92; Aarhus, 1990, Cat. 140; St. Petersburg, 1994, Cat. 176

A. L. Gun remembers, 'The court was very interested in the factory; Alexander III, Maria Feodorovna and Maria Pavlovna visited particularly often ... The factory was generally engulfed with orders from the court for personal needs, presents, foreign exhibitions ... Displays were often arranged at the Winter Palace, and the best items were sent: it became something of an improvised exhibition, and the royal personages chose according to personal taste ...' (A. E. Fersman, 1921, p. 25). LT

299 Carriage Clock, 1840s (p. 174)

Peterhof, Imperial Lapidary Factory
In a tetrahedral malachite case; face, base and frame of ormolu with embossed floral decoration.
Malachite, mosaic, 'rough velvet' set, ormolu
35.8 × 20.5 × 12.5 cm
Provenance: Acquired from the State Museum of Ethnography of the USSR in 1941; previously at the Winter Palace. ЭРКм-218
Previous Exhibitions: Delhi, 1984, Cat. 87; Sofia, 1984, Cat. 87; St. Petersburg, 1994, Cat. 177
Literature: Voronikhina, 1963, No. 10, p. 89; Semeonov, 1987, vol. i, No. 63, p. 199
LT

300 Flat Round Plate, Early 20th century

Peterhof, Imperial Lapidary Factory. From a sketch by A. L. Gun
Plate on three small legs with a band and open-work piping round the edge; in a suede case with a white satin lining; inside the lid of the case is the mark of the Imperial Lapidary Factory in Peterhof
Green jade, engraving
2 × 20.5 cm
Provenance: Acquired from the State Museum of Ethnography of the USSR in 1941. ЭРКм-409
Previous Exhibitions: Moscow–Paris, 1981; St. Petersburg, 1994, Cat. 179

Andrei Leontevich Gun (1841–1924) was an academician of architecture and professor at the St. Petersburg Academy of Arts. He was an architect at the Peterhof Lapidary Factory from 1873, becoming director of the factory from 1886 to 1911.

The brochure of the Peterhof Lapidary Factory for 1897 reads: 'The main concern of the factory is manufacturing articles for the Royal Court. The factory's work is varied; without curtailing the production of the Florentine mosaic articles which have brought it universal fame, the factory has increased the production of articles from jade and other hard stones (what we used to term "tough stones") ... The former Grand Duke Alexei Alexandrovich placed a large number of orders, particularly of jade, for the Countess Beauharnais. The former grand dukes Vladimirovich used to order a large number (in batches) of small items as presents for their friends and servants ...' (A. E. Fersman, 1921, pp. 24–5). LT

297

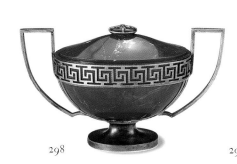

298

290

300

Stone

288 Pair of Vases in the form of a Crater, 1826–30

Peterhof, Imperial Lapidary Factory. From a design by I. I. Galberg
Vases on plinths, with ormolu Bacchic masks.
Malachite, mosaic, ormolu
67 × 24 × 24 cm
Provenance: Acquired from The State Museum of Ethnography of the USSR in 1941;
previously at the Winter Palace. ЭРКм-325a, 6; 326a, 6
Previous Exhibition: Essen, 1990, pp. 404, 411, Cat. 358

The architect Ivan Ivanovich Galberg (1782–1863) graduated
from the Academy of Arts. In 1805 he worked as assistant to the
architect G. Quarenghi on alterations to the Small Hermitage,
and later as architect of His Imperial Majesty's Study from 1817.
In the 1820s and 1830s he participated in the construction of the
Mikhailovsky Palace and the Alexandrinsky Theatre in St.
Petersburg. He was famous as a teacher. LT

289 Jade Ink Set, 1910s

St. Petersburg
Crystal ink-well and sand-box, with a bell stand in the centre; ormolu on the
casing and base.
Dark-green jade, crystal, ormolu, engraving
11 × 27.5 × 16 cm
Provenance: Acquired from the State Hermitage Expert Purchasing Commission
in 1980. ЭРКм-1083
LT

290 Paper Knife, Early 20th century (p. 176)

In a case with the mark of the Imperial Lapidary Factory, Peterhof
Dark-green jade, carving, leather, silk, suede, metal
Knife: 0.6 × 18.5 × 1.7 cm; case: 2 × 24.2 × 4.8 cm
Provenance: Acquired from the State Hermitage Expert Purchasing Commission
in 1986. ЭРКм-1119
LT

291 Writing Set Articles, 1902–11 (p. 169)

Peterhof, Imperial Lapidary Factory. From a sketch by A. L. Gun
Decahedral crystal ink-well with a detachable ormolu and onyx round lid:
Light-green onyx with brown veins, crystal, ormolu, engraving
15 × 9 × 9 cm. ЭРКм-1143a, 6
Onyx paperweight with a pen set in ormolu:
11 × 14.8 × 7.8 cm. ЭРКм-1144
Provenance: Acquired from the State Hermitage Valuing and Purchasing Commission
in 1989. ЭРКм-1144
LT

292 White Marble Desk Clock, Late 19th century (p. 169)

France, Paris. Le Roy and Son studio
On the clock-face: *Le Roy & Fils, 35 Av^{ue} De L'Opera Paris.*
Enamel face and ormolu surround in neo-classical style.
Clock: marble, ormolu, engraving
Mechanism: copper alloys, steel, enamel, bronze
14.6 × 7.8 × 6.5 cm
Provenance: Acquired from the State Museum of Ethnography of the USSR in 1941;
previously at the Winter Palace. ЭРКм-484
LT

293 Pair of Vases in the form of Shallow Bowls, Late 19th century
(p. 169)

Italy
Light-brown marble with golden speckles and black veins, engraving
5.9 × 14.7 cm
Provenance: From the original Hermitage Collection. ЭРКм-1013, 1014
LT

294 Ovoid Vase in the form of a Tripod, Second half of the 19th century
(p. 169)

Italy
Reddish-brown marble with white pattern, ormolu, engraving
26.3 × 12.2 × 9.1 cm
Provenance: Acquired from the State Museum of Ethnography of the USSR in 1941.
ЭРКм-394
LT

295 Round Box, 1885 (p. 169)

With hinged lid and applied decorations of ormolu.

Italy, Trieste
Stamp on red silk lining inside: *К.П.Н.З.А. 1885 D. TRIEST*
Aragonite, ormolu, engraving, silk
7.8 × 14.1 × 14.9 cm
Provenance: Acquired from the State Museum of Ethnography of the USSR in 1941.
ЭРКм-480
LT

296 Alabaster Electric Desk Bell, c. 1872 (p. 169)

Vienna
Marks: *A.H.* [masters], two marks of the Vienna assay office 1866–72
With mother-of-pearl bell-push, mounted in silver open-work in neo-classical style.
Alabaster, engraving, gilding, silver, mother-of-pearl
2.5 × 7.1 × 7.1 cm
Provenance: Acquired from the State Museum of Ethnography of the USSR in 1941;
previously at the Anichkov Palace in St. Petersburg. ЭРКм-197
LT

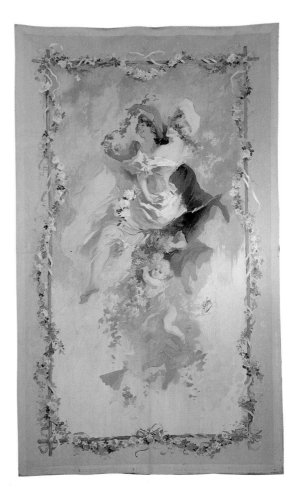

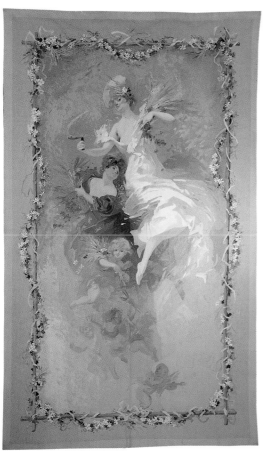

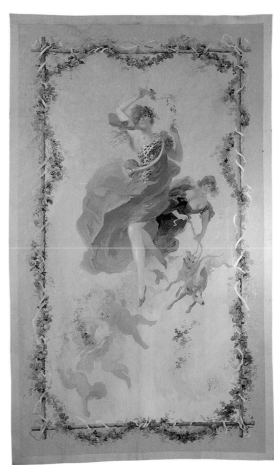

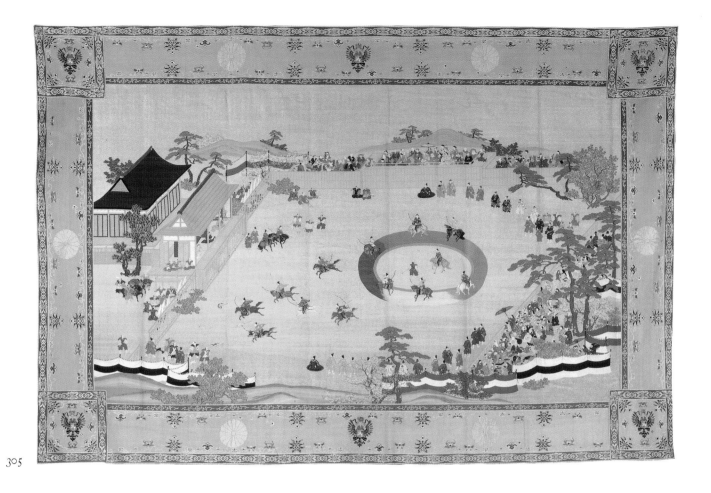

305

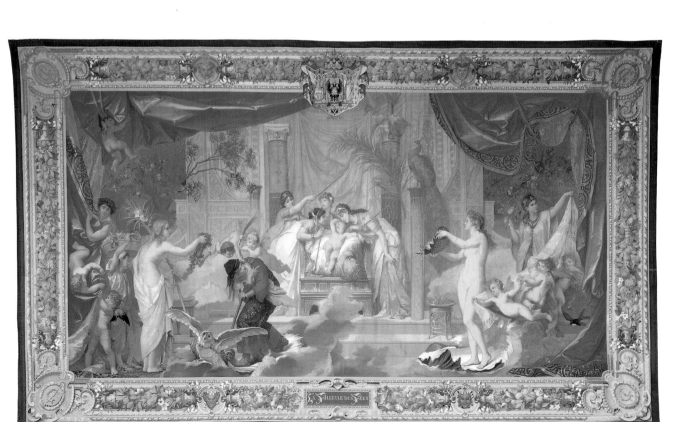

304

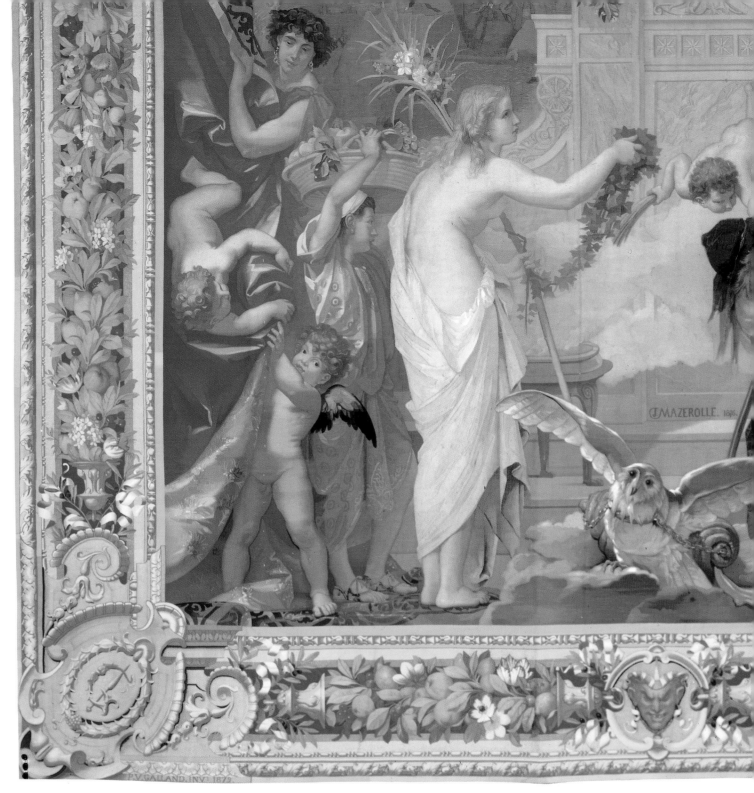

304
(detail)

305 *Dog Hunt* Carpet (*Inuoumano*), 1888–90

Japan, Kyoto. Kavasima Manufactory
Silk, paper, gold thread
290 × 440 cm
Provenance: Acquired from the Museum of the Revolution in 1930. ЯТ-2049
Previous Exhibitions: St. Petersburg, 1894, No. 367; Nagasaki, 1990, p. 38, 39; Berlin, 1993, No. 12/23, p. 411; St. Petersburg, 1994, Cat. 345

The carpet was a present from Emperor Meiji to Tsarevich Nikolai Alexandrovich on 7 May 1891. It depicts a dog hunt: galloping horsemen are shooting at running dogs, and another group of horsemen are waiting their turn inside a large circle set in the centre of a huge arena, with spectators all around. The main field is fringed by a border with a stylised floral decoration and a depiction of the chrysanthemums of the Japanese imperial crest; in the centre of the horizontal stripes of the border is depicted the Russian crest — the double-headed eagle beneath the imperial crown. MU

Banners and Standards

The reign of Emperor Alexander II saw the introduction of an entirely new design for banners and standards. This pseudo-Russian style fully corresponded to both the ideology and the art of the time. In place of the flags with the square cross which had existed for 150 years there appeared panels with icons, traditional decorations, and inscriptions imitating interwoven ornaments. The symbolism of the flag corresponded precisely to the formula: 'Autocracy, Orthodoxy, *Narodnost* [National Character].' Instead of the state coat of arms, the central place on the front and back of the panel was taken by the emperor's monogram and an icon depicting a saint or a church festival which corresponded to the feast day of the regiment. The character of the decorations and inscriptions was in line with the interpretation of folk traditions. At the same time, the traditions of Russian military heraldry were also respected. This was reflected in the fact that regimental colours were preserved for the colours of the banners or their borders. Thus the banner of the Life-Guard Preobrazhensky Regiment with its icon of the 'Transfiguration of Christ' was red, while that of the Life-Guard Semeonovsky Regiment was blue with an icon of 'The Presentation of the Blessed Virgin'. The banner of the Life-Guard Engineers Battalion, which it was awarded on its 100th anniversary, was black and silver with an image of The Saviour Not-Made-With-Hands. Traditional standards in the form of the labarum were also preserved for the heavy cavalry guards — the Cavalier Guards, Horse Guards and His and Her Majestys' Cuirassier Regiments. Their standards were fixed not to the staff, but to the cross-beam, hung by chains to the upper part. The new banner designs were still bestowed at regimental anniversaries, or as an award or on the formation of a new unit. Thus, in 1896, on the occasion of its 100th anniversary, Emperor Alexander III's 68th Borodinsky Life-Infantry Regiment received its new St. George jubilee banner. The panels of the banners, on which the icons were painted in oils, turned out to be cumbersome and not very durable. For this reason the new banner design introduced in 1900 differed from the previous one not only in the monogram of the reigning emperor, but also in that the regimental icons were replaced by a woven image of The Saviour Not-Made-With-Hands. These banners were presented throughout the remaining years of the empire, in particular to the Orenburg Cossack Regiments in 1915. One other innovation in the life of the army at that time was the movement designed to inculcate a patriotic spirit into young boys. In army units and military academies *poteshny* (toy soldier) brigades were formed, in which boys learned the basics of military training. Some brigades had their own banners; for example the General Staff Poteshny was presented with its banner in a ceremony that took place in 1911 on Palace Square in St. Petersburg. GVV

306 St. George Anniversary Banner of the Life-Guard Engineers Battalion, 1912

Silk, embroidery, wood, bronze
109 × 119 cm
Provenance: Acquired from the Artillery Museum in Leningrad in 1950. ГЭ-ЗН
Previous Exhibition: St. Petersburg, 1994, Cat. 312
GVV

307 St. George Anniversary Banner of the Life-Guard Semeonovsky Regiment, 1883

Silk, oils, embroidery
111 × 163 cm
Provenance: Acquired from the Artillery Museum in Leningrad in 1950. ГЭ-ЗН 2984
Previous Exhibition: St. Petersburg, 1994, Cat. 313
GVV

308 St. George Anniversary Standard of His Majesty's Life-Guard Cuirassier Regiment, 1902

Silk, embroidery
60 × 11 cm
Provenance: Acquired from the Artillery Museum in Leningrad in 1950. ГЭ-ЗН 3077
Previous Exhibition: St. Petersburg, 1994, Cat. 314
GVV

309 Anniversary Banner of the 14th Orenburg Cossack Regiment, 1915

Silk, embroidery, wood, bronze
10 × 80 cm
Provenance: Acquired from the Artillery Museum in Leningrad in 1950. ГЭ-ЗН 3127
Previous Exhibition: St. Petersburg, 1994, Cat. 315
GVV

310 St. George Anniversary Banner of Emperor Alexander III's 68th Borodinsky Life-Infantry Regiment, 1896

Silk, embroidery
111 × 163 cm
Provenance: Acquired from the Artillery Museum in Leningrad in 1950. ГЭ-2979
Previous Exhibition: St. Petersburg, 1994, Cat. 316
GVV

311 Banner of the General Staff Poteshny Brigade, 1911

St. Petersburg
Silk, metallic thread, wood
60 × 60 cm
Provenance: Acquired from the Artillery Museum in Leningrad in 1950. ГЭ-ЗН 3522
Previous Exhibition: St. Petersburg, 1994, Cat. 317
GVV

306

307

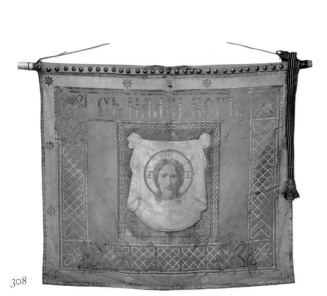

308

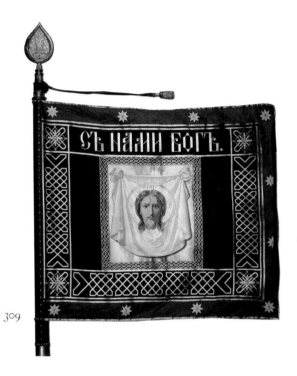

309

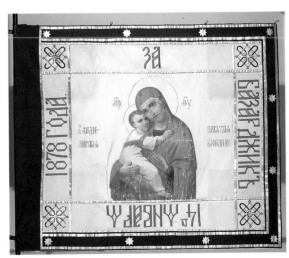

310

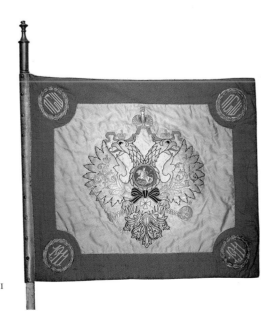

311

Costumes

312 Festive Costume of Tsarevich Alexei Nikolaevich, *c. 1909*

Velvet, taffeta, silver, copper, pearls, metal thread, embroidery work
Length: of jacket along the back 35 cm, of breeches 47 cm
Provenance: Acquired from the State Museum of Ethnography of the USSR in 1941; previously at the Alexander Palace in Tsarskoe Selo. ЭПТ-12797, 12798
Previous Exhibitions: Paris, 1989, Cat. 130; St. Petersburg, 1994, Cat. 219

The State Hermitage funds contain several items of clothing which belonged to Alexei: a winter coat, a summer coat, a dressing gown, and dress uniforms. The velvet suit belonged to the heir to the throne when he was no more than five years old. The monogram *H II* indicates that the suit belonged to Alexei, since only the heir to the throne had the right to wear the monogram of the reigning emperor on his epaulettes. EM

313 Festive Dress of One of the Daughters of Nicholas II,
Late 19th century

Moscow
Bodice bears the mark of Moscow shop: *магазин детских нарядов АМСТЕРДАМ москва* [children's outfitters AMSTERDAM Moscow].
White crepe, short flounced sleeves; bows of broad moiré ribbon at shoulders and waist; collar decorated with lace; gold embroidery on flounces and hem
Length 103 cm
Provenance: Acquired from the State Museum of Ethnography of the USSR in 1941; previously at the Alexander Palace in Tsarskoe Selo. ЭПТ-13594
Previous Exhibition: London, 1987, Cat. 90
EM

314 Russian Style Ceremonial Dress of One of the Daughters of Nicholas II, Early 20th century

St. Petersburg
Length along the back 95.5 cm
Provenance: Acquired from the State Museum of Ethnography of the USSR in 1941; previously at the Alexander Palace in Tsarskoe Selo. ЭПТ-13600
Previous Exhibition: Paris, 1989, Cat. 129

Children's ceremonial court dresses had no train — their décolletage was higher than on adult women's dresses — but the long, folded back sleeves stretching below the knees and the mid-line of the front emphasised by a vertical panel with buttons repeated the typical official ceremonial dress of ladies at court. EM

315 Summer Dress of One of the Daughters of Nicholas II,
Early 20th century

St. Petersburg
White cambric, open, short sleeves, seamed at the waist, gathered skirt; flounces at the collar, sleeves, hem and on the breast; finished with white satin-stitch embroidery and braided linen lace; underdress of pink silk fabric, repeating the cut of the dress, sleeveless, frills on the hem and collar, sleeves trimmed with braided linen lace
Provenance: Acquired from the State Museum of Ethnography of the USSR in 1941; previously at the Winter Palace. ЭПТ-13538, 13582
Previous Exhibition: St. Petersburg, 1994, Cat. 221

In the late 19th and early 20th centuries girls' summer dresses were frequently made from white cambric tinged by the shade of the coloured underdresses worn beneath. Depending on its function, a dress would be decorated with the appropriate degree of elaboration with English satin-stitch embroidery, lace insertions and frills. The waist was defined by a wide silk ribbon which was tied in a large bow. The semi-transparent white fabrics and monotone trimmings contrasted elegantly with the coloured background provided by the underdresses. The daughters of Nicholas II are shown wearing dresses of this type in family photographs. EM

316 Summer Dress of One of the Daughters of Nicholas II,
Early 20th century

St. Petersburg
White cambric, open, short sleeves, seamed at the waist, gathered skirt; flounces at the collar, sleeves, hem and on the breast, trimmed with white satin-stitch embroidery and braided linen lace; underdress of pale-blue satin, repeating the cut of the dress, sleeveless, frill on the hem, collar and sleeves trimmed with braided linen lace
Length: of dress 90 cm, of underdress 83 cm
Provenance: Acquired from the State Museum of Ethnography of the USSR in 1941; previously at the Winter Palace. ЭПТ-13534, 13579
EM

317 Uniform of a Colonel of the Life-Guard Grenadier Regiment which belonged to Emperor Nicholas II, 1908–17

St. Petersburg
Double-breasted tunic of dark blue-green broadcloth; collar of medium blue broadcloth with red braid; red lapel, cuffs and braid; regimental officer's embroidery of the 1908 pattern on the collar and cuff flaps; gilded buttons; colonel's shoulder-boards of gold piping with red stripes and backing, embroidered with the silver monogram *A III* under a crown; officer's sash of silver thread with black and orange stripes; gold cord aiguillette of court pattern. Note that the embroidered officer's badge is incorrectly positioned.
Lengths: back of tunic 65 cm, shoulder-boards 16 × 6 cm, sash 99.5 × 5 cm, aiguillette 90 cm
Provenance: Tunic acquired from the Pushkin palace-museums in 1973; previously in the Alexander Palace at Tsarskoe Selo (wardrobe of Emperor Nicholas II); sash and aiguillette from the State Museum of Ethnography of the USSR in 1941. ЭПТ-18196 а, б, в, г; 10769, 10806
Previous Exhibition: St. Petersburg, 1994, Cat. 234

The Life-Guard Grenadier Regiment was formed on 30 March 1756 as the 1st Grenadier Regiment. It performed many feats on the field of battle under this name, for which in 1775 it was granted the honorary title of Life-Guard. At the same time, all ranks of the regiment, as an honour, were granted the right to wear aiguillettes on the right shoulder, gold for officers and silk for other ranks. At the beginning of the 19th century, this distinction was replaced by tabs on the collar and cuffs of the tunic. On 13 April 1813, for its feats in the Patriotic War of 1812, the Life-Guard Grenadier Regiment was incorporated into the Imperial Guard under the same name. In 1908, the tunics of the officers in the regiment were decorated with gold embroidery depicting the old mark of distinction, the aiguillette, and in 1913, the distinction itself was restored.

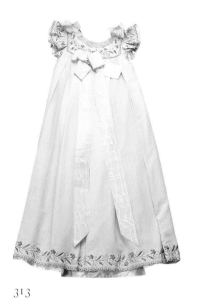

313

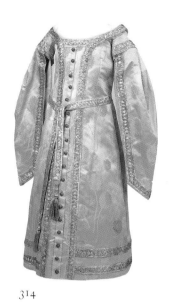

314

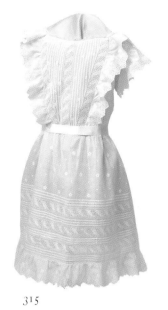

315

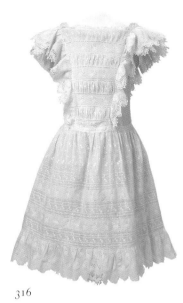

316

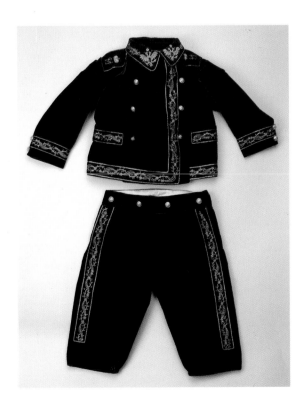

312

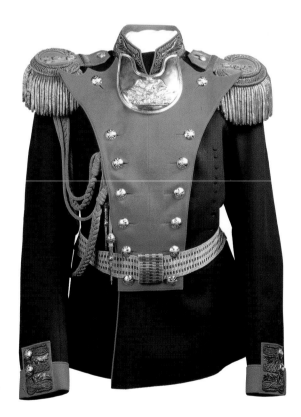

317

Emperor Nicholas II was entered in the regimental rolls from birth. On the day of his coronation, he became colonel-in-chief of the Life-Guard Grenadier Regiment. On 30 July 1904, the new-born heir to the throne, Tsarevich Alexei Nikolaevich, was enrolled with the rank of second lieutenant. SL

318 Colonel's Uniform of the Life-Guard Finland Regiment, which belonged to Emperor Nicholas II, 1908–17

St. Petersburg
Double-breasted tunic of dark blue-green broadcloth with red cuff flaps and piping; regimental officer's embroidery of the 1908 pattern; gold buttons; gold shoulder-boards of the Guards pattern, with superimposed monogram *A III* under a crown. Officer's shako covered in blue-green broadcloth with red piping on cap band and gold braid round the top edge; bottom and peak of black patent leather; chinstrap covered in gilded brass scales; on front, plated St. Andrew's star and badge of distinction with the inscription: *За Филиппополь 5 января 1878 года* [For Plovdiv 5 January 1878].
Lengths: back 61 cm, shoulder-boards 11 cm; *height* of shako: 17.5 cm
Provenance: Acquired from the Central Museum Stocks Depository in 1960; before 1941 it was in the Alexander Palace at Tsarskoe Selo (wardrobe of Emperor Nicholas II). ЕД-625-II, ЕД626-II, ЕД627-II
From the State Palace Museum, Tsarskoe Selo

The Life-Guard Finland Regiment traces its history from the Imperial Battalion of the militia, formed on 12 December 1806 from Finnish serfs on the court estates of the capital. On 22 January 1808, the battalion became part of the Guards, and from 8 April of the same year began to use the name Finland. On 19 October 1811, the Life-Guard Finland Battalion was developed into a regiment of the same name. For valiant war service in the wars of the 19th century, the Finlanders were awarded many battle honours, including a regimental St. George Banner, silver and St. George trumpets, and cap badges with the inscription: *За Филиппополь 5 января 1878 года* [For Plovdiv 5 January 1878].

On the eve of its centenary, in 1906, the regiment received a new honour — the new-born heir to the Russian throne was named as its commander-in-chief. The Life-Guard Finland Regiment thus became the first Guards infantry regiment to have Tsarevich Alexei as commander-in-chief. For this occasion, the Finland officers built a special commemorative study for their most august commander in the Officers' Mess buildings (the regiment's barracks were located between the 19th and 20th lines on Vasilievsky Island in St. Petersburg). AK

319 Officer's Uniform of Her Majesty Empress Maria Feodorovna's Cavalry Guards Regiment, which belonged to Emperor Nicholas II, 1900s–1910s

St. Petersburg
Tunic of white broadcloth with red collar, cuffs and piping; the collar, lapels and cuffs are faced in gold braid with red stripes; embroidery in the form of tabs and silver buttons; officer's helmet of gilded brass with a silver double-headed eagle screwed on under a crown; plated St. Andrew's star on the front; chinstrap covered in silver-plated metal scales; round metal cockade on the right; officer's sash of silver thread with black and yellow stripes; cartridge pouch of the Guards pattern with plated St. Andrew's star on a silver flap, with red leather strap faced with regimental silver braid; cuirass (breast and back plates) of gilded steel, trimmed at the edge with a red cord, with shoulder straps of red leather, trimmed with regimental silver braid.
Length of short tunic 70 cm, length of shoulder-boards 18.5 cm, height of helmet 34.5 cm, length of sash 92 cm, cartridge pouch 11 × 8.5 cm, height of cuirass 44.5 cm, length of cord 158 cm
Provenance: Acquired from the State Museum of Ethnography of the USSR in 1941; the tunic was previously in the Alexander Palace at Tsarskoe Selo (wardrobe of Nicholas II). ЭРТ-12757, 13360, 10768, 10821, 10822, 18797
Previous Exhibition: St. Petersburg, 1994, Cat. 237

The Cavalry Guards, or Knight Guards — one of the most outstanding Guards cavalry regiments — trace their origin from a company of bodyguards formed by Peter the Great on the occasion of the coronation of Ekaterina Alexeevna in 1724. Throughout the 18th century, the Cavalry Guards existed as an elite body for the personal protection of the monarch, but were not officially part of the Guards. On 11 January 1799, Paul I established the Cavalry Guards Corps as officially part of the Guards; a year later, it was reorganised as a regiment.

During the reign of Nicholas II, the commander-in-chief of the regiment was his mother, the Dowager Empress Maria Feodorovna, who held this title from 2 March 1881 to 4 March 1917. Nicholas himself and his son Alexei were enrolled in the regiment from birth. TK

320 Officer's Ball Uniform of Her Majesty Empress Maria Feodorovna's Cavalry Guards Regiment, which belonged to Emperor Nicholas II, 1900s–1910s

St. Petersburg
Tunic of red broadcloth with pale blue collar, cuffs and piping; collar, lapels and cuffs trimmed with silver braid with pale blue stripes; embroidery in the form of tabs and silver buttons.
Length of back 72.5 cm
Provenance: Acquired from the State Museum of Ethnography of the USSR in 1941; previously in the Alexander Palace at Tsarskoe Selo (wardrobe of Emperor Nicholas II). ЭРТ-17758
Previous Exhibition: St. Petersburg, 1994. Cat. 238

At the beginning of the 20th century, all officers of the Russian Imperial Guard were expected to have available a special ball uniform made up from the ordinary prescribed officer uniform, but put on in a certain order. Only officers of the Cavalry Guards and Life-Guard Horse Regiments had the special ball uniforms established in the reign of Alexander I, which were red, with differing colours of metal fittings — gold for the first and silver for the second. In ball uniform, weapons had to be removed during dances, and on such occasions gloves were an essential accessory. Occasions for wearing full dress or standard ball uniforms were regulated by special rules, which were obligatory for all Guards officers. TK

321 Colonel's Uniform of His Majesty's Life-Guard Hussars Regiment, in which Emperor Nicholas II was married, 1894

St. Petersburg
[Description of uniform: only dolman shown] Dolman of scarlet broadcloth with gold cords, braids, buttons and 'pips'; the shoulder-boards bear a plated double monogram *A II* and *A III* under a crown; on the lining is a sewn label with the inscription in ink: *В этом доломане Его Величество бракосочетался сохранять навсегда* [In this dolman His Majesty was married, preserve forever].
Court pattern aiguillette of gold cord with metal gilded tips; short fur-lined cloak of white broadcloth trimmed with Siberian weasel fur. Gold cords, braid, buttons and 'pips'; *chakchirs* (Hussar breeches) of dark blue diagonal-weave cloth with gold braid trimming; Hussar high over-shoes of black leather, with stamp on the sole: *Скороходъ* [Footman] under a crown and the date *1896*; peaked cap of scarlet broadcloth with yellow piping and peak of black patent leather. Mark on the lining: *Фабрикант АА Сенковского в Москве* [A.A. Senkovsky, Moscow: manufacturer].
Officer's pouch of red Morocco leather, with lid covered in scarlet broadcloth. On the lid, a monogram embroidered in gold: *A III* under a crown framed by plant ornament embroidered in gold.
Hussar officer's sash of silver thread with interwoven black and orange silk.
Length of back 64 cm, length of aiguillette 66–88 cm, length of back of fur-lined cloak 64 cm, length of *chakchirs* 100 cm, over-shoes 28.3 × 49.8 cm, diam. of peaked cap 25 cm, pouch 32.3 cm, length of sword sash 80 cm, length of hussar sash 100.5 cm

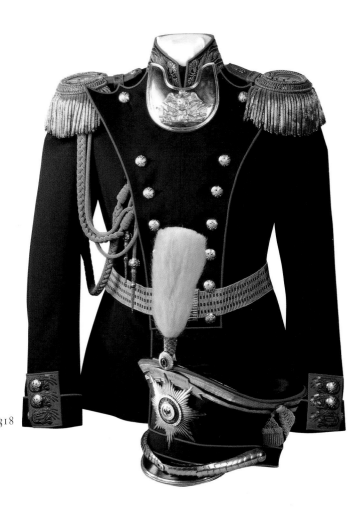

318

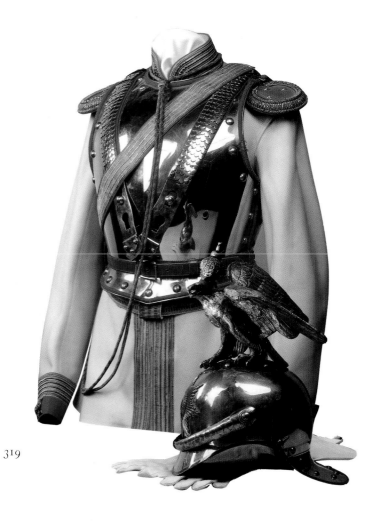

319

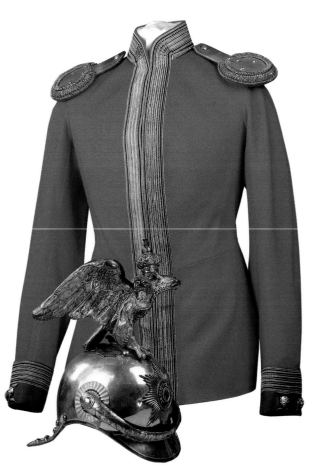

320

Provenance: Acquired from the Alexander Palace at Tsarskoe Selo in 1941 (wardrobe of Emperor Nicholas II). ЕД-568-II, ЕД-569-II, ЕД-571-II, ЕД-534-II, ЕД-679-II, ЕД-363-II, ЕД-577-II, ЕД-578-II
Previous Exhibition: St. Petersburg, 1994, Cat. 240
From the State Palace Museum, Tsarskoe Selo

The Life-Guard Hussars Regiment, like the Cossack Regiment, traces its history back to 1775, from the Court Convoy detachments of Catherine II. From September 1798, when the regiment had its baptism of fire in the battles against revolutionary France, until it was disbanded at the beginning of 1918, the Life-Guard Hussars Regiment was responsible for some of the most glorious episodes in the military history of Russia.

From the time of its formation, the regiment wore attractive uniforms in the 'Hungarian' style which was common to all hussars: 'The Life-Guard Hussars were particularly impressive in appearance on parades. At the command "Gallop", a line of red dolmans flew at you; the line had hardly had time to pass, however, before it turned into a white one, a result of the white fur-lined cloaks thrown over their shoulders.' (A. A. Ignatiev, 1955, vol i, p. 92.)

Emperor Nicholas II was enrolled in the Life-Guard Hussars Regiment on 6 May 1868. In 1889–90, he spent two periods in the regiment ranks' annual manoeuvres near Tsarskoe Selo. On 2 November 1894, he became commander-in-chief of the Life-Guard Hussars and was married in this very uniform. AK

322 Colonel's Uniform of His Majesty's 17th Nizhegorodsky Dragoon Regiment, which belonged to Emperor Nicholas II

St. Petersburg
Single-breasted tunic of dark green broadcloth; crimson collar, cuffs and piping with a dark green flap on the collar; gold embroidery in the form of tabs marked *За воинское отличие* [For military distinction] and gold buttons; officer's peaked cap [not shown] of crimson broadcloth with three dark green pipings and a peak of black patent leather.
Length of back 66 cm, *diam.* of peaked cap 25 cm
Provenance: Acquired from the Alexander Palace at Tsarskoe Selo in 1941 (wardrobe of Emperor Nicholas II). ЕД-561-II, ЕД-357-II
Previous Exhibition: St. Petersburg, 1994, Cat. 241
From the State Palace Museum, Tsarskoe Selo

The 17th Nizhegorodsky Dragoon Regiment traces its history from the Dragoon Regiment of Morelli de Carrière, formed in 1701. The Nizhegorodsky Dragoons were glorified in the numerous wars which Russia waged in the Caucasus in the 19th century. The regiment's uniform is itself a reminder of this. Like all dragoons of the Caucasus Cavalry Division, they wore round caps of the Asian style with a border of astrakhan fur. The *gazyrs* on the breast of the tunic were also a distinction of the regiment.

Nicholas II had special links with the Caucasus Cavalry Division. He himself was commander-in-chief of the Nizhegorodsky Regiment, Tsarevich Alexei was commander-in-chief of the 16th Tver Dragoon (from July 1907) and Nicholas was also enrolled in the third regiment of the Division — the 18th Seversky Dragoons, which bore the name of his Danish grandfather, King Christian IX.

On 27 November 1917, while in Tobolsk, Nicholas II wrote in his diary, 'Nizhegorodsky Day! Where are they and what has become of them?' (Diaries of Nicholas II, 1991, p. 659.) AK

323 Child's Officer's Greatcoat of the Life-Guards Chasseurs Regiment, which belonged to the Tsarevich Alexei Nikolaevich, 1910s

St. Petersburg
Greatcoat of thick grey cloth; green tabs with scarlet piping; shoulder-boards of a Second Lieutenant, gold-braided with scarlet stripe and piping, and plated monogram: *N II* under a crown.
Length of back 94 cm
Provenance: Acquired from State Museum of Ethnography of the USSR in 1941; previously in the Alexander Palace at Tsarskoe Selo. ЭРТ-12799
Previous Exhibition: St. Petersburg, 1994, Cat. 242

'The Life-Guards Chasseurs are fine young men, faithful servants of the Tsar,' sang the troops of the Chasseurs Regiment in the humorous verses known among the Russian military at the beginning of the 20th century under the general name 'The Crane'. In 1796, the Life-Guards Chasseurs Battalion was formed from the Chasseurs detachments of the Guards regiments and Gatchina forces. In 1806, they were developed into a regiment. The faithful service of the Chasseurs was marked by numerous awards. Nicholas II was commander-in-chief of the regiment, and the tsarevich was enrolled at birth, on 30 July 1904. SL

324 Child's Second Lieutenant's Uniform of the Life-Guard Engineers Battalion, which belonged to the Tsarevich Alexei Nikolaevich, 1910s

St. Petersburg
Tunic of blue-green broadcloth with black collar, cuffs and lapel; red flaps on cuffs, red piping, with white piping on cuff flaps themselves; embroidered Guards Artillery badge and silver buttons; silver epaulettes, guards badge with plated monogram: *N II* under a crown; officer's shako covered in blue-green cloth with black cap band, red piping and silver braid round the top edge; bottom and peak of black patent leather; chinstrap covered in silver-plated brass scales; on front, a plated St. Andrew's star on top of crossed engineers' axes and badge of distinction with the inscription: *За Балканы в 1877* [For the Balkans, 1877]; at the sides of the shako crown, plated crossed engineers' axes; above the cockade, a plume of black horsehair; officer's sash of silver thread with black and yellow stripes.
Length of back 55 cm, epaulettes 13.5 × 8.5 cm, height of shako 13.5 cm, sash 81 × 4 cm
Provenance: Acquired from the Alexander Palace at Tsarskoe Selo in 1941 (wardrobe of the Tsarevich Alexei Nikolaevich). ЕД-769-III, ЕД-770-III, ЕД-772-III
Previous Exhibition: St. Petersburg, 1994, Cat. 244
From the State Palace Museum, Tsarskoe Selo

The Life-Guard Engineers Battalion marked its centenary on 27 December 1912. Its first commander-in-chief was Nicholas I, who conferred particular distinction on his engineers. On 14 December 1825, it was to them that he entrusted the protection of the heir.

Nicholas II, the last commander-in-chief of the Engineers (from 1894 to 1917), ordered that the new-born tsarevich be enrolled in the Battalion at birth, on 30 July 1904. SL

325 Child's Uniform of a Cornet of His Majesty's Life-Guard 1st Urals Company in the Composite Cossack Regiment, which belonged to the Tsarevich Alexei Nikolaevich, 1910s

St. Petersburg
Tunic of Cossack cut of crimson cloth with white piping; tabs embroidered in silver on the collar and cuffs; silver epaulettes of the cavalry pattern on crimson backing with plated silver monogram: *N II* under a crown; breeches of dark blue diagonal-weave cloth with crimson stripes; shoulder sword sash of silver braid on a backing of crimson velvet; cartridge-pouch with binding of silver braid on a backing of crimson velvet. St. Andrew's star on the silver flap of the cartridge-pouch; on the cross sash, a plated silver monogram: *N II* under a crown; officer's sash of silver thread with black and orange stripes.
Length of back of tunic 52.5 cm, length of breeches 79 cm, epaulettes 14 × 9 cm,

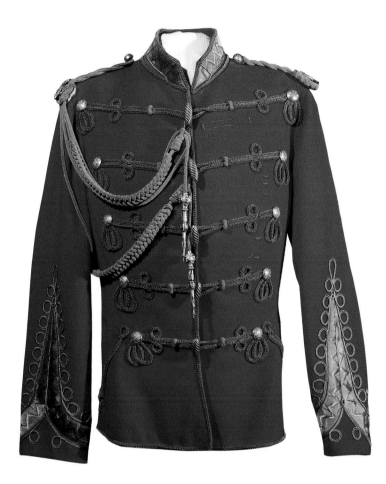

321

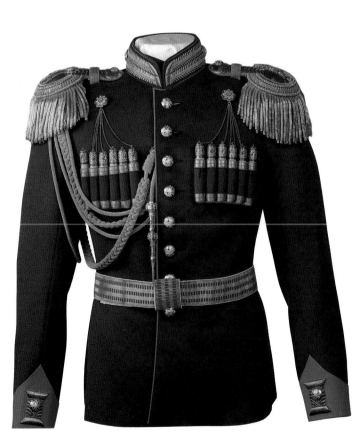

322

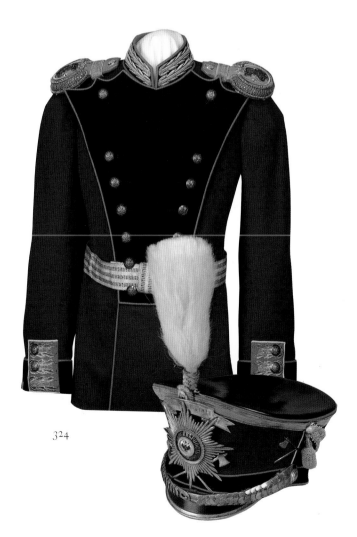

324

length of sword sash 105 cm, cartridge-pouch 12 × 7 cm, cross sash 75 × 3.5 cm, officer's sash 81 × 4 cm
Provenance: Acquired from the State Museum of Ethnography of the USSR in 1941; previously in the Alexander Palace at Tsarskoe Selo (wardrobe of the Tsarevich Alexei Nikolaevich). ЭРТ-13372, 13374, 13373 a, 6; 13376, 13375 a, 6; 13367
Previous Exhibition: St. Petersburg, 1994, Cat. 245

On 6 April 1830, the Urals Cossack Company, which had existed since the time of Paul I, achieved Guards status. In 1906, with the incorporation of detachments from the Orenburg, Siberian, Trans-Baikal, Astrakhan, Semirechensk, Amur and Ussur Composite Cossack forces, the Life-Guard Cossack Regiment was formed. Each company or platoon of the regiment wore tunics with the distinctive colours of those Cossack forces which they represented. Thus, the Urals Company, the oldest in the regiment, in whose ranks the tsarevich was enrolled from birth, wore tunics (*chekmens*) of a crimson colour with white piping on the cuffs and double collar tabs. SL

326 **Child's Officer's Uniform of His Imperial Majesty's Own Convoy, which belonged to the Tsarevich Alexei Nikolaevich,** 1910s

St. Petersburg
Circassian coat of scarlet broadcloth and dark blue velvet *gazyrs*, embroidered with Cossack silver braid; *gazyr* heads of gilded silver; *beshmet* (short buttoned caftan) of white piqué embroidered with Cossack silver braid with gold stripes; waist sash of white kid, covered in Cossack braid.
Lengths: back of coat 94 cm, *beshmet* 70 cm, sash 80 × 2 cm
Provenance: Acquired from the State Museum of Ethnography of the USSR in 1941; previously in the Alexander Palace at Tsarskoe Selo (wardrobe of the Tsarevich Alexei Nikolaevich). ЭРТ-13365, 13370, 13366
Previous Exhibition: St. Petersburg, Cat. 246

From May 1891, His Imperial Majesty's Own Convoy, whose terms of service were clearly defined by its name, consisted of four companies. Two of them were formed from the Cossacks of the Kuban forces and two from the Cossacks of the Ter forces. The special features of the equipment of these forces were also reflected in the Convoy soldiers' clothing. They wore the *papakhas* (fur hats) worn by the Kuban and Ter Cossacks, and Circassian coats with *gazyrs*, but unlike the usual black ones, these were red (for parade dress) or blue.

Nicholas II himself was commander of the Convoy from 1894 to 1917. The tsarevich was enrolled in this unit from birth. SL

327 **Child's Second Lieutenant Uniform of His Majesty's 84th Shirvansky Infantry Regiment, which belonged to the Tsarevich Alexei Nikolaevich,** 1912–17

St. Petersburg
Tunic of camouflage-colour broadcloth; collar, lapel and cuffs of blue-green broadcloth with red piping; old embroidered tabs with the inscription: *За военное отличие* [For military distinction] and buttons with eagles; epaulettes of blue broadcloth bearing decoration and plated monogram: *N II* in gold; breeches of blue-green broadcloth with red piping in the side seams.
Lengths: back of tunic 51 cm, breeches 81 cm, epaulettes 13.5 × 8.5 cm
Provenance: Acquired from the Pushkin palace-museums; previously in the Alexander Palace at Tsarskoe Selo (wardrobe of the Tsarevich Alexei Nikolaevich). ЭРТ-18200 a, 6, в, г; 18199
Previous Exhibition: St. Petersburg, 1994, Cat. 249

The military service of the Shirvansky Infantry Regiment, formed in 1724, took place in the Caucasus for almost the entire period of its existence. For distinction in battles with the enemy the regiment was given many awards, including the tabs inscribed 'For military distinction', granted to officers of the regiment in January 1879 for feats in the recent Russo-Turkish War. Nicholas II became commander-in-chief of the regiment on 9 October 1888 when he was still tsarevich. On 9 October 1913 he wrote in his diary: 'It is 25 years today since I became commander of the Shirvansky Regiment. For this reason, a thanksgiving service was held at 11.30 in front of the barracks of my company. Alexei was enrolled in the regiment. After the service, I was given an album and then we were photographed with the company.' (Diaries of Nicholas II, 1991, page 427.) SL

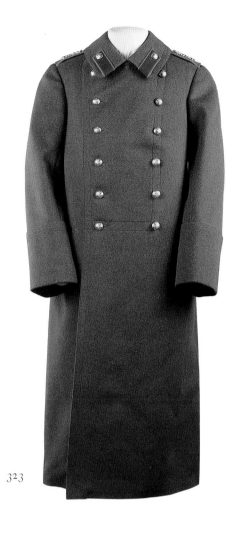

323

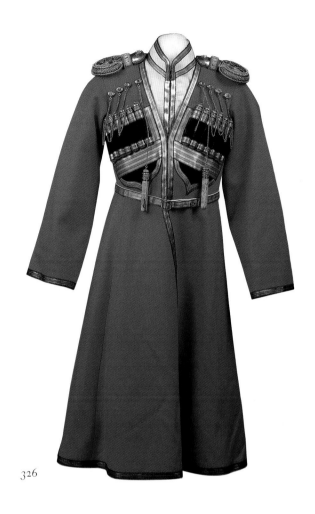

326

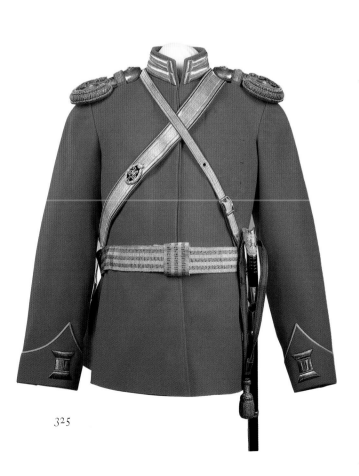

325

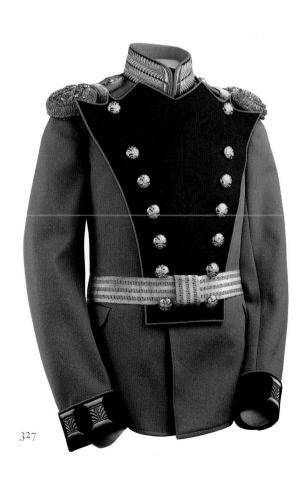

327

328 Child's Set of Uniform and Accoutrements of a Second
Lieutenant of His Imperial Highness the Tsarevich's
12th East Siberian Rifle Regiment, which belonged to
Alexei Nikolaevich, 1910s

St. Petersburg
Double-breasted tunic of blue-green broadcloth with crimson piping, gold
embroidered tabs and buttons; breeches of blue-green broadcloth with crimson piping
in the side seams; officer's boots of black leather; *papakha* (fur hat) of black lambskin
with top of blue-green broadcloth, embroidered across in gold braid with crimson
stripes; on front, above the cockade, a badge of distinction with the inscription: *За
Тюриченъ 17–18 апреля и Ляоян 16–17 и 18 августа 1904* [For Tiurichen 17–18
and Liaoyan, 16–17 and 18 August 1904]; officer's peaked cap of blue-green
broadcloth with crimson piping and peak of black patent leather; epaulettes with a
field of crimson broadcloth, with metal fittings and plated monogram: *A under a
crown*, in gold; silver stars; shoulder-boards of gilded braid with crimson stripes and
piping; plated monogram: *A under a crown* in gold; stars embroidered in silver thread;
sword sash of black watered silk covered in gold braid, with gilded metal fittings;
officer's sash of silver thread with black and yellow stripes; officer's sword of
1881–1909 pattern, child's version with single-edged blade, with the monogram *N II*
under a crown engraved on one side, and the state crest on the other; hilt of bone,
gilded pommel with monogram *N II* on the top end; officer's sword-knot of the
infantry pattern; scabbard of black leather with gilded metal fittings; white chamois
leather gloves with stamp on button: *J. Vergnes*; wooden chest bound in crimson
Morocco leather with gilded hooks and handles on the side walls. Inscription imprinted
in gold on the lid: *12-го Восточно-Сибирскаго стрелкового Его Императорского
Высочества Наследника Цесаревича полк* [His Imperial Highness, the Tsarevich's
12th East Siberian Rifle Regiment] and monogram: *A under a crown*; lined inside with
crimson satin and fitted with an insert box having recesses for separate objects.
Length of back of tunic 51 cm, length of breeches 62 cm, height of *papakha* 16.5 cm,
diam. of peaked cap 24 cm, length of epaulettes 12.2 cm, shoulder-boards 11 × 4.8
cm, sword sash 109 × 1.5 cm, sash 100 × 4 cm, length of sword 54.5 cm, length of
gloves 20.5 cm, boots 30.1 × 20.2 cm, chest 81.3 × 53 × 31.2 cm
Provenance: Acquired from the Alexander Palace at Tsarskoe Selo in 1941 (wardrobe
of the Tsarevich Alexei Nikolaevich). ЕД-828-II, ЕД-839-II
Previous Exhibition: St. Petersburg, 1994, Cat. No. 250
From the State Palace Museum, Tsarskoe Selo

On 30 July 1904, when blood was being spilt on the fields of
Manchuria, Adjutant-General Kuropatkin, the commander-in-
chief of the Russian army fighting there, received the following
imperial telegram addressed to him: 'Today the Lord has
bestowed on Her Highness and myself a son, Alexei. I hasten to
inform you of this gift from God to Russia and to us. In order to
share our joy with the valiant forces on active duty, I appoint the
new-born tsarevich commander-in-chief of the 12th East Siberian
Rifle Regiment.' In such a way was the army informed of the
name of the first military unit to be granted the honour of having
the heir to the Russian throne as its commander-in-chief. AK

329 Commander-in-Chief's Uniform of Her Majesty Empress
Alexandra Feodorovna's 5th Alexandriysky Hussars
Regiment, 1907–17

St. Petersburg, workshop of P. Kitaev
Dolman of black broadcloth with silver braid and cords; in the shoulder-cords, a plated
silver monogram: A under a crown; the collar bears the following marking woven in
yellow silk — four armorial bearings above, two at the sides, with the text: *Fournisseur
de la Famille Impériale. P. J. Kitaeff St. Petersbourg*
Length of back 60 cm
Provenance: Acquired from State Museum of Ethnography of the USSR after 1941;
previously in the Winter Palace (wardrobe of Empress Alexandra Feodorovna).
ЭРТ-12759
Previous Exhibition: St. Petersburg, 1994. Cat. 251

The long-awaited birth of the tsarevich was also marked by a
unique honour awarded to his mother — Empress Alexandra
Feodorovna was appointed commander-in-chief of the 5th
Alexandriysky Dragoon Regiment. Exactly three years later,
the tsarevich himself was enrolled in the regiment. In December
1907, the Alexandriysky Regiment had the Hussar title returned
to it along with its traditional black and silver Hussar uniform.
Unlike the other Hussar regiments in the army, which wore
speckled *chakchirs* (Hussar breeches) decorated with cords on
the side-seams in full dress uniform, the Alexandriysky wore
black ones with silver braid decoration in the Hussar 'zigzag'.
The commander-in-chief's uniform made for Alexandra
Feodorovna followed this tradition. SL

330 Commander-in-Chief's Uniform of Her Imperial Highness
Grand Duchess Olga Nikolaevna's 3rd Elizavetgradsky
Hussars Regiment, 1910s

St. Petersburg
Dolman of pale blue broadcloth with gold braids, cords, buttons and 'pips'; skirt of
cheviot decorated with gold cord at the sides; officer's peaked cap of pale blue
broadcloth with white cap band, yellow piping and peak of black patent leather.
Lengths: back of dolman 60 cm, skirt 102 cm
Provenance: Acquired from the Alexander Palace at Tsarskoe Selo in 1941
(wardrobe of Grand Duchess Olga Nikolaevna). ЕД-663-II, ЕД-665-II, ЕД-666-II
Previous Exhibition: St. Petersburg, 1994, Cat. 252
From the State Palace Museum, Tsarskoe Selo

Grand Duchess Olga Nikolaevna became commander-in-chief
of the 3rd Elizavetgradsky Hussars Regiment on 11 July 1909.
One of her activities in this position was to concern herself with
the decoration of her regiment's uniform. In 1911, on the petition
of their most august commander-in-chief, the Elizavetgradsky
troops were given short white fur-lined cloaks to be worn with
full-dress uniform. A similar distinctive garment was also worn
by the 2nd Pavlogradsky Hussars and the 11th Izyumsky
Hussars. The Elizavetgradsky Hussars recorded Olga
Nikolaevna's involvement in their regimental song:

We Hussars are not of foil,
We are all of damask steel.
How we value Olga's name,
Our white cloaks and our flag of fame!
AK

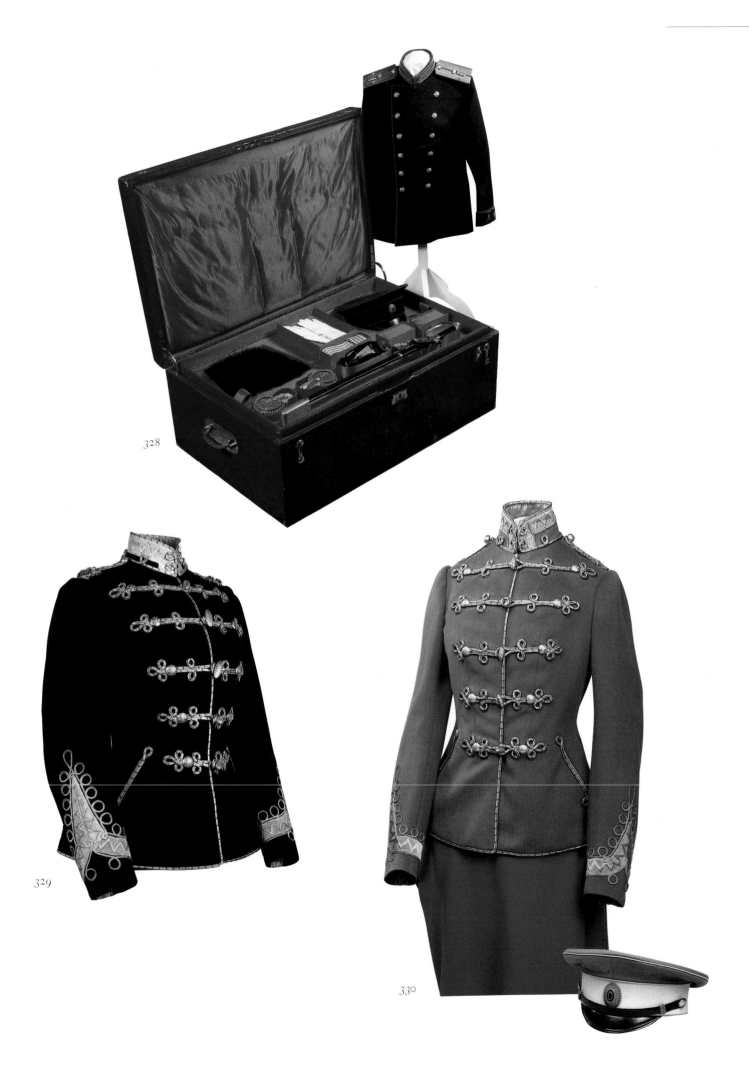

328

329

330

331 Commander-in-Chief's Uniform of Her Imperial Highness Grand Duchess Tatiana Nikolaevna's 8th Voznesensky Lancer Regiment, 1910s

St. Petersburg, workshop of A. I. Kitaev
Tunic of dark green broadcloth with lapel, cuffs, piping and collar flap in yellow; silver embroidery in form of tabs and buttons; silver epaulettes of the cavalry pattern; riding-habit skirt of dark blue broadcloth with yellow piping at the sides.
Lengths: back of tunic 58 cm, epaulettes 12 cm, skirt 138 cm
Provenance: Acquired in 1960; formerly in the Alexander Palace at Tsarskoe Selo (wardrobe of Grand Duchess Tatiana Nikolaevna). ЕД-476-II; ЕД-474-II; ЕД-477-II
Previous Exhibition: St. Petersburg, 1994, Cat. 253
From the State Palace Museum, Tsarskoe Selo

The Voznesensky Lancers trace their origins from the 4th Ukrainian Cossack Regiment, formed on 8 October 1812 and renamed a Lancer regiment in 1816. The regiment was given the name Voznesensky in 1830. Grand Duchess Tatiana Nikolaevna became commander-in-chief of the regiment in 1911. AK

332 Colonel's Uniform of the 2nd Dragoon Regiment of the British Army (Royal Scots Greys), which belonged to Nicholas II, 1890s

London
Single-breasted tunic of scarlet broadcloth with black collar; braid, cords, embroidery and buttons with French imperial eagle in gold; shoulder-boards woven from gold cord with superimposed embroidered silver stars and gold-embroidered crown on scarlet velvet; black bearskin busby with plume of white feathers and a gilded metal grenade at the base; officer's waist sword sash, of red leather with gilded braid and embroidery with the star of the Order of the Garter.
Length of back 68 cm, length of shoulder-boards 14 cm, height of busby 36 cm, sword sash 76.5 cm x 5 cm
Provenance: Acquired in 1960; previously in the Alexander Palace at Tsarskoe Selo (wardrobe of Emperor Nicholas II). ЕД-1036-II, ЕД-11037-II, ЕД-1056-II, ЕД-1058-II
Previous Exhibition: St. Petersburg, 1994, Cat. 257
From the State Palace Museum, Tsarskoe Selo

Nicholas II was made commander-in-chief of the famous Scots Greys on the occasion of his wedding by Queen Victoria; King Edward VII of England was commander-in-chief of the 9th Kiev Hussars Regiment of the Russian Army. AK

333 Sailor's Cap from the Yacht *Standart*, Late 1900s – early 1910s

St. Petersburg
St. George ribbon bears the inscription in gold: ШТАНДАРТЪ [STANDART]; tinplate cockade on the crown.
Woollen, silk threads, tinplate, broadcloth, leather, ribbon, stamp
Height 10 cm, *diam.* of top 27 cm
Provenance: Acquired from State Museum of Ethnography of the USSR in 1941; previously in the Alexander Palace at Tsarskoe Selo. ЭРТ-10961
Previous Exhibition: St. Petersburg, 1994, Cat. 259

The cap most probably belonged to the Tsarevich Alexei Nikolaevich: the royal family sailed every summer on the imperial yacht *Standart* among the reefs of the Gulf of Finland, and in photographs of the time the tsarevich is frequently seen posing in his sailor's uniform and cap (see no. 509). The *Standart* was built in Denmark and was considered the best of its type worldwide. It was quite a large sea-going vessel, of a displacement of 4,500 tonnes. The yacht was painted black, which complemented gold decorations on the bow and stern, and was very comfortable inside. SL

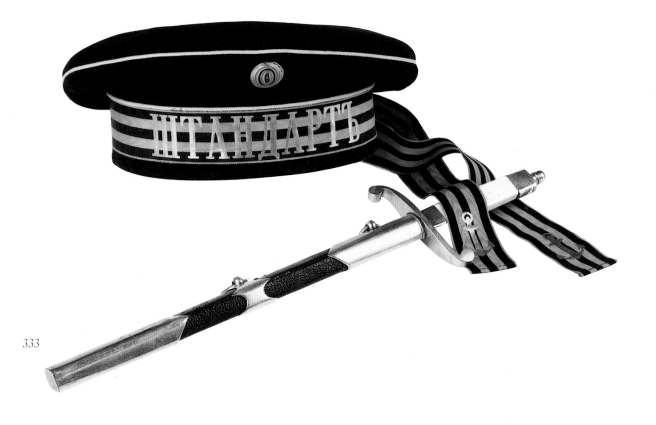

333

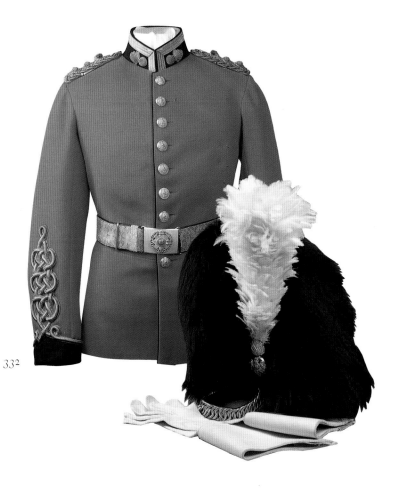

332

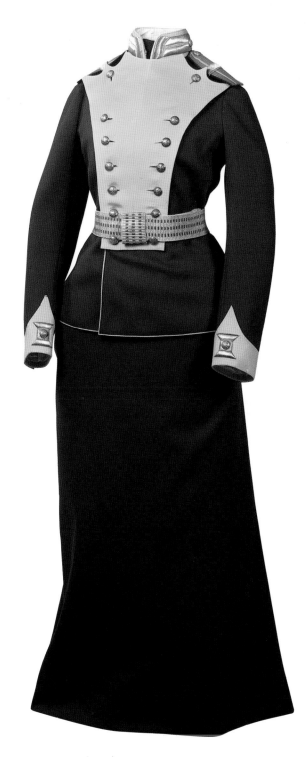

331

334 Priest's Vestments, Second half of 19th century

Phelon (outer robe) and stole of pale-blue brocade with large-scale flower pattern and superimposed embroidered crosses; under-chasuble of smooth pale-blue silk. Mitre of violet velvet with embroidery of silver thread in the form of bouquets of flowers tied with bows, and five images in painted enamel depicting God the Father, Jesus Christ, the Mother of God, John the Baptist and the Crucifixion.
Length of *phelon* back 152 cm, stole 146 × 36 cm, overall length of under-chasuble 149 cm, mitre 19 × 19 cm
Provenance: Acquired from the State Museum of Ethnography of the USSR in 1941. ЭРТ-7831, ЭРТ-7876, ЭРТ-7851, ЭРТ-11532
Previous Exhibitions: Aarhus, 1990, Cat. 162; St. Petersburg, 1994, Cat. 260

The form and elements of decoration, as well as the colour of Church vestments, have specific symbolic significance connected to various episodes in Church history. Thus, vestments of a pale-blue colour are normally used by the clergy on holy days devoted to the Mother of God and her miracle-working icons. The Mother of God has long been particularly honoured in Russia as the patron saint and protector of the Russian land. IK

335 Deacon's Vestments, Second half of 19th century

Russia
Surplice of pale-blue brocade with large-scale flower pattern; stole of pale-blue silk with embroidery in the form of a fine beaten mesh.
Overall length of surplice 150 cm, stole 303 × 11 cm
Provenance: Acquired from the State Museum of Ethnography of the USSR in 1941. ЭРТ-14723, ЭРТ-14747
Previous Exhibition: St. Petersburg, 1994, Cat. 261
IK

336 Priest's Vestments, Second half of 19th century

Russia
Phelon (outer robe) of gold brocade with gold embroidery on the shoulders in the form of stylised palm leaves.
Kamelaukion (tall cylindrical hat) of violet velvet.
On the bottom of the *kamelaukion* is an inscription sewn in white threads: *Прот. А.П.Б.* [Prot. A.P.B.]
Overall length of *phelon* 149 cm, *kamelaukion* 16 × 21.5 cm
Provenance: Acquired from the State Museum of Ethnography of the USSR in 1941. ЭРТ-16033, ЭРТ-11530
Previous Exhibition: St. Petersburg, 1994, Cat. 262

337 Priest's vestments, Second half of 19th century

St. Petersburg, factory of I. A. Zheverzheev (the under-chasuble)
On the lining of the under-chasuble there is a stamp in gold paint: *Поставщик двора Его Императорского Величества фабрикант И. А. Жевержеев. С. Петербург* [Supplier to the court of His Imperial Majesty, factory-owner I. A. Zheverzheev. St. Petersburg] and a depiction of a double-headed eagle.
Phelon (outer robe) and stole of gold brocade with large-scale stylised pattern; under-chasuble of white silk.
Mitre of red velvet with gold embroidery in the form of a rhombic mesh, with five images depicting God the Father, Jesus Christ, the Mother of God, Ioann Rylsky and St. Nicholas the Miracle-Worker.
Overall length of *phelon* 151 cm, stole 108 × 31 cm, overall length of under-chasuble 149 cm, mitre 20 × 22 cm
Provenance: *Phelon* and stole acquired from the Nikolo-Bogoyavlensky Cathedral in St. Petersburg in 1983; under-chasuble acquired from the State Museum of Ethnography of the USSR in 1941. ЭРТ-19773, ЭРТ-19774, ЭРТ-14755, ЭРТ-16559
Previous Exhibition: St. Petersburg, 1994, Cat. 264

Ivan Alexeevich Zheverzheev opened a factory in 1862 and began supplying woven silk products in 1892. He soon received the honour of supplying the court of His Imperial Majesty due to the high quality and originality of his brocade designs and priests' vestments.

Church vestments were generally made of stylish and decorative brocade fabrics. Before the 18th century, expensive fabrics were imported from other countries. With the development of silk weaving in Russia in the 18th century, Russian fabrics came to be used more and more widely. However, only from the beginning of the 19th century were special fabrics produced for the Church. The silk weaving mills were concentrated around Moscow. The Bogorodsky district played a particularly significant role in this, containing the great majority of the silk and brocade fabric enterprises. The Moscow mills of Ivan Kolokolnikov, the Sapozhnikovs, Vasily Polyakov and Grigory Zaglodin were renowned for their church fabrics, as was the St. Petersburg mill of Ivan Zheverzheev, whose products frequently won awards at artistic exhibitions in Russia and abroad. IK

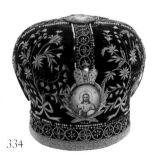

334

336

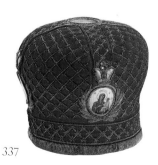

337

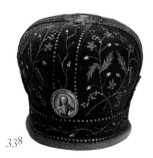

338

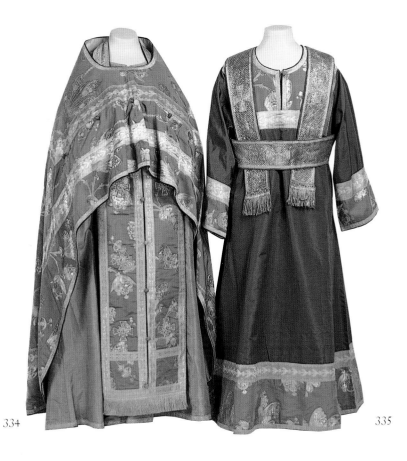

334

335

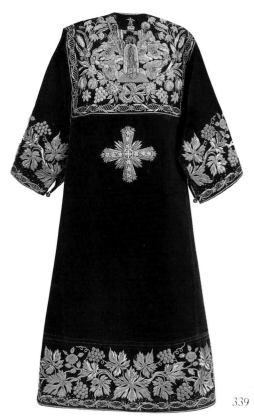

339

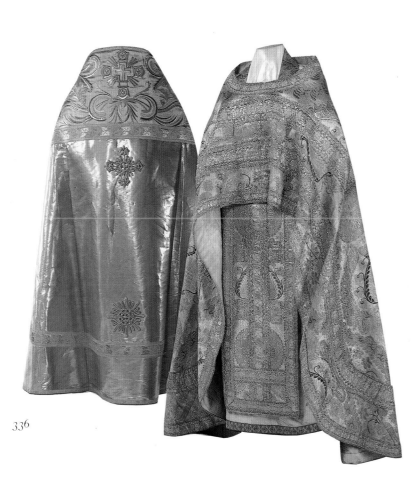

336

337

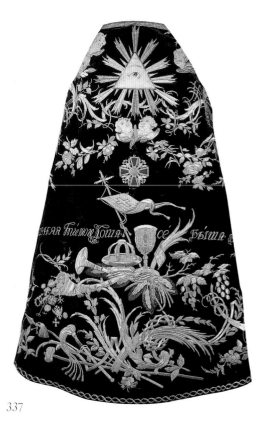

338

338 Priest's Vestments, Late 19th century

Russia
Phelon (outer robe) and stole of violet velvet with gold embroidery.
Mitre of violet velvet with gold embroidery in the form of shoots of flowers and bouquets, and four images in painted enamel depicting Jesus Christ, the Mother of God, John the Baptist and the Crucifixion.
Overall length of *phelon* 147 cm, stole 143 × 27 cm, mitre 18.5 × 23 cm
Provenance: Acquired from the State Museum of Ethnography of the USSR in 1941.
ЭРТ-15961, ЭРТ-15963, ЭРТ-15962, ЭРТ-15969
Previous Exhibition: St. Petersburg, 1994, Cat. 265

Church vestments were frequently decorated with gold embroidery, giving them a particularly ceremonial appearance. Gold embroidery, achieved through sewing on twisted gold thread, has a long history in Russia. The centres for this craft were traditionally convents, where embroidery skills were preserved and developed over the centuries. There was also a gold embroidery workshop in the Voskresensky Convent in St. Petersburg, where there was an art school for 'girls with a spiritual calling'. Here, the highly skilled embroiders of the future were not only taught, but also fulfilled numerous orders for vestments, shrouds and other church items. These vestments are distinguished by the particular richness of the finish and the abundance of gold embroidery. On the shoulder area of the *phelon*, at the back, there is a depiction of the All-Seeing Eye surrounded by heads of angels. Below, there are liturgical symbols and a horn of plenty as an allegory of the godly nature of secular and church authority. Further below is a depiction of the instruments of the passion. The entire surface is covered by garlands of flowers and grape vines. Texts from the Bible are integrated into the overall artistic design.

The superimposed cross on these vestments is the badge of the Order of St. Alexander Nevsky. This order, founded in 1725, was awarded not only to secular people but also to the clergy. In such a case, the badges of the order could be placed on the priest's vestments. IK

339 Deacon's Vestments, Late 19th century

Moscow
Surplice of red velvet with gold embroidery and sewn pearls; on the shoulder area a depiction of the Ascension of the Mother of God and figures of the Archangel Michael and the Apostle Peter; garlands of flowers and grape vines on the edge and sleeves; stole of red velvet with gold embroidery.
Overall length of surplice 135 cm
Provenance: Acquired from the State Depository of Valuables in 1951.
ЭРТ-16033 а, б, в
Previous Exhibition: St. Petersburg, 1994, Cat. 266

All the clergy in large churches would usually have ceremonial vestments made from the same fabric, with embroidery of identical design. There might be several sets of vestments: for the bishop, priests and deacons. Such large orders were usually fulfilled in convents with well organised gold embroidery workshops. Here, the traditions of sewing with river pearls were also preserved for church vestments and icon frames. IK

340 Priest's Vestments, Early 20th century

Russia
A mark is sewn onto the lining of the *phelon*, printed in gold: Пресвитера Благовещенского [Of Presbyter Blagoveshchensky]
Phelon (outer robe) of gold brocade with a depiction of a double-headed eagle framed by elaborate plant ornament; on the shoulder area at the back, a woven depiction of a crown in sun rays; stole of gold embroidery with plant decoration and superimposed embroidered crosses.
Overall length of *phelon* 146 cm, stole 145 × 34.5 cm
Provenance: *Phelon* acquired from the church of the Winter Palace in 1941; stole from the State Museum of Ethnography of the USSR in 1941. ЭРТ II-1254, ЭРТ-15850

Vestments of gold brocade were intended for particularly ceremonial festival services, such as Easter. In the palace church, these ceremonial sets of vestments could also be used during weddings of members of the tsar's household or for coronations.

The *phelon* belonged to Peter Afanasievich Blagoveshchensky, who from 1911 was the head of the court clergy as protopresbyter of the cathedral of the Winter Palace. IK

341 Mitre of Gold Brocade, 1840s

Gold, silver, diamonds, rubies, almandines, amethysts, pearls, silk, embroidery
Height 22.5 cm
Provenance: Acquired from the Cathedral of the Winter Palace. Э-9716
Previous Exhibition: St. Petersburg, 1994, Cat. 267

This mitre of ornamented gold brocade is embroidered with pearls and decorated with nine medallions of painted enamel depicting the saints and Jesus Christ, framed with precious stones. The mitre also comes with a green silk case. LY

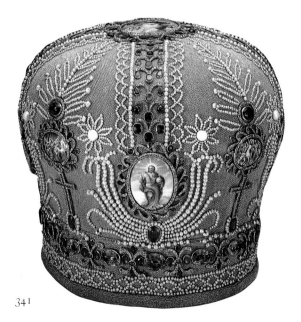

341

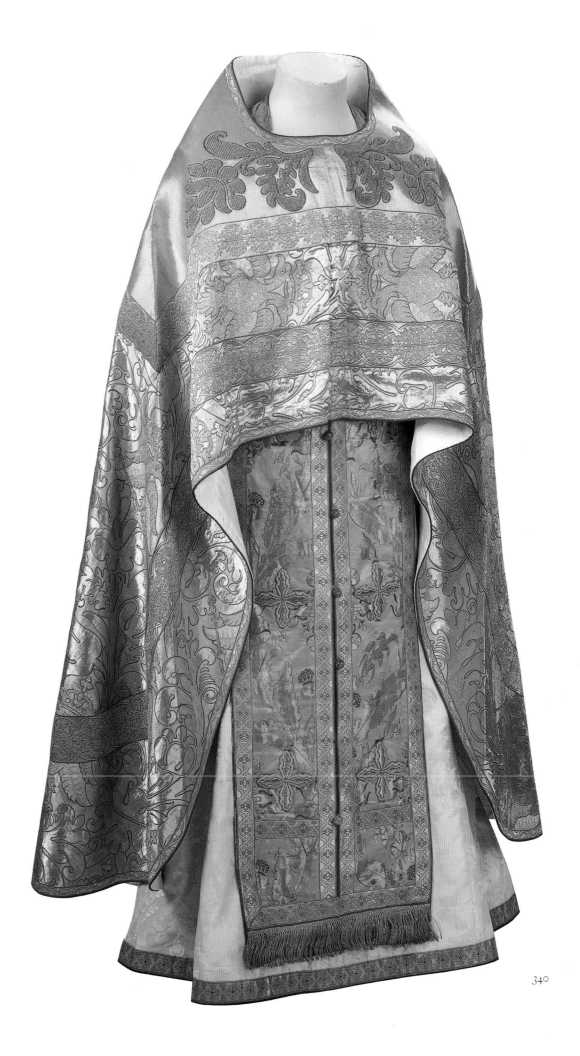

340

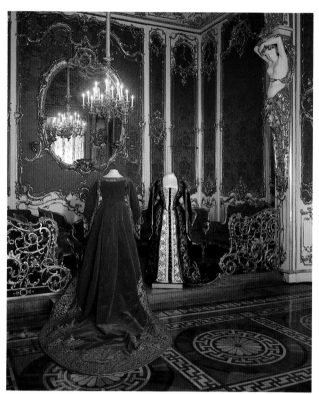

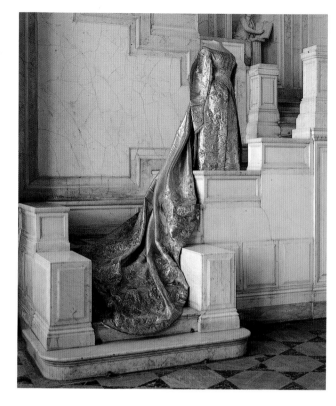

342 Ceremonial Court Costume of Empress Alexandra Feodorovna, 1896

St. Petersburg, workshop of O. N. Bulbenkova
Dress (bodice, skirt, train) of pink and cream satin; long bodice with pointed lower front, large oval décolletage and long sleeves with folded cuffs, with partly exposed arm-holes; bell-shaped skirt with folds at the back; detachable train at the waist with soft folds at the rear; decorated with ornament of roses and laurel branches embroidered in silver and gold thread and silk.
Length back of bodice 38 cm, skirt 170 cm, train 403 cm
Provenance: Acquired from the State Museum of Ethnography of the USSR in 1941; until 1917 in the wardrobe of Empress Alexandra Feodorovna at the Winter Palace. ЭРТ-13152 а, б, в
Previous Exhibitions: St. Petersburg, 1993, Cat. 44; St. Petersburg, 1994, Cat. 192

According to documentary records, this ceremonial outfit was made in 1896 for one of the official receptions during the coronation celebrations. It was made at the workshop of Olga Nikolaevna Bulbenkova (née Suvorova, 1835–1918) who was born in Nizhny Novgorod into a priest's family. From the age of nine Bulbenkova lived in St. Petersburg with her aunt, the wife of the merchant Butakov. The aunt owned a haberdashery shop on Nevsky Prospect. After finishing secondary school she went to work in the fashionable workshop of Miss Watt, of which she soon became the owner. Initially 'Miss Olga's' workshop was located at 8 Moika Embankment, and later at 68 Ekaterinsky Canal. From 1910 the workshop was effectively managed by Olga Nikolaevna's niece, Ariadna Konstantinovna Willim (1890–1976). It produced mainly ceremonial costumes for members of the imperial family and their circle for coronation celebrations, weddings and other festive occasions. Dresses from this workshop were worn by three Russian empresses: Maria Alexandrovna, wife of Emperor Alexander II, Maria Feodorovna, wife of Emperor Alexander III, and Alexandra Feodorovna, wife of Emperor Nicholas II. The workshop also produced seven ceremonial dresses (including the wedding dresses) for the wedding of Nicholas's sister, Grand Duchess Xenia Alexandrovna, in 1894. The workshop existed

until 1917, carrying out its last major commission for the imperial court in 1913 for the celebrations of the 300th anniversary of the House of Romanov. TK

343 Ceremonial Court Costume of a Lady-In-Waiting,
Second half of 19th century

St. Petersburg, workshop of O. N. Bulbenkova
The workshop's trade-mark is printed in gold paint on a moiré ribbon on the corsage of the bodice: *Г-жа Ольга Платья С.-Петербург Мойка № 8* [Miss Olga's Dresses St. Petersburg 8 Moika Embankment].
Dress (bodice, skirt, train) of green velvet and white satin; long bodice, pointed lower front and square décolletage, long sleeves folded back with partly exposed arm-holes; bell-shaped skirt, folds at the back; detachable train at waist with soft folds in centre at back; formal uniform embroidery in gold on bodice, centre of skirt and perimeter of train; *kokoshnik* (head-dress) of green velvet.
Length bodice 52 cm, skirt 169 cm, train 270 cm, kokoshnik 30 cm
Provenance: Acquired from the State Museum of Ethnography of the USSR in 1941; previously in the collection of the princes Yusupov. ЭРТ-13147 а, б, в; 13148
Previous Exhibitions: Leningrad, 1962, Cat. 58; Leningrad, 1974, Cat. 102; New York, 1976, Cat. 411; London, 1987, Cat. 86; Paris, 1989, Cat. 122; St. Petersburg, 1994, Cat. 191
Literature: Korshunova, 1979, No. 163; Korshunova, 1983, No. 175

Until 1834 the Russian court had no strict regulations for female ceremonial court costumes. Since the time of Peter the Great they had generally been sewn in accordance with the dominant fashion of the time, which developed under a very strong French influence and responded sensitively to changes in artistic style.

This all changed with a special decree of 1834, which established the character of female court costume, strictly defining the cut, texture and colour of the fabric and decoration. Several details were used to lend this costume a national character: exposed arm-holes, long sleeves folded back, reaching almost down to the knees, and a vertical line at the centre of the front, emphasised by decoration and a panel with buttons, as in the Russian *sarafan* (peasant woman's dress). The importance accorded to this event is

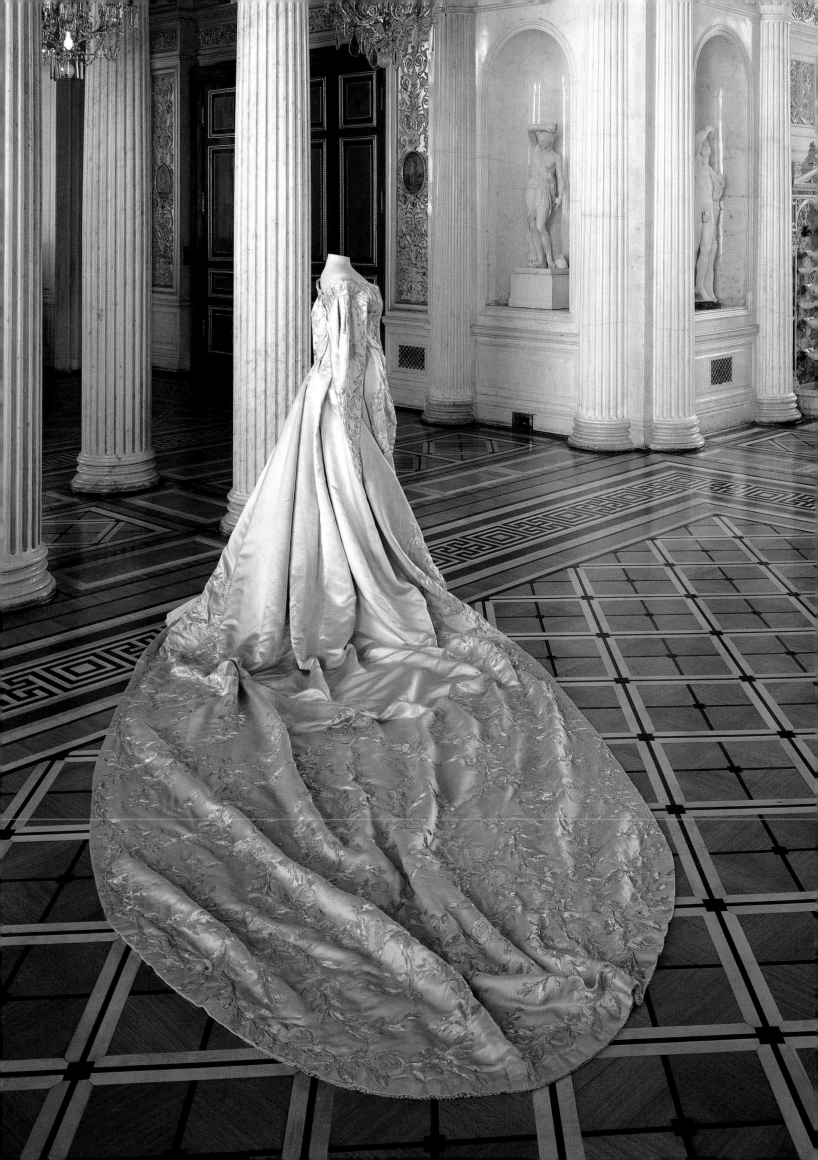

indicated by the inclusion of the decree on female ceremonial costume in the Codex of Laws of the Russian Empire. As early as 1833 we find the following interesting comment on the design for the new type of ceremonial costume in the journals of the memoirist P. G. Divov: 'St. Petersburg is preoccupied with the transformation in the costumes for maids of honour and ladies of the court. They have thought up a new so-called national costume which these ladies will be obliged to wear for important events at court. It is something in the nature of a Frenchified *sarafan*.' (P. G. Divov, 1899–1900, p. 136.)

According to the 1834 decree, the female ceremonial court costume was to consist of an upper velvet dress without fastenings with a very open train, long sleeves folded back with exposed arm-holes. It was worn over a lower dress consisting of a corsage and a wide skirt of white satin. The colour of the velvet and the design of the gold or silver embroidery adorning the dress were determined by the rank of its owner, as was the length of the train: the higher the rank of the lady at court, the longer the train of her dress. According to the decree, ladies-in-waiting and maids of the bedchamber had an upper dress of green velvet with gold embroidery identical to the embroidery on the ceremonial uniform jackets of court officials, and a lower dress of white fabric, normally of satin. The empress's maids of honour had dresses of scarlet velvet with similar embroidery. Ladies possessing no rank at court, but invited to a reception at the palace, had to present themselves at the court in dresses cut in the same fashion as the ladies at court, but their dresses were sewn from different fabrics and decorated differently. This official ceremonial outfit was complemented by *kokoshniks* (head-dresses) with veils of lace or tulle for ladies, and headbands with veils for unmarried girls. The empress's maids of honour wore a diamond monogram on a light blue ribbon to the left of the chest, while ladies-in-waiting wore a portrait of the empress in a diamond frame.

The general form of the female ceremonial costume introduced by the decree of 1834 was retained until 1917 with only minor changes to some details. From the middle of the 19th century the costume consisted of a velvet corsage, a white satin skirt and a detachable train. TK

344 Ceremonial Court Costume, Late 19th – early 20th centuries

St. Petersburg, workshop of O. N. Bulbenkova
The workshop's trade-mark is printed in gold on the ribbon of the corsage: *Г-жа Ольга Платья С.-Петербург Мойка № 8* [Miss Olga's Dresses St. Petersburg 8 Moika Embankment].
Dress (bodice, skirt and train) of silver brocade; long bodice with pointed lower front, large oval décolletage and long sleeves folded back with partially exposed arm-holes; bell-shaped skirt with soft folds at the back; detachable train at waist with double broad gathered fold at the back; finished with luxuriant embroidered gloss and matt floral ornament in silver thread; *kokoshnik* (head-dress) of silver brocade with veil.
Length: bodice 39 cm, skirt 153 cm, train 330 cm, *kokoshnik* 60 cm
Provenance: Acquired from the State Museum of Ethnography of the USSR in 1941.
ЭРТ-13153 а, 6, в; 6102, 13139 6
Previous Exhibitions: Leningrad, 1962, Cat. 57; Leningrad, 1974, Cat. 99, 100; New York, 1976, Cat. 402, 403; Leningrad, 1981, Cat. 524; St. Petersburg, 1994, Cat. 185
Literature: Korshunova, 1979, No. 160; Korshunova, 1983, No. 172

The decoration on all the ceremonial costumes of the ladies at court provides a fine example of the Russian art of gold thread embroidery, a continuation of the gold embroidery tradition of Ancient Rus. The variety of materials employed in the

embroidery and the use of different stitches for metal threads, as well as the introduction into the embroidered design of sequins, and silver and gold plaques of various forms, both gloss and matt, produced a richness of texture on the embroidered surfaces. Gold-thread work was carried out in the workshops of St. Petersburg, including the workshop of I. Vasiliev, and also in the convents of Moscow: Novodevichy, Ivanovsky and others. Sometimes embroiders were invited from Torzhok, one of the oldest centres of gold-thread work, to execute a commission from the court. The work of the Russian gold embroiderers was justly famous and was exhibited in Russia and as far away as the USA. Two ceremonial court dresses with gold needlework were exhibited at the World Fair in Chicago in 1893. They were produced by the seamstresses of the Ivanovsky and Novodevichy convents in Moscow, and the Khotkovo convent outside Moscow. TK

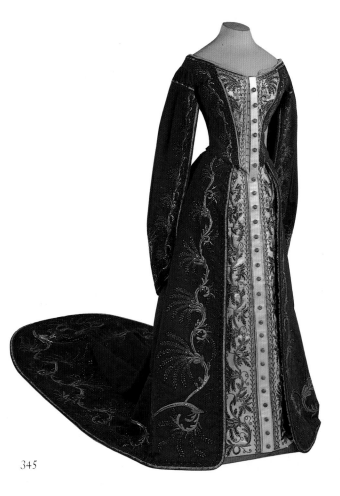

345

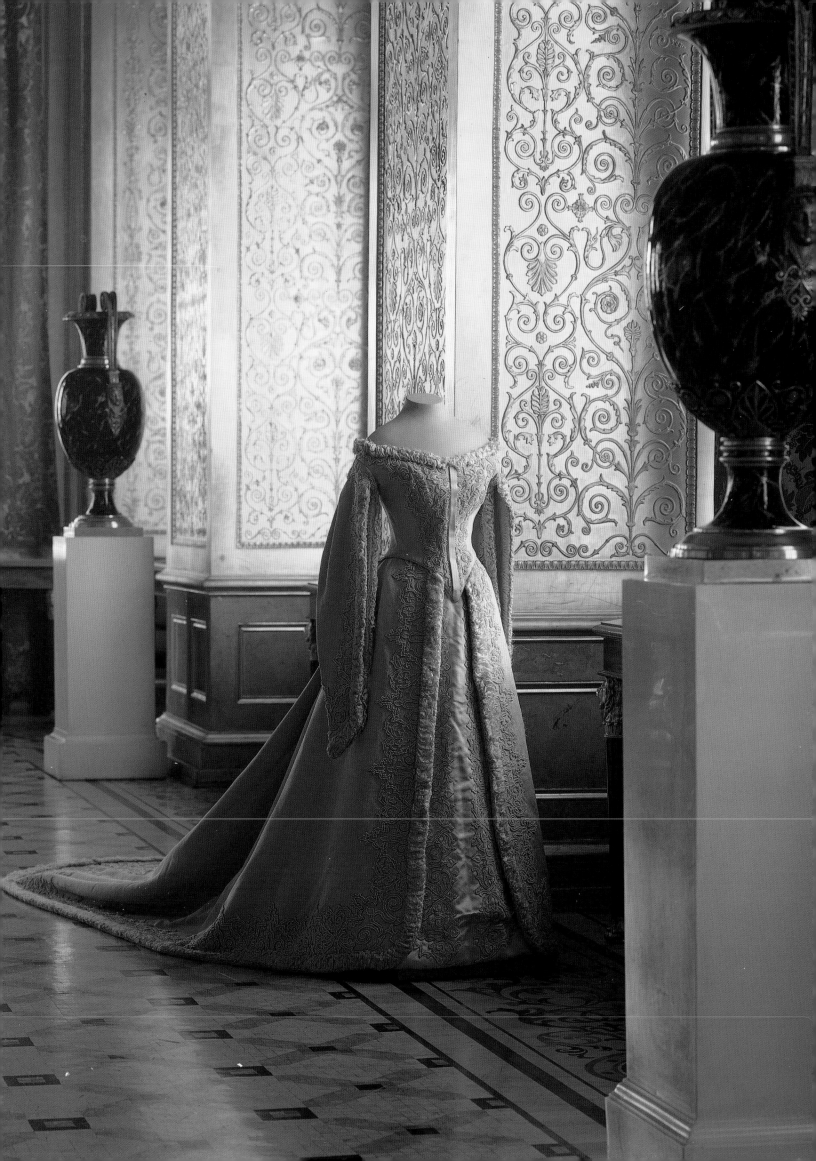

345 Ceremonial Court Costume of a Maid of Honour of the Empress, Late 19th – early 20th centuries (p.202)

St. Petersburg, accredited to workshop of O. N. Bulbenkova
Dress (bodice, skirt, train) of scarlet velvet and white satin; long bodice with pointed lower front, large oval décolletage and long sleeves folded back with partially exposed arm-holes; bell-shaped skirt with folds at the back; detachable train at the waist, with folds along the back; formal uniform embroidery along the bodice, the centre of the skirt and the edge of the train; *kokoshnik* (head-dress) of scarlet velvet.
Length back of bodice 33 cm, skirt 140 cm, train 270 cm, *kokoshnik* 60 cm
Provenance: Acquired from the State Museum of Ethnography of the USSR in 1941.
ЭРТ-13137 а, б, в; 13138
Previous Exhibitions: Aarhus, 1990, Cat. 153; St. Petersburg, 1993, Cat. 45; St. Petersburg, 1994, Cat. 193

The empress's reception of the ladies at court at the Winter Palace, known as the 'kissing of the hand', stood out even among the other court receptions. The ceremony is vividly described by the former page of the bedchamber B. V. Guerois:

'The ladies of all classes and all courts — the great court and the lesser grand dukes' courts — would all be dressed in their heavy uniform dresses cut in the Russian style, with wide-slit sleeves, and wearing *kokoshniks*. The dresses were made of velvet of various colours, depending on the rank and court; they were embroidered with gold or silver and very open on the shoulders and the breast. The train consisted of an immense detachable sash three to four *arshins* [approx. 2.5m] in length. This is an anomaly, since the Russian *sarafan* which served as the model for the design of the court costume had no such accessory. Imagine a young woman in ancient Rus, floating through a gracious Russian dance with the traditional shawl in her hand and hampered by a massive train at her feet! The ceremonial *sarafan*-like dresses of the boyars' wives or daughters in the 16th and 17th centuries reached down to the ground, with a long veil behind, but no train. The technique for the kissing of the hand required that each lady hold the train of the one walking in front of her. The resulting file of ladies, winding like a snake of seemingly infinite length, with its tail lost in the next hall, presented a sight which was not without its comical aspect ...' (Guerois, 1970, pp. 42–3.) TK

346 Ceremonial Court Costume of Empress Alexandra Feodorovna, Late 19th – early 20th centuries (p.203)

St. Petersburg, workshop of O. N. Bulbenkova
The workshop's trade-mark is printed in gold on a silk ribbon on the corsage of the bodice: Г-жа Ольга Платья С.-Петербург Мойка № 8 [Miss Olga's Dresses St. Petersburg 8 Moika Embankment].
Dress (bodice, skirt, train) of pale-blue and white silk; long bodice with pointed lower front and large oval décolletage, long sleeves folded back and partially exposed arm-holes; bell-shaped skirt, with folds at the back; detachable train at waist with soft folds along the back; embroidered with artificial pearls on the bodice, the centre of the skirt and the edge of the train; trimmed with imitation-fur fringes.
Length bodice 39 cm, skirt 103 cm, train 300 cm
Provenance: Acquired from the State Museum of Ethnography of the USSR in 1941; previously in the wardrobe of Empress Alexandra Feodorovna at the Winter Palace.
ЭРТ-13146 а, б, в
Previous Exhibitions: Leningrad, 1962, Cat. 53; Leningrad, 1974, Cat. 96, 97; St. Petersburg, 1994, Cat. 186
TK

347 Ceremonial Court Costume, Late 19th century (p. 200)

St. Petersburg
Dress (bodice, skirt, train) of crimson velvet and white satin; open bodice with oval décolletage; long sleeves, folded back with partially exposed arm-hole; bell-shaped skirt, with folds at the back; detachable train at waist with soft folds at the back; finished with gilded thread embroidery and tinsel-silver in a stylised floral design of various textures; *kokoshnik* (head-dress) of crimson velvet.
Length bodice 37 cm, skirt 115 cm, train 259 cm, *kokoshnik* 52 cm
Provenance: Acquired from the State Museum of Ethnography of the USSR in 1941.
ЭРТ-13136 а, б, в; 6105
Previous Exhibitions: Delhi, 1984, Cat. 126, 127; St. Petersburg, 1994, Cat. 187

M. P. Bok, the daughter of P. A. Stolypin, attended many receptions in the palace as a maid of honour to Alexandra Feodorovna; later, when she married a diplomat she was able to observe court life in the countries of Western Europe. These experiences make her comments on Russian ceremonial court costume of the early 20th century particularly interesting: 'At all the festivities at foreign courts that required court dress, Russian ladies always stood out from the crowd. The court costumes of all the others consist of a train which is attached at the shoulders over an ordinary ball dress. Traditionally the English ladies are only required to wear a special head apparel, consisting of three ostrich feathers. The Russian ladies, though, invariably attracted attention for their beauty and the richness of our national dresses. The *kokoshnik*, the veil, the richly embroidered Russian dress cut in traditional fashion with a train and a large number of precious stones could not fail to produce an impression.' (Bok, 1990, p. 293.) TK

348 Ceremonial Court Costume, Late 19th – early 20th centuries

St. Petersburg
Dress (bodice, skirt, train) of straw-coloured satin with braided gilt thread in a stylised floral design; open bodice with large oval décolletage with train; long sleeves, folded back with partially exposed arm-holes; bell-shaped skirt with soft folds at the back; detachable train at waist with folds at the back; finished with a ruche of yellow and straw-coloured ribbon and metal thread embroidery over wide-mesh tulle in a stylised floral design; *kokoshnik* (head-dress) of gold brocade.
Length bodice 37 cm, skirt 142 cm, train 291 cm, *kokoshnik* 63 cm
Provenance: Acquired from the State Museum of Ethnography of the USSR in 1941.
ЭРТ-13145 а, б, в; 13170
Previous Exhibitions: Leningrad, 1962, Cat. 54; St. Petersburg, 1994, Cat. 188
TK

349 Ceremonial Court Costume of Grand Duchess Tatiana Nikolaevna, c. 1913

St. Petersburg, workshop of O. N. Bulbenkova
Dress (bodice, skirt, train) of white satin; open bodice with large oval décolletage, with pointed lower front; long sleeves, folded back with partially exposed arm-holes; bell-shaped skirt with folds at the back; detachable train at waist, with soft folds at back; trimmed with lace matching the colour of the dress, garlands of artificial roses and a panel of pink velvet with pearl buttons; *kokoshnik* (head-dress) of pink velvet.
Length bodice 31 cm, skirt 140 cm, train 267 cm
Provenance: Acquired from the State Museum of Ethnography of the USSR in 1941; previously at the Alexander Palace in Tsarskoe Selo. ЭРТ-9430 а, б, в; 6998
Previous Exhibitions: Paris, 1989, Cat. 126; St. Petersburg, 1994, Cat. 190

According to A. K. Willim, who managed O. N. Bulbenkova's leading St. Petersburg fashion workshop, 'Miss Olga's', at the beginning of the 20th century, ceremonial court dresses of white satin decorated with garlands of artificial roses were made at the workshop for the emperor's eldest daughters, the grand duchesses Olga and Tatiana, to wear for the 300th anniversary of the House of Romanov. There was a tradition in the emperor's family of dividing the daughters into pairs. The oldest two, Olga and

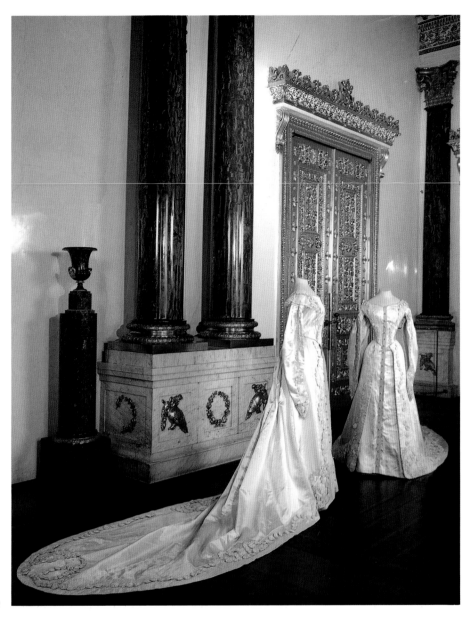

349, 350

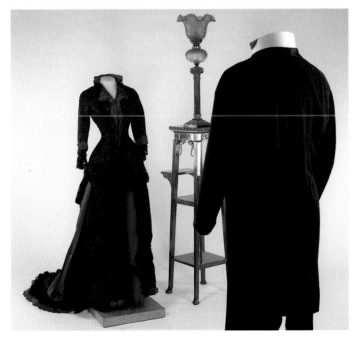

363, 351

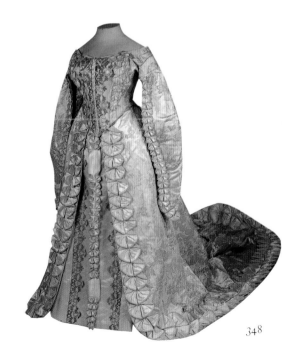

348

Tatiana, were known as the 'Big Pair' and the youngest two, Maria and Anastasia, were the 'Little Pair'. The empress also dressed them in pairs: the two older girls and the two younger girls wore dresses which were almost identical.

The fact that this costume comes from the Alexander Palace at Tsarskoe Selo, where the family lived, and that the mark reads 'T.N.' embroidered on the waist in pink silk, indicates that the dress belonged to Grand Duchess Tatiana Nikolaevna. TK

350 Ceremonial Court Costume of Grand Duchess Olga Nikolaevna, *c.* 1913 (p.205)

St. Petersburg, workshop of O. N. Bulbenkova
The workshop's trade-mark is printed in gold on a ribbon on the corsage: *Г-жа Ольга. Придворные шлейфы и платья. Екатерининский канал. д. 68, кв. 4.* [Miss Olga. Court trains and dresses. Apt. 4, 68 Ekaterinsky Canal].
Dress (bodice, skirt, train) of white satin; open bodice with large oval décolletage, with pointed lower front; long sleeves, folded back with partially exposed arm-holes; bell-shaped skirt with folds at the back; detachable train at waist with soft folds at the back; finished with draped tulle and garlands of artificial flowers, panel of pink velvet at the front with pearl buttons; *kokoshnik* (head-dress) of pink velvet.
Length bodice 35 cm, skirt 138 cm, train 262 cm, *kokoshnik* 60 cm
Provenance: Acquired from the State Museum of Ethnography of the USSR in 1941; ЭРТ-13142 a, б, в; 13143
Previous Exhibition: St. Petersburg, 1994, Cat. 189
TK

351 Man's Formal Costume, 1880s–1894 (p.205)

St. Petersburg, workshop of E. Henri
The workshop's trade-mark on collar of tail-coat: *Ed. Henri*
Tail-coat, waistcoat and trousers of black woollen fabric, collar of tail-coat in black satin, buttons covered in black silk.
Length back of tail-coat 115 cm, waistcoat 70 cm, trousers 118 cm
Provenance: Acquired from the State Museum of Ethnography of the USSR in 1941; ЭРТ-12732, 12733, 12734
Previous Exhibitions: Leningrad, 1962, Cat. 86; Leningrad, 1974, Cat. 158; Aarhus, 1990, Cat. 157; St. Petersburg, 1994, Cat. 194

This costume probably belonged to Emperor Alexander III. TK

352 Ceremonial Chamberlain's Uniform, Late 19th – early 20th centuries

St. Petersburg
Dress uniform jacket of black cloth, single-breasted, standing collar and cuffs of scarlet cloth; on collar, sides, back and cuffs, formal uniform decoration of stylised floral motifs and peacock feathers in gold-thread embroidery and sequins; gilt buttons with crest; trousers of white cloth with gold braid along external seams; two-pointed hat of black felt covered in design of gold thread embroidery and sequins similar to the decoration of the uniform jacket, with white ostrich feathers at the sides; chamberlain's key of gilt bronze with blue moiré ribbon; rapier with gilded hilt in scabbard of lacquered leather; shoes of black lacquered leather.
Length jacket 91 cm, trousers 104 cm, hat 17 cm, shoes 29 cm
Provenance: Acquired from the State Museum of Ethnography of the USSR in 1941. ЭРТ-10987, 10985, 11538, 11984 a, б
Previous Exhibition: St. Petersburg, 1994, Cat. 195

The court title of chamberlain originated in Western-European monarchies; it was introduced into Russia in the 18th century. Initially, a chamberlain was employed at the court for the management of a specific sector of the court administration, and these functions account for the fact that the accepted regalia of a chamberlain in many countries, including Russia, was a key on a ribbon. TK

353 Ceremonial Head-Chamberlain's Uniform, Late 19th – early 20th centuries

St. Petersburg
Dress uniform jacket of black cloth, single-breasted, standing collar and cuffs of red cloth; on collar, sides, back and cuffs, formal uniform decoration of stylised floral motifs and peacock feathers in gold-thread embroidery and sequins; gilt buttons with crest; trousers of white cloth with gold braid along external seams; two-pointed hat of black felt covered in design of gold thread embroidery and sequins similar to the decoration of the uniform jacket, with white ostrich feathers at the sides; chamberlain's key of gilt bronze with blue moiré ribbon; rapier with gilded hilt in scabbard of lacquered leather; shoes of black lacquered leather.
Length jacket 81 cm, trousers 105 cm, hat 16.5 cm, shoes 30 cm
Provenance: Acquired from the State Museum of Ethnography of the USSR in 1941; previously in the collection of the counts Bobrinsky. ЭРТ-10989, 11999, 11537, 9628, 12266 a, б; 11988 a, б
Previous Exhibitions: Leningrad, 1974, Cat. 98; New York, 1976, Cat. 404, 405; London, 1987, Cat. 91; Paris, 1989, Cat. 127; Aarhus, 1990, Cat. 155; St. Petersburg, 1993, Cat. 46; St. Petersburg, 1994, Cat. 196
Literature: Korshunova, 1979, No. 161; Korshunova, 1983, Nos. 173, 174

Each court rank had a dress uniform jacket corresponding to its title, and there were also distinctions between the uniforms for balls, festivities and daily use. The higher an individual's position, the greater the amount of gold embroidery on his uniform jacket. A. A. Mosolov, Head of the Office of the Ministry of the Court, notes that 'the Head Steward of the Household had not a single seam without its gleaming arabesques and garlands'. (Mosolov, 1992, p. 189.) The decoration of the uniform jackets of the chamberlains was no less luxurious. For the most part they were made in the workshops of St. Petersburg, and their price was extremely high. For instance, in 1870 a chamberlain's dress uniform jacket and hat made by Vladimir Zaleman, whose workshop was on Nevsky Prospect, was valued at 1,000 roubles. Ceremonial dress uniform required the addition to the chamberlain's jacket of long trousers of white cloth with gold piping down their sides. Ball dress uniform required knee-length pantaloons and white silk stockings, which frequently resulted in comic situations. 'A court official's legs had to be not too fat and not too bony, for the pantaloons only reached to the knees. If truth be told, there were some pantaloons which did not always remain where they were supposed to be. The individual concerned would suddenly bend down and begin twisting at his calf. It was what you might call a special kind of sculpture.' (Mosolov, 1992, p. 198.) In this connection, elderly court officials would enter the Ministry of the Court and ask whether they might be allowed to appear in long white trousers, although this was not in accordance with the rules. Permission is known to have been granted. TK

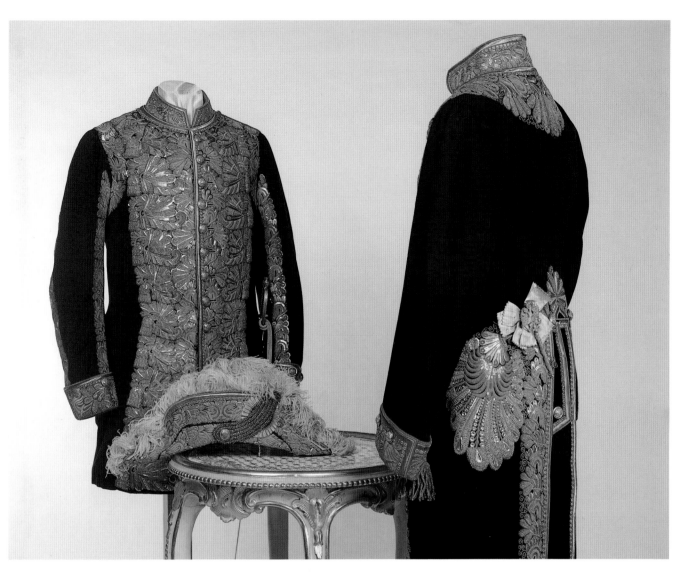

352, 353

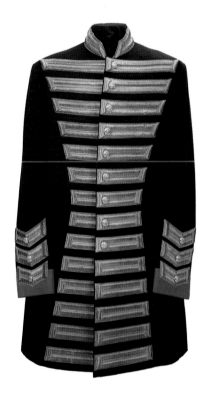

354

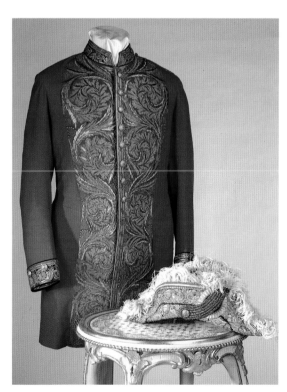

355

354 Chamberlain's Uniform, Late 19th – early 20th centuries

St. Petersburg
Uniform jacket of black cloth, single-breasted, standing collar and cuffs of scarlet cloth; on collar, sides, cuffs and back, applied 'bars' of gold braid; gilt buttons with crest; trousers of white, diagonally woven woollen fabric with stripes of gold braid.
Length along the back of jacket 85 cm, trousers 105 cm
Provenance: Acquired from the State Museum of Ethnography of the USSR in 1941. ЭPT-109977, 10287
TK

355 Senator's Ceremonial Uniform, Late 19th – early 20th centuries

St. Petersburg
Dress uniform jacket of scarlet cloth, collar and cuffs of dark-green velvet. Formal uniform embroidery of stylised oak and laurel branches, gilt buttons with the inscription *закон* [law]; trousers of white cloth with stripes of gold braid; shoes of black lacquered leather.
Length along the back of jacket 98 cm, trousers 105 cm, rapier 90 cm, shoes 29 cm
Provenance: Acquired from the State Museum of Ethnography of the USSR in 1941; jacket previously in the collection of Senator E. E. Reitern. ЭPT-10990, 10998, 11985 a, 6
Previous Exhibitions: Leningrad, 1962, Cat. 61; Leningrad, 1974, Cat. 105, 106; New York, 1976, Cat. 413, 414; London, 1987, Cat. 92; Paris, 1989, Cat. 128; St. Petersburg, 1994, Cat. 197
Literature: Korshunova, 1979, No. 158; Korshunova, 1983, Nos. 110, 111
TK

356 Uniform of a Court Footman of the Bedchamber,
Late 19th – early 20th centuries

St. Petersburg
Ceremonial caftan of blackish-green cloth with rounded flaps, unfastened; decorated on collar, sides, sleeves and back with several rows of smooth and formal uniform gold braid with crests; epaulette on right shoulder of red cloth with applied gilt metal eagle under a crown in ornamental frame and aiguillette of cord woven from gold and red silk threads.
Waistcoat of scarlet cloth, fastened with hooks, flaps cut at an angle; decorated on collar, sides and pocket flaps with three rows of formal uniform gold braid; gilt buttons with crest; kamashi-trousers of blue velvet to the knees with sewn-on brown cloth leggings fastened with gilt buttons with crests; gold braid fastening with copper buckle and tassel; shoes of black lacquered leather with gilded rectangular buckles with patterned edges.
Length along the back of caftan 103 cm, trousers 112 cm, epaulettes 12 cm, shoes 29 cm
Provenance: Acquired from the State Museum of Ethnography of the USSR in 1941; previously at the Winter Palace. ЭPT-12100, 12098, 12107, 11939, 11979 a, 6
Previous Exhibitions: Leningrad, 1962, Cat. 55; Paris, 1989, Cat. 137; Aarhus, 1990, Cat. 156; St. Petersburg, 1994, Cat. 198

The costumes of servants at the imperial courts, including footmen of the bedchamber, doormen, Cossacks of the bedchamber, and ordinary footmen were distinguished by their decorative appearance. They were made of brightly coloured fabrics, richly decorated with gold uniform braid bearing gilt buttons and representations of the imperial crest. The duties of footmen at the imperial palaces were varied in the extreme, both in everyday life and during official receptions, ceremonial dinners and balls:

'No lady had the right to introduce her own footman into the palace (it was not permitted even at the balls of the grand dukes). Cloaks and coats therefore had to be entrusted for safe-keeping to footmen of the court. The owner's visiting card would be attached to each lady's cloak or *sortie-de-bal*. The footman (white stockings, lacquered shoes and a jacket embroidered with gold braid with the state eagle) had to indicate in a low voice where it would be found among the other things after the ball. Drilled in the subtlest detail, the footmen slid quite silently across the parquet floors.' (Mosolov, 1992, p. 197.) TK

357 Court Blackamoor's Uniform, Late 19th – early 20th centuries

St. Petersburg
Outer jacket (*bambette*) of black cloth, unfastened, with long sleeves decorated with gold uniform braid with crests and embroidered designs in gold and silver cord.
Sleeveless inner jacket (*bambette*) of crimson velvet, unfastened, decorated with gold uniform braid with crests and embroidered designs in gold and silver cord.
Camisole of white cloth, decorated with formal gold braid with crests; on left side decorative pendants in the form of acorns, braided with gold thread.
Wide trousers of scarlet cloth reaching below the knees with black satin sash embroidered with gold cord and gold uniform braid with crests.
Leggings of black cloth, embroidered along the edge and in the centre with cord of gold and scarlet silk thread; fastened with hooks; blackish-green sash with gold tinsel tassel; Morocco-leather shoes.
Length along the back of inner sleeveless jacket 53 cm, outer jacket 54 cm, camisole 45 cm, trousers along side seam 117 cm, sash 11 × 341 cm, leggings 45 cm, fez 19 cm, shoes 30 cm
Provenance: Acquired from the State Museum of Ethnography of the USSR in 1941; previously at the Winter Palace. ЭPT-11901, 11899, 11946, 11904, 11961 a, 6; 11954, 11956, 11970 a, 6
Previous Exhibitions: Leningrad, 1962, Cat. 62; New York, 1976, Cat. 426–32; London, 1987, Cat. 92; London, 1987, Cat. 93; Paris, 1989, Cat. 133; St. Petersburg, 1994, Cat. 199

Following the fire of 1837 at the Winter Palace, the architect A. P. Briullov created the Large Dining Room for the imperial family, known as 'The Blackamoor Hall'. The service there was provided by black servants dressed in the exotic costumes of 'blackamoors'. These servants also attended at festive receptions and balls at the Winter Palace and other imperial palaces until the revolution of 1917, as indicated in written and visual documentary sources of the 19th and early 20th centuries:

'When an event takes place at the Winter Palace, the members of the imperial family gather in the Malachite Hall, to which only individuals of the very highest rank are allowed access. Court blackamoors in ceremonial costume guard the entrance to this hall ... The blackamoors also lend a special atmosphere to the occasion when guests arrive at the Winter Palace for court balls ... The visitors walk between two lines of Cossacks in red quilted coats and blackamoors, that is court negroes in large turbans. These blackamoors are a kind of tradition in themselves.' (Mosolov, 1992, pp. 193, 196, 199.) TK

358 Footman's Ceremonial Uniform, 1912–3

Caftan of black cloth with flaps cut at an angle, unfastened, decorated on the chest, back, pocket-flaps and seams with uniform gold braid with eagles; gilt buttons with crest, epaulettes of red cloth with applied gilt metal double-headed eagle under a crown in an ornamental frame, with an aiguillette of gold cord with red streaks.
Camisole of scarlet cloth with three rows of gold braid, gilt buttons with crest.
Trousers of scarlet mock-velvet, knee-length, gold braid garters with a buckle and a fringe of gold thread.
Kilt of green patterned damask with gold uniform braid.
Length along the back of caftan 90 cm, camisole 68 cm, epaulettes 12 cm, trousers 77 cm, kilt 45 cm
Provenance: Acquired from the State Museum of Ethnography of the USSR in 1941; previously at the Winter Palace. ЭPT-12097, 12096, 11821, 11816
Previous Exhibition: St. Petersburg, 1994, Cat. 200

The uniform of a footman at the Russian court had its origins in the 18th century, as exemplified by the typical late 18th-century cut of the caftan with its cut-away side-flaps, standing collar and decoratively shaped pocket-flaps, as well as the cut of the short pantaloons with garters below the knee.

During a reception in 1914 at the Alexander Palace, the French ambassador to Russia, M. Paléologue, was greatly impressed by 'the picturesque uniform of the footman from the period of

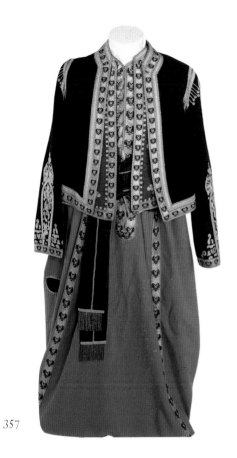

357

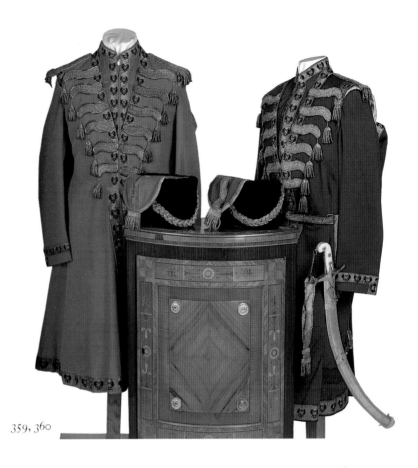

359, 360

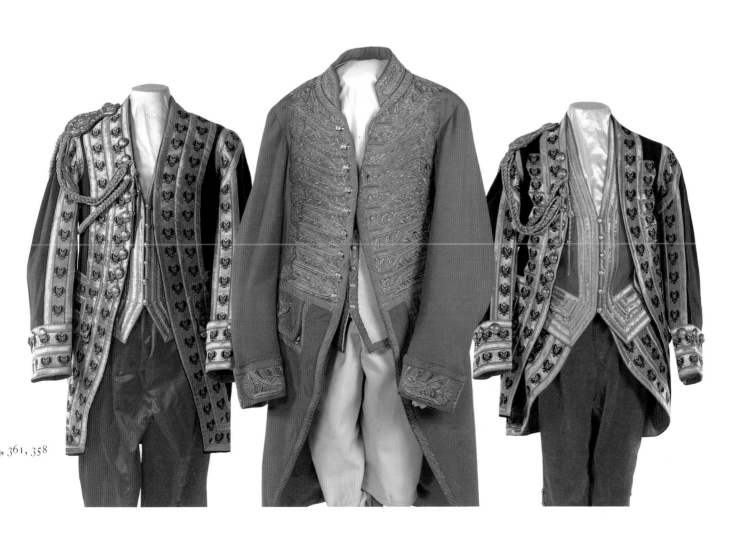

361, 358

Elizaveta, in his cap decorated with red, yellow and black feathers'. (M. Paléologue, 1991, p.126.) TK

359 Ceremonial Uniform of a Cossack of the Bedchamber,
Late 19th – early 20th centuries

St. Petersburg
Outer caftan of red cloth, collarless, waisted, with grouped folds at the centre of the back; folded sleeves with partially exposed arm-holes and black velvet cuffs, fastened to the waist on hooks; decorated on collar, sides, hem and cuffs with uniform gold braid with crests; on the chest six pairs of gold braid brandenburgs with gold thread tassels; epaulettes with gold thread fringe; inner caftan jacket of red cloth with standing collar, long narrow sleeves, waisted, grouped folds at the back, fastened to the waist with hooks; gold braid on collar and sides similar to braid on outer caftan; trousers of dark-blue cloth with double stripes of gold braid with red silk stripes at the edge along the external seams.
Papakha (Caucasian hat) of black sheep's wool, with red cloth cap embroidered with gold braid, and tassel of gold thread, tinsel gold chain on crown; sabre with white ivory handle in gilt silver scabbard, sword sash of gold braid.
Length of outer caftan 125 cm, length of inner caftan 95 cm, length of trousers 110 cm, hat 16.5 x 22 cm, length of sabre 96 cm, length of shoes 30 cm
Provenance: Acquired from the State Museum of Ethnography of the USSR in 1941; previously at the Winter Palace. ЭРТ-11924, 11927, 11914, 12639, ЭРО-7002
Previous Exhibitions: Paris, 1989, Cat. 136; St. Petersburg, 1994, Cat. 201
TK

360 Ceremonial Uniform of a Cossack of the Bedchamber,
Late 19th – early 20th centuries

St. Petersburg
Outer caftan of bright-blue cloth, collarless, waisted, with grouped folds at the centre of the back; swept-back sleeves with partially exposed arm-holes and black velvet cuffs; fastened to the waist on hooks; decorated on collar, sides, hem, arm-holes and cuffs with uniform gold braid with crests; on the chest six pairs of gold braid brandenburgs with gold thread tassels; epaulettes with gold thread fringe; inner caftan of bright-blue cloth with standing collar and long narrow sleeves, waisted, grouped folds at the back, fastened to the waist with hooks; gold braid on collar and sides similar to braid on outer caftan; trousers of dark-blue cloth with double stripes of gold braid with red silk streaks at the edge along the external seams.
Papakha (Caucasian hat) of black sheep's wool, with blue cloth cap embroidered with gold braid, with a tassel of gold thread, tinsel gold chain on wool crown; sabre with white ivory handle in gilt bronze scabbard, sword-knot and sash of gold braid with blue stripes.
Length of outer caftan 126 cm, length of inner caftan 93 cm, length of trousers 109 cm, hat 16 x 22 cm, length of sabre 96 cm
Provenance: Acquired from the State Museum of Ethnography of the USSR in 1941; previously at the Winter Palace. ЭРТ-11923, 11926, 11915, 12638, 12251 а, 6, в
Previous Exhibitions: Leningrad, 1974, Cat. 110; New York, 1976, Cat 420–424; Paris, 1989, Cat. 135; St. Petersburg, 1994, Cat. 202
TK

361 Ceremonial Uniform of a Keeper of the Bedchamber,
1912–13

St. Petersburg
Caftan of scarlet cloth with flaps cut away at an angle and standing collar, no fastenings; gold embroidery on flaps, back, collar and pocket-flaps; camisole of white cloth with gold embroidery on sides; trousers of white cloth with gold braid on side seams.
On the lining of the caftan: *К. Ф. Бахтинъ* [K. F. Bakhtin, the owner's name]; and the date *1913*
Length along the back of caftan 104 cm, camisole 69 cm, trousers 110 cm
Provenance: Acquired from the State Museum of Ethnography of the USSR in 1941; previously at the Winter Palace. ЭРТ-11945, 11830, 11872
Previous Exhibitions: Leningrad, 1974, Cat. 110; New York, 1976, Cat 420–424; Paris, 1989, Cat. 135; St. Petersburg, 1994, Cat. 203

In the late 19th and early 20th centuries the staff of the supreme court included three keepers of the bedchamber, one senior and two junior. One of them was Bakhtin, the owner of this caftan. Their duties included supervising the court servants and maintaining special housekeeping journals which recorded the events at court from one day to the next. TK

362 Costume of a Wet-Nurse, Late 19th – early 20th centuries

St. Petersburg
Costume (sarafan, jacket) of light-blue patterned silk; sarafan on shoulder-straps with folds on the bodice and skirt, white metal open-work buttons fastening along the centre of the front; trimmed with silver lace.
Jacket with standing collar and cape, with long sleeves, waisted at the back, with soft folds; fastened with white metal open-work buttons. Trimmed with silver lace and fringe; *kokoshnik* (head-dress) of gold brocade, embroidered with artificial pearls. Necklace of three threads of large artificial pearls tied with ribbons matching the colour of the costume.
Length sarafan 120 cm, jacket 85 cm, *kokoshnik* 14 x 16 cm
Provenance: Acquired from the State Museum of Ethnography of the USSR in 1941; previously in the collection of the princes Yusupov. ЭРТ-7136, 7137, 7134, 11497
Previous Exhibition: Paris, 1989, Cat. 132

In the families of the Russian aristocracy wet-nurses traditionally wore dresses which in their cut and decoration borrowed from Russian folk costume. A sarafan with shoulder-straps with a fastening at the centre, emphasised by wide strips of gold braid or lace, with an over-jacket, was a type of folk costume widely used throughout the regions of Russia. As a rule the costume was completed with a *kokoshnik*, the traditional head-dress of Russian folk costume, which had an immense variety of forms and range of decoration. TK

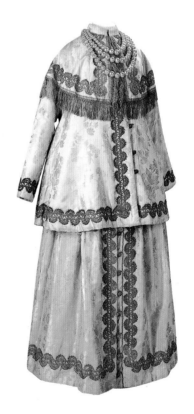

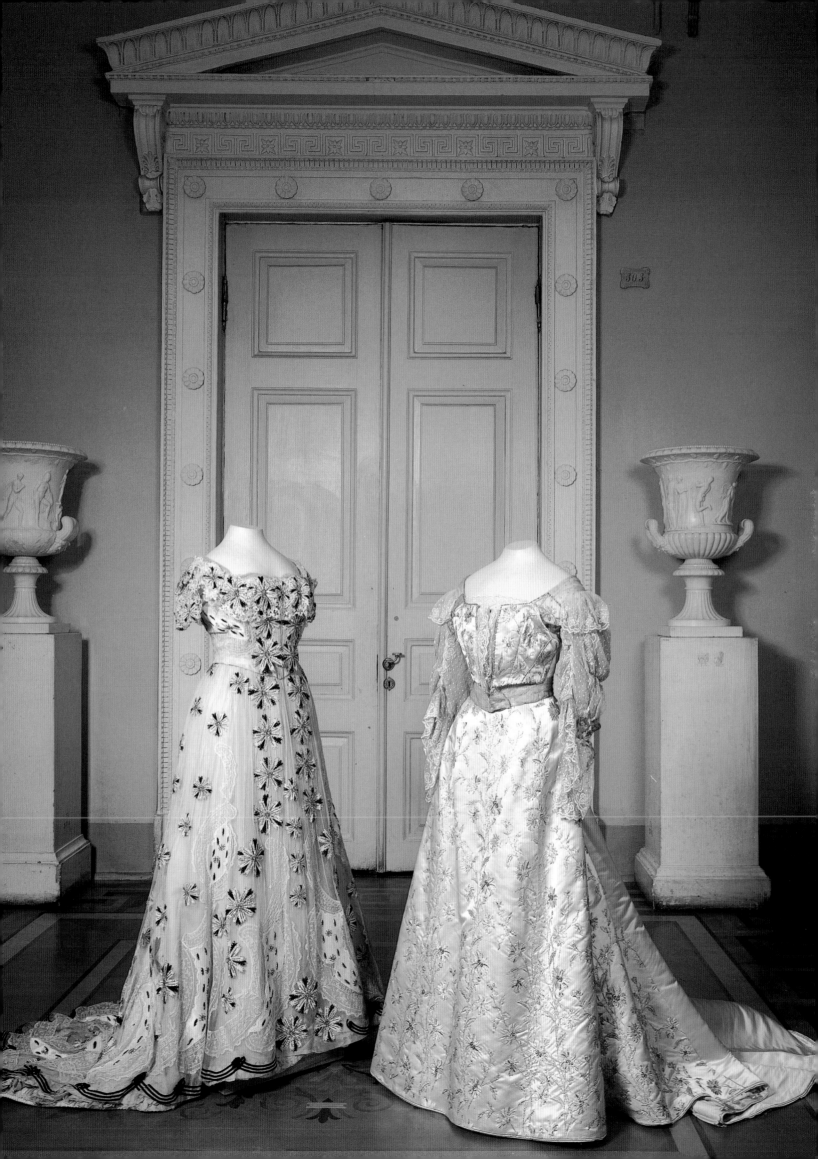

363 Evening Dress of Empress Maria Feodorovna, 1880s (p. 205)

Paris, firm of Fromont
The firm's trademark is printed in gold on a white silk ribbon on the corsage: *Fromont, rue de la Paix 9*; on the left an illustration of heraldic lions with a shield and the inscription: *Breveté de S.A.R. La Princesse de Galles* [Patented by Her Royal Highness the Princess of Wales]
Dress (bodice, skirt) of black satin; long bodice with V-neck décolletage, standing collar and lapels of scarlet satin, sleeves to below the elbows; straight skirt, slightly draped in front, with inserts of scarlet satin at the centre and sides, with bustle and train; decorated with black lace, scarlet silk embroidery and black bugles.
Length along the back of bodice 64 cm, skirt 114 cm
Provenance: Acquired from the State Museum of Ethnography of the USSR in 1941; previously at the Anichkov Palace in St. Petersburg. ЭРТ-8613 a, 6
Previous Exhibitions: Leningrad, 1962, Cat 84; Leningrad, 1974, Cat. 154; Paris, 1989, Cat. 82; Aarhus, 1990, Cat. 148; St. Petersburg, 1994, Cat. 204
Literature: Korshunova, 1979, No. 107; Korshunova, 1983, No. 112
TK

364 Evening Dress of Empress Alexandra Feodorovna,
Early 20th century (p. 215)

Moscow, workshop of N. Lamanova
The workshop's trade-mark is printed in gold on a silk ribbon on the corsage: *Н. Ламанова* [N. Lamanova]
Dress (bodice, skirt) of turquoise velvet; bodice with square décolletage, deep waist; short chiffon sleeves; bell-shaped skirt with soft folds at the centre of the back, with a train; decorated overall with inserts of lace and beadwork, sequins, imitation gems.
Length bodice 34 cm, skirt 183 cm
Provenance: Acquired from the State Museum of Ethnography of the USSR in 1941; previously at the Winter Palace. ЭРТ-9463 a, 6
Previous Exhibitions: Leningrad, 1962, Cat 98; Leningrad, 1974, Cat. 181; New York, 1976, Cat. 435; London, 1987, Cat. 79; St. Petersburg, 1994, Cat. 207
Literature: Korshunova, 1979, Nos. 145, 146; Korshunova, 1983, Nos. 157, 158

One of the most famous Russian designers at the turn of the 20th century was Nadezhda Petrovna Lamanova (1861–1941) who, over the course of a long and interesting life, made an immense contribution to the development of the Russian school of fashion design. From 1881 she studied at the Moscow tailoring school of O. A. Suvorova, and in 1885 she opened her own workshop in Moscow, producing work that rapidly became well known among the aristocracy and the artistic intelligentsia. Orders from the imperial court were also fulfilled here and at the beginning of the century Lamanova was awarded the title of 'supplier to the court'. In 1902–3 she took part in the First International Exhibition of Historical and Modern Costumes at the Tauride Palace, where her works were exhibited beside costumes from the leading fashion firms of Paris. At that time her Moscow workshop was located on Bolshaya Dmitrovka Street in the Adelheim building. Following the Russian Revolution of 1917, this talented designer played a tremendously important role in the development of the Soviet school of fashion design. In 1925 Lamanova's works, created jointly with the sculptor V. I. Mukhina and drawing on the traditions of Russian folk costume, were awarded the Grand Prix in Paris. It would be hard to overstate Lamanova's importance in the development of Russian theatrical costume. She was involved in the creation of costumes for many productions at the Moscow Arts Theatre, where she worked from 1901 until the end of her life; she also produced costumes for other theatres and for films, including *Circus* and *Alexander Nevsky*. TK

365 Evening Dress of Empress Alexandra Feodorovna,
Early 20th century (p. 211)

St. Petersburg, workshop of A. Brisac
Gold trade-mark on a white silk ribbon on the corsage: *A. Brisac. St. Petersbourg*
Dress (bodice, skirt) of pink satin; smooth satin with woven design matching the tone of the background, in the form of a vertical garland of chrysanthemums on long stems; open bodice with square décolletage, long, with draped sash, argentine lace bouffe sleeves to below the elbows; bell-shaped skirt with a train; front of bodice and skirt are decorated with silver thread embroidery, tinsel-silver, sequins and imitation gems following the pattern of the fabric.
Length along the back of bodice 34 cm, skirt 125 cm
Provenance: Acquired from the State Museum of Ethnography of the USSR in 1941; previously in the wardrobe of Empress Alexandra Feodorovna at the Winter Palace. ЭРТ-12908 a, 6
Previous Exhibitions: St. Petersburg, 1993, Cat 17; St. Petersburg, 1994, Cat. 209
Literature: Korshunova, 1979, No. 107; Korshunova, 1983, No. 112

The collection of costumes at the Hermitage includes several dozen dresses from the wardrobe of Empress Alexandra Feodorovna at the Winter Palace, many of which were made in the workshop of Auguste Brisac, whom his contemporaries described as the empress's favourite designer. They include costumes for the most varied of occasions: balls, visits, domestic wear, and so on, and are distinguished by the craftsmanship and subtle feeling for the style of the time which are so typical of their designer. Brisac's workshop was initially located at 42 Moika Embankment, then in 1908 at 8 Konyushennaya Square, and from 1916 at 24 Kamennoostrovsky Prospect, by which time the workshop was already owned by his son, V. Brisac. TK

366 Evening Dress of the Empress Alexandra Feodorovna,
Early 20th century

St. Petersburg, workshop of A. Brisac
The workshop's trade-mark is printed in gold on a white silk ribbon on the corsage: *A. Brisac. St. Petersbourg*
Dress (bodice, skirt) of white tulle with an underdress of chiffon and satin; open bodice of white tulle with square décolletage and pointed lower front, draped sash, bloused at the front; sleeves to below the elbow with bouffes at the shoulder; bell-shaped skirt with a train; flounces of lace on the décolletage, lower sleeves and hem; entire dress embroidered with gold beads and sequins in a design of stripes and branches of blossom with inlays of chiffon; full ensemble [not shown here] includes a second bodice, closed with a standing collar and long sleeves.
Length along the back of bodice 36 cm, skirt 164 cm
Provenance: Acquired from the State Museum of Ethnography of the USSR in 1941; previously in the wardrobe of Empress Alexandra Feodorovna at the Winter Palace. ЭРТ-8617 a, 6
Previous Exhibitions: St. Petersburg, 1993, Cat 15; St. Petersburg, 1994, Cat. 206
TK

367 Evening Dress of Empress Alexandra Feodorovna,
Early 20th century

St. Petersburg, attributed to workshop of A. Brisac
Dress (bodice, skirt) of straw-coloured satin; open bodice with oval décolletage, and pointed lower front; sleeves to below the elbows, with bouffes at the shoulders; bell-shaped skirt, with a fold at the centre of the back; draped tulle and garlands of artificial roses on the décolletage, the lower sleeves and the hem; dress is decorated with polychrome embroidery in satin stitch in a complex design of roses and laurel branches against a background of winding stems embroidered in gold thread and small metallic plaques in the form of leaves.
Length along the back of bodice 38 cm, skirt 169 cm
Provenance: Acquired from the State Museum of Ethnography of the USSR in 1941; previously at the Winter Palace. ЭРТ-8611 a, 6
Previous Exhibitions: St. Petersburg, 1993, Cat 16; St. Petersburg, 1994, Cat. 208
TK

Books

383 *An ABC in Pictures*, Alexander Benois, Published 1904

St. Petersburg, Department of State Documents. 34 pages with colour illustrations.
Card binding. 33 × 26 cm
Provenance: Acquired from the Imperial Libraries in the 1920s. Inv. no. 90331
Previous Exhibitions: St. Petersburg, 1994, No 108; Frankfurt-am-Main, 1997, No 16.

This book belonged to the Tsarevich Grand Duke Alexei
Nikolaevich (1904–1918). On the instructions of Nicholas II,
a special library was put together for Alexei, partly housed at
the Winter Palace, and partly at Tsarskoe Selo. It consisted of
a few shelves comprising both copies of books in the emperor's
collection as well as books that had been presented to the
tsarevich. The book-plate in this ABC reads: 'From the Library
of H.R.H. the Tsarevich Grand Duke Alexei Nikolaevich.' oz

384 Coronation Book, Published 1899

Published by the Ministry of the Imperial Court by kind permission of his Royal
Highness the Sovereign and Emperor. Binding by Otto Kirkhner of St. Petersburg.
Colour illustrations printed in A. A. Levinson's Printing Press in Moscow. Compiled by
V. S. Krivenko. Illustrated by N. Samokish, E. Samokish-Sudkovskaya and S. Vasilkovsky.
With an appendix of reproductions from originals by A. Benois, V. Vasnetsov, K.
Lebedev, V. Makovsky, I. Repin, A. Ryabushkin and V. Serov. The following took part in
the compilation: N. Oprits, E. Barsov, G. Frank, A. Arshenevsky, V. Nouvel, F. Tsaune,
K. Linden and S. Belokurov. Vol. 1–2. St. Petersburg, Department of State Documents,
1899. 45 × 35 cm
Vol. 1: 428 pages, 66 pages of colour illustrations, illustration inserts and vignettes in
the text; title page with a watercolour by N. S. Samokish. Binding: green leather with
polychrome and gold design after a sketch by N. S. Samokish; round metal medallion is
fixed to the upper part of the binding with an image of Emperor Nicholas II and
Empress Alexandra Feodorovna; inscription along the edge reads: Emperor Nicholas II
and Empress Alexandra Feodorovna, crowned 1896 in Moscow. Copy belonged to
Grand Duchess Olga Nikolaevna, eldest daughter of Nicholas II. Inv. no. 367560
Vol. 2: 336 pages, 27 pages of colour illustrations, 58 pages of photographic
reproductions. Binding: beige leather with polychrome and gold design after a sketch
by N. S. Samokish; round metal medallion is fixed to the upper part of the binding
with an image of the coat of arms of the Russian empire and an inscription around the
crown: God Be with Us. Copy belonged to Her Royal Highness Empress Alexandra
Feodorovna. Inv. no. 371919
Provenance: Acquired from the Imperial Libraries in the 1920s.
Previous Exhibition: St. Petersburg, 1994, No 319

The Coronation Book was published three years after the
coronation of Nicholas II and Alexandra Feodorovna. It follows
in the tradition of similar works published to mark such
ceremonies in Russia, dating back to the accession to the throne
of Anna Ioannovna. The first volume contained a history of the
coronation of the great princes of Moscow, the tsars and the
emperors, as well as a detailed account of the coronation of
Nicholas and Alexandra. The second volume consists of official
documents connected to the celebrations: photographs and lists
of royalty, government delegations and others present at the
ceremony, manifestos, decrees, awards, invitations, posters,
menus and programmes of events. Copies of the Coronation Book
were signed and given to particular people and institutions. They
were printed in two languages, French and Russian. The two
volumes shown here belonged to members of Nicholas II's family:
his wife Alexandra Feodorovna and his eldest daughter Olga
Nikolaevna. Alexandra Feodorovna's books all contained a book-
plate with her initials 'A.F.' oz

385 Cortège on the Day of the Christening of His Imperial Majesty the Tsarevich Alexei Nikolaevich, New Peterhof, 11 August 1904, Published 1904

Album of photographs, St. Petersburg, 1904. 17 pages of photographs by His Majesty's
court photographer C. E. de Hahn & Co. Binding by St. Petersburg book-binder M. F.
Boush; white leather binding with gold imprint and border. Fly-leaves in white moiré.
Copy belonged to Empress Maria Feodorovna. 29.5 × 40.5 cm
Provenance: Acquired from the Imperial Libraries in the 1920s. Inv. no. 135870
oz

385

386 In Memory of the Blessed Coronation of Their Imperial Majesties Nikolai Alexandrovich and Alexandra Feodorovna on 14th May, 1896, Published 1896

St. Petersburg, Goppe publishers, 1896. Parts 1–2 bound together, 210 pages, colour
illustrations in the text. White leather binding with gold imprint and border. Fly-leaves
in blue moiré. Monogram A Φ [AF] stamped in gold on right fly-leaf. After the title
page a printed dedication from the publisher E. Goppe to Emperor Nicholas II. Book-
plate of Empress Alexandra Feodorovna. Copy belonged to Empress Alexandra
Feodorovna. 42 × 31 cm
Provenance: Acquired from the Imperial Libraries in the 1920s. Inv. no. 111822
oz

The robe of blue silk with a pale-blue lining is embroidered with nine dragons, shimmering pearls and various jewels indicative of wishes for wealth, high station and happiness. The robe is a symbolic representation of the order of the elements: the waves below representing water; the mountains rising from the waves representing earth; the sky with clouds representing air. In the centre are two lotus blossoms, possibly indicating that the owner of the robe was not married.

Robes and caps were worn by officials to formal receptions and ceremonies. The cap was crowned with a setting of appropriate stones and ornaments according to rank, at the very top of which was a pearl (no longer extant). MLM

382 Folding Fan in a Box, 1860s

China, Qing dynasty (1644–1911)
Ivory, relief and open-work carving, silk, satin-stitch embroidery on silk, trimmed with marabou down; silk cord with tassels
Wooden box: covered externally with smooth black lacquer with design in two shades of gold; internally upholstered with white and red silk, lid with painted flowers and birds.
Length of fan 33.7 cm, *length* of box 43 cm
Provenance: Acquired from the Ethnography Department of the State Russian Museum in 1933. ΛΗ-199 a, 6
Previous Exhibitions: St. Petersburg, 1894, No. 267; St. Petersburg, 1994, Cat. 349

The fan was acquired in one of the shops of Guangzhou (Canton) or Hong Kong, which the tsarevich visited in March or April of 1891. Fans are traditional items of daily life in China, used by both men and women. However, their forms were very varied; they could be round, leaf-shaped, large or small. The materials used were also various, including silk, paper, feathers, leaves, bamboo and ivory.

One side of this fan is embroidered with a scene from Chinese life (possibly an illustration of a literary theme). On the shoreline at the left there is a pavilion in which a lady is sitting at a table with a candle, holding a scroll in her left hand. A young man is sitting on the terrace holding a spinning top in his hand and watching a junk in which a young woman is playing on a lute. In the centre is a small island with a pavilion. Embroidered beside the building are bamboo, pine and banana trees. The sun is setting in the sky. The illustration is embroidered in satin stitch and the faces are made of thin plaques of painted ivory. The silk is secured to 15 flat plates of ivory with open-work carving, while the end plates are decorated with multi-level relief carving illustrating flowers.

The box is upholstered internally with red and white silk with painted flowers and birds. It is covered on the outside with black lacquer with a design in two tones of gold lacquer. In the centre of the lid is a drawing of a bundle of Qing dynasty coins. The most recent coin shows the reign title of Emperor Tongzhi (1862–74), from which the fan can be dated.

Fans were exported in large numbers from China. Although the article was intended for export to Europe, the design employs themes and symbols common in China, predominantly good wishes of various kinds: for longevity, youth, steadfastness, success in one's career and wealth. In the shops of Hong Kong the tsarevich's eye was probably caught by the unusually large dimensions of this fan trimmed with marabou down, and he bought it as a present for his mother, Empress Maria Feodorovna, who had a collection of fans at the Anichkov Palace, including some from China. MLM

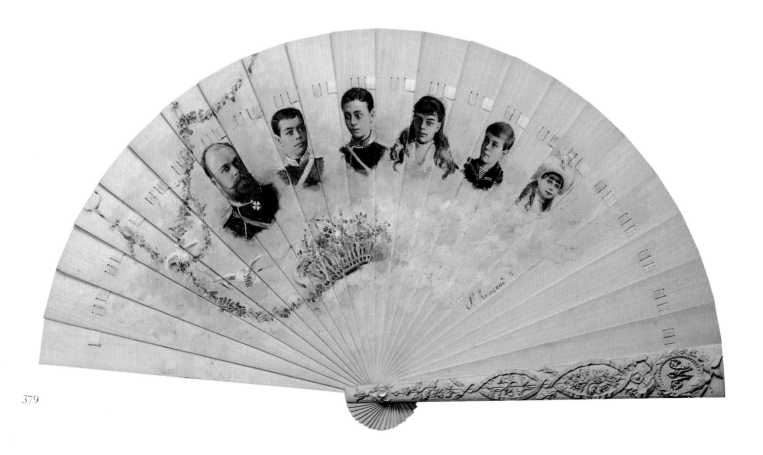

379

378 Large Fan of Vologda Lace, 1883

Russia
Fan with the letter 'M' woven into the front face under the cap of Monomakh; in a
wooden case with a double-headed eagle under the cap of Monomakh and letter
'M' carved on its lid.
Lace, satin, ivory, wood, carving
Fan 49.5 x 27 cm, case 53.7 x 32 cm
Provenance: Acquired from the State Museum of Ethnography of the USSR in 1941;
previously at the Anichkov Palace. ЭРТ-6751 a, 6
Previous Exhibitions: Aarhus, 1990, Cat. 165; St. Petersburg, 1994, Cat. 225; London,
1997, Cat. 71

The fan was made to mark the coronation of Emperor Alexander
III in 1883. YP

379 Folding Fan, 1886

St. Petersburg, designed by the painter I. N. Kramskoi
Fan with carved face plate bearing gold letter 'M'; portraits of Emperor Alexander III
and his children: Nikolai (future Emperor Nicholas II), Georgy, Xenia, Mikhail and Olga.
Signed on the side: *I. Kramskoi, 1886*
Length 26.1 cm
Provenance: Acquired from the State Museum of Ethnography of the USSR in 1941;
previously at the Anichkov Palace. ЭРТ-12696
Previous Exhibitions: St. Petersburg, 1994, Cat. 232; London, 1997, Cat. 55

The fan can be dated by the ages of the imperial couple's children
depicted on it. It was possibly presented to Empress Maria
Feodorovna on the occasion of her twentieth wedding
anniversary or her name day. YP

380 Hat of an Official, First half of 19th century

China, Qing dynasty (1644–1911)
Velvet, untwisted silk, gilt bronze finial, peacock's feathers
Diam. 31 cm
Provenance: From the original Hermitage Collection. ΛT-7942
Previous Exhibitions: St. Petersburg, 1894; St. Petersburg, 1994, Cat. 352
MLM

381 Robe with Dragons, First half of 19th century

China, Qing dynasty (1644–1911)
Silk, chain-stitch embroidery, coloured silk and applied gold thread embroidery
Length along back 148 cm
Provenance: From the original Hermitage Collection. ΛT-7670
Previous Exhibitions: St. Petersburg, 1894; St. Petersburg 1994, Cat. 353

During his travels to the Far East in 1890 and 1891 the Tsarevich
Nikolai Alexandrovich (the future Nicholas II) visited the
Russian colony in Hankou in April 1891. Here A. P. Malygin,
a member of the trading house 'Tokmakov, Molotkov and Co.'
presented the tsarevich with two robes of yellow and blue silk, a
belt, a pair of boots, and a black velvet hat covered with
untwisted red silk, decorated with two peacock's feathers,
indicating the rank of an official.

380

381

378

382

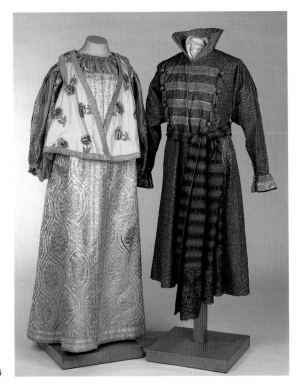

373, 374

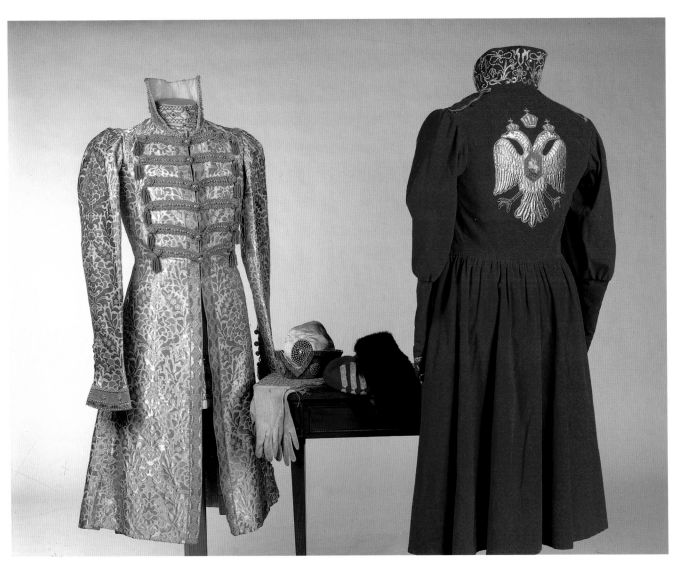

376, 375

374 Masquerade Costume of Count A. A. Bobrinsky, 1903

St. Petersburg; sash, Moscow
Boyar's costume of the 17th century; caftan of red silk with colourful design, peak collar (*kozyr*) and cuffs of gold brocade and gold braid; on the chest gold braid brandenburgs with tassels and large metal buttons; waisted, flared hem; trousers of light-blue patterned satin; tall boots of red Morocco leather and velvet with gold embroidery; gloves of yellow suede with large cuffs of pink velvet embroidered with metal thread, beads and appliqué work, trimmed at the edge with a gold fringe; sash of silken fabric with a fine pattern, with transverse stripes.
Length of caftan along the back 121 cm, length of side seam of trousers 101 cm, length of gloves 36 cm, sash 52 × 273 cm; boots: height 52 cm, length 30 cm
Provenance: Acquired from the State Museum of Ethnography of the USSR in 1941; previously in the collection of the counts Bobrinsky.
ЭPT-13406, 13460, 13425 a, б, 13782 a, б, 11964
Previous Exhibitions: Paris, 1989, Cat 142; St. Petersburg, 1994, Cat 216

The costume is made of contemporary materials, but with the addition of several authentic 17th-century accessories which might have been kept in the count's family (buttons of various forms). After the balls of February 1903, everyone who took part was photographed (see no. 394). By order of the court, the photographs were used to produce phototypes, which make it possible to attribute the masquerade costumes preserved in the Hermitage collection with great accuracy. EM

375 Masquerade Costume of Adjutant-General D. B. Goltsyn, 1903

St. Petersburg; sash, Slutsk (17th century)
Costume of a 17th-century lord falconer; caftan of red velvet, waisted, fastened with hooks; appliqué gold embroidery double-headed eagles on the chest and the back; tall collar and cuffs decorated with gilt thread embroidery and artificial pearls; trousers of scarlet satin; cap of red velvet with soft headband trimmed with gold braid and fur; boots of yellow Morocco leather, tall, with pointed upturned toes and applied metal open-work at the heels; silk sash 'Slutsk style'
Length of caftan along the back 123 cm, length of side seam of trousers 120 cm; hat: height 26 cm, circumference 58 cm; boots: height 48 cm, length 32 cm; sash 30 × 366 cm
Provenance: Acquired from the State Museum of Ethnography of the USSR in 1941.
ЭPT-13409, 13392, 13416, 13426 a, б, 18766
Previous Exhibitions: Paris, 1989, Cat. 143; St. Petersburg, 1994, Cat. 218

Tsar Alexei Mikhailovich was particularly fond of hunting with falcons, and in his time there was a falconry court in Moscow. The senior official at the court — the Lord Falconer — had ordinary, novice and sub-falconers under his command. Alexei Mikhailovich's work *Regulations, or a New Exposition and Arrangement of the Way of the Falconer* defined the rules of hunting and keeping falcons and also the ritual procedure for promoting falconers to senior ranks.

According to the author of a comment in the newspaper *Sankt-Peterburgskiye Vedomosti*, at the masquerades of 1903 the Horse Guards wore falconers' costumes made of white velvet with embroidered eagles. The costume of the Lord Falconer, the highest rank, was of red velvet with gold embroidery. EM

376 Masquerade Costume of Prince F. F. Yusupov, 1903

St. Petersburg. Trousers and hat: workshop of Laifert brothers. Boots: Kazan
Boyar's costume of the 17th century; caftan of patterned silver brocade, fitted at the waist; 'peak' collar, sleeves narrow at the wrist, fastened with buttons; decorated with blue velvet, gold braid, cord and tassels of gilded metallic thread and gold thread; cream silk shirt, decoration of gold cord and coloured pieces of glass on collar, edges of sleeves and hem-line; trousers of green plush, to the knees, decorated with strips of brocade embroidered with artificial pearls and coloured pieces of glass; cap of white satin with band of gold brocade, artificial pearls and pieces of coloured glass; gloves of light-yellow suede with cuffs embroidered in gilded thread, with gilded fringes; patterned boots of coloured Morocco leather with upturned points.

Length of caftan along the back 117 cm, shirt 186 cm, trousers 112 cm, hat 16.5 × 42.5 cm, boots 35 × 27 cm, gloves 48 cm
Provenance: Acquired from the State Museum of Ethnography of the USSR in 1941; previously in the collection of the princes Yusupov. ЭPT-13399, 13396, 13391, 13419, 13427 a, б; 13779 a, б
Previous Exhibitions: New York, 1976, Cat. 433–48; Paris, 1989, Cat. 140; St. Petersburg, 1994, Cat. 217

This costume is typical of carnival and theatrical outfits: bright colours, extensive use of coloured glass in imitation of precious stones, and embroidery in imitation of sewn gold, create an ensemble typical of 17th-century costume. The beauty and elegance of Prince F. F. Yusupov's wife, Z. N. Yusupova (no. 30), shone brightly at the balls of 1903. Grand Duke Alexander Mikhailovich recalled: 'At the ball there was competition for first place between Grand Duchess Elizaveta Feodorovna (Ella) and Princess Zinaida Yusupova. I danced all the dances with Zinaida Yusupova until we reached the "Russian" dance. The princess dances this better than any regular ballerina.' (Grand Duke Alexander Mikhailovich, 1991, p. 212.)

Prince F. F. Yusupov's costume was made at the Laifert brothers' workshop in St. Petersburg. This masquerade and theatrical dress workshop which belonged to the Laifert family for fifty years is mentioned in sources from the 1860s until 1912. It was one of the most prestigious establishments of its kind in St. Petersburg and was located at the very centre of the capital, on Karavannaya Street. EM

377 White Plush Bear, Early 20th century

St. Petersburg
Height 73 cm
Provenance: Acquired from the State Museum of Ethnography of the USSR in 1941; previously at the Alexander Palace in Tsarskoe Selo. ЭPT-14794
Previous Exhibition: St. Petersburg, 1994, Cat. 224

A bear, a dog and a cat, all of white plush, have survived from among the toys in the Alexander Palace at Tsarskoe Selo, the country residence of the imperial family close to St. Petersburg. The toys were evidently made for the Tsarevich Alexei. EM

sarafan, shirt and sleeveless jacket previously at the Novo-Mikhailovsky Palace in St.
Petersburg, *kokoshnik* previously in the collection of the Counts Stroganov.
ЭРТ-13429, 13436, 13437, 11496
Previous Exhibition: St. Petersburg, 1994, Cat. 215

This costume, with the exception of the hat, belonged to Grand
Duchess Maria Georgievna, daughter of King George of Greece
and wife of Grand Duke Georgy Mikhailovich, the uncle of
Nicholas II. It is called a costume of a peasant girl from the town
of Torzhok, but the materials and trimmings of the sarafan, the
sleeveless jacket and the shirt are only vaguely reminiscent of
Russian folk dress. This kind of costume is more typical of
theatrical productions and is not a true representation of
women's clothing in the 17th century. EM

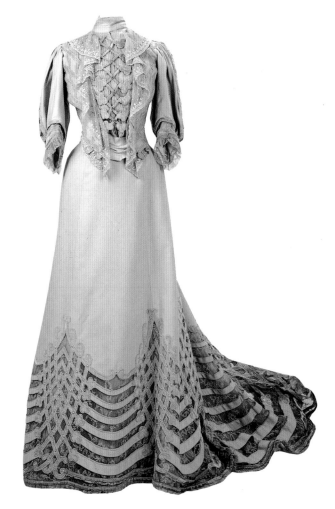

371

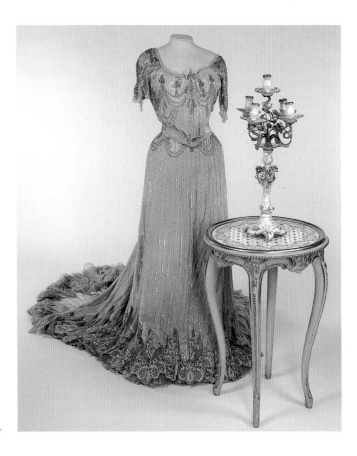

364

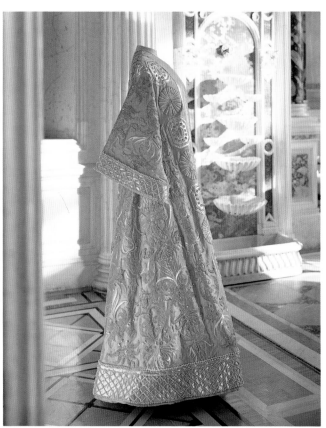

372

368 Evening Dress of Empress Alexandra Feodorovna,
Early 20th century (p.213)

St. Petersburg
Dress (bodice, skirt) of black tulle on white satin underdress; open bodice with rounded décolletage and short sleeves; bell-shaped skirt with train; embroidered with black sequins and steel beads in a design of stripes and branches of blossoming lilies, interwoven ribbons, etc.; opening of the décolletage, lower sleeves and skirt are decorated with flounces of black lace.
Length bodice 30 cm, skirt 135 cm
Provenance: Acquired from the State Museum of Ethnography of the USSR in 1941; previously at the Winter Palace. ЭPT-12890 a, 6
Previous Exhibitions: St. Petersburg, 1993, Cat 12; St. Petersburg, 1994, Cat. 210

The 1900s was a period when the style of art nouveau reigned supreme in costume art. Soft flexible fabrics with delicate tones (such as velvet, satin and tulle), flowing linear silhouettes with skirts firmly moulded to the hips then expanding at the knees and spreading out in a fan-shape across the floor, reflect the aesthetic ideal of art nouveau in the costumes of the time. The dresses are also remarkable for their abundant decorations: flounces, ruches and pleats, as well as extremely fine lace and embroidery work using a variety of techniques and materials, all of which could be combined in a single costume. TK

369 Evening Dress of Empress Alexandra Feodorovna,
Early 20th century (p. 211)

St. Petersburg, attributed to the workshop of A. Brisac
Dress (bodice, skirt) of black tulle on light-green silk underdress; bodice with square décolletage, and short sleeves; bell-shaped skirt with train; decorated with lace, appliqué work in velvet in the form of rosettes, ermine, beadwork and sequins.
Length bodice 31 cm, skirt 113 cm
Provenance: Acquired from the State Museum of Ethnography of the USSR in 1941; previously in the wardrobe of Empress Alexandra Feodorovna at the Winter Palace. ЭPT-8616 a, 6
Previous Exhibition: St. Petersburg, 1994, Cat. 211
TK

370 Evening Dress of Empress Alexandra Feodorovna,
Early 20th century (p.213)

St. Petersburg, workshop of A. Brisac
The workshop's trade-mark is printed in gold on a white silk ribbon on the corsage:
A. Brisac. St. Petersbourg
Dress (bodice, skirt) of smoke-coloured silk crepe on silver brocade underdress; open bodice, with pointed lower front and short sleeves in the form of double flounces; bell-shaped skirt with train; dress decorated with a design of fantastic flowers and stylised art nouveau floral motifs in silver sequins, colourless glass beads and white silk.
Length along the back of bodice 29 cm, skirt 170 cm
Provenance: Acquired from the State Museum of Ethnography of the USSR in 1941; previously in the wardrobe of Empress Alexandra Feodorovna at the Winter Palace. ЭPT-12862 a, 6
Previous Exhibitions: Paris, 1989, Cat 100; St. Petersburg, 1994, Cat 213
TK

371 Visiting Dress of Empress Alexandra Feodorovna,
Early 20th century

St. Petersburg, workshop of A. Brisac
The workshop's trade-mark is printed in gold on a silk ribbon on the corsage — a shield bearing a crest and the wording: *A. Brisac. St. Petersbourg*
Dress of lilac cloth; closed bodice with a standing collar, with pointed lower front; sleeves to below the elbow, with bouffes at the shoulders; bell-shaped skirt with soft folds at the centre of the back, with train; decorated with appliqué work in cloth and velvet matching the tone of the dress and lace.
Provenance: Acquired from the State Museum of Ethnography of the USSR in 1941; previously in the wardrobe of Empress Alexandra Feodorovna at the Winter Palace. ЭPT-8687 a, 6
Previous Exhibition: St. Petersburg, 1993, Cat no. 11
TK

372 Masquerade Costume of Empress Alexandra Feodorovna,
1903

St. Petersburg
Ceremonial dress of a Russian empress of the 17th century; *platno* dress of gold brocade with embroidery in metallic thread and sequins in a stylised floral design over the entire surface; loose with wide sleeves to below the elbow; fastened with hooks and buttons; trimmed with strips of silver brocade covered with artificial pearls on the centre of the front, hem and lower sleeves; head-dress of gold brocade decorated with artificial pearls; high-heeled shoes of gold brocade embroidered with sequins, artificial pearls and large green glass inserts.
Length of dress along the back 158 cm, hat 17 × 57 cm, shoes 25.5 cm
Provenance: Acquired from the State Museum of Ethnography of the USSR in 1941; previously at the Winter Palace. ЭPT-13435, 13440, 2486 a, 6
Previous Exhibitions: Paris, 1989, Cat 139; St. Petersburg, 1994, Cat 214

This costume is a copy of an outfit belonging to Maria Ilinichna, the wife of Tsar Alexei Mikhailovich. It consists of a *platno*, a garment of old Russian cut with wide sleeves which was worn for specially festive or ceremonial occasions, a cap and a shawl (*ubrus*), complemented by high-heeled shoes. The costume was specifically made for a masquerade ball held in 1903. This was one of the most famous masquerades held at the Winter Palace, recorded both in written testimony and in photographs of the revellers in their costumes (*see* no. 394). At the behest of Emperor Nicholas II, who was well known for his fondness for the epoch of Alexei Mikhailovich, the guests had to present themselves at the ball in 17th-century costume. The entire court spent several months preparing for the masquerade, which was held twice. The first occasion, on 11 February 1903, opened with a concert in the Hermitage Theatre, including performances from the finest artists of the time — Chaliapin, Figner, Herdt and A. P. Pavlova. This was followed by dinner in the Hermitage and later there was dancing in the Pavilion Hall. The ball continued until two o'clock in the morning; 390 people were invited. The second occasion, the so-called 'Great Ball', was held in the Winter Palace, with 250 people attending. There was dancing in the Concert Hall, tables were laid for supper in the Nicholas Hall, and in the other halls and galleries there were buffets and tea-tables. During supper the famous Archangel choir performed, and afterwards the dancing resumed, continuing until three o'clock in the morning. Grand Duke Alexander Mikhailovich wrote about this ball in his memoirs: 'His Majesty and Her Majesty were dressed in the costumes of Moscow tsars and tsarinas of the time of Alexei Mikhailovich. Alix [Alexandra Feodorovna] looked stunning, but His Majesty was not tall enough for his luxurious costume.' (Grand Duke Alexander Mikhailovich, 1991, pp. 211, 212.) The newspaper *Sankt-Peterburgskiye Vedomosti* also wrote in detail about the masquerade and the costumes. EM

373 Masquerade Costume of Grand Duchess Maria Georgievna,
1903 (p.217)

St. Petersburg
Costume of 17th-century peasant girl from the town of Torzhok; sarafan of light-green satin, on shoulder straps, not fastened, cut on the bias. Embroidered with silver thread, sequins, trimmed with galloon.
Shirt of gold crepe with embroidery in coloured silk and artificial pearls. Long, wide collar and sleeves; sleeveless jacket of white velvet with embroidered design of branches of blossom in coloured silk, trimmed at the edge with gold braid; *kokoshnik* (head-dress) of silver brocade and pink satin with silk ribbons, semicircular forehead piece with festoons, decorated with artificial pearls, imitation gems, silver thread embroidery and sequins.
Length of sarafan along the back 126 cm, shirt 40 cm, sleeveless jacket 54 cm, height of *kokoshnik* 24 cm
Provenance: Acquired from the State Museum of Ethnography of the USSR in 1941;

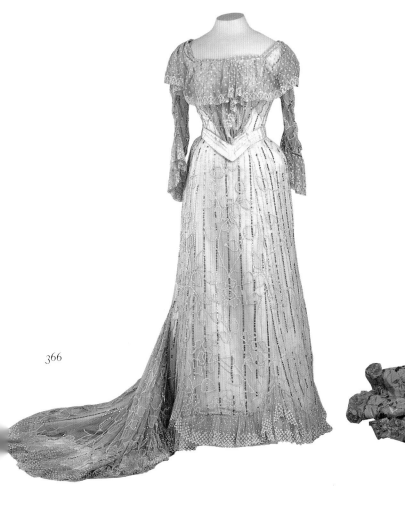

366

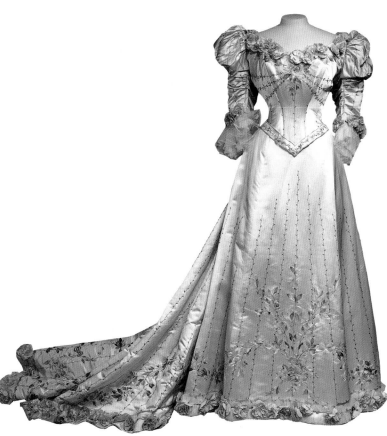

367

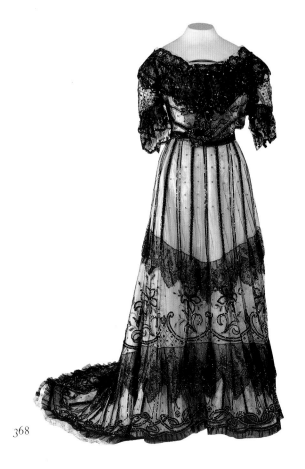

368

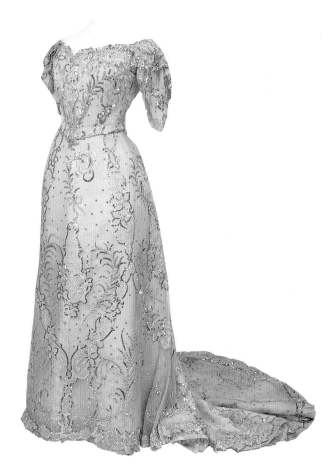

370

383

386

384

387 *Histoire de Turenne*, by Th. Cahu, Published 1898

Paris. 78 pages, colour illustrations in the text. Artist Paul Dufrèche. Work of the Paris book-binder E. Engel. Leathercloth polychrome binding with stamped design. Reverse side of outer fly-leaf contains pencilled inscription in English from Empress Alexandra Feodorovna to Nicholas II: *For Darling Nicky from Alix. Xmas 1898.* Book-plate of Emperor Nicholas II. Copy belonging to Emperor Nicholas II. 26 x 34.5 cm
Provenance: Acquired from the Imperial Libraries in the 1920s. Inv. no. 126734
OZ

388 *Jeanne d'Arc*, by Boutet de Monvel, Published 1896

Paris. 47 pages, colour illustrations in the text. Leathercloth binding. Outer fly-leaf contains pencilled inscription in English from Empress Alexandra Feodorovna to Nicholas II: *For my darling Nicky wishing you a happy Xmas 1896. From your loving Alix.* Book-plate of Emperor Nicholas II. Copy belonged to Emperor Nicholas II. 24.5 x 32 cm
Provenance: Acquired from the Imperial Libraries in the 1920s. Inv. no. 89945
OZ

389 Programme du Spectacle de Gala au Grand Théâtre Impérial de Moscou le 17 Mai 1896, donné à l'occasion du Couronnement de Sa Majesté L'Empereur Nicolas Alexandrovitsch et de Sa Majesté L'Impératrice Alexandra Feodorowna, Published 1896

Moscow, programme for a gala performance at the Bolshoi Theatre, Moscow, on 17 May 1896, on the occasion of the coronation of His Majesty Emperor Nicholas Alexandrovich and Her Majesty Empress Alexandra Feodorovna. Printed by the Imperial Theatres of Moscow, printing press of A. A. Levinson. 24 pages, 10 chrome lithographs. Artists: I. Petrov-Roppet, Y. Ryabushkin, A. von Goppen, E. Samokish-Sudkovskaya, K. Pervit. Bound by St. Petersburg binder A. Schell. Yellow leather binding with gold border. The centre of the outer cover contains a polychrome stamped design of the Russian coat of arms. Fly-leaves in blue moiré, framed in blue leather with gold stamped design. Along the margins of all the fly-leaves are numerous representations of the coat of arms of the Romanov house. The centre contains a gold stamped monogram of Emperor Nicholas II. 32 x 23 cm
Provenance: Acquired from the State Museum of Ethnography of the USSR in 1941; Inv. no. 265572
OP

390 International Exhibition, Glasgow, Published 1888

T. and A. Constable, Glasgow. 160 pages.
Green leather binding with gold stamped design and border. The centre of the outer cover contains a stamped coat of arms of Queen Victoria of England. The inner cover has a typographical device. Marbled paper fly-leaf framed in green leather with gold stamped design. The first clean page after the title page has an inscription written in ink: *Alix Glasgow. 1888.* Book-plate of Empress Alexandra Feodorovna. Copy belonged to Empress Alexandra Feodorovna. 18.5 x 13 cm
Provenance: Acquired from the Imperial Libraries in the 1920s. Inv. no. 127700

The book contains 18 hand-written comments made in English by Princess Alice of Hesse-Darmstadt, the future Empress Alexandra Feodorovna, during her visit to the International Exhibition in Glasgow in 1888. oz

391 *Souvenirs d'une Mission*, by le Baron de Baye, Published 1905–9

Paris, Librairie Nilsson. Work of the Paris book-binder Gruelle.
1) Ostafiero, 1908, 33 pages, 3 pages of illustrations, colour illustrations in the text.
2) Kouskovo, 1905, 42 pages, 5 pages of illustrations, colour illustrations in the text.
3) Viasiomy, 1908, 48 pages, 2 pages of illustrations, colour illustrations in the text.
4) Voronovo, 1909, 99 pages, 9 pages of illustrations, colour illustrations in the text.
Dark-green leather binding with gold imprint on the spine, red border. Double fly-leaf in marbled paper framed in green leather with gold imprint. This presentation copy has a hand-written dedication from the author to Emperor Nicholas II. All four works bound together. Book-plate of Nicholas II reads: *Property of His Majesty's Library in the Winter Palace.* Copy belonged to Emperor Nicholas II. 25 x 16 cm
Provenance: Acquired from the Imperial Libraries in the 1920s. Inv. no. 9067
OZ

392 *Vologda in Ancient Times*, by G. Lukomsky, Published 1914

St. Petersburg, Sirius. 364 pages with colour illustration in the text. Half-leather binding with gold stamping, marked on spine 'NA'. Book-plate reads: From the library of His Imperial Majesty the Tsarevich and Grand Duke Alexei Nikolaevich. Copy belonged to the Tsarevich Alexei Nikolaevich. 18.5 x 13 cm
Provenance: Acquired from the Imperial Libraries in the 1920s. Inv. no. 2408

The book is from the collection of Nicholas II, but was later transferred to the library of his son, Alexei Nikolaevich. oz

393 His Royal Highness Emperor Nicholas II Serving in the Army, Published 1915

Petrograd, R. Golike and A. Vilborg. Compiled by Major-General Dubensky, September–October 1914. 196 pages with many illustrations. Card binding. 27 x 20 cm
Provenance: Acquired from the State Museum of Ethnography of the USSR in 1941; Inv. no. 365644

Under instruction from the palace, the Ministry of the Imperial Court issued a whole series of publications describing the travels of Nicholas II in the army and around Russia during the 1914 war. This volume was compiled by Major-General Dmitry Nikolaevich Dubensky (1858–?), editor of the journal *Chronicle of the 1914 War*, who accompanied the sovereign on his travels. Nicholas II wanted personally to see his troops and their leaders on the field of battle, to thank them and to console those who had shed blood in defending Russia; he hoped by his presence to inspire his troops to even greater feats of defiance. He visited the General Headquarters, fortifications, German trenches and field hospitals, including the hospital named after his sister, Olga Alexandrovna, who had tended the wounded from the very start of the war. The book contains numerous illustrations, plans and a map of Nicholas II's travels, as well as a portrait of him in infantry uniform based on a work by Mikhail Rundaltsov. GY

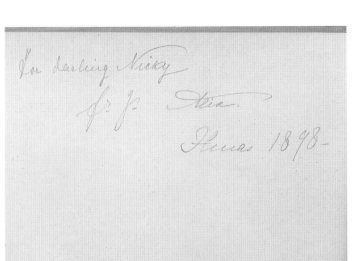

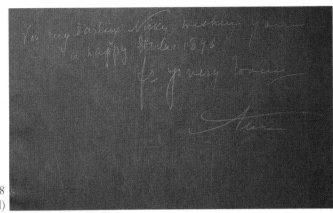

388
(detail)

387

388

389

389

PROGRAMME
DU SPECTACLE DE GALA
au
Grand Théâtre Impérial de Moscou
le 17 Mai 1896,
DONNÉ À L'OCCASION du
COURONNEMENT
DE SA MAJESTÉ L'EMPEREUR
Nicolas Alexandrovitsch
et
DE SA MAJESTÉ L'IMPÉRATRICE
Alexandra Féodorowna

389

390

391

393

394 Pages from the Album of the Costume Ball held in the Winter Palace in February 1903

St. Petersburg, Department of State Documents, 1904. 21 engravings, 174 colour prints.
Page 1: Emperor Nicholas II in the costume of Tsar Alexei Mikhailovich (top left). Photo-engraving from a photograph by L. Levitsky. 48.5 × 34.5 cm. Inv. no. 235619/1
Page 2: Empress Alexandra Feodorovna in the costume of Tsarina Maria Ilinichna (centre left). Photo-engraving from a photograph by L. Levitsky. 48.5 × 34.5 cm. Inv. no. 235619/2
Page 3: Grand Duchess Elizaveta Feodorovna in the costume of a 17th-century princess (top right). Photo-engraving from a photograph by L. Levitsky. 48.5 × 34.5 cm. Inv. no. 235619/3
Page 4: Grand Duchess Maria Georgievna in the costume of a peasant woman from Torzhok in the time of Tsar Alexei Mikhailovich (bottom left). Photo-engraving from a photograph by F. Boissonas and F. Eggler. 48.5 × 34.5 cm. Inv. no. 235619/4
Page 5: Adjutant-General his Highness Prince Dmitry Borisovich Golitsyn, master of the imperial hunt, in the costume of Tsar Alexei Mikhailovich (bottom centre). Photo-engraving from a photograph by F. Boissonas and F. Eggler. 48.5 × 34.5 cm. Inv. no. 235619/5
Page 6: Master of the Household Count Alexei Alexandrovich Bobrinsky in the costume of a 17th-century nobleman (bottom right). Photo-engraving from a photograph by L. Levitsky. 48.5 × 34.5 cm. Inv. no. 235619/6
Page 7: A group of guests who danced the 'Russian' dance at the ball. Photo-engraving from a photograph by Rentz and F. Shrader. 48.5 × 34.5 cm. Inv. no. 235619/7
Provenance: Acquired from the State Museum of Ethnography of the USSR in 1941; Inv. no. 235619

January each year saw the opening of the season of court balls in St. Petersburg. The first ball was held in the Great Nicholas Hall of the Winter Palace for more than 3,000 guests. Balls for 800 were held in the Concert Hall, and the Shrove-tide Ball took place in the Hermitage Pavilion.

1903 was the last year that balls were held at the Winter Palace. On 11 February about 390 guests were invited to attend a performance at the Imperial Hermitage dressed in costumes from the 17th century. Nicholas II was dressed as Tsar Alexei Mikhailovich — in a gold brocade caftan with a staff in his hand. Alexandra Feodorovna was dressed as Tsarina Maria Ilinichna, Alexei Mikhailovich's first wife; she wore a brocade dress with silver decorations (no. 372). Two days later a costume ball was held in the Concert Hall; guests included foreign diplomats and their families. The ball opened with a performance of the polonaise from the opera *A Life for the Tsar*, played by the court orchestra wearing the uniforms of 17th-century trumpeters. During the ball a wonderful performance of a Russian national dance was given by Princess Z. N. Yusupova. GY

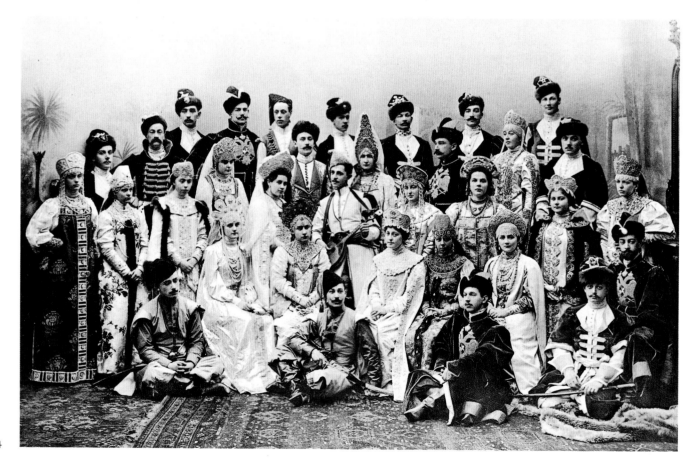

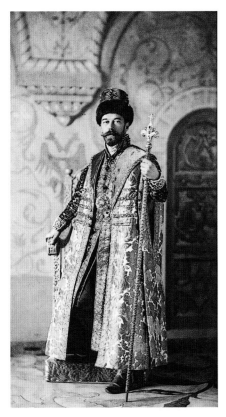

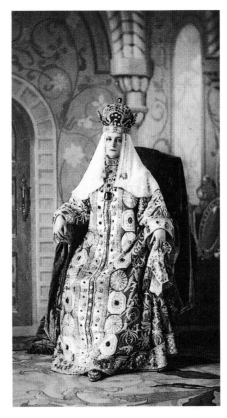

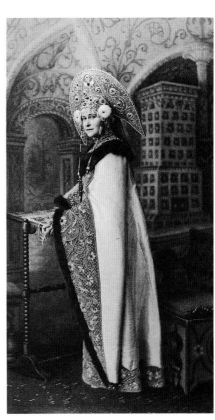

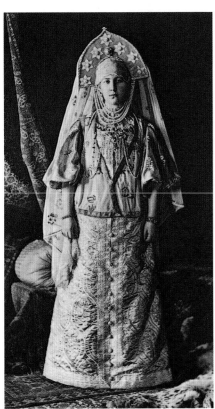

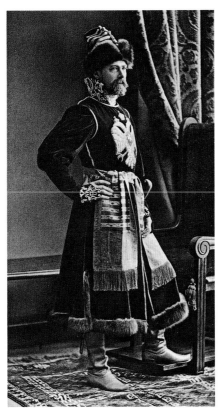

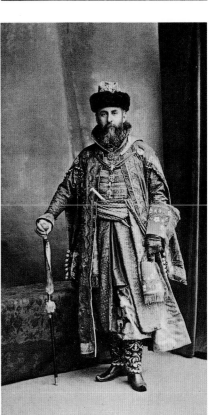

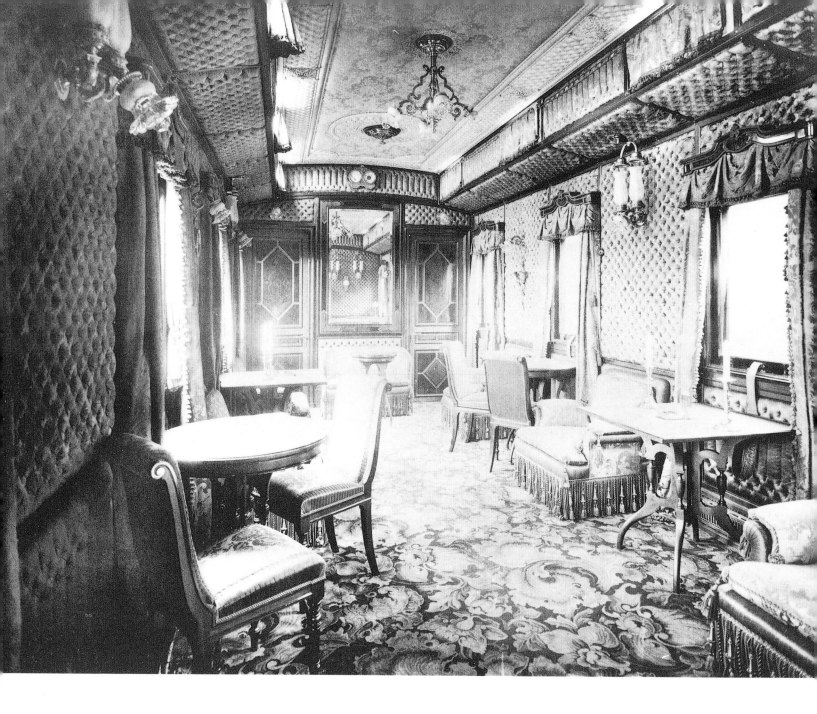

395 The Imperial Broad-Gauge Train for Travels about Russia, built in 1896–7

Published by the Ministry of Communications; compiled under the direction of the Temporary Committee for the Construction of Imperial Trains by the engineer P. Malevinsky. 220 pages containing many illustrations, 23 pages of illustrations, 25 pages of drawings. St. Petersburg/Moscow: typography by I. N. Kushnerev and co., 1900. Binding: brown leather with gold imprint and border. The inscription before the title reads: *confidential*. 34.5 × 25.5 cm
Provenance: Acquired from the State Museum of Ethnography of the USSR in 1941; Inv. no. 234288

After the derailment of the imperial train on 17 October 1888, a new train was needed that met the requirements of contemporary railway technology. There were ten carriages, of which seven provided living quarters for the imperial family: four private cars, a dining-car, a carriage for the children and a sleeping-car for the grand duchesses. Of the remaining three cars, one contained the imperial kitchen, and two were occupied by luggage and servants. The carriages were designed to provide maximum comfort and space for the passengers. The decoration was highly luxurious, but harmonious, making much use of mahogany, walnut, beech, maple, leather, velvet, silk and ormolu. The book also gives a detailed description of the exterior of the carriages, as well as technical data and plans. GY

396 The Childhood, Education and Youth of the Russian
Emperors, 1914

St. Petersburg, printing house of A. Benke, 1914. Published to celebrate the tenth
birthday of his Royal Highness the Tsarevich Grand Duke Alexei Nikolaevich.
Compiled by I. N. Bozheryanov. 138 pages with many illustrations; colour inserts
and vignettes in the text. Leathercloth binding, polychrome with gold design, and
a circular portrait of the heir to the throne, Alexei. 37 x 28 cm
Provenance: Acquired from the State Museum of Ethnography of the USSR in 1941;
Inv. no. 365703
GY

The Forbes Collection

397 Coronation Egg, 1897

Egg: varicoloured gold, translucent lime yellow and black enamel, diamonds, velvet lining

Coach: gold, platinum, translucent strawberry red enamel, diamonds, rubies, rock crystal

Length of egg: 12.5 cm; Length of coach: 9 cm

Marks: initials of workmaster Henrik Wigström, St. Petersburg 1896–1908; the name Wigström is roughly scratched on the inner surface of the shell, dated 1897.

Provenance: presented by Nicholas II to his wife Alexandra Feodorovna, Easter 1897; purchased by Emanuel Snowman for Wartski, London, 1927.

Previous Exhibitions: Paris, 1900, Exposition Universelle; St. Petersburg, 1902, von Dervise Mansion; London, 1935, Cat. 586, p. 111; Wartski, 1949, Cat. 6, pp. 3, 10, ill. p. 31; Wartski, 1953, Cat. 286, p. 25; V & A, 1977, Cat. 01, pp. 12, 93, ill. p. 101; Munich, 1986/7; Lugano, 1987, Cat. 119, pp. 11, 13, 113, ill. pp. 112–113; Paris, 1987, Cat. 119, pp. 6, 8, 109, ill. pp. 108–9; Burlington House Fair, London, 1987, no catalogue issued; San Diego/Kremlin, 1989/90, Nos. 7, 14, Cat. pp. 14, 21, 46, 86, 98, ill. pp. 10, 47, 98; St. Petersburg/Paris/London, 1993/94, No. 110, Cat. p. 256, ill. p. 257; New York/San Francisco/Virginia/New Orleans/Cleveland, 1996/97, No. 285, Cat. p. 266

Literature: Bainbridge, 1949, pp. 74, 76, ill. p. 58; Snowman, 1953, pp. 48, 52, 81–2, ill. pl. XXIV and dust jacket; Snowman, 1962, pp. 52, 56, 86–7, ill. pl. LXXIII and dust jacket [1974 edition]; Bainbridge, 1966, pp. viii, 73, 75, ill. pl. 89 and dust jacket; Waterfield/Forbes, 1978, pp. 52, 129, ill. p. 118; Forbes, 1979, pp. 1,237–8, ill. p. 1,237, pl. XVI; Habsburg/Solodkoff, 1979, pp. 105, 107, 158, ill. pl. 126 and catalogue pl. 37; Snowman, 1979, p. 97; Forbes, 1980, pp. 5, 14, 62, ill. p. 15 and an unnumbered page; Solodkoff, 1984, pp. 13, 17, 64, 65, 109, 126, 156, ill. pp. 9, 74, 186; Kelly, 1985, p. 14, ill. pp. 14–15; Forbes, 1986, ill. pp. 52–3; Habsburg, 1987, Cat. 539, pp. 12, 40, 94–5, 97–8, 272, 274, ill. p. 273; Forbes, 1987, No. 4, p. 11, ill. p. 14; Solodkoff, 1988, pp. 27–8, 34, 38, 43, 104, 119, ill. p. 35 and dust jacket; Hill, 1989, pp. 14, 57, ill. pl. 31–2; Habsburg/Lopato, 1994, Cat. 110, p. 256, ill. p. 257; Kelly, 1994, p. 9, 10; Habsburg, 1996, p. 23, ill. pl. 4; Odom, 1996, p. 175; Elsebeth Welander-Berggren, 1997, Cat. p. 70

From the FORBES Magazine Collection, New York, all rights reserved

The egg opens to reveal a removable miniature replica by George Stein of the coach used for Alexandra Feodorovna's entry into Moscow in 1896. The colour scheme of the egg is an allusion to the gold ermine-trimmed robes worn by their Imperial Majesties. A tiny egg, pavé-set with brilliants, once hung inside the coach. Beneath a portrait diamond set at the top of the egg, the monogram of Tsarina Alexandra Feodorovna is emblazoned in rose diamonds and rubies. The date 1897 appears beneath a smaller portrait diamond at the bottom of the egg. The egg is visible in a 1902 photograph showing items from the Imperial collection at the von Dervise Mansion, St. Petersburg.

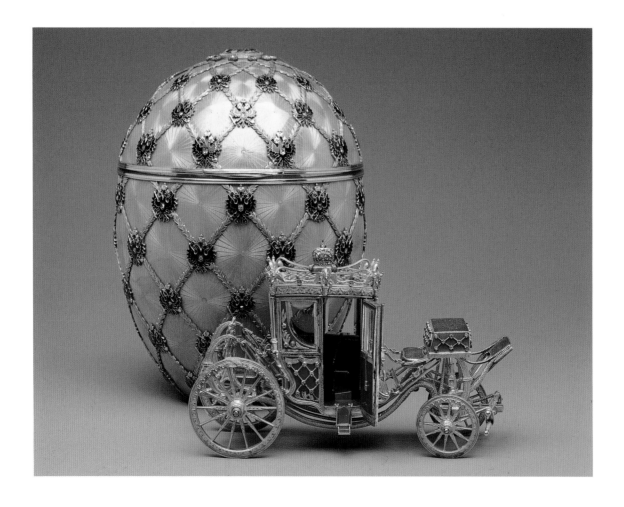

398 Nicholas and Alexandra Wedding Icon, 1894

Silver gilt, enamel, rubies, emeralds, sapphires, tourmalines, garnet
30.3 × 30.3 cm (open); 30.3 × 16.5 cm (closed)
Provenance: presented to Tsarina Alexandra Feodorovna by her sister Grand
Duchess Elizaveta, November 14, 1894; Armand Hammer; Mrs Ferdinand William
Roebling, Jr.; private collector, Pennsylvania.
Previous Exhibitions: Hammer Galleries, New York, 1930s; New Jersey State
Museum, Trenton, New Jersey, early 1940s
Literature: Bainbridge, 1949, pl. 31; WHERE New York, June 1997, p. 66
From the FORBES Magazine Collection, New York, all rights reserved

This icon was a gift marking the marriage of Tsar Nicholas II and
his bride Alexandra. Presented to Alexandra by her sister Grand
Duchess Elizaveta, the triptych is dated November 14, 1894,
the day of the imperial couple's wedding. When open, the three
hinged panels of the icon depict Our Lady of Kazan flanked by
the patron saints of Nicholas and Alexandra. The top of the
centre panel depicts The Holy Napkin containing the Saviour
Not-Made-With-Hands with the image of the living Saviour
made for King Agbar of Edessa. When closed, the top panels are
decorated with paintings of the Annunciation as well as cruciform
miniatures of the Virgin and Child and Christ. Miniatures of the
Four Evangelists set in tabernacle panels adorn the lower panels.

Icons play an important role in the Russian Orthodox faith.
Weddings and other life events are often marked through the
blessing of an icon, and cherished icons picturing the Virgin or
beloved saints are often passed down through generations in a
family. Formerly part of a private collection, the Nicholas and
Alexandra Wedding Icon has not been on public view since the
early 1940s.

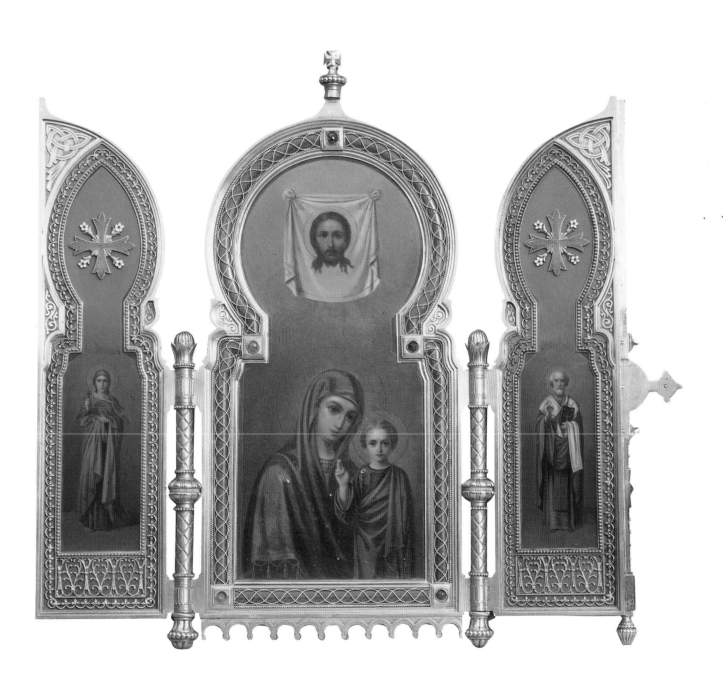

PHOTOGRAPHS IN THE STATE ARCHIVE OF THE RUSSIAN FEDERATION OF THE LAST RUSSIAN EMPEROR AND HIS FAMILY

Judge not according to the appearance, but judge righteous judgement. (John VII: 24)

Nicholas II, the last Russian emperor, was a keen amateur photographer. Today, thanks to his passion we have a vast collection of photographs taken by the emperor himself and by members of his family in addition to those taken by official photographers. These photographs do not simply give us an official portrait of Nicholas II and his family by the finest court photographers, but also a pictorial record of his private life and reign.

In the words of Versilov, the hero of Dostoevsky's novel *The Youth*:

Photographs very rarely resemble one another, and this is hardly surprising: for the original — that is, every one of us — very rarely looks like itself. Only on very rare occasions does the human face express the essence of a man, or his most characteristic thought ... Photographs find man as he is; it is more than likely that Napoleon, taken at another moment, might have looked quite stupid, or Bismarck tender.

Nicholas II obtained a camera in the year of his coronation; he took pictures throughout his life, and left his descendants a collection of photographs astonishing in its breadth and variety. It is a collection that lets us study the 'original' in all his guises: emperor, husband and father. Everyone who looks at these photographs will see the last tsar of Russia in their own way. One feeling, however, unites us: these photographs attract us because in them we see a human life. And regardless of the time and tragedy that separates us from that life, we can comprehend it and identify with it.

Today, the State Archive of the Russian Federation holds the private collections of Emperor Nicholas II, Empress Alexandra Feodorovna and their children, Grand Duchesses Olga, Tatiana, Maria and Anastasia, and the heir to the throne, Alexei. The Archive contains 4,509 items, of which more than a quarter are individual photographs or albums. In addition to these collections, the private archives of the grand dukes and courtiers contain correspondence and photographs of the last tsar's family. For example, the State Archive possesses the fascinating private records of A. A. Mosolov, who was head of the Chancellery of His Royal Highness, and V. F. Dzhunkovsky, governor of Moscow; both contain large collections of photographs of Nicholas II and his family.

This vast collection of documents and photographs has its own history, which deserves its own account. After the events of 1917, the Provisional Government decided to take control of the State Archive of the Russian Empire, which had existed since 1834, and which was then renamed the State Archive of the Ministry of Foreign Affairs. Private documents which members of the royal family had been unable to take with them, or which had been seized after their arrest, were gathered from the nationalised imperial palaces and grand dukes' residences and placed in the Archive. The Archive also took possession of private documents that the royal family had left behind at the Alexander Palace in Tsarskoe Selo after their exile to Siberia in August 1917. Any documents that the tsar and his family had with them at the time of their murder in July 1918 were then delivered to Moscow from Ekaterinburg. Here they were handed to the Bolshevik leadership by Y. M. Yurovsky, one of the instigators of that bloody event. The Bolsheviks searched through them to try to find compromising material about Nicholas II, but when this failed, the documents were handed over to the State Archive.

When the State Archive of the Russian Soviet Federal Socialist Republic was established in 1920, its collection was centred around the documents in the former State Archive of the Russian Empire relating to the history of the House of Romanov. This collection became known as the New Romanov Archive. Throughout the 1920s, many documents and photographs held in museums and archives around the country were added to the collection. Two decrees from the All Russian Central Executive Committee and the Council of People's Commissars of the Russian Federation were instrumental in this process. These decrees ordained that all documents relating to the Romanov family should be transferred to the State Archive. In 1925 the New Romanov Archive formed the basis of the Archive of the October Revolution, and was renamed The Department of the Fall of the Old Regime.

Although the archives were combined, and then divided again, the documents relating to the House of Romanov from the end of the nineteenth and the beginning of the twentieth centuries were kept together. They are now preserved in the State Archive of the Russian Federation. Whilst the existence of these materials has never been concealed, for many decades access to them was limited; these private documents and photographs of the Romanov family effectively lay untouched.

The sections devoted to the private collections of the last imperial family in the State Archive contain a large number of official portraits taken by some of the finest

photographers of Russia and Europe at the turn of the twentieth century. These include some wonderful portraits of Nicholas, taken by court photographers in Russia. Foremost among these was Sergei Lvovich Levitsky, the father of Russian photography. A lawyer by training, he fell in love with photography and dedicated his whole life to pursuing the art. Having mastered photographic techniques in Paris under some of the leading masters of the time, he returned to St. Petersburg in 1849 to open Letopis ['chronicle'], a daguerreotype studio. Ten years later he went to Paris again, returning to Russia in 1867, a world-renowned master of photography. Levitsky was court photographer to Emperors Alexander II, Alexander III and Nicholas II, continuing until his death in 1898. Shortly before his coronation in 1896, Nicholas wrote the following entry in his diary for 3 May: 'At 2.15 went to be photographed by Levitsky's son, since the old man was unwell. He took all sorts of photographs: a group of three with our daughter, as a couple and on my own.' (Diaries of Nicholas II, 1991, p. 142.) Nicholas II's private accounts for 1896 show that Levitsky was paid for 283 photographs of the imperial family during that year. (ГА РФ. Ф601. Оп.1. Д.1713. Л.57.)

One of the first photographs of Nicholas taken by Levitsky dates from the early 1870s (no. 423); it shows a three-year-old child with remarkable curls. This was followed by a series of portraits of Nicholas on his own or with his parents or brothers. One photograph of Nicholas from 1881 is particularly striking, showing a well-built young man in a sailor's outfit — the very uniform he was wearing on 1 March 1881, when his grandfather Emperor Alexander II died before his eyes from fatal injuries caused by a terrorist bomb. After the accession to the throne of Nicholas II and Alexandra Feodorovna, Levitsky's portraits of Nicholas as tsarevich were widely copied and published in numerous official publications in Russia and abroad.

There were other equally popular photographers at court: C. I. Bergamasko; A. A. Pasetti, whose studio was taken on by new owners at the beginning of the twentieth century and became known as Boissonas and Eggler; L. Gorodetsky (formerly known as V. Lapre); D. Asikritov; and F. Orlov of Yalta. Many photos of the imperial family taken by these photographers between 1880 and 1910 were frequently published in newspapers and magazines, and kept in family albums. For the most part, these photographers took the pictures in their studios where they were able to attain new standards of lighting, composition, perspective and artistic elegance. A notable exception was the court photographer Pasetti, who chose instead to take his photographs outdoors, capturing the most important processions and parades in which the emperor participated. For example, Nicholas II's private accounts for 1895 record payment to Pasetti for photographs showing views of parades on the Champ de Mars in Paris.

The largest collection of official portraits of Nicholas and members of his family was taken by the C. E. de Hahn and Co. studio. It is particularly interesting that the name of the court photographer, C. E. de Hahn, should appear so regularly in the memoirs and private documents of the Romanov family, since a search through the 'All Petersburg' directory for the years 1896–1917 reveals no one with that name living in the capital or its suburbs. Nor is there any record of the name or address of his studio. Nevertheless, it is well known that there was a court photographer called C. E. de Hahn, who became private photographer to the emperor in 1911. The mystery is explained in the archive documents which reveal that his real name was Alexander Karlovich Yagelsky.

Yagelsky's story is very interesting. From the beginning of the 1890s, the C. E. de Hahn studio at Tsarskoe Selo was run by Casimira-Ludwiga-Evgenevna Yakobson (hence the initials 'C. E.'). She was the wife of an assistant to the senior court engineer, and her maiden name was Hahn. It was she who owned the 'exclusive right to produce photographic images of His Imperial Highness the Sovereign Emperor Nicholas Alexandrovich' (ГА РФ. Ф640. Оп.2. Д.63. Л.1). Co-owner of the studio from its foundation in 1891 was Alexander Karlovich Yagelsky, a photographer who had come to Russia from Warsaw at the end of the 1880s.

In August 1897 another woman, Wanda Zaelskaya, the widow of a titular councillor, succeeded Yakobson as co-owner of the C. E. de Hahn studio. She and Yagelsky subsequently obtained the exclusive rights to take pictures of the emperor and his family, issued by the Chancellery of the Imperial Academy of Arts (ГА РФ. Ф640. Оп.2. Д.63. Л.7). Yagelsky's first work for the imperial court dates from 1891. Almost all the 'Hahn' photographs were taken by A. K. Yagelsky and in 1911 he was awarded the title of 'Photographer to His Majesty' (Russian State Historical Archive (RSHA), РГ ИА. Ф648. Оп.43. Д.1518. Л.33). It is hardly surprising that Yagelsky has remained a little-known photographer, since all his works were produced under the name of 'C. E. de Hahn' (always inscribed on the passe-partout without inverted commas). Furthermore, the emperor and his circle referred to Yagelsky simply as 'Hahn'.

There is another interesting aspect of his story. In March 1896 the department of police applied to the St. Petersburg province gendarmerie for information 'about the personal relations and degree of political untrustworthiness of the photographer A. K. Yagelsky and his assistant I. K. Yagelsky ... in connection with their application for permission to take photographs at the forthcoming coronation' (ГА РФ. Ф102. Д-3.1895 г. Д.1425 т.5. Л.29, об.). Despite the positive reference given by the gendarmerie, the police department did not grant the photographer permission, the reason being that in 1889 A. K. Yagelsky had been summoned to appear at 'an inquiry into political affiliation' concerning his brother Ignaty Karlovich, who had been discovered in possession of 'rebellious photographs'. As a result of the inquiry, both brothers lost the right of residency in Moscow.

After his initial rejection, Yagelsky made a second

application to be allowed to photograph the coronation, in which he described his five years' work at the imperial court; again his application was turned down (ГА РФ. Ф102. Д-3.1895 г. Д.1422 т.5 Л.68, 163–164.), though fortunately, this setback did not hinder his future career.

Yagelsky did not just take official portraits of the imperial family; he effectively produced the photographic record of the main events in which the emperor and his family participated. He photographed parades and military reviews at Tsarskoe Selo and Peterhof, he joined the royal family on board the yacht *Standart* during overseas voyages, and he witnessed meetings between Nicholas II and foreign heads of state. During the First World War he photographed the emperor at army headquarters at the front.

The beginning of the twentieth century saw dramatic developments in the field of photo-reportage (we need think only of the work of one of the first photo-chroniclers, K. K. Bulla (1853–1929), whose 'snapshots' were printed on the pages of the capital's magazines). In addition to official portraits, Yagelsky was a master of the art of instant photography, and left an enormous collection of photographs of the emperor and his family in moments of rest and relaxation. E. S. Botkin, physician to his majesty, told an interesting story about C. E. de Hahn in a letter to his children dated 15 September 1910:

Freidberg. The other day the three of us [Nicholas II, aide-de-camp Drentelen and Botkin] *went for our first walk on foot around Freidberg. I think the sovereign must have had his picture taken at least eight times, by four photographers. Each would take a shot, then run on ahead to the next street, we would look, they would snap again ... One of the four photographers was good old Hahn, who walked along looking gloomy with his 'belly'* [this was how the imperial circle referred to Hahn's camera], *like a hunter out of luck and with an empty game-bag, then suddenly ... there was the sovereign ... now Hahn ran ahead and took his picture. A bit later, when he noticed that Hahn was still following behind, his highness stopped and said to him: 'Well come on, take some photographs of us for the album.'* (T. Melnik-Botkina, 1993, p. 105.)

Yagelsky accompanied the emperor and his family wherever they went, and took thousands of photographs. In his notes to the Office of His Imperial Highness dated 3 December 1911, he writes:

On every journey my first duty is to record the most important moments in which his highness participates, be they abroad or at home; pictures are produced on plates measuring 18 x 24 centimetres. Larger plates are occasionally used — 21 x 27 or 24 x 30 — but never less than 18 x 24. On average between 1,500 and 2,000 copies of 18 x 24 prints are produced ... Additional commissions include private portraits of the emperor and tsarevich, which are produced in the following sizes: study, boudoir, salon and panel, as well as extra, meaning about 18 x 32 ... I only use plates from the French firm Jougla, and original platinum paper from the firm Tropp and Munch in Freidberg. The film is made by Lumière. (РГ ИА. Ф468. Оп.43. Д.1518. Л.33 об., 35.)

As required, Yagelsky would present specimen contact proofs to the Chancellery of the Ministry of the Imperial Court for selection and permission to reproduce them. The head of the Chancellery, A. A. Mosolov, would look through all the prints, and the successful ones would then be presented to the emperor for inspection. As a result of this procedure, Nicholas II's photo collection contained a vast number of contact prints of the emperor and his family taken by C. E. de Hahn. Once Nicholas II and Alexandra Feodorovna had chosen the photos most suitable for reproduction, Yagelsky would receive permission from the Ministry of the Imperial Court to print photographs and mount them in passe-partouts showing the trade-mark of the C. E. de Hahn studio. These photographs were kept in the royal albums or printed in official publications. Reproductions would also be made for members of the royal circle if they appeared in any of the photographs. The following example gives some indication of the volume of work carried out by Yagelsky in his role ascourt photographer. Hahn's accounts for 1897 reveal the emperor paid the following sums from his private funds: 762 roubles for 58 photographs of various groups and 104 pictures of parades or military exercises; 667 roubles for photographs taken at Spala and Beloviej; and 342 roubles for 114 photographs taken during the visits by the German emperor and the French president in the summer of 1897 (ГА РФ. Ф601. Оп.1. Д.1718. Л.16).

Yagelsky, however, did not limit his activities to still photography. From the beginning of the 1890s, the court photographer began to use cinefilm, and in 1901 he showed his first 'cinematographic spectacle' to the imperial family. Watching cinefilms soon became one of the family's favourite pastimes. Nicholas II's diary for 1907 contains one of the most interesting references to the 'cinematography of Hahn': '20 January [1907], Saturday ... from 5 until 6.15 Hahn showed them [the children] cinefilms, some comical, some from his stay on board the *Standart*. They were absolutely delighted. We had lunch with all the Konstantinoviches [the family of Grand Duke Konstantin Konstantinovich], after which we all enjoyed the same show. We sat and watched until 12.' (Diaries of Nicholas II, 1991, p. 351.) Mosolov also left some stories about Yagelsky, including the following anecdote. Cinefilms were often shown at Livadia, Nicholas II's summer residence in the Crimea. On one occasion the family watched a film taken by Yagelsky of a parade in Livadia. The film showed the commander-in-chief of the Odessa military district, Count Musin-Pushkin, shaking his fist in annoyance at a poorly executed march-past by the troops. This caused the emperor to smile, and his children to roar with laughter. After the showing the count complained strongly to Mosolov: 'My dear chap, what on earth is going on? Place your Hahn under arrest! Who does he think he is! In the first place he's lying. I never shook my fist ... arrest him for a week without fail. You cannot show the commander-in-chief doing something he never did, even to the sovereign!' (Mosolov, 1993, p. 60.)

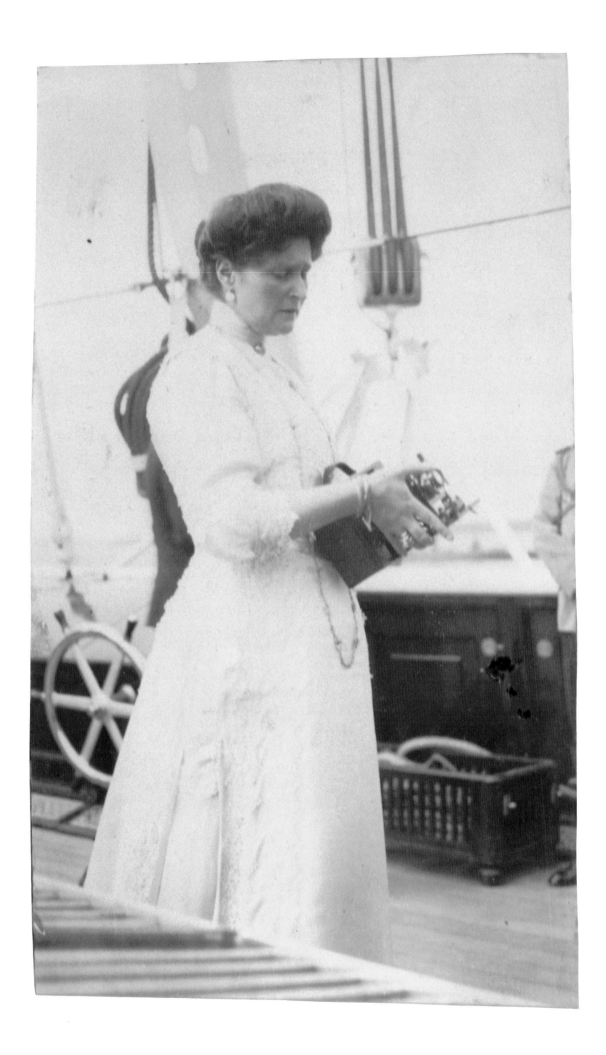

It is worth noting the count's reference to 'your' Hahn. Yagelsky was not simply 'Hahn', but referred to as 'our Hahn', not only by the head of the Chancellery of the Ministry of the Imperial Court, but also by the royal family and its circle. It is also interesting that the C. E. de Hahn studio worked only for the imperial court. This is why the 'All Petersburg' directory for 1896–1917, which lists all the photo studios in and around the town, makes no reference to Hahn's studio. A. K. Yagelsky died in 1916.

The most extensive photographic chronicle of the emperor's life, however, was left by the royal family itself. From the time of Alexander II it had become a tradition with the Romanov family to compile family albums containing formal photographic portraits of their family and entourage.

As tsarevich Nicholas had no personal photograph album himself, but his German bride, Princess Alice of Hesse, brought with her several albums with portraits of her family — her father Ludwig of Hesse and her English mother, Alice, as well as her sisters and brother. The age of amateur photography was only just beginning.

Nicholas II started to take amateur photographs in 1896. Unfortunately, we do not know when and where the emperor acquired his first camera, but his personal accounts for November 1896 contain an entry about a payment to the firm 'London Stereoscopic & Photographic Co.' for photographic accessories amounting to 9 pounds sterling (at the exchange rate of the time, 85 roubles and 65 kopecks). In December of the same year an invoice from the owner of a warehouse for photographic and optical accessories in St Petersburg was paid for 25 roubles to cover photographic work, two boxes of film and a camera cover (ГА РФ. Ф601. Оп.1. Д.1714. Л.95 об., 105 об.).

The first family album dates from this year. It contains family photographs and was housed with the personal papers of Nicholas II (ГА РФ. Ф601. Оп.1. Д.1560). The album includes 508 photographs from the period 1896–7. The first photographs in the album (acquired from the Daziaro studio in St. Petersburg) were taken at Ilinskoye, the Moscow estate of the tsar's uncle and governor-general of Moscow, Grand Duke Sergei Alexandrovich. The emperor and Alexandra Feodorovna went to Ilinskoye at the end of May after the coronation in Moscow. Nicholas described their arrival in his diary on 26 May 1896: 'It is an indescribable joy to come to this fine, quiet spot! The greatest consolation is to know that all the festivities and ceremonies are over!' (Diaries of Nicholas II, 1991, p. 148.)

The photographs show the relaxed atmosphere of the royal family in the company of their relatives — walking, drinking tea, playing games. It is difficult to say with any certainty which of these photographs were taken by Nicholas, since his enthusiasm for photography was shared by the entire imperial family: both Alexandra Feodorovna and several of the grand dukes also took pictures. The Dowager Empress Maria Feodorovna was also a great admirer of photography. It is known that 'she was invited by professor Schnerl to be editor of the Munich journal *Photographic World*, which was popular in Europe at the time, and also to assist in producing the album *The Photographic Art of Royal Persons*' (M. Zemlianichenko, N. Kalinin, Moscow, 1993, p. 83). The album contains amateur photographs of the town and churches of Nizhny Novgorod, the first amateur family photograph of the one-year-old Olga in Peterhof, and interiors of the rooms of the Alexander Palace at Tsarskoe Selo. In his diary entry of 19 October 1896, Nicholas writes: 'At 8 o'clock we travelled to Tsarskoe and went straight from the station to the house. I rejoiced at my magnificent [bath-house], which was even larger than at the Winter Palace; the dining-room has been redecorated.' (Diaries of Nicholas II, 1991, p. 175.) It was possibly the emperor himself who photographed his new rooms.

The photographs in the album portraying military reviews at Krasnoe Selo, and views of Vienna and Kiev are certainly notable. Of particular interest are the photographs taken in the autumn of 1896 during the family visits to Germany, England and France. In these, one can see many representatives of the European monarchies — the relatives of the Russian emperor — playing on the lawn, drinking tea in family groups and walking along the garden avenues. These photographs are especially noteworthy because they are not posed; everyone looks natural and relaxed. Proof that many of the royal families were captivated by photography is provided by photographs showing Victoria-Maria, the wife of the Prince of Wales (the future King George V), and the wife of the German Kaiser Wilhelm II, holding cameras.

Several of the photographs in the album from 1897 show some notable developments. First, the family had acquired a second camera. In February 1897, Pasetti's account was paid from the personal funds of the Empress Alexandra Feodorovna for the acquisition of 'one photographic camera and its accessories' (ГА РФ. Ф640. Оп.1. Д.73. Л.15). Photography became a family passion and more and more photographs were taken. Second, Nicholas and Alexandra began increasingly to photograph one another and their children, Olga and Tatiana. Of great interest are the photographs showing the interiors of the private rooms in the palaces at Peterhof and Tsarskoe Selo.

It is important to note that in the report on the expenditure of the imperial couple's personal funds for the period 1896–1911, information concerning payments made for developing films and printing photographs is not consistently present. In the document drawn up by the Cabinet of His Imperial Highness in March 1908, however, there is information concerning payments to Yagelsky. He was paid not only for photographic prints and for arranging 'cinema shows at the Royal Court', he also received payments made 'from funds held by the Office of Her Imperial Highness the Empress Alexandra Feodorovna and the Department for the affairs of the most August Children of Their Imperial Highnesses'. These payments were for photographic work carried out

between 1901 and 1907, and totalled 10,592 roubles and 85 kopecks (РГ ИА. Ф468. Оп.14. Д.3225. Л.3, 3 об.). Only from 1912 were payments regularly made against the invoices of the St. Petersburg photographer, I. M. Ponomaryov, for various photographic work.

The identity of the manufacturer of the imperial family's first camera is not known, but it is probable that it was Kodak. Proof that the imperial family used the company is found in Tsarevich Alexei's personal effects: negatives of amateur photographs have survived for the period 1911–12, preserved in Kodak packets (ГА РФ. Ф682. Оп.1. Д.175). Thanks to the investigation carried out between 1918 and 1919 by N. A. Sokolov into the assassination of the imperial family, there is documentary evidence to show that in the final years the Romanovs used a US-made camera.

In 1917, when the imperial family was exiled from Tsarskoe Selo to Siberia, they took with them a camera of the 'panorama company Kodak from the Karpov shop ... along with instructions, and two boxes containing 33 negatives'. These items were found after the murder of the imperial family in Ekaterinburg at the apartment of Mikhail Letemin, the guard for the Ipatiev house, during a search by the investigator Nametkin on 6 August 1918. As well as the items found at the Ipatiev house, three reels of Kodak film were recovered from the stoves and rubbish at the Popov house, where the guards of the Romanovs were accommodated (Sokolov, 1990, pp. 342, 352).

Some special features in the design and format of the first family album are of particular note. The photographs in the album consist of small-scale, contact prints. The accompanying captions for 1896 are hand-written by the emperor, although from the start of 1897 they are in the hand of the empress. Various little garlands and vignettes have been drawn in watercolours between the photographs. Such decoration is unusual, since all the later personal albums of the emperor are formal and without any embellishment. Later on, only albums belonging to the youngest daughters Maria and Anastasia have such intricate designs (the photographs are coloured in with watercolours and coloured pencils, with little flowers drawn on the pages between the photographs).

That Nicholas himself glued the photographs into the albums is shown by a diary entry of 29 October 1896: 'Fussed with some photographs, singling them out for gluing into the big album' (Diaries of Nicholas II, 1991, p. 177). It should be noted that in the private papers of Alexandra Feodorovna there are no albums with photographs taken by the family, and none of the 900 photographs taken between 1896 and 1916 are in albums. Whilst it is obvious that the albums were for all the family, it is apparent that it was Nicholas himself who was mostly concerned with their presentation, since only a few of the captions for the photographs are in the empress's hand. Of interest is the diary entry made by Nicholas on 12 December 1913: 'After breakfast many people pestered me with intolerable questions which vexed and annoyed me! Had a good walk in between the showers. Glued

photographs into the album.' (Diaries of Nicholas II, 1991, p. 437.) This favourite occupation calmed him and brought him into a state of mental equilibrium.

In 1896, small amateur photographs begin to appear in Nicholas's diary alongside the entries. In almost every diary after this year the emperor illustrated various entries with photographs. In addition, the first page would show photographs of Nicholas, the empress and the children, and the last page, family events described in the diary.

The only other of the emperor's personal albums to survive is for 1900–1. It is difficult to say why there is no album for 1898–9, since the photographs taken by the imperial family at this time were kept loose in other dossiers in the personal papers of Nicholas II. Principally, they relate to a hunting trip made by the imperial family to Skornevitsy (near Warsaw) in 1899.

The album for 1900–1 is particularly interesting as it highlights the growing confidence of the emperor's skills as a photographer. Nicholas had obtained a special camera that allowed panoramic pictures to be taken. He took the first pictures in Beloviej and Spala, and at his hunting residences in Poland, photographing nature and the palaces. At Tsarskoe Selo he photographed military parades and reviews in panorama; in the Crimea — the sea, ships, the palaces and nature. Although the artistic merit of these photographs is questionable, their historical significance is undeniable.

The personal photographs, diaries and letters of the emperor complement one another, and enable us not merely to reconstruct and understand events more clearly, but to identify the entourage of Nicholas and his family, to see their characters, moods and attachments. Of notable interest are several photographs in the emperor's album for 1900–1, which document the dramatic story of Nicholas II's serious illness in 1900.

The court physician, Girsh, had not recognised the symptoms of typhus from which the emperor was suffering, and he was virtually at death's door. Despite her pregnancy, Alexandra tended to him herself and did not leave her husband for an instant. It was with considerable effort that her relatives succeeded in persuading her to leave Nicholas's rooms, if only for the night. The critical state of the emperor forced the Minister of the Imperial Court, Baron Fredericks, against the wishes of Alexandra, to draw up a document concerning the heir to the throne, who at that time was Grand Duke Mikhail Alexandrovich, the younger brother of Nicholas II. However, the emperor's strong constitution helped him combat this serious disease. In a letter to his mother he wrote:

Thank God, I have survived this illness better than many other poor sufferers [there was an epidemic of typhus in Yalta]. *I assure you, dear mama, that I feel hale and hearty and quite strong. I was able to stand on my own feet all the time and now I can walk between the bed and the chair with complete ease; my legs do not tremble, although they have become very thin. I am cautious in my diet and I strictly observe the orders of the doctors. Fortunately I do not have*

that voracious appetite that usually occurs with those recuperating from typhus. Of my dear little wife, I can say that she was my guardian angel and looked after me better than any sister of mercy. (ГА РФ. Ф642. Оп.1. Д.2326. Л.89–91.)

It is possible that the unique pictures dating from this time were taken by Alexandra Feodorovna. They show the emaciated Nicholas sitting in an armchair at his writing desk, wearing indoor attire and covered with a rug. Perhaps it was at this very table that he wrote the letter to his mother.

The emperor photographed the empress more and more. However, Alexandra rarely looks happy in them and there is hardly ever a smile on her face. She has several expressions — sad, serious, sorrowful, anxious, but never happy. More frequently in the photographs of 1900–1 the empress is lying on a couch or sitting in an armchair; her frequent pregnancies sapped her health, which was already frail.

Unfortunately, there is no album for the years 1902–4, although during this period there were many family events: journeys to relatives abroad, yachting trips, holidays in Livadia during the summer of 1902, a pilgrimage to Sarov in 1903 (only in the album for 1905 with a few pictures taken during the journey), and finally the birth in 1904 of the long-awaited heir. The first photograph showing the newly born Alexei, barely more than a month old, is glued into the emperor's diary before the entry of 8 September 1904: 'Alix and I were very alarmed by the bleeding of young Alexei that came at intervals from his umbilical cord until evening ... How painful it is to experience such anxieties!' (Diaries of Nicholas II, 1991, p. 228.)

The next family albums of the emperor that have survived date from 1905–10, 1910–11 and 1911–13 (ГА РФ. Ф601. Оп.1. Д.1521, 1527, 1530). Like all the others, they are designed personally by the emperor, as testified by his written inscriptions for the photographs. Which were the pictures taken by the emperor himself in those years? Principally, scenes of the family on holiday: journeys abroad on the yacht *Standart*, meetings with relatives in Germany, walks in Livadia, playing tennis, enjoying picnics and games with the children. There are also photographs of military reviews and parades in Peterhof, Krasnoe Selo, and the visits of the imperial family to various towns. The emperor continued to have a passion for panoramic photographs. His attention was drawn in particular to ships, his beloved *Standart*, and above all, to the Crimean countryside and the architecture of the Livadia Palace.

Over time the household of Nicholas and Alexandra amassed a large collection of personal family photographs and albums in addition to the albums of official photographs. It is clear that they greatly enjoyed looking through these albums with their close friends and relatives. For example, in his diary for March 1908 Nicholas writes: 'After lunch I examined my old albums with Irene [the Prussian sister of Empress Alexandra

Feodorovna].' (ГА РФ. Ф601. Оп.1. Д.251. С.74.) Nicholas and Alexandra also made albums for the children, in which some of the pictures duplicated their own albums, and some were devoted to the particular child the album was for. The captions were generally written by the empress ('For Marie, Papa & Mama').

By this time the eldest daughters were beginning to take photographs themselves. They were taught the art of photography by the court photographer Yagelsky. In a memo sent to the Cabinet of His Imperial Highness on 3 December 1911, Yagelsky observes that: 'For the entire time I taught photography to the imperial children — although it occurs not systematically, but usually during walks and in the skerries — I have a right to consider this a labour, excepting the honour that has been conferred on me and my moral satisfaction.' (РГ ИА. Ф468. Оп.43. Д.1518. Л.35.)

Thirty-three albums for the period 1906–17 with family photographs from the personal collections of the Grand Duchesses Olga, Tatiana, Maria and Anastasia are kept in the State Archive of the Russian Federation. They include albums presented by their parents, as well as ones they made themselves. Imitating their father, the children glued in the photographs themselves and wrote the captions — the location, surnames and Christian names of those depicted. There are many photographs in particular devoted to the holidays in Livadia and sailing on the *Standart* in the period 1912–14. With growing frequency, members of the family are depicted holding cameras. Thus, for example, in a photograph taken during a walk in 1913 to the Kosmodomiansky Monastery in the Crimea, the Grand Duchesses Olga and Tatiana are pictured holding cameras. Typical comments recorded by the emperor in his diary during the period 1913–14 include: 'Until tea I was gluing photographs into the album, and Alix and the daughters were doing the same thing with the officers'; 'I summoned the officers from the yacht; our daughters were sticking in photographs and I had a good game of dice'; Diaries of Nicholas II, 1991. pp. 412, 414, 428, 431, 433, 437, 484.)

The last family album was begun in 1914. In the spring, the family visited their beloved Livadia. The First World War was only four months away, but at the time no one could have suspected that tragedy was round the corner. The photographs show the carefree faces of the children playing with the officers on the *Standart*, and the calm domestic atmosphere. Then a visit to Odessa; the return to Tsarskoe Selo; the encounter with the British squadron; the holiday in the skerries; the family at Peterhof. These were the last peacetime photographs.

The first amateur photographs taken of the emperor from the First World War period date from September 1914, and show the arrival of Nicholas II in Baranovichi, a small Belorussian town which became the headquarters of the Supreme Commander of the Russian army. The album contains pictures of the royal arrival, the officers at the headquarters and the reviews of the troops.

Most of the photographs of the war years were taken

from 1915 to 1916. In August 1915 Nicholas took supreme command of the Russian army. The headquarters were moved to Mogilev, and alongside his father, the eleven-year-old heir Alexei rode out 'to war'. These photographs leave a remarkable impression. After a serious attack of haemophilia in 1912, the sick Alexei appears in the photographs either in an invalid chair or in the arms of the boatswain Derevenko, but in these war photographs he looks a healthy and lively child. Beside his father he made the rounds of the troops, played war games with local urchins and visited the wounded in hospital.

The empress and her daughters made frequent visits to the headquarters. The photographs capture imperial family at rest on the outskirts of Mogilev on the banks of the river Dniepr. Again, it impossible to say exactly who took these pictures, since by this time the whole family and their close entourage were taking pictures. In a letter to her husband on 22 June 1916 the empress wrote: 'The pictures taken by Derevenko and Baby [Alexei] are very sweet; please ask him to send me another 12 of each — showing him with a gun, running, at his lesson in the tent, and also with you in the boat, since I shall paste up the albums for our exhibition and most of what I have are old photographs. Let him also send me the other good pictures — yours and Alexei's — from the previous lot.' (The Correspondence of Nicholas and Alexandra, 1926, vol. 4, p. 332.)

In all the albums of Nicholas and the members of his family, it is sometimes difficult to distinguish the pictures taken by the imperial family or their courtiers, from the work of the court photographer Yagelsky, for he accompanied the family almost everywhere right up until his death in the autumn of 1916. He was with them in Tsarskoe Selo, in Livadia (where a special pavilion for his work was fitted out), in the skerries, on board the *Standart* and abroad. It is possible to establish that Nicholas, Alexandra or the children are the authors of certain photographs. Certainly it appears that during the war years the girls themselves photographed the wounded in the hospitals they supported, and they wrote the surnames of those depicted under each photograph.

The last amateur photographs were taken by the youngest members of the family in the spring and summer of 1917 at Tsarskoe Selo at the time of their arrest. Looking at the photographs of this period, it is difficult to imagine that the man working in his kitchen garden near the Alexander Park, or sawing firewood, had until recently been the emperor of the Russian Empire; the soldiers standing alongside him are not guards of honour, but prison guards. The photographs from the Tobolsk period of the family's incarceration are missing from the State Archive, but a few pictures survive in private collections and have been reproduced in various publications. There are no known photographs of the Romanovs in Ekaterinburg. If we believe the evidence of the guard M. Letemin, Nicholas's camera was stolen by him from the Ipatiev house after the murder of the imperial family. Whether or not it contained film we can only surmise.

In 1918, in Ekaterinburg, a former professional photographer, Y. M. Yurovsky, who used to take pictures 'as a souvenir', together with his detachment, shot Nicholas II and his family in order to wash away the very memory of the last Russian emperor.

Alia Barkovets
The State Archive of the Russian Federation

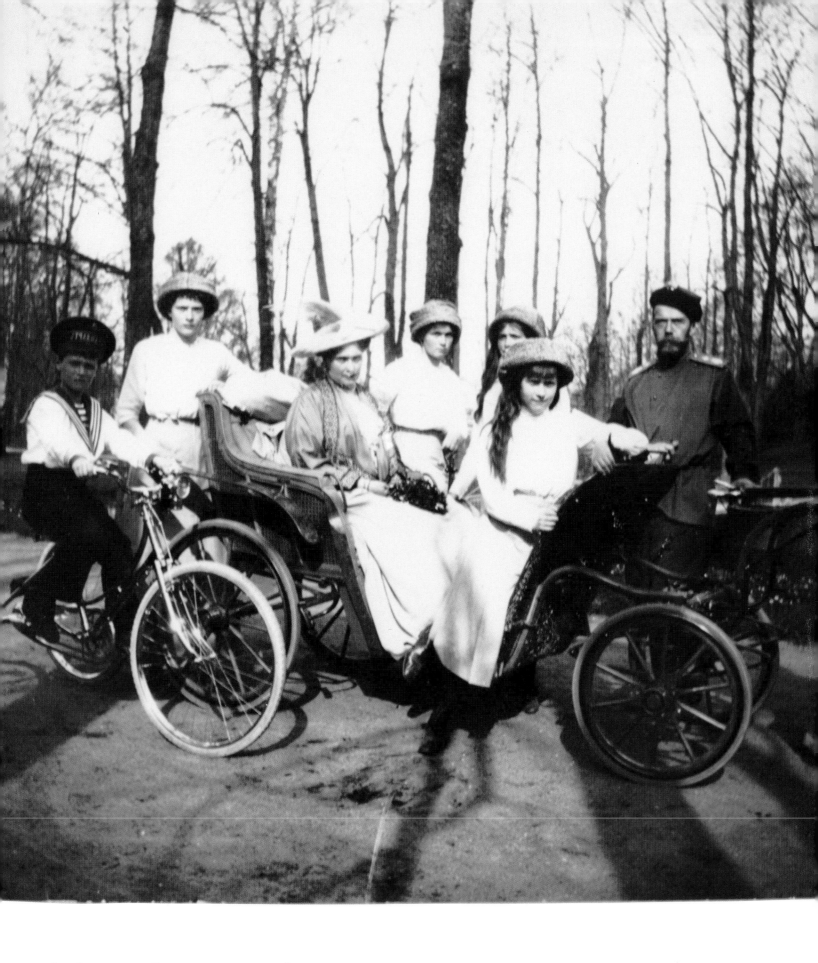

THE STATE ARCHIVE
OF THE RUSSIAN FEDERATION

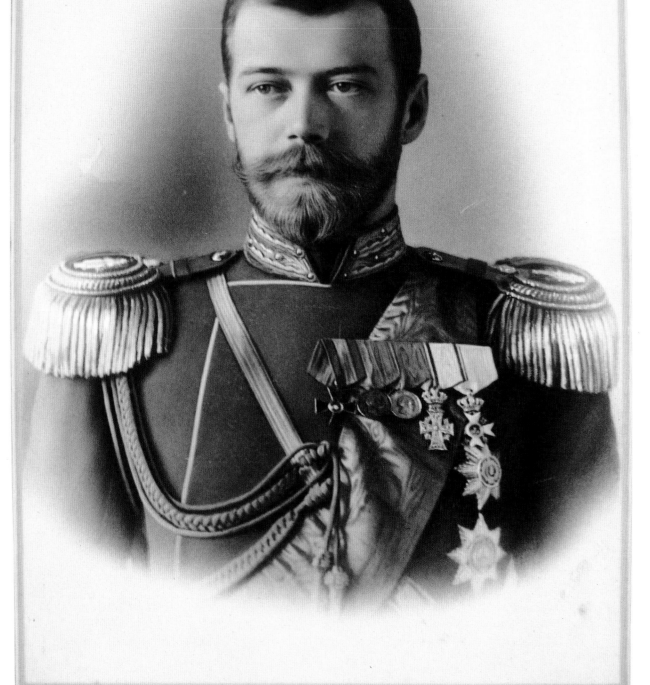

Ники 1898г.

J. Pasetti St Petersbourg

Genealogy

The Romanovs and the Royal Families of Europe

399 Portrait of Emperor Nicholas II, 1898

Photograph by A. A. Pasetti, photographer to the court of Grand Duchess
Alexandra Iosifovna; subsequently photographer to the imperial court.
Took many portraits, including of members of the imperial family.
Owned a studio at 24 Nevsky Prospect in St. Petersburg.
Photograph signed and dated by the emperor: *Ники* [Nicky] *1898.*
Stamped at the bottom of the mount: *A. Pasetti. St. Petersbourg. Nevsky, 24.*
Mounted photograph: 19 × 30 cm; 20 × 33 cm
ГА РФ. Ф.601. Оп.1. Д.2154 Л.68

Nicholas II Alexandrovich (Nicky) (1868–1918): eldest son of
Emperor Alexander III; emperor from 20 October 1894 to
2 March 1917. In 1894 married Alexandra Feodorovna, born
Princess Alice of Hesse-Darmstadt (1872–1918). Children: Olga
(1895–1918), Tatiana (1897–1918), Maria (1899–1918), Anastasia
(1901–1918), Alexei (1904–1918).

The entire family of Nicholas II was shot in Ekaterinburg on the
night of 16–17 July 1918.

The emperor had a distinctive character, forged from contradictions.
Each of his positive qualities seemed to coexist with its negative
counterpart. Thus, while he was gentle, kind and forgiving, everyone
knew that he never forgot a wrong. He would quickly become attached
to people, yet could turn away from them just as rapidly. At times he
could be touchingly trusting and open, but on other occasions his
reserve, suspiciousness and caution were striking. His love for his
country was boundless — he would have given his life for Russia if
convinced of the necessity — but at the same time he was somehow
over-preoccupied with his own peace of mind, his daily routine, his
state of health; in order to preserve these things, perhaps without even
realising it, he ended up sacrificing the interests of the realm. The
emperor was particularly vulnerable to outside influences. In fact
he was constantly subject to one influence or another, sometimes
submitting almost without realising it, after the very first impression
... One further fundamental trait of the emperor's character must be
mentioned as it explains a great deal: that is his optimism, combined
with a kind of fatalistic tranquillity, an insouciance about the future.
(Shavelsky, 1994, pp. 116–117.)

400 Portrait of Emperor Alexander II ('Anapa'), 1870s

Photograph by Sergei Lvovich Levitsky
Stamped on mount: *Фотография Левицкого на Мойке 30. С. Петербург*
[Photographed by Levitsky, 30 Moika Embankment, St. Petersburg]
Mounted photograph: 10 × 12 cm; 11 × 17 cm
ГА РФ. Ф.828. On.1. Д.1063. Л.1 об (No. 2)

Alexander II Nikolaevich (1818–81): emperor from 1855 to 1881.
Eldest son of Emperor Nicholas I. In 1841 married Maria
Alexandrovna, born Princess of Hesse-Darmstadt (1824–80).
Children: Alexandra (1842–49), Nicholas (1843–65), Alexander
(1845–94), Vladimir (1847–1909), Alexei (1850–1908), Maria
(1853–1920), Sergei (1857–1905), Pavel (1860–1919). In the 1860s
and 1870s Alexander II introduced a series of fundamental
reforms aimed at modernising Russia: the emancipation of the
serfs in 1861, as well as various land, judicial, urban and military
reforms. On 1 March 1881 he was killed in St. Petersburg by a
bomb thrown by the terrorist I. I. Grinevitsky.

*His fundamental gift was his heart, his kind, ardent, humane heart,
which drew him to all that was generous and magnanimous,
and alone inspired him to all the great achievements of his reign.
Intellectually limited by a narrowness of vision and lack of culture,
he never fully grasped the value and importance of the reforms he
promulgated, and which made his reign one of the most glorious,
splendid episodes in the history of our country. His heart possessed
the instinct of progress which his mind feared.*
(Tiutcheva, 1990, pp. 82–3.)

*As a man, Emperor Alexander II was kind, gentle and sensitive;
he possessed both a sensitive heart and a sensitive mind. While highly
receptive to ideas and impressions, with an easy grasp of the issues
that confronted him, he did not like to dwell on them or go into them
too deeply.*
(Meshchersky, 1995, p. 369.)

*Although he was not influenced by men, Alexander II had an
unusual weakness for women. His intimates, who were sincerely
devoted to him, used to say that in the company of women he became
a completely different person. He had a passion for visiting girls'
schools, where the pupils would crowd around him and he would
shower them with compliments. He found his last favourite, Princess
Dolgorukaya, at the Smolny Institute, and married her immediately
after the death of the empress.*
(Chicherin, 1934, p. 18.)

*The first blow to the solidarity of the imperial family was dealt by
the second marriage of Emperor Alexander II. This marriage to
Princess Dolgorukaya — who was subsequently given the title of
Princess Yurevskaya — was the second morganatic union in the
family ... The marriage of Emperor Alexander Nikolaevich was
greeted with universal condemnation within the imperial family, a
judgement that was only exacerbated by the fact that no one dared to
express it openly in front of the emperor ... A certain discord began to
form between the Winter Palace [the emperor's residence] and the
Anichkov Palace [the residence of the heir]. The tsar's open liaison
and, in particular, his subsequent marriage offended the heir, who
considered such behaviour to be incompatible with the dignity of a
Russian emperor.*
(Mosolov, 1993, pp. 63–4.)

401 Portrait of Empress Maria Alexandrovna, Before June 1869

Photograph by Sergei Lvovich Levitsky
Inscribed in black ink on the reverse of the photograph by the Foreign Minister
A. M. Gorchakov: *Donné par S. M. Impératrice. Juin 1869* [Given by Her Majesty the
Empress, June 1869].
On the left of the mount: *Левицкий на Мойке, 30. С. Петербург.* [Levitsky, 30
Moika Embankment, St. Petersburg.]
Mounted photograph: 14 × 10 cm; 16.5 × 10.5 cm
ГА РФ. Ф.828. On.1. Д.1063. Л.2 (No.3)

Maria Alexandrovna (1824–80): born Princess Maria of Hesse-
Darmstadt, daughter of Grand Duke Ludwig II of Hesse.
Married Emperor Alexander II in 1841; became empress in 1855.
She had eight children (see no. 400).

The first time I set eyes on the grand duchess [Maria Alexandrovna]
*she was already 28 years old, but she still looked very young. She
retained that youthful appearance all her life — when she was 40 she
could have been taken for a woman of 30. Despite her tall, shapely
figure, she was so thin and fragile that she did not at first strike one
as a belle femme; but she was unusually elegant ... Her features were
not perfect, but her beauty lay in her wonderful hair, the delicate
colour of her skin, and her large, slightly protruding, blue eyes which
were both gentle and penetrating. Above all, hers was an
extraordinarily sincere and deeply religious soul, a soul which, like
its corporeal shell, seemed to have come straight out of the frame of a
medieval painting ... She seemed almost out of place and uneasy in
her role as mother, wife and empress. She was tenderly attached to her
husband and children, and conscientiously fulfilled the duties which
her family and exalted rank demanded of her ... The tsarina's mind
was like her soul: subtle, refined, penetrating, extremely ironic, but
lacking in ardour, breadth and initiative.*
(Tiutcheva, 1990, pp. 78–80.)

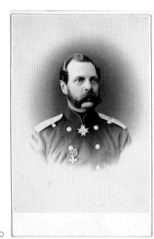
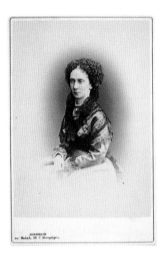

400

401

402 Portrait of King Christian IX of Denmark, Early 1860s

Photograph by Carl Jagerspacher, photographer to the court of Denmark
At the bottom of the mount: *C. Jagerspacher K. u. K. Hof Photograph. Gmunden ob Oesterr* [C. Jagerspacher, court photographer. Gmunden, Austria].
Trade-mark of the photographic studio on the reverse.
Mounted photograph. 12.5 × 18.5 cm; 13 × 21 cm
ГА РФ. Ф.642. Оп.1. Д.3463. Л.2

Christian IX (1818–1906): king of Denmark from 1863 to 1906. Son of Duke Wilhelm of Schleswig-Holstein-Sondenburg-Glücksburg. Came to the throne after the death of King Frederick VII in 1863. In 1842 married Louise (1817–98), daughter of the landgraf of Hesse-Kassel. Children: Frederick (Friedrich) (1843–1912), who became King Frederick VIII of Denmark; Alexandra (1844–1925), Queen of England from 1905; Wilhelm (1845–1913), who was King George I of Greece from 1863; Dagmar (1847–1928), who, as Maria Feodorovna, was Russian empress from 1881; Tira (1853–1933); and Voldemar (1858–1939).

I liked the king very much, he has such an open, honest character; it will be easy to be friends with him and grow fond of him.
(From a letter of Nicholas, when tsarevich, to his mother Empress Maria Alexandrovna. Copenhagen, 24 August [5 September] 1864. ГА РФ. Ф.641. Оп.1. Д.33. Л. 140 об.–141.)

403 Portrait of Queen Louise of Denmark, Early 1860s

Photograph by Carl Jagerspacher, photographer to the court of Denmark
At the bottom of the mount: *C. Jagerspacher K. u. K. Hof Photograph. Gmunden ob Oesterr* [C. Jagerspacher, court photographer. Gmunden, Austria].
Trade-mark of the photographic studio on the reverse
Mounted photograph: 12.5 × 18.5 cm; 13 × 21 cm
ГА РФ. Ф.662. Оп.2. Д.107. Л.4

Louise-Wilhelmina (1817–98): born Princess of Hesse-Kassel. In 1842 married the son of the Duke of Schleswig-Holstein-Sondenburg-Glücksburg, who in 1852 became heir to the Danish crown, and in 1863 came to the throne as King Christian IX. She had six children (see no. 402).

The Queen (Louise) is clever and very pleasant, but I will write about her later as I am unable to say anything nasty about anyone in this letter because I am happy.
(From a letter of Nicholas, when tsarevich, to his mother Empress Maria Alexandrovna. Copenhagen, 24 August [5 September] 1864. ГА РФ. Ф.641. Оп.1. Д.33. Л.141.)

404 Portrait of Emperor Alexander III, Early 1890s

Lithograph by the publishers R. Golike and A. Wilborg Ltd
Emperor's signature reproduced on the lithograph
Mounted lithograph. 11 × 16.5 cm; 20 × 28 cm
ГА РФ. Ф.662. Оп.2. Д.107. Л.4

Alexander III Alexandrovich (1845–94): second son of Emperor
Alexander II; emperor from 1881 to 1894. In 1866 married Maria
Feodorovna (1847–1928), born Princess Dagmar of Denmark.
Children: Nicholas (1868–1918), Alexander (1869–70), Georgy
(1871–99), Xenia (1875–1960), Mikhail (1878–1918), Olga
(1882–1960). Alexander III died from kidney disease on 20
October 1894 at Livadia in the Crimea.

Emperor Alexander III had a commanding presence. He was not
handsome, and was somewhat bear-like in his manner; he was very
tall … Emperor Alexander III undoubtedly had an ordinary mind
and very ordinary capabilities, and in this respect Emperor Nicholas
II surpassed his father both in terms of his brain and his education.
In appearance he was like a huge Russian peasant from the central
provinces, and the most suitable apparel for him would have been
a sheepskin jacket, a long coat and bast sandals. Nevertheless his
appearance was certainly imposing, for it reflected his overpowering
personality, his splendid heart, his good humour, his fairness allied
with firmness. I was therefore not at all surprised when I overheard,
as I recall, Emperor Wilhelm II say that he envied the majesty, the
autocratic majesty which emanated from the person of Alexander
III. (Witte, 1960, pp. 188–90.)

405 Portrait of the Dowager Empress Maria Feodorovna, 1880s

Photograph by A. A. Pasetti
Empress's later signature at the bottom of photograph: *Мария* [Maria] *1899*, and
A. Pasetti, St. Petersbourg
Mounted photograph: 10.5 × 16 cm; 18 × 26 cm
ГА РФ. Ф.642. Оп.1. Д.3418. Л.9

Maria Feodorovna (Minnie) (1847–1928): born Princess Dagmar
of Denmark, fourth child of King Christian IX and Queen Louise
of Denmark. On 28 October 1866 she married the heir to the
Russian throne, Alexander Alexandrovich (the future Emperor
Alexander III), and was empress from 1881. She emigrated in
1919 and died in Denmark, where she is buried in the royal vault
at Roskilde.

Empress Maria Feodorovna is not a woman of outstanding
intelligence; she is honourable, noble and has learned much because
she has suffered greatly in life. She is remarkably affable, generous
and loyal in her sentiments; she is a true empress.
(Witte, 1960, p. 284.)

In essence she [Maria Feodorovna] *never left the scene, and*
continued to take first place at all ceremonial occasions.
(Vyrubova, 1994, p. 220.)

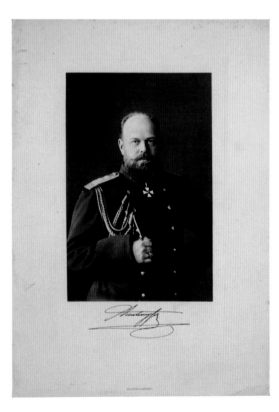

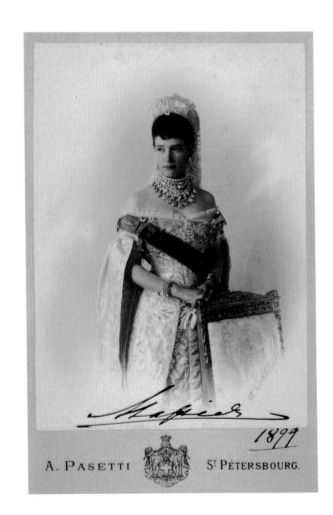

406 Portrait of Grand Duke Vladimir Alexandrovich, 1893

Photograph by V. Lapre
Signature of Grand Duke Vladimir Alexandrovich at the bottom left-hand corner
of photograph: *Wladimir. 1893*
At the bottom of the mount: *В. Лапре. Царское Село. Московская ул., No. 21* [V.
Lapre. 21 Moskovskaya Street, Tsarskoe Selo]
Trade-mark of the photographic studio on the reverse
Mounted photograph: 13 × 19 cm; 14 × 21 cm
ГА РФ. Ф.642. Оп.1. Д.3363. Л.3

Grand Duke Vladimir Alexandrovich (1847–1909): third son of
Emperor Alexander II, adjutant-general, commander-in-chief of
the Guards and the St. Petersburg military district from 1884 to
1905, member of the Council of State, president of the Academy
of Arts. In 1874 he married Princess Maria, daughter of Grand
Duke Friedrich-Franz II of Mecklenburg-Schwerin; in Russia she
took the name Grand Duchess Maria Pavlovna (the elder).
Children: Alexander (1875–7), Kyril (1876–1938), Boris
(1877–1943), Andrei (1879–1956), Elena (1882–1957).

*Grand Duke Vladimir Alexandrovich — the father of Grand Duke
Kyril Vladimirovich, the senior surviving member of the imperial
family — had undoubted artistic talents. He could draw, he was
interested in ballet, and he was the first to finance the foreign tours of
S. P. Diaghilev. He collected ancient icons, visited Paris twice a year
and loved to hold elaborate receptions at his wonderful palace in
Tsarskoe Selo. Although a kind man by nature, his somewhat
extravagant character meant that he sometimes gave the impression of
being unapproachable. Anyone meeting Grand Duke Vladimir for
the first time would be struck by the abrupt manner and booming
voice of this Russian grand seigneur. He regarded the young grand
dukes with little more than contempt. One could not talk to him on
any other theme except art or the finer points of French cuisine ...
Because of his position and age he was commander of the Guards
Academy; he viewed these military duties, however, as little more than
a hindrance to his love of the arts.*
(Grand Duke Alexander Mikhailovich, 1991, p. 114.)

407 Portrait of Grand Duke Sergei Alexandrovich, Late 1880s

Photograph by D. Asikritov, court photographer to Grand Dukes
Sergei Alexandrovich and Pavel Alexandrovich, and to Grand Duchesses
Elizaveta Feodorovna and Maria Alexandrovna; photographic studio at
Vargin House on Tverskaya Street, Moscow.
Stamped at the bottom of the mount in gold: *Д. Асикритов. Москва*
[D. Asikritov, Moscow]
Trade-mark of the photographic studio on the reverse
Mounted photograph: 13 × 20 cm; 14 × 22 cm
ГА РФ. Ф.648. Оп.1. Д.105. Л.6.

Grand Duke Sergei Alexandrovich (1857–1905): fifth son of
Emperor Alexander II. In 1884 married Elizaveta Feodorovna,
born Princess of Hesse-Darmstadt. Took part in the Russo-
Turkish war of 1877–8, member of the Council of State,
lieutenant-general, adjutant-general. From 1891 was governor-
general of Moscow and commander of the Moscow military
district. Killed in Moscow on 4 February 1905 in a bomb attack
by the terrorist I.V. Kalyaev.

*Grand Duke Sergei Alexandrovich played a fateful role in the fall of
the Romanov dynasty, and was partly responsible for the catastrophe
that occured during the celebrations for Nicholas II's coronation at
Khodynka Field in 1896. Try as I might, I simply cannot find one
redeeming feature in his character. He was a mediocre officer, but
nevertheless commanded the Preobrazhensky Regiment — the most
brilliant of all the Guards infantry regiments. He was entirely
ignorant of domestic government, but still served as governor-general
of Moscow, a post which at the very least should have been entrusted to
an experienced state figure. Stubborn, rude and unpleasant, he defied
his own shortcomings, throwing complaints from anyone back in
their faces, and thereby providing rich fodder for slander and
calumny ... He married the eldest sister of the empress, Grand
Duchess Elizaveta Feodorovna. It would be hard to think of a greater
contrast than that presented by this couple!*
(Grand Duke Alexander Mikhailovich, 1991, p. 116.)

408 Portrait of Grand Duke Alexei Alexandrovich, 1868

Photograph by Sergei Lvovich Levitsky
Signed in black ink at the bottom of the photograph: В. Кн. Алексей Александрович.
Назн[ачен] Флиг[ель]-адъют[антом] 1868. Сент[ябрь] 17. [Grand Duke Alexei
Alexandrovich. Appointed aide-de-camp 17 September 1868]
In the lower left-hand corner: Левицкий на Мойке, 30. С. Петербург [Levitsky, 30
Moika Embankment, St. Petersburg]
Mounted photograph: 10 × 14 cm; 11 × 17 cm
ГА РФ. Ф.681. Оп.1. Д. 83. Л.1

Grand Duke Alexei Alexandrovich (1850–1908): fourth son of
Emperor Alexander II. Adjutant-general, admiral, head of the
Russian fleet and department of naval affairs from 1880 to
1905. As a young man he fell in love with Alexandra Vasilievna
(1844–99), the daughter of the poet V. A. Zhukovsky; he married
her secretly in Italy.

*Grand Duke Alexei Alexandrovich had a reputation as the most
attractive member of the royal family, although his colossal weight
was a significant barrier to his success with the ladies. A man of
refinement from head to toe, a real 'Beau Brummell' whom ladies
loved to cosset, Alexei Alexandrovich was a great traveller ... It would
be hard to imagine a more modest comprehension of naval affairs
than that shown by this admiral of a mighty power. At the merest
reference to current reforms in the navy, a fearful grimace would
spread across his charming face.*
(Grand Duke Alexander Mikhailovich, 1991, p. 115.)

409 Portrait of Grand Duchess Maria Alexandrovna, 1874

Photograph by Sergei Lvovich Levitsky
In the lower left-hand corner: Левицкий на Мойке, 30. С. Петербург [Levitsky, 30
Moika Embankment, St. Petersburg]
Mounted photograph: 9.5 × 13.5 cm; 10.5 × 16.5 cm
ГА РФ. Ф.828. Оп.1. Д.1063. No. 22

Grand Duchess Maria Alexandrovna (1853–1920): daughter of
Emperor Alexander II, sister of Emperor Alexander III, aunt of
Emperor Nicholas II. In 1874 she married Prince Alfred Ernest
Albert (1844–1900), Duke of Edinburgh and Earl of Ulster —
the second son of Queen Victoria.

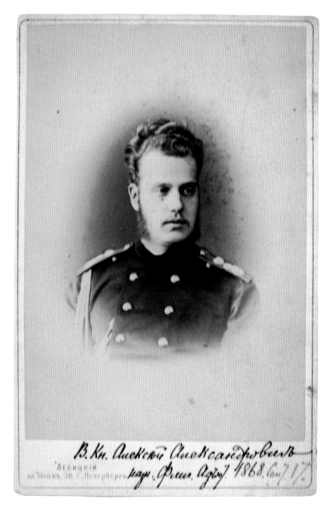

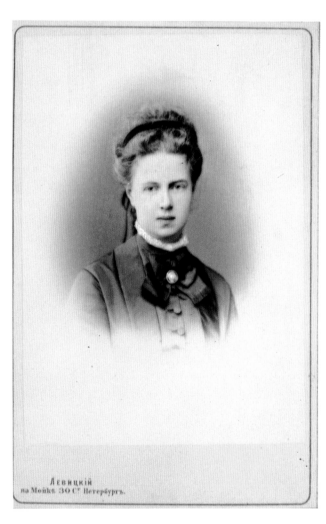

410 Portrait of Grand Duke Pavel Alexandrovich

Photograph by D. Asikritov
Stamped at the bottom of the mount: Д. Асикритов. Тверская. Д. Варгина. Москва
[D. Asikritov, Tverskaya, Vargin House, Moscow]
Mounted photograph: 10 x 15 cm; 11 x 17 cm
ГА РФ. Ф.613. Оп.1. Д.646. Л.15

Grand Duke Pavel Alexandrovich (1860–1919): youngest son
of Emperor Alexander II. In 1889 married Princess Alexandra
Georgievna of Greece (1870–91). Children: Maria (1890–1958),
Dmitry (1891–1942). In 1902 he contracted a morganatic
marriage to Olga Valerianovna Pistolkors (who became Princess
Paley in 1915), and had three children: Vladimir, Irina and
Natalia. Commander of the Life-Guard Horse Regiment from
1890 to 1896, commander of the Guards Corps, and cavalry
general. He was shot in the Peter and Paul Fortress in January
1919.

*Uncle Pavel — Grand Duke Pavel Alexandrovich — was the nicest
of the four uncles of the tsar, although he too was rather arrogant, a
trait he picked up from his brother Sergei to whom he was very close.
He was a good dancer, a great success with the ladies, and he looked
quite fetching in his dark-green and silver dolman, his raspberry
breeches and boots of a Grodno hussar. The carefree life of a cavalry
officer suited him down to the ground, and Grand Duke Pavel never
occupied a position of responsibility ... During the First World War
he commanded the Guards Corps on the German Front, but he had
absolutely no say in state affairs.*
(Grand Duke Alexander Mikhailovich, 1991, p. 117.)

411 Portrait of Grand Duke Georgy Alexandrovich, 1895

Photograph by A. Engel, photographer working at the turn of the 20th century;
photographic studio in Tiflis.
On the back of the photograph is an inscription in Grand Duke Georgy
Alexandrovich's hand: *For the dear Goat from the Weeping Willow 1895*; further
down he has drawn a bottle and written: *Do you remember the story with the bottle?*
Stamped at the bottom of the photograph: А. Энгель. Тифлис [A. Engel, Tiflis]
Trade-mark of the photographic studio on the back
Mounted photograph: 10 x 14 cm; 11 x 17 cm
ГА РФ. Ф.675. Оп.1. Д.159. Л.2

Grand Duke Georgy Alexandrovich (Georgie) (1871–99): son of
Emperor Alexander III and brother of Emperor Nicholas II;
heir to the throne 1894–99. At the beginning of the 1890s Georgy
Alexandrovich fell ill with tuberculosis and spent the last years
of his life almost permanently in the small town of Abas-Tuman
in the Caucasus. He is buried in the Peter and Paul Cathedral
in St. Petersburg.

*He was twenty-seven years old and his death was an irreplaceable
loss. Intellectual and magnanimous, with an engaging personality,
the grand duke would have been Nicholas's main support. Of the three
brothers, he was the one who could have become a strong and popular
tsar. Had he been alive he would have willingly accepted the burden
of the throne, which Nicholas, through weakness, abdicated in 1917.*
(Vorres, 1985, p. 83.)

410

411

412 Portrait of Grand Duchess Xenia Alexandrovna, 1892

Photograph by A. A. Pasetti
Photograph signed by the grand duchess: Ксения [Xenia] 1892
At the bottom of the mount: A. Pasetti. S. Petersbourg. Nevsky, 24
Trade-mark of the photographic studio on the back
Mounted photograph: 10 × 14 cm; 11 × 17 cm
ГА РФ. Ф.662. Оп.2. Д.81. Л.2.

Grand Duchess Xenia Alexandrovna (1875–1960): eldest daughter of Emperor Alexander III, sister of Emperor Nicholas II. In 1894 she married Grand Duke Alexander Mikhailovich. Children: Irina (1895–1970) who married Prince Yusupov in 1914, Andrei (1897–1981), Feodor (1898–1968), Nikita (1900–74), Dmitry (1901–80), Rostislav (1902–77), Vasily (1907–89). She emigrated in 1919 and lived in England until her death; she is buried in the South of France alongside her husband (d. 1933).

Ai-Todor, where everything was so pleasing to the eye, owed its attractiveness to Grand Duchess Xenia Alexandrovna. Her greatest asset was not so much her beauty as her exceptional charm, inherited from her mother, Empress Maria Feodorovna. Her magnificent grey eyes penetrated the very depths of your soul. Her gentle nature, modesty and extreme goodness contributed to her irresistible charm. As a child, whenever she visited it felt like a holiday, and after she left I would run through the rooms, delightfully breathing in the lingering aroma of lily-of-the-valley.
(Prince Felix Yusupov, 1993, p. 79.)

413 Portrait of Grand Duke Mikhail Alexandrovich, October 1902

Photograph by S. L. Levitsky
Stamped at the bottom of the photograph: Левицкий [Levitsky]
Trade-mark of the photographic studio on the back
10.5 × 16 cm
ГА РФ. Ф.642. Оп.1. Д.3425. Л.10

Grand Duke Mikhail Alexandrovich (1878–1918): youngest son of Emperor Alexander III, brother of Emperor Nicholas II; heir to the Russian throne 1899–1904. Major-general, member of the Council of State. In the autumn of 1912 he secretly contracted a morganatic marriage abroad to N. S. Wulfert (1881–1952) (neé Sheremetevskaya; by her first marriage Mamontova). After Nicholas abdicated in his favour, Grand Duke Mikhail refused to accept the throne. He was murdered on 13 June 1918.

[Witte] has a very high opinion of the heir [Misha], whom he got to know extremely well while giving him 170 lectures on the subject of finance. The heir is very little known or appreciated in society, but Witte reckons he has a lucid mind, strong convictions, and a moral purity that is crystal clear. Misha avoids affairs of state, never ventures an opinion, and maybe even hides behind this perception of him as a cheerful, insignificant young boy.
(Diary of Grand Duke Konstantin Konstantinovich, 26 February 1904. ГА РФ. Ф.660. Оп.1. Д.52. Л.128 об.–129.)

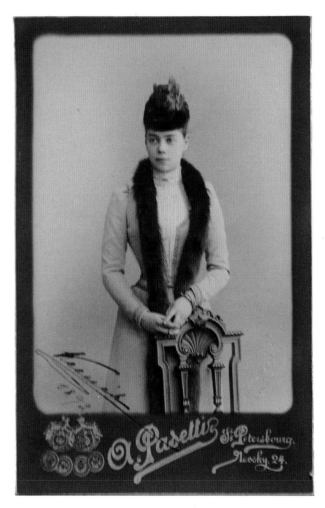

414 Grand Duchess Olga Alexandrovna with her Husband,
Prince P. A. Oldenburg, Early 1900s

Photograph by W. Jasvoine, photographer working in St. Petersburg, with a
photographic studio at 17 Bolshaya Morskaya Street.
Photographer's signature stamped bottom right of photograph: *В. Ясвоин* [W. Jasvoine]
Stamped at bottom of mount: *W. Jasvoine. S. Petersbourg. Grande Morskaja N17*
Trade-mark of the photographic studio on the back
Mounted photograph: 10 × 14 cm; 10.5 × 16 cm
ГА РФ. Ф.643. Оп.1. Д.138. Л.5

Grand Duchess Olga Alexandrovna (1882–1960): daughter of
Emperor Alexander III, sister of Emperor Nicholas II. In 1901
married Prince P. A. Oldenburg. The marriage was dissolved in
autumn 1915. She made a second, morganatic marriage in 1916
to Colonel N. A. Kulikovsky.

Prince Piotr Alexandrovich Oldenburg (1868–1924) was a major-
general in the retinue of His Imperial Highness.

*The marriage of Grand Duchess Olga Alexandrovna to Prince Piotr
Alexandrovich Oldenburg was celebrated the day before yesterday
at Gatchina. The grand duchess is not beautiful; her snub nose and
generally small features are only compensated by her wonderfully
expressive eyes, full of kindness and intelligence, and her look is
very direct. Wishing to live in Russia, she chose to marry the son
of Prince Alexander Petrovich Oldenburg. In breeding and in his
considerable financial standing — money inherited from Grand
Duchess Ekaterina Pavlovna — the prince is entirely suitable, but
his appearance falls well short of satisfactory. Despite his age, he
has lost almost all his hair and generally gives the impression of
being feeble, in poor health, and altogether unlikely to engender
a large family. Obviously considerations that have little to do with
ensuring a successful married life were given first priority, and
this will surely in time give cause for regret.*
(Diary of A. A. Polovtsov, member of the Council of the State,
29 July 1901. ГА РФ. Ф.583. Оп.1. Д. 54. Л.28.)

415 Portrait of Empress Alexandra Feodorovna, 1901

By Alexander Petrovich Sokolov (1829–1919)
Watercolour in a brown leather travelling frame with mount
35 × 45 × 40 cm
ГА РФ. Ф.601. Оп.1. Д.2157. Л.1

Alexandra Feodorovna (Alix) (1872–1918): born Princess Alice of Hesse-Darmstadt, younger daughter of Grand Duke Ludwig IV of Hesse. In 1894 married Nicholas II and became empress. She was shot along with her husband and children in Ekaterinburg during the night of 16–17 July 1918.

She was tall and slender, always serious, with an ever-present hint of deep melancholy. She would often get reddish blotches on her face, revealing her highly nervous state, but her features were nonetheless beautiful and severe. Those who saw her for the first time greatly admired her majesty, and those who saw her daily could not deny that she possessed a rare regal beauty. Her faith was known to all. She believed in God ardently; she loved the Orthodox Church and was inclined to piety, particularly in its ancient, established form. In her daily life she was modest and chaste, while in her political thinking she was a staunch monarchist, and saw her husband as the sacred, anointed sovereign of God. Once she became Russian tsarina, she came to love Russia more than her original homeland. She was sensitive, compassionate and responsive to the sorrow of others, and showed great persistence and inventiveness in setting up various charitable institutions ... And yet, for all her qualities, she never inspired love in Russia as she should have ... One is struck by the almost universal hostility towards the empress. Her Russian relatives, members of the Russian imperial family, almost without exception did not like her. Towards the end even her sister, the noble and saintly Grand Duchess Elizaveta Feodorovna, was estranged from her. Nor did she get on with the dowager empress. High society, with very few exceptions, was hostile to her, and even within her retinue she had few supporters ... She had many enemies and few friends ... Those who surrounded her — or rather grovelled around her — were capable of little more than crawling: the supporters in her camp were either naïve, mercenary, hypocritical or corrupt ... She was accused of having a harmful influence on the tsar, of hindering Russian progress and so forth. And indeed, in her temperament, her views, her whole outlook, there was much that separated her from her family, from society, and to a certain extent from the whole nation.
(Shavelsky, 1994, pp. 159–60.)

We were always together, and later I became the person dearest to [Alix] after her immediate family. Our mother had inspired her with feelings for her old homeland, and we all felt a close affinity to both countries [England and Germany] ... As she was easily embarrassed, and honest to a fault, she would unsmilingly tilt her head to one side if something displeased her, with the result that people often thought that she was unhappy, or bored, or simply capricious. Her life in Russia was difficult from the very beginning. First there was her official betrothal in the Crimea at the deathbed of Alexander III, followed by the return journey with his body across the whole of Russia and the wedding just two days after the endless funeral ceremonies ... Also, many of her relatives took against her from the very start, in particular Michen [Grand Duchess Maria Pavlovna, wife of Nicholas II's uncle Grand Duke Vladimir]. They called her 'cette raide anglaise' [that stuck-up Englishwoman]. Then others, friends of Alexander III and Empress Maria, dug their heels in and tried to get the upper hand over Alix. She was therefore extremely lonely, since at first Nicky had so much work on that she would see him only for lunch and dinner — and then only briefly — when he would return utterly exhausted. And supper was mostly taken with Empress Maria ... Empress Maria was a typical mother-in-law and empress. It has to be said that Alix, with her serious, severe manner, was not the easiest of daughters-in-law for such a vainglorious mother-in-law. According to family law established by Emperor Paul, Maria, as the first of the two to be crowned, had precedence over the younger empress. This was not a problem in the case of Alexandra (widow of Nicholas I) whose relationship with Maria, wife of Alexander II, was perfectly harmonious; in their case it was noted that whenever the imperial couple attended an official function, either [the dowager empress] did not appear at all or had already taken her place before they arrived. Empress Maria (widow of Alexander III), however, would always arrive at the same time as her son and daughter-in-law, and often kept them waiting. Nicholas II always had to appear with both empresses, his mother on the right, Alix on the left; on entering a room it was always Alix who, through lack of space, was obliged to step back. Nicky, with his fine sense of tact, constantly tried to find some sort of modus vivendi, but each time he ran up against the iron will of his mother.
(Grand Duke Ernst-Ludwig of Hesse, 1983, pp. 68–9.)

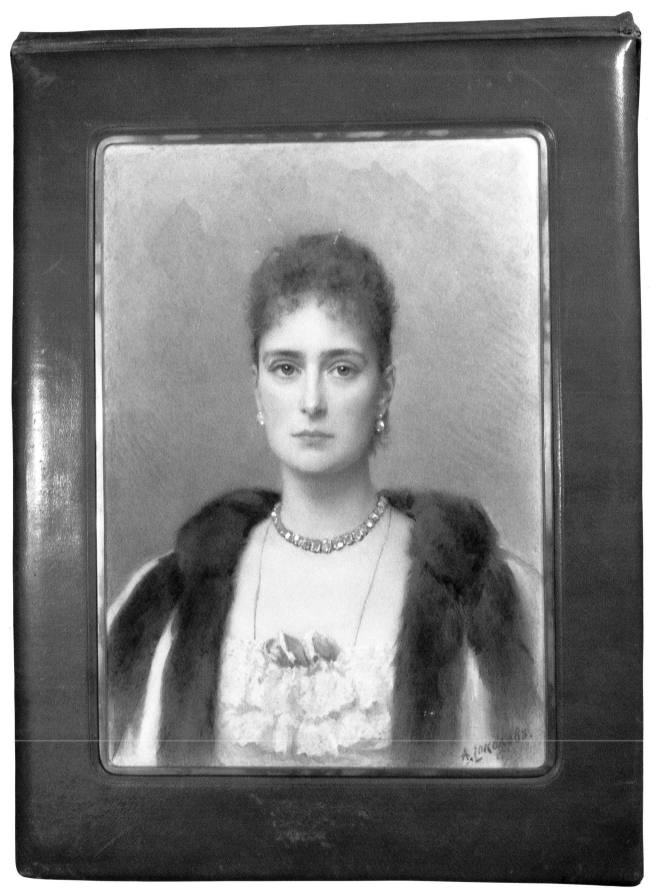

416 Portrait of Queen Victoria, 1895

Photograph by W. and D. Downey, photographers to the British court
Signed by the queen on the photograph: *Victoria R[egina] I[mperatrix]. Cimaiz. 14 Avril 1895.*
At the bottom of the mount: *W. and D. Downey. 57 & 61, Ebury Street. London. S.W. Photographers to the Queen.*
Mounted photograph: 17.5 × 28.5 cm; 19 × 33 cm
ГА РФ. Ф.642. Оп.1. Д.3358. Л.1

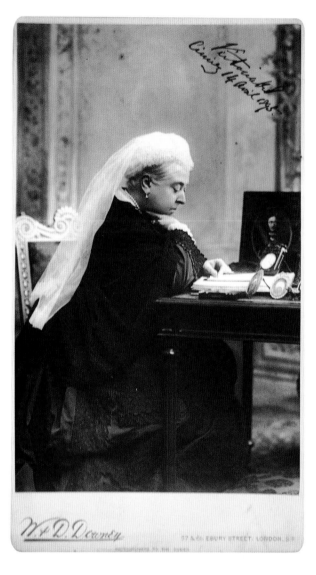

Victoria (1819–1901): Queen of Great Britain (1837–1901) and Empress of India, the daughter of Edward, Duke of Kent, the fourth son of King George III and Princess Victoria of Saxe-Saalfeld-Coburg. In 1840 she married Prince Albert of Saxe-Coburg (1819–61). Children: Victoria (1840–1901), who married Emperor Friedrich III of Germany in 1858; Albert-Edward (1841–1910), who married Princess Alexandra of Denmark in 1863; Alice (1843–78), who married Ludwig of Hesse; Alfred (1844–1900), who married Maria Alexandrovna, daughter of Alexander II, in 1874; Helena (1846–1923), who married Prince Christian of Schleswig-Holstein in 1866; Louise (1848–1939), who married the Marquess of Lorne in 1871; Arthur, Duke of Connaught (1850–1944), who married Princess Louise-Margaret of Prussia in 1879; Leopold (1853–84); and Beatrice (1857–1944), who married Prince Henry of Battenberg in 1885. Queen Victoria died on 22 January 1901.

[Victoria] *is very small, her figure is bad, her face plain, but she's very agreeable to talk to ...*
(From Tsarevich Alexander Nikolaevich's Diary for 1839; Bokhanov, 1997, p. 14.)

The Queen — a round ball on shaky legs — was extremely kind to me. I lunched with her and the Battenbergs, with music playing in the courtyard. She has two Indian servants. Then she awarded me the Order of the Garter, which I was not expecting at all!
(From Nicholas's Diary, 19 June 1893. ГА РФ. Ф.601. Оп.1. Д.230. С.152–153.)

The British people had good reason to be proud of this remarkable woman. From her writing desk in London, the queen kept a close eye on what was going on in distant countries, and her pertinent remarks testify to her sharp, discerning mind and her acute understanding of events.
(Grand Duke Alexander Mikhailovich, 1991, pp. 94–5.)

416

417 Portrait of Grand Duke Ludwig IV of Hesse, Before 1878

Photograph by Hills and Saunders, photographers to the British court
At the bottom of the mount: *H.R.H. Prince Louis of Hesse. Hills & Saunders.*
36, Porchester Terrace. W. By appointment to the Queen. Also at Eton – Harrow –
Oxford and Cambridge.
Trade-mark of photographic studio on the back
Mounted photograph: 10 × 13.5 cm; 10 × 16.5 cm
ГА РФ. Ф.677. Оп.1. Д.1283а. Л.26 об. (No. 51)

Ludwig IV of Hesse (1837–92): grand duke of Hesse from 1877 to
1892. Married to Alice (1843–78), daughter of Queen Victoria.
Children: Victoria (1863–1950); Elizabeth (Ella) (1864–1918);
Irene (1866–1953), Ernst-Ludwig (1868–1937); Alice (1872–1918)
— Empress Alexandra Feodorovna from 1894; Maria (1874–8).

[Ludwig] *was the favourite son-in-law of my grandmother, Queen*
Victoria. He was the favourite partly because he was married to her
favourite daughter, but more because of his personality which was
highly influential within the family: all the relatives poured their
hearts out to him, and he was always the unifying link of the family.
I never saw the family so stricken with grief as after his death,
because he was the best friend of every one of them. One can truly
say of him that he was a man with a big heart.
(Grand Duke Ernst-Ludwig of Hesse, 1983, p. 44.)

418 Portrait of Grand Duchess Alice, Wife of Grand Duke
Ludwig IV of Hesse, Before 1878

Photograph by Hills and Saunders, photographers to the British court
At the bottom of the mount: *H.R.H. Princess Louis of Hesse. Hills & Saunders.*
36, Porchester Terrace. W. By appointment to the Queen. Also at Eton – Harrow –
Oxford and Cambridge.
Mounted photograph: 10 × 13.5 cm; 11 × 16.5 cm
ГА РФ. Ф.677. Оп.1. Д.1283а. Л.27 (No. 53)

Alice of Hesse (1843–78): born Princess Alice, daughter of Queen
Victoria and Prince Albert; in 1862 she married Grand Duke
Ludwig IV of Hesse. She died from diphtheria in 1878.

My mother Alice was the second daughter of Queen Victoria and
Prince Albert. She was devoted body and soul to her parents. She
idealised her father, and his influence suffused her whole being.
When he died in 1861 she was betrothed to my father. Her mother
was close to despair, and the young Alice had to take everything in
hand. Older people have told me how, despite her terrible grief and
her youth, she dealt with everything with remarkable tact and her
mother was entirely dependent on her. One can imagine her mother's
renewed grief when, after marrying my father in July 1862, she left
her homeland for ever ... She would often receive people from the arts.
One day I came and sat down in the corner of the music room to listen
to a man with a big red beard who was playing something to my
mother, and discussing the music with her. He then took out some
music and suggested that they play together. She said she couldn't ...
but nevertheless they began to play. At the end he turned to her with
his hands on his knees and said, 'Are you me, or am I you?', so
deeply had she empathised with him. It was Brahms, and I had
been the first to hear his 'Hungarian Dances'.
(Grand Duke Ernst-Ludwig of Hesse, 1983, pp. 49–50.)

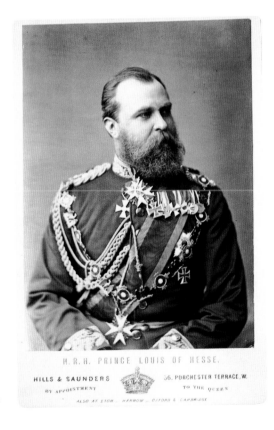

417

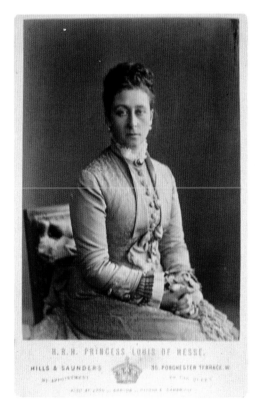

418

419 Portrait of the Family of Grand Duke Ludwig IV of Hesse,
1885

Photograph by Carl Backofen (Darmstadt) and J. S. Schroeder (Dresden),
photographers to the court of Grand Duke Ludwig IV
Seated from left to right: Alix, Grand Duke Ludwig, Irene; standing: Ernst-Ludwig,
Ella, Victoria.
On the left of the mount: *Carl Backofen (Darmstadt), J. S. Schroeder (Dresden),
Gesetzlich geschützt.*
Stamped in red ink on the back: *Канцелярия Ее Величества Государыни
Императрицы Александры Федоровны* [office of Her Majesty Empress Alexandra
Feodorovna]; and in black ink the date: *1885*
Mounted photograph: 15 × 10.5 cm; 16 × 10.5 cm
ГА РФ. Ф.640. Оп.3. Д.14. Л.44

Victoria (1863–1950) married Louis of Battenberg, Marquess of
Milford Haven (1854–1921); Ella (1864–1918) married Grand
Duke Sergei Alexandrovich (1857–1905) in 1884, and in 1891
converted to Orthodoxy; Irene (1866–1953) married Prince Henry
of Prussia, brother of Emperor Wilhelm II; Ernst-Ludwig
(1868–1937) came to the throne in 1892 as Grand Duke of Hesse
and the Rhine, and in 1894 he married Princess Victoria-Melita
of Saxe-Coburg-Gotha, whom he divorced in 1901, marrying
secondly Princess Eleonore of Solms-Hohensolms-Lich
(1871–1937); Alix (1872–1918) married the heir to the Russian
throne, Nikolai Alexandrovich, in 1894, converted to Orthodoxy
and took the name of Alexandra Feodorovna, becoming empress
in 1896.

419

420 Portrait of Grand Duchess Elizaveta Feodorovna, 1893

Photograph by V. Lapre, court photographer to Grand Duke Vladimir Alexandrovich, with a studio at 21 Moskovskaya Street, Tsarskoe Selo.
Signed by Grand Duchess Elizaveta Feodorovna on the photograph: *Ella. 1893.*
At the bottom of the mount: *В. Лапре. Царское Село* [V. Lapre, Tsarskoe Selo]
Trade-mark of the photographic studio on the back
Mounted photograph: 13 × 20 cm; 14 × 22 cm
ГА РФ. Ф.648. Оп.1. Д.106. Л.7

Grand Duchess Elizaveta Feodorovna (Ella) (1864–1918): born Princess of Hesse-Darmstadt, second daughter of Grand Duke Ludwig IV, and sister of Empress Alexandra Feodorovna. In 1884 married Grand Duke Sergei Alexandrovich. In 1910 she became a nun. She was murdered in Alapaevsk on 17 July 1918. In 1992 she was canonised by the Russian Orthodox Church.

I also like Ella very, very much. She is so feminine; her beauty is something I will never tire of. Her eyes are extraordinarily beautifully defined and her look is so calm and gentle. Despite her gentle nature and her shyness, one senses in her a certain self-assurance, a recognition of her own strength … He [Sergei Alexandrovich] *was talking to me about his wife and he was enraptured by her, full of her praises; he thanks God every day for his happiness.*
(Diary of Grand Duke Konstantin Konstantinovich, 10 September 1884. ГА РФ. Ф.660. Оп.1. Д.25. Л. 37–37 об.)

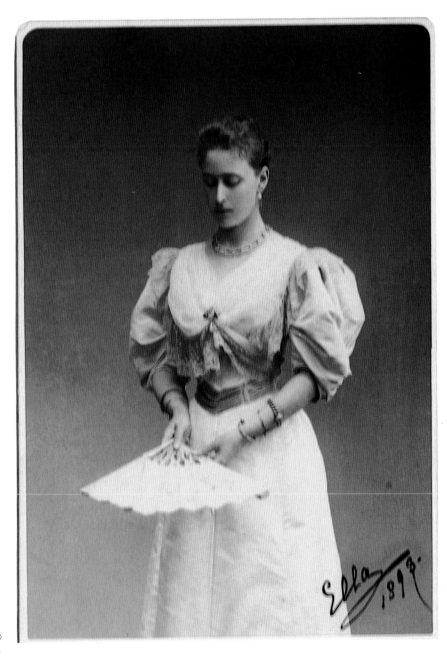

420

Early Years

From Childhood to Marriage

421 Emperor Alexander II in his Coffin, 1881

Photograph by Sergei Lvovich Levitsky
Stamped at the top of the photograph: *R.G.K. Ruoes No 74.*
In the lower right half of the photograph: *Левицкий* [Levitsky]
Mounted photograph: 23 × 17 cm; 27 × 22 cm
ГА РФ. Ф. 678. Оп.1. Д.1101. Л.2.

What dreadful misery and misfortune that our emperor has been taken from us in such a terrible way! The heart breaks at the sight of him. His face, head and torso are intact, but his legs are completely destroyed below the knees, so that I did not understand what I was seeing: a bloody mass with half a boot instead of the right leg, and of the left only the heel remained! I have never seen anything so terrible in my life!
(Empress Maria Feodorovna in a letter to her mother, Queen Louise of Denmark, 4 [16] March 1881. ГА РФ. Ф. 642. Оп.1. Д. 646. Л.33–45.)

At 3 o'clock precisely we heard a massive explosion. 'That was a bomb,' my brother Georgy said. At that moment an even stronger explosion shattered the windows in our room. A minute later a servant burst in, out of breath. 'The emperor has been killed,' he screamed. Huge crowds were gathering around the Winter Palace. Women were crying hysterically. We went in through one of the side entrances. There was no need to ask any questions: large drops of blood led us up the marble staircase and along the corridor to the emperor's study. Father was standing at the door giving orders to some servants. He embraced mother and she fainted, so stunned was she to find him unharmed. Emperor Alexander II was lying on the couch near the desk. He was unconscious. Three doctors were gathered around him, but it was clear that the emperor could not be saved. He had only minutes left to live. He looked terrible: his right leg had been blown off, his left leg shattered, and his face and head were covered with wounds. One eye was closed, the other stared ahead, expressionless. Members of the imperial family kept coming in, one after the other. The room was packed. Nicky was standing near me, deathly pale in his blue sailor's suit, and I seized his arm. His mother, the tsarina, was there, still holding a pair of skates in her trembling hands. 'Silence,' announced the doctor. 'The emperor is dead!'
(Grand Duke Alexander Mikhailovich, 1991, pp. 50–51.)

422 Diary of Emperor Nicholas II, Entry for 1 March 1914

Exercise book with black leather cover
17 × 22 cm; open 34 × 22 cm

The thirty-third anniversary of Anpapa's [Alexander II's] excruciating death. To this day I can still hear those two terrible explosions.

ГА РФ. Ф.601. Оп.1. Д.261. С.1–201 (с.40–41)

Every year the imperial family marked several anniversaries that were milestones in Russian history, including the Guards' revolt on Senate Square of 14 December 1825, and the murder of Emperor Alexander II on 1 March 1881. The murder of his grandfather, who died in front of Nicholas's eyes, left an indelible impression on the twelve-year-old boy. This appalling event was etched on his mind forever, and most certainly was a significant influence on the formation of Nicholas's general outlook. It was inevitable that Nicholas would be preoccupied with the terrible price paid by the tsar-liberator for his attempts to reform the autocratic foundations of the state.

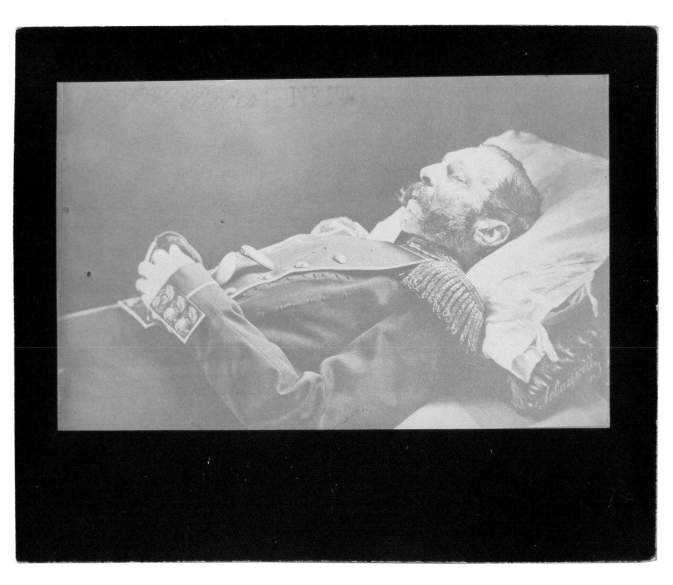

423

424

423 Portrait of Nicky (Grand Duke Nikolai Alexandrovich), 1871

Photograph by Sergei Lvovich Levitsky
On the lower part of the photograph: *Левицкий на Мойке, 30. С. Петербург*
[Levitsky, 30 Moika Embankment, St. Petersburg]
Mounted photograph: 10 × 14 cm; 10.5 × 16 cm
ГА РФ. Ф.678. Оп.1. Д.1086. Л.36

A year and a half after his wedding, a long-awaited first child was
born to Grand Duke Alexander Alexandrovich, the heir to the
Russian throne. He was named Nicholas after Alexander's
grandfather and deceased elder brother.

6/18 May. Monday. The birth of our son Nicholas. Minnie [Maria
Feodorovna] *woke me just after four saying that she was starting to
have strong pains which were stopping her from sleeping; however she
slept intermittently until 8 o'clock ... Minnie had already begun to
suffer quite badly, and even cried out from time to time. At about
12.30 my wife went to the bedroom and lay down on the couch where
everything was already prepared. The pains were getting more and
more intense, and Minnie was really suffering. Papa returned and
helped me support my darling throughout. At last, at 3.30, the final
moment came, and at once all the pain was over. God has sent us a son
whom we have called Nicholas. What joy, it's impossible to imagine;
I rushed to embrace my darling, who had cheered up straightaway
and was terribly happy. I cried like a child, and my heart felt so light
and glad.*
(Diary of Tsarevich Alexander Alexandrovich for 1868.
ГА. РФ. Ф.677. Оп.1. Д.301. Л.168 об.–169.)

424 Lock of Hair Cut from the Three-Year-Old Nicky by His
Mother, Tsarina Maria Feodorovna, 1871

Kept in an envelope among the personal effects of Empress Alexandra Feodorovna
and inscribed in her hand.
Inscribed in English in pencil: *Nicky's hair when three years old*
Envelope: 10 × 17 cm
ГА РФ. Ф.640. Оп.2. Д.14

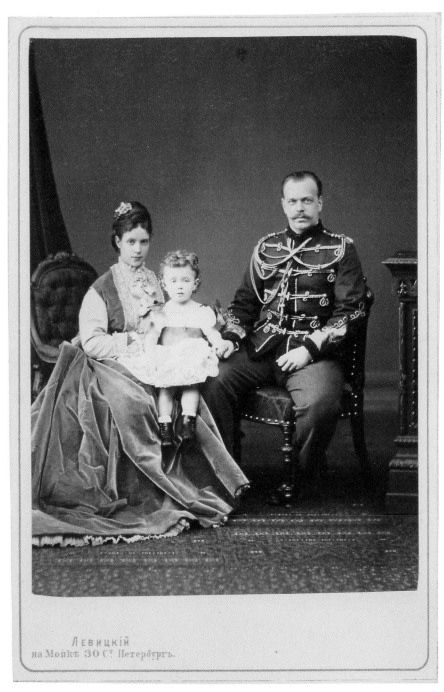

425

425 Tsarevich Alexander Alexandrovich with his Wife
Maria Feodorovna and Eldest Son Nicky (Grand Duke
Nikolai Alexandrovich), 1870

Photograph by Sergei Lvovich Levitsky
On the bottom left of the mount: *Левицкий на Мойке, 30. С. Петербург*
[Levitsky, 30 Moika Embankment, St. Petersburg]
Mounted photograph: 10 × 13.5 cm; 11 × 16.5 cm
ГА РФ. Ф.828. Оп.1. Д.1063. Л.11 (No. 21)

His [Nicky's] *father, the future Emperor Alexander III, understood
that his children should not be cut off from earthly life and turned
into little celestial beings. He realised that this rarefied existence
would come in its own time, and so for the moment it was vital that
they should have their feet firmly on the ground. Hot-house plants
are never strong. The children's quarters comprised a reception room,
drawing-room, dining-room, play room and the so-called bedchamber
… In the playroom there was sand, a swing, hoops and all kinds of
toys. They had special beds, intentionally without pillows, but the
incredibly well-sprung mattresses had bolsters at the head. There was
a basin with running water, but no bathroom, so the children would
bathe in their mother's bathroom.*
(Surguchev, 'The Childhood of Nicholas II', *Bezhin Lug*,
No. 1 (1992), pp. 38, 40.)

426 Russian Language Exercise Book Belonging to Grand Duke
Nikolai Alexandrovich, 1880

Exercise book with paper cover
Inscribed by Nicholas in black ink on the cover: *No 13. Русский язык. Ив. Фед.
Рашевский. 6-го Октября 1880 г.* [No. 13. Russian language. Iv[an] Feod[orovich]
Rashevsky, 6 October 1880]
18 × 22 cm; open 36 × 22 cm
ГА РФ. Ф. 601. Оп.1. Д.163. Л.21–41

427 Russian Language Exercise Book Belonging to Grand Duke
Nikolai Alexandrovich, 1880

Exercise book with paper cover
Inscribed by Nicholas in black ink on the cover: *No 14. Русская грамматика. Ив. Фед.
Рашевский. 14-го Октября 1880* [No. 14, Russian grammar. Iv[an] Feod[orovich]
Rashevsky, 14 October 1880]
ГА РФ. Ф.601. Оп.1. Д.163. Л.42–62

*The grand duke was quite taken with his studies from the very first,
and by this world of exercise books, which he regarded as treasures too
valuable to be sullied with ink, of enchanting and essentially simple
books such as* The Native Word, *by pictures he couldn't tear himself
away from. He was particularly intrigued by a picture entitled
'Together it's crowded, but alone it's boring', and the grey hot-air
balloon. He was completely enchanted by the poem 'On a Rosy
Dawn'. I don't know whether it was the comforting rhythm of the
verses, or the images of morning it evoked, but since he hadn't yet
learnt to read, he would continually ask his mother to read it to him,
and as she did so he would reverently repeat the words after her ... He
only agreed to write in his exercise book after his mother showed him
a whole pile stacked up in reserve. He had an unusual respect for
paper, and wrote his lines with the utmost care, breathing heavily
and sometimes even sweating from the exertion; he would always
place a blotter under his hand. He often rushed off to wash his hands,*

*although the reason had probably more to do with the water source,
which seemed to flow magically from the walls. His writing was
girlishly neat, and his mother reverently kept these exercise books.*
(Surguchev, 'The Childhood of Nicholas II', *Bezhin Lug*,
No. 1 (1992), p. 40.)

Nicholas's exercise books for Russian, history, French, military
topography, fortifications, statistics, political economy, military
affairs, civil law, finance, international law, and physics, dating
from 1879 to 1889, are kept among the personal effects of the
emperor at the State Archive of the Russian Federation (Ф. 601.
Оп.1. Дела 160–216).

428 Time-Table of Lessons for Grand Duke Nikolai
Alexandrovich at Tsarskoe Selo from 9 October 1878

Compiled by Lieutenant-General G. G. Danilevich
Black ink
Signed by Lieutenant-General G. G. Danilevich in the lower right-hand corner
21 × 27 cm
ГА РФ. Ф.601. Оп.1. Д.160. Л.1

*In 1877 Adjutant-General G. G. Danilevich, director of the Second
St. Petersburg Military School, was appointed tutor to Nicholas. A
twelve-year period of study was planned for the young grand duke,
eight of which were to cover the school syllabus, and the final four —
university studies. The school syllabus was extremely onerous, and
a great deal of time was spent on practical subjects: the tsarevich
studied mineralogy, botany, and zoology, as well as the basics of
anatomy and physiology. The university course combined the
disciplines of the politics and economics departments of the Faculty
of Jurisprudence. The sheer number of subjects to be studied meant
that Nicholas's education had to be extended by a year. His teachers
were all famous professors: N. Kh. Bunge, E. E. Zamyslovsky,
N. N. Beketov, N. N. Obruchev, Ts. A. Kyu, M. I. Dragomirov. It
was traditional for the emperor to be above all a military man, and for
this reason Nicholas's military studies were modelled on the course of
the General Staff Academy. Theoretical knowledge was bolstered by
practical experience: the tsarevich attended two summer camps with
the Guards regiments in order to experience military service at first
hand. Nicholas owes his moral sensibilities to Danilevich. The
extraordinary restraint which was a defining trait of Nicholas's
character certainly stemmed from the influence of Danilevich ...
Instead of teaching his pupil to fight his weakness, Danilevich taught
him to circumvent it and despite the reticent nature of most members
of the family, he further instilled in the future emperor a reserve that
was often to be interpreted as a lack of feeling ... The schooling of 'the
Jesuit' Danilevich bore fruit, certainly helping the emperor to become
a cultivated man, but it hindered him in the task of ruling.*
(Mosolov, 1993, pp. 17–18.)

35

427

17

428

429 Drawing by Tsarevich Nikolai Alexandrovich, 26 February 1882

Pencil on paper glued onto card. Signed and dated by Nicholas in the bottom left-hand corner: *Ники 26-го Февраля 1882 г.*
23 × 31 cm; 28 × 36 cm
ГА РФ. Ф.601. Оп.1. Д.216. Л.3

Grand Duke Nikolai Alexandrovich was taught to paint by the artist Kyril (Karl) Vikentevich Lemokh (1841–1910), who was keeper of the art department of the Russian Museum of Emperor Alexander III from 1897 to 1910.

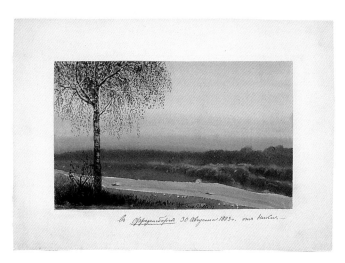

430 Watercolour by Tsarevich Nikolai Alexandrovich,

30 August 1883

Watercolour on paper glued onto card. Signed and dated by Nicholas on the lower part of the picture: *Ники. 30 авг. 83.*
Inscribed in Nicholas's hand on the lower part of the mount: *В Фреденсборге 30 августа 1883 г. от Ники* [In Fredensborg, 30 August 1883, from Nicky]
21.5 × 13 cm; 29 × 20.5 cm
ГА РФ. Ф. 601. Оп.1. Д.216. Л.9

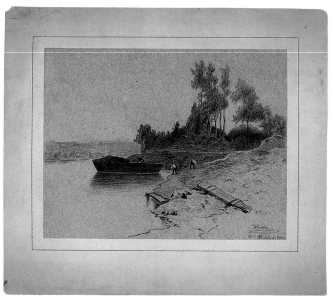

431 Drawing by Tsarevich Nikolai Alexandrovich,

14 November 1886

Pencil on coloured paper glued onto card. Signed and dated by Nicholas in bottom right-hand corner: *Ники. 14-го ноября 86 г.*
22 × 29 cm; 33 × 39 cm
ГА РФ. Ф.601. Оп.1. Д.216. Л.4

263

EARLY YEARS

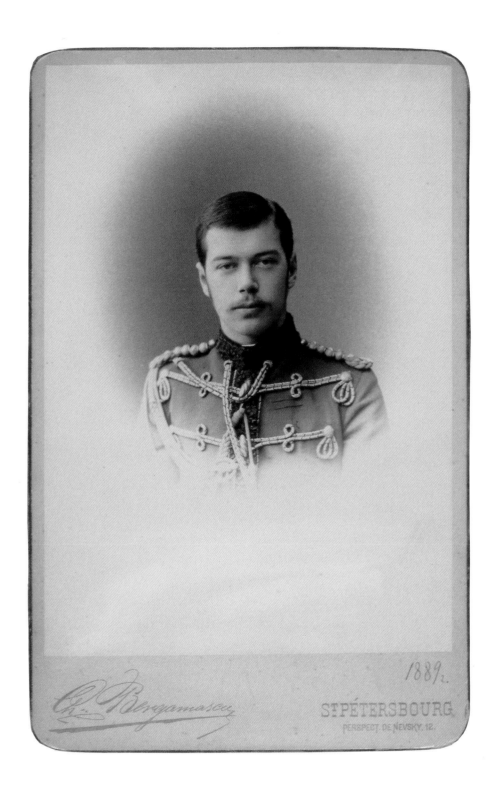

432 Tsarevich Nikolai Alexandrovich in the Uniform
of the Hussars, 1889

Photograph by C. Bergamasco
Stamped in the lower right-hand corner: Левицкий [Levitsky]
At the bottom of the mount: *Ch. Bergamasco St. Petersbourg perspective de Nevsky, 12.*
Trade-mark of the photographic studio on the back
Mounted photograph: 13 × 18 cm; 14 × 22 cm
ГА РФ. Ф.601. Оп.1. Д.1464. Л.3

I've already completed two camps with the Preobrazhensky Regiment
without you, and I've got to know and love the service, and in
particular our brave soldiers! I'm sure that this summer training has
done me enormous good, and I've noticed great changes in myself. In
a month I will join the Hussars to begin my cavalry training.
(Letter from Tsarevich Nikolai Alexandrovich to Grand Duke
Alexander Mikhailovich, 19 March 1889. ГА РФ. Ф. 645. Оп. 1. Д.
102. Л. 53 об.)

433 Tsarevich Nikolai Alexandrovich and His Companions During Their Journey to India, 18 December 1890

Unknown photographer
Inscribed by Nicholas at the bottom of the photograph: *Между Эллорой и ст. Нангун. 18 декабря 1890 г.* [Between Ellora and Nangoon station, 18 December 1890]
Mounted photograph: 30 × 21 cm; 34 × 27 cm
ГА РФ. Ф.601. Оп.1. Д.1468. Л.1

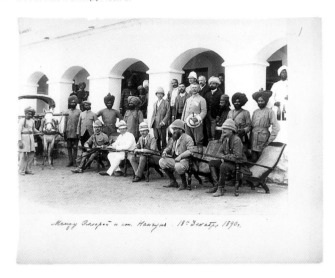

In 1890–1 Nicholas undertook a remarkable journey around Asia lasting many months. The reason for the expedition was twofold: to broaden the horizons of the future tsar and to teach him to make his own decisions.

Nicholas and his brother Georgy left Gatchina on 23 October 1890 accompanied by a small retinue. They took the train to Vienna, and from there to Trieste where, on 26 October, they boarded the frigate *Pamyat Azova*. In Greece they were joined by their first cousin, Prince George of Greece. Their first stop was Port Said, from where they continued southwards along the Suez Canal to Ismailiya to be met by the ruler of Egypt, Hussain; then on to Cairo, where they took a trip down the Nile, staying in Egypt for three weeks. They proceeded through Aden to Bombay, where they arrived on 11 December. They spent almost two months in India and Ceylon, where Georgy fell gravely ill and had to return home.

Somewhere between Ellora and Nangoon station. We got up early ... had breakfast and took a group photograph; the merchant-photographer was very amusing! ... We had a lively ride on to Nangoon station.
(Nicholas's Diary, 18 December 1890. ГА РФ. Ф.601. Оп. 1. Д.224. Л. 356.)

434 Tsarevich Nikolai Alexandrovich (right) and His Travelling Companions: Grand Duke Alexander Mikhailovich, Prince George of Greece, and Grand Duke Sergei Mikhailovich, 1891

Photograph by Scowen and Co. Colombo and Kandy
At the bottom of the mount: *Scowen and Co. Colombo and Kandy*
Trade-mark of the photographic studio on the back
Mounted photograph: 9.5 × 13.5 cm; 10.5 × 16.5 cm
ГА РФ. Ф.601. Оп.1. Д.1470. Л.1

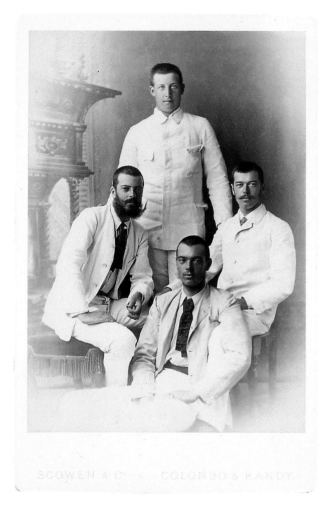

Got up at 7 o'clock to watch our arrival in Colombo. Ceylon was already visible, and Adam's Mount was pushing up through the clouds. The morning was ideal and really rather hot.
(Nicholas's Diary, 31 January 1891. ГА РФ. Ф. 601. Оп. 1. Д.225. Л. 47–8.)

435 The Newspaper *Bataviaasch Nieuwsblad*, reproduced in silk, with an article about Tsarevich Nikolai Alexandrovich's visit to the Island of Java, 4 March 1891

In French
Light-coloured silk with red stripe down the right edge
27 × 42 cm; open 54 × 42 cm
ГА РФ. Ф.601. Оп.1. Д.1472. Л.1

Thursday 28 February ... At 6.30 we arrived in Batavia where we were met by our friend the governor-general and a pack of adjutants. The heat was terrible, and particularly striking after the mountain air. Had a simple dinner at 7.30 — none of the Dutch were there.

Two hours later we set out in our frock-coats for a ball. I sat under a canopy with Georgie, the governor-general and his wife, and watched the couples go by. Joined in a waltz and one quadrille: there wasn't a single presentable face; I was bored and sweated like hell.

Friday 1 March ... We rested out of the heat until 4 o'clock when we went out on a crocodile hunt. We got into boats being towed by a steamer, and accompanied by music and a crowd of people we went down to a little tributary with inlets where these beasts were to be found. Georgie was the first to kill a huge crocodile, I got another ... In the evening we sorted through our photographs of places and people in Java.
(Nicholas's Diary, 28 February – 1 March 1891. ГА РФ. Ф. 601. Оп. 1. Д. 225. Л. 87.)

436 Tsarevich Nikolai Alexandrovich and his Retinue in Bangkok, 8 March 1891

Unknown photographer
Inscribed by Nicholas on the bottom of the mount: *Приезд в Бангкок 8-го марта 1891* [Arrival in Bangkok, 8 March 1891]
Mounted photograph: 21.5 × 27 cm; 23 × 28 cm
ГА РФ. Ф.601. Оп.1. Д.1473. Л.2

Got up at 6 o'clock. The night had been stifling. We had the same problems getting onto the launch and reached the Siamese yacht, on which we sailed into Bangkok ... At 11.30 we dropped anchor in Bangkok.
(Nicholas's Diary, 8 March 1891. ГА РФ. Ф.601. Оп.1. Д.225. Л.92–93.)

437 Visiting Card of the Viceroy of Canton, 1891

In Chinese
Characters written in black Indian ink on red paper
Inscribed by Nicholas at the top of the card: *Визитная карточка вице-короля Кантонского* [Visiting card of the Viceroy of Canton].
15 × 27 cm
ГА РФ. Ф.601. Оп.1. Д.1465. Л.99

At 3.30 we arrived in Canton and docked at an attractive jetty with thousands of Chinese crowding right up to the edge ... We were received with great ceremony by the viceroy in the dining-room; I talked to him through an interpreter. He is an elderly man with a friendly face, and is obviously going to great trouble to ensure that we are all right.
(Nicholas's Diary, 24 March 1891. ГА РФ. Ф.601. Оп.1. Д.225. Л.124–125.)

438 Tsarevich Nikolai Alexandrovich in a Rickshaw, Nagasaki, Japan, 1891

Inscribed in black ink at the bottom of the mount: *Государь император, будучи наследником престола во время его пребывания в Японии* [His Majesty the Emperor, during his stay in Japan when heir to the throne]
Mounted photograph: 22 × 18 cm; 25 × 31 cm
ГА РФ. Ф.601. Оп.1. Д.2154. Л.42

Got up for church ... it was grey out with intermittent rain which spoilt the beautiful view of Nagasaki ... At 2.30 I went with Kochubei to the same jetty and got into yesterday's rickshaw.
(Nicholas's Diary, 17 April 1891. ГА РФ. Ф.601. Оп.1. Д.225. Л.164–165.)

439 Programme for a Sailing and Rowing Competition in Kobe, Japan, 6 May 1891

Indian ink on paper
Signed by the artist, Povasi, in black ink in the lower right-hand corner
13.5 × 19 cm
ГА РФ. Ф.601. Оп.1. Д.1465. Л.11

At 3 o'clock the sailing race began, with boats from the whole squadron. I followed the Azov boats with keen interest. Despite the fact that the frigate has only been sailing for eight months, and the Nakhimov three years too long, its boats took 10 out of the 16 prizes. The rowing race was just as successful.
(Nicholas's Diary, 6 May 1891. ГА РФ. Ф. 601. Оп.1. К.225. Л.202–204.)

440 Menu of a Dinner held in Kyoto, Japan, 27 April 1891

Indian ink on white paper with gold border
Inscribed by Nicholas in blue pencil at the top: *Обед в Киото. 27 апреля 1891 г.* [Dinner in Kyoto, 27 April 1891]
16 × 23 cm
ГА РФ. Ф. 601. Оп.1. Д.119. Л.5

Saturday 27 April ... at 4 o'clock we went by train to Osaka and then Kyoto, where we arrived at 6.15 ... We were splendidly greeted in the old capital of Japan, their Moscow; we rode in rickshaws through streets thronging with people. Russian, Japanese and Greek flags were everywhere — even on the paper lanterns. We were taken to a large hotel where Georgie and I refused to stay, settling happily into a wonderful little Japanese house. After a communal dinner we went to the tea house to see a real geisha dance; we had a very jolly time with them until 12 o'clock.

Sunday 28 April. A sunny morning and at 9.30 we set out in our rickshaws for an exhibition of Kyoto handicrafts. My eyes were darting all over the place, there were so many wonderful things to see; I bought a few artefacts. Then we visited an old palace where there was a beautiful collection of old things ... At the race course the municipal leader with all his representatives delivered a triumphal speech in my honour, which of course I answered. We saw an archery competition from a distance, and some original races in ancient costumes, which are only worn for racing once a year! Returned home for lunch, and at 2.30 we went for another look round Kyoto, where we were already beginning to find our way around quite well! We visited a famous factory where they make magnificent sashes and wonderful materials for furniture. We saw a most wonderful tapestry being made, which had been started two years ago.
(Nicholas's Diary, 27–8 April 1891. ГА РФ. Ф.601. Оп. 1. Д.225. С.184–186.)

435

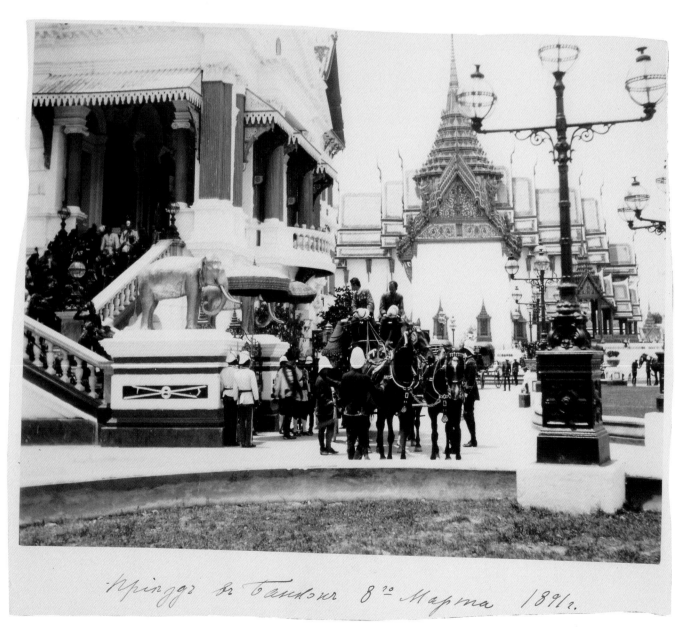

436

437

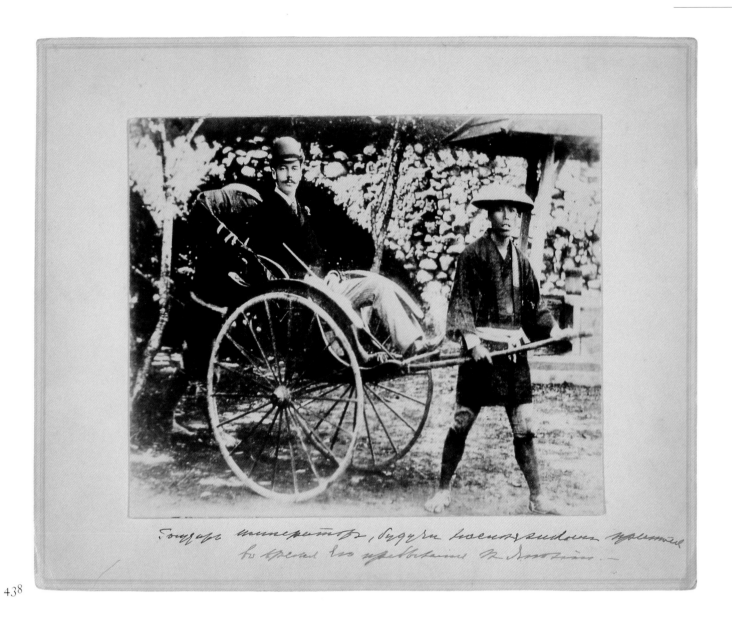

438

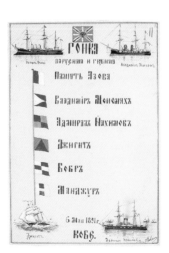

439

440

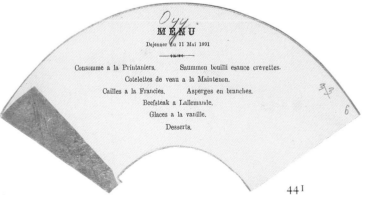

441

441 Menu of a Lunch held in Otsu, Japan, 11 May 1891

Semicircular white paper with gold border
Inscribed by Nicholas in blue ink, centre top: *Оцу* [Otsu]
19 × 10 cm

Consommé à la Printaniers
Saumon bouilli à sauce crevettes
Côtelettes de veau à la Maintenon
Cailles à la Française. Asperges en branches
Beefsteak à l'allemande
Glaces à la vanille
Desserts

ГА. РФ. Ф.601. Оп.1. Д. 119. Л.6

My Dearest Darling Mama,
I am writing you these lines so that you hear directly from me about
the unfortunate incident that took place in Japan, the very country
that interested me more than any other and which, after seeing it, I
liked so much. Having spent a couple of pleasant days in Kyoto, we
set off on the morning of 29 April in our rickshaws for the town of
Otsu. We visited the temple and had lunch with the governor, and were
just getting ready for our return to Kyoto when it happened: we had
not gone two hundred paces when suddenly a Japanese policeman
rushed into the middle of the street and, wielding a sabre with both
hands, struck me from behind on the right-hand side of my head.
I cried out in Russian: 'What's the matter with you?', and jumped
out of the rickshaw. Turning round, I saw that he was coming at me
again with his sword raised, so I ran as fast as I could down the
street, stemming the wound to my head with my hand. I tried to hide
in the crowd, but they immediately ran off, and I had to take to my
heels again to escape the pursuing policeman. In the end I stopped
and turned round to see dear Georgie about ten paces from me, with
the policeman, whom he had knocked to the ground with one blow of
his cane, lying at his feet. Had Georgie not been in the rickshaw
behind me, dearest Mama, perhaps I would never have seen you
again! But God willed otherwise! When that monster fell, he was
pounced upon by two rickshaw drivers; one of them used his sabre
to seize him by the neck and drag him bound to the nearest house. I
was bandaged up and taken back to the governor's house. I was very
touched by the Japanese, who knelt in the street as we passed and
looked terribly sad. We returned to Kyoto by train, where I spent
another two days. I have received a thousand telegrams from various
Japanese expressing their regret. The emperor himself, and all the
princes, came; I felt sorry for them, so stricken were they.
(From Nicholas's letter to his mother Empress Maria
Feodorovna, 2 May 1891. ГА РФ. Ф.601. Оп.1. Д.2321. Л.175–176.)

The blow was struck across the felt hat worn by the Tsarevich. The
lesions sustained are as follows:

1 The first, or occipital-parietal, wound is linear in form,
measuring nine centimetres, with torn edges, and has penetrated
the whole thickness of the skin down to the bone; it is situated in
the area of the right parietal bone six centimetres from the upper
edge of the ear, extending slightly downwards. Furthermore,
vessels of the nape and temporal arteries have been cut. At
the rear edge of the wound, the parietal bone has lost about a
centimetre of periosteum, consistent with a blow from a sharp
sabre.

2 The second, or front parietal, wound is situated some six
centimetres higher than the first and runs almost parallel, being
ten centimetres in length; it has penetrated right through the

skin down to the bone, and occupies the area of the parietal and
part of the frontal bone ... While cleaning the second wound,
I removed a wedge-shaped splinter, about two and a half
centimetres long, which was in the clots of blood.
Kyoto, 29th day of April 1891. State Councillor Rambakh,
State Councillor V. Popov, Collegiate Councillor M. Smirnov.
(From the medical findings attached to the report made by Prince
Baryatinsky to Emperor Alexander III. ГА РФ. Ф. 677. Оп.1.
Д.701. Л.12–13.)

442 Princess Alice of Hesse, 1882

Photograph by Carl Backofen (Darmstadt), J. S. Schroeder (Dresden)
Inscription at the bottom of the mount, partially missing: *Carl Backofen. Darmstadt. J. S. Schroeder. Dresden*
On the back the stamp: *Канцелярия ее величества государыни императрицы Александры Федоровны* [office of Her Majesty Empress Alexandra Feodorovna] and the date in black ink: *1892*
Mounted photograph: 10 × 14.5 cm; 10.5 × 16 cm
ГА РФ. Ф. 640. Оп.3. Д.14. Л.1. No.25

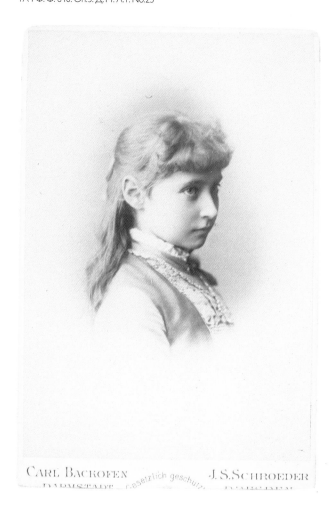

CARL BACKOFEN J.S.SCHROEDER

Alix, in the words of her mother in a letter to Queen Victoria, was
born 'a sweet, happy little thing, always laughing, with dimples
in her cheeks'. By the time she was christened (her godparents
were the future Tsar Alexander III and the future King Edward
VII), her mother had already nicknamed her 'Sunny': 'Our
Sunny, dressed all in pink, was much admired by everyone,' she
wrote in the same letter.

The American writer Robert Massie described Alix's childhood thus:

An English governess, Mrs. Orchard, ruled the nursery. Mrs. Orchard was not one for frills. The children's bedrooms were large and airy, but plainly furnished. Meals were simple; Alix grew up eating baked apples and rice puddings. Mrs Orchard believed in strict daily schedules with fixed hours for every activity ...
In 1878, when Alix was six, diphtheria swept the palace in Hesse-Darmstadt. All but one of the Grand Duke's children were stricken. Victoria sent her own physician from England to help the German doctors, but, despite their efforts, Alix's four-year-old sister, May, died. Then, worn out from nursing her children, Alix's mother, Princess Alice, also fell ill. In less than a week she was dead.

The death of her mother at thirty-five had a shattering effect on the six-year-old Alix. She sat quiet and withdrawn in her playroom while her nurse stood in the corner, weeping. Even the toys she handled were new; the old, familiar toys had been burned as a precaution against the disease. Alix had been a merry, generous, warm little girl, obstinate but sensitive, with a hot temper. After this tragedy she began to seal herself off from other people. A hard shell of aloofness formed over her emotions, and her radiant smile appeared infrequently.
(Massie, 1968, pp. 28–9.)

443 Diary of Tsarevich Nikolai Alexandrovich for 1884

Cover of painted Karelian birch; beige moiré end-papers; brown leather spine with blocking; stamped in gold: *1884*
10 × 13 cm; open 20 × 13 cm

The weather today was wonderful. We lunched as usual with all the Darmstadts. We jumped with them on the net. At 3 o'clock we all went out in the four-horse break. Papa led the way in the family charabanc with Aunt Marie and Victoria [Alix's elder sister]. *We looked around Oserki and everyone signed their name in the book at the mill. We drank fresh milk and ate black bread. Ernest, sweet little Alix and Sergei came to dine with us. Alix and I wrote our names on the back window of the little Italian house (we love each other).*
(Nicholas's Diary, 31 May 1884. ГА РФ. Ф.601. Оп.1. Д.219. Л.1–372.)

Alix first came to St. Petersburg when she was twelve years old for the wedding of her sister Ella to Grand Duke Sergei Alexandrovich. Here she met the sixteen-year-old heir to the Russian throne, and so began a childhood infatuation which subsequently grew into a lifelong love.

443

444 Russian Language Exercise Book Belonging to Princess Alice of Hesse, 1889–90

In Russian, English and German
Signed by Princess Alice in black ink within a white oval in the centre of the blue paper cover: *R. Alix. 1889/1890*
10.5 × 16.5 cm; open 21 × 16.5 cm
ГА РФ. Ф. 640. Оп.2. Д.124. Л.1–16 (л.4 об.–5)

After her daughter's death, Queen Victoria treated Grand Duke Ludwig as her own son and invited him often to England with his motherless children. Alix, now the youngest, was the ageing Queen's special favourite and Victoria kept a close watch on her little grandchild. Tutors and governesses in Darmstadt were required to send special reports to Windsor and receive, in return, a steady flow of advice and instruction from the Queen. Under this tutelage, Alix's standards of taste and morality became thoroughly English and thoroughly Victorian ... Alix was an excellent student. By the time she was fifteen, she was thoroughly grounded in history, geography, and English and German literature. She played the piano with a skill approaching brilliance, but she disliked playing in front of people.
(Massie, 1968, p. 29.)

445

445 Letter from Tsarevich Nikolai Alexandrovich to Grand Duke Alexander Mikhailovich, 25 September 1891

Fredensborg, Denmark
Crown and monogram of Nicholas stamped in gold at the top of the letter
12.5 × 20 cm; open 25 × 20 cm

Generally I think it's time I got married, for I find myself looking more and more often at pretty faces. Besides, I terribly want to get married, I feel I need to build myself a nest.

ГА РФ. Ф. 645. Оп.1. Д. 102. Л. 95 об.–96

Within just a few months Nicholas is writing in his diary:
21 December 1891. In the evening I sat with Mama and Aprak [Princess A. A. Obolenskaya, lady-in-waiting to Empress Maria Feodorovna] *discussing the family life of the young people of society today; the conversation struck a most sensitive chord within me, touching as it did on that dream and hope that I live by from day to day. Already a year and a half has passed since I spoke to Papa about it at Peterhof, and since then nothing has changed either for better or worse! My dream is one day to marry Alix H[esse]. I have loved her for a long time, but all the more deeply and strongly since the winter of 1889 when she spent six weeks in St Petersburg! For a long time I resisted my feelings, trying to deceive myself about the impossibility of fulfilling my most cherished dream. But since this winter Eddy* [the eldest son of the Prince of Wales, who had courted Alix] *has either withdrawn or been turned down, the only obstacle or gulf between us is the question of religion! This is the only barrier; I am almost convinced that our feelings are mutual! Everything is dependent on the will of God. Trusting in His mercy, I look to the future calmly and with humility.*
(Nicholas's Diary. ГА РФ. Ф. 601. Оп.1. Д.227. С.107–108.)

446 Matilda Kshessinskaya

Photograph by Hélène de Mrosovsky, who had a photographic studio at 20 Nevsky Prospect, St. Petersburg
Trade-mark of the studio in lower right-hand corner: *Hélène de Mrosovsky. Nevsky, 20*
Mounted photograph: 10 × 15 cm; 21 × 29 cm
ГА РФ. Ф.10060 (New acquisition from the family archive of Grand Duke Andrei Vladimirovich)

Matilda Felixovna Kshessinskaya (1872–1971): famous Russian ballerina, daughter of a dancer, prima ballerina of the Marinsky Theatre. From 1891 to 1893 she was close to Nicholas. Common-law wife of Grand Duke Sergei Mikhailovich. In 1921 she married Grand Duke Andrei Vladimirovich. She emigrated and died in France.

Nicholas met Matilda Kshessinskaya in March 1890 at the graduation day of the Imperial Ballet School. The love affair with 'Malechka' reached its culmination in the winter of 1892–3. The tsarevich would often visit the lively, enchanting little ballerina at home, sometimes staying the night. The affair was broken off by Nicholas a few months before his engagement.

1 April 1892. Gatchina. Sandro's birthday, he's twenty-six! And I'm following close on his heels, with only two years between us. I've noticed something very strange within myself: I never thought that two identical feelings, two loves could co-exist within the heart. I have loved Alix H[esse] for three years already and constantly cherish the hope that, God willing, one day I will marry her! The following winter I fell madly in love with Olga D[olgorukaya], though now that has passed! And since the summer camp of 1890 I have been passionately in love (platonically) with little K[shessinskaya]. The heart is a surprising thing! And all the time I never stop thinking about Alix! Should I conclude from all this that I am exceptionally

446

447

amorous? *To a certain extent, yes; but I should add that deep down I am a stern judge and extremely discriminating! This is the mood I described yesterday as not very pious!*

25 January 1893. St. Petersburg. In the evening I dashed off to see my M.K. [Matilda Kshessinskaya], and spent a wonderful evening with her. I am completely under her spell — the pen is trembling in my hand!
(Nicholas's Diaries for 1892 and 1893. ГА РФ. Ф.601. Оп.1. Д.228. С.37–38. Д.229. С.2–3.)

447 Letter from Princess Alice of Hesse to Tsarevich Nikolai Alexandrovich, 8 November 1893

Darmstadt, Germany
In English
Crown and monogram of Princess Alice stamped in gold at the top of the grey paper
14.5 × 19 cm; open 30 × 19 cm

You know what my feelings are as Ella has told them to you already, but I feel it my duty to tell them to you myself. I thought about everything for a long time, and I only beg you not to think that I take it lightly for it grieves me terribly and makes me very unhappy. I have tried to look at it in every light that is possible, but I always return to one thing. I cannot do it against my conscience. You, dear Nicky, who have also such a strong belief will understand me that I think it is a sin to change my belief, and I should be miserable all the days of my life, knowing that I had done a wrongful thing. I am certain that you would not wish me to change against my conviction. What happiness can come from a marriage which begins without the real blessing of God? For I feel it a sin to change that belief in which I have been brought up and which I love. I should never find my peace of mind again,

and like that I should never be your real companion who should help you on in life; for there always should be something between us two, in my not having the real conviction of the belief I had taken, and in the regret for the one I had left. It would be acting a lie to you, your Religion and to God. This is my feeling of right and wrong, and one's innermost religious convictions and one's peace of conscience toward God before all one's earthly wishes. As all these years have not made it possible for me to change my resolution in acting thus, I feel now is the moment to tell you again that I can never change my confession. I am certain that you will understand this clearly and see as I do, that we are only torturing ourselves, about something impossible and it would not be a kindness to let you go on having vain hopes which will never be realized.
And now Goodbye my darling Nicky, and may God bless and protect you. Ever your loving Alix

ГА РФ. Ф.601. Оп. 1. Д.1147. Л.3–5

The greatest obstacle to Nicholas's dream of winning his beloved was Alix's unwillingness to change religion, for a future Russian empress could not remain outside the Orthodox faith. For all the entreaties of her elder sister Elizaveta Feodorovna, Alix was unyielding in her decision. Nicholas described how he felt in his diary for 1893:

18 November. This morning I opened a packet that had been lying on the table since last night, and in a letter from Alix from Darmstadt learnt that everything is over between us — for her changing religion is out of the question — and faced with this implacable obstacle all my hopes, my best dreams and most cherished wishes for the future are in ruins. This future that until so recently seemed bright, tempting and almost within reach — and now it seems quite

indifferent!!! Yes, sometimes it is hard indeed to submit to the will
of God! I walked about all day in a daze, it's so hard to appear calm
and happy when an issue affecting the whole of the rest of your life
is suddenly decided in this way!
The weather on my walk was entirely appropriate for my mood: it
was thawing and a storm was blowing. We dined downstairs.
(Nicholas's Diary, 18 November 1893. РФ. Ф.601. Оп.1. Д.231. Л. 135–136.)

448 Letter from Tsarevich Nikolai Alexandrovich to Princess
Alice of Hesse, 17 [29] December 1893

Gatchina, near St. Petersburg
In English
Crown and monogram of the tsarevich at the top of the page
12.5 × 19.5 cm; open 25 × 19.5 cm

My dearest Alix
Please excuse my not having answered your letter sooner, but you may
well imagine what a blow it proved to me. I could not write to you all
these days on account of the sad state of mind I was in. Now that my
restlessness has passed I feel more calm and am able to answer your letter
quietly. Let me thank you first of all for the frank and open way in which
you spoke to me in that letter! There is nothing worse in the world than
things misunderstood and not brought to the point. I knew from the
beginning what an obstacle there rose between us and I felt so deeply for
you all these years, knowing perfectly the great difficulties you would have
had to overcome! But still it is so awfully hard, when you have cherished a
dream for many a year and think — now you are near to its being realized —
then suddenly the curtain is drawn and — you see only an empty space
and feel oh! so lonely and so beaten down!! I cannot deny the reasons you
give me, dear Alix; but I have got one which is also true: you hardly know
the depth of our religion. If you only could have learnt it with somebody,
who knows it, and could have read our books, where you might see the
likeness and difference of the two — perhaps then! it would not have
troubled you in the same way as it does now! Your living quite alone without
anyone's help in such a matter, is also a sad circumstance in the barrier
that apparently stands between us! It is too sad for words to know that
that barrier is — religion! Don't you think, dearest, that the five years, since
we know each other, have passed in vain and with no result? Certainly not
— for me at least. And how am I to change my feelings after waiting and
wishing for so long, even now after that sad letter you sent me? I trust in
God's mercy: maybe it is His will that we both, but you especially should
suffer long — maybe after helping us through all these miseries and trials —
He will yet guide my darling along the path that I daily pray for!
Oh! do not say 'no' directly, my dearest Alix, do not ruin my life already!
Do you think there can exist any happiness in the whole world without you!
After having involuntarily! kept me waiting and hoping, can this end in
such a way? Oh! do not get angry with me if I am beginning to say silly
things, though I promised in this letter to be calm! Your heart is too kind
not to understand what tortures I am going through now. But I have spoken
enough and must end this epistle of mine. Thank you so much for your
charming photo.
Let me wish, dearest Alix, that the coming Year may bring you peace,
happiness, comfort and the fulfilment of your wishes. God bless you and
protect you!
Ever your loving and devoted Nicky

ГА РФ. Ф.640. Оп.1. Д.89. Лл.164–167 об.

449 Diary of Princess Alice of Hesse, 1894

In English
Dark claret-coloured leather cover with metal padlock; decorative end-papers
14 × 21 cm; open 28 × 21 cm
ГА РФ. Ф.640. Оп. 1. Д. 298. Л. 1–378

Entry for 8 April 1894 — the day of Nicholas and Alexandra's engagement (contained within the diary illustrated).

In the spring of 1894 Grand Duke Ernst-Ludwig of Hesse was to be married in Coburg to Princess Victoria-Melita, the daughter of Marie and Alfred, Duke and Duchess of Edinburgh. Eminent guests from all over Europe descended upon the capital of Saxe-Coburg-Gotha. Nicholas arrived on 4 April as the representative of the Russian imperial family. A few days later Nicky and Alix had a discussion, and on 8 April everything was settled. Queen Victoria played an important role in the outcome, persuading her favourite granddaughter that essentially Orthodoxy and Protestantism 'differ very little from each other'.

455 Book in the form of an Owl, given to Nicholas by Princess Alix in Coburg on 29 April 1894

Ferdinand von Haas. Ernst und Scherz
In German
Tied with a grey cloth bow
Inscribed by Alix on the last page: *For my darling Nicky dear from his deeply loving and devoted old Owl. A. Easter 1894. April 29th Coburg*
9 × 12 cm; open 18 × 12 cm
ГА РФ. Ф.601. Оп.1. Д.1147. Л.9–15

456 Letter from Queen Victoria to Tsarevich Nikolai Alexandrovich, 22 April 1894

Windsor
In English
White paper with black border; at the top a crown, the monogram of the queen, and the inscription: *Windsor Castle*
11 × 17.5 cm; open 22 × 17.5 cm

Dear Nicky,
I must thank you very much for so kindly sending me that splendid copy of your Travels which I shall value very much. I need not say how much my thoughts [have] been with you and my sweet Alicky since we left dearest Coburg and I am sure the parting from her will have been very painful for both. We are looking forward with such pleasure to her arrival on Friday and I shall watch over her most anxiously and carefully that she should get rest and quiet and do all to get strong which she has not been for some time. While she is here, alone without you, I think she ought to go about and out as little as possible as she would be stared at and made an object of curiosity which in her present position as your Bride would be both unpleasant and improper. As she has no Parents, I feel I am the only person who can be answerable for her. All her dear Sisters after their beloved Mother's death looked to me as their second Mother, but they had still their dear Father. Now poor dear Alicky is an Orphan and has no one but me at all in that position. Anything you wish, I hope you will tell me direct. I am so sorry not to be able to take her to Balmoral, which is the finest air in the world, but it was rather too bracing for her 2 years ago. I hope in the autumn she might be able to do so.
Believe me with true affection, dear Nicky, your devoted (future)
Grandmama
Victoria RI

ГА РФ. Ф.601. Оп.1. Д.1194. Л.121–124 (letter contained within the collection illustrated)

457 Letter from Tsarevich Nikolai Alexandrovich to Queen Victoria, 2 June 1894

Peterhof
In English
White paper with stamped gold and red crown and Nicholas's monogram in blue at the top
12 × 20 cm; open 24 × 20 cm

Dearest Grandmama,
Your third kind letter gave me such great pleasure which I thank you for most heartily. I leave tomorrow in the afternoon on board Papa's new yacht the 'Polar Star' that he kindly lent me for coming to England ... You don't know, dearest Grandmama, how happy I am to come and spend some time with you and my beloved little bride. What a different impression for me this time – with my stay in London last year for Georgie's wedding. This separation from Alix has made my love for her still stronger and deeper than it was before! Now, dearest Grandmama, I must end; with fondest thanks for your kind letter and hoping to see you very soon again believe me your most loving and devoted (future) grandson.
Nicky

ГА РФ. Ф. 601. Оп.1. Д.1111. Л. 5–6 об.

452 The relatives of Tsarevich Nikolai Alexandrovich and Princess Alice of Hesse attending the Wedding in Coburg of Ernst-Ludwig and Victoria-Melita

Photograph by E. Uhlenhuth, Coburg
Front row, seated left to right: Princess Beatrice of Coburg and Princess Feodora Saxe-Meiningen;
Second row, seated left to right: Wilhelm II (Alix's first cousin); Queen Victoria; Victoria (Queen Victoria's daughter and Alix's aunt);
Third row, standing left to right: Alfred of Saxe-Coburg-Gotha, standing in front of Edward, Prince of Wales; Tsarevich Nikolai Alexandrovich; Princess Alice of Hesse; Victoria Battenberg and Irene of Prussia (Alix's sisters); Grand Duchess Maria Pavlovna (wife of Grand Duke Vladimir Alexandrovich); Grand Duchess Maria Alexandrovna (daughter of Alexander II, Duchess of Saxe-Coburg-Gotha);
Fourth row left to right: Edward, Prince of Wales (obscured by Alfred); Princess Beatrice of Battenberg; Prince Alexander Hohenloe; Duchess Charlotte of Saxe-Meiningen (partly obscured); Arthur, Duke of Connaught; Louise-Margaret, Duchess of Connaught (only hat and cloak visible);
Fifth row, left to right: Prince Ludwig Battenberg (in the bowler-hat); Prince Henry Battenberg; King Ferdinand I of Romania (in light-coloured overcoat); Queen Marie of Romania (partly obscured); Princess Louise of Saxe-Coburg (partly obscured); Grand Duke Sergei Alexandrovich; Grand Duchess Elizaveta Feodorovna; Grand Duke Vladimir Alexandrovich; Alfred, Duke of Saxe-Coburg-Gotha;
Back row, left to right: Grand Duke Pavel Alexandrovich (almost completely obscured); Prince Philip of Saxe-Coburg (in spectacles); Count Arthur von Mensdorff-Pouilly.
Stamped in gold to the right: *E. Uhlenhuth. Coburg am Albertplatz*
Mounted photograph: 22 × 16 cm; 25 × 16.5 cm
ГА РФ. Ф.640. Оп.1. Д.390. Л.1

453 Nicky and Alix after their Engagement, Coburg, 1894

Photograph by E. Uhlenhuth
Stamped in gold at the bottom of mount: *E. Uhlenhuth Hof-Photograph. Coburg. 1894*
Mount edged in gold
Mounted photograph: 12.5 × 19.5 cm; 13 × 22 cm
ГА РФ. Ф.640. Оп.1. Д.366. Л.1

21 April. On the train.
However sad it seems now, my heart rejoices at the thought of what has happened and turns to God with a prayer of thanks! The weather is wonderful, even a little too hot for the train! We lunched in Konitsa; I had an old picture of Alix with me, surrounded by her familiar pink flowers! I was very touched by the buffet attendant who asked for her to be brought into the carriage. At 7 o'clock we crossed the border. While they moved the luggage I wrote my dear fiancée a letter.
(Nicholas's Diary, 21 April 1894. ГА РФ. Ф.601. Оп.1. Д.232.)

454 Nicky and Alix after their Engagement, Coburg, 1894

Photograph by E. Uhlenhuth
Stamped in gold at the bottom of mount: *E. Uhlenhuth Hof-Photograph. Coburg. 1894*
Mount edged in gold
Mounted photograph: 12.5 × 19.5 cm; 13 × 22 cm
ГА РФ. Ф.640. Оп.1. Д.366. Л.6

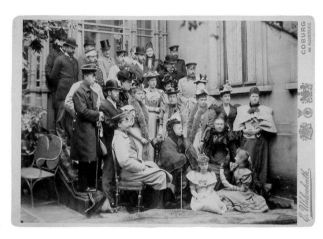

452

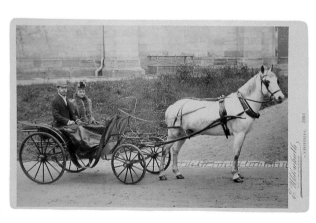

454

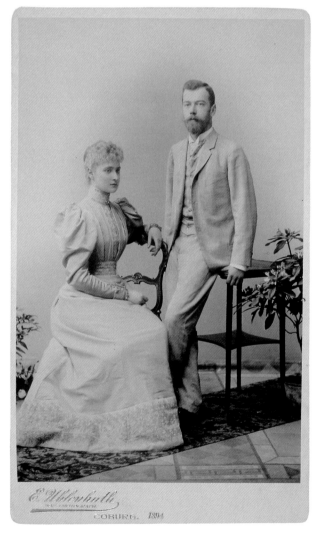

453

Vendredi, le ³⁄₂₀. Avril 1894.

Déjeûner dînatoire.

Potage Pohlebka.

Oeufs de vanneaux.

Poulets à la paprica.

Côtelettes de mouton sautées.

Salade.

Pointes d'asperges en légume.

Gaufres à la crême.

450 **Menu for a Lunch Held on the Day of Nicholas and Alexandra's Engagement,** Friday 8 [20] April 1894

In French
Light-coloured paper with the Russian and Danish coats of arms beneath a crown; inscribed by Nicholas in pencil at the top: *В день нашей помолвки* [the day of our engagement]
12 × 18 cm

Déjeuner dînatoire
Potage Pohlebka
Oeufs de vanneaux
Poulets à la paprica
Côtelettes de mouton sautées
Salade
Pointes d'asperges en légume
Gaufres à la crème

ГА РФ. Ф.601. Оп.1. Д.119. Л.8

451 **Love Note from Nicky to Alix,** 1894

In English
White paper with gold crown and monogram of Nicholas
12.5 × 20 cm

I love you my darling!!!!

ГА РФ. Ф.640. Оп.1. Д.90. Л.1

Gatchina. December 17/29 1893.

My dearest Alix,

Please excuse my not having
answered your letter sooner,
but you may well imagine
what a blow it proved to me.
I could not write to you all
these days on account of
the sad state of mind I was
in. Now that my restlessness
has passed I feel more calm
and am able to answer your
letter quietly. Let me thank

... ve years, since
... ch other, have
... in and with no
... ainly not —
... t. And now
... ge my feelings
... & wishing for
... now after that
... sent me?
... God's mercy,
... His will that

448

449

1894

Tagebuch
für
Alix von Hessen

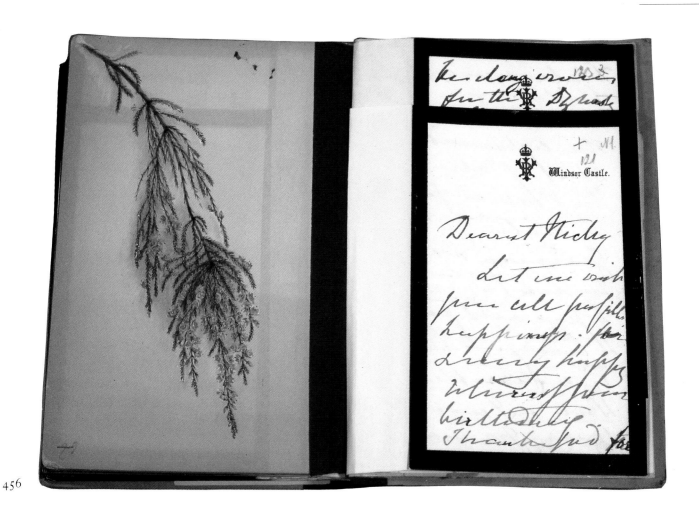

456

Windsor Castle.

Dearest Nicky

Let me wish
you all possible
happiness for
a very happy
return of your
birthday. I thank God for...

457

best possible good; that
staying happily here with
her husband. Adolphus of
Mecklembourg came to be pre-
sent at her funeral. —
The weather continues to be
heavenly and we are all in
the park or on the lawn as
much as possible. Mamma
leaves for Abbastouman - Georgie's
place - on the 21st with Xenia
& Sandro; Papa & the rest of us
remain here for a fortnight longer.
Now dearest grandmama let
me wish you again every possible
blessing for your birthday and
believe me your most devoted
and affectionate grandson Nicky

N3 June 2/14 1894. Peterhof.

Dearest grandmama,
Your third kind letter gave
me such great pleasure which
I thank you for most heartily.
I leave tomorrow in the after-
noon on board Papa's new
yacht the "Polar Star" that
he kindly lent me for coming
to England. I hope of reaching
Gravesend on the 20th without
stopping on the road. I am
afraid it shall be too late for

458 Nicky and Alix after their Engagement, England, 1894

Photograph by I. W. Ryde
Stamped at the bottom of mount: *Mullins. By appointment to the Queen.
Photographer Ryde, I. W.*
Mount framed in gold
Mounted photograph: 17.5 × 28.5 cm; 18.5 × 32 cm
ГА РФ. Ф.640. Оп.1. Д.366. Л.13

*How happy I am to have so many of your dear photographs with me
— they're on the writing table and cupboards, and everywhere I look
I can see my dear little girl looking at me …*
(From Nicky's letter to Alix of 23 April 1894. Ф.640. Оп.1. Д.89.
Л.5–5 об.)

459 Diary of Tsarevich Nikolai Alexandrovich: Entry for 20
October 1894

Exercise book with black leather cover
18 × 22 cm; open 36 × 22 cm

My God, my God, what a day! The Lord has called unto Him our adored,
dear, ardently beloved Papa.
My head is spinning, I don't want to believe it – it seems an inconceivably
terrible reality. All morning we were upstairs with him! His breathing was
laboured, and he had to be administered oxygen the whole time. At about
3.30 he took Holy Communion, and soon after he started to have slight
convulsions … and then the end came quickly! Father Ioann stood at his
bedside for over an hour supporting his head.
A saint has died! Lord, help us in these painful days! Poor dear Mama!
At 9.30 in the evening we held a requiem – in the same bedroom! I felt
completely shattered. Dear Alix is suffering pains in her legs again! In
the evening I went to confession.

ГА РФ. Ф.601. Оп.1. Д.233. Л.1–207 (л.115–116)

*Nicky and I stood on the veranda of the wonderful Livadia Palace
holding bags of oxygen, and witnessed the end of a Colossus. He
died as he had lived, an inveterate enemy of grandiose words and
melodramatic effects. He only mumbled a short prayer and bid
farewell to his wife. To everyone who was gathered around Alexander
III's lifeless body at the end — relations, doctors, court officials and
servants — it seemed that our country had lost the only support that
prevented Russia from falling into the abyss. And nobody understood
this better than Nicky. At that moment, for the first and last time in
my life, I saw tears in his blue eyes. He took my arm
and led me down to his room, where we embraced and wept together.
He could not collect his thoughts. The realisation that he was now
emperor, and the terrifying burden of power this entailed, seemed
to crush him. 'Sandro, what am I going to do?' he exclaimed
pathetically. 'What is to become of Russia now? I am not yet ready
to be tsar! I cannot rule an empire. I don't even know how to talk to
the ministers.'*
(Grand Duke Alexander Mikhailovich, 1991, pp. 140–1.)

460 *Wedding March*, dedicated to the Marriage of Emperor
Nicholas II and Alexandra Feodorovna on 14 November 1894

Composed by Boris Schell
Musical score (typographic copy)
Publisher's trade-mark in the lower right-hand corner: *Литография Р. Голике. СПБ*
[Lithograph by R. Golike, St. Petersburg].
27 × 36 cm; open 54 × 36 cm
ГА РФ. Ф.601. Оп.1. Д.6. Л.1–5

*The day of my wedding! We all had coffee together and then went to
get dressed: I put on my Hussars uniform and at 11.30 went with
Misha to the Winter Palace. The whole of Nevsky Prospect was lined
with troops waiting for Mama and Alix to drive past. While final
touches were made to her dress in the Malachite hall, we all waited in
the Arabian room. At 12.50 the procession into the Great Church
began, from where I emerged a married man! My best men were
Misha, Georgie, Kyril and Sergei. In the Malachite hall we were
presented with an enormous silver swan from the family. Alix
changed and then joined me in a carriage harnessed in Russian style
with a postilion, and we rode to Kazan cathedral. There were swarms
of people on the streets — we could barely pass! On our arrival at the
Anichkov Palace we were met by a guard of honour. Mama was
waiting for us in our rooms with the bread and salt. We sat all evening
answering telegrams. We dined at 8 o'clock and collapsed into bed
early as she had a terrible headache!*
(Nicholas's diary, 14 November 1894. ГА РФ. Ф.601. Оп.1. Д.233.
Л.141–142.)

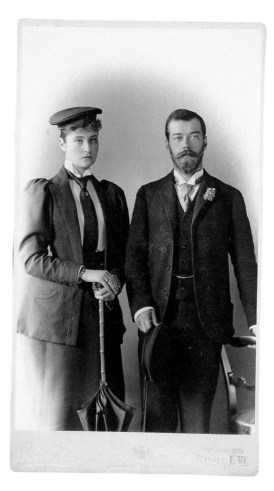

458

114.

[handwritten diary text in Russian cursive, largely illegible]

19ᵗ Октябрь. Среда.

Angels guard the day & night. [illegible]

[handwritten diary text in Russian cursive, largely illegible]

459

115.

May love and peace, and blessings without end
Wreath all your path like flowers, oh, my friend!
And if a storm should touch you where they grow,
Believe, indeed, I would not have it so!—

[handwritten diary text in Russian cursive, largely illegible]

20ᵗ Октябрь. Четвергъ.

[handwritten diary text in Russian cursive, largely illegible]

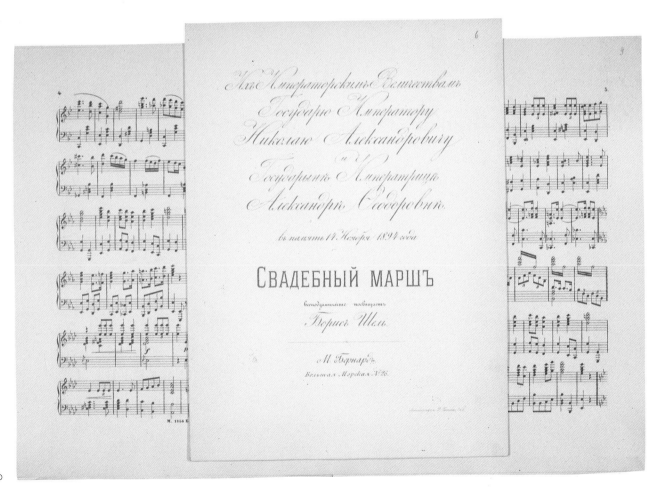

Его Императорскимъ Величествамъ
Государю Императору
Николаю Александровичу
и
Государынѣ Императрицѣ
Александрѣ Ѳеодоровнѣ

въ память 14 Ноября 1894 года

СВАДЕБНЫЙ МАРШЪ

всеподданнѣйше посвящаетъ

Борисъ Шель.

М. Бернардъ.
Большая Морская № 25.

6

4

5

9

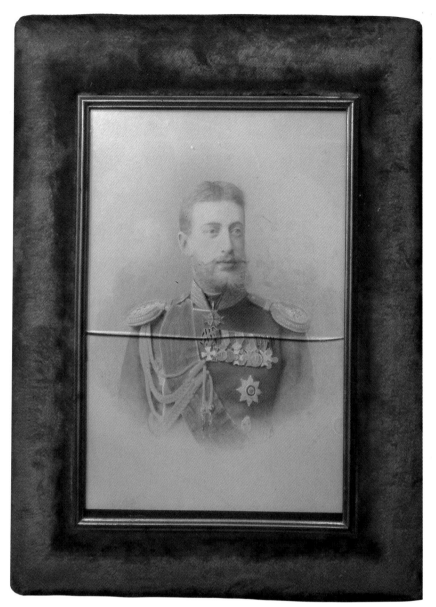

461

461 Portrait of Grand Duke Konstantin Konstantinovich

Unknown photographer
Coloured photograph in red velvet frame with mount, under glass
Framed photograph: 20 × 27 cm
ГА РФ. Ф.643. Оп.1. Д.153. Л.1

Yesterday at 10.30 in the morning our whole family, together with the foreign princes, gathered in the Arabian room of the Winter Palace. I arrived with Mama. After an absence of many years she decided to participate in the imperial procession, in a Russian dress of silver brocade and pearls. The bridegroom arrived a little before the empress and the bride. He was wearing his Life-Guard Hussars uniform. If I had not expected him to be dressed in this way for the wedding, I would have been disappointed since it would be nice to see him more often in our Preobrazhensky uniform. I gave the bride a bouquet of white roses tied with white velvet ribbons on which gold monograms of Peter I had been embroidered. It was painful to watch the poor

empress. In a simple, low-necked dress covered with white crepe, with pearls around her neck, she seemed even paler and more frail than usual, like a victim being led to the slaughter; finding herself in front of thousands of eyes at such a difficult and grief-stricken time was inexpressibly painful for her. While she and the grand duchesses attended the bride in the Malachite hall, where ladies-in-waiting were arranging her hair and attaching the gold ermine-lined mantle to her dress, I saw the emperor standing in the Arabian room. I was standing in the corner, by the entrance to the Pompeii gallery ... The procession to the church was led by the empress with the king of Denmark; behind them processed the emperor and his bride. The halls were full. The poor empress cried virtually all the time in church. The best men were: for the emperor, Misha, Georgie of Greece, Kyril and Sergei Mikhailovich, and for the bride, Boris, Mitya, Nikolai Mikhailovich and Georgy Mikhailovich. It sounded strange and unaccustomed to hear Father Yanyshev read: The

462

463

marriage of God's servant, the Most Devout, Most Autocratic
Great Sovereign Emperor Nikolai Alexandrovich ...
The tsar is slightly shorter than his bride, but not noticeably. They
both stood erect and motionless under the crowns. As they circled
the lectern I was able to see their faces: their eyes were lowered, their
expression concentrated. And then we heard, after the Emperor's
name, his bride being addressed by name for the first time: the
Most Devout Majesty Empress Alexandra Feodorovna. As they
left the church, the couple led the way, with the dowager empress
and her father behind them.
(Diary of Grand Duke Konstantin Konstantinovich, 15
November 1894. ГА РФ. Ф.660. Оп.1. Д.41. Л.152, 152 об.)

462 Address from the Peasants of Kiev Province to Nicholas II
on the Occasion of his Marriage, November 1894

In a red leather binding with gold stamped inscriptions and moiré lining
35.5 × 44 cm
ГА РФ. Ф.601. Оп.1. Д.55. Л.1

463 Address from the Jewish Community of Kishinev to
Emperor Nicholas II and Empress Alexandra Feodorovna
on the Occasion of their Marriage, November 1894

In a blue velvet binding with gold stamped inscriptions and moiré lining
31 × 44 cm
ГА РФ. Ф.601. Оп.1. Д.56. Л.1–2

The Coronation

Tragedy on Khodynka Field

464 Announcement of the Coronation of Nicholas II,
14 May 1896

Chromolithograph
28 × 40 cm
ГА РФ. Ф.601. Оп.1. Д.119. Л.41

14 May, Moscow.
A great ceremonial, but morally grave, day for Alix, Mama and
myself. We were on our feet from 8 o'clock, although our procession
did not set off until 9.30. Luckily the weather was divine; the Red
Porch was a dazzling sight. It all took place in the Uspensky
Cathedral, and although the whole thing seemed like a dream, I shall
not forget it as long as I live!!! At 9 o'clock we went out onto the upper
balcony, where Alix switched on the electric illuminations on the Ivan
the Great bell-tower, and then all the other towers and walls of the
Kremlin lit up in turn. We went to bed early.
(Nicholas's diary, 14 May 1896. ГА РФ. Ф.601. Оп.1. Д.236. С.9–10.)

I felt as if I had woken from a magical dream, and I could not believe
that everything I had seen, heard and experienced was for real. By
7 o'clock I had already crossed the great rooms of the palace, teeming
with people, and found myself at the Red Porch.
The Ivan the Great bell started to ring out, a salute was fired; there
wasn't a cloud in the sky, and Cathedral Square was flooded with
sunshine. The shrill cry of swallows could be heard, soaring high
overhead in the blue skies. It was already hot. The troops were
starting to line up, spectators were taking their places in the stands.
At 8 o'clock the family and the foreign princes assembled in the
Formal Drawing-Room of the palace. At 8.45 the doors opened and
Empress Maria Feodorovna appeared; our hearts bled at the sight of
her. She was wearing a crown and a heavy purple robe, like a victim
prepared for sacrifice. Her face was a picture of suffering.
We all followed her into the Uspensky Cathedral. Her assistants were
Alexei and the Danish crown prince. The procession was so long —
with the foreigners we numbered so many — that by the time she
entered the cathedral we had not even reached the Red Porch. We heard
the distant cheers coming from the square, greeting her appearance at
the Red Porch. In the cathedral the grand duchesses and princesses
stood to the right of the throne, a little below the upper dais; we men
stood to the left. The empress mounted her throne, which was just to
the right of the thrones for the tsar and the young tsarina. We took our
places ... A great roar from the square announced their Majesties'
procession. The priests went out to meet them and anoint them with
incense and holy water. And then their Majesties entered and bowed
to the cathedral icons. The tsar looked very serious, the expression on
his face one of piety and supplication, and his whole being seemed to
radiate majesty. The young tsarina was the embodiment of gentleness
and goodness. Empress Maria Feodorovna looked every bit as young
as she had 13 years before on the day of her own coronation.
When the tsar and his wife mounted their thrones, the dignitaries
carrying the royal regalia and their assistants obstructed my view, so
that I saw almost nothing; I could only see the tsar with difficulty,
but I could hear perfectly as he recited the creed. His assistants were
Vladimir and Misha. They helped him put on the purple robe, and at
that moment his large diamond chain of St. Andrew the First-Called
broke. I could barely see as he placed the crown on his head and took
the sceptre and orb; I could not see the empress kneeling before him
at all — only when he raised her up and kissed her. The words of
Metropolitan Pallady were virtually inaudible, nor could I properly
hear the prayers read by the tsar as he kneeled. It was only when
everyone else knelt down, and the tsar alone remained standing,
that I was able to feast my eyes on him.
(Diary of Grand Duke Konstantin Konstantinovich,
14 May 1896. ГА РФ. Ф.660. Оп.1. Д.43. Л.60 об.–61.)

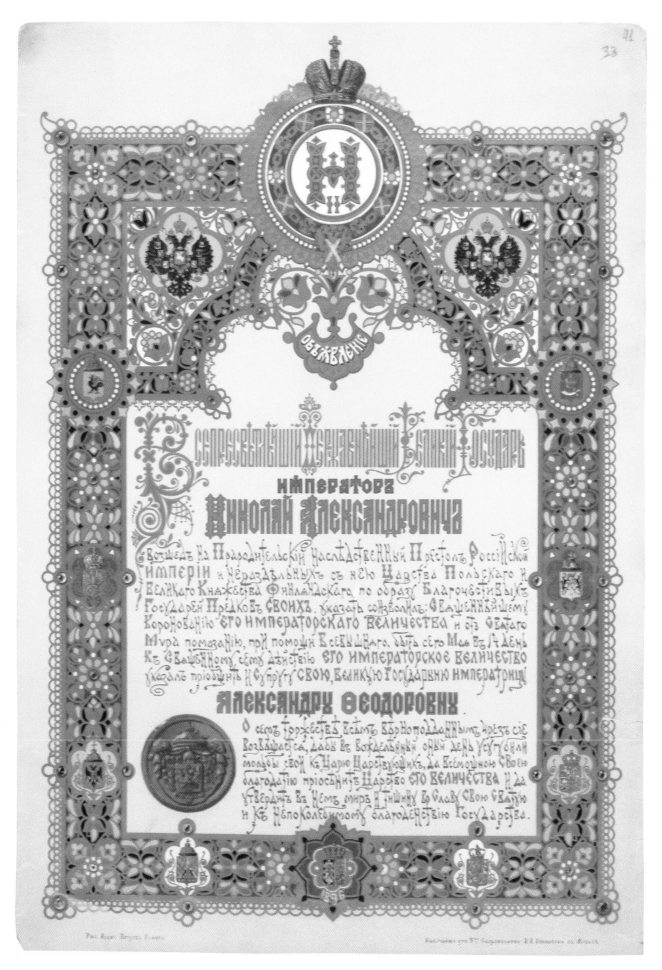

465 Coronation Lunch Menu, 14 May 1896

Chromolithograph from an original drawing by V. M. Vasnetsov
93 × 33 cm
ГА РФ. Ф.601. Оп.1. Д.119. Л.42

The coronation lunch took place in the Palace of Facets and lasted just one hour — from 3 to 4 o'clock. The tsar and tsarina sat on thrones to eat. The menu comprised the following dishes: *rassolnik* (meat or fish soup with pickled cucumbers), *bortsch* (beetroot soup), and *pirozhki* (meat pasties), followed by steamed sturgeon, lamb, pheasant in aspic, capons, salad, asparagus; and for dessert, fruits in wine and ice-cream.

Their majesties (all three of them) donned their purple robes and the procession set off to the Palace of Facets for the celebration feast. They disrobed in the Vladimir Hall, and the family went up to the 'hiding place'. Through a low window I could see how hungrily the emperor was eating, sitting on his throne between the two empresses. By 5 o'clock it was all over.
(Diary of Grand Duke Konstantin Konstantinovich, 14 May 1896. ГА РФ. Ф.660. Оп.1. Д.43. Л.62–62 об.)

466 Coronation Dinner Menu, 26 May 1896

Chromolithograph from an original drawing by A. M. Vasnetsov
46 × 29 cm
ГА РФ. Ф.601. Оп.1. Д.1687. Л.28

On 26 May 1896 a ceremonial feast took place marking the end of the coronation celebrations. Nicholas II wrote in his diary: 'At 7 o'clock there was a large dinner for the Moscow authorities and representatives of various estates.' (ГА РФ. Ф.601. Оп.1. Д.236. Л.28.) The menu for the dinner comprised the following dishes: bouillon, Russian soup, *pirozhki* (meat pasties), steamed Gatchina trout, wild goat, fillet of chicken with truffles, cold lobster, roast duck, salad, artichokes with mushrooms, a hot pudding, ice-cream, and other desserts.

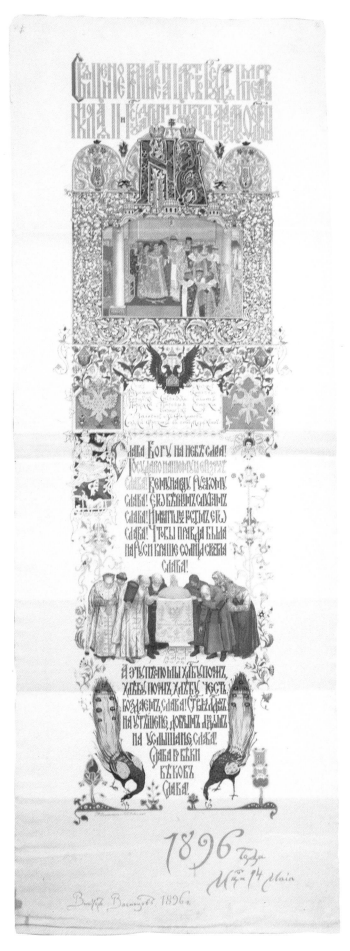

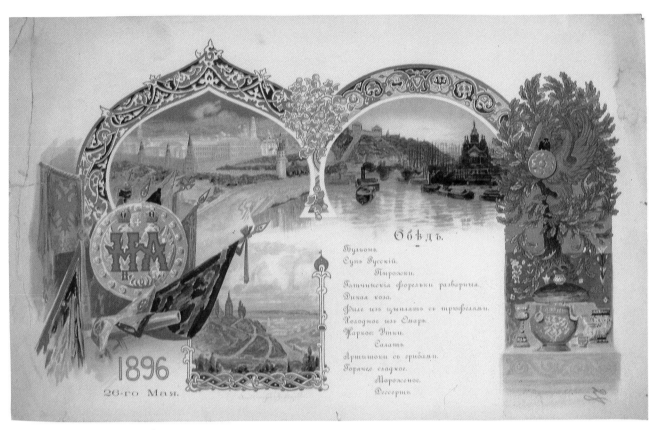

466

468

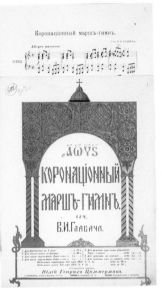

472

467 Kerchief with a Picture of Emperor Nicholas II and
Empress Alexandra Feodorovna, 1896

Cotton
75 × 76 cm
ГА РФ. Ф.601. Оп.1. Д.2252. Л.1

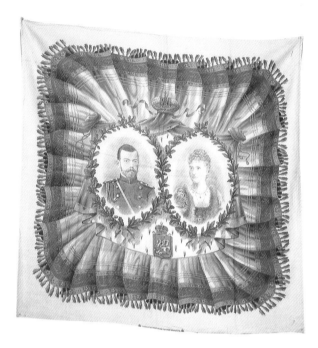

The kerchief was specially made by the Prokhorovskaya
Manufactory in Moscow for the coronation celebrations. Such
kerchiefs were used to wrap up presents which were distributed
to the crowd on Khodynka Field.

*Every visitor to the field stalls will receive a kerchief containing
sweets, gingerbread, sausage, an enamel mug, and a programme of
the festivities. They will also be given a bread roll, a pound in weight.
Special stalls will be set up around the edge of the field for dispensing
beer and mead.*
(From the imperial decree concerning the public holiday on
Khodynka Field, 18 May 1896. ГА РФ. Ф.601. Оп.1. Д.140. Л.1.)

468 Coronation Hymn, 1896

Composed by V. I. Glavach, director of the orchestra of the imperial yacht *Standart*
Musical score (typographic copy)
Red cloth cover with gold stamping
26 × 34 cm; open 52 × 34 cm
ГА РФ. Ф.601. Оп.1. Д.135. Л.1–8

469 Victims of the Khodynka Catastrophe, 18 May 1896

Stereoscopic photograph by F. Kratky Kolin
Inscribed on the side of the mount: *Déposé atelier F. Kratky Kolin*
Mounted photograph: 16.5 × 7.5 cm; 17.5 × 9 cm
ГА РФ. Ф.102. Д.3. 1895. Д.1422. Т.6. Л.146

On 18 May 1896 a large public festival in honour of Nicholas II's
coronation was planned on Khodynka Field. Temporary theatres
and sideshows were constructed around the field, as well as 150
stalls for distributing presents and 20 booths with free wine and
beer. From the previous evening an excited crowd had started
to gather on Khodynka Field, and at 5 o'clock in the morning,
without waiting for the festival to be officially opened, a mass
of people overran the inadequate guard presence and surged
towards the pavilions. The resulting crush was catastrophic:
according to official figures, 1,389 people were killed and a further
1,300 badly injured.

In spite of this tragedy, Nicholas II and Alexandra Feodorovna
arrived at Khodynka Field at 1 o'clock in the afternoon, in the
face of pleas from Grand Duke Alexander Mikhailovich (husband
of the tsar's sister, Xenia) and his brothers that the coronation
celebrations be cancelled. The emperor, however, influenced by
his uncles, grand dukes Sergei and Alexei, not only ordered that
the festivities should continue but that very same evening
attended a ball given by the French ambassador, thereby
provoking general censure.

*Up until now, thank God, everything has gone perfectly, but today a
great sin has taken place. A crowd spent the night on Khodynka
Field waiting for the moment when food and mugs would start to be
distributed. They were pressed against the barriers and the most
terrifying crush ensued, during which, it is terrible to record, around
1,300 people were trampled to death!! ... This news has left the most
abominable impression. At 12.30 we had lunch and then Alix and I
set off for Khodynka to attend this melancholy 'popular celebration'.
There was nothing much to see; from the pavilion we looked out onto
the huge crowd surrounding the platform where they kept playing the
national anthem and 'Glory to God' ... At 8 o'clock we dined with
Mama and then went to Montebello's ball. It was very beautifully
done, but the heat was unbearable.*
(Nicholas's Diary, 18 May 1896. ГА РФ. Ф.601. Оп.1. Д.236.
Л.14–15.)

Grand Duke Alexander Mikhailovich recalled how his brother
Nikolai attempted to explain to the emperor the full horror of
what had happened:

*He tried to evoke the image of the French kings dancing in the Park
of Versailles, ignoring all warnings of the approaching storm. He
appealed to the good nature of the young emperor: 'Remember,
Nicky,' he concluded, looking him straight in the eyes, 'the blood of
those five thousand men, women and children will leave an indelible
stain on your reign. Of course you cannot bring the dead back to life,
but you can show your concern for their families ... You must not give
your enemies cause to say that the young tsar danced while his dead
subjects were being taken to the mortuary.' That night Nicky attended
a grand ball given by the French ambassador. The radiant smile on
the face of Grand Duke Sergei led the foreigners present to conclude
that the Romanovs had completely lost their minds. The four of us left
at the beginning of the dancing — a serious breach of etiquette which
drew from Uncle Alexei the malicious comment: 'There go the four
imperial followers of Robespierre!'*
(Grand Duke Alexander Mikhailovich, 1991, p. 143.)

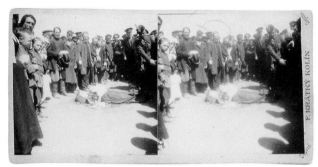

469

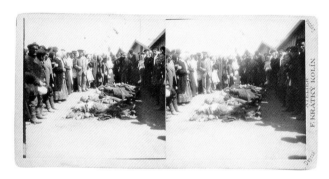

471

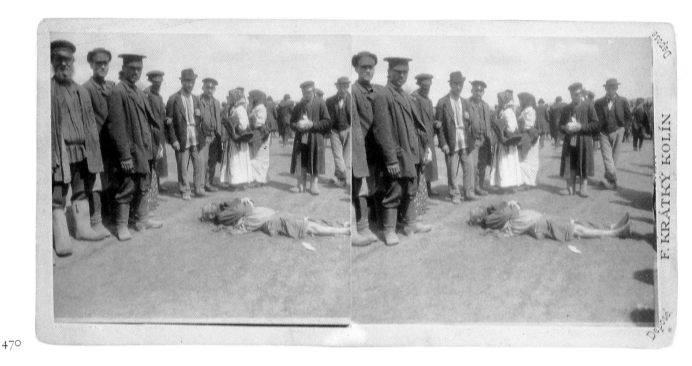

470

470 Victims of the Khodynka Catastrophe, 18 May 1896

Stereoscopic photograph by F. Kratky Kolin
Inscribed on the side of the mount: *Déposé atelier F. Kratky Kolin*
Mounted photograph: 16.5 × 7.5 cm; 17.5 × 9 cm
ГА РФ. Ф.102. Д.3. 1895. Д.1422. Т.6. Л.14в

*18 May. A nightmarish day! From yesterday evening a whole mass
of people started to converge on Khodynka from all sides for today's
popular celebration, and early this morning the entire crowd rushed
towards the place where they were handing out gifts. The most
appalling crush ensued from the sheer pressure of numbers, and a
great number of people, including of course children, were trampled
to death.*
(Diary of Grand Duchess Xenia Alexandrovna, 18 May 1896.
ГА РФ. Ф.662. Оп. 1. Д.9. Л.19 об.)

Olga, Nicholas's other sister, recalled how as the magnificent
imperial procession approached Khodynka they passed the dead
bodies being taken away:

*My blood froze. I felt sick. Those wagons were carrying away the
dead, disfigured beyond all recognition.*
(Recollections of Grand Duchess Olga Alexandrovna;
from Vorres, 1985, p. 78.)

471 Victims of the Khodynka Catastrophe, 18 May 1896

Stereoscopic photograph by F. Kratky Kolin
Inscribed on the side of the mount: *Déposé atelier F. Kratky Kolin*
Mounted photograph: 16.5 × 7.5 cm; 17.5 × 9 cm
ГА РФ. Ф.102. Д.3. 1895. Д.1422. Т.6. Л.14г

472 Address from the Belgian Colony in St. Petersburg to
Nicholas II on the occasion of his Coronation in 1896 (p. 285)

The address is presented in a glass-topped wooden case, lined in white velvet, with a
white moiré silk ribbon; its binding is of grey velvet with moiré end-papers. The front
cover of the address is decorated with coloured enamel on a silver plate, and bears
Nicholas II's monogram in silver and gilt with blue enamel. The back cover is
decorated with silver-gilt crowns in each corner. The crown over the monogram is
missing.
Case: 40.3 × 53.7 × 5.5 cm
Address: 31.8 × 45.5 × 1.5 cm
ГА РФ. Ф.601. Оп.1. Д.131. Л.1–10

Family Life

473

474

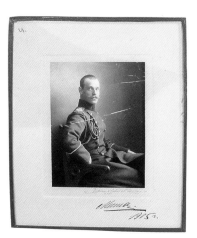

477

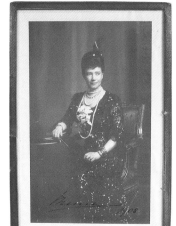

478

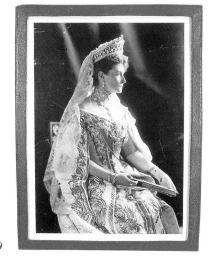

479

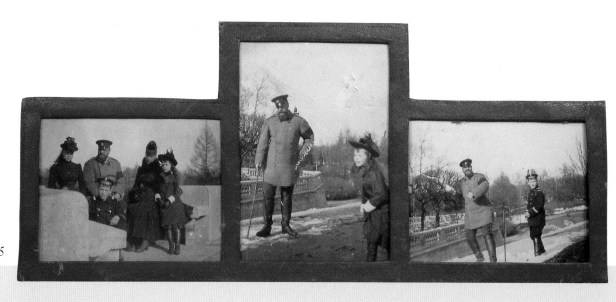

475

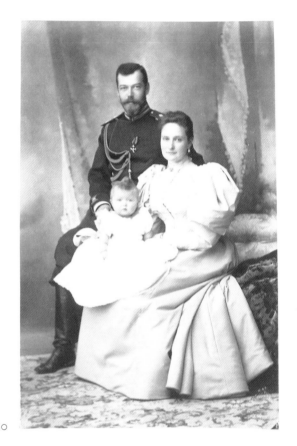

480

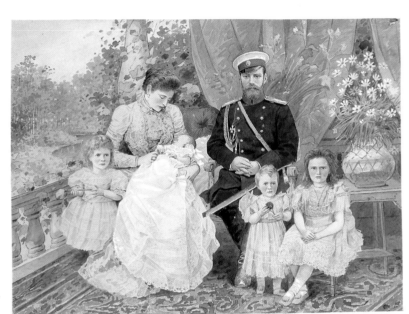

481

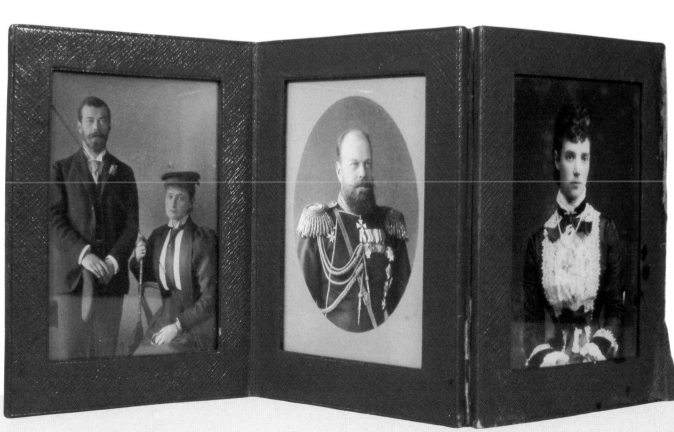

476

473 Portrait of Tsarevich Alexander Alexandrovich, Late 1870s

Unknown photographer
Red leather frame with mount; photograph under glass
Photograph: 15.5 × 24.5 cm
Frame: 17.5 × 24.5 cm
ГА РФ. Ф.643. Оп.1. Д.139. Л.1 (from the private collection of
Grand Duchess Olga Alexandrovna).

474 Portrait of Emperor Alexander III, Late 1880s

Unknown photographer
Red leather frame with mount; reverse side in moiré silk; photograph under glass
Photograph: 8 × 10 cm
Frame: 13 × 16 cm
ГА РФ. Ф.643. Оп.1. Д.139. Л.2 (from the private collection of
Grand Duchess Olga Alexandrovna).

475 Emperor Alexander III with Empress Maria Feodorovna
and their Children, 1891

Unknown photographer
Left: Empress Maria Feodorovna, Emperor Alexander III with Grand Duchesses
Xenia and Olga, and Grand Duke Mikhail
Centre: Emperor Alexander III with Grand Duchess Olga
Right: Emperor Alexander III with Grand Duke Mikhail
Red leather frame
Each photograph: 7 × 10 cm
Frame: 12.5 × 29 cm
ГА РФ. Ф.643. Оп.1. Д.140. Л.1 (from the private collection of
Grand Duchess Olga Alexandrovna).

476 Portraits of Members of the Royal Family

Unknown photographer(s)
Left: Tsarevich Nikolai Alexandrovich and his fiancée Princess Alice of Hesse [1894]
Centre: Emperor Alexander III [late 1880s]
Right: Empress Maria Feodorovna [late 1880s]
Folding red leather frame; photographs under glass (the fourth photograph is missing)
Each photograph: 9.5 × 13 cm
Frame: 17 × 40 cm
ГА РФ. Ф.643. Оп.1. Д.141. Л.1–3 (from the private collection of
Grand Duchess Olga Alexandrovna).

477 Portrait of Grand Duke Mikhail Alexandrovich, 1905

Unknown photographer from the Boissonas and Eggler photographic studio
Red leather frame with mount; photograph under glass
Signed and dated by the grand duke on the mount: Миша. [Misha] 1905
Trade-mark of the photographic studio: Boissonnas et Eggler St. Petersbourg
Mounted photograph: 9.5 × 12.5 cm; 17.5 × 20.5 cm
ГА РФ. Ф.643. Оп.1. Д.141. Л.4 (from the private collection of
Grand Duchess Olga Alexandrovna).

478 Portrait of Empress Maria Feodorovna, 1908

Unknown photographer
Red leather frame with mount; photograph under glass
Inscribed by Grand Duchess Olga Alexandrovna at bottom of the photograph:
Мама. [Mama] 1908
Mounted photograph: 17.5 × 28 cm; 23.5 × 34 cm
ГА РФ. Ф.643. Оп.1. Д.142. Л.1 (from the private collection of
Grand Duchess Olga Alexandrovna).

479 Portrait of Empress Alexandra Feodorovna in the Costume
of a Russian Tsarina, 1907

Unknown photographer
Red leather frame with mount; photograph under glass
Signed by Alexandra Feodorovna at the bottom of the mount: Alix. 1907
Mounted photograph: 14.5 × 20 cm; 18 × 23.5 cm
ГА РФ. Ф.643. Оп.1. Д.145. Л.1 (from the private collection of
Grand Duchess Olga Alexandrovna).

480 Portrait of Emperor Nicholas II with Empress
Alexandra Feodorovna and their Daughter
Grand Duchess Olga Nikolaevna, 3 May 1896

Photograph by S. L. Levitsky
On the reverse side: the stamp of the office of Empress Alexandra Feodorovna; the
date inscribed in black ink: 3 мая 1896 г.; and the trade-mark of the photographic
studio.
10 × 16 cm
ГА РФ. Ф.640. Оп.3. Д.13. No. 52

*3 November. A day I will remember for ever, during which I suffered
a very great deal! At about 2 o'clock Mama arrived from Gatchina.
She, Ella and I did not leave Alix's side the entire time. At 9 o'clock
precisely we heard a baby's cry and we all breathed a sigh of relief!
God has sent us a daughter whom, with a prayer, we have named
Olga! When all the concern was over and the terrors had ceased, we
entered a simply blissful state of happiness at the thought of what
had happened.*
(Nicholas's Diary, 3 November 1895. Ф.601. Оп.1. Д.235. С.45–46.)

*3 November. The birth of a daughter (Olga) to Nicky and Alix!
Great joy, though it is a shame it's not a son! The labour already
started last night. At 10 o'clock we went to Tsarskoe. Poor Nicky and
Mama met us looking completely worn out and exhausted! The baby
is enormous, weighing ten pounds, and had to be pulled out with
forceps! It must have been a terrible thing to witness, but thank God
everything ended well.*
(Diary of Grand Duchess Xenia Alexandrovna, 3 November
1895. Ф.662. Оп.1. Д.8. Л.201–202.)

481 Emperor Nicholas II and Empress Alexandra Feodorovna
with the Four Grand Duchesses, 1901

Unknown artist
Popular print
25.5 × 18.5 cm
ГА РФ. Ф.601. Оп.1. Д.2163. Л.10

Nicholas and Alexandra loved each other passionately, and there
was only one shadow over their family life — the birth of one
daughter after another, while they and the whole country longed
for an heir.

In 1895 Olga was born, then in 1897 Tatiana. The tsar told Grand
Duke Konstantin Konstantinovich that they had named their
daughters Olga and Tatiana 'like in Pushkin's Evgeny Onegin'
(ГА РФ. Ф.660. Оп.1. Д.50. Л.67). Maria was born in 1899 followed
by Anastasia in 1901. It is hard to describe the general
disappointment that followed the birth of the fourth daughter,
Anastasia. Grand Duke Konstantin Konstantinovich wrote in his
diary on 6 June 1901: 'Lord, instead of joy everyone felt
disappointment, we had so wanted a son — instead of which it's a
fourth daughter.' (ГА РФ. Ф.660. Оп.1. Д.48. Л.86.)

482 Letter from Empress Alexandra to Emperor Nicholas II,
27 August 1901

In English
13.5 × 21 cm

My own precious One,
I want you to find these lines when we are separated so as that you may
feel Wify is near to you. My thoughts and earnest prayers will follow you
all the time. Mr P[hilippe]'s too I know and that is one comfort to me,
as otherwise our parting would be too awful.
The idea of having to part makes me wretched, but God grant we shall
soon be together again – your sweet kisses – how I shall yearn for them.
We have been so lucky that we are always together, only it makes every
separation harder to bear.
Don't forget Saturday evening towards 10.30 – all our thoughts will fly to
Lyons then. How rich life is since we know him and everything seems easier
to bear.

ГА РФ. Ф.601. Оп.1. Д.1148. Л.22–23 об.

A month after the birth of their fourth daughter, Anastasia, on 5
June 1901, the imperial couple began to meet regularly with a
certain Monsieur Philippe. His real name was Philippe Nizier-
Vachot, a Frenchman from Lyons, who had a reputation as a
hypnotist and was apparently able to cure nervous diseases. In
France, Philippe had been prosecuted for practising as a doctor
without a diploma and was considered a charlatan. He managed
to persuade the empress that if she followed his instructions she
would give birth to a son.

In the summer of 1902 the thirty-year-old empress, the mother of
four daughters, became convinced that as a result of Philippe's
predictions she was pregnant. This soon became common
knowledge, and everyone awaited the birth of an heir — most
fervently of all Alexandra Feodorovna herself. But there was to
be no miracle.

I don't remember whether I have already noted this in the diary, but
since 8 August we have been waiting every day for confirmation of the
empress's pregnancy. And now suddenly we are told that she is not
pregnant, that there never was a pregnancy, and that the symptoms
that seemed to suggest it resulted from nothing more than anaemia!
What a disappointment for the tsar and tsarina! The poor things!
Alix sent word of the sad discovery to Mama and my wife. Alix was
very tearful when Ott and Hunst [the doctors] diagnosed that not only
was there no pregnancy, but there never had been. There is a lot of
gossip going around the family. All summer talk has been of their
highnesses' increasing closeness to Militsa. It is said that they make
frequent — almost daily — visits to Znamenka and stay late into the
evening, and that at the same time the empress has apparently
avoided seeing the dowager-empress on the pretext of exhaustion.
It is also said that at Militsa's their highnesses have met a certain
Filippov [sic], who is not exactly a doctor or scientist, but inoculates
against or claims to cure certain diseases including syphilis.
It is suggested — on what grounds I do not know — that this
Filippov has been influencing the empress in her attempt to produce
a son rather than a daughter. Sergei Mikhailovich told me that
politically unfavourable reports about Filippov were received from
our main secret-police agent in Paris, and that the tsar ordered the
dismissal of this agent within 24 hours, which left the whole of the
Okhrana [secret police] in a most difficult position, the agent
apparently being in possession of all information relating to
political criminals.

(Diary of Grand Duke Konstantin Konstantinovich, 20 August
1902. ГА РФ. Ф.660. Оп.1. Д.50. Л.134.)

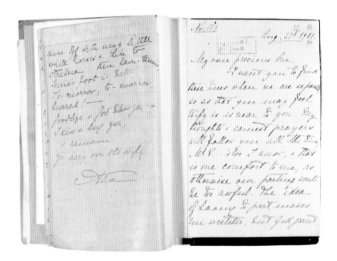

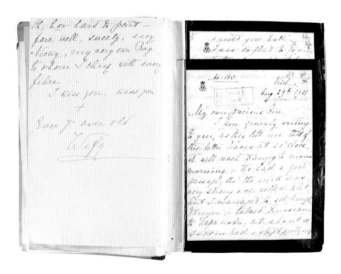

483 Portrait of Emperor Nicholas II and Empress Alexandra Feodorovna in Costumes of the Russian Tsars of the 17th Century, January 1903

Photographer from the photographic studio of Levitsky and Co.
Stamped on the mount: Левицкий. С. Петербург [Levitsky. St. Petersburg]

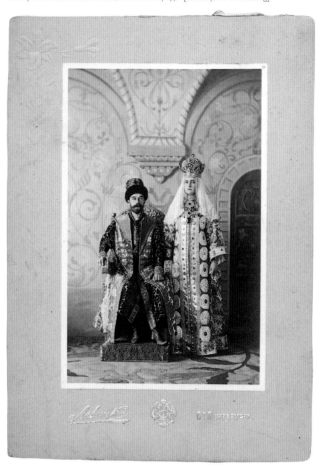

Mounted photograph: 13 × 19.5 cm; 19 × 26 cm
ГА РФ. Ф.640. Оп.1. Д.366. Л.20

We all turned out in court dress of the seventeenth century. Nicky was dressed as Alexei, second tsar of the Romanov dynasty, in a crimson costume with gold and silver, with a few extra things brought especially from the Kremlin. Alix was superb. She came as Tsarina Maria Miloslavskaya, first wife of Alexei. She wore a sarafan [robe] of gold brocade embroidered with emeralds and silver thread [see no. 372]; her earrings were so heavy that she was unable to bend her head. (Recollections of Grand Duchess Olga Alexandrovna; from Vorres, 1985, p. 102.)

484 Diary of Emperor Nicholas II for 1903: Entries for 17–19 July

Exercise book in black leather cover
22.5 × 38.5 cm

After Empress Alexandra Feodorovna's false pregnancy in 1902, Monsieur Philippe told her that if she sought the intercession of Saint Seraphim of Sarov she would give birth to a son. The Orthodox Church knew of no such saint, but it transpired that there had once been a monk at the monastery at Sarov who had

been able to perform miracles. The emperor demanded that the Holy Synod canonize Seraphim. When the chief procurator of the Synod, Pobedonostsev, objected that a canonization could not simply be ordered at the whim of the emperor, Alexandra Feodorovna replied: 'The emperor can do anything.' Seraphim was consequently canonized, and the imperial family journeyed

to Sarov to pray to the holy relics of Seraphim in the hope of a miracle.

17 July, Sarov. At six o'clock we arrived at the Sarov monastery. There was a very special feeling on entering the cathedral of the Assumption and then the church of St. Zosima and St. Savvaty, where we prayed to the relics of the holy father Seraphim.

18 July, Sarov. At 6.30 the night service began. During the procession, while the relics of St. Zosima and St. Savvaty were taken out of the church, we carried the coffin on a litter. It was very moving watching how the crowd, especially the infirm, the cripples and the unfortunate, reacted to the procession. The moment of the glorification and then the honouring of the relics was particularly impressive. After that we left the cathedral, having attended three hours of the service.

19 July, Sarov. We got up at 7.30 and went to Mama's and then to a service which lasted, together with prayers, from 9.00 until 12.30. It was just as affecting as yesterday; there was a procession with the coffin, this time with the relics visible. One felt enormously inspired, both from the solemn event and from the extraordinary mood of the crowd. We had a bite with Mama and at 2.30 lunched in the refectory. We rested for about an hour. The heat was intense, as was the dust from the huge number of pilgrims. At 4.30 we set off for the pavilion of the Tambov nobility where we were entertained to tea. At 7.30 we dined with Mama. Then we went in twos and threes down to the source where, with genuine emotion, we bathed in freezing water. We got back safely; nobody recognised us in the darkness.

We have heard of many people being cured today and yesterday. Another cure took place in the cathedral while the holy relics were being carried around the altar. Truly God works miracles through his saints. Great is His ineffable mercy towards dear Russia; this manifestation of the Lord's grace towards us all brings inexpressible comfort. In you we put our trust, Lord; we shall never be confounded. For ever and ever. Amen!

ГА РФ. Ф.601. Оп.1. Д. 246. Л.1–198 (42–43)

485 Manifesto of Emperor Nicholas II on the occasion of the
Birth of the Heir, Alexei Nikolaevich, 30 July 1904

Typographic text
Green folder with the imperial coat of arms stamped in gold
22 × 34 cm; open 44 × 34 cm
ГА РФ. Ф.601. Оп.1. Д.2136. Л.1

486 Letter from Kaiser Wilhelm II of Germany to
Emperor Nicholas II, 16 [29] August 1904

In English
Wilhelm's gold crown stamped at the top of white paper with the inscription:
Schloss Wilhelmshöhe
11.5 × 18.5 cm; spread: 23 × 18.5

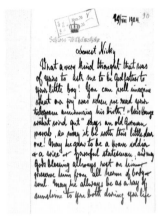

*It happened during the war with Japan. The entire nation was
deeply dispirited by the losses in Manchuria, and yet I remember
the rejoicing among the people when this news was announced.
My sister-in-law never gave up the hope that she would give birth to a
son, and I am convinced that it was Seraphim who brought it about.*
(Recollections of Grand Duchess Olga Alexandrovna; from
Vorres, 1985, p. 122.)

At last the long-awaited heir was born. But very soon the joy
was overshadowed by the first signs of a terrible disease —
haemophilia.

*Friday 30 July. An unforgettable and great day for us, during which
we were clearly visited by the mercy of God. At 1.15 in the afternoon
Alix gave birth to a son, whom we named Alexei as we prayed.
Everything happened wonderfully fast — at least for me. In the
morning I visited Mama as usual, and then I received a report
from Kokovtsev and artillery officer Klepikov, who was wounded
at Vafangoi. I went on to have lunch with Alix who was already
upstairs, and half an hour later the happy event occurred. I have
not the words adequately to thank God for this comfort He has sent
us in this time of sore trials!* (Л.156–157.)

*Wednesday 8 September. At 11 o'clock I went to church with the
children, and then lunched alone. Alix and I were very concerned
about little Alexei's bleeding from his navel, which lasted
intermittently until evening! We had to send for Korovin and the
surgeon Feodorov; at about 7 o'clock they applied a bandage. The
little boy was remarkably calm and happy! How hard it is to endure
such moments of anxiety!*

*Thursday 9 September. Found blood on the bandage again this
morning; from 12.00 until evening there was nothing. The little one
was calm all day, hardly cried at all, and his healthy appearance
reassured us!*
(Nicholas's Diary for 1904. ГА РФ. Ф.601. Оп.1. Д.247. Л.186–187.)

Dearest Nicky,

*What a very kind thought that was of yours to ask me to be Godfather
to your little boy! You can well imagine what our joy was when we read
your telegram announcing his birth! 'Was lange währt, wird endlich gut'
[A long wait brings good results] says an old German proverb, so may it
be with this little dear one! May he grow to be a brave soldier and a wise
and powerful statesman; and may God's blessing always rest on him and
preserve him from all harm of body and soul. May he always be as a ray
of sunshine to you both during your life, as he is now in the time of trial!
Henry is the bearer of these lines and of my sincerest and heartfelt wishes
for you, Alix and the Boy! Accompanied by the gift of a Goblet for my little
Godchild, which he will, I hope, begin to use, when he will think, that a
man's thirst cannot be quenched by milk only! Perhaps he may then find
out for himself one day, that 'Ein gut Glas Branntwein soll Mitternacht nicht
schädlich sein' [A good shot of vodka does no harm at midnight], is not
only 'truism', but that often 'Im Wein ist Wahrheit nur allein' [In vino
veritas] as the butler sings in Undina, to be wound up by the classical
words of our great reformer Dr Martin Luther: 'Wer nicht liebt Wein, Weib
und Gesang, der bleibt ein Narr sein Leben lang' [He who does not love
wine, women and song will remain a fool all his life]. These would be
the maxims I would try to see my Godchild educated up to! There is great
sense in them and nothing can be said against them!*

ГА РФ. Ф.601. Оп.1. Д.1199. Л.90–91 об.

487 Portrait of Kaiser Wilhelm II of Germany, 11 August 1897

Photograph by F. C. Schaarwächter
Inscribed at the bottom of the photograph: *C. Schaarwächter Königl. Hof-Photograph. Berlin. W. Leipzigen. 130*; and the word: *PhotoCrayon*
Signed and dated by Kaiser Wilhelm in pencil on the bottom of the mount: *Peterhof. Wilhelm. 11/VIII-97*
Mounted photograph: 14.5 × 22 cm; 24 × 33 cm
ГА РФ. Ф.640. Оп.1. Д.432. Л.1

Close dynastic ties had long existed between the Russian imperial family and the ruling houses of Germany, and Germany was the chief source of brides for the Russian tsars and grand dukes. Thus Nicholas was by no means breaking with family tradition when he fell in love with Princess Alice of Hesse, the cousin of Kaiser Wilhelm. Both Wilhelm and Alix were grandchildren of Queen Victoria, their mothers being the English queen's two eldest daughters, Princess Victoria and Princess Alice. But whereas Alix looked up to her grandmother all her life, Wilhelm disliked intensely his English relations and in his inimitable way made no secret of his hatred of all things English. This possibly explains why Alix disliked her German cousin from childhood, but there is another reason for the coolness that existed between them, one with romantic overtones: at the beginning of the 1880s Wilhelm, then a student in Bonn, fell in love with Alix's elder sister Ella — considered by general consent the most beautiful princess in Europe at the time. But Wilhelm's behaviour and style of courtship so shocked the austere family of Grand Duke Ludwig that Ella rejected his offer of marriage. Emperor Alexander III regarded Wilhelm as a badly educated, foolish young man and treated him with disdain until the day he died. Such family antipathy could not help but be reflected in Nicholas's own feelings towards Wilhelm. The kaiser's boastful and bombastic manner, his over-familiarity, and his constant insistence on his own greater experience and seniority, annoyed Nicholas intensely.

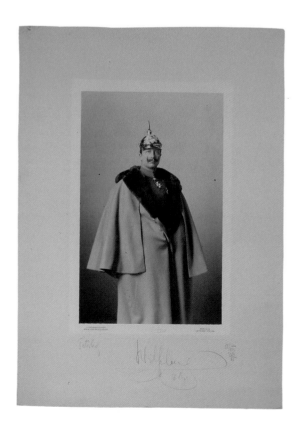

488 Portrait of Grand Duke Sergei Alexandrovich, 1894

Photograph by V. Lapre
Stamped on the mount: *В. Лапре. Царское Село* [V. Lapre, Tsarskoe Selo]
Trademark of the photographic studio on the back of the photograph
Signed by Grand Duke Sergei Alexandrovich in the lower left-hand corner of the photograph: *Serge. 1894*
Mounted photograph: 16.5 × 22 cm; 17 × 24.6 cm

ГА РФ. Ф.642. Оп.1. Д.3453. Л.10

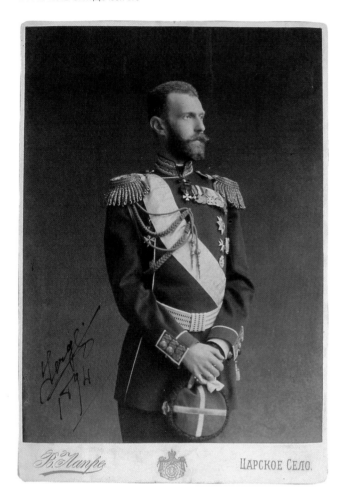

4 February, St. Petersburg. Poor Uncle Sergei was killed in Moscow this afternoon! It is simply terrible, terrible — awful, sad and shameful. He was riding out in his carriage when some swine threw a bomb and he was killed instantly — blown to pieces! No, it is simply not possible! Poor Ella, how desperately sorry I am for her, what unimaginable grief, and there all on her own. I so want to go to her, be there with her, the poor thing, at this terrible time. At 5.30 we went to Tsarskoe and found everyone gathered. Alix of course wants to go, Mama too, but they have been dissuaded — it's just too great a risk, although it seems awful to leave poor Ella quite alone; it's too unbearable to contemplate!
(Diary of Grand Duchess Xenia Alexandrovna for 1905. ГА РФ. Ф.662. Оп.1. Д.23. Л.87–89 об.)

It was nearing the end of a beautiful winter's day, everything was quiet, the city bustle was muffled by the snow. Suddenly we heard a terrible explosion which rattled the windows. The silence that followed was so oppressive that for several seconds we could not move or even look at each other. Fräulein Hase was the first to react. She rushed to the window; I followed ... 'Quick, quick!' — my mind was racing.

Maybe one of the old Kremlin towers had collapsed? ... Dmitry came running from his study. We looked at each other, not daring to utter a word. A flock of crows, frightened by the explosion, frantically circled the bell-tower before disappearing. The square started to show signs of life; everyone was running in the same direction. Now the square was almost filled with people. My aunt ran out of the house, a cloak thrown over her shoulders ... She rushed to where the body was lying in the snow. She gathered fragments of dismembered flesh and placed them on an ordinary army stretcher which had been hurriedly fetched from a nearby workshop. Soldiers from the barracks opposite covered the body with their greatcoats; then, lifting the stretcher onto their shoulders, they carried the corpse to the Chudov monastery and took it into the church, next door to the palace entrance where we were staying. It was only after all this had been done that we were fetched. We went down to the first floor, along a narrow corridor and through an inside door to the monastery. The church was filled to bursting; everyone was kneeling, many were in tears. The stretcher had been placed beneath the altar steps on the stones. It evidently could not have contained very much because the greatcoats were only covering a very small pile. Out of one end a boot was visible. Drops of blood were dripping onto the floor, slowly forming into a small dark stain. My aunt was kneeling by the stretcher. Her bright dress looked out of place against the modest garments surrounding her. I did not dare look at her. Her face was white, her expression one of extraordinary, utterly striking, immobility. She was not weeping, but the look in her eyes made an impression on me that I will never in my life forget. Leaning on the arm of the governor, my aunt slowly moved towards the door; noticing us, she stretched out her arms to us, and we ran to her. 'He loved you so much, he loved you,' she kept repeating, pressing our heads against her. I noticed some drops of blood on the right sleeve of her elegant blue dress. She had blood on her hand as well, even under the nails of her fingers, in which she gripped tightly the medals that my uncle always wore on a chain around his neck.

(Grand Duchess Maria Pavlovna (the younger), 1930, pp. 67, 68, 69 ,70.)

489 I. P. Kalyaev, February, 1905

Photograph of the Moscow Secret Police Department
Two photographs, mounted: full-face and profile. Inscribed under the photographs: Цирк[уляр] Д[епартамента] пол[иции] 1905 г. No. 2000 Иван Каляев. Виновник взрыва 4 февраля [Police department circular. 1905, no. 2000 Ivan Kalyaev. Accused of the 4 February explosion].
Mounted photograph: 8.4 × 12.2 cm; 10.5 × 12.8 cm
ГА РФ. Ф.1742. Оп.1. Д.14500. Л.17

Ivan Platonovich Kalyaev (1877–1905), a member of the Socialist Revolutionary party, assassinated Grand Duke Sergei Alexandrovich in Moscow on 4 February 1905. He was executed in the Shlisselburg fortress on 10 May 1905. The photograph was taken immediately after his arrest in Moscow by the secret police department. A few days later he was visited in prison by Grand Duchess Elizaveta Feodorovna, the widow of his victim. Kalyaev described their meeting in a letter to his comrades, written from prison:

We looked at one another with, I have to admit, a certain mystical feeling, like two people who have been condemned to death and then spared: I — by chance, she — by the will of the organisation, by my will, since both I and the organisation were determined to avoid unnecessary bloodshed. And looking at the grand duchess, I could not help seeing on her face a kind of gratitude — if not towards me, then at least to fate which had spared her life. 'I beg you, take this icon in memory of me. I will pray for you.' I took the icon. To me this was a symbol of her acknowledgement that I had won, a symbol of her gratitude to fate for preserving her life, and the penitence of her conscience for the crimes of the grand duke. 'My conscience is clear,' I repeated. 'I am very sorry that I have caused you this grief, but I have fulfilled my duty, which I will carry through to the end; I will endure everything that lies ahead. Goodbye; you and I will not see each other again.'
(Savinkov, 1990, p. 99.)

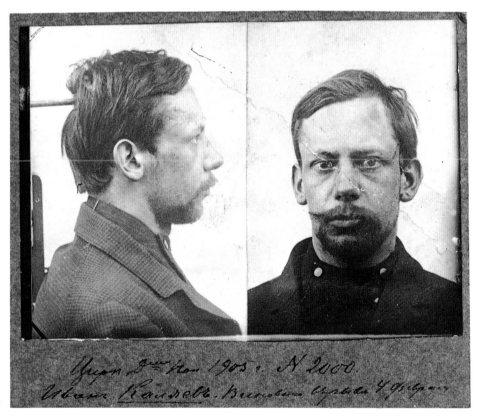

489

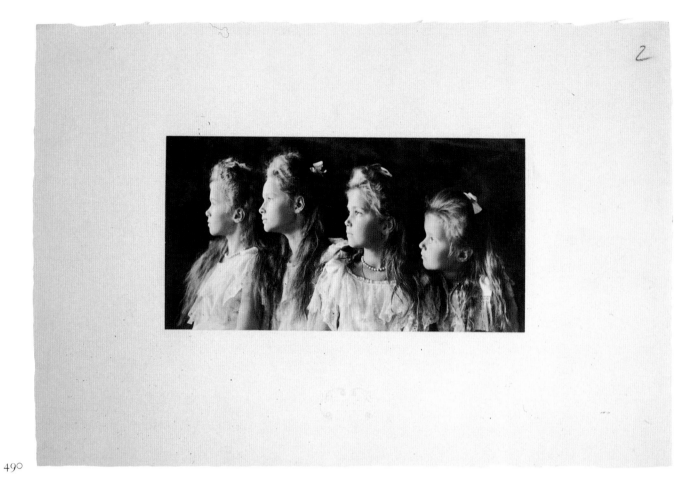

490

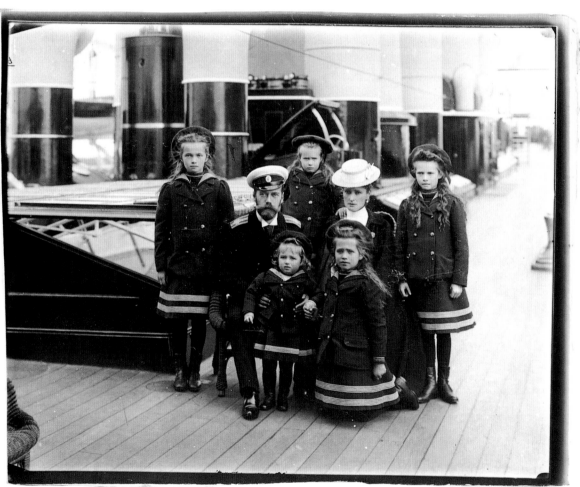

491

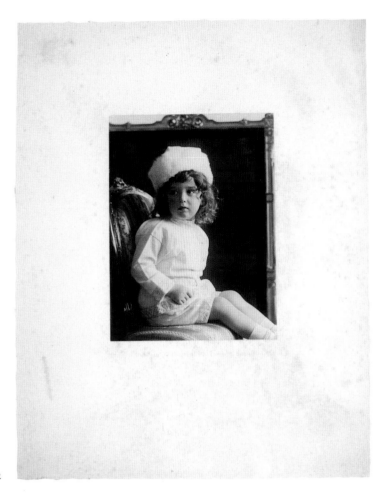

492

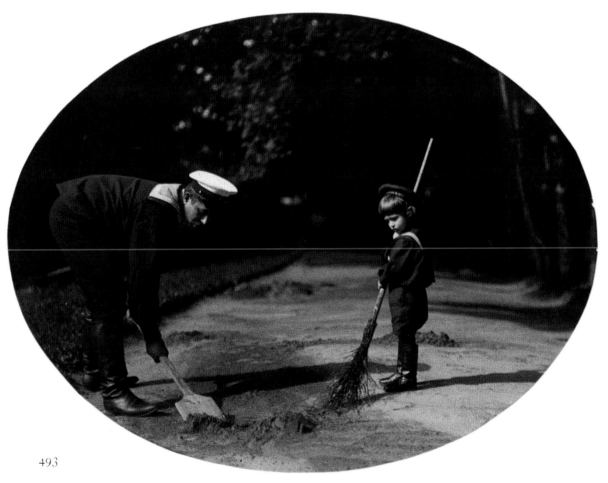

493

490 Portrait of Grand Duchesses Olga, Tatiana, Maria and Anastasia, 1906

Photographer from the Boissonas and Eggler photographic studio
Stamped at the bottom of the mount: *Boissonas et Eggler*
Trade-mark of the photographic studio on the reverse
Mounted photograph: 18.5 × 9.5 cm; 32.5 × 22.5 cm
ГА РФ. Ф.640. Оп.1. Д.385. Л.1

Our apartments at Tsarskoe Selo were in the Great Palace of Catherine II. The young empress would have us come often to the Alexander Palace to play with her daughters, of whom at the time there were but two. Their nursery apartments occupied an entire wing on the second floor of the Alexander Palace. These rooms, light and spacious, were hung with flowered cretonne and furnished throughout with polished lemonwood... The emperor's daughters were governed as we were, by an English head nurse assisted by innumerable Russian nurses and chambermaids, and their nursery staff was uniformed as ours was, all in white, with small nurse-caps of white tulle. With this exception: two of their Russian nurses were peasants and wore the magnificent native peasant costumes. Dmitry and I spent hours examing our young cousins' toys; one could never tire of them, they were so fine. Especially enchanting to me was the French President's gift to Olga at the time when she was taken with her parents on their first visit to France. In a trunk covered with soft leather was a doll with a complete trousseau: dresses, lingerie, hats, slippers, the entire equipment of a dressing-table, all reproduced with remarkable art and fidelity.
(Grand Duchess Maria Pavlovna (the younger), 1930, p. 34.)

491 Emperor Nicholas II and Empress Alexandra Feodorovna with their Children on Board the Yacht *Standart*, 1907

Unknown photographer
Mounted photograph: 30 × 25 cm; 30.5 × 25.5 cm
ГА РФ. Ф.640. Оп.1. Д.371. Л.30

The emperor particularly loved the yacht Standart. *Built in Denmark, she was considered the best ship of her kind in the world, a vessel of 4,500 tons' displacement. Painted black, with gold ornaments at the bow and stern, the* Standart *had great seafaring qualities and was extremely comfortably appointed ... As soon as the imperial party boarded the yacht, each of the children would be assigned a special 'uncle', that is a sailor responsible for the personal safety of that child. The children had great fun with these sailors, playing all sorts of tricks on them and teasing them ... The younger officers of the* Standart *gradually joined in the grand duchesses' games. As they grew up, these games imperceptibly turned into a series of flirtations which were of course completely innocent. I do not employ the word 'flirtation' in the vulgar sense it is given nowadays: the officers of the* Standart *were more like pages or medieval knights ... Even the empress became more sociable and carefree the moment she stepped onto the deck of the* Standart. *She joined in the children's games and had long conversations with the officers.*
(Mosolov, 1993, pp. 173–4.)

492 Grand Duke Alexei Nikolaevich, 1907

Photographer from the Boissonas and Eggler photographic studio
Stamped at the bottom of the mount: *Boissonas et Eggler*
Trade-mark of the photographic studio on the reverse
Mounted photograph: 9.5 × 12.5 cm; 21 × 26 cm
ГА РФ. Ф.640. Оп.1. Д.382. Л.8

Even in our house a certain melancholy reigned. My uncle and aunt undoubtedly knew already that the child was born suffering and that from his birth he carried in him the seeds of an incurable illness, haemophilia — a tendency to bleed easily, an inability of the blood to clot quickly. There is no doubt that the parents were quickly advised as to the nature of their son's illness. Nobody ever knew what emotions were aroused in them by this horrible certainty, but from that moment, troubled and apprehensive, the empress's character underwent a change, and her health, physical as well as moral, altered.
(Grand Duchess Maria Pavlovna (the younger), 1930, p. 61.)

493 Tsarevich Alexei Nikolaevich and the Boatswain A. E. Derevenko, 1907

Photograph by court photographer Alexander Karlovich Yagelsky
C. E. von Hahn photographic studio
Stamped in the lower left corner of the mount: *C.E. Hahn and Co. Tzarskoe Selo*
Mounted photograph: 16.5 × 12.5 cm; 32.5 × 24 cm
ГА РФ. Ф.640. Оп.1. Д.382. Л.13

At three years old Tsarevich Alexei fell while playing in the park and received a wound that started to bleed. The court doctor was called; he tried every known medical means to stop the flow of blood but without success. The tsarina fainted. She did not have to hear the opinions of the specialists to realise the significance of this bleeding: it was haemophilia, the terrible inherited disease which had afflicted male members of her family for the last three hundred years. The healthy blood of the Romanovs could not withstand this tainted blood of the Hesse-Darmstadts, and as a result of the carelessness shown by the Russian court in choosing a bride for Nicholas II, an innocent young child was to suffer. In that one night the emperor aged ten years. He could not bear the thought that his only son, his beloved Alexei, was doomed by medical science to an untimely death, or at the very least to the life of an invalid. 'Is there really no specialist in the whole of Europe who can cure my son? Let him ask for anything, let him spend his whole life at the palace. But Alexei must be saved!' The doctors were silent. They had no choice but to answer in the negative, for it would have been wrong to nurture false hopes in the emperor. They were obliged to tell him that even the most famous specialists in the world were powerless against the haemophilia that was undermining the young heir's strength: 'Your Majesty must be made aware,' said one of the court physicians, 'that the Tsarevich will never be cured of his illness. The attacks of haemophilia will occur from time to time. It is essential to take the most stringent steps to ensure that his Highness is protected from falls, even scrapes, for the smallest amount of bleeding can prove fatal to haemophiliacs.' A burly sailor was charged with ensuring Alexei Nikolaevich's safety, and he would carry the boy in his arms during long public occasions.

Life lost all meaning for these royal parents. We were afraid to smile in their presence. When visiting their Majesties, we behaved as though we were in a house of mourning. The emperor sought oblivion in endless work, but the empress refused to submit to her fate. (Voeikov, 1933, pp. 182–3.)

494 Drawing by Empress Alexandra Feodorovna for her Daughter Olga, August 1904

Coloured pencil on paper
Inscribed by P. V. Petrov [Russian tutor to the imperial children] at the top: *Рисунок императрицы Александры Федоровны для вел. кн.Ольги Николаевны. Август, 1904. Александрия* [Drawing done by Empress Alexandra Feodorovna for her daughter Olga Nikolaevna, August 1904, Alexandria]
In pencil in lower right corner: *П. Петров* [P. Petrov]
16 × 17.5 cm
ГА РФ. Ф.611. Оп.1. Д.87. Л.1

The empress really brought up her daughters herself, and she did so extremely well. It would be difficult to imagine more enchanting, pure and intelligent girls. She only exercised her authority when absolutely necessary, and this never disturbed the atmosphere of complete trust which existed between her and her daughters. She understood the exuberance of youth and never restrained them when they played games and had fun. She also liked to be present at their lessons, where she would discuss the direction and content of their studies. (S. Buxhoeveden; from Nektaria, 1996, pp. 51–2.)

The empress would get up at 9 o'clock and drink egg-flip in bed. Then she worked in her study and received visits. After this she would sometimes go for a drive in the park with her children or with one of her ladies-in-waiting … From after lunch until tea the empress did handiwork or painted. (Volkov, 1993, p. 56.)

495 Drawing by Empress Alexandra Feodorovna for her Daughters, 26 April 1905

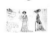

Coloured pencil on paper
Inscribed by P. V. Petrov in the lower left corner: *Рисунки, сделанные рукою императрицы Александры Федоровны для в. кн. 26 апреля 1905 г. П. Петров* [Drawings done by Empress Alexandra Feodorovna for the grand duchesses. 26 April 1905. P. Petrov]
11 × 19.5 cm
ГА РФ. Ф.611. Оп.1. Д.87. Л.82

496 Drawing by Empress Alexandra Feodorovna for her Children, November 1911

Indian ink, pencil and blue pencil on cardboard
Inscribed in black ink by P. V. Petrov at the bottom: *Набросок, сделанный рукою императрицы. Ливадия. Ноябрь 1911.* [Sketch drawn by the empress, Livadia, November 1911]
9.5 × 13.5 cm
ГА РФ. Ф.611. Оп.1. Д.87. Л.3

497 Watercolour by Grand Duchess Olga Nikolaevna, January 1911

Watercolour on paper
Monogrammed by the grand duchess in black ink in the lower right corner: *О.Н.*
Signed and dated by the grand duchess in black ink on the reverse: *Ольга. Январь 1911.* [Olga, January 1911]
12.5 × 5.5 cm
ГА РФ. Ф.611. Оп.1. Д.87. Л.3

The children of Nicholas II were taught to paint by the artist Dmitry Nikolaevich Kardovsky (1866–1943) — an outstanding teacher who was a professor from 1907, member of the Academy of Arts from 1911, and an Honoured Artist of the Russian Soviet Federal Socialist Republic from 1929.

These drawings done by the empress and her children have survived thanks to P. V. Petrov, the children's Russian language teacher, who carefully collected and annotated them, and kept them in his personal archive.

498 Watercolour by Grand Duchess Olga Nikolaevna, January 1911

Watercolour on paper
Monogrammed by the grand duchess in black ink in the lower right corner: *О.Н.*
Signed and dated by the grand duchess in black ink on the reverse: *Ольга. Январь 1911 г.* [Olga, January 1911]
6 × 11 cm
ГА РФ. Ф.611. Оп.1. Д.87. Л.41

499 Watercolour by Grand Duchess Olga Nikolaevna, January 1911

Watercolour on paper
Signed and dated by the grand duchess on the reverse: *Ольга. Январь 1911* [Olga, January 1911]
7.5 × 8 cm
ГА РФ. Ф.611. Оп.1. Д.87. Л.43

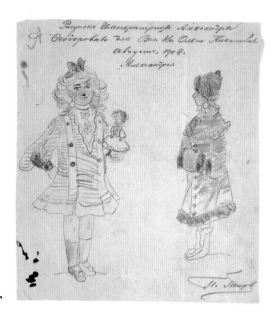

Рисунокъ Императрицѣ Александрѣ
Ѳеодоровнѣ для Вел. Кн. Ольги Николаевны.
Августъ, 1904.
Александрія

П. Петровъ

294

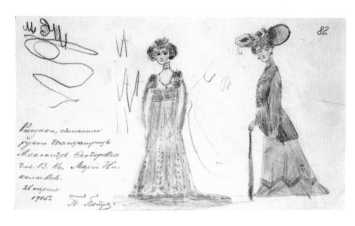

82

Рисунки, сдѣланные
рукою Императрицы
Александры Ѳеодоровны
для В. Кн. Маріи Ни-
колаевны.
26 апрѣля
1915. П. Петровъ

295

набросокъ, сдѣланный рукой
Императрицы. Лифляндія,
мартъ 1914.

296

14

42

297 298

499

1908

TH. 500

501 1908

TH

502

03

504

505

500 Drawing by Grand Duchess Tatiana Nikolaevna,
28 November 1908

Coloured pencil on paper
Dated by the grand duchess in pencil in the lower left corner: *1908. 28/XI*
Monogrammed by the grand duchess in pencil in the lower right corner: *T.H.*
20.5 × 12.5 cm
ГА РФ. Ф.611. Оп.1. Д.87. Л.65

Tatiana Nikolaevna was by nature both reserved and strong-willed, but less open and spontaneous than her elder sister. She was also less gifted, but compensated for this by having great perseverance and an even temperament. She was very pretty, although she lacked Olga Nikolaevna's charm.

If the empress showed any favouritism towards any of her daughters, then it was surely towards Tatiana Nikolaevna. It was not that the other sisters loved their mother any the less, but Tatiana Nikolaevna knew how to surround her mother with constant care and attention, never permitting herself to appear in a bad mood. In society, thanks to her beauty and innate sense of how to behave, she eclipsed her sister who was less concerned with her appearance and tended to withdraw into the background. Nevertheless the two sisters loved each other tenderly; there was only a year and a half between them, and this naturally drew them very close. They were known as the 'big children' while Maria Nikolaevna and Anastasia Nikolaevna were the 'little children'.
(Gilliard, 1921, pp. 59–60.)

501 Drawing by Grand Duchess Tatiana Nikolaevna,
28 November 1908

Coloured pencil on paper
Dated by the grand duchess in pencil in the lower left corner: *1908. 28/XI*
Monogrammed by the grand duchess in pencil in the lower right corner: *T.H.*
11 × 11 cm
ГА РФ. Ф.611. Оп.1. Д.87. Л.64

502 Drawing by Grand Duchess Tatiana Nikolaevna,
30 January 1912

Pencil on paper
Inscribed by P. V. Petrov at the top of the drawing: *Набросок, изображающий меня, сделан в. кн. Т.Н. на уроке 30 января 1912 г. П. Петров.* [Sketch of myself drawn by Grand Duchess T[atiana] N[ikolaevna] during the lesson of 30 January 1912. P. Petrov.]
12.5 × 20.5 cm
ГА РФ. Ф.611. Оп.1. Д.87. Л.75

503 Drawing by Grand Duchess Maria Nikolaevna, 17 May 1906

Coloured pencil on paper
Signed and dated by the grand duchess in pencil in the top left corner:
17 мая 1906 г. Мария. [17 May 1906. Maria]
Inscribed by P. V. Petrov in pencil on the reverse: *Рисунок исполненный великой княжною Марией Николаевной и ею подписанный, 17 мая 1906 г. в Александрии. Поднесен мне, причем вел.кн. пояснила: 'Это Вы, а это ваша кухарка, а это ваша собака, и вот дом, в котором вы живете, а тут собачья будка'. Н. Петергоф. 17 мая 1906 г. П. Петров* [Drawing done by Grand Duchess Maria Nikolaevna and signed by her, 17 May 1906 in Alexandria. Presenting it to me, the grand duchess explained: 'This is you, and this is your cook, and this is your dog and here is the house you live in, and there is the dog kennel.' Peterhof, 17 May 1906. P. Petrov]
16.5 × 16.5 cm
ГА РФ. Ф.611. Оп.1. Д.87. Л.83

504 Painting by Grand Duchess Maria Nikolaevna, June 1913

Oil on cardboard
Inscribed by P. V. Petrov in pencil on the reverse: *Первый рисунок масляными красками вел. кн. Марии Николаевны. Исполнен на 'Штандарте', в июне 1913 г.* [Grand Duchess Maria Nikolaevna's first oil painting. Painted on the *Standart* in June 1913]
11 × 16 cm
ГА РФ. Ф.611. Оп.1. Д.87. Л.110

505 Watercolour by Grand Duchess Anastasia Nikolaevna, 1913

Watercolour on cardboard
Monogrammed and dated by the grand duchess in black ink in the lower right corner:
A.H. 1913
9 × 13.5 cm
ГА РФ. Ф.651. Оп.1. Д.313. Л.5

She was my favourite goddaughter! I liked her fearlessness. She never whined or cried even when she was hurt. She was a courageous tomboy; God only knows which of her cousins taught her to climb trees, but she loved climbing them even when she was a very small girl. Something that was not widely known was that she had a weak spine, and the doctors prescribed massage. Anastasia hated what she called 'fuss'. A hospital sister, Tatiana Gromova, used to come to the palace about twice a week, and my naughty little niece would jump into a cupboard or under a bed to put off the massage for at least another five minutes. I think that the doctors were right about the weak muscles, but anyone who saw Anastasia playing would never have believed it, so nimble and energetic was she. And what a little mischief-maker!
(Recollections of Grand Duchess Olga Alexandrovna; from Vorres, 1985, pp. 108–9.)

506 Grand Duchesses Olga, Tatiana, Maria and Anastasia, with Tsarevich Alexei, 1908

Unknown photographer
Mounted and in a wooden frame
Inscribed by V. F. Djunkovsky on the reverse: *Августейшие дети государя
Николая II в 1908 году.* [The most august children of Emperor Nicholas II in 1908]
Photograph: 16 × 22 cm
Mount: 19.5 × 22.5 cm
Frame: 22 × 28 cm
ГА РФ. Ф.826. Оп.1. Д.937. Л.4

*The grand duchesses were charming — so fresh and the picture
of health. It would have been difficult to find four sisters more
different in character and at the same time so harmoniously united
by a friendship which in no way precluded personal independence,
but which ensured that there remained a strong bond between them
in spite of their contrasting temperaments. They invented a shared
name, OTMA, formed from the first initials of their Christian
names, and they would sometimes use this collective identity when
giving presents or sending letters written by one of them on behalf
of all four.*

*I think I can be forgiven the pleasure of narrating a few personal
memories here. This will allow me to recall to life, in all their high
spirited and cheerful youth — or almost childhood — these young
girls who, just at the moment when others blossom into existence,
became victims of the most terrible fate ... Their relationship with the
emperor was charming. To them he was emperor, father and friend all
in one. Their feelings for him altered according to circumstance and
they always knew how to behave towards their father in any given
situation. These feelings ranged from religious veneration to the most
trusting lack of restraint and the most heartfelt friendship ...*

*Their mother, whom they adored, was virtually infallible in their
eyes ... They were wonderfully considerate and attentive to her. By
mutual agreement, and completely of their own accord, they arranged
a system whereby each of them would take it in turn to spend the day
with their mother and keep her company. When the empress was
unwell, the one whose turn it was to fulfil this daughterly duty would
stay at her side and not go out at all ... The characteristics that made
these four sisters so charming are quite hard to explain: it was their
great simplicity, their naturalness and freshness, and their
instinctive goodness.*
(Gilliard, 1921, pp. 57, 60, 63.)

507 Tsarevich Alexei Nikolaevich in the Uniform of the Dragoons Regiment, of which he was Commander-in-Chief, 1911

Photograph by court photographer Alexander Karlovich Yagelsky
C. E. von Hahn photographic studio
Mounted photograph: 10 × 14 cm; 10.5 × 16 cm
ГА РФ. Ф.640. Оп.1. Д.380. Л.4

508 Tsarevich Alexei Nikolaevich in the Uniform of the Life-Guard Sapper Battalion, 1911

Photograph by court photographer Alexander Karlovich Yagelsky
C. E. von Hahn photographic studio
Mounted photograph: 10 × 19.5 cm; 12 × 23 cm
ГА РФ. Ф.640. Оп.1. Д.379. Л.2

Emperor Nicholas II was commander-in-chief of the Life-Guard
Sapper Battalion from 1894 to 1917. On 30 July 1904 he ordered
that Tsarevich Alexei Nikolaevich be enlisted into the rolls of the
battalion.

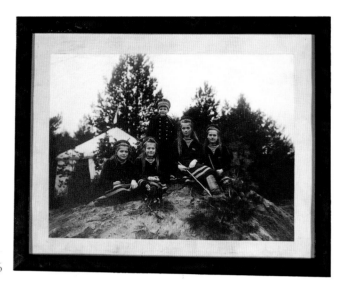

506

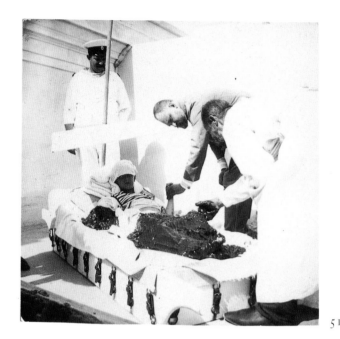

515

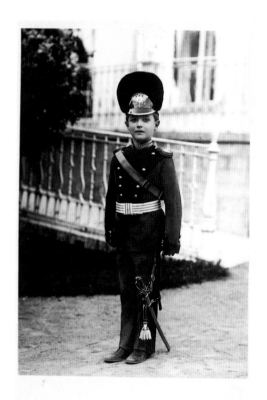

507

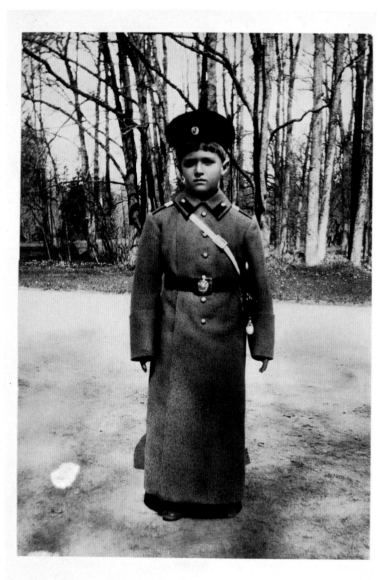

510

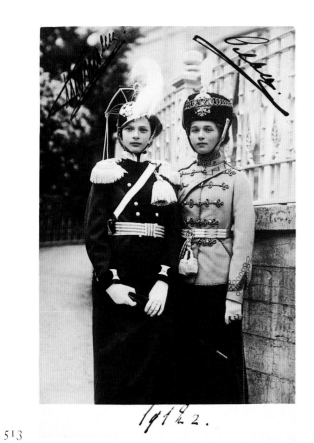

513

514

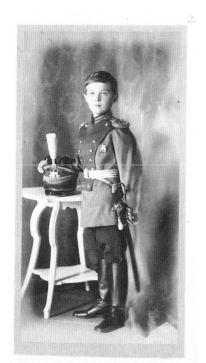

508

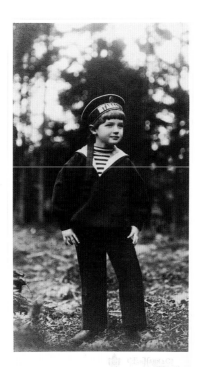

509

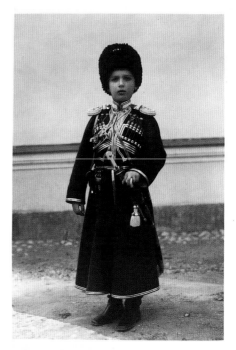

511

516 Watercolour by Tsarevich Alexei Nikolaevich, 1912

Watercolour on paper
Inscribed by the tsarevich in black ink at the bottom of the page: офицер военных
учебных заведений [officer of the military educational institutions]
22 × 35.5 cm
ГА РФ. Ф.682. Оп.1. Д.22. Л.6

517 Watercolour by Tsarevich Alexei Nikolaevich, 1912

Watercolour and pencil on paper
Signed by the tsarevich in pencil in the top left corner: А. Романов [A. Romanov]
22 × 35 cm
ГА РФ. Ф.682. Оп.1. Д.22. Л.2

518 Emperor Nicholas II with Empress Alexandra Feodorovna
and their Children, Livadia, 1914

Photographer from the photographic studio of Levitsky and Co.
Trade-mark of the photographic studio and stamp of the Imperial Academy of Arts
on the reverse
Photograph: 10.5 × 16 cm
ГА РФ. Ф.611. Оп.1. Д.102. Л.208

*In 1914 when war broke out, Olga Nikolaevna was almost nineteen
and Tatiana Nikolaevna had just celebrated her seventeenth birthday.
They had never attended a ball; they had only taken part in one or two
parties given by their aunt, Grand Duchess Olga Alexandrovna.
From the beginning of the war they had only one thought: to alleviate
the worries and anxieties of their parents by surrounding them with
a love which manifested itself in the most touching and tender acts of
consideration. What an example — if only it had been known — was
shown by the intimate and dignified tenderness of this imperial
family, but how few people even suspected it! It is true that, being
indifferent to general opinion, the family hid from public view.*
(Gilliard, 1921, p. 107–8.)

516

517

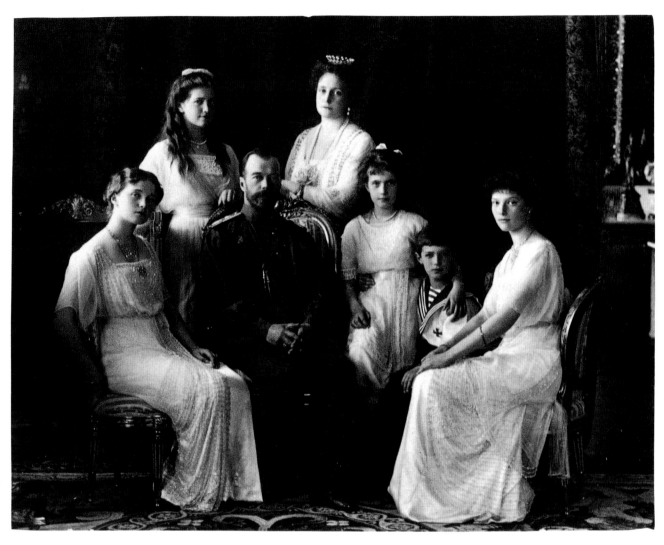

518

519 Notebook of Grand Duchess Olga Nikolaevna, 1911

White silk cover with a pattern stamped in gold; dated *1911* in yellow metal numerals
on cover; yellow metal padlock; date *1911* stamped in gold on the spine; white moiré
silk end-papers
9.5 × 13 cm; open 19 × 13 cm

*29 March/11 April: Had lunch with Papa and Mama. In the afternoon
went to review new recruits of the Guards Corps and another company.
The review was terribly good. Had tea with S[ophia] I[vanovna Tiutcheva].
After tea talked on the phone to Nik[olai] P[avlovich Sabline] and P.A.
Voron[ov]. Had dinner with Mama and Ania. Went to church. Papa had
dinner with the hussars.*

*7/20 August: At 10 o'clock drove with Papa, T[atiana] and Al[exei] to
Krasnoe Selo for the parade of the Moscow regiment. There was a service
and the parade. In the afternoon we walked in the garden. After that
there was nothing much. After dinner worked in Mama's room.*

ГА РФ. Ф.673. Оп.1. Д.12. Л.1–185 (Л. 46 об., 112)

The children all kept diaries; it was a traditional part of growing
up in the Russian imperial family. Imitating their parents, they
carefully noted down all the events of the preceding day. Many
of the grand duchesses' diaries have not survived. While they
were under arrest at Tsarskoe Selo in 1917, and later during their
exile in Tobolsk, the girls burned many of their diaries.

519

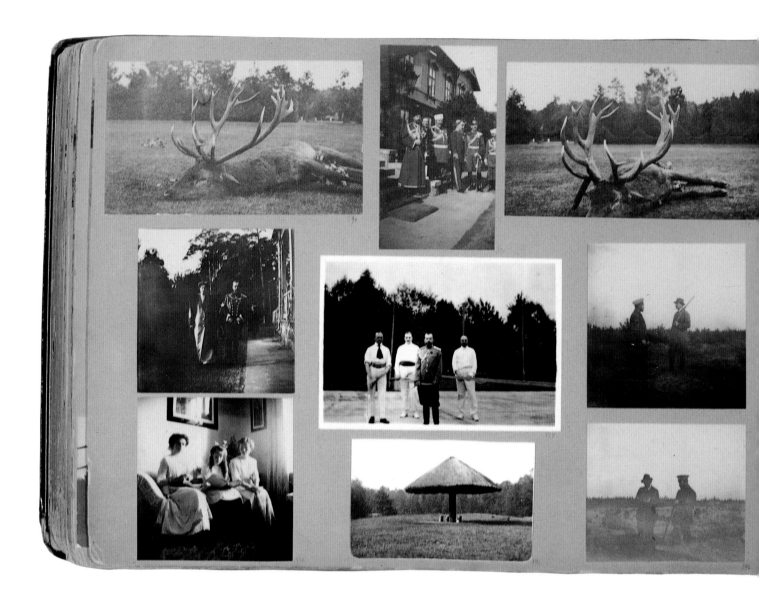

520 Photograph Album of Nicholas II

Amateur photographs of members of the imperial family, taken between 1911 and 1913
Album in a dark claret-coloured leather cover, containing a total of 470 photographs
41 × 29 cm; open 82 × 29 cm
The pages reproduced here show photographs taken during the imperial family's stay at Spala from September to November 1912 (9 photos on the left); and at Tsarskoe Selo in 1913 (9 photos on the right). The photographs are inscribed by Nicholas II: *1913-й г. Царское Село* [1913, Tsarskoe Selo]
ГА РФ. Ф.601. Оп.1. Д.1530. Л.1–26 (22 об.–23)

As soon as the company Kodak started to produce cameras for amateur enthusiasts, photography very quickly became popular all over the world. Kodak made a special camera for Nicholas II, enabling him to take panoramic views. This enthusiasm for photography was shared by all members of the imperial family. Nicholas stuck the photographs into his album himself and annotated them.

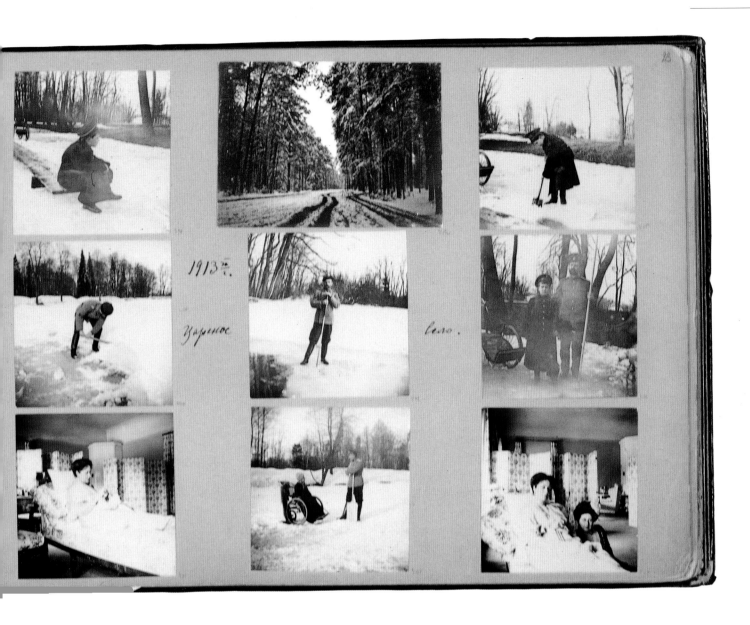

1913 г.

Царское Село.

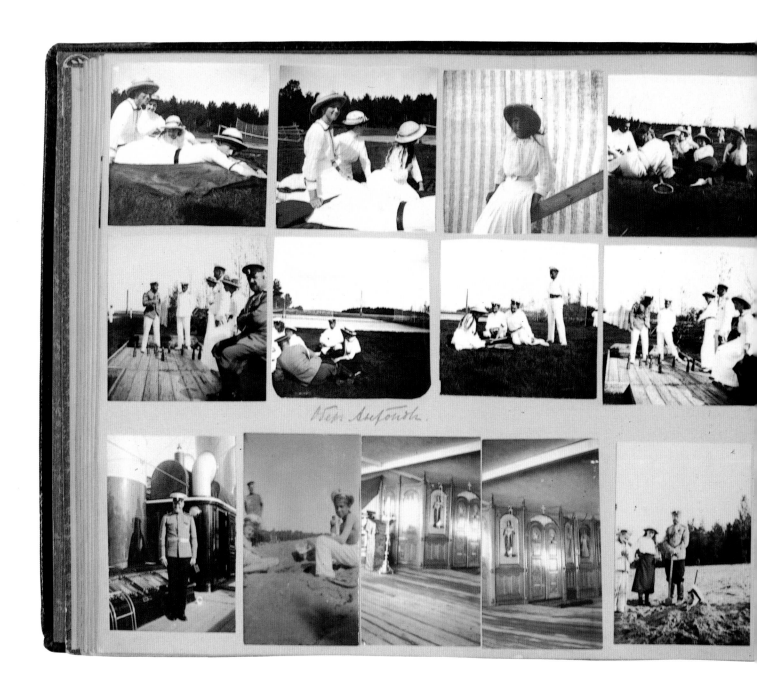

521 Photograph Album of Grand Duchess Anastasia Nikolaevna

Amateur photographs of members of the imperial family, taken in 1913
Album in a dark-brown leather cover with a gold border, containing a total of
401 photographs
41 × 29 cm; open 82 × 29 cm
The pages reproduced here show photographs taken during the imperial family's stay
in the skerries. Two of the photographs are annotated by Grand Duchess Anastasia
Nikolaevna (on the left: *Обер Антонов* [Captain Antonov]; on the right *командир*
[commander]).
ГА РФ. Ф.683. Оп.1. Д.116. С.1–41 (С.14–15)

*Saturday 22 June. This morning we all went out in canoes for a good
trip around Tukholm and towards the sound … It was hot but a SW
was blowing … Enjoyed a game of tennis and went swimming.*
(Nicholas's Diary, 22 June 1913. ГА РФ. Ф.601. Оп.1. Д.260. Л.50.)

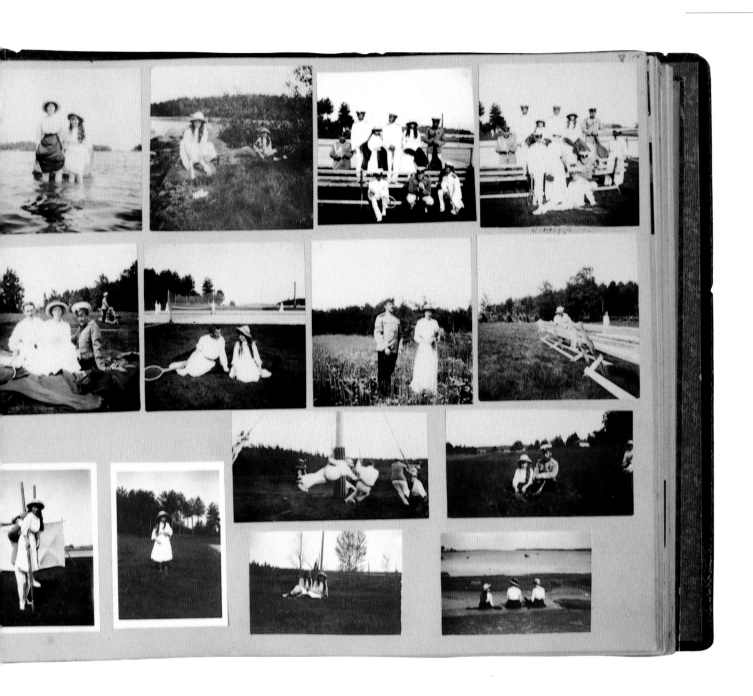

522

523

522

523

522 Menu for a Ceremonial Dinner in Honour of the Tercentenary
of the House of Romanov, 19 May 1913

Kostroma
Chromolithograph
34.5 × 23.5 cm

Soup from young greens
Pirozhki [meat pasties]
Steamed sturgeon
Saddle of wild goat with garnish
Roast chicken and fowl
Salad
Asparagus with sauce
Pears and ice cream
Strawberry jelly with champagne
Desserts

ГА РФ. Ф.601. Оп.1. Д.119. Л.91

1913, the last year of peace in Russia, was marked by events
celebrating the tercentenary of the rule of the Romanov dynasty.
The anniversary festivities, which began in St. Petersburg on
21 February and ended in Moscow on 27 May, were organised
with maximum pomp.

The emperor made a trip down the Volga on the steamship
Mezhen, and visited, among other places, Nizhny Novgorod,
Kostroma and Yaroslavl.

*The nineteenth of May arrived. From early morning Kostroma was
the scene of unusual activity: huge crowds of people started to head
down to the banks of the Volga, and by 8 o'clock the whole riverside
was a sea of heads. All the tributaries and even the Kostroma and
Muravievka rivers were teeming with rafts laden with people.
At last the imperial flotilla came into sight; the salute rang out
from the battery on Gorodishchensky hill, the bells started to chime,
and a tremendous 'Hurrah!' filled the air. The* Mezhen *came
into Kostroma flying the imperial standard and headed towards
the designated imperial jetty by the Ipatiev monastery.*

*The emperor, in his uniform of the Erivansky regiment, received the
report of Governor Stremoukhov, greeted the reception party, and then
stepped ashore where he accepted the bread and salt [a traditional
welcome] from the local peasants and approached the Erivansky
guard of honour. After the ceremonial inspection, their majesties
went by carriage to the Ipatiev monastery between lines of Erivansky
soldiers and Cossacks. A mighty 'Hurrah!' accompanied them on
the route. By the Green gates of the Ipatiev monastery the emperor,
with his family and members of his retinue, was met by Archbishop
Tikhon and the brethren of the monastery, as well as a religious
procession that had come from Kostroma.*

*The steamships on the Volga were superbly lit, their myriad lights
reflecting in the waters which were dotted with hundreds of small
boats filled with joyfully singing people. Equally memorable was
the firework display which took place at 11 o'clock on the spit near*

529 Letters from Empress Alexandra Feodorovna to
Emperor Nicholas II, 1915–16

Total of 93 letters written between 1 November 1915 and 31 March 1916
In English
16.5 × 23 × 4 cm; spread 33 × 23 cm
ГА РФ. Ф.601. Оп.1. Д.1150. Л.1–346

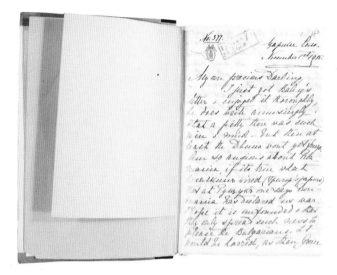

Nicholas's separation from his family during the war explains the
large volume of family correspondence written over the course of
the last two and a half years of his reign. Alexandra Feodorovna
numbered all their letters from the previous two decades and
they amounted to some seven hundred, not counting notes and
telegrams. Almost two-thirds of the total number date from the
period September 1914 to March 1917. The majority were sent by
the empress, who sometimes wrote twice a day. These are many-
paged letters, full of daily reports, confessions, and entreaties.
The emperor was always pleased to receive these communications
and wrote to his wife:

Tenderest thanks for your dear letters & for all your love in each line!
I drink them & savour every word you write & often bury my nose &
press my lips to the paper you have touched.
(ГА РФ. Ф.640. Оп.1. Д.109. Л. 49)

Without these letters we would not know the exact and irrefutable
truth about this woman ... we would not know with such incredible,
inexorable clarity how she served her terrible times. And we need to
know. This truth does not belong to her.
(Gippius, 1923, p. 208.)

Extracts from letters written by Nicholas and Alexandra between
1915 and 1917:

Nicholas: *Fancy, my Wify, helping huzy when away! What a pity you did*
not perform that duty long ago, or at least now during the war!

Alexandra: *You bear all so bravely and by your self – let me help you*
my Treasure. Surely, there is some way in wk [work] a woman can be of
help and use.

Nicholas: *Yes, these days we spent together, were indeed hard ones –*
but it is only thanks to you that I stood them more or less calmly. You are
so staunch and enduring… And then I intend becoming sharp and biting.

Alexandra: *Darling remember… Царь правим, а не Дума! [the tsar*
rules, not the Duma!].

Alexandra: *I am but a woman fighting for her master and child, her*
two dearest ones on earth.

Alexandra: *To follow our Friend [Rasputin] concur[s] lovy I assure is right.*

Nicholas: *Only please don't mix in our Friend! It is I who carry the*
responsibility and I want to be free to choose accordingly.

ГА РФ. Ф.601. Оп.1. Д.1148–1151; Ф.640. Оп.1. Д.102–112

530 Letter from Grand Duchess Maria Nikolaevna to her Mother
Empress Alexandra Feodorovna, 15 December 1914

In English and Russian
11 × 16 cm; spread 22 × 16 cm

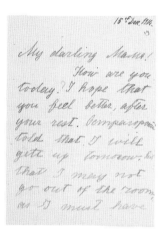

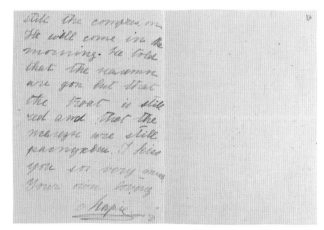

My darling Mama!
How are you today? I hope that you feel better, after your rest.
Острогорский [Ostrogorsky] told that I will get up tomorrow but that
I may not go out of the room, as I must have still the compress on. He
will come in the morning. He told that the налеты [spots] are gone but
that the throat is still red and that железы [tonsils] are still распухли
[swollen]. I kiss you so very much. Your own loving
Мария [Maria]

ГА РФ. Ф.640. Оп.1. Д.86. Л.19–20

and Representatives from practically all the countries of the world. I saw Sir Arthur Nicholson today and he told me of all your kindness and sympathy which has touched me deeply and all the sorrow which has been expressed in Russia. Everyone loved and respected beloved Papa and they knew that his great object was Peace. I can't yet realize that I shall never see his dear face again or hear his dear voice, his illness was so sudden and the end came so quickly, but it was quite peaceful without a struggle. Yes, dearest Nicky, I hope we shall always continue our old friendship to one another, you know I never change and I have always been very fond of you. Yes, indeed I know how from the first my dear Father tried to do all he could to bring our two countries together and you may be sure that I shall show the same interest in Russia that He did. And I know you will do the same and I feel certain that when our two peoples know each other better and understand each other, that our endeavours will be crowned with success. We are now working splendidly together in Persia, there may be difficulties with Germany, but I think they can be overcome. If only England, Russia and France stick together the peace in Europe is assured.
Ever your devoted friend,
Georgie.

ГА РФ. Ф.601. Оп.1. Д.1219. Л.27–28 об.

528 Nicholas II at Army Headquarters, September 1914

Unknown photographer
Baranovichi
Mounted photograph: 11 × 15.5 cm; 15.5 × 19.2 cm
ГА РФ. Ф.601. Оп.1. Д.682. Л.2

The assassination in Sarajevo of the heir to the Austrian throne, Archduke Franz Ferdinand, finally shattered the fragile peace in Europe. On 19 July 1914, at 7 o'clock in the evening, the German ambassador, Count de Pourtalès, handed a note to the Russian foreign minister, S. D. Sazonov, which ended as follows: 'His majesty the emperor, my august monarch, responds to the call on behalf of the empire and considers himself to be in a state of war with Russia ...'

The events of the end of July allowed [Nicholas] to see clearly the German duplicity to which he had fallen victim. On the other hand, he had never been so close to his people; he felt himself carried along by them. His trip to Moscow had shown him how popular this war was, and how grateful the people were for his dignified and firm stand which had once more raised the prestige of the Russian nation abroad. Never had the enthusiasm of the masses been manifested so spontaneously or with such strength. He felt as if the whole country was behind him and he hoped that the political dissension, which had ceased in the face of a common enemy, would not reappear for the duration of the war.
(Gilliard, 1921, p. 99.)

At that time a telegram arrived from Rasputin in Siberia, begging the emperor 'not to get involved in the war, that war will be the end of Russia and of themselves and, to a man, they will all perish.' The tsar was annoyed by the telegram and took no notice of it.
(Vyrubova, 1990, p. 146.)

Grand Duke Nikolai Nikolaevich became supreme commander. Aged 57, he was the grandson of Nicholas I, and had graduated from the General Staff Academy with a silver medal. He fought bravely during the Russo-Turkish war, for which he was awarded the most highly regarded decoration for Russian officers, the Order of St. George, fourth degree, together with a gold weapon inscribed *For Bravery*. As his headquarters, the grand duke chose the large railway junction of Baranovichi, which lay between the German and Austrian fronts. The commander and his staff were billeted in ordinary railway carriages, thereby demonstrating their readiness to share the asceticism and simplicity of military life. Nicholas II took every opportunity to visit the army command centre. During his visits, the army headquarters gained the appellation 'imperial', but the regime of work and daily life changed little. After receiving reports in the morning and having lunch, the emperor would visit the troops and the field hospitals, and if there was time he would take a walk in the surrounding area. After dinner there would be further meetings to discuss forthcoming operations, but Nicholas always stuck to his role as honoured guest, and avoided getting directly involved in issues which remained the prerogative of the supreme commander.

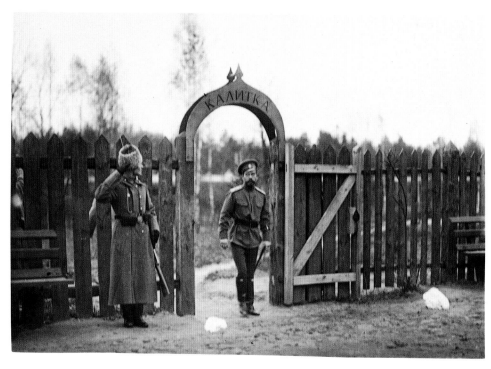

525 Emperor Nicholas II and Empress Alexandra Feodorovna during a Ceremonial Procession at the Kremlin, 1913

Unknown photographer
Mounted photograph: 16 × 11 cm; 29 × 25 cm
ГА РФ. Ф.601. Oп.1. Д.1655. Л.60

The Imperial procession, which traditionally takes place in Moscow accompanied by great splendour and pageantry, was extended on this occasion by processing out onto Red Square and returning to the Kremlin through the Saviour Gates; it was also distinguished by a remarkable orderliness given the far greater than usual crowds filling every inch of the square.

There was only one sad note — the sight of the heir being carried the whole time in the arms of a Cossack. We were all used to this, but I well remember that as the procession slowed down momentarily opposite the monument to Minin and Pozharsky, I heard loud exclamations of grief at the sight of the poor child. It can be said without exaggeration that the crowd felt deeply affected by the helpless condition of the emperor's only son.
(Kokovtsov, 1991, p. 224.)

526 King George V of England and Emperor Nicholas II of Russia (the first cousins Georgie and Nicky), Early 1910s

Photograph by Ernst Sandau
Trade-mark (partially missing) of the photographic studio in the lower left corner of the mount
Mounted photograph: 15.5 × 22 cm; 16 × 24.5 cm
ГА РФ. Ф.601. Oп.1. Д.2172. Л.4

In 1910, on the death of his father Edward VII, George V succeeded to the English throne. George and Nicholas II were linked not only by family ties but by a long-standing friendship. However, despite constant protestations of friendship and loyalty to his Russian cousin, George V refused to come to the help of Nicholas and his family in 1917 when the Provisional Government entered into discussions with its English counterpart about sending the imperial family, then under arrest, to England. Fearing the possibility of a workers' uprising in England, George refused to offer a safe haven to Nicholas. When he learned that the imperial family had perished, he was filled with remorse at what had happened.

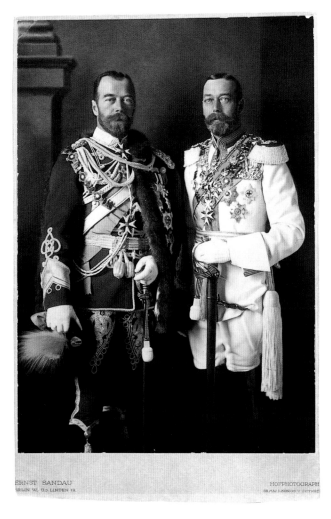

526

527 Letter from King George V of England to Emperor Nicholas II, 14[27] May 1910

In English
Monogram of George V at the top of the first page
12 × 20 cm; spread 24 × 20 cm

My dearest Nicky,
... These last three weeks have been terrible, my heart has been nearly breaking and at the same time I have had to carry on all my duties and bear my new responsibilities and see so many people to arrange about the last sad ceremonies and entertain William, 7 Kings and numerous Princes

*the Ipatiev monastery. On Susaninskaya square a school orchestra
from the town of Kineshma played and sang 'God Save the Tsar'
by popular request, almost without ceasing. That night the normally
quiet Kostroma barely slept.*

(Memoirs of V. F. Djunkovsky. ГА РФ. Ф.826. Оп.1. Д.53. Л.122.)

523 Menu for a Ceremonial Dinner in Honour of the Tercentenary
of the House of Romanov, 20 May 1913

Kostroma
Chromolithograph
34.5 × 23.5 cm
ГА РФ. Ф.601. Оп.1. Д.119. Л.92

*20 May. The second day of the celebrations in Kostroma dawned.
At 10 o'clock the royal steamer left the imperial jetty by the Ipatiev
monastery and sailed towards the town jetty. Tens of thousands of
people crowded the bank. Their majesties were met on the jetty by the
town authorities and then walked up to the square between lines of
boy-soldiers bearing arms, rows of grammar-school pupils and other
schoolchildren. On the square the troops were already waiting in
formation, and behind them the crowd was a sea of heads. Their
majesties were accompanied right up to the cathedral by constant
shouts of 'Hurrah!', drowning the music of the orchestra.*

*Their majesties visited the Red Cross hospital, after which they
inspected the best preserved of the ancient monuments: the church of
the Resurrection in the Forest. They attended the opening of the
Zemstvo [district council] exhibition, where all the imperial family
members and high-ranking military and civil grandees, as well as
representatives of the Zemstvo were already gathered.*

*The emperor's departure was a wonderful spectacle: opposite the
exhibition, all along both sides of the decorated jetty, the whole length
of the steep river bank was just a sea of heads. The entire city had
turned out. When these thousands of people caught sight of the tsar
they were united in one joyful cry. The bells at the exhibition rang
out, followed by the bells of all the churches in the city. Shouts of
'Hurrah!' and the national anthem filled the air as the steamship
Mezhen cast off from the jetty and the tsar bowed to the people from
the deck.*

*Those two days in Kostroma will forever be impressed on my
memory, and I was grateful that God allowed me to witness that
unparalleled upsurge of patriotic feeling from the people. The only
thing that cast a shadow for me was the presence of Rasputin, both in
the Ipatiev cathedral and at the foundation-laying ceremony for the
monument. As soon as I arrived in Kostroma, I was met by an
anxious-looking Governor Stremoukhov seeking my advice. It seems
that on that same morning Rasputin had arrived in Kostroma with
bishop Varnava or some other person, and had demanded that the
ticket office issue him with a ticket for all the celebrations.
Stremoukhov had delayed a decision until my arrival. My advice
was not to issue Rasputin with a ticket under any circumstances,
but nor should he be removed from the town. If he wished to attend the
celebrations, then let him stand with the crowd wherever he liked — it
was nobody else's business — but tickets were for official personages
only, and Rasputin, who did not occupy any official position, had no
right to one. If Rasputin insisted, I told Stremoukhov to say that his
request had been submitted to me and that I had refused. Nevertheless,
Rasputin did get into the Ipatiev cathedral and stood right by the*

*altar, having been conducted there by an agent of the palace security
on the personal order of the empress. He was also present at the
laying of the foundation stone for the monument on the square,
standing to the side with the same security agent. There was no sign
of him at any of the other events, nor, fortunately, did he appear on
the steamship Mezhen.*

(Memoirs of V. F. Djunkovsky. ГА РФ. Ф.826. Оп.1. Д.52. Л.126.)

524 Kerchief Depicting the Tsars of the Romanov Dynasty, 1913

Cotton
ГА РФ. Ф.601. Оп.1. Д.2251. Л.2

*The tsar's trip had evidently been planned as a 'family' celebration of
the Romanov dynasty; its significance as a 'state' occasion was not
accorded due recognition ...*

*The first stop was in Vladimir, then Nizhny [Novgorod], Kostroma,
Yaroslavl, Suzdal, and Rostov, and everywhere my impression was
one and the same — the absence of any real enthusiasm and
comparatively small crowds.*

(Kokovstov, 1991, p. 228.)

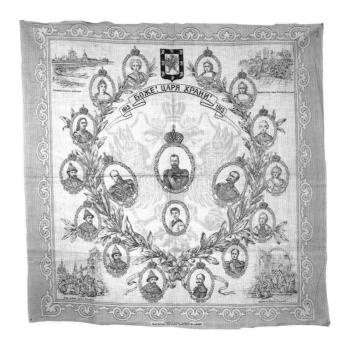

531 Grand Duchess Olga Nikolaevna, Empress Alexandra
Feodorovna, Grand Duchess Tatiana Nikolaevna and
Lady-in-Waiting A. A. Vyrubova, dressed in nurses'
uniforms, Autumn 1914

Photograph by court photographer Alexander Karlovich Yagelsky
C. E. von Hahn photographic studio
Mounted photograph: 12 × 17 cm; 23 × 31 cm
Signed by A. A. Vyrubova and Tatiana Nikolaevna at the top of the photograph:
Аня [Ania] and *Татьяна* [Tatiana]
Signed and dated by Alexandra Feodorovna at the bottom: *Мама* [Mama] *1914 г.*
Trademark of the photographic studio at the bottom of the mount and on the
reverse: *C. E. de Hahn and Co*
ГА РФ. Ф.673. Оп.1. Д. 168. Л.1

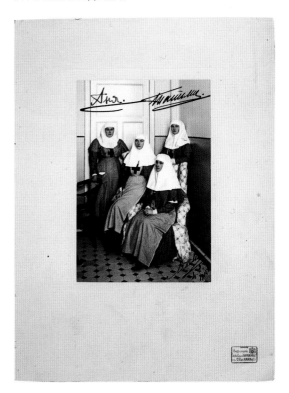

During the First World War, Empress Alexandra Feodorovna
and her elder daughters — Grand Duchesses Olga and Tatiana —
completed courses for medical attendants and then started to
work as nurses in the Tsarskoe Selo hospitals. They washed
soldiers' wounds and assisted with operations. On 2 March 1915
the empress wrote in a letter to her husband: 'And how much
sorrow in all around! Thank God that we have the possibility of
at least making some comfortable in their suffering & give them a
feeling of homeliness in their loneliness.' (ГА РФ. Ф.601. Оп.1.
Д.1149. Л.35–36.)

532 Letter from Grand Duchess Tatiana Nikolaevna to her
Mother Empress Alexandra Feodorovna, 7 August 1915

Tsarskoe Selo
In English
11 × 15 cm; spread 22 × 15 cm
Ц[арское] С[ело] *1915 г. 7-е августа* [Tsarskoe Selo, 7 August 1915]

Mama darling mine,
Please give Ania this photo of [illegible] I did at Krasnoe during the review.
I'm sure she will be very pleased that he is here. Mama, sweet, I am so
awfully sad. I see so little of you. I hate going away for so long. Really, we
never see you now. It doesn't matter if sisters go earlier to bed – I'll remain.
For me it is better to sleep less and see more of you, my beloved one. God
bless you, deary, 1000 kisses to you and Papa dear.
Your own true loving child, Tatiana

ГА РФ. Ф.640. Оп.1. Д.118. Л.31–32

533 Letter from Grand Duchess Olga Nikolaevna to her mother
Empress Alexandra Feodorovna, 13 November 1915

Tsarskoe Selo
In English
10.5 × 10.5 cm

Mama darling!
I kiss you my sweet Angel and pray for you. Sleep well & God bless and
keep you well for all who love you.
Yr ever own girl, Olga.
13 Nov[ember], 1915. Ц[арское] С[ело] [Tsarskoe Selo]

ГА РФ. Ф.640. Оп.1. Д.117. Л.7

534 Photograph Album of Grand Duchess
Tatiana Nikolaevna, 1916

Amateur photographs of members of the imperial family
Album in a dark claret-coloured cloth cover with gold border, containing a total of
318 photographs
41 × 29 cm; open 82 × 29 cm

The pages reproduced here show 24 photographs taken during the imperial family's
visit to General Headquarters at Mogilev. Grand Duchess Tatiana Nikolaevna has
inscribed in black ink on the photographs the following names: *Вася Агаев* [Vasya
Agayev], *Женя Макаров* [Zhenya Makarov], *Китаевский* [Kitaevsky], *Паленый*
[Paleny], *Панишко* [Panishko], *Середа* [Sereda] – children from the municipal gardens
ГА РФ. Ф.651. Оп.1. Д.263. Л.1–26. (л.13 об.–14)

Disasters at the front had made it necessary to move the General
Headquarters (*Stavka*) of the Russian army deep into Belorussia
to the provincial capital of Mogilev on the banks of the Dniepr.
In 1915 Nicholas decided to take his son with him to General
Headquarters. Alexandra Feodorovna visited Mogilev several
times with her daughters. Once there they would go for walks
together, read books, and play on the banks of the Dniepr.

*After his first trip to Tsarskoe Selo at the end of September, the
emperor returned to Mogilev with the heir. Accompanying them were
the boy's tutors: privy councillor P. V. Petrov, the Frenchman
Gilliard, the Englishman Mr. Gibbs, and Alexei's attendant — the
sailor Derevenko. From that time onwards Alexei Nikolaevich
became part of our staff family. During his time at General
Headquarters the heir stayed with his father at the* [governor's]

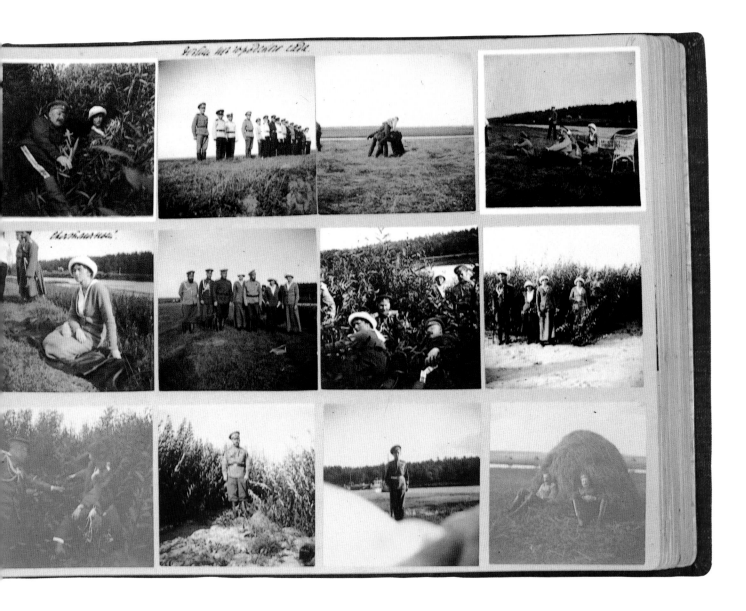

palace. They shared a small, completely plain, bedroom devoid of any imperial luxuries. Alexei Nikolaevich studied in a little room on the second floor, opposite the main stairs and next to the hall. He always joined us for lunch at the communal table, sitting to the left of the emperor, and for the most part I sat to the left of the heir. Dinner, however, he always took with his tutors. When the weather was good, Alexei Nikolaevich would join us for a walk, and he always accompanied his father to church ...

During the summer of 1916 Alexei Nikolaevich took part almost daily in military training in the municipal gardens near the palace with his 'company', a group of local secondary school pupils of the same age. In all about 25 of them would join in the game, including two young Jews. At the ordained time they would assemble in the garden, give the heir a military welcome when he arrived, and then parade in front of him.

That summer the heir also discovered another pastime, one which demonstrated his love for military exercises and his deep attachment to his father. In the morning, before the emperor appeared for morning tea, Alexei Nikolaevich would stand guard at the entrance to the tent; he would salute the emperor when he came in and then remain on guard while the emperor drank his tea. As his father left the tent Alexei Nikolaevich would salute once more, and only then relinquish his sentry duty. The Lord had invested in this unfortunate boy some wonderful innate qualities: a strong agile mind, great resourcefulness, a kind and compassionate heart, and an enchanting royal simplicity; his spiritual qualities were matched by his physical appearance.

When the empress arrived at General Headquarters with her daughters, life in the palace changed. Then the whole imperial family would be present at lunch. The empress generally appeared from the study first, always graceful and regal, but her look somehow full of melancholy; even her smile was sorrowful. Next to her the tsar seemed small and not very majestic. After lunch the tsar would go round the guests, while the tsarina would sit by the window and summon one or other of the guests and engage them in conversation. The tsar took dinner alone with his family.
(Memoirs of G. I. Shavelsky. ГА РФ. Ф.1486. Оп.1. Д.5. Л.285–291.)

535 Diary of Grand Duchess Maria Nikolaevna for 1916

Cover of blue moiré silk; gold stamped design stamped around the edge; date *1916* on the cover; broken yellow metal lock; pink moiré fly-leaf.
13 × 18 cm; open 26 × 18 cm

Friday 6/19 May

5 of us went to church with Papa and Mama. Was congratulated.
At lunch sat with Uncle Kyril and Igor. In the afternoon 5 of us walked
with Papa along the railway track. Had tea in the train. Went to the
picture-house. At dinner sat with Uncle Sergei and Uncle Boris. Returned
to the train.

ГА РФ. Ф.685. Оп.1. Д.10. Л.65. об.

536 English Language Exercise Book of Grand Duchess
Maria Nikolaevna, 1916

Blue cover, inscribed by the grand duchess in black Indian ink: *English. Marie.*
18 × 22 cm; open 36 × 22 cm
ГА РФ. Ф.685. Оп.1. Д.3. Л.51–70

The imperial children were taught English by Sidney Gibbs, who
was also Alexei's principal tutor. He followed the imperial family
into exile to Tobolsk and then Ekaterinburg, where he was not
permitted to join them at their final residence, the Ipatiev house.
After the family were shot, Gibbs returned to London via the
Far East. He converted to Orthodoxy and became a monk, taking
the name of Nicholas, and was made archimandrite.

537 Arithmetic Exercise Book of Tsarevich Alexei Nikolaevich,
1916

Grey paper cover signed by the tsarevich: Алексей Романов [Alexei Romanov]
18 × 22 cm; open 36 × 22
ГА РФ. Ф.682. Оп.1. Д.19. Л.1–17

It is of course well known that the heir suffered from haemophilia,
that his condition was often aggravated, and that there was a constant
threat of a tragic conclusion. One particularly bad attack left the
boy with a limp. The illness inevitably left its mark, too, on Alexei
Nikolaevich's upbringing and education. Incapacitated as he was, he
was permitted and forgiven much that a healthy child would not have
been, and his lessons were carefully managed to avoid over-tiring him
— to the obvious detriment of his scholastic endeavours. As a result he
developed a mischievous streak which often went beyond the bounds of
what is acceptable. He also fell behind in his studies, and this became
increasingly evident. In the autumn of 1916 Alexei Nikolaevich was
already twelve, the age of a cadet pupil of the third class, and yet he
still did not know, for example, simple fractions. However, this
backwardness in his studies could also have been due to the choice of
his teachers. Old Petrov and a couple of foreigners covered all the
subjects except arithmetic which was taught by General Voeikov …
'What utter nonsense!,' I said once to Professor Feodorov. 'General
Voeikov teaching the heir arithmetic! What sort of teacher is he?
When has he ever taught anyone anything? He knows a thing or
two about horses and soldiers, but not about academic studies.'
'Well what do you expect! These gentlemen,' Feodorov replied,
pointing to the Marshal of the Court, 'have convinced the emperor
that it is cheaper to do it this way. A separate teacher is expensive.'
I almost fell back in horror. So the choice of tutors and teachers to the
heir to the Russian throne was dictated by cheapness, by whoever was

least expensive. *And Voeikov continued to teach the heir arithmetic right up until the revolution.*
(Memoirs of G. I. Shavelsky. ГА РФ. Ф.640. Оп.1. Д.79. Л.7.)

538 Letter from Tsarevich Alexei Nikolaevich to his Mother, Empress Alexandra Feodorovna, 9 September 1916

In English
13.5 × 9 cm

Sept. 9. 1916
My dear Mama
This is my first English letter to you. Today I took my cat into the garden but she was very timid and ran on to the balcony. She is now asleep on the sofa and Джой [Joy – the dog] is under the table.
With love to you and my sisters. From
Alexey

ГА РФ. Ф.640. Оп.1. Д.79. Л.7

539 Letter from Tsarevich Alexei Nikolaevich to his Mother, Empress Alexandra Feodorovna, 9 December 1916

In English
13 × 8.5 cm

Stavka, 9th December 1916.
My dear Mama
Yesterday we again went into the forest and played at robbers, it was very jolly. As usual I had the pony. The snow is now very deep and the trees are quite covered too, so that we often get a shower of snow as we go under them. With much love from Alexey.

ГА РФ. Ф.640. Оп.1. Д.80. Л.24

540 Diary of Tsarevich Alexei Nikolaevich for 1916

Yellow silk cover with gold stamped pattern and the date *1916*; yellow metal lock; date *1916* stamped in yellow on the spine; pink moiré end-papers; inscribed by Empress Alexandra Feodorovna on the first page: *Первый дневник моего маленького Алексея. Мама. Царское Село.* [The first diary of my little Alexei. Mama. Tsarskoe Selo.]
13 × 18 cm; open 26 × 18 cm
ГА РФ. Ф.601. Оп.1. Д.1150. Л.156

In 1916, to be like his father, Tsarevich Alexei started to keep his first diary. The empress wrote to her husband at General Headquarters on 4 January 1916:

Baby seriously writes his diary, only is so funny about it. As little time in the evening, he writes in the afternoon about dinner & bed.
(ГА РФ. Ф.682. Оп.1. Д.189. Л.1–37.)

On days when Alexei was ill, one of his sisters, or his teacher
P. V. Petrov, wrote the entries for him.

27 July
*After a mud bath went to meet Mama and sisters. Had a family lunch in
the train. After lunch went for a drive. Then played at war in the woods.
Had dinner with the cadets [Agayev and Makarov]. Went to the municipal
gardens. The boys were playing. Sisters there also. Saw Mama in the
evening. Went to bed early.*

28 July
*In the morning studied after my mud bath. Had lunch with Mama in the
train. In the afternoon we sailed on the Dniepr and played at war. Had
dinner with the cadets. Watched some games in the municipal gardens.
Read. In the evening went to see Mama in the train. Went to bed early.*

29 July
*Had mud bath. Played in the garden. Studied. Had lunch alone with Mama
in the train. Went sailing on the Dniepr. The boys were playing, Papa
and I watched it all. Had dinner with the cadets. After dinner went to see
Mama and got a mass of presents. Went to bed late.*

30 July [Alexei's birthday]
*Went to church. Had lunch with everyone. Received a whole pile of
telegrams. Cadets gave me a pretzel. Went sailing on the Dniepr. I gave
the cadets boots and balalaikas. Went to see Mama. Went to bed late.*

31 July
*Went to church. Played in the gardens. Had lunch with everyone. Went
sailing on the Dniepr. Played and had dinner with the cadets. Went to the
picture-house. Saw Mama in the evening. Went to bed quite late.*

1 August
*Had mud bath. Then signed 13 telegrams and wrote 3 letters (yesterday
19 telegrams). Had lunch with everyone in the tent. A walk along the
Dniepr with Mama and sisters. Had dinner with the cadets. Went to the
municipal gardens. In the evening was in the train. Went to bed late.*

(From Alexei's Diary. Л. 213–218.)

On 13 December 1916 Empress Alexandra Feodorovna wrote to
her husband at General Headquarters:

*We must hand on a strong country to Baby [Alexei] and we dare not be
weak — for his sake, or else it will be even more difficult for him to
rule, trying to correct our mistakes and taking a strong grip of the
reins which you are loosening. You have been made to suffer for the
mistakes of your royal predecessors, and God alone knows the
torments you have been through. But your legacy must be lighter for
Alexei! He has a strong will and he knows his own mind. Don't let
anything slip through your fingers and force him to build it all up
again. Be firm ...*
(ГА РФ. Ф.601. Оп.1. Д.1151. Л.450.)

541 Grigory Rasputin, 1915

Unknown photographer
16 × 22 cm
ГА РФ. Ф.612. Оп.1. Д.47. Л.7

On 1 November 1905 Emperor Nicholas II wrote in his diary:
'We made the acquaintance of a man of God — Grigory from
Tobolsk province.' (ГА РФ. Ф.601. Оп.1. Д.249. Л.71.)

*From the very beginning there was something about him that I
didn't like and even repulsed me. He was of medium height,
muscular, almost thin. His hands were disproportionately long ...
His face, framed by a shaggy beard, was coarse: thickset features, a
long nose, a wandering expression in his small pellucid grey eyes,
which looked out from beneath thick brows. His strange manner was
striking. Although he was pointedly informal, one sensed a certain
reserve, even mistrust: one could say that he was constantly wary
of his companions.*
(Prince Felix Yusupov, 1993, pp. 104–5.)

There are many reasons for the appearance of such a man
as Grigory Rasputin in St. Petersburg society. Much can
be explained by the then modish enthusiasm amongst the
aristocracy for mysticism and spiritualism, and the fashion
for all things inherently Russian.

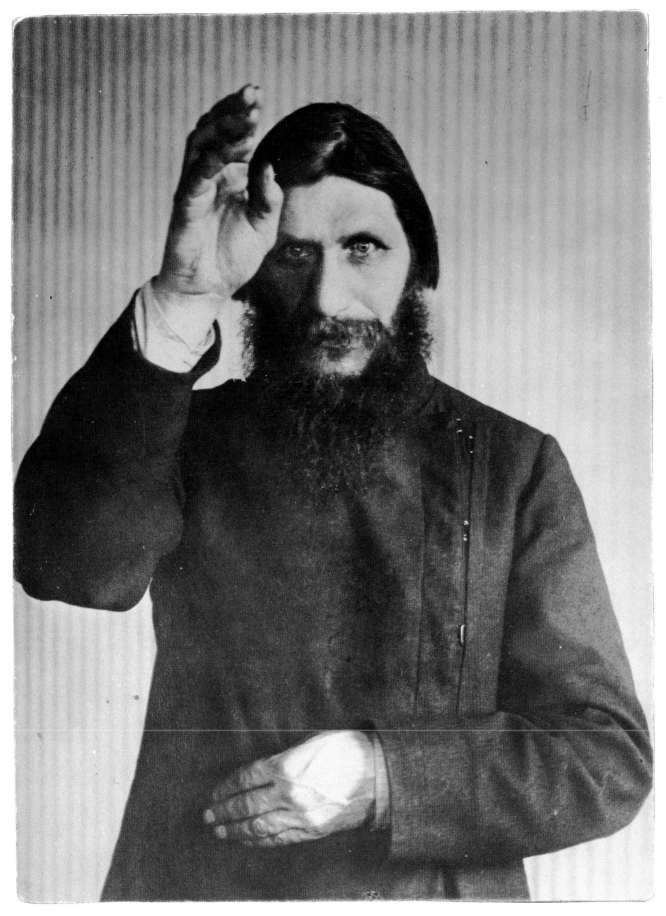

542 G. E. Rasputin with Empress Alexandra Feodorovna and the Imperial Children, 1910

Amateur photograph
Bottom row, left to right: Grand Duchesses Maria, Olga, the nursery-maid
M. Vishnyakova; top row, left to right: Grand Duchess Anastasia, Tsarevich Alexei,
Grand Duchess Tatiana, G. E. Rasputin, Empress Alexandra Feodorovna
8.5 × 8.5 cm
ГА РФ. Ф.612. Оп.1. Д.47. Л.8

After first meeting Nicholas and Alexandra in 1905, Rasputin did not immediately become the 'dear Grigory' to whom the imperial couple opened their souls. At first their meetings were accidental and infrequent. But from around the beginning of 1907 it seems that systematic meetings between Rasputin and the imperial family were occurring. The children, too, were present at these meetings, which took place at the house of Ania Vyrubova, lady-in-waiting to Alexandra Feodorovna.

On 25 June 1909 Olga Nikolaevna wrote to her father from Peterhof: *My dear darling Papa ... This evening Grigory is coming to see us. We are all so wonderfully happy to see him again ...* (ГА РФ. Ф.601. Оп.1. Д.1317. Л.33.)

Alexei's illness forged a fatal bond between the imperial family and Rasputin, for on several occasions the *staretz*, or holy man, seemed to have had a beneficial effect on the tsarevich. He undoubtedly had psychotherapeutic powers. According to contemporary accounts, Rasputin would say a prayer and lay his hands on the young boy, and the pain would leave him. The empress became firmly convinced that 'our friend Grigory' was irrefutably a 'man of God', bringing hope and support to her family.

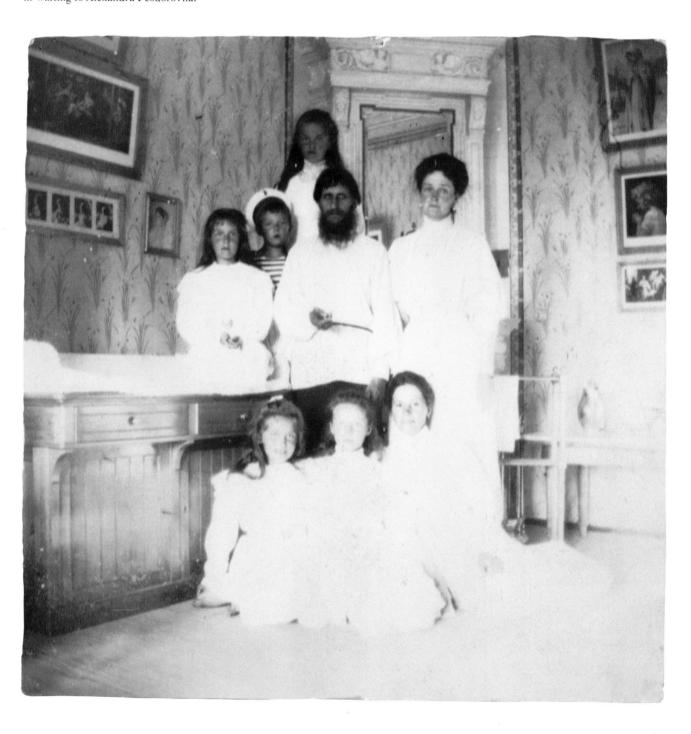

543 Notebook of Empress Alexandra Feodorovna, 1911

Blue calico cover
Signed by Alexandra Feodorovna in blue ink on the reverse of the flyleaf: *Александра*
Inscribed by Grigory Rasputin in black ink on the facing page: *Здесь мой покой славы источник во свете подарок моей сердечной маме Григорий февраля утре 1911* [Here is my peace, source of glory on earth, a present for my warm-hearted Mama. Grigory, February morning 1911]
14 × 22 cm; spread 28 × 22 cm
ГА РФ. Ф.640. Оп.1. Д.309. Л. 1–68

Despite all the gossip and unattractive rumours surrounding Rasputin, Alexandra Feodorovna could only see one side of him. In the words of the palace commandant V. N. Voeikov, the empress regarded him as 'a holy man', whom she 'always loved' (Voeikov, 1926, p. 200). In her eyes he was an Orthodox Christian, a prayer always on his lips, a man who wanted nothing for himself, but constantly mourned the fate of 'the simple people'. Rasputin received from Alexandra Feodorovna nothing more lavish than amulets, small icons, belts, embroidered shirts, and handkerchiefs. He in turn would send her Easter cakes that had been blessed, Easter eggs, and icons. But her most treasured gifts were the prayers and words of advice that he addressed to her, either personally or by telephone. She carefully kept all his notes and copied them into her notebook. Above all, the empress came to believe almost religiously in Rasputin's self-fulfilling prophecy: 'If I am no more, there will be no more tsar, no more Russia.'

544 Telegram from G. E. Rasputin to Empress Alexandra Feodorovna, 23 August 1916

Telegraph form on blue paper, with attached sheet of text written in Rasputin's hand: *Царское Село. Государыне императрице, Не грустите когда бы они с вами по радостно они поехали приготовить необъятную красоту всем воинам и вы успокоитесь тем же духом. Григорий Новый.* [Tsarskoe Selo. To her Majesty the Empress. Do not be sad when they are with you for they have gone joyfully to prepare unbounded beauty for all the troops and you should quieten your spirit with this. Grigory the New.]
22 × 29 cm
ГА РФ. Ф.612. Оп.1. Д.50. Л.1

During the war years Rasputin became quite at home within the tsar's family. The more complex the situation in the country became, the more Nicholas seemed to need the presence of this holy man and preacher, who talked about peace, love, hope and divine grace. On 17 October 1914 Nicholas received news of a combined Turkish and German attack on the Russian fleet in the Crimea. That evening he wrote in his diary: 'Felt utter fury against the Germans and Turks for their foul attack in the Black Sea! Only in the evening, under the influence of Grigory's soothing words, did my soul regain its equilibrium.' (ГА РФ. Ф.601. Оп.1. Д.202. Л.37.)

Rasputin was a natural preacher, and it is telling that the empress, in letters to her husband where she describes her meetings with 'dear Grigory', quotes from his telegrams, but never his spoken words. She herself admitted that it was 'difficult to convey what he says — words alone are not sufficient; it is the spirit in which they are spoken that illuminates them so.' (Correspondence of Nicholas and Alexandra Romanov, 1925, vol. v, p. 57.)

When I started to hear rumours that Rasputin was not as he seemed, that his behaviour in his private life was very different from the impression he gave within the imperial family, I warned my sister, but she remarked that she considered such rumours to be simply the kind of slander which generally pursued people who led a holy life. In December 1916 I had a final decisive conversation with the emperor and empress about Rasputin. I told them that Rasputin was creating considerable unrest within society and by compromising the imperial family was leading the entire dynasty to its destruction. They replied that Rasputin was a great man of prayer, that all the rumours were nothing but slander, and they asked me never to touch on the subject again.
(From the deposition of Grand Duchess Elizaveta Feodorovna to the Extraordinary Investigating Commission for the investigation into illegal activities by former ministers. Petrograd, 1917. ГА РФ. Ф.1467. Оп.1. Д.479. Л.23.)

I first talked to the former tsar about Rasputin on 17 March 1916. I told him that rumours about Rasputin's close relationship with the imperial family, his great influence over high government appointments, as well as the granting of contracts and deliveries for the army, and his leaking of military secrets acquired through his association with the tsar's family, that such rumours were rife in the army, and were causing considerable concern and damage to imperial prestige. The tsar listened silently, without interrupting, and when I said that Rasputin had been seen getting drunk with Jews and Germans, he remarked: 'So I have heard.' At the end of the conversation the former tsar asked whether I had been afraid to raise such a matter with him. My relations with the tsar were not affected by this conversation ...
(From the deposition of G. I. Shavelsky, Archpriest of the Russian army and fleet, to the Extraordinary Investigating Commission. ГА РФ. Ф.1467. Оп.1. Д.479. Л.24 об.)

544

545 Prince Felix Yusupov and his Wife Irina Alexandrovna, 1914

Photographer from the photographic studio of Boissonas and Eggler
Trade-mark of the photographic studio stamped in the lower left corner: *Boissonas et Eggler*
Mounted photograph: 11.5 × 12 cm; 19.5 × 26 cm
ГА РФ. Ф.642. Оп.1. Д.3476. Л.1

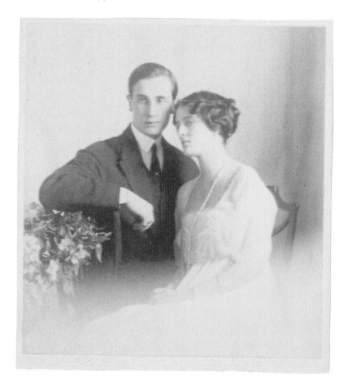

The monarch and the monarchy were in danger. This was clear to every member of the extended imperial family. The phrase 'something must be done' was constantly on the lips of those aristocrats who, by both birth and position, were inextricably linked to the dynasty. The central plan for 'saving the emperor' consisted in getting rid of Rasputin and distancing Empress Alexandra Feodorovna from the centre of power. Many plans were hatched, but only one — conceived by Prince Felix Yusupov — was destined to be realised. In February 1914 Yusupov had married Irina, the daughter of Grand Duchess Xenia Alexandrovna and Grand Duke Alexander Mikhailovich, and the favourite niece of Nicholas II. Irina's parents were fierce opponents of Rasputin, while Felix's mother, Zinaida Nikolaevna Yusupova, was another member of the aristocratic circle who despised Rasputin.

The plan for the murder began to take shape in November 1916. Yusupov drew into the plot Grand Duke Dmitry Pavlovich, Nicholas's second cousin and a great favourite of the tsar. They were joined by V. M. Purishkevich, a member of the State Duma from Bessarabia and a well-known figure in right-wing political circles.

The night of 16–17 December was chosen by the conspirators to carry out their 'plan of action'. Many versions of the night of the murder exist, notably that of Yusupov himself. Grand Duke Dmitry Pavlovich was the only principal participant not to leave a written record of the event.

546 Grand Duke Dmitry Pavlovich, 1910

Photographer from the photographic studio of Boissonas and Eggler, 24 Nevsky Prospect, St Petersburg
Inscribed by the grand duke in the lower right-hand corner of the mount:
Дмитрий. 1910 год. На память о удивительно милом вечере 30 октября.
[Dmitry, 1910. In memory of a wonderful evening 30 October.]
Trade-mark of photographic studio on the reverse
Mounted photograph: 10 × 19 cm; 22 × 34 cm
ГА РФ. Ф.646. Оп.1. Д.295. Л.1

The place chosen for the murder was the Yusupov palace on the Moika, and the night of 16 December was designated for putting the plan into action. Before the crime, the young Felix spent a long time praying alone in Kazan cathedral. At home he informed his people that he would be having a few young men around with some ladies for drinks and supper, so all the extra staff were sent home and only a few servants remained downstairs — and they kept out of the way. Those invited were Grand Duke Dmitry Pavlovich, Purishkevich, Sukhotin, and a doctor brought along by Purishkevich, whose name I don't remember. Tea and refreshments had been prepared for them upstairs, while downstairs in the young Yusupovs' dining-room a cold supper and drinks were laid out, and it was here that Rasputin and Yusupov sat down together. They spent about 3 hours there (from 12.15 until 3 o'clock), until Grisha [Rasputin] was drunk. Felix served him wine laced with poison (potassium cyanide), but to his astonishment and increasing despair it had no effect. Seeing that his plan was not working and that Rasputin was just getting gradually drunk, Felix left him alone in the dining-room and dashed upstairs to the other conspirators where he declared in a very agitated voice: 'Gentlemen, I don't understand, but the poison isn't working. Give me a revolver, we'll have to finish him off by shooting him.' It turned out that Dmitry Pavlovich had a revolver; for some time he refused to give it to Yusupov, but eventually he was persuaded.

Returning to the dining-room, Yusupov sat right next to Rasputin and still talking to him fired a shot at point blank range. The bullet entered Rasputin's lung, passed through his liver, and he fell unconscious to the floor — to all intents and purposes a dead man. With the deed apparently completed, Yusupov returned upstairs and summoned the others to the dining-room. The doctor observed Rasputin's dying agony and declared that in a few minutes he would cease to breathe ... Then something unbelievably dramatic occurred. As Yusupov knelt beside the body, feeling for a pulse or a heartbeat, both of which seemed to have stopped, the supposed corpse suddenly opened his left eye, then his right and stared with a look of ferocious, burning hatred at his would-be murderer, who jumped back in horror. He only managed to step a few paces back before Rasputin, with a tremendous effort, drew himself up to his full height, and threw himself like a wild animal at Yusupov (who had left the revolver upstairs), tearing off his epaulettes and clutching at his jacket. Yusupov screamed and together with Rasputin struggled out onto the winding staircase where he managed to shake him off. Rasputin fell to his knees and tried to climb the stairs on all fours, foaming at the mouth, roaring and snarling like a wounded beast.

In an instant Yusupov ran to Purishkevich for help. On returning to the staircase, they found to their amazement that Rasputin was no longer there: he had managed to escape as far as the inner entrance, where he had summoned sufficient strength to haul himself up and open the unlocked door into the courtyard. Catching him up, Purishkevich fired two shots: one hit him in the back of the head,

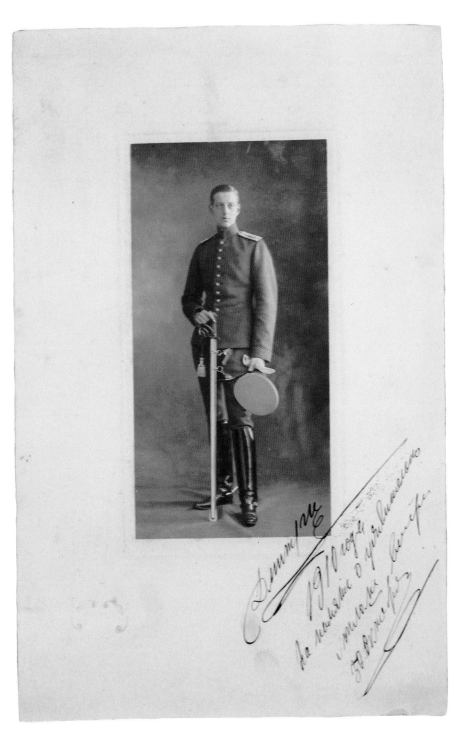

546

the other in the leg. Rasputin let out a groan as he fell to the ground
and then started to crawl towards one of the outer gates of the palace.
Here Yusupov caught up with him and started to hit him with a
rubber club until his victim finally expired.
(From the notes of Grand Duke Nikolai Mikhailovich, 19
December 1917, published in the journal *Красный архив* [Red
Archive], 1931, No. 6, pp. 98–101.)

547

547 Collective Letter Written by Members of the Imperial Family
to Emperor Nicholas II appealing for Clemency for Grand
Duke Dmitry Pavlovich (after the Murder of Rasputin), with
Emperor Nicholas II's Resolution, 29 December 1916

Hand-written text
22 × 35.5 cm; spread 44 × 35.5 cm
Inscribed by Emperor Nicholas II in black ink at the top: *Никому не дано право заниматься убийством; знаю, что совесть многим не дает покоя, так как не один Дмитрий Павлович в этом замешан. Удивляюсь вашему обращению. Николай.*
[Nobody has the right to commit murder; I know that many are troubled by their conscience, since Dmitry Pavlovich is not the only one involved in this. I am surprised at your request. Nicholas]

YOUR IMPERIAL MAJESTY, all of the signatories to this letter fervently and earnestly ask YOU to moderate your harsh decision concerning the fate of Grand Duke Dmitry Pavlovich. We know him to be physically frail and deeply shaken, as well as morally distressed. As his former guardian and principal trustee, YOU know how ardently his heart is filled with love for YOU, THE EMPEROR, and for our homeland. We beg YOUR IMPERIAL MAJESTY to take into account the youth and decidedly poor health of Grand Duke Dmitry Pavlovich and to permit him to reside at either Usov or Ilinskoe. YOUR IMPERIAL MAJESTY must be aware of the basic conditions endured by our troops in Persia; in view of the absence of proper living quarters, epidemics and other scourges of humanity, for Grand Duke Dmitry Pavlovich to take up residence there would be the equivalent of his complete destruction, and the heart of YOUR IMPERIAL MAJESTY will surely be moved to compassion for a young man whom you have loved, who from childhood has been fortunate to spend a great deal of time in YOUR company, and to whom YOU have always been as good as a father.
May the Lord God inspire YOUR IMPERIAL MAJESTY to change your decision and replace anger with mercy.

YOUR IMPERIAL MAJESTY'S
Deeply devoted and sincerely loving

Olga [Konstantinovna, dowager queen of Greece]; *Maria* [Pavlovna
(the elder), grand duchess]; *Kyril* [Vladimirovich, grand duke];
Victoria [Feodorovna, grand duchess]; *Boris* [Vladimirovich, grand duke];
Andrei [Vladimirovich, grand duke]; *Pavel* [Alexandrovich, grand duke];
Maria [Pavlovna (the younger), grand duchess]; *Elizaveta* [Feodorovna,
grand duchess]; *Ioann* [Konstantinovich, prince of imperial blood];
Elena [Petrovna, princess]; *Gavril* [Konstantinovich, prince of imperial
blood]; *Konstantin* [Konstantinovich, prince of imperial blood];
Igor [Konstantinovich, prince of imperial blood]; *Nikolai Mikhailovich*
[grand duke]; *Sergei Mikhailovich* [grand duke]

ГА РФ. Ф.644. Оп.1. Д.53. Л.1–2

The empress encouraged the emperor to deal severely with those
responsible; but in fact the most guilty of all — Felix Yusupov — got
away with being exiled to one of his country estates, while Grand
Duke Dmitry was ordered to go to Persia. Grand Duke Dmitry was
kept under house arrest at his palace in Petrograd right up to his
departure, forbidden even to go out or receive anyone. He left on the
night of 23 December [5 January] and no one, not even his father,
was able to embrace him or bid him farewell. The emperor's relations,
and the town as a whole, were greatly disturbed by this. It was decided
that a petition should be addressed to the emperor, begging him not to
punish Grand Duke Dmitry so severely and not to exile him to Persia
in view of his delicate state of health. It was I who drafted the text of
the petition. At that moment his exile seemed like the height of cruelty,
but God willed that it actually spared Dmitry's precious life, for
those who remained in Russia perished at the hands of the Bolsheviks
in 1918–19 ... This historical document remained in my house at
Tsarskoe Selo, and I do not know what happened to it afterwards.
(Princess Olga Paley, 1926, pp. 344–5.)

548 Brief Report by Secretary of State A. Taneev concerning 'the
Movement of His Imperial Majesty's Personal Funds' during
the Twenty-Year Period from 1896 to 1916,
Compiled in February 1917

Typographic copy
15.5 × 33 cm; spread 31 × 33 cm
ГА РФ. Ф.601. Оп.1. Д.1756. Л.4 об.–5

In peacetime the imperial family's budget was made up from
three sources: the state treasury allocated 11 million roubles
every year for expenditure; a sum of about two and a half million
roubles was received in the form of income from appanage or
crown domains, these being the property of the emperor and his
relatives. (The former palace lands were given the title 'appanage'
in 1797 on the establishment of the 'Foundation for the Imperial
Family'. The initial surface area of these lands was 4.2 million
desyatins (about 11 million acres), besides which another 3.5
million *desyatins* (about 9.5 million acres) were held in common
ownership with the treasury and landowners. This category
included not only arable land, but also woods, vineyards,
orchards and mines which had already been acquired by
Catherine II. A significant proportion of the appanage lands was
leased out to tenants.) The third source of revenue was income
from deposits held in foreign banks. However, financial dealing,
which was the responsibility of the minister of court, was subject

to stringent restrictions. In order to prevent rumours of the tsar
being personally interested in the development of this or that
branch of industry, the imperial family was forbidden to invest in
private companies and enterprises, either in Russia or abroad.
At the beginning of every year Nicholas II received about 20
million roubles. From this sum each of the grand dukes was
allocated a pension of 200,000 roubles, and large sums also went
on legacies at the birth or death of a member of the imperial
family.

The emperor was responsible for the upkeep of five extensive
palaces and a large number of staff. Twice a year, at Christmas
and on the emperor's name day, the butlers, coachmen, grooms,
footmen, cooks and servants each received expensive presents
such as gold watches, cigarette cases, brooches and rings. The
tsar spent about two million roubles a year on the upkeep of the
imperial theatres, the ballet and the theatrical school. During
the First World War more than 20 million pounds sterling of the
imperial family's private funds, which had been held in foreign
banks, was spent on hospitals and aid for the wounded. On
21 February 1917, according to calculations made by the
secretary of state of the imperial court ministry, 'the sums at the
disposal of His Imperial Majesty's Own Chancellery amount to:
in cash — 469,858 roubles and 23 kopecks; in interest-bearing
securities — 1,793,383 roubles and 23 kopecks.' (ГА РФ. Ф.601.
Оп.1. Д.1756. Л.2.)

548

Affairs of State

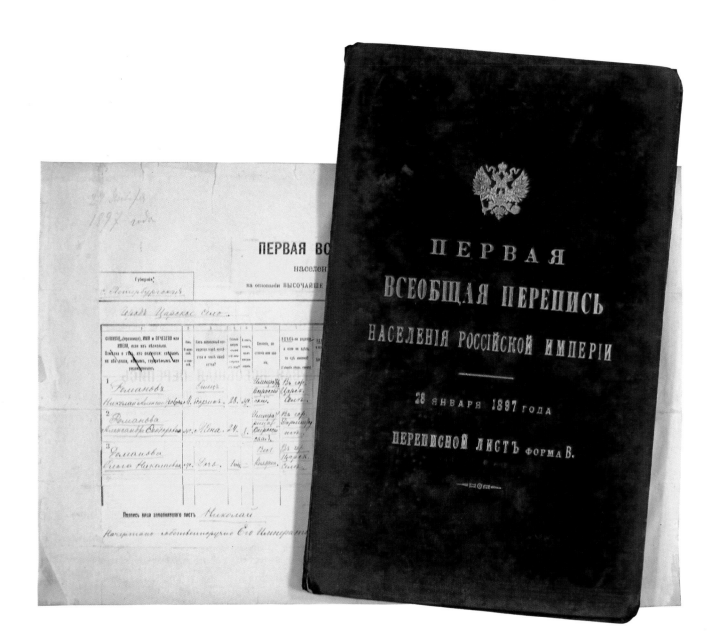

549 Questionnaire of the First General Census of the Population,
Completed by Emperor Nicholas II in His Own Hand,

28 January 1897

Velvet cover
Cover 27 x 44 cm; spread 52 x 39 cm
ГА РФ. Ф.601. Оп.1. Д.2. Л.1–2

The first all-Russian census was conducted at the beginning of 1897. This revealed that Russia had a population of 126.4 million people (not counting the two and a half million inhabitants of the Grand Duchy of Finland). As the head of a family, Nicholas II also completed a form. He provided information about himself, his wife and his daughter Olga. To the question relating to his occupation, Nicholas replied: 'Хозяин земли русской' — 'Master of the Russian land'. In the mind of the last tsar, autocracy and Russia were indivisible.

551 Address from Citizens of America to Emperor
Nicholas II Regarding his Convocation of a Peace
Conference at the Hague, 1899

In English
21 × 28.5 cm

To His Imperial Majesty Nicholas II Czar of All the Russias

*We, the undersigned, sovereign citizens of the United States of America,
without regard to race, creed, or political affinity, desire to express our
hearty sympathy with the Czar's noble effort for the cause of God and
humanity. Appreciating the difficulties which confront him at home and
abroad, we admire the high moral courage with which he dares to face
them, in the faith which, in all ages, has removed mountains. We think
no more fitting place can be found from which to start an American
crusade, than this city of Philadelphia (Brotherly Love), and this State of
Pennsylvania, whose founder, in 1693, published an appeal for arbitration
to the nations of Europe, while war was raging among them, and practically
gave them an illustrious example of what a colony can be whose chief
defenses are arbitration and justice extended to all men. Here, from the
cradle of liberty, where later we proclaimed that not only ourselves, but
all the world, had a right to 'life, liberty and the pursuit of happiness' we
stretch forth the helping hand to Russia, our friend, when she 'bringeth
good tidings, when she publisheth peace.'*

*The Czar of Russia, Nicholas II, has called a Conference of all those
nations which send representatives to St. Petersburg, to meet at
The Hague, May 18th, 1899, to consider a plan to promote 'Arbitration
and Gradual Disarmament.'*

550 The Anthem *God Save the Tsar* Embroidered on Silk, 1890s

Cover 27 × 35; spread: 54 × 35
ГА РФ. Ф.601.Оп.1. Д.2032. Л.1–2

In 1833 Emperor Nicholas I, on his return from a visit to
Austria and Prussia, ordered his aide-de-camp Alexei Lvov
to compose a new anthem. In the 1830s France, Austria and
England all had their own national anthems, while Russia's
was set to an English tune. For the new anthem, Lvov adapted
the words of V. Zhukovsky's 'Prayers of the Russian People'
(although in his memoirs he maintains that Zhukovsky wrote
the words especially for his music). Nicholas I and his family
were delighted with the anthem. At its first performance in
1833, when it was sung by a choir accompanied by two military
orchestras, Nicholas I was so enraptured by the new anthem
that he ordered it to be repeated several times.

The anthem was first performed in public at the Bolshoi Theatre
in Moscow on 6 December 1833, in honour of the name day of
Nicholas I; at Christmas the same year, by personal order of
the emperor, it was performed by military orchestras in every
hall of the Winter Palace. A week later, Nicholas I decreed that
the anthem should be performed at all parades and official
ceremonies.

551

We desire to send him the enclosed address of sympathy, and invite all who will unite with us to add their signatures.

Mrs. ALANSON HARTPENCE, 405 South Twenty-Second Street.
PHILIP C. GARRETT, Logan, Pa.
Mrs. E. D. GILLESPIE, 250 South Twenty-First Street.
Miss JULIANNA WOOD, 1620 Locust Street.
RICHARD WOOD, 1620 Locust Street.
Mrs. LOUIS RODMAN FOX, 1800 DeLancey Place.
Mrs. WILLIAM BACON STEVENS, Rittenhouse Square.
HERBERT M. WELSH, Editor of City and State.
Miss REBECCA WETHERILL, 1340 Walnut Street.
Miss IDA CUSHMAN, 1340 Walnut Street.
Miss ALICE CUSHMAN, 1340 Walnut Street.
ASA S. WING, Vice-President Life and Trust Co.
Miss JOLLIFFE, Aldine Hotel.
Rev. FLOYD W. TOMKINS, Rector of Holy Trinity.
Miss AGNES REPPLIER, 1208 Spruce Street.
Rev. EDWARD B. HODGE, Cor. Sec. of Board of Education
of Presbyterian Church.
G. COLESBERRY PURVES, 1812 Pine Street.
ISAAC SHARPLES, President of Haverford College.
Most Rev. PATRICK J. RYAN, Roman Catholic Archbishop of Philadelphia.
Rev. GEORGE DANA BOARDMAN, West Philadelphia.
Mr. and Mrs. JOHN H. CONVERSE.
FRANCIS B. GUMMERE, Professor, Haverford College.
Rev. JOSEPH MAY, First Unitarian Church.
JOHN M. SHRIGLEY, Williamson Free School of Mechanical Trades.
Miss REBECCA MOSS, 269 South Twenty-First Street.
Rev. CYRUS D. FOSS, Methodist Episcopal Bishop, Philadelphia.
HOWARD M. JENKINS, Editor of Friends Intelligencer.
M. CAREY THOMAS, President of Bryn Mawr College.
J. B. REEVE, Pastor Lombard Street Cen. Presbyterian Church.
With many others.

The address was signed by a total of 4,665 American citizens from 50 towns of the United States.
ГА РФ. Ф.601. Оп.1. Д.721. Л.1

During the first years of his reign Nicholas was preoccupied with finding solutions to two related problems: ending the threat of war and making economies in state resources. On 12 August 1898 the representatives of the foreign powers in St. Petersburg were presented with a memorandum by the Russian foreign minister which was highly critical of the escalating international arms race; the anti-military stance taken by Russia received a very muted response from the leading world powers.

However, this Russian initiative did achieve a positive result. In the early summer of 1899, the first international conference was held in the Dutch city of The Hague, attended by plenipotentiary envoys from 27 countries. Important international guidelines were established on matters relating to military activity in both war- and peacetime in the form of a declaration concerning the peaceful resolution of military disputes, and the rules and conventions governing war on land and at sea. The declaration was confirmed by the international court at The Hague (which functions to this day under the aegis of the UN).

552 Diary of Emperor Nicholas II for 1905, Entry for 17 October

Exercise book in a black leather cover
18 × 22 cm; spread 36 × 22 cm

Nikolasha and Stana came to lunch [Grand Duke Nikolai Nikolaevich and his wife]. We sat and talked while we waited for Witte to arrive. Signed the manifesto at 5 o'clock. After such a day my head felt heavy and my thoughts became muddled. Lord, help us, save and pacify Russia!

ГА РФ. Ф.601. Оп.1. Д.249. С.1–201 (с.61–62)

17 October 1905 was one of the most important days in Russia's twentieth-century history, and a fateful day in the life of Nicholas himself. His signing of the manifesto of 17 October, by which the emperor granted the country a Duma (a legal and consultative body) and guaranteed a series of democratic reforms, was considered by Empress Alexandra Feodorovna to be a fatal mistake which undermined the foundations of the autocracy.

The chief proponent of the manifesto was Sergei Witte, chairman of the Committee of Ministers. He recounts how he was told by the Minister of Court, Baron Fredericks, that on the eve of signing this crucial document Nicholas II had wavered between declaring a dictatorship and conceding to the demands of the nation, and that he only reached a decision after receiving an ultimatum from Grand Duke Nikolai Nikolaevich:

The grand duke drew a revolver from his pocket and said: 'You see this revolver. I am going to the emperor now and I shall beseech him to sign the manifesto and Count Witte's programme, and either he signs, or in his presence I will put a bullet through my head with this

[Handwritten diary page in Russian]

552

553 The Fundamental State Laws of the Russian Empire,
23 April 1906

22 × 31 cm; spread 44 × 31 cm
ГА РФ. Ф.601. Оп.1. Д.907. Л.2–8

*After the adoption of the manifesto of 17 October, it became necessary
to re-draft the Fundamental Laws of the Russian Empire. At the
beginning of April 1906 this was discussed in the presence of
Emperor Nicholas II at Tsarskoe Selo. The essential tenet of such
an undertaking was that any review of the Fundamental Laws could
only be initiated by the emperor. The most contentious part of the new
draft was clause 4 which read: 'Supreme autocratic power is invested
in the emperor of all the Russias.' The previous version had read:
'autocratic and unlimited'. For Nicholas this was an issue that
caused him great anguish: 'I held onto the draft for a whole month.
One question tormented me constantly: did I have the right, in
relation to my ancestors, to change the limits of powers which I
had inherited from them.'*
(Oldenburg, 1992, p. 315.)

Three days later the emperor crossed out the word 'unlimited'
from the formulation of the clause on power, leaving simply
'autocratic'. According to the Fundamental Laws of 1906, no bill
presented by the government could become law without the
approval of the State Duma and the Council of State. In effect,
the emperor's power was no longer absolute.

*revolver.' And with those words he hurried away. After a short time
the grand duke returned and relayed to me the order to prepare the
final draft of the manifesto and the address, which I was then to take
with me to the emperor for his signature.*
(Witte, 1960, vol. iii, pp. 41–2.)

The emperor described the events to his mother in Denmark:

*During these terrible days I have been with Witte almost all the time;
our conversations began first thing in the morning and continued
until dark. I was faced with choosing between two courses of action:
to appoint an energetic military man and crush the sedition with the
utmost force, as a result of which there would be a respite of a few
months before force would be required once more … The other way
was to grant the population citizens' rights — freedom of speech,
freedom of the press, the right of public assembly and unions, and
the inviolability of the individual. Furthermore, every bill has to
pass through the State Duma — this is in effect the granting of a
constitution. Witte argues passionately for the latter course of action,
saying that although it is not without risk, it is the only way at the
present time … He told me straight that if I wanted to name him
prime minister, I would have to agree to his programme and not
hinder his policies.*
(ГА РФ. Ф.640. Оп.1. Д.2328. Л.11–14 об.)

553

554 Sergei Yulevich Witte, 4 February 1904

Photograph by K. Shapiro
Inscribed by Witte in black ink at the bottom of the photograph: *В знак глубокого уважения и сердечной дружеской преданности. Сергей Витте. 4 февраля 1904 г.* [As a mark of deep resepct, sincere friendship and devotion. Sergei Witte. 4 February 1904].
Stamped in the lower right corner. *К. Шапиро* [K. Shapiro]
Mounted photograph: 13.5 × 19.5 cm; 14 × 20 cm
ГА РФ. Ф.660. Оп.3. Д.123. Л.1

Sergei Yulevich Witte (1849–1915), count (from 1905), secretary of state, member of the Council of State, honorary member of the Academy of Sciences, director of the department of railways, Minister of Finance (1892–1903), chairman of the Committee of Ministers (1903–5), Prime Minister (from 20 October 1905 to 20 April 1906) and chairman of the Finance Committee (1906–15).

'An outstanding figure, who showed at crucial moments that he was not up to the task. A great mind, but a shallow soul.' (Vodovozov, 1922, p. 1.) This was an opinion of Witte that was often expressed, both in his lifetime and after his death in 1915.

Despite such unflattering assessments of Witte's character, he was nonetheless the one government official who understood that in order to preserve the monarchy, concessions had to be made to society, that some measure of reform was needed. Not only was he aware of this, he was able to convince Nicholas II of the necessity of these changes, which resulted in the adoption of the manifesto of 17 October and the new Fundamental State Laws.

555 Nicholas II Meeting the French President E. F. Loubet, 1902

Unknown photographer
24 × 18 cm
ГА РФ. Ф.601. Оп.1. Д.754. Л.17

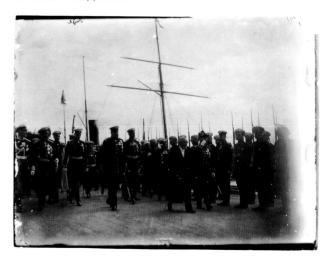

Tuesday 7 May.
At 8 o'clock in the morning I went to Peterhof with Uncle Sergei; atrocious weather. Misha joined us at Ligov. From the jetty we boarded the Alexandria *and went over to Kronstadt. At the same time a detachment of French ships entered the roadstead between two lines of our ships. The cruiser* Montcalm *with Loubet on board came alongside, and Uncle Alexei escorted the president onto the* Alexandria. *Once his full retinue had boarded, we headed back to Peterhof.*
(Nicholas's Diary for 1902. ГА РФ. Ф.601. Оп.1. Д.244. Л.45 об.–46.)

From the first days of his reign Nicholas, following his father's example, strove to turn the Franco-Russian alliance from an instrument of retaliation into one of European reconciliation. During the emperor's first visit to the French Republic in the autumn of 1896, a joint declaration was issued confirming the strongest ties of allegiance between St. Petersburg and Paris. The French President F. Faure's return visit to Russia in 1897 was a further demonstration of the firm intention of the two powers to strengthen their alliance. Four years later, in August 1901, Nicholas II visited France for the second time. He was present at manoeuvres of the French navy at Dunkirk and of the army at Rheims. Germany viewed this growing alliance between Russia and France with displeasure, and Wilhelm II tried to maintain ties with Russia, largely through his personal correspondence with his Russian 'cousin Nicky'.

In the spring of 1902 the French President E. F. Loubet paid a return visit to St. Petersburg.

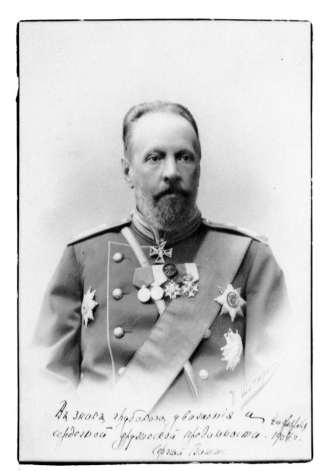

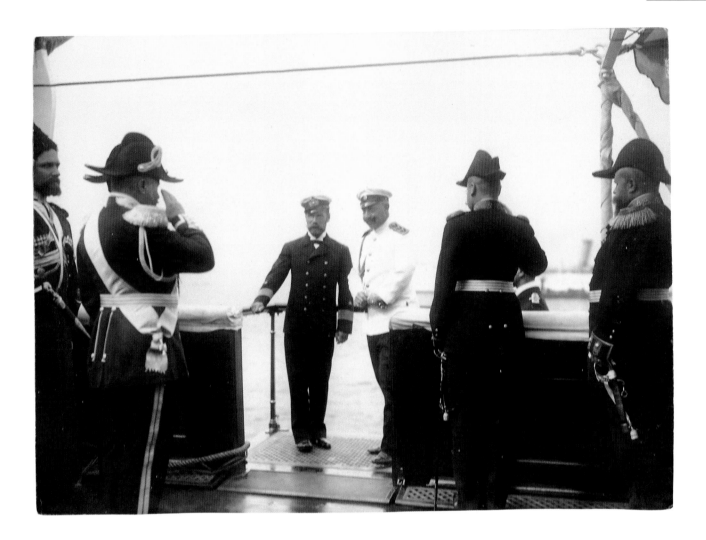

556 Meeting of Emperor Nicholas II and Emperor Wilhelm II,
Svinemunde, 1907

Unknown photographer
22 × 16 cm
ГА РФ. Ф.601. Оп.1. Д.752. Л.10

On 21 July 1907 a meeting took place at Svinemunde between
Nicholas and Wilhelm, their first such encounter since the talks
at Bjorko two years previously. That meeting in June 1905 had
ended with Nicholas unexpectedly signing an agreement drawn
up by Wilhelm, which completely contradicted all Russia's
previous alliance obligations towards France. A few months later,
Nicholas was obliged to send Wilhelm a letter effectively reneging
on his signature of the agreement. Wilhelm, however, refused to
believe that Russia would not change her pro-France policies; it
was only after the meeting at Svinemunde that he was finally
convinced.

The German emperor's bizarre behaviour did not go unnoticed by
his contemporaries:

*The German emperor's retinue clearly paid little attention to their
monarch's eccentric behaviour. At Svinemunde, when replying to
Nicholas II's toast, Wilhelm got carried away and gave a most
unexpected impromptu speech, which was accurately noted down
by my stenographers. A little later the Germans handed me their text
of the speech, which bore very little relation to the incautious remarks
just made by Wilhelm II. Chancellor von Bülow asked Izvolsky to
release the text they had prepared to the Gavas agency, since this was
the speech that the kaiser 'should have given', had his temperament
not got the better hand of his discretion. Izvolsky hesitated, but
eventually gave in.*
(Mosolov, 1993, p. 145.)

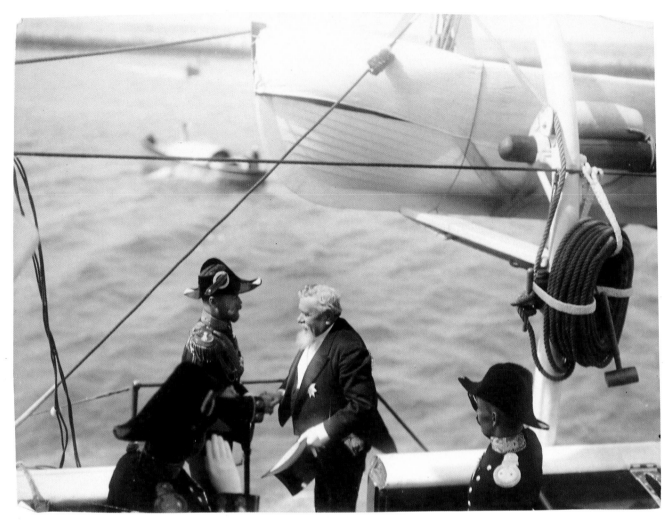

557 Emperor Nicholas II and the French President Armand
Fallières on Board the Yacht *Standart*, Revel, 14 July 1908

Unknown photographer
23 × 17 cm
ГА РФ. Ф.601. Оп.1. Д.754. Л.31

In July 1908 Nicholas II travelled to Revel, where he met the
new French president Armand Fallières. Shortly before, in May
of the same year, the Russian emperor had met the English king
Edward VII. It was the first visit to Russia of a reigning British
monarch, and it is significant that it was also at Revel that
Nicholas received the British monarch: the triple alliance of
Russia, France and England had become a reality.

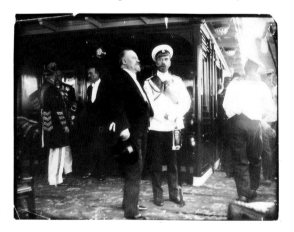

558

558 Emperor Nicholas II and the French President Raymond
Poincaré on Board the Yacht *Alexandria*, Kronstadt, July 1914

Unknown photographer
24 × 18 cm
ГА РФ. Ф.601. Оп.1. Д.754. Л.12

In January 1913, Prime Minister Raymond Poincaré was elected
president of France.

*Our ambassador in Paris wrote to inform me that the new president
of the republic intended to make an official visit to Russia at the first
available opportunity. On 7 July Monsieur Poincaré arrived at
Kronstadt on the battleship* La France, *accompanied by his prime
minister and foreign minister, Monsieur Viviani.*

*The meeting between the emperor and the president took place on
the Kronstadt roadstead; it was a highly ceremonial and amicable
encounter ... The yacht then took us to Peterhof, where rooms had
been prepared for the president in the great Petrovsky Palace.*

*The president's visit to Russia lasted three days: three fateful days
in the history of mankind, in the course of which a series of insane
and criminal decisions were made, which plunged Europe into
unprecedented disaster, reduced it to ruins and set back its normal
development for many long years.*
(Sazonov, 1990, p. 179.)

559 Nicholas II's Decree to the Army and Navy Declaring Himself Supreme Commander, 23 August 1915

22 × 32 cm
Typewritten text
Inscribed in Nicholas II's hand:

With a firm belief in the mercy of God and an unshakeable faith in our final victory, we will fulfil our sacred duty to defend Russia to the end and we will not bring shame unto the land of Russia. Nicholas.

ГА РФ. Ф.601. Оп.1. Д.619. Л.1

In the summer of 1915, Nicholas II decided to relieve Grand Duke Nikolai Nikolaevich of his position as supreme commander, and to assume command of the army himself. It was a tragic mistake which bore fatal consequences for the country. From that moment on, every reversal at the front was linked directly with the emperor. And since he was stationed almost permanently at General Headquarters at Mogilev, he essentially relinquished the reins of government.

On hearing of the emperor's intention, the president of the Fourth State Duma, M. V. Rodzianko, begged him to reconsider his decision, on 12 August 1915:

Is it not evident, Your Majesty, that You are voluntarily handing over Your own inviolable person to the judgement of the people — and that this will be the ruin of Russia. Think, Your Majesty, against whom you are raising Your hand — against Yourself, sire! The people will interpret this move as the work of the Germans who surround You, and who in the minds of the people are linked to our enemies and the betrayal of Russia's cause.
(ГА РФ. Ф.601. Оп.1. Д.616. Л.1 об.)

The government was of the same opinion. On 21 August 1915 eight ministers addressed the following letter to the emperor:

Your Majesty, once more we dare to suggest to You that, in our opinion, Your decision threatens Russia, You Yourself and Your dynasty with tragic consequences.
(ГА РФ. Ф.601. Оп.1. Д.620. Л.1)

The Dowager Empress Maria Feodorovna also tried to dissuade her son from taking such an ill-considered step. On 12 August she wrote in her diary:

Nicky came with all four daughters. He started to talk about assuming supreme command instead of Nikolai. I was so horrified I almost had a stroke. I told him everything, I insisted that it would be a huge mistake! I begged him not to do it. Especially now, when our situation at the front is so serious. I added that if he did it, everyone would think it was at Rasputin's bidding. I think this made an impression, for he blushed deeply! He doesn't understand how dangerous it is, and what misfortune this could bring to us and the whole country.
(*Posledniye Novosti* [Latest News], 21 July 1933.)

However, Nicholas genuinely believed that his presence would raise the fighting morale of the troops, strengthen their faith in victory, and help turn the tide of the war. He was also strongly encouraged in this course of action by Empress Alexandra Feodorovna.

Monday 24 August ... Signed the edict for [Grand Duke Nikolai Nikolaevich] *and the order to the army about assuming supreme command as from yesterday. Lord, help and guide me!*
(Nicholas's Diary for 1915. ГА РФ. Ф.601. Оп.1. Д.263. Л.73.)

560 Portrait of Grand Duke Nikolai Nikolaevich (the Younger), Early 1900s

Unknown artist
Lithograph in a wooden frame under glass; crown above the portrait
15.5 × 21 cm; frame 24.5 × 33 cm
ГА РФ. Ф.826. Оп.1. Д.937. Л.1

Grand Duke Nikolai Nikolaevich (the younger) (1856–1929), was the eldest son of Nikolai Nikolaevich (the elder) and his wife Alexandra Petrovna. Grandson of Nicholas I, he became an adjutant-general and cavalry general. He graduated from the Nikolaevsky engineers' college and the Nikolaevsky General Staff academy. In 1871 he joined the Lifeguard Hussars regiment. From 1895 to 1905 he was inspector-general of the cavalry, and from 1905 to 1908 chairman of the Council for State Defence. He commanded the Guards and the St. Petersburg military district from 1905 to 1914.

In 1914 he became supreme commander of all the Russian forces, a position he held until August 1915 when he was removed from the post and appointed governor-general of the Caucasus and commander of the Caucasus regiments. On 2 March 1917 he was reappointed supreme commander by Nicholas II, but was removed from the post a week later by the Provisional Government. He then resided at his brother's estate in the Crimea until April 1919, when he emigrated with Empress Maria Feodorovna.

In 1907 he married Grand Duchess Anastasia Nikolaevna, born princess of Montenegro. There were no children. He died in France on 5 January 1929.

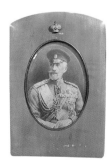

559

560

The Church

561 Dossier from the Third Department of His Imperial
Majesty's Office: Titular-Councillor N. A. Motovilov's
Report on the Prophecies of St. Seraphim of Sarov, 1854

25 × 38 cm; spread 50 × 38 cm

*They will wait for a time of great hardship to afflict the Russian land, and
on an agreed day, at the agreed hour, they will raise up a general rebellion
all over the Russian land, and, since many soldiers will join in their evil-
doing, there will be no one to stop them, and at first much innocent blood
will be spilt, it will run in rivers over the Russian land, and they will kill many
of your brother nobles and priests, as well as merchants who support the
emperor.* (Prophecy of St. Seraphim of Sarov.)

ГА РФ. Ф.601. Оп.1. Д.2. Л.1–2

In 1854, N. A. Motovilov (1809–79), a hereditary noble and
owner of estates in several provinces, contacted Count V. F.
Adlerberg, Minister of the Imperial Court, asking permission to
inform the emperor of the prophecies of Seraphim of Sarov. Born
P. S. Moshnin, Seraphim (1759–1833) was a novice, then a monk
at the Sarov monastery; he became a hermit, observing a strict
vow of silence for many years, and was famous for his righteous
life. Motovilov knew Seraphim, and during their conversations
the *staretz* (holy man) revealed his prophecies, bidding Motovilov
to bring them to the attention of the emperor after his death.
Motovilov received permission from the court, and sent the
emperor several notes in which he revealed the prophecies of
Seraphim of Sarov. In 1905 Empress Alexandra Feodorovna
ordered that copies of the prophecies be made for her.

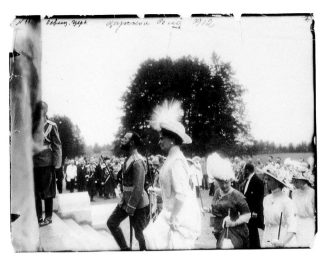

562

563

562 Emperor Nicholas II and Empress Alexandra Feodorovna, with Grand Duchesses Tatiana and Olga, at the Consecration of the Feodorovsky Cathedral at Tsarskoe Selo, 20 August 1912

Unknown photographer
24 × 18 cm
ГА РФ. Ф.601. Оп.1. Д.1672. Л.7

Monday 20 August.
At 9 o'clock the whole family set out for Tsarskoe Selo, all except
Alexei. At 10 o'clock the consecration of our regimental church began.
It has turned out remarkably beautifully and is quite in the spirit of
the ancient Moscow churches. We liked it enormously, also the lower
church which is reminiscent of a cave.
(Nicholas's Diary for 1912. ГА РФ. Ф.601. Оп.1. Д.258. С.192.)

563 The Feodorovsky Cathedral at Tsarskoe Selo, 1913

Unknown photographer
24 × 18 cm
ГА РФ. Ф. 601. Оп.1. Д.1672. Л.14

In 1881, after Alexander II was murdered by terrorists, Alexander
III ordered the formation of His Imperial Majesty's Combined
Infantry Regiment, whose duty it was to guard the imperial family.
In 1908, at the request of the regiment's command, Nicholas II
decided to construct a regimental church at Tsarskoe Selo. He
personally chose the location, in a glade near the Alexander Palace.
At first a temporary chapel was created in the building of the
regimental training detachment. It was dedicated to St. Seraphim
of Sarov, and decorated with frescoes in the style of the 17th century.
Subsequently this church was incorporated into the Feodorovsky
Cathedral as a crypt containing the altar of St. Seraphim.

The construction of the Feodorovsky Cathedral was carried out
at the same time as the furnishing of the temporary chapel. The
foundations of the cathedral were laid on 20 August 1909, the first
stone being placed by Nicholas himself. It was decided to model this
new cathedral on the Cathedral of the Annunciation in the Moscow
Kremlin — the family church of the first Romanovs. The architect
V. A. Pokrovsky was charged with drawing up the plans, and the
cathedral took exactly three years to build. On 20 August 1912 the
Feodorovsky cathedral was consecrated in the presence of the imperial
family.
(Alexeev and Baranovsky, 1992, pp. 1–2.)

564 The Imperial Family on the Steps of the Feodorovsky Cathedral, 20 August 1912

Unknown photographer
24 × 18 cm
ГА РФ. Ф.601. Оп.1. Д.1672. Л.21

The Feodorovsky Cathedral had several entrances situated on
different sides of the building, each intended for a different
category of visitor. The main west door was decorated with a large
mosaic panel depicting the Feodorovskaya Mother of God with many
saints in multicoloured vestments. This entrance was used only
occasionally, primarily on feast days.

Two entrances were assigned for the imperial family: one,
situated on the south-west corner of the building with a stone porch
and hipped roof crowned by a golden eagle, led to the upper church;
the other, leading to the crypt, was approached from the south side.
Both entrances were decorated with mosaic panels.

The upper church was dedicated to the apparition of the icon of the
Feodorovskaya Mother of God, while the crypt contained a shrine
with some of the relics of St. Seraphim of Sarov, as well as an icon
of him painted by V. P. Gurianov.

Alexandra Feodorovna had her own chapel in the crypt. This was
a narrow room with a low ceiling decorated in old-Russian style,
and with niches in the walls containing icons.
(Alexeev and Baranovsky, 1992, pp. 4–5.)

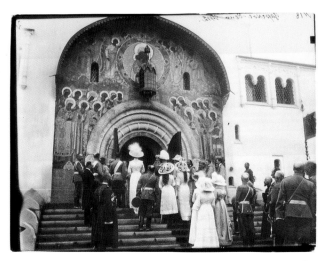

565 Emperor Nicholas II and His Family on the Porch of the
Feodorovsky Cathedral, 20 August 1912

Unknown photographer
24 × 18 cm
ГА РФ. Ф.601. Оп.1. Д.1672. Л.5

*On completion of all the building in October 1913, the next question
to arise was that of the interior decoration of the cathedral. The
decoration of the crypt was carried out by the artists I. Shcherbakov
and N. Pashkov, with the participation of V. Vasnetsov who also
designed the vestments for the officiating clergy.*

*The cathedral as a whole was dedicated to the Feodorovskaya Mother
of God, for it was in front of an icon of her that the first tsar of the
Romanov dynasty, Mikhail Feodorovich Romanov, was blessed when
he accepted the tsar's crown in the Ipatiev monastery at Kostroma in
1613. While the family were in residence at Tsarskoe Selo, their
imperial majesties attended the cathedral every Sunday and on
feast days.*

*After the revolution, in the 1930s, the cathedral was closed and was
later used as a store for the 'Lenfilm' film studio.*
(Alexeev and Baranovsky, 1992, pp. 7–8.)

The Feodorovsky Cathedral has now been returned to the
Russian Orthodox Church and restoration work is nearing
completion.

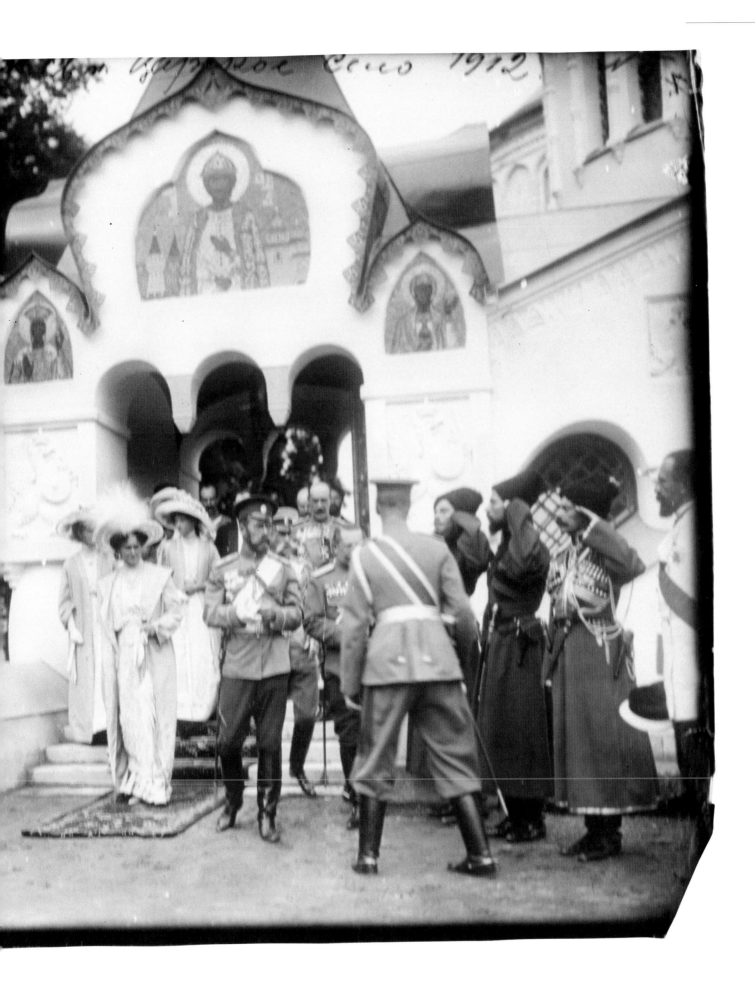

The Army

566 Emperor Nicholas II Inspecting Five Batteries of the
31st Artillery Brigade, Belgorod, 4 May 1904

Photograph by court photographer Alexander Karlovich Yagelsky
C. E. von Hahn Photographic Studio
Stamped on the mount: *C. E. de Hahn & Co. Tsarskoe Selo*
Inscribed by Nicholas in pencil on the reverse: Белгород [Belgorod]
Mounted photograph: 16.5 × 22 cm; 26 × 35.5 cm
ГА РФ. Ф.601. Оп.1. Д.363. Л.14

*At 9 o'clock we arrived at Belgorod. At the station we met
deputations from the estates and the town. Drove by carriage with
Misha to the cathedral, through streets thronging with people, then
to the field, where 5 mobilized batteries with all their transport were
waiting — the 31st artillery brigade. After inspecting them I took
my leave and returned to the station.*
(Nicholas's Diary, 4 May 1904. ГА РФ. Ф.601. Оп.1. Д.247. С.88.)

On 27 January 1904, Japanese destroyers attacked the Russian
squadron anchored off Port Arthur in the Far East. This marked
the beginning of the Russo-Japanese war. Although in peacetime
the Russian army comprised almost a million soldiers, in January
1904 the Russian armed forces in the Far East barely numbered
100,000 men. Japan also held the advantage at sea. Public
opinion in Russia assumed that the war would be won quickly,
but defeat followed upon defeat. Nicholas II made a number of
visits to the troops being dispatched to the front. In 1904 he
travelled the length and breadth of Russia, believing it his
duty to see off those who were going to die for their country.

The war ended in defeat for Russia, concluded by an ignominious
treaty signed in Portsmouth in the USA in August 1905.

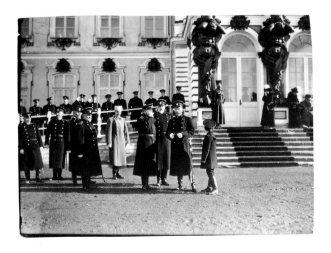

567 Emperor Nicholas II and Tsarevich Alexei Nikolaevich
Inspecting Young Sailors of the 1st Squadron of the
Baltic Fleet, 14 April 1909

Unknown photographer
23 × 17 cm
ГА РФ. Ф.601. Оп.1. Д.1646. Л.152

*Tuesday 14 April. A wonderful spring day. After lunch I went with
Alexei onto the palace square, where I inspected the young sailors of
the 1st squadron of the Baltic Fleet. Their appearance and drill made
a most favourable impression on me.*
(Nicholas's Diary, 14 April 1909. ГА РФ. Ф.601. Оп.1. Д.1646.
Л.152.)

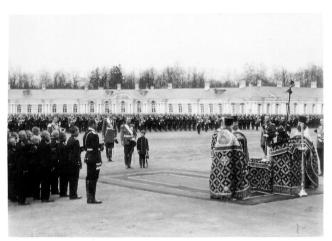

568 Emperor Nicholas II and Tsarevich Alexei Nikolaevich
at a Parade of Guards Rifle Regiments, Peterhof, 17 April 1911

Unknown photographer
Inscribed in pencil on the reverse: *1911 г. Стрелки* [1911, Riflemen]
22 × 15.5 cm
ГА РФ. Ф.601. Оп.1. Д.1646. Л.2

*At 11 o'clock I went with Alexei to the palace square for the church
parade of the Life-Guard 1st and 2nd Rifle Regiments. They looked
splendid in their new formation of two battalions each. They marched
past three times.*
(Nicholas's Diary, 17 April 1911. ГА РФ. Ф.601. Оп.1. Д.256.
Л.164–165.)

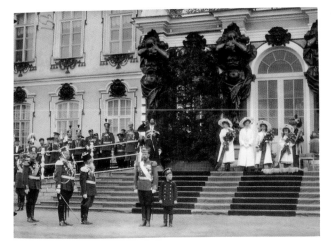

569 Emperor Nicholas II and Tsarevich Alexei Nikolaevich
at the Celebrations to Mark the 100th Anniversary of
the Convoy Regiment, Peterhof, 18 May 1911

Unknown photographer
Dated in pencil on the reverse: *[1]911*
21 × 15.5 cm
ГА РФ. Ф.601. Оп.1. Д.1646. Л.153

*Wednesday 18 May. The 100th anniversary of the Convoy. It has got
noticeably colder. At 11 o'clock went with all the children to the Great
[Palace] and mounted my horse at the gates. It took an hour and a
half to get through the Te Deum, the oath of allegiance, the blessing of
the new standard and the triple march past. All the companies looked
dashing, orderly and very alike. Many former officers and Cossacks
of the Convoy took part in the parade. All the old uniforms were on
show ... I stayed talking for a long time, and before leaving I was
photographed with the whole group by the entrance.*
(Nicholas's Diary, 18 May 1911. ГА РФ. Ф.601. Оп.1. Д.256.
С.189–190.)

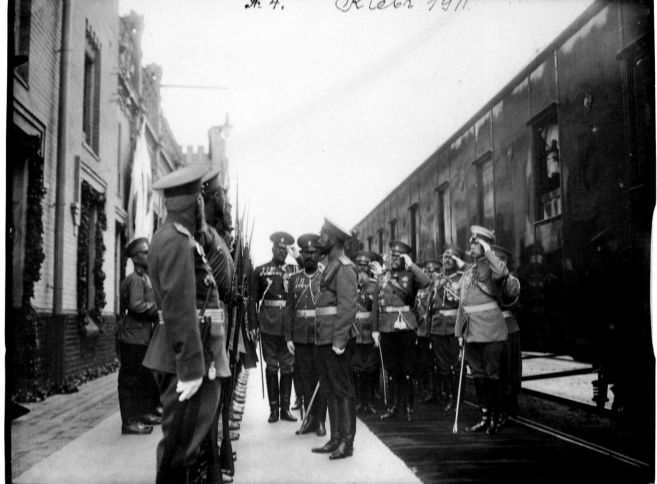

570 Ceremonial Reception for Emperor Nicholas II in Kiev,
29 August 1911

Unknown photographer
Inscribed in mirror-writing in black ink at the top of the photograph: *Киев 1911*
[Kiev 1911]
Inscribed in pencil on the reverse: *Киев* [Kiev]
24 × 18 cm
ГА РФ. Ф.601. Оп.1. Д.1529. Л.22

At the end of August 1911 a monument in memory of Alexander
II was due to be unveiled in Kiev, in the presence of Nicholas II.
The celebrations started with a visit to the holy places of Kiev:
the Cathedral of St. Sophia and the Pecherskaya monastery.

*We arrived in Kiev at 11 o'clock on a cold grey morning. Among those
at the station to meet us were Andrei and Sergei, and a guard of
honour of the 129th Bessarabian regiment. There was a most hearty
welcome on the streets and everywhere was orderly. Rows of soldiers
and school-children lined the way.*
(Nicholas's Diary, 29 August 1911. ГА РФ. Ф.601. Оп.1. Д.257.
Л.85.)

571 Emperor Nicholas II Inspecting the Cavalry During His
Visit to Kiev, 31 August 1911

Unknown photographer
24 × 18 cm
ГА РФ. Ф.601. Оп.1. Д.1529. Л.17

*I left for the manoeuvres at 9 o'clock ... and turned up at a good time:
I watched one and a half divisions march across the road and assume
battle formation, then advance and engage in a skirmish with the
cavalry of the eastern army. I went round every one of the units; the
sight of the regiments and the cavalry batteries is most gratifying.*
(Nicholas's Diary, 31 August 1911. ГА РФ. Ф.601. Оп.1. Д.257.
Л.88–89.)

On 1 September 1911, the day after the inspection, Nicholas II
attended a performance of Rimsky-Korsakov's opera *The Tale of
Tsar Saltan* at the town theatre. At the end of the second interval,
the Prime Minister P. A. Stolypin was shot by Dmitry Bogrov, a
former agent of the Kiev secret police. Nicholas II visited the
wounded minister on several occasions, and Stolypin died in a
Kiev hospital on 5 September.

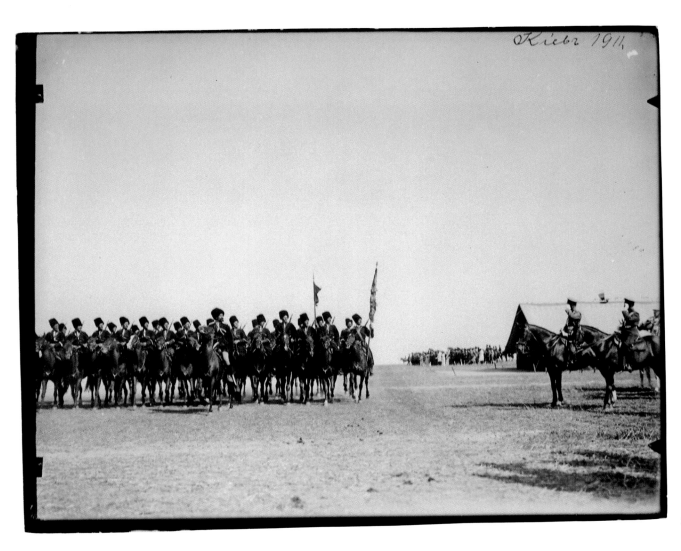

Kiebr 1911.

571

572 Reception of Nicholas II and Members of his Family on
their arrival in Moscow for the Celebrations marking the
Centenary of the Battle of Borodino, August 1912

Unknown photographer
Inscribed in pencil on the reverse: *Москва. авг[уст] 1912 г.* [Moscow, August 1912]
Photograph: 24 × 18 cm
ГА РФ. Ф.601. Оп.1. Д.1667. Л.51

In 1912 Russia celebrated the 100th anniversary of the Battle of
Borodino, a crucially important battle in Russia's victory over
Napoleon in the Patriotic War of 1812.

*The whole of Moscow's high society, as well as courtiers and high-
ranking members of the administration, gathered at the Alexander
station to await the arrival of the imperial train. One particular
group in the reception party was made up of members of the
emperor's retinue whose forbears had taken part in the Patriotic War.
Just before 10 o'clock several members of the imperial family arrived,
including Grand Duchess Elizaveta Feodorovna. At 10 o'clock the
Ivan the Great bell rang out, announcing the arrival of the imperial
train. Another resounding peal of bells was taken up by the bells of all
the churches in Moscow. The train slowly approached the platform.
The emperor appeared at the door of the carriage, the empress behind
him with the heir-tsarevich and the most august daughters. The
emperor was wearing the uniform of the Ekaterinoslavsky regiment,
and the heir the uniform of the Kiev regiment.* (Memoirs of V. F.
Djunkovsky, 1911–12. ГА РФ. Ф.826. Оп.1. Д.51. Л.274–275.)

The emperor described his impressions to his mother, the
Dowager Empress Maria Feodorovna, on 10 September 1912:

*My dear Mama
I have been meaning to write to you for ages, but there has been no
time. I have had so many impressions, and such wonderful ones, that
it is difficult to describe them. Of course the most enjoyable days were
25 and 26 August at Borodino. We were all filled with a common
feeling of gratitude towards our ancestors. No description of the
battle could begin to convey the strength of feeling that penetrates
your heart when you yourself are standing on the very ground that
has been washed with the blood of 58,000 of our heroes, those who were
wounded and killed during the two days of the Battle of Borodino.
A few of the old redoubts and batteries have been perfectly restored
by the sappers: Shevardino and the Semenovsky fortifications.*

*To have been present at the requiem and the solemn Te Deum, to
have seen the famous icon of the Hodegetria Mother of God — the
very one that was at the battle — borne in front of the troops, these are
moments rarely experienced! And to crown everything, they managed
to find a few old men who remembered the arrival of the French, and,
most incredibly, among them one who actually participated in the
battle, former sergeant-major Vintoniuk, 122 years old. Can you
imagine — talking to a man who remembers everything, and can
describe every detail of the fighting, and can show you the place where
he was wounded and so on; I told them to stand near us in the tent*

during the service and I watched them. They were all able to kneel down with the aid of a stick, and to get up again without anyone's help! The French delegation attending the celebrations was also extremely interested in the veterans and talked to the old soldier through one of our people.

The parade at Borodino was very original in that all the army units and Guards regiments that took part in the battle were represented by a company or a platoon from the regiment, and a battery. Many regiments have already erected monuments to their forbears, while others are in the process of doing so, approximately in the places where they fought and demonstrated the excellence of their own units. On the afternoon of the 26th I rode around the whole battlefield and saw these monuments for myself — which only added to the strong impression created by everything that I have seen and heard.
(ГА РФ. Ф.642. Оп.1. Д.2332. Л.14–16.)

573 Emperor Nicholas II before a Guard of Honour at the Great Kremlin Palace, 1912

Unknown photographer
Inscribed in mirror-writing in black ink at the top of the photograph: *Москва. 1912* [Moscow, 1912]
Photograph: 24 × 18 cm
ГА РФ. Ф.601. Оп.1. Д.1667. Л.83

At the Iversky Gates the emperor and empress, together with the imperial children and other members of the imperial family, got out of their carriages and walked towards the chapel of the Iverskaya Mother of God. Having kissed the cross, they entered the chapel. After a short service, their majesties went over to the Great Kremlin Palace. Here they were met by a guard of honour of the 12th Astrakhan Regiment of Grenadiers. The emperor passed along the front rank, and then went to the doorway and entered his quarters in the palace. At this moment the imperial standard was raised over the Great Kremlin Palace.
(Memoirs of V. F. Djunkovsky. ГА РФ. Ф.826. Оп.1. Д.51. Л.275 об.)

We all felt sad as we left Borodino early on 27 August, and proceeded to Moscow for the last part of the celebrations. In Moscow, too, everything went very well and efficiently, but it was more tiring and less interesting. I am sure you have already heard about our stay in Moscow, so I will limit myself to a brief account of what I did

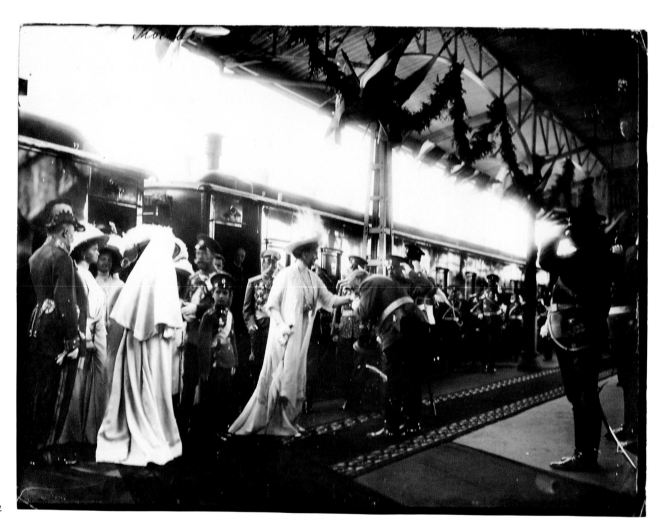

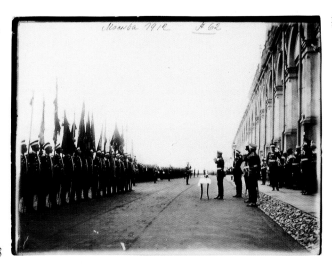

573

there. On the 27th, the day of our arrival, there was the usual
procession to the Uspensky Cathedral; at 4 o'clock we were received
by the nobility at the house of the assembly of nobles, where Samarin
presented us with a beautiful ancient standard on behalf of the entire
Russian nobility.

On the 28th there was a big parade on Khodynka Field, in which four
army corps participated — 70,000 men. Here something incredible
happened: during the inspection a soldier from the Sofisky Regiment
broke ranks and came towards me with a petition. Various generals
tried to catch him, but he almost reached me and stopped only when I
shouted at him. I was extremely cross, and the whole of Moscow's
military command heard from me about it. In the afternoon we
visited the town Duma, and that evening hosted a dinner for all the
military.

On the 29th there was an Episcopal mass in the Cathedral of the
Saviour, followed by a requiem in memory of Emperor Alexander
Pavlovich and all his associates. In the afternoon there was a review
of all the pupils from the Moscow middle and lower schools on the
Kremlin Square opposite Anpapa's [Alexander II's] monument,
while around them stood 25,000 boys and girls from village schools.

With the children I then visited a very interesting exhibition about the
1812 War in the Historical Museum, where Sofa Shcherbatova very
kindly offered us tea. From there we went to see a beautiful and very
successful panoramic depiction of the Rubo-Borodino battle.

On 30 August, our last day in Moscow, we went to the Uspensky
Cathedral for the end of the service and took part in the procession
onto Red Square, where a manifesto was read out and a solemn Te
Deum was celebrated. The crowd on the square was enormous, a
veritable sea of heads — the silence and calm were absolute.
(From a letter of Emperor Nicholas II to his mother the Dowager
Empress Maria Feodorovna, 10 September 1912. ГА РФ. Ф.642.
Оп.1. Д.2332. Л.16–17.)

574 Telegram from Emperor Wilhelm II of Germany to
Nicholas II, 19 July 1914

Inscribed by Nicholas at the top of the telegram: Получена в день объявления войны
[Received on the day war was declared]
24 × 28 cm

His Majesty the Czar
Thanks for your telegram I yesterday pointed out to your government the
way by which alone war may be avoided although I requested an answer
for noon today no telegram from my ambassador conveying an answer
from your government has reached me as yet I therefore have been
obliged to mobilise my army immediate affirmative clear and unmistakable
answer from your government is the only way to avoid endless misery
until have received this answer alas I am unable to discuss the subject of
your telegram as a matter of fact I must request you to immediately order
your troops on no account to commit the slightest act of trespassing over
our frontiers
Willy

ГА РФ. Ф.601. Оп.1. Д.550. Л.82

By July 1914 the First World War was a political inevitability.
The fact that Russia was obliged by its external obligations to
be the first to declare a general mobilisation gave the German
government a convenient excuse to start the war. At midnight
on the night of 18–19 July, the German ambassador, Count
de Pourtalès, came to see the Russian foreign minister,
S. D. Sazonov, with an ultimatum demanding an end to the
mobilisation. The latter assured the ambassador that Russian
forces would not cross the frontier while talks were still in
progress. Over the course of these crucial few days Nicholas and
Wilhelm exchanged telegrams in an attempt to settle the conflict.
However, at seven o'clock on the evening of 19 July, de Pourtalès
handed Sazonov a note containing an official declaration of war.
That same day Nicholas had received this final telegram from his
'dear cousin Willy'.

574

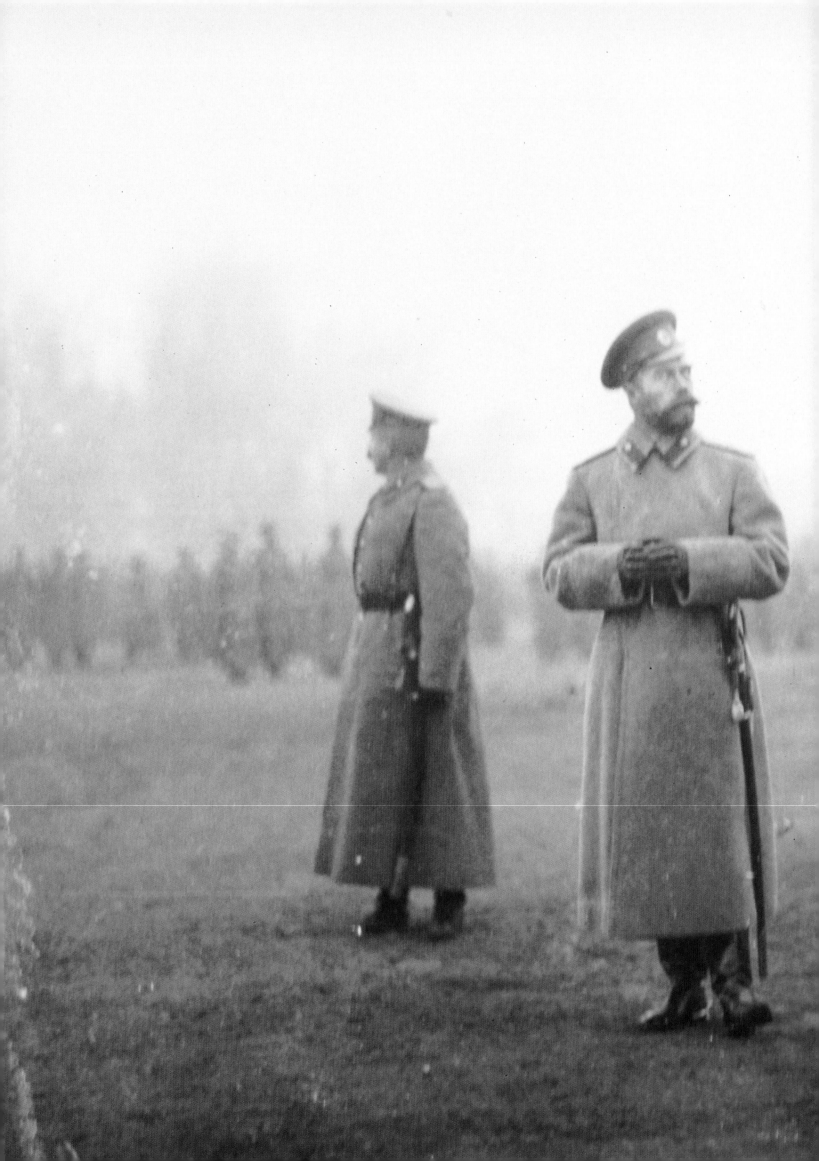

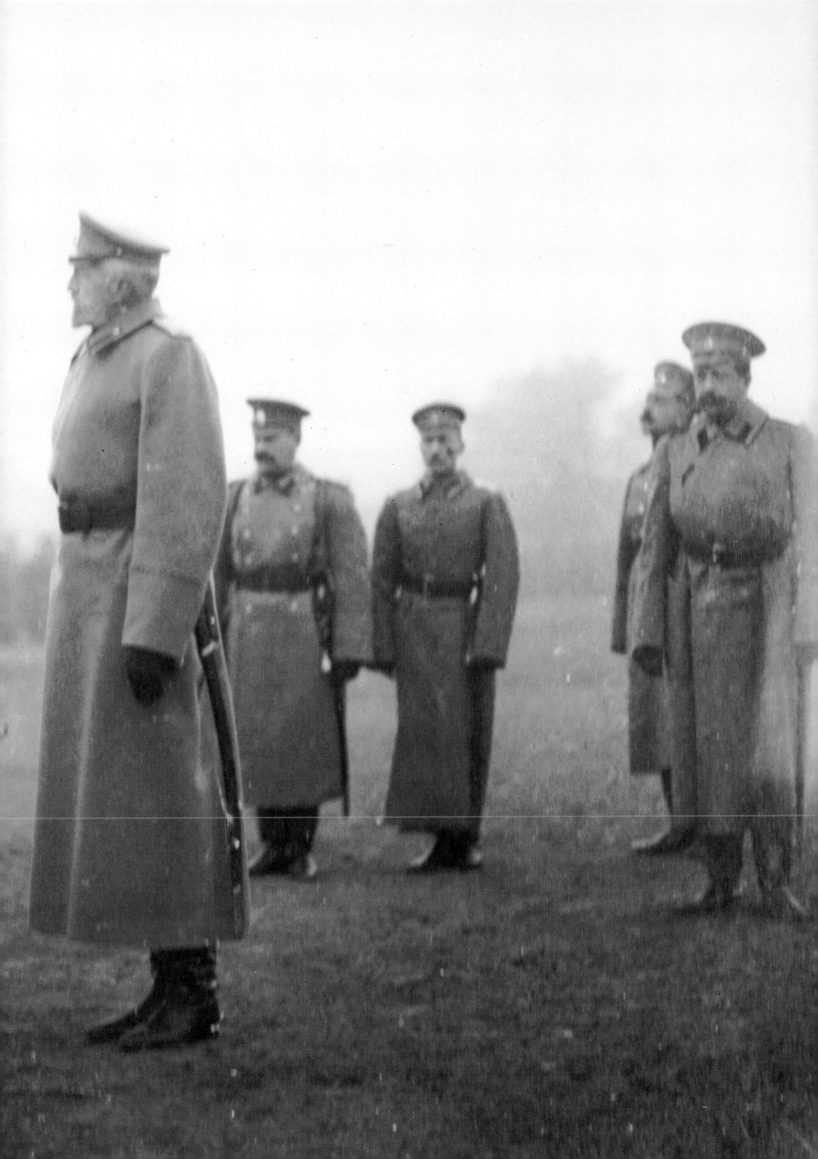

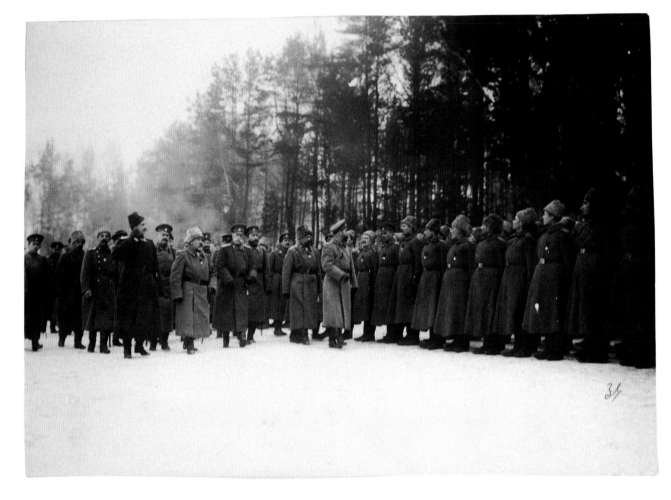

575 Emperor Nicholas II at General Headquarters, Baranovichi, 1914

Unknown photographer
Mounted photograph: 15.5 × 11 cm; 20 × 15.5 cm
ГА РФ. Ф.601. Оп.1. Д.682. Л.18

Nicholas II made his first visit to General Headquarters and to the front line in the second half of September 1914. The visit did not last long. After a few military reversals, the situation at the front improved, bolstering hopes of a rapid end to the war. Nicholas's second visit to Headquarters came at the end of October. General Headquarters were based at the small town of Baranovichi, which became the 'nerve centre of military Russia' and which was commanded by the tsar's uncle, Grand Duke Nikolai Nikolaevich (pictured in conversation with Nicholas). Nicholas visited Baranovichi several times up until the summer of 1915.

576 Emperor Nicholas II Inspecting Troops at the Front, 1915

Photograph by Alexander Karlovich Yagelsky
C. E. von Hahn Photographic Studio
Trade-mark of the photographic studio on the reverse: *C. E. von Hahn & Co.*
21.5 × 15.5 cm
ГА РФ. Ф.601. Оп.1. Д.679. Л.34

After assuming supreme command of the Russian army in August 1915, Nicholas II returned to General Headquarters (now at Mogilev) in his new capacity. His daily life was taken up with reports, receiving ministers, discussing plans for military action, and visiting the units at the front. On 21 October 1915, the St. George Council of the South-Western Front 'on the occasion of the visit of his majesty the emperor to the forward positions', where he 'displayed true valour and selflessness', proposed that the sovereign leader should 'grant his adoring troops the great kindness and joy of allowing himself to be presented with the Order of St. George the Great Martyr and Victor, Fourth Degree'. (*Niva*, 1915, No. 45, pp. 817–8.)

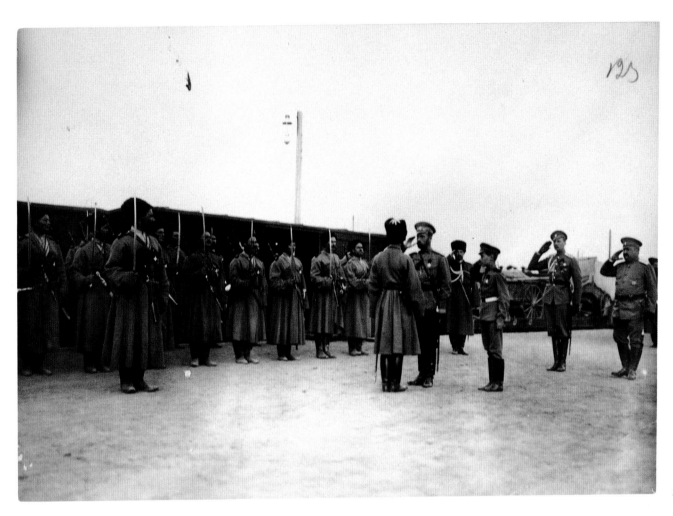

577

577 Emperor Nicholas II and Tsarevich Alexei Nikolaevich
Inspecting the 1st Kuban Company of the Convoy Regiment,
Mogilev, 1916

Unknown photographer
22 × 16 cm
ГА РФ. Ф.601. Оп.1. Д.679. Л.123

22 June ... At 6.30 the two of us [Nicholas and Alexei] *went to the
station to see the 1st Kuban Company of the Convoy, just back
from the campaign in southern Bukovina. The Cossacks looked
magnificent in their threadbare grey Circassian coats. Almost all
of them received St. George crosses or medals.*
(Nicholas's Diary for 1916. ГА РФ. Ф.601. Оп.1. Д.264. Л.108.)

578

22 June. Studied and played with the muzhik's [peasant's] *little dogs.
Had lunch with everyone. Wrote to Mama. In the afternoon ran in
the water ... After dinner we went to the station. A company of the
Convoy had arrived from active service. Then I studied and read.
Went to bed early.*
(Alexei's Diary, 22 June 1916. ГА РФ. Ф.682. Оп.1. Д.189. Л.178.)

578 Emperor Nicholas II and Tsarevich Alexei at General
Headquarters, Mogilev, 1916

Photograph by Alexander Karlovich Yagelsky
C. E. von Hahn Photographic Studio
Trade-mark of the Photographic Studio on the reverse: *C. E. von Hahn & Co.*
23 × 17 cm
ГА РФ. Ф.601. Оп.1. Д.679. Л.14

Alexei often participated in reviews of the troops at General
Headquarters. He took his duties very seriously and was, like his
father, genuinely interested in military affairs. After he visited
the wounded in the area around Klevan station, which was under
distant enemy fire, the St. George Council awarded the tsarevich
a Silver Medal of the Fourth Degree on a St. George ribbon. The
twelve-year-old heir was also very proud of the lance-corporal's
shoulder-boards on his overcoat.

The Abdication

Under Arrest at Tsarskoe Selo

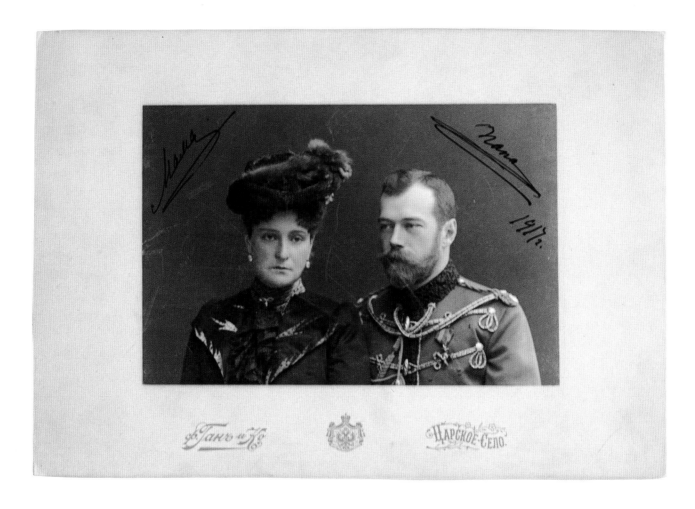

579 Emperor Nicholas II and Empress Alexandra Feodorovna,
Late 1890s

C. E. von Hahn Photographic Studio
Later inscriptions by Alexandra Feodorovna in black ink in the top left corner:
Мама [Mama]; and in the top right corner: *Папа, 1917 г.* [Papa, 1917]
Trade-mark of the photographic studio on the mount: *ф. Ган и Ко. Царское Село.*
[von Hahn & Co. Tsarskoe Selo]
Mounted photograph: 17 × 11 cm; 26 × 18 cm
ГА РФ. Ф.601. Оп.1. Д.2169. Л.16

Nicholas returned to Tsarskoe Selo from General Headquarters
on 19 December 1916, and stayed there for more than two
months. The situation in the country was tense, and Nicholas
spent his time consulting with his ministers and relatives. The
emperor saw in the last New Year of his reign quietly at home;
he wrote in his diary: 'At six o'clock we went to church. In the
evening I worked. At ten to midnight we went to the service.

I prayed fervently to the Lord to have mercy on Russia.'
(ГА РФ. Ф.601. Оп.1. Д.265. Л.27.)

The political situation in Russia was coming to a head. From the
tribunes of the Duma accusations of treason were already being
directed at the empress. The government was clearly incapable
of dealing with the situation in the country. Nicholas, however,
seemed oblivious to the impending crisis, and on 22 February he
left once more for the front.

*In the first few days of March the imperial family were assailed
by the blows of fate: one after another the grand duchesses came down
with measles; the only one who remained on her feet was Grand
Duchess Maria Nikolaevna. The empress was deeply aggrieved to
discover that the people whom she had trusted and on whose devotion
she had so depended now began to abandon her.*

With the departure of the Guards company battalion the military units deserted. These men, who only the day before had given her majesty a magnificent welcome, began to leave on 1 March, and by the next day small groups of soldiers, already completely brainwashed by propaganda, had started wandering around the palace. Even many of those closest to her began to follow the example set by the lower military ranks: officers and doctors, who had all received so much kindness from the empress. The empress's and grand duchesses' personal servants remained loyal — all except the tsarevich's companion, the boatswain Derevenko.

The empress's response to such cruel disloyalty was one of pure Christian forgiveness: 'We must not blame the Russian people, nor the soldiers, for they have been deceived.'
(Voeikov, 1933, p. 253.)

580 Telegram to Emperor Nicholas II in Pskov from the Chief-of-Staff of the Supreme Command at General Headquarters, Adjutant-General M.V. Alexeev, 2 March 1917

Typewritten copy
The telegram relays the text of other telegrams received from the front-line commanders, Grand Duke Nikolai Nikolaevich, Adjutant-General A. A. Brusilov, and Adjutant-General A. E. Evert, with their 'deeply loyal request' for the emperor to abdicate from the throne

22 × 33 cm
ГА РФ. Ф.601. Оп.1. Д.2102. Л.1

On the day Nicholas arrived back at General Headquarters — 23 February — strikes and disturbances broke out in Petrograd. These gradually assumed the character of political agitation against the regime. On 27 February the State Duma, in an attempt to remain at the head of the growing political movement, formed a Provisional Committee (which, from 1 March, became the Provisional Government). At the same time the Petrograd Soviet of Workers' and Soldiers' Deputies was formed.

On 28 February, having learned of events in Petrograd, Nicholas tried to return to Tsarskoe Selo but was unable to reach the capital. The imperial train was stopped near the station of Maliye Vishery and Nicholas was forced to return to Pskov, where the staff headquarters of the Northern front were based.

On 2 March, at 2.30 pm, the chief-of-staff of the supreme command, Adjutant-General M. V. Alexeev sent this telegram to the emperor in which he relayed the contents of telegrams from the commanders at the front, all of whom insisted that Nicholas II must abdicate in favour of his son, for the sake of the dynasty, the army and a victorious conclusion to the war.

The tsar's uncle, Grand Duke Nikolai Nikolaevich, wrote in his telegram:

A victorious conclusion to the war, which is so vital for the well-being and future of Russia, demands extraordinary measures. I, as a loyal subject, believe that by the bond and spirit of my oath of allegiance it is necessary to beg Your Imperial Majesty on my knees to save Russia and Your heir, in the knowledge of Your great love for Russia and for him. Make the sign of the cross and pass on Your inheritance to him. There is no other way …

Later in the afternoon of 2 March, on the emperor's orders, a draft manifesto was drawn up for Nicholas's abdication in favour of his son Alexei, under the regency of Nicholas's brother Mikhail. But at this point Nicholas had second thoughts. His subsequent decision was influenced by a conversation he had with the court physician S. P. Feodorov, which took place around 4 pm. The contents of this conversation are known to us from the account of General A. Spiridovich, who heard of it from Feodorov himself in the summer of 1918:

The retinue was greatly agitated: everyone wanted the emperor to retract the abdication. Feodorov went up to the emperor and expressed surprise about the abdication, to which the emperor replied: 'You know, Sergei Pavlovich, I'm a down-to-earth sort of person … Of course I never looked upon Rasputin as a saint, but what he foretold generally came to pass. He predicted that if the heir lived to the age of 17, he would be completely cured. Can that be true?' Feodorov replied that it was impossible to make any definite assessment. Then Nicholas started to talk about how he would live with Alexei after the abdication. Feodorov expressed some doubt that the new government would allow the young tsar to continue living in the family of the former emperor. He suggested that it was more likely he would have to live with the regent's, Grand Duke Mikhail Alexandrovich's, family. At that point, according to Feodorov, 'the emperor expressed the greatest surprise that such a thing could happen, and then declared that he would never give his son into the care of the grand duke's wife, and said some very harsh things about her.'
(Spiridovich, 1962. vol. iii, pp. 297–8.)

On 2 March 1917, at 10 o'clock in the evening, two deputies from the State Duma, V. V. Shulgin and A. I. Guchkov, arrived in Pskov. Nicholas II informed them of his decision to abdicate the throne, both for himself and on behalf of his son, in favour of his younger brother Grand Duke Mikhail Alexandrovich.

581 Emperor Nicholas II's Act of Abdication, 2 March 1917

Typewritten text
Signed by Nicholas II in pencil in the bottom right corner: *Николай*
Witnessed by Count Fredericks in black ink in the bottom left corner: *министр
императорского двора генерал-адъютант граф Фредерикс* [Minister of the Imperial
Court Adjutant-General Count Fredericks]
22 × 35 cm

*In these days so decisive for the survival of Russia, We consider it the duty
of Our conscience to facilitate the close unity of Our people and the
cooperation of all the nation's forces for the speedy attainment of victory.
In this respect, and in accordance with the State Duma, We think it right
to abdicate the throne of the Russian State and to resign supreme power.
Not wishing to be separated from Our beloved son … We transfer Our
inheritance to Our brother Grand Duke Mikhail Alexandrovich, and give
him Our blessing on his accession to the throne of the Russian State.
We command Our brother to govern in full and inviolable unity with the
people's representatives in the legislative assemblies, according to the
tenets established by them and to which he should bring his inviolable
oath of allegiance.
Pskov, 2 March 1917. 3 o'clock.*

ГА РФ. Ф.601. Оп.1. Д.2100a. Л.4,5

The text of the abdication was prepared in advance by the head
of the diplomatic office at General Headquarters, N. Bazili, and
then approved by Alexeev before being forwarded to Pskov.
After a discussion with the State Duma representatives Shulgin
and Guchkov, Nicholas made some corrections to the abdication
text, inserting the phrase about the new emperor's oath of
allegiance to the constitution. A fair copy of the manifesto was
then made, which the tsar signed and handed to Guchkov. By
this time it was 11.40 at night, but to avoid the impression that
the act had been signed under pressure from the Duma deputies,
the time of signing the document was given as 3 pm. After all,
Nicholas had taken the decision to abdicate earlier that afternoon.

*When the emperor left, a general, who had been sitting in the corner
and who turned out to be Yury Danilov, went up to Guchkov with
whom he was acquainted. 'Won't the abdication in favour of Mikhail
Alexandrovich cause serious complications later, in view of the fact
that there is no such provision in the law of succession?' As Guchkov
was already engaged in conversation with Baron Fredericks, he
introduced me to Danilov and I answered his question … The
abdication in favour of Mikhail Alexandrovich was not in
accordance with the law of succession, but it was impossible to deny
that it had great advantages in the present circumstances. If the
young Alexei did come to the throne, there would be one very difficult
question to resolve: should he stay with his parents or would he have to
be separated from them. In the first case, that is if the parents stayed
in Russia, the abdication would appear fictitious … This was
particularly so in the case of the empress, for it would be said that
she ruled through the son just as she had through the father … And
with the general attitude towards her now, this would cause the most
impossible complications. To separate the young emperor from his
parents, leaving aside the difficulty of such a course of action, could
have a very harmful effect on him. The throne would be occupied by a
youth who regarded those around him as jailers who had taken his
father and mother away … Given the child's fragile state of health he
would feel this most acutely.*
(Shulgin, 1989, p. 255.)

582 Diary of Nicholas II for 1917

Exercise book with paper cover
18 × 22 cm; spread 36 × 22 cm

*Thursday 2 March. Ruzsky came in the morning and recited his long
telephone conversation with Rodzianko. According to him the situation in
Petrograd is such that the ministry from the Duma is now powerless to
do anything because they are in conflict with the Social Democrat party in
the form of the workers' committee. My abdication is necessary. Ruzsky
relayed his conversation to General Headquarters, and Alexeev
communicated it to all the commanders-in-chief. By 2.30 they had all sent
their answers, the essence of which is that for the sake of Russia's salvation
and in order to maintain order at the front, this step has to be taken.
I agreed. We received a draft of the manifesto from Headquarters. In the
evening Guchkov and Shulgin arrived from Petrograd; I spoke with them
and handed them the recopied manifesto, signed. At 1 o'clock in the
morning I left Pskov with a heavy heart. All around only betrayal, cowardice
and deceit!*

ГА РФ. Ф.601. Оп.1. Д.265. Л.66–67

THE ABDICATION

I bumped into the grand duke, who made a rather inappropriate joke: 'Well, it's no bad thing finding oneself in the position of an English king. Very easy and convenient, what?' 'Yes, your Highness,' I replied. 'It's very restful ruling with a constitution'. With this, we both went into the meeting room. Rodzianko was acting as chairman and was making an introductory speech justifying the necessity [for the grand duke] to renounce the throne! ... Kerensky then spoke in much the same vein. Then it was my turn. I tried to argue that a strong centre of power was needed to bolster the new order, and that this could only be achieved by relying on a symbol of power that was familiar to the masses. The monarchy was just such a symbol. Without the support of this symbol, the Provisional Government simply wouldn't survive until the opening of the Constituent Assembly ...

The grand duke, who had remained silent throughout, asked for a few minutes to think things over. As he went out, he asked to speak to Rodzianko alone. The outcome, of course, was predictable. Returning to the assembled deputies, he said that he agreed to Rodzianko's proposal.
(Miliukov, 1991, p. 469.)

582

On 3 March the train bearing the former emperor arrived at General Headquarters at Mogilev. The following day, the Dowager Empress Maria Feodorovna arrived from Kiev. It was to be her last meeting with her son.

The emperor saw his mother alone for two hours. The dowager empress never told me what they had talked about. When I was called in, Maria Feodorovna was sitting and sobbing; he was standing motionless, looking down at his feet, and of course, smoking. We embraced. I did not know what to say. His calm testified to the fact that he felt his decision to have been the right one.
(Grand Duke Alexander Mikhailovich, 1991, p. 227.)

A month later, when he was under arrest at Tsarskoe Selo, during his confession to Father Afanasy Belyaev, Nicholas said: 'And so, completely alone, with no close advisor, deprived of my liberty, like a cornered criminal, I signed the act of abdication on behalf of myself and my son and heir. I decided that if it was necessary for the good of Russia, I was ready to do anything. I feel so sorry for the family!'
(Memoirs of A. Belyaev. ГА РФ. Ф.601. Оп.1. Д.2077. Л.10–11.)

583 Grand Duke Mikhail Alexandrovich, 1916

Photograph by L. Gorodetsky
Stamped at the bottom of the mount: Л. Городецкий. Царское Село [L. Gorodetsky, Tsarskoe Selo]
Trade-mark of the photographic studio on the reverse
Mounted photograph: 16 × 22 cm; 17.5 × 24.5 cm
ГА РФ. Ф.642. Оп.1. Д.3425. Л.3

The meeting with the grand duke took place in Prince Putiatin's apartment on Millionnaya street. The gathering included members of the government, Rodzianko, and several members of the Provisional Committee. Guchkov arrived later. On entering the apartment,

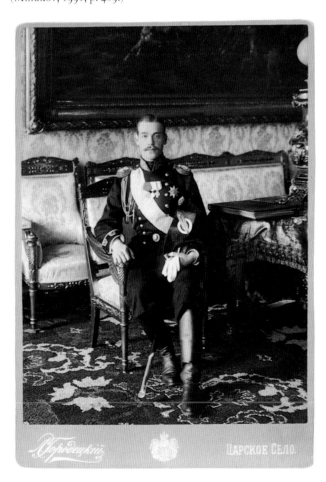

583

584 Act of Grand Duke Mikhail Alexandrovich, Renouncing the Throne, 3 March 1917

Handwritten
22 × 35 cm

A heavy burden has been placed upon me by the will of my brother who has transferred to me the Imperial Throne of all the Russias at this time of unprecedented warfare and national disturbance.

Inspired with the thought shared by the entire nation that the good of the country comes before everything, I took the firm decision only to accept supreme power if such be the will of our great people, who, by national suffrage and through their representatives in the Constituent Assembly, must establish a form of government and new Fundamental Laws for the Russian State.

Therefore, calling upon the blessing of God, I ask all citizens of the Russian State to submit to the Provisional Government ... until, convened in the shortest possible time on the basis of universal, free, equal and secret elections, the Constituent Assembly shall, by its decision as to the form of government, express the will of the people.
Mikhail
3/III – 1917, Petrograd

ГА РФ. Ф.601. Оп.1. Д.2100а. Л.6–7

Friday 3 March. It appears that Misha has abdicated. His manifesto concludes with a call for elections for a Constituent Assembly within six months. God knows who advised him to sign such a vile document! In Petrograd the disturbances have stopped — long may it remain that way.
(Nicholas's Diary, 3 March 1917. ГА РФ. Ф.601. Оп.1. Д.265. Л.68.)

It was not Nicholas's abdication, but this renunciation by Mikhail in favour of a decision on the future of the monarchy by the Constituent Assembly, which formally and in practice brought to an end the monarchical regime in Russia. By refusing power even conditionally, Mikhail had to all extents and purposes broken the lawful 'chain' of succession. None of the other Romanovs could now claim a throne that had been circumvented, so to speak, by Mikhail, and this alone obstructed any legal possibility of restoring the monarchy. During March many of the grand dukes declared their support for the Provisional Government.

585 Minutes of the Tenth Meeting of the Provisional Government on 7 March 1917

The minutes record the resolution to place the former emperor Nicholas II and Alexandra Feodorovna under arrest.
Typewritten copy; signed by the ministers of the Provisional Government in black ink on the verso of sheet 24: князь Львов; П. Милюков; А. Керенский; Н. Некрасов; А. Коновалов; А. Мануйлов; А. И. Гучков; А. Шингарев; М. Терещенко; В. Львов; Годнев; В. Набоков
[Prince Lvov; P. Miliukov; A. Kerensky; N. Nekrasov; A. Konovalov; A. Manuilov; A. I. Guchkov; A. Shingarev; M. Tereshchenko; V. Lvov; Godnev; V. Nabokov]
21 × 33 cm; spread 42 × 33 cm

Motion: 1. The placing under arrest of the abdicated emperor Nicholas II and his wife.
Resolved: 1. To declare the abdicated emperor Nicholas II and his wife under arrest and to deliver the abdicated emperor to Tsarskoe Selo.

ГА РФ. Ф.1779. Оп.2. Д.2. Ч.1. Л.15, 24 об.

The motion to arrest Nicholas II and Alexandra Feodorovna was signed by Prime Minister Prince G. E. Lvov and his ministers: P. N. Miliukov (Foreign Affairs), A. F. Kerensky (Justice), N. V. Nekrasov (Communications), A. I. Konovalov (Trade and Industry), A. A. Manuilov (Public Education), A. I. Guchkov (Army & Navy), A. I. Shingarev (Agriculture), M. I. Tereshchenko (Finance), V. N. Lvov (Procurator of the Synod), I. V. Godnev (State Controller), and V. D. Nabokov (Secretary to the Provisional Government).

The empress was arrested first, at Tsarskoe Selo. Commissars from the Provisional Government were then sent to General Headquarters to arrest Nicholas.

Three days passed. Then, on 11 March at 10.30 in the morning, Her Majesty summoned me and told me that General Kornilov had just informed her on behalf of the Provisional Government that the emperor and she were under arrest, and that all those who did not wish to submit to a prison regime should leave the palace before 4 o'clock. I replied that I had decided to stay. 'The emperor is returning tomorrow; Alexei must be warned, he must be told everything ... Would you do it? I'm going to talk to the girls.' It was clear that she was suffering at the thought of how upset the grand duchesses — who were still sick — would be on hearing of their father's abdication, and she was worried that the emotion would worsen their state of health. I went back to Alexei Nikolaevich and told him that the emperor would be returning from Mogilev the following day and that he would not be going back again. 'Why?' 'Because your Papa no longer wishes to be commander-in-chief.' This news affected him deeply because he loved going to General Headquarters. After a brief pause I added: 'You know, Alexei Nikolaevich, your father no longer wishes to be emperor.' He looked at me in astonishment, trying to read from my face what had happened. 'How? Why?' 'Because he is very tired and he has had a lot of difficulties recently.' 'Ah yes! Mama told me that his train was stopped when he wanted to come here. But surely Papa will become emperor again afterwards?' I explained to him then that the emperor had abdicated in favour of Grand Duke Mikhail Alexandrovich, who in turn had renounced the throne. 'But then, who will be emperor?' 'I don't know, for the moment nobody ...' Not a word about himself, no allusion to his rights as heir. He was very red and agitated. After a few minutes' silence he said: 'But then, if there is no longer an emperor, who will govern Russia?' I explained to him that a Provisional Government had been formed which would be responsible for the affairs of state until a Constituent Assembly was convened, and that maybe then his uncle Mikhail would ascend the throne. Once again I was struck by the modesty of this child.

(Gilliard, 1921, pp. 179–80.)

Thursday 9 March.

I arrived at Tsarskoe Selo quickly and safely — at 11.30. But my God, what a difference: there were guards on the streets and in the park around the palace, and even some kind of ensigns in the entrance! I went upstairs and there I found my darling Alix and the dear children. She looked cheerful and well, but they were all lying in a darkened room. They all feel well apart from Maria whose measles have only recently begun. We lunched and dined in Alexei's playroom. I saw dear Benckendorff. Went for a walk with Valya Dolg[orukov] and did a bit of work in the garden with him as we weren't allowed to venture any further!! After tea I unpacked my things. In the evening they rounded up everyone from the other side and put everyone together.

Saturday 11 March.

In the morning I received Benckendorff from whom I learnt that we are to remain here for quite some time. This is good news. Continued burning letters and papers. Anastasia's ears have started to hurt — the same as happened to the others. From 3 o'clock until 4.30 walked and worked in the garden with Valya D[olgorukov]. The weather was pretty bad, wind chill two degrees below. At 6.45 we went to vespers. Alexei had his first bath. Went to see Ania and Lily D[ehn], and then the others.

(Nicholas's Diary for 1917. ГА РФ. Ф.601. Оп.1. Д.265. С.75.)

586 Dinner Menu for the Imperial Family at Tsarskoe Selo,
18 March 1917

Black ink on white paper stamped with a gold eagle
Signed in pencil in the top right-hand corner by all those who dined that day with the imperial family: П. Бенкендорф, Е. Нарышкина, В. Долгоруков, М. Бенкендорф, А. Гендрикова, Буксгевден [P. Benckendorff, E. Naryshkina, V. Dolgorukov, M. Benckendorff, A. Hendrikova, Buxhoeveden]
13 × 20.5 cm

Dinner:
Consommé with Beetroot
Kasha [buckwheat] *and Pirozhki* [meat pasties]
Boiled Perch with Hollandaise Sauce
Roast Turkey
Salad
Semolina Pudding

ГА РФ. Ф.553. Оп.1. Д.33. Л.1

Of the six members of the retinue who dined that day with the imperial family, two — the lady-in-waiting Countess A. V. Hendrikova and marshal of the court Prince V. A. Dolgorukov — shared the fate of the family and were shot in Siberia in 1918.

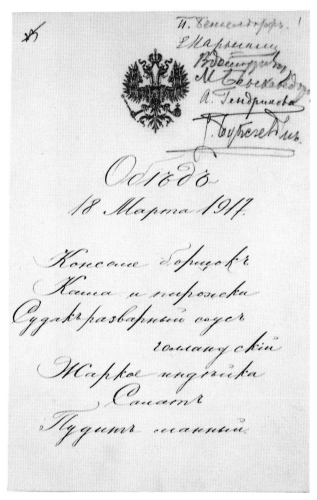

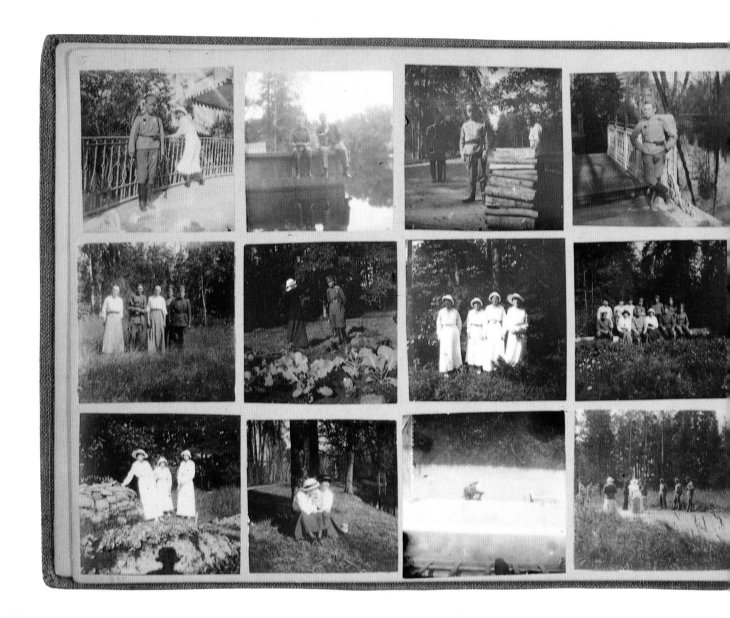

587 Photograph Album of Grand Duchess Anastasia Nikolaevna with Amateur Photographs of the Family, Spring–Summer 1917

Cover of grey-coloured material; monogram of Emperor Nicholas II with a crown stamped in gold in top corner; gold border to the pages
451 photographs in all; illustrated here: pages 24–5 (12 photographs on each page)
Album: 28 × 38 × 4.2 cm; spread 28 × 77.4 cm
ГА РФ. Ф.683. Оп.1. Д.125. Л.24об., 25

A typical day during their time under arrest at Tsarskoe Selo went thus: they got up at 8 o'clock, had prayers and then morning tea with everyone together, except of course those who were sick and could not yet leave their rooms. They were allowed to go for a walk twice a day: from 11.00 to 12.00 in the morning and from 2.30 until 5.00 in the afternoon. When there were no lessons, the empress and her daughters stayed indoors sewing, embroidering or knitting. They were never without work of some sort. The emperor read in his study or sorted out his papers. In the evening after tea the emperor would go into his daughters' room, they would draw up an armchair and table for him and he would read aloud from the Russian classics, while his wife and daughters either did needlework or drew. The emperor had been accustomed to physical activity since childhood, and this trait he had passed on to his own children. He used his morning break for a

constitutional walk, for the most part accompanied by Dolgorukov. Sometimes, instead of Dolgorukov, one of his daughters would go with him, after they had recovered from their illness. During the time allocated them in the afternoon, the whole family, with the exception of the empress, engaged in physical work: they cleared the pathways of snow, or cut blocks of ice for the cellar, or else pruned dead branches and felled old trees, preparing firewood for the next winter. When the warm weather came, the whole family started to lay out a large kitchen garden, and they were even helped in this work by a few officers and soldiers of the guard, who had grown used to the imperial family and wanted to show their concern and goodwill.

In time, as they recovered from their illness, the children resumed their studies. Since they were forbidden to have teachers come in from the outside, their parents organized lessons for them as best they could using the courtiers who shared their captivity. So it was that the emperor undertook to teach the heir history and geography; the empress taught all the children scripture; Grand Duchess Olga Nikolaevna did English language with her younger sisters and brother; Ekaterina Adolfovna Schneider taught mathematics as well as Russian grammar to the younger grand duchesses and the heir;

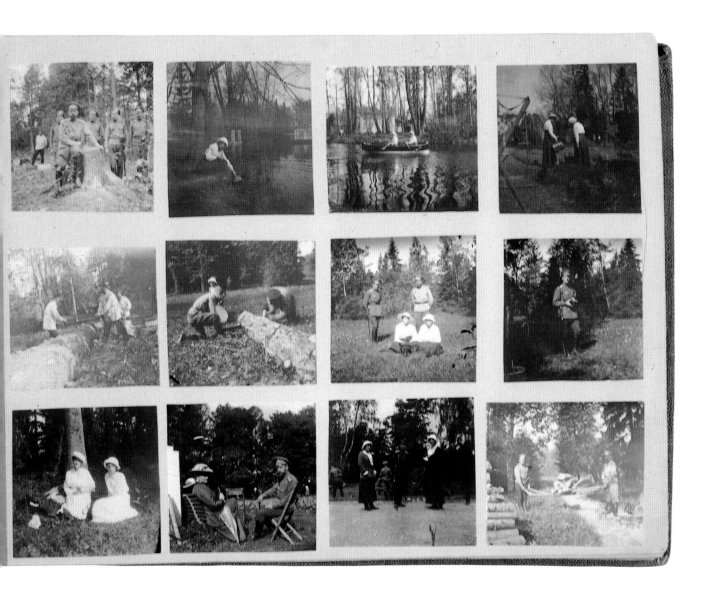

Countess Hendrikova taught history to Grand Duchess Anastasia Nikolaevna; Baroness Buxhoeveden did English with the elder grand duchesses; Doctor Botkin did Russian literature with Alexei Nikolaevich, while Dr Derevenko taught him science, and Gilliard taught everyone French.
(Memoirs of Klavdia Bitner, teacher to the imperial children, recorded by General Dietericks; Dietericks, 1922, pp. 194–5.)

28 April. In the afternoon we went for a walk and then set to work making a kitchen garden in the little garden opposite Mama's windows. T[atiana], M[aria] Anast[asia] and Valya [Dolgorukov] dug the earth energetically, while the commandant and officers of the watch looked on and occasionally made suggestions.

29 April. In the afternoon the whole family went into the garden; Alix watched us digging the earth from a chair on the grass.

30 April. At 2 o'clock we all went out into the garden with several of our people who wanted to work. Everybody started to dig with great energy and even enjoyment, and we worked unaware of the time until 5 o'clock.

10 May. In the afternoon we worked hard in the garden and even started to plant a few vegetables.

15 May. We went into the garden at 2.15 and worked the whole time with the others on the vegetable patch; Alix and the girls planted various vegetables in the beds we had prepared.
(Nicholas's Diary for 1917. ГА РФ. Ф.601. Оп.1. Д.265. С.106–107, 117.)

15 June. We finished the vegetable garden some time ago, and it is now in magnificent shape. We have planted every conceivable type of vegetable, including five hundred heads of cabbage. The servants also created their own vegetable patch on the other side of the palace, where they can grow whatever they like. We went to help them dig — the emperor as well. To occupy our free time, now that the vegetable garden is finished, we asked and were given permission to fell the dead trees in the park. So now we go from one place to the next accompanied by a sentry who follows us everywhere. We are becoming expert woodcutters. It will give us additional firewood for next winter.
(Gilliard, 1921, p. 194.)

589

588 Tsarevich Alexei Nikolaevich Bathing in a Pond in the Park of the Alexander Palace at Tsarskoe Selo, June 1917

Photograph taken by Grand Duchess Maria Nikolaevna
Inscribed in French by P. V. Petrov in pencil on the reverse: *Photo prise par M[aria] N[ikolaevna]. Juin 1917: Alexis Nikolaevitch se baignant dans l'étang près de 'l'Île des enfants'.* [Photo taken by Maria Nikolaevna. June 1917: Alexei Nikolaevich bathing in the pond next to the 'children's island']
4.5 × 6.5 cm
ГА РФ. Ф.611. Оп.1. Д.102. Л.54

In the afternoon we walked from 2.00 until 5.00. Everyone does something in the garden. If it's not too stuffy, Mama also comes out and lies on the bench under the tree by the water. Papa walks deep into the garden (with many others) where he fells and cuts up dry trees. Alexei plays on the 'children's island', runs around barefoot and sometimes goes for a swim.
(Extract from a letter from Grand Duchess Olga Nikolaevna to her teacher P. V. Petrov, dated 19 June 1917. ГА РФ. Ф.611. Оп.1. Д.102. Л.54.)

589 Drawing by Tsarevich Alexei Nikolaevich,

Tsarskoe Selo, 31 May 1917

Coloured pencil on paper
Inscribed by Alexei beneath the drawing: *Это электрическая дама* [This is the electric lady]
10.5 × 18 cm
ГА РФ. Ф.682. Оп.1. Д.22. Л.19

590

'The electric lady' was the name Alexei gave to Ekaterina Adolfovna Schneider, who taught him Russian language and literature in the spring of 1917. Schneider shared the same fate as the imperial family, and was shot in Siberia.

590 Drawing by Tsarevich Alexei Nikolaevich,

Tsarskoe Selo, 31 May 1917

Pencil on paper
Inscribed by Alexei beneath the drawing: *Часовой* [The guard]
8.5 × 9 cm
ГА РФ. Ф.682. Оп.1. Д.22. Л.18

Sunday 10 June. The children were playing on their island a few days ago (an artificial island in the middle of a small lake). Alexei Nikolaevich was playing with his small rifle to which he is very attached because it's the same one the emperor was given by his father when he was a child. An officer came up to us and warned me that the soldiers had decided to remove the tsarevich's gun and that they were coming to take it from him. Hearing this, Alexei Nikolaevich put his toy down and went back to the empress who was sitting on the lawn a little distance from us. A moment later, the officer of the guard turned up with two soldiers and demanded the 'weapon'. I tried to interject and explain that this was no weapon, only a toy, but it was pointless, and they took it. Alexei Nikolaevich started to sob. His mother asked me to try once more to convince the soldiers, but I fared no better than the first time and they went off with their trophy.

Half an hour later the officer of the guard took me aside and asked me to tell the tsarevich that he was sorry about what he had had to do. Unable to dissuade the soldiers, he had decided to accompany them to make sure that they did not behave in a rude manner. Colonel Kobylinsky [palace commandant] *was very displeased when he heard of what had happened, and he returned the gun to Alexei Nikolaevich piece by piece; he now only plays with it in his room.*
(Gilliard, 1921, pp. 193–4.)

591 A. F. Kerensky, 1917

Unknown photographer
Signed and dated by Kerensky in black ink on the left of the photograph:
А. Керенский 24/IX
9 x 14 cm
ГА РФ. Ф.601. Оп.2. Д.71. Л.1

Alexander Feodorovich Kerensky (1881–1970) was a lawyer, and leader of the workers' faction in the Fourth State Duma. A member of the Socialist Revolutionary party from March 1917, he was minister of Justice in the Provisional Government from March to May 1917, and then Army and Navy minister from May to September. From 8 [21] July he was Prime Minister, and from 30 August [12 September] Supreme Commander. On 25 October [7 November], after the Bolshevik coup, Kerensky fled St. Petersburg. He emigrated and lived in the USA.

The first to arrive was Kerensky, casually dressed in a jacket, and the emperor was informed of his arrival. The emperor asked for Kerensky to be brought to him. Kerensky stayed with the emperor a short while.
(Volkov, 1993, p. 70.)

The first meeting between A. F. Kerensky and the imperial family took place on 3 April 1917. At that time the Provisional Government was engaged in negotiations with England to see if they would accept the imperial family. But King George V, Nicholas II's cousin, was alarmed by the Russian Revolution and the possible repercussions on public opinion in his own country. He therefore refused to offer a refuge to the imperial family. The family themselves wanted to go to Livadia in the Crimea and live there in a private capacity. However, by the middle of July, the Petrograd Soviet had begun to foment anti-Romanov feeling in St. Petersburg. There was now a threat of unsanctioned reprisals against 'Nicholas the Bloody' — the name increasingly used for the former tsar. In view of these circumstances, the Provisional Government decided to evacuate Nicholas and his family deep into the country, to Tobolsk.

The Prime Minister of the Provisional Government, A. F. Kerensky, personally composed the 'instructions to those persons accompanying the former emperor and his family to their new place of residence', which he signed on 31 July 1917:

1 *During the journey the former emperor and empress, their family and those persons who choose to accompany them of their own free will, will all be treated as persons under arrest.*

2 *During the journey, none of the persons mentioned above in clause 1 may have any communication with anyone other than with the persons designated by me to accompany them.*
(ГА РФ. Ф.601. Оп.2. Д.14. Л.1.–1 об.)

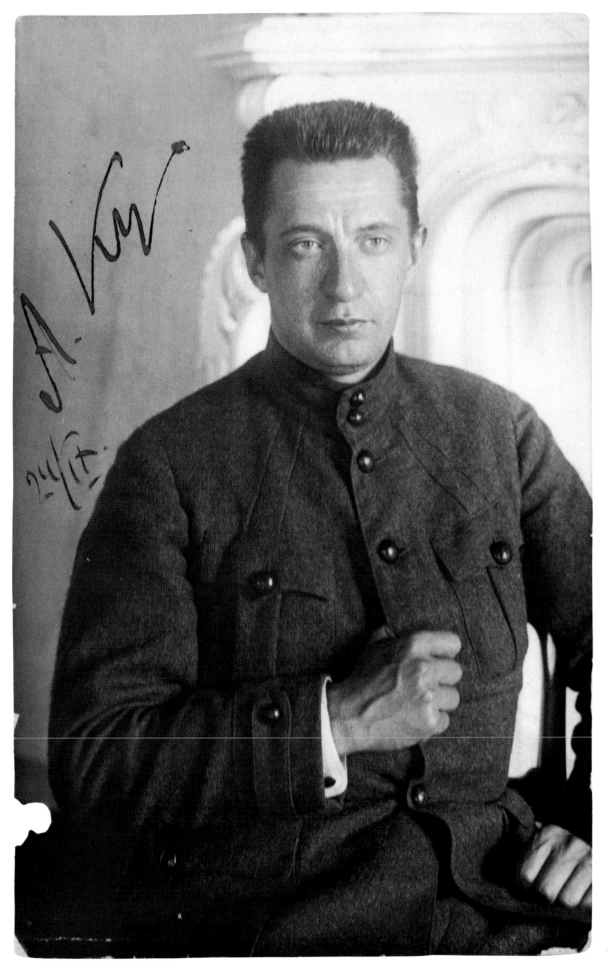

The Final Months

Imprisonment in Tobolsk and Tragedy in Ekaterinburg

592 The House in Tobolsk where the Romanov Family was Held
 in Captivity, End of 1917

Unknown photographer
14 x 9 cm
ГА РФ. Ф.601. Оп.1. Д.2110. Л.33

At dawn on 1 August 1917 two trains set off from Tsarskoe
Selo under the flag of the Japanese Red Cross, bearing the
imperial family, their retinue and servants, and the soldiers
of the Detachment of Special Purpose, who were to guard the
detainees. On 6 August they arrived in Tobolsk, where the family
were lodged in a specially assigned house which had previously
belonged to the governor of Tobolsk. Part of the retinue and staff
were lodged with them, but the majority were housed opposite
in the residence of the merchant Kornilov.

*At the beginning the conditions of our captivity were fairly similar
to those at Tsarskoe Selo. We had all the essentials. Nevertheless the
emperor and the children suffered from the lack of space. In fact for
exercise they only had a small kitchen-garden and a yard which had
been made by fencing off the wide, little-used street which ran along
the south-east side of the house. It was very little, and always in view
of the soldiers, whose guard-house dominated all the space available
to us. Members of the retinue and staff, on the other hand, enjoyed
greater freedom here than in Tsarskoe Selo, and in the beginning at
least were allowed to walk around the town or the immediate
surroundings.*
(Gilliard, 1921, pp. 200–1.)

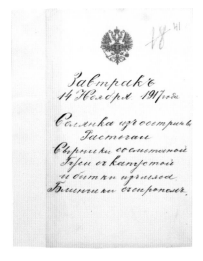

593

593 Ration Card no. 54 issued in the name of 'Ex-Emperor Nicholas Alexandrovich Romanov' by the Tobolsk City Food Committee, Autumn 1917

On the right: stamp of the Tobolsk City Food Administration
11 x 35 cm

November 1917
Flour: 5 poods [approx. 80 kilos], 10 lbs
Sugar: 7.5 lbs

December 1917
Flour: 5 poods, 10lbs
Sugar: 7.5 lbs

ГА РФ. Ф.601. Оп.2. Д.23. Л.43–44

At the beginning the local population brought the imperial family a lot of provisions. Throughout the family's stay in Tobolsk provisions were also obtained from the Ivanovsky Convent which was situated not far from the town. Until the October revolution there was plenty of everything, although they lived modestly. Dinner consisted of two dishes, and desserts were only served on holidays. In the morning they had tea at about 8 o'clock. Lunch was at 1 o'clock, tea and buns were served at 5.00 and dinner at 8.00.
(Volkov, 1993, p. 77–8.)

In the spring of 1918 the imperial family and their servants were all put on soldiers' rations.

Monday 25 February 1918. Colonel Kobylinsky has received a telegram informing him that from 1 March 'Nicholas Romanov and his family are to be put on soldiers' rations and that each member of the family will receive 600 roubles a month, to be taken from the interest on their personal capital.' Up until now all our expenses had been paid by the State ...

Friday 1 March. The new regime has certainly come into effect. From today butter and coffee have been banished from our table as luxuries.
(Gilliard, 1921, pp. 212–3.)

594 Lunch Menu for the Imperial Family, 14 November 1917

Black ink on white paper, with a double-headed eagle stamped in gold at the top
11 x 17 cm

Lunch:
Sturgeon soup
Rastegai [an open pasty]
Cheese pancakes with sour cream
Goose with cabbage and meat balls
Pancakes with syrup

ГА РФ. Ф.601. Оп.1. Д.23. Л.41

594

In November 1917, the financial situation of the detainees became much worse. Nicholas wrote in his diary:

Wednesday 14 [27] February. We are going to have to cut back on our expenditure on food and service quite considerably, since the marshal's allowance stops from 1 March, and furthermore we are only permitted to receive 600 roubles each a month from our own capital. These past few days have been spent calculating the minimum sum required to make ends meet.

Wednesday 28 February [13 March]. In the last few days we have started to receive butter, coffee, biscuits for tea, and jam from various kind people who have heard about the reduction in our food allowance. It is so touching!
(Nicholas's Diary for 1918. ГА РФ. Ф.601. Оп.1. Д.266. Л.59, 64.)

The family continued to live quietly in Tobolsk. They heard delayed rumours of what was happening in the capital but they

by no means knew everything that was going on outside.
In the spring of 1918, after the old army had been disbanded, the question arose of replacing their guard, which was a detachment formed by the Provisional Government. Rumours began to circulate in Siberia and the Ukraine about a monarchist plot to free the family.

Meanwhile in Tobolsk a dispute arose between the detachment guarding the imperial family and the new city authorities. Both sides sent telegrams of complaint to Moscow (where the Soviet government had moved in March 1918) asking for the conflict to be resolved. At a meeting of the praesidium of the All-Russian Central Executive Committee on 1 April 1918, it was decided to dispatch forthwith to Tobolsk a special detachment 'to strengthen the guard'. It was also decided that 'if it proves possible all the detainees should immediately be moved to Moscow'. (ГА РФ. Ф.1235. Оп.34. Д.36. Л.9.)

It was precisely this attempt to move the family to the new capital which precipitated the conflict between the Ekaterinburg Bolsheviks and the central government: the Ural Regional Soviet began to consider dealing with Nicholas itself. In March 1918, shortly before these events, a separate peace had been signed with Germany, which had been opposed by many members of the Ural Soviet, led by its chairman A. G. Beloborodov. The suspicion arose in Ekaterinburg that the plan to move the family to Moscow could be part of a secret undertaking to save the lives of Nicholas, his wife and children and hand them over to Germany. In fact the Treaty of Brest-Litovsk contained no such secret protocols relating to the Romanovs.

595 Programme of a Play Performed by the Imperial Family in Tobolsk, 4 February 1918

Programme written by Alexandra in English

Amateur dramatics were one of the imperial family's favourite distractions in captivity. On 4 February 1918 they performed the English play *Packing up*, the main roles being performed by the children: *Ал. Н.* – Alexei Nikolaevich; *М. Н.* – Maria Nikolaevna; *А. Н.* – Anastasia Nikolaevna; and *S. Gibbs* – Sidney Gibbs [English tutor to Alexei]

8.5 × 11 cm
ГА РФ. Ф.601. Оп.1. Д.266. Л.3

Sunday 4[17] February. After dinner there was a repeat performance of the play 'A la Porte' and the English [play] 'Packing up' which was performed by Anastasia and Alexei — very lively and funny.
(Nicholas's Diary for 1918. ГА РФ. Ф.601.Оп.1. Д.266. Л.55–56.)

596 Programme of a Play Performed by the Imperial Family in Tobolsk, 18 February 1918

Programme written by Alexandra in English

On 18 February 1918 another English play, *The Crystal Gazer*, was performed by Maria Nikolaevna and Sidney Gibbs.

8.5 × 11 cm
ГА РФ. Ф.601. Оп.1. Д.266. Л.4

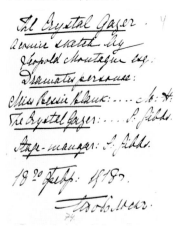

Sunday 18 February [3 March]
Worked in the garden and sawed wood. Rehearsed after tea. The performance took place in the evening. First there was an English play, 'The Crystal Gazer', with Maria and Mr Gibbs, and then ours — 'The Bear' — which was played by Olga, Maria again, and myself. There was a lot of nerves before the performance, but I think it turned out well.
(Nicholas's Diary for 1918. ГА РФ. Ф.601. Оп.1. Д.266. С.61.)

For the most part these plays were staged in foreign languages under the guidance of Gilliard or Gibbs. Only one was in Russian, and this was the only time his majesty himself took part ... Most of the time the actors were Tatiana Nikolaevna, Maria Nikolaevna and Alexei Nikolaevich, and, for the men's parts, Gilliard and Gibbs. Anastasia Nikolaevna and Olga Nikolaevna took part less often, and occasionally another member of the entourage would take part.
(Melnik-Botkina, 1993, p. 83.)

597 Floor Plan of the Ipatiev House in Ekaterinburg, 1918

Indian ink on prepared cloth
57 × 35 cm
ГА РФ. Ф.601. Оп.2. Д.40. Л.1

At a meeting on 6 April 1918, the praesidium of the Central Executive Committee made the following resolution: 'In addition to the resolution already adopted, [it is resolved] to ask Comrade Sverdlov to communicate by direct line with Ekaterinburg and Omsk ... concerning the transfer of the detainees to the Urals.' (ГА РФ. Ф.1235. Оп.34. Д.36.Л.31.) Y. M. Sverdlov carried out this resolution of the Central Executive Committee and dispatched a special detachment commanded by the commissar V. V. Yakovlev to escort the imperial family from Tobolsk to Ekaterinburg. Yakovlev was given the title of extraordinary plenipotentiary.

However, the rumours and mistrust surrounding the fate of the imperial family were so acute that Ekaterinburg obviously did not believe that Yakovlev would take Nicholas to the Urals.

Furthermore, the Ural Soviet did not even see the necessity, believing that the former tsar could simply be shot along the way.

Thursday 12[25] April.
After lunch Yakovlev arrived with Kobylinsky and told us that he had received an order to take me away, but without saying where to. Alix decided to go with me and bring Maria; there was no point in protesting. It was terrible leaving the other girls and Alexei — who is ill — especially in such circumstances! We immediately began packing the bare necessities. Then Yakovlev said that he would come back for Olga, Tatiana, Anastasia and Alexei, and that we would probably see them in about three weeks. We spent a very sombre evening; that night, of course, nobody could sleep.
(Nicholas's Diary for 1918. ГА РФ. Ф.601. Оп.1. Д.266. Л.86–7.)

Thursday 25 April.
At half past eleven the servants gathered in the main hall. Their majesties and Maria Nikolaevna said goodbye to them. The emperor embraced all the men, the empress all the women. Almost everyone was in tears. Their majesties retired and we all went down to my room. At half past three in the morning the carriages drew up in the courtyard ... At half past four we went up to their majesties who were just coming out of Alexei Nikolaevich's room. The emperor, empress, and Maria Nikolaevna said goodbye to us. The empress and the grand duchesses were crying. The emperor seemed calm and found a word of encouragement for each of us; he embraced us. As the empress bid me farewell she asked me not to go down again, but to stay with Alexei Nikolaevich. I went to his room and found him crying in his bed.
(Gilliard, 1921, p. 221.)

On 29 April Nicholas, Alexandra Feodorovna and Maria arrived in Ekaterinburg, accompanied by their doctor E. S. Botkin, marshal of the court Prince V. A. Dolgorukov, the tsar's valet T. I. Chemodurov, the footman I. D. Sednev, and the maid A. S. Demidova. The house where the Ekaterinburg Bolsheviks wanted to lodge the family was not yet ready. Its owner, N. N. Ipatiev, had only moved out at 3 o'clock that same day, 29 April. The family moved in on 30 April.

At 3 were told to get out of the train ... Their chief took us three in an open motor, a truck with soldiers armed to their teeth followed us. Drove through bystreets till reached a small house, around which high wooden palings have been placed.
(Alexandra's Diary, 17 [30] April 1918 [entry in English]. ГА РФ. Ф.640. Оп.1. Д.326. Л.55.)

That day the empress made a sign on the window frame in her room. She drew a swastika and next to it put the date: *17/30 April 1918.*

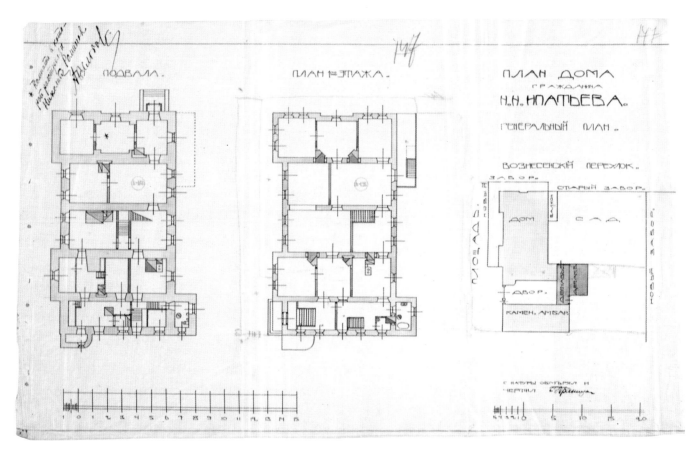

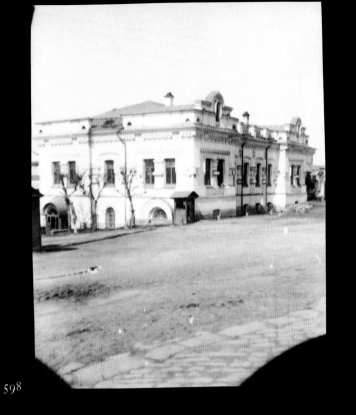

598

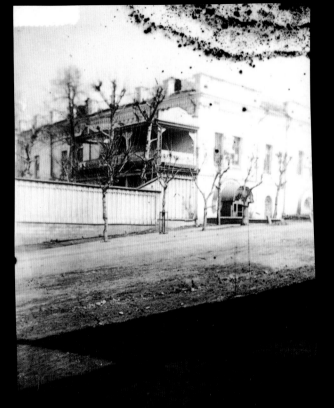

599

600

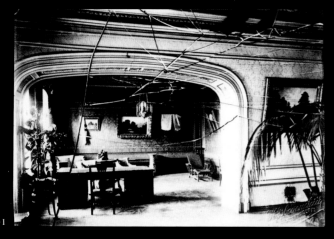

601

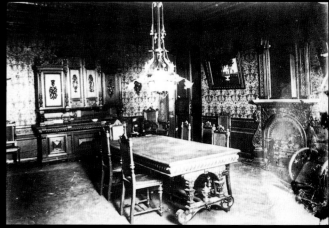

602

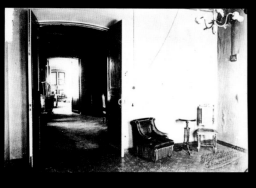

603

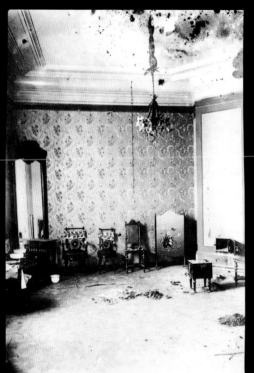

604

605

598 The Ipatiev House in Ekaterinburg where the
Imperial Family were Killed, 1918

View from the corner of Voznesensky Prospect and Voznesensky Lane
Contemporary print from the original negative taken during the investigation of 1918
11.5 × 14.5 cm
Office of the Public Prosecutor of the Russian Federation

The Ipatiev house (or, as it was codenamed, the House of
Special Purpose) was named after its owner, the merchant
Nikolai Nikolaevich Ipatiev, a retired captain in the Engineers.

Until 1945 there was a plaque on the outside wall
commemorating the execution of the imperial family, and
inside the house a museum where the possessions of the
imperial family were displayed. In 1977, however, on the
orders of the Central Committee of the Politburo of the
Communist Party, the Ipatiev house was destroyed.

On 20 May 1918 the remaining children — Olga, Tatiana,
Anastasia and Alexei (who was still unwell from a severe
attack of his illness at the beginning of April) — left Tobolsk
for Ekaterinburg. They were accompanied by I. L.Tatishchev,
P. A. Gilliard, S. I. Gibbs, A. V. Hendrikova, S. K. Buxhoeveden,
E. A. Schneider and A. A. Tegleva, among others. They arrived
in Ekaterinburg on 23 May and the children were taken to the
Ipatiev house. Very few of the retinue or servants were allowed
to stay with the family. By 28 May the only people in the Ipatiev
house with the family were: Doctor Botkin, the cook Kharitonov,
the valet Trupp, the maid Demidova and the kitchen boy Leonid
Sednev (who was taken away on the day of the execution).

599 The Ipatiev House in Ekaterinburg, 1918

N. Vvedensky
View from Voznesensky Lane onto the garden terrace
Contemporary print from the original negative taken during the investigation of 1918
10.5 × 15.5 cm
Office of the Public Prosecutor of the Russian Federation

*In Ekaterinburg the Romanov family were lodged in a private
residence, surrounded by a tall wooden fence. This residence was
totally unlike the governor's house in Tobolsk, where the large rooms
and hall were more like a country palace. The Romanovs' guard was
tightened in Ekaterinburg, and a much stricter regime introduced by
comparison with Tobolsk.*
(Melnik-Botkina, 1993, p. 175.)

*The house is good and clean. We have been assigned four large rooms:
a corner bedroom, a dressing-room, a dining-room with windows onto
the garden and a view of the lower part of the town, and finally a
spacious arched hall without doors ... By the entrance is the room of
the officer on guard. The soldiers are lodged in two rooms next to the
dining-room. To go to the bathroom or the W.C. we have to go past the
sentry at the door of the guard room.*
(Nicholas's Diary, 17 [30] April 1918. ГА РФ. Ф.601. Оп.1.
Д.266. С.94.)

600 The Outer Fence Around the Ipatiev House in Ekaterinburg,
1918

Unknown photographer
View from Voznesensky Prospect
Contemporary print from the original negative taken secretly during the family's
imprisonment in the house in 1918
10.5 × 15.5 cm
Office of the Public Prosecutor of the Russian Federation

*They built two fences around the house; one of these was so high that
only the top of the gold cross on the cathedral could be seen, but just to
be able see this cross was a source of great comfort to the prisoners.*
(Melnik-Botkina, 1993, p. 95.)

*A very tall wooden fence has been put up around the house some two
sazhens [about 4.25 metres] from the windows; a row of guards are
lined up along it, in the little garden also.*
(Nicholas's Diary, 17 [30] April 1918. ГА РФ. Ф.601. Оп.1.
Д.266. С.94.)

601 The Hall and Drawing-Room of the Ipatiev House in
Ekaterinburg, 1918

N. Vvedensky
These rooms were occupied by Doctor Botkin and the valet T. I. Chemodurov
Trade-mark of the photographer in the lower left corner of the photograph:
Н. Введенский. Екатеринбург [N. Vvedensky, Ekaterinburg]
Contemporary print from the original negative taken during the investigation of 1918
10.5 × 15.5 cm
Office of the Public Prosecutor of the Russian Federation

Evgeny Sergeevich Botkin (1865–1918) was court physician to
Emperor Nicholas II, and senior lecturer at the Military-Medical
Academy. He took part in the Russo-Japanese war of 1904–5.
Botkin accompanied the imperial family to Tobolsk and
Ekaterinburg, and was executed with them on the night of
16–17 July 1918.

Terenty Ivanovich Chemodurov (1849–1919) was Nicholas II's
valet from 1908. He followed the imperial family into exile to
Tobolsk and Ekaterinburg. On 24 May 1918 he was taken from
the Ipatiev House to prison, where he was rescued by the White
Army on 25 July 1918.

602 The Dining-Room in the Ipatiev House in Ekaterinburg, 1918

N. Vvedensky
Trade-mark of the photographer in the lower right corner of the photograph:
Н. Введенский. Екатеринбург [N. Vvedensky, Ekaterinburg]
Contemporary print from the original negative taken during the investigation of 1918
10.5 × 15.5 cm

Office of the Public Prosecutor of the Russian Federation

The door which can be seen in the photograph leads to the grand duchesses' room. By the fireplace is Alexandra Feodorovna's wheelchair.

As soon as the emperor, the empress and Maria Nikolaevna arrived at the house they were subjected to a thorough and humiliating search … The regime in the Ipatiev House was extremely harsh and the behaviour of the guards disgraceful, yet the emperor, empress and Grand Duchess Maria Nikolaevna bore everything with apparent calm, and appeared not to notice either the people around them or what they were doing. The day was generally spent thus: in the morning the whole family had tea which was served with black bread left over from the day before; lunch was at 2 o'clock and was sent over ready cooked from the local Soviet of Workers' Deputies — it consisted of meat soup and a hot dish, and for second course usually cutlets. As we had not brought any table linen or cutlery with us, and they gave us none, we had to dine without a tablecloth; the plates and crockery were extremely simple. By order of the emperor, everyone sat at table together and often they would only give us five spoons for seven people. Supper consisted of the same dishes as lunch.
(From the deposition of T. I. Chemodurov; Sokolov, 1990, pp. 162–3.)

603 View from the Room of the Maid A. S. Demidova across the Dining-Room, Ante-room and Kitchen of the Ipatiev House in Ekaterinburg, 1918

N. Vvedensky
Trade-mark of the photographer in the lower right corner of the photograph:
Н. Введенский. Екатеринбург [N. Vvedensky, Ekaterinburg]
Contemporary print from the original negative taken during the investigation of 1918
10.5 × 15.5 cm

Office of the Public Prosecutor of the Russian Federation

Anna Stepanovna Demidova (1878–1918) was Empress Alexandra Feodorovna's maid. She was shot with the family in the Ipatiev House on the night of 16–17 July 1918.

604 The Grand Duchesses' Room in the Ipatiev House, 1918

N. Vvedensky
Contemporary print from the original negative taken during the investigation of 1918
10.5 × 15.5 cm

Office of the Public Prosecutor of the Russian Federation

Ashes, as well as pieces of articles destroyed after the murder, can be seen on the floor.

The valet Ivan Sednev and Alexei's attendant Nagorny found themselves in the same prison as Prince G. E. Lvov:

Both Sednev and Nagorny painted a bleak picture of the regime in Ekaterinburg … From the start [the guards] *started pilfering things. At first they stole the gold and silver. Then they started to take linen and footwear. The tsar could not endure it and became extremely angry. He protested, but was cursorily informed that he was now a prisoner and no longer in a position to give orders … Gradually things got worse. At the beginning, for instance, they were allowed twenty minutes for the daily walk, but this was gradually reduced to five minutes. They were forbidden from doing any kind of physical work; the heir was ill … The grand duchesses were particularly badly treated. They did not dare go to the bathroom without asking permission. When they needed to go, they were invariably escorted up to the door of the bathroom by a Red Army guard. In the evening they were made to play the piano. They shared a table with the servants.*
(From the deposition of Prince G. E. Lvov; Sokolov, 1990, p. 165.)

605 The Staircase in the Ipatiev House Leading Down to the Cellar where the Execution of the Imperial Family Took Place, 1918

N. Vvedensky
Contemporary print from the original negative taken during the investigation of 1918
11.5 × 16.5 cm

Office of the Public Prosecutor of the Russian Federation

I then went down to the lower floor, most of which formed a basement. It was with intense emotion that I entered the room which had maybe — there was still some doubt — been the scene of their death. The sight of this room was oppressive beyond all imagination. The light came in through a single window with iron bars, set in the wall at about a man's height. The walls and floor bore numerous marks of bullets and bayonet thrusts. From the very first look it was evident that the most brutal crime had taken place there and that several people had been murdered.
(Gilliard, 1921, p. 231.)

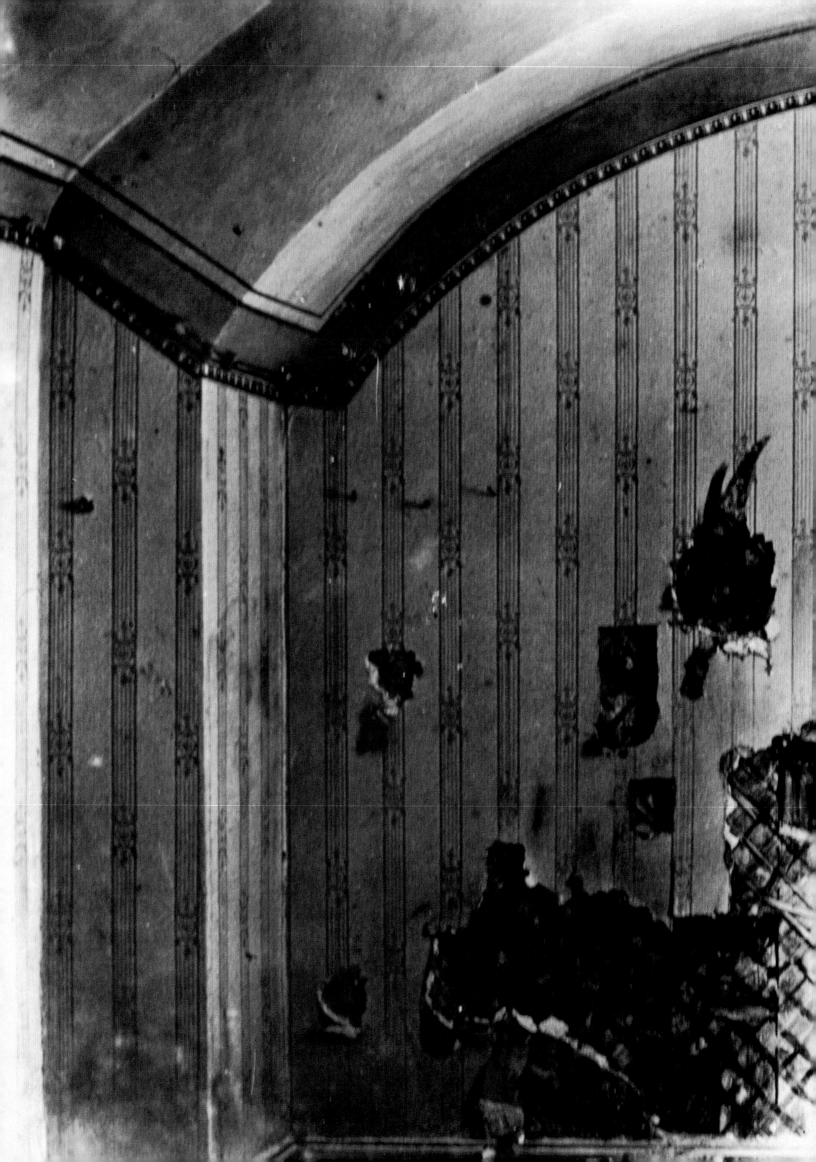

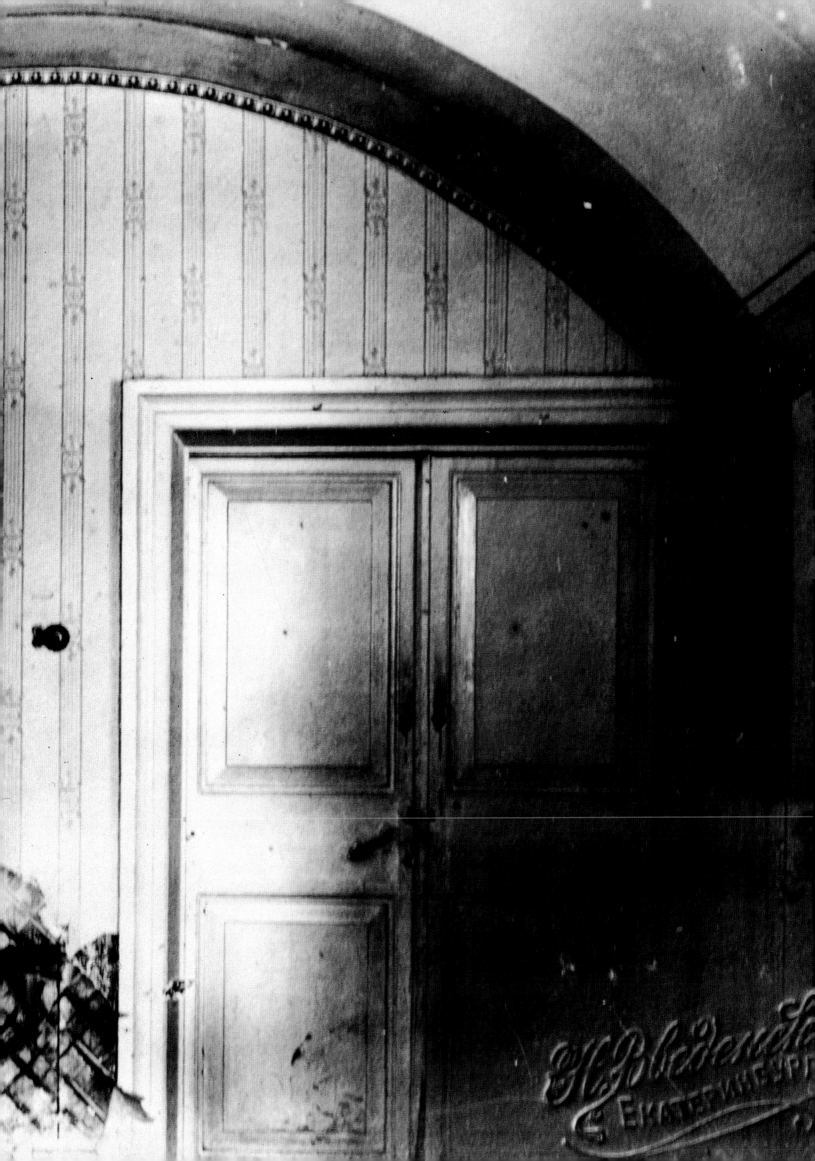

606 The East Wall of the Room in the Ipatiev House where the Imperial Family were Murdered, 1918

N. Vvedensky
Trade-mark of the photographer in the lower right corner of the photograph:
Н. Введенский. Екатеринбург [N. Vvedensky, Ekaterinburg]
Contemporary print from the original negative taken during the investigation of 1918
19 × 28 cm

Office of the Public Prosecutor of the Russian Federation

The rooms were filled with smoke and the smell of gun powder. In the back room with the barred window, which was next to the store, the walls and floor were full of bullet holes. The bullets were particularly numerous (or rather the holes they had made) in one wall, the same one as in the photograph you showed me, but there were traces of bullets in the other walls as well. There were no bayonet marks anywhere on the walls of the room. Where there were bullet marks in the walls and floor, there was blood around them; it was spattered on the walls and on the floor it had formed little pools. There were also spots and pools of blood in all the rooms you have to pass through to get from the room with the bullet marks out into the yard of the Ipatiev House. There were similar marks on the stones in the yard towards the gates.
(From the deposition of Filipp Proskuryakov, one of the guards at the Ipatiev House who helped to clean up the rooms after the murder; Sokolov, 1990, p. 279.)

607 The Last Diary of Nicholas II for 1918

Exercise book with a black leather cover
17 × 22 cm

The last entry in Nicholas's diary is dated 30 June [13 July], three days before the execution:

Saturday 30 June.
Alexei took his first bath since Tobolsk; his knee is getting better, but he still cannot unbend it completely. The weather is warm and pleasant. We have no news whatsoever from the outside.

ГА РФ. Ф.601. Оп.1. Д.266. Л.134

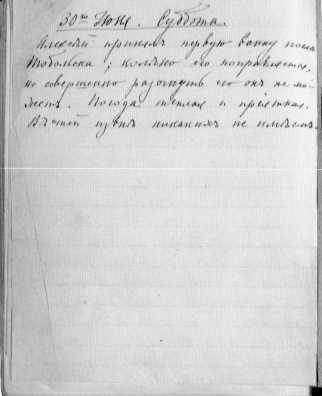

607

607

608 The Last Diary of Alexandra Feodorovna for 1918

Exercise book with a black paper binding; cover of lilac cloth with a white silk lining;
white swastika sewn into the top right corner
The exercise book was given to Alexandra Feodorovna for New Year 1918 by
Grand Duchess Tatiana Nikolaevna, who made the cover herself.
In English
11 × 18 cm; spread 22 × 18 cm

3/16 July, Irina's 23rd B[irth] D[ay] – Ekaterinburg
Grey morning, later lovely sunshine. Baby has a slight cold. All went out 1/2
hour in the morning. Olga and I arrange our medicines. T[atiana] read
дух[овное] чтение [religious reading]. They went out. T[atiana] stayed
with me and we read: Кн[игу] пр[орока] Амоса и пр[орока] Авдии

[Book of the Prophets Amos and Audios]. *Tatted.*
Every morning the коменд[ант] [commandant] *comes to our rooms; at*
last after a week brought eggs again for Baby.
8h. Supper.
Suddenly Ленька Седнев [Lenka Sednev] *was fetched to go and see his*
uncle and flew off – wonder whether it's true and we shall see the boy
back again!
Played bezique with N[icky]. 10 1/2 to bed. 15 degrees.

ГА РФ. Ф.640. Оп.1. Д.326. Л.1–186 (л.93 об.)

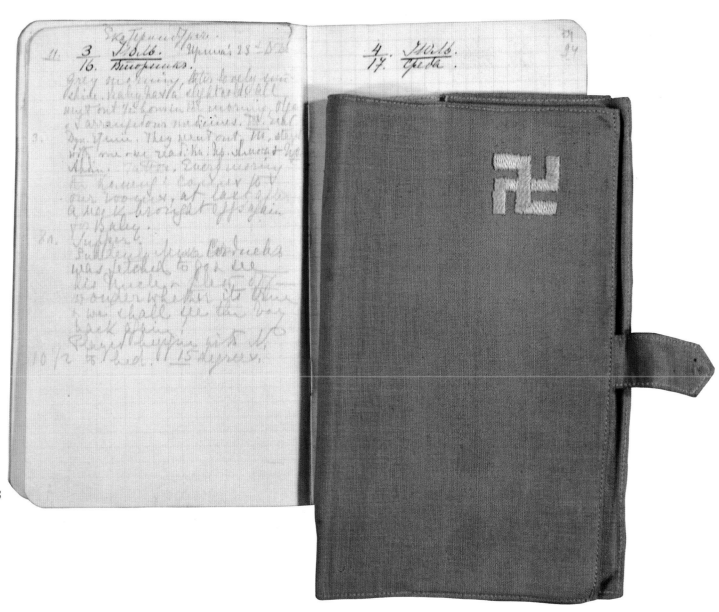

608

609 Draft for a Telegram from Lenin in Reply to an Inquiry from the Danish Newspaper *National Tidende* Regarding Rumours in the Western Press about the Death of Nicholas II,

16 July 1918

In English
Black ink on white paper
Inscribed in pencil under the text of the telegram: *Вернули с телеграфа. Не имеют связи* [Returned from the telegraph. No connection]
17 × 22 cm

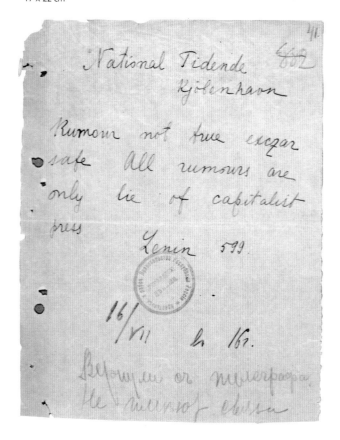

Rumour not true excbar safe all rumours are only lie of capitalist press. Lenin.
16/VII 16.00 hours.

ГА РФ. Ф.P-130. Оп.2. Д.1109. Л.41

This telegram was composed only a few hours before the execution of the imperial family.

610 Telegram from the Chairman of the Petrograd Soviet G. E. Zinoviev to V. I. Lenin and Y. M. Sverdlov, 16 July 1918

White telegraph form, typewritten
21 × 23 cm

From The Smolny, Petrograd

To Sverdlov, The Kremlin, Moscow. Copy to Lenin.

Following received from Ekaterinburg by direct line: inform Moscow that the trial agreed with Filippov [sic] *cannot be delayed because of the military situation, we cannot wait. If you disagree inform us at once out of turn. Goloshchekin. Safarov.*

Communicate directly with Ekaterinburg on this matter. Zinoviev.

ГА РФ. Ф.P-130. Оп.2. Д.653. Л.12

At the beginning of July 1918, the military commissar for the Urals region, F. I. Goloshchekin, visited Moscow. He was an old acquaintance of Y. M. Sverdlov from their days in the pre-revolutionary underground (Goloshchekin's underground pseudonym was Filipp). There is no doubt that Goloshchekin's conversations with Sverdlov (in whose flat he was staying) must have touched on the question of Nicholas II's fate, but unfortunately the surviving documents do not amount to a complete picture of what happened. However, it can be said with certainty that Sverdlov continued to insist that Nicholas should be brought to trial. This is proved by the above telegram, which was sent from Ekaterinburg shortly before the execution (which took place during the night of 16–17 July). It is one of the key documents in establishing the sequence of events, since there are no surviving documents of the meetings of the Ural Soviet, during which, according to witnesses, the fate of Nicholas II was never once discussed; and it was on 16 July that the decision to execute Nicholas was taken.

Communications at that time were extremely bad. The telegrams which reached the Soviet of People's Commissars and the Central Executive Committee were full of inaccuracies and errors, with words and sentences often mixed up or omitted. The above telegram is no exception, but it does prove clearly that Goloshchekin had agreed with Sverdlov not to execute the tsar without a trial. It is a matter of speculation whether the trial was supposed to be organised in Ekaterinburg, or whether Sverdlov still hoped to transfer the Romanovs to Moscow: no further evidence on this point remains. What is important, however, is that Sverdlov and Goloshchekin had already agreed on a death sentence for the tsar. Lenin's involvement in the discussions and decision on the tsar's fate is also intimated.

611 Telegram from the Praesidium of the Ural Regional Soviet to the Chairman of the Council of People's Commissars V. I. Lenin and the Chairman of the Central Executive Committee Y. M. Sverdlov about the Execution of Nicholas Romanov, 17 July 1918

White telegraph form, typewritten
22.5 × 24 cm

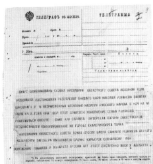

CONCERNING THE APPROACH OF THE ENEMY TOWARDS EKATERINBURG AND THE DISCOVERY BY THE EXTRAORDINARY COMMISSION OF A WHITE GUARD PLOT AIMED AT RESCUING THE FORMER TSAR AND HIS FAMILY. THE DOCUMENTS ARE IN OUR HANDS. ACCORDING TO THE RESOLUTION OF THE PRAESIDIUM OF THE REGIONAL SOVIET NICHOLAS ROMANOV WAS EXECUTED ON THE NIGHT OF THE SIXTEENTH OF JULY. HIS FAMILY HAVE BEEN EVACUATED TO A SAFE PLACE. IN THIS REGARD WE WOULD LIKE TO GIVE NOTICE OF THE FOLLOWING. IN VIEW OF THE APPROACH OF COUNTER-REVOLUTIONARY GANGS TOWARDS THE RED CAPITAL OF THE URALS, AND THE POSSIBILITY OF THE CROWNED EXECUTIONER [NICHOLAS] ESCAPING THE JUSTICE OF THE PEOPLE (A WHITE GUARD PLOT TO REMOVE HIM AND HIS FAMILY HAS BEEN DISCOVERED AND COMPROMISING DOCUMENTS FOUND; THESE WILL BE PUBLISHED), THE PRAESIDIUM OF THE REGIONAL SOVIET CARRIED OUT THE WILL OF THE REVOLUTION BY RESOLVING TO EXECUTE THE FORMER TSAR NICHOLAS ROMANOV, WHO WAS GUILTY OF COUNTLESS BLOODY ACTS OF VIOLENCE AGAINST THE RUSSIAN PEOPLE. THE SENTENCE WAS CARRIED OUT ON THE NIGHT OF 16 JULY 1918. THE FAMILY OF ROMANOV, WHO ARE KEPT WITH HIM UNDER GUARD [IN] THE INTERESTS OF PRESERVING PUBLIC SAFETY, HAVE BEEN EVACUATED FROM THE TOWN OF EKATERINBURG.

THE PRAESIDIUM OF THE REGIONAL SOVIET: WE ASK YOU TO SANCTION PUBLICATION OF THE AFORESAID CONSPIRACY DOCUMENT; WE ARE SENDING NOTIFICATION BY EXPRESS COURIER TO THE SOVIET OF PEOPLE'S COMMISSARS AND THE CENTRAL COMMITTEE. WE ARE WAITING BY THE TRANSMITTER, WE ASK YOU TO REPLY URGENTLY, WE ARE WAITING BY THE TRANSMITTER.

ГА РФ. Ф.601. Оп.2. Д.27. Л.8–9

This telegram testifies to the dismay of the Ural Soviet leadership when it first became clear that everyone in the Ipatiev House, and not just the former emperor, had been shot. It is difficult to know what exactly Beloborodov, chairman of the Soviet, hoped to gain by trying to conceal from Moscow the truth about the Ekaterinburg massacre. It was only some time later that he sent a second telegram (no. 612) in which he admitted that 'the whole family shared the same fate as the head'.

612 Cipher Telegram sent by the Chairman of the Ural Regional Soviet A. G. Beloborodov from Ekaterinburg to the Secretary of the Soviet of People's Commissars N. P. Gorbunov, 17 July 1918

Pink telegraph form with typewritten text; signature of A. G. Beloborodov in black ink; stamp of the Executive Committee of the Soviets of Workers', Peasants' and Soldiers' Ural Deputies on the left. Stamped at the bottom: *за счет Президиума Областного совета Урала* [on behalf of the praesidium of the Ural Regional Soviet]
21 × 25.5 cm

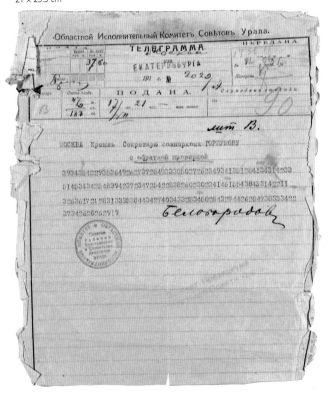

INFORM SVERDLOV THAT THE WHOLE FAMILY SHARED THE SAME FATE AS THE HEAD. OFFICIALLY THE FAMILY WILL PERISH DURING THE EVACUATION.

ГА РФ. Ф.1837. Оп.1. Д.51 (Archive of the investigator N. A. Sokolov)

It was with this telegram from Beloborodov that Moscow found out that not just the tsar, but all his family and attendants, had been killed. The coded text was found in the Ekaterinburg General Post Office when the White forces entered the town. The telegram was added to evidence compiled for N. A. Sokolov's investigation. For a long time Sokolov was unable to decipher the message, and only managed to do so in 1920 after he had emigrated.

In Soviet newspapers and leaflets, only Nicholas's execution was mentioned. A. A. Ioffe, the Soviet envoy-plenipotentiary in Berlin, recounts in his memoirs the difficult situation he found himself in when he was being questioned on all sides about the fate of the Romanovs. Unable to extract any information from Moscow, he was obliged to say that only Nicholas had been shot and that the rest of the family was still alive. He asked the advice of F. E. Dzerzhinsky, the chairman of the Extraordinary Committee, who was visiting Berlin. He replied that he had told Lenin of his [Ioffe's] difficulties and that Lenin had laughed and replied: 'It's better Ioffe doesn't know anything. It will be easier for him to lie.' (Archive of the President of the Russian Federation. Ф.3. Оп.58. Д.280.)

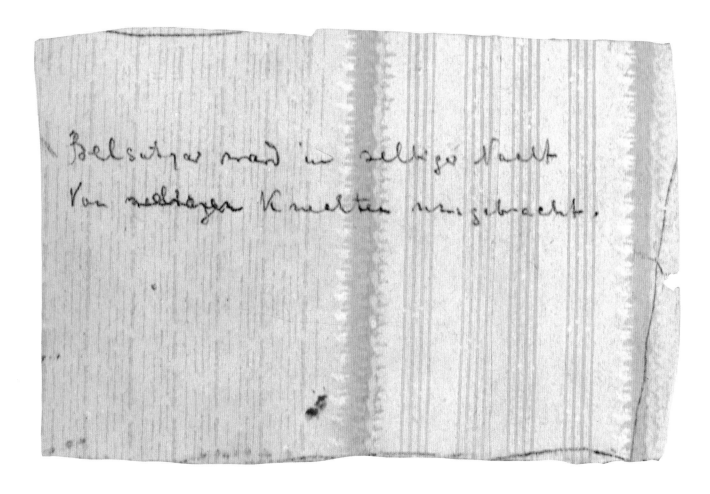

613 Fragment of Wallpaper with an inscription in German,
discovered by the Magistrate I. A. Sergeev in the Room of
the Ipatiev House where the Imperial Family was Executed

Light yellow striped wallpaper; faded spots of blood
Line from Heine's poem 'Belsatzar':

Belsatzar ward in selbiger Nacht Von seinen Knechten umgebracht.
[On this same night was Balthazar murdered by his servants]

12.5 × 8 cm
ГА РФ. Ф. 1837. Оп.I Д.57 (Archive of the investigator N. A. Sokolov)

On 25 July 1918, Ekaterinburg was taken by the forces of the
Siberian Army and the Czech Legion. On 30 July a judicial
inquiry was instigated into the circumstances surrounding the
disappearance of the imperial family, which was entrusted to
A. Nametkin, a senior investigator from the Ekaterinburg
regional court; Nametkin led the inquiry until 7 August when
he was relieved of his duties. His material was given to
I. A. Sergeev, a member of the Ekaterinburg regional court.
It was Sergeev who carried out a painstaking inspection of the
scene of the murder and who found the above inscription.

The examining magistrate N. A. Sokolov, in his book *The Murder
of the Imperial Family*, which was published in Berlin in 1925,
wrote: 'This is the 21st line of the famous work "Belsatzar" by
the German poet Heinrich Heine. It differs from Heine's original
line only by the omission of the word "aber", which means "but
nonetheless". When you read the work in the original, it becomes
clear why that word has been omitted. Heine's 21st line stands in

opposition to the preceding 20th line; it follows and is linked
to the previous line by the word "aber". Here the inscription
expresses a self-contained idea. The word "aber" has no place
here.' (Sokolov, 1925, p. 218.)

It is possible that the inscription was left by one of the captured
Austro-Hungarians who formed the guard at the Ipatiev House.

614 Y. M. Yurovsky, 1920s

Unknown artist
Pencil on paper
Inscribed in printed letters beneath the drawing: Юровский [Yurovsky]
19 × 26.5 cm
ГА РФ. Ф.1742. Оп.6. Д.323. Л.I

Yakov Mikhailovich Yurovsky (1878–1938) was born in Klinsk
in Tomsk province to a family of exiles. He joined the Bolshevik
party in 1905. In 1912 he was sent for revolutionary work to
Ekaterinburg, where he opened a photographic studio. After the
October Revolution he became a member of the Ekaterinburg
Regional Executive Committee and the collegium of the
Extraordinary Commission. On 4 July 1918 he was appointed
commandant of the Ipatiev House, where the imperial family
were imprisoned. He was one of the organisers and executors of
the family's murder. Soon afterwards he was named head of the
Extraordinary Commission for the Moscow region and member
of the collegium of the Moscow Extraordinary Commission. He
then worked for the Cheka (secret police) in Viatka, and in 1919

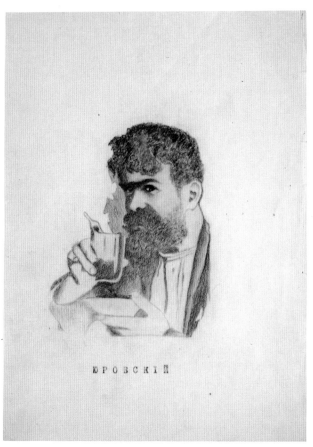

614

in Europe were continuing to attack Soviet Russia, the Ural Executive Committee had ordered them to be shot. Nicholas turned away from the squad towards his family, then, as if remembering something, turned back to the commandant and said: 'What? What?' The commandant quickly repeated himself and ordered the squad to get ready. The members of the execution squad had already been told who was to fire at whom, and had been ordered to shoot straight at the heart in order to avoid an excessive amount of blood and to finish it quickly. Nicholas did not utter another word and turned back to his family. The others made a few incoherent exclamations; all this lasted just a few seconds. Then the firing began, and continued for some two to three minutes. Nicholas was killed outright by the commandant himself. Alexandra Feodorovna and the Romanovs' attendants also died immediately.

ГА РФ. Ф.601. Оп.2. Д.27. Л.31–34

In 1997, expert examination of this typewritten text by the Office of the Public Prosecutor of the Russian Federation confirmed that it had been corrected by the historian M. N. Pokrovsky and that the hand-written notes in the margins were his. At the end there is a hand-written note by Pokrovsky regarding the burial location of the imperial family's remains. It was in this very place that the remains were discovered in 1978.

became head of the Ekaterinburg Province Extraordinary Commission. Later he was engaged in economic and party work. On several occasions he addressed Bolshevik meetings about his recollections of the imperial family's murder.

615 Description by Y. M. Yurovsky, Commandant of the Ipatiev House, of the Execution of the Imperial Family and the Disposal of their Remains, 1921

As recorded by the historian M. N. Pokrovsky
Typewritten text with Pokrovsky's hand-written corrections
23.5 x 35.5 cm

When the automobile arrived, everyone was asleep. Botkin was woken up and he roused all the others. The following explanation was given: 'In view of the unrest in the town it is essential to move the Romanov family from the upper to the lower floor.' They got dressed in half an hour. Downstairs, a room with a plastered wooden partition had been chosen (to avoid ricochets) and all the furniture removed. The squad were ready in the next room. The Romanovs did not suspect a thing. The commandant went to fetch them personally on his own and led them downstairs into the lower room. Nicholas was carrying Alexei in his arms, the others brought with them pillows and various small objects. On entering the empty room, Alexandra Feodorovna asked: 'Aren't there even any chairs? Can we not sit down?' The commandant ordered two chairs to be brought. Nicholas seated Alexei on one of them, Alexandra Feodorovna sat on the other. The commandant ordered the others to stand in line. When they had taken their places, the squad was summoned. As the squad came in, the commandant told the Romanovs that in view of the fact that their relatives

615

616 Bayonet Blade from a Winchester Rifle used in the Murder of the Imperial Family

54 × 3.5 cm

Office of the Public Prosecutor of the Russian Federation

Alexei, three of his sisters, and Botkin were still alive. They had to be shot again. This surprised the commandant, as they had aimed straight for the heart. It was also surprising that the bullets from the revolvers kept ricocheting off something and bouncing around the room like hail. When they tried to stab one of the girls, the bayonet wouldn't go through her corsage. Because of all this, the whole procedure, including the 'verification' (checking the pulse etc.) took 20 minutes. Then they started carrying the bodies out and laying them in the automobile, which had been lined with cloth to avoid leaving traces of blood. At this point the stealing began: it became necessary to post 3 reliable comrades to guard the bodies while the loading was completed (the bodies were brought out one by one). Under threat of execution, everything that had been stolen was returned (a gold watch, a diamond cigarette-case etc.).
(From the recollections of Y. M. Yurovsky. ГА РФ. Ф.601. Оп.2. Д.27. Л.31–34.)

This bayonet blade was handed over to the Office of the Public Prosecutor of the Russian Federation in the mid-1990s by M. M. Medvedev, the son of one of those who took part in the execution.

617 Icons of the Imperial Family Found in the Ipatiev House in Ekaterinburg after the Murder, 1918

N. Vvedensky
Contemporary print from the original negative taken during the investigation of 1918
10.5 × 15 cm

Office of the Public Prosecutor of the Russian Federation

At Botkin's request they allowed a priest and a deacon to visit us at 8 o'clock. They conducted the service quickly and well; it was a great comfort to be able to pray, even in such circumstances, and to hear 'Christ is Risen'.
(Nicholas's Diary, 21 April 1918. ГА РФ. Ф.601. Оп.1. Д.266. Л.98–99.)

During the investigation of 1918, more than 60 icons belonging to the imperial family were found in the Ipatiev House. Among them was one particularly dear to Alexandra Feodorovna — the Feodorovskaya Mother of God. In the words of Nicholas's valet, T. I. Chemodurov: 'The empress never went anywhere without this icon. To deprive the empress of this icon would be like depriving her of life itself.' (Sokolov, 1925, p. 244.)

618 The Personal Effects of the Imperial Family, Found in the Ipatiev House in Ekaterinburg after their Murder, 1918

N. Vvedensky
The photograph shows toys of Tsarevich Alexei Nikolaevich
Contemporary print from the original negative taken during the investigation of 1918
11 × 16.2 cm

Office of the Public Prosecutor of the Russian Federation

The day after my arrival I went to the Ipatiev house for the first time. I walked through the rooms on the upper floor which had served as their prison; they were in a state of indescribable disorder. It was obvious that every effort had been made to obliterate the traces of those who had lived there. Piles of ashes had been shovelled out of the stoves. They contained a mass of small half-burned objects, such as tooth-brushes, hair-pins, buttons etc.; among them I found the handle of a hair brush on which the initials of the empress 'A. F.' could still be seen on the blackened ivory.
(Gilliard, 1921, p. 230.)

In the appendix to chapter 19 of his book *The Murder of the Imperial Family*, the investigator N. A. Sokolov gives a detailed list of the family's personal effects which were discovered during the investigation of 1918–19; it lists 461 items. The investigator Nametkin found 93 scorched objects in the stoves of the Ipatiev House. Among these were fragments of boxes, wallets, shards of porcelain, metal springs, parts of shoulder-straps, hair-pins, tie-pins, hair-slides, cuff-links, buttons and so on. Four objects were found in the stoves and among the rubbish at Popov's house, where the guards had been lodged. Of particular value was an oval wooden icon of a Guardian Angel. The front was cracked, and on the back the emperor had written in black ink: 'Christ is Risen. 25 March 1912. Livadia.'

A great many objects (140 according to the list) were found in the cesspit by the Ipatiev House. Among these were three icons, some women's toiletries, ampoules and bottles for medicines and cosmetics, as well as fragments of toys. When he inspected these objects, the tsar's valet T. I. Chemodurov recognised a black silk moiré tie with the ribbon of the order of St. Vladimir sewed onto it, which had belonged to E. S. Botkin, as well as the St. George ribbon taken from the emperor's overcoat. 'The emperor never parted with that overcoat; he wore it all the time,' recalled Chemodurov. (Sokolov, 1925, p. 343.)

In the house itself 57 icons were discovered. Among them were several that had been given to the family by Grigory Rasputin.

In the rooms of the empress and the grand duchesses, 250 books were found including Alexandra's personal books such as *On Coping with Grief*, The Book of Prayer and The Bible; books belonging to Olga Nikolaevna — *And Mary Sings Magnificat* and *L'Aiglon* by Rostand (a gift from Gilliard); numerous religious books belonging to Tatiana Nikolaevna, given to her by the empress; and five books belonging to Maria and Anastasia. A few of Alexei's exercise books were discovered, as well as *How to play the Balalaika*, and a notebook for 1917 in which the tsarevich's tutors, Gibbs and Gilliard, had made notes on the heir's activities and state of health.

But the greatest number of objects — 117 items — were found when the former guards at the Ipatiev House were summoned and subjected to searches by the investigators Nametkin and Sergeev at the end of July and August 1918. The guards had shamelessly stolen gold watches and silver objects, clothes, bed linen, china, even Alexei's toys. The heir's pet dog, a spaniel called Joy, was found with the guard M. Letemin. Gold crosses taken from the bodies in the basement of the Ipatiev House were discovered in the possession of the messenger P. Lylov — a guard at the Ural Regional Soviet.

A few days after the execution, Y. M. Yurovsky took the jewellery, archives and personal effects of the imperial family from Ekaterinburg to Moscow and handed them over to the commandant of the Kremlin, Malkov.

618

619 Diary of Tsarevich Alexei Nikolaevich for 1917

N. Vvedensky
Contemporary print from the original negative taken during the investigation of 1918
11.5 × 15 cm
Office of the Public Prosecutor of the Russian Federation

Three diaries of Tsarevich Alexei Nikolaevich are known: the first
— for 1916 — is preserved in the State Archive of the Russian
Federation; the second — for 1917 — was discovered after the
murder in the possession of the Ipatiev House guard M. Letemin
(its cover is reproduced in N. A. Sokolov's book *The Murder of the
Imperial Family*, but its present whereabouts are unknown); the
third — for 1918 — was published in the book *Tsarevich Alexei* by
Princess Eugenia of Greece (Paris, 1990) and was in the possession
of the Greek royal family up until its publication. Its present
whereabouts are also not known.

620 Order from the Ural Regional Commissar for Supplies, P. L. Voikov, for the Immediate Delivery from the Store of Five Poods [82 kg] of Sulphuric Acid, 17 July 1918

Handwritten; stamp of the Commissar for Supplies
18 × 22 cm
ГА РФ. Ф.1837. Оп.1. Д.1530. Л.5 (Archive of the investigator N. A. Sokolov)

The sulphuric acid referred to in the order was intended for the
destruction of the imperial family's bodies.

*On 17 July 1918 a certain Zimin, an employee of the Commissar for
supplies, appeared in the pharmacy in Ekaterinburg and presented
the owner, Metzner, with a written demand from the Regional
Commissar: 'I order you immediately and without delay on
presentation of this* [note] *to release from your store five poods
of sulphuric acid. Regional Commissar for Supplies Voikov.*

620

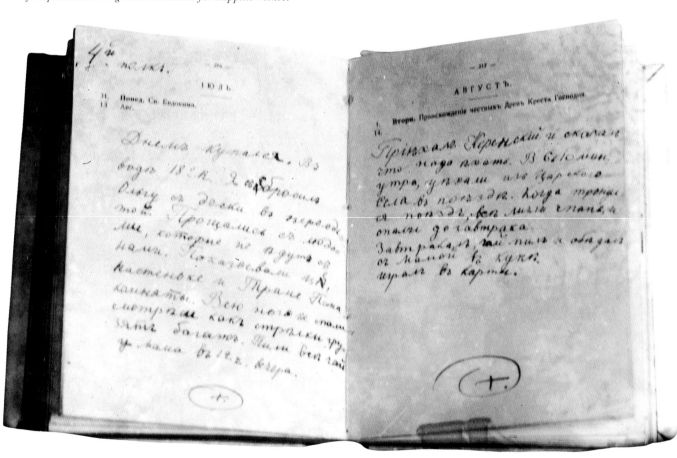

619

The sulphuric acid was handed over and Zimin confirmed its receipt on Voikov's demand note. The same day, late at night, Zimin again appeared in the shop and presented another demand from Voikov: 'I order you to provide another three jugs of Japanese sulphuric acid on presentation of this note. Regional Commissar of Supplies Voikov.' This batch of sulphuric acid was also handed over to Zimin and he again signed for it on the note [see no. 621].

In all 11 poods 4 lbs [approximately 185 kg] of sulphuric acid were handed over. On 18 July the shop received 196 roubles and 50 kopecks in payment ... Late at night on 17 July and during the day on 18 July, some Red Army soldiers and one of the Commissar's men took the acid, in wooden boxes tied with rope, to the mine. (Sokolov, 1925, pp. 257–8.)

Once all items of value had been gathered in bags, everything else found on the bodies was burned, and the bodies themselves were thrown into the pit. In the process a few precious items were dropped (someone's brooch, Botkin's false teeth), and when they tried to implode the pit with grenades, obviously the corpses were disfigured and some of their limbs blown off; this is how the commandant explains the Whites' discovery of a severed finger and so on at that place.

But it was never the intention to leave the Romanovs there. The pit had only been designated as a temporary burial place from the very first. Once the operation was finished and a guard had been posted, at about 10 or 11 o'clock in the morning (by now 17 July) the commandant went to report to the Ural Executive Committee, where he found Safarov and Beloborodov. The commandant told them what they had found, and expressed his regret that he had not been allowed to carry out a search of the Romanovs in his own time.

The commandant learned from Chutskayev (chairman of the Urban Executive Committee) that nine versts [approximately 9.5 km] along the Moscow high road there were some very deep abandoned mines, suitable for burying the Romanovs. The commandant set off for these mines, but took some time to get there because the motor broke down. He eventually reached the mines on foot, and found that there were indeed three very deep shafts, full of water. He decided to weight the bodies down with stones and submerge them. As there were some watchmen there who would make unwelcome witnesses, it was decided that an automobile with cheka [secret police] agents would accompany the lorry carrying the corpses, and would arrest the whole lot on the pretext of a search. The commandant had to get back by commandeering a pair of horses he came across on the way. And there were further delaying circumstances: when accompanying one of the cheka agents to the place to organise the operation, the commandant fell from his horse and bruised himself badly (later, the cheka agent also fell). In case this plan did not succeed, the contingency plan was to burn the corpses or bury them in clay pits filled with water, having first made them unrecognisable by using sulphuric acid.

It was already getting on for 8 o'clock in the evening when they finally made it back to town. They started to obtain everything they needed including kerosene and sulphuric acid. Horse-drawn carts, without drivers, were taken from the prison. They had intended to set out at 11 o'clock at night, but the incident with the cheka agent delayed them and they only reached the mine, with ropes to pull up the bodies, at 12.30 in the early morning of 18 July. In order to seal off the mine as they carried out this operation, they informed the

village of Koptiaki that they would be searching the woods for Czechs who were hiding there, and that no one from the village was allowed out under any pretext. It was made clear that anyone straying into the surrounding area would be shot on sight. In the meantime it was beginning to get light (it was already the third day [since the murder] — the 18th). They now had the idea of burying some of the corpses right there by the mine, so they started to dig a large pit, and had almost dug it out completely when a peasant who was known to Yermakov came up to him, and it was clear that he could see the pit. So the idea was abandoned.

It was then decided to transport the corpses to the deep mine shafts. As the carts had turned out to be rickety and falling apart, the commandant went into town for some vehicles (a truck and two light vehicles, one for the cheka agents). They were only able to set off at 9 o'clock in the evening. They crossed the railway line, and after half a verst reloaded the corpses onto the truck. They made slow progress, laying down railway sleepers over the treacherous places, getting stuck several times. At around 4.30 in the morning of 19 July, the vehicle finally got completely stuck; the only option was to bury or incinerate the bodies, without reaching the mine. One comrade, whose name I forget, promised to undertake the latter, but left without fulfilling his promise.

They wanted to burn Alexei and Alexandra Feodorovna, but by mistake they burned Alexei and the lady-in-waiting instead. They then buried the remains right there under the bonfire, then lit another, completely covering all trace of any digging. At the same time they dug a communal grave for the others. By 7 o'clock in the morning this pit, which measured 3 arshins [2.5 metres] square and 2 arshins [1.75 metres] deep was ready. The corpses were laid in the pit, their entire bodies covered with sulphuric acid to render them unrecognisable, and also to prevent the stench from the grave (the pit was not very deep). Having covered the pit over with earth and brushwood, they put down some sleepers and drove over it several times until no trace of the pit remained. The secret was preserved completely — the Whites never found this burial place. (Recollections of Y. M. Yurovsky. ГА РФ. Ф.601. Оп.2. Д.27. Л.33–34.)

621 Order from the Regional Commissar for Supplies,
P. L. Voikov, for the Immediate Delivery of a Further Three
Jugs of Japanese Sulphuric Acid, 17 July 1918

Handwritten; stamp of the Commissar for Supplies at the bottom;
confirmation of receipt of the sulphuric acid inscribed in pencil
18 × 22 cm
ГА РФ. Archive of the investigator N. A. Sokolov No. 19. Л.3

622 Fragments of the Jugs which Contained the Sulphuric Acid
used to Destroy the Bodies of the Imperial Family

Coloured clay; five fragments
Office of the Public Prosecutor of the Russian Federation

In July 1991 the presumed burial place of the imperial family's
remains was excavated by the Public Prosecutor of the
Sverdlovsk region in the presence of representatives of the
administration, as well as forensic experts, archaeologists and
other specialists. The skeletons of nine human corpses, with
extensive bodily injuries, were unearthed.

The excavation also revealed these fragments of the jugs which
had contained the sulphuric acid used to disfigure the bodies.

Piotr Lazarevich Voikov (1888–1927) came from a family of
school teachers. From 1903 he was a member of the Russian
Social Democratic party. He later emigrated and studied at the
universities of Geneva and Paris. He was married to the daughter
of a rich Polish factory owner. After the February Revolution
he returned to Russia, and in 1917 became a member of the
Ekaterinburg Soviet of Deputies and the Military-Revolutionary
committee. From January to December 1918 he was Commissar
for Supplies for the Ural region, and was thus directly involved
in the detention of the imperial family in the Ipatiev House. He
was also involved in the circumstances surrounding the murder,
specifically the disposal of the bodies of the Romanovs and
their companions. From October 1920 he was a member of the
collegium of the People's Commissariat for external trade, and
from 1924 he was the Soviet Union's envoy-plenipotentiary in
Poland. On 7 July 1927 he was killed in Warsaw by a nineteen-
year-old White guard named Boris Koverda. Voikov is buried
by the Kremlin wall.

623 Directive from Admiral A. V. Kolchak with the order
to 'all places and all persons' to assist the investigator
N. A. Sokolov, 3 March 1919

Typewritten text on a sheet of paper with the stamp in the top left corner:
Верховный Правитель [Supreme Ruler]. Beneath the text are the signatures of
Admiral Kolchak and Major-General Martianov, who was director of the Supreme
Ruler's office; the coat of arms of the Supreme Ruler.
22 × 36 cm
ГА РФ. Ф.1837. On.1. Д.9 (Archive of the investigator N. A. Sokolov)

In November 1918, Admiral A. V. Kolchak controlled Siberia
and the Far East where he was known as Supreme Ruler. On
17 January 1919 he ordered General Dietericks, a former
commander-in-chief at the front, to obtain for him all the
personal effects of the imperial family that had been found
and all the documents relating to the investigation. These were
presented to Kolchak in Omsk at the beginning of February.
On 5 February the admiral met N. A. Sokolov, a senior examining
magistrate for the Omsk regional court. On 7 February Sokolov
accepted the case, and on 3 March Kolchak, before departing for
the front, sent Sokolov this directive, requesting 'all places and
all persons' to give him assistance in his investigation.

Nikolai Alexeevich Sokolov (1882–1924) was born in the town of
Mokshan in Penza province. He studied at the Penza secondary
school and then at the Faculty of Law at Kharkov university.
Before the Revolution he served as an examining magistrate in
serious cases for the court of Penza province. He did not support
the Soviet regime and in 1918, disguising himself as a peasant,

illegally crossed the front line into territory held by the White Guards. At the beginning of 1919 he was entrusted with the investigation into the murder of the imperial family in Ekaterinburg, and the murder of the grand dukes at Alapaevsk. He summarised the work of his predecessors, collated the protocols of interrogations of both witnesses and accused, and generally clarified the material evidence. Sokolov searched for the secret burial place of the imperial family until the very last moment of the Reds' advance into the area; as they approached he evacuated all material relating to the investigation to Chita and from there to Kharbin in China. There he made several copies which were transported to Europe with the help of the French general Janin. One copy of the documents remained in the hands of General Dietericks, who subsequently wrote a book, *The Murder of the Imperial Family and Other Members of the Romanov Dynasty in the Urals* (Vladivostok, 1922).

Sokolov later went to France where he continued his investigation, collecting further material. He used his archive to write a book, *The Murder of the Imperial Family* (Berlin, 1925), which was published in Russian only after his death. In November 1924 he was buried in the cemetery of the town of Salbris, south of Paris, where his friends erected a cross over his grave with the inscription: 'Your truth is the truth of ages.'

624 A Human Finger, Discovered by Examining Magistrate N. A. Sokolov During his Inspection of the Area around the Four Brothers Pit

Unknown photographer
Two photographs glued to a single sheet of paper
3.5 × 4.5 cm; 4.5 × 5 cm; 23 × 35 cm
N. A. Sokolov suggested that the finger belonged to Alexandra Feodorovna (the photograph of Alexandra was used for comparison)
The photographs are attached to Sokolov's memorandum of 24 October 1920, which accepts the murder of the imperial family as a documented fact.
Office of the Public Prosecutor of the Russian Federation

On 30 June 1918 the magistrate A. Nametkin inspected a mine shaft, known as Ganin's Pit, which was situated 150 *sazhens* (about 320 metres) from the Isetsky mine. Here he discovered burnt objects and valuables which were identified as belonging to members of the imperial family. He also found a piece of human skin, Dr Botkin's dentures (no. 625) and a severed finger (illustrated here).

These items, together with fragments of bone, were discovered by N. A. Sokolov near the Four Brothers Pit during a second inspection of the area, and were subsequently taken by him to Europe in a small case belonging to the empress. The case is now kept in a commemorative chapel in Brussels, sealed within a wall near the altar.

623

625

626

625 Set of Dentures, Discovered by Examining Magistrate
N. A. Sokolov During his Inspection of the Area around the
Four Brothers Pit

Unknown photographer
At the bottom of the page the signature of the examining magistrate: *Н. Соколов*
[N. Sokolov]
Five photographs glued onto a single sheet of paper:
3.5 × 5 cm; 4.5 × 5.5 cm; 4 × 11 cm; 2 × 2.5 cm; 4 × 9.5 cm; 23 × 35.5 cm
According to the testimony of P. A. Gilliard and S. Gibbs, these dentures belonged
to the doctor E. S. Botkin.

Office of the Public Prosecutor of the Russian Federation

One of those who fulfilled their duty to the very end and
remained loyal to the imperial family was the tsar's court
physician, Evgeny Sergeevich Botkin.

Botkin remained at the side of his imperial patients, even when
he realised that his days were numbered. An unfinished letter,
written by Botkin a week before he was shot, has survived:

*I do not think I am destined to write again from anywhere; my
voluntary incarceration here is limited not so much by time as by my
own earthly existence. In essence I am already dead — dead to my
children, to my friends, to my work ... I am dead but not yet buried,
or buried alive: the end result is the same.*
(ГАРФ. Ф.740. Оп.1. Д.12. Л.1–4.)

626 Belt-Buckle with Fastening, Discovered by Examining
Magistrate N. A. Sokolov During his Inspection of the Area
around the Four Brothers Pit

Unknown photographer
Two photographs glued onto a single sheet of paper:
3 × 7 cm; 23 × 35 cm
According to the testimony of P. A. Gilliard, S. Gibbs, A. A. Tegleva and others, the
belt-buckle belonged to Tsarevich Alexei Nikolaevich (the photograph of the tsarevich
in uniform was used for comparison).

Office of the Public Prosecutor of the Russian Federation

627 Fragments of Glass of Two Pairs of Pince-Nez,
Discovered by Examining Magistrate N. A. Sokolov During
his Inspection of the Area around the Four Brothers Pit

Unknown photographer
Signature of the examining magistrate at the bottom of the page: *Н. Соколов* [N. Sokolov]
Four photographs glued onto a single sheet of paper:
4 × 9 cm; 2.5 × 7 cm; 3 × 7 cm; 7 × 10 cm
The testimony of P. A. Gilliard and others established that these were exactly the type of pince-nez worn by the doctor, E. S. Botkin

Office of the Public Prosecutor of the Russian Federation

628 P. Z. Ermakov at the Burial Place of the Imperial Family's
Remains, 1920s

Unknown photographer
Inscribed in pencil on the reverse: *Место где сожжены Романовы* [the place where the Romanovs were burned]; stamp of the Sverdlovsk Museum of Local Lore, History and Economy with the code *с/м 14450* [s/m 14450] and the date *июнь 1949* [June 1949]
Photograph: 16 × 11.5 cm

Office of the Public Prosecutor of the Russian Federation

Peter Zakharovich Ermakov (1884–1952) was a clerk at the
Verkhne-Isetsky factory. He began his revolutionary activity in
1905, specialising in terrorist acts and 'expropriations', and was a
friend of F. I. Goloshchekin. In 1911 he was arrested and sent into
exile, from which he returned after the February Revolution.
After the October Revolution Ermakov became the Verkhne-
Isetsky Military Commissar, and was actively involved in
crushing counter-revolutionary activity. Goloshchekin entrusted
Ermakov with organising the execution of the imperial family,
and the subsequent destruction of the bodies.

627

629

In the 1920s Ermakov served in the militia; from 1927 he was one of the directors of prisons in the Ural region. He died in 1952 and was buried with honours beside the War monument in Moscow. A street in Sverdlovsk was named after him.

In the 1920s, Ermakov attended a party conference in the Urals. It was then that he re-visited the burial place of the imperial family's remains and had this photograph taken.

629 Original Dossier from the Preliminary Investigation carried out by Senior Examining Magistrate N. A. Sokolov into the Murder of the Grand Dukes in Alapaevsk,
Initiated 7 February 1919

24 × 36; spread: 48 × 36

Office of the Public Prosecutor of the Russian Federation. Λ.1–305.

Chronicle of members of the Romanov family killed by the Bolsheviks in 1918–19 (see nos. 630–9):

Perm, the night of 12–13 June 1918: Grand Duke Mikhail Alexandrovich.

Ekaterinburg, the night of 16–17 July 1918: Nicholas II, Alexandra Feodorovna, Grand Duchesses Olga, Tatiana, Maria and Anastasia, and Tsarevich Alexei.

Alapaevsk (Verkhotursky district near Ekaterinburg), the night of 17–18 July 1918: Grand Duchess Elizaveta Feodorovna, Grand Duke Sergei Mikhailovich, Princes of Imperial Blood Ioann Konstantinovich, Igor Konstantinovich and Konstantin Konstantinovich, and Prince Vladimir Paley (son of Grand Duke Pavel Alexandrovich).

Peter and Paul Fortress, Petrograd, 27 January 1919: Grand Dukes Nikolai Mikhailovich, Dmitry Konstantinovich, Pavel Alexandrovich, and Georgy Mikhailovich.

In all, 18 members of the Russian imperial family were executed. During the investigation of 1918–19, only the remains of the victims of Alapaevsk were discovered. They were transported out of Russia and buried within the confines of the Russian Orthodox mission in Peking. The remains of Grand Duchess Elizaveta Feodorovna and her companion, the nun Varvara Yakovleva, were taken to Jerusalem where they were laid to rest in the Orthodox Church of Mary Magdalene.

628

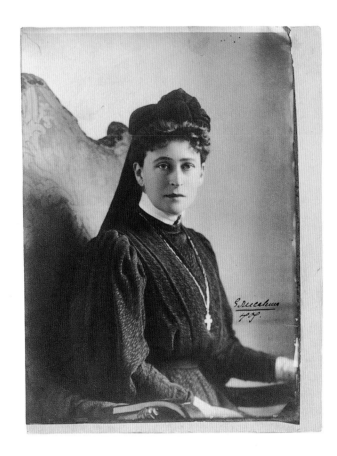

630 Grand Duke Mikhail Alexandrovich, 1900s

Photograph by P. Danielsen
Stamped in the lower right corner of the photograph: *Eneberettiget*
At the bottom of the mount: *P. Danielsen. Osterbrogade 44*
Mounted photograph: 12 × 17.2 cm; 12.8 × 20.2 cm
ГА РФ. Ф.668. Оп.1. Д.123. Л.1

Grand Duke Mikhail Alexandrovich (1878–1918), youngest son
of Alexander III and younger brother of Nicholas II, was shot
during the night of 12–13 June 1918 in the vicinity of Perm.

631 Grand Duchess Elizaveta Feodorovna, 1909

Unknown photographer
Signed on the photograph: *Елизавета* [Elizaveta] *1909*
Mounted photograph: 16.5 × 23.5 cm; 18.4 × 24.2 cm
ГА РФ. Ф.642. Оп.1. Д.3453. Л.24

Grand Duchess Elizaveta Feodorovna (1864–1918), elder
sister of Alexandra Feodorovna, was killed during the night
of 17–18 July 1918 near Alapaevsk in the Urals. In 1992 she
was canonised by the Russian Orthodox Church.

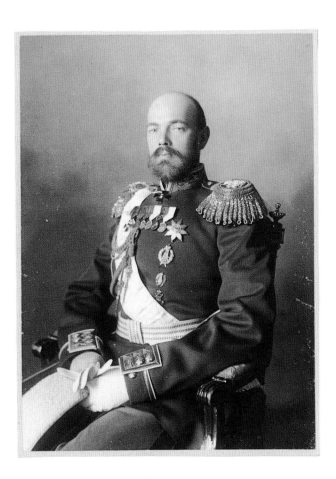

632 Grand Duke Sergei Mikhailovich, 1916

Photograph by P. Zhukov
Stamped at the bottom of the mount: *П. Жуков. С.П.Б. Морская 12* [P. Zhukov,
12 Morskaya Street, St. Petersburg]
Mounted photograph: 13 × 18 cm; 25 × 34.7 cm
ГА РФ. Ф.660. Оп.3. Д.137. Л.1

Grand Duke Sergei Mikhailovich (1869–1918), son of Grand
Duke Mikhail Nikolaevich, grandson of Nicholas I, first cousin
of Alexander III and first cousin once-removed of Nicholas II,
was killed along with the other Romanov grand dukes and Grand
Duchess Elizaveta Feodorovna during the night of 17–18 July
1918 near Alapaevsk in the Urals.

633 Prince of Imperial Blood Ioann Konstantinovich, 1916

Unknown photographer
13.3 × 19.4 cm
ГА РФ. Ф.659. Оп.1. Д.59. Л.1

Prince of Imperial Blood Ioann Konstantinovich (1886–1918),
son of Grand Duke Konstantin Konstantinovich, was killed
during the night of 17–18 July 1918 near Alapaevsk in the Urals.

634 Prince of Imperial Blood Konstantin Konstantinovich, 1915

Photograph by P. Zhukov
Inscribed by Konstantin Konstantinovich on the photograph: *Твой Кругленький 1915 г.*
[Your little round one, 1915]
Stamped at the bottom of the mount: *П. Жуков. С.П.Б. Морская 12* [P. Zhukov,
12 Morskaya Street, St. Petersburg]
Mounted photograph: 10.5 × 22 cm; 17.5 × 32.5 cm
ГА РФ. Ф.660. Оп.3. Д.71. Л.7

Prince of Imperial Blood Konstantin Konstantinovich
(1890–1918), son of Grand Duke Konstantin Konstantinovich,
was killed during the night of 17–18 July 1918 near Alapaevsk
in the Urals.

635 Prince Vladimir Pavlovich Paley (centre) with two
fellow-soldiers, 1914–16

Photographer from the Boissonas and Eggler photographic studio
Stamped at the bottom of the mount: *Boissonas et Eggler*
Mounted photograph: 10.2 × 14.2 cm; 19.5 × 26 cm
ГА РФ. Ф.613. Оп.I. Д.628. Л.8

Prince Vladimir Pavlovich Paley (1897–1918), son of Grand
Duke Pavel Alexandrovich from his morganatic marriage to Olga
Valerianovna Pistolkors (from 1915 Princess Paley), was killed
during the night of 17–18 July near Alapaevsk in the Urals.

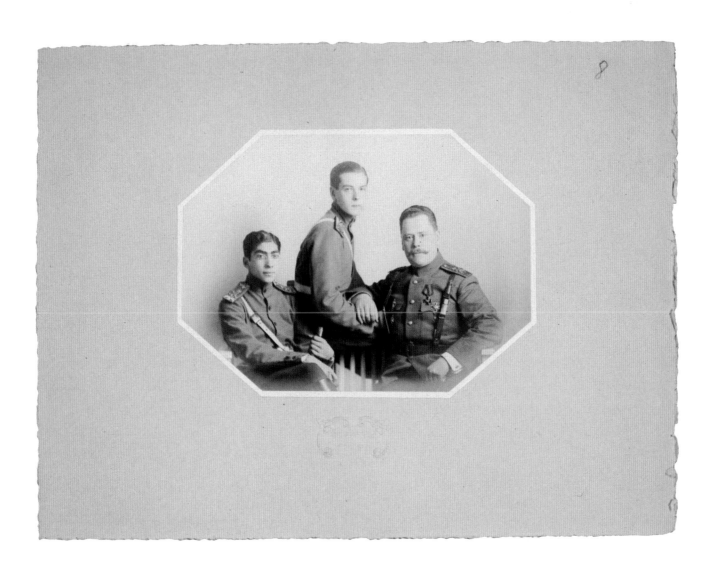

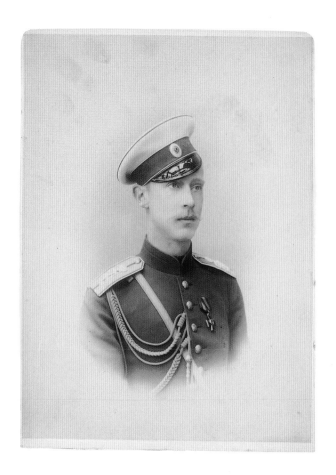

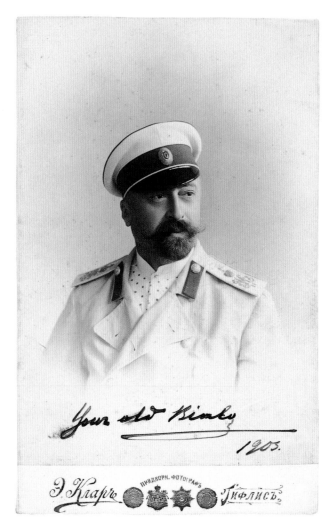

636 Grand Duke Dmitry Konstantinovich, 1897

Photograph by A. A. Pasetti
Stamped at the bottom of the photograph: A. Pasetti
Mounted photograph: 17.5 x 23.7 cm; 18 x 24.7 cm
ГА РФ. Ф.765. Оп.1. Д.8. Л.1

Grand Duke Dmitry Konstantinovich (1860–1919), son of Grand
Duke Konstantin Nikolaevich, grandson of Nicholas I, first
cousin of Alexander III and first cousin once-removed of Nicholas
II, was shot in the Peter and Paul Fortress on the orders of the
All-Russian Extraordinary Commission in January 1919.

637 Grand Duke Nikolai Mikhailovich, 1903

Photograph by Edward Clare, court photographer to Grand Duke Mikhail Nikolaevich
Inscribed by Nikolai Mikhailovich with a dedication to his brother, Grand Duke
Alexander Mikhailovich, at the bottom of the photograph: Your old Bimbo. 1903
Stamped at the bottom of the mount: Э. Клар. Придворн[ый] фотограф. Тифлис
[E. Clare, court photographer, Tiflis]
Trade-mark of the photographic studio on the reverse
Photograph in mount: 13.2 x 19 cm; 13.2 x 21.2 cm
ГА РФ. Ф.645. Оп.1. Д.404. Л.3

Grand Duke Nikolai Mikhailovich (1859–1919), son of Grand
Duke Mikhail Nikolaevich, grandson of Nicholas I, first
cousin of Alexander III and first cousin once-removed of Nicholas
II, was shot in the Peter and Paul Fortress on the orders of the
All-Russian Extraordinary Commission on 29 January 1919.

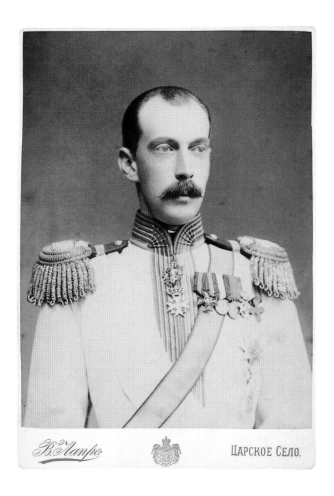

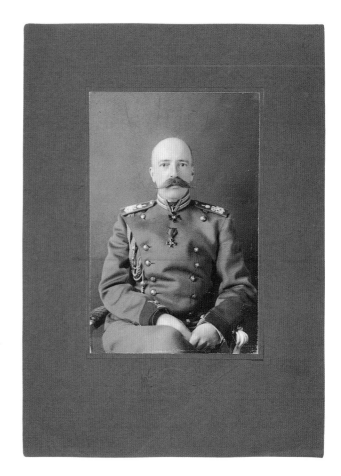

638 Grand Duke Pavel Alexandrovich, 1916

Photograph by V. Lapre.
Stamped at the bottom of the mount: *В. Лапре. Царское Село* [V. Lapre, Tsarskoe Selo]
Trade-mark of the photographic studio on the reverse
Mounted photograph: 16.5 × 22 cm; 17 × 24.5 cm
ГА РФ. Ф.613. Оп.1. Д.646. Л.4

Grand Duke Pavel Alexandrovich (1860–1919), youngest son of Alexander II, younger brother of Alexander III, uncle of emperor Nicholas II, was shot in the Peter and Paul Fortress on the orders of the All-Russian Extraordinary Commission on 29 January 1919.

639 Grand Duke Georgy Mikhailovich, 1916

Photograph by P. Zhukov
Stamped at the bottom of the mount: *П. Жуков. Морская 12. С.П.Б.* [P. Zhukov. 12, Morskaya Street, St. Petersburg]
Mounted photograph: 10.2 × 15.3 cm; 18.5 × 25.5 cm
ГА РФ. Ф.662. Оп.2. Д.211. Л.1

Grand Duke Georgy Mikhailovich (1863–1919), son of Grand Duke Mikhail Nikolaevich, grandson of Nicholas I, first cousin of Alexander III and first cousin once-removed of Nicholas II, was shot on the orders of the All-Russian Extraordinary Commission on 29 January 1919.

Family Tree of the Royal Families of Europe

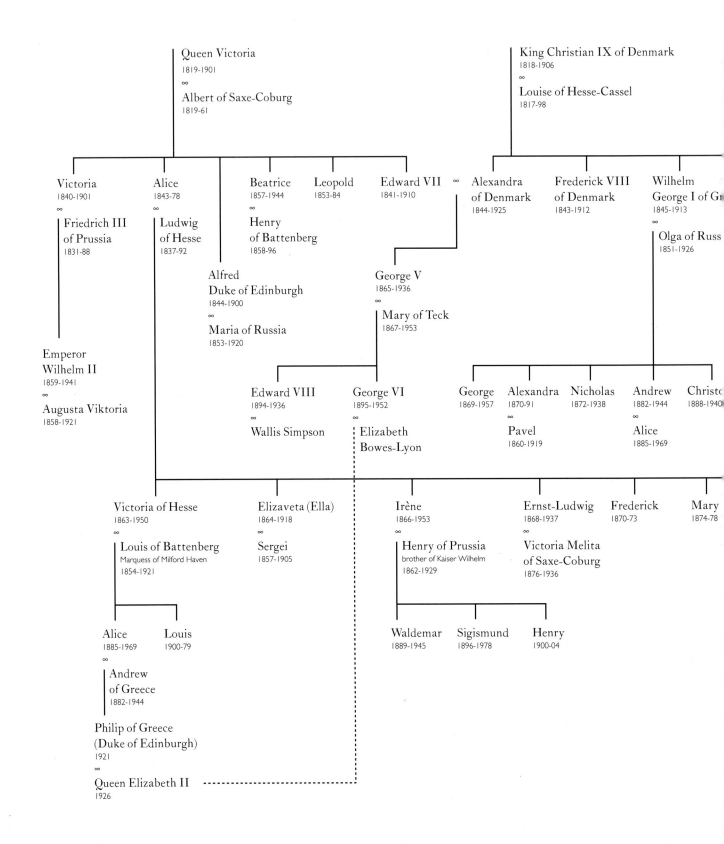

Queen Victoria
1819-1901
∞
Albert of Saxe-Coburg
1819-61

King Christian IX of Denmark
1818-1906
∞
Louise of Hesse-Cassel
1817-98

Victoria
1840-1901
∞
Friedrich III
of Prussia
1831-88

Alice
1843-78
∞
Ludwig
of Hesse
1837-92

Beatrice
1857-1944
∞
Henry
of Battenberg
1858-96

Leopold
1853-84

Edward VII
1841-1910
∞

Alexandra
of Denmark
1844-1925

Frederick VIII
of Denmark
1843-1912

Wilhelm
George I of Gr
1845-1913
∞
Olga of Russ
1851-1926

Emperor
Wilhelm II
1859-1941
∞
Augusta Viktoria
1858-1921

Alfred
Duke of Edinburgh
1844-1900
∞
Maria of Russia
1853-1920

George V
1865-1936
∞
Mary of Teck
1867-1953

Edward VIII
1894-1936
∞
Wallis Simpson

George VI
1895-1952
∞
Elizabeth
Bowes-Lyon

George
1869-1957

Alexandra
1870-91
∞
Pavel
1860-1919

Nicholas
1872-1938

Andrew
1882-1944
∞
Alice
1885-1969

Christo
1888-1940

Victoria of Hesse
1863-1950
∞
Louis of Battenberg
Marquess of Milford Haven
1854-1921

Elizaveta (Ella)
1864-1918
∞
Sergei
1857-1905

Irène
1866-1953
∞
Henry of Prussia
brother of Kaiser Wilhelm
1862-1929

Ernst-Ludwig
1868-1937
∞
Victoria Melita
of Saxe-Coburg
1876-1936

Frederick
1870-73

Mary
1874-78

Alice
1885-1969
∞
Andrew
of Greece
1882-1944

Louis
1900-79

Waldemar
1889-1945

Sigismund
1896-1978

Henry
1900-04

Philip of Greece
(Duke of Edinburgh)
1921
∞
Queen Elizabeth II
1926

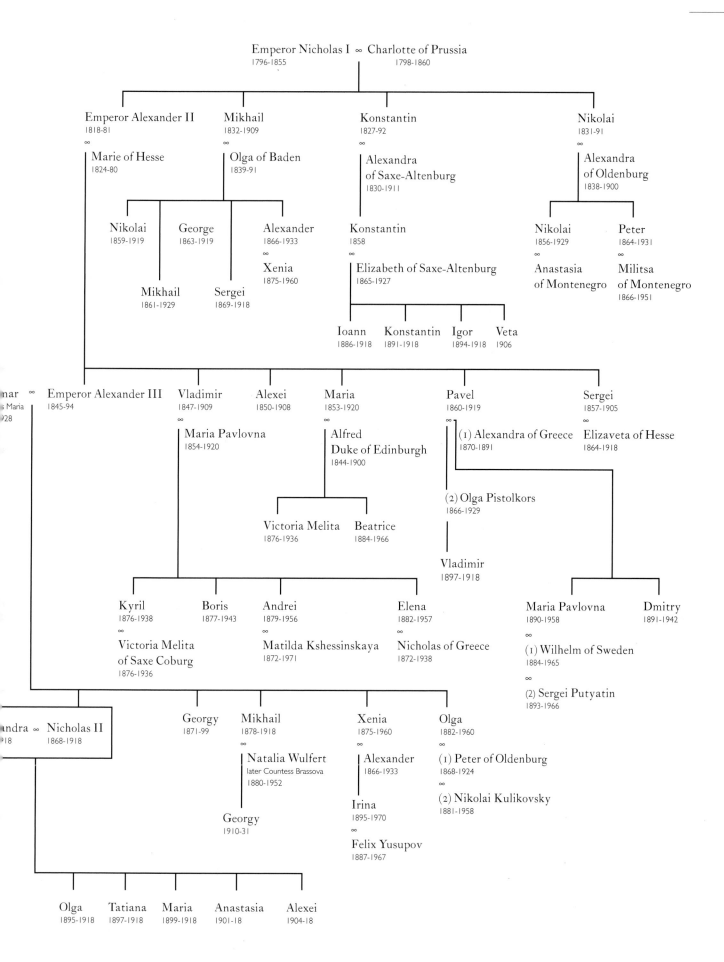

Emperor Nicholas I ∞ Charlotte of Prussia
1796-1855 · 1798-1860

Emperor Alexander II
1818-81
∞
Marie of Hesse
1824-80

Mikhail
1832-1909
∞
Olga of Baden
1839-91

Konstantin
1827-92
∞
Alexandra
of Saxe-Altenburg
1830-1911

Nikolai
1831-91
∞
Alexandra
of Oldenburg
1838-1900

Nikolai
1859-1919

George
1863-1919

Alexander
1866-1933
∞
Xenia
1875-1960

Mikhail
1861-1929

Sergei
1869-1918

Konstantin
1858
∞
Elizabeth of Saxe-Altenburg
1865-1927

Nikolai
1856-1929
∞
Anastasia
of Montenegro

Peter
1864-1931
∞
Militsa
of Montenegro
1866-1951

Ioann
1886-1918

Konstantin
1891-1918

Igor
1894-1918

Veta
1906

nar ∞
Maria
928

Emperor Alexander III
1845-94

Vladimir
1847-1909
∞
Maria Pavlovna
1854-1920

Alexei
1850-1908

Maria
1853-1920
∞
Alfred
Duke of Edinburgh
1844-1900

Pavel
1860-1919
∞
(1) Alexandra of Greece
1870-1891

(2) Olga Pistolkors
1866-1929

Vladimir
1897-1918

Sergei
1857-1905
∞
Elizaveta of Hesse
1864-1918

Victoria Melita
1876-1936

Beatrice
1884-1966

Kyril
1876-1938
∞
Victoria Melita
of Saxe Coburg
1876-1936

Boris
1877-1943

Andrei
1879-1956
∞
Matilda Kshessinskaya
1872-1971

Elena
1882-1957
∞
Nicholas of Greece
1872-1938

Maria Pavlovna
1890-1958
∞
(1) Wilhelm of Sweden
1884-1965
∞
(2) Sergei Putyatin
1893-1966

Dmitry
1891-1942

andra ∞ Nicholas II
918 1868-1918

Georgy
1871-99

Mikhail
1878-1918
∞
Natalia Wulfert
later Countess Brassova
1880-1952

Georgy
1910-31

Xenia
1875-1960
∞
Alexander
1866-1933

Irina
1895-1970
∞
Felix Yusupov
1887-1967

Olga
1882-1960
∞
(1) Peter of Oldenburg
1868-1924
∞
(2) Nikolai Kulikovsky
1881-1958

Olga
1895-1918

Tatiana
1897-1918

Maria
1899-1918

Anastasia
1901-18

Alexei
1904-18

BIBLIOGRAPHY

Alexander Mikhailovich, Grand Duke, *Memoirs* (Moscow, 1991)

Andolenko, S. *Russian Army Medals* (Paris, 1966)

Andreeva, L. V. *Soviet Porcelain of the 1920s and 1930s.* (Moscow, 1975)

'Artistic Furnishings in Russian Interiors of the 19th century'; *The Hermitage, A Guide* (Leningrad, 1986)

Asvarishch, B. J. *The Hermitage Catalogue of Western European Painting: German and Austrian Painting of the 19th and 20th Century* (Moscow/Florence, 1988)

Awes-Münze: Advertising Prospectus; Werner & Sohn (Berlin)

Bartenev, S. P. 'Memories of the Late Tsarevich Georgy Alexandrovich'; *Russian Archive*, 1909, vol. iii, ed. 2

Belitskaya, E. I. *The Artistic Treatment of Coloured Stone* (Moscow, 1983)

Benois, A. *My Memoirs*, vols. i-v. (Moscow, 1980)

Biriukova, N. Y. *Late 15th to 20th Century French Tapestries in the Hermitage Collection* (Leningrad, 1974)

Bok, M. P. *Memoirs of My Father P.A. Stolypin* (Leningrad, 1990)

Buranov, Y., Khrustalev, V. *The Fall of the Imperial House 1917-1919* (Moscow, 1992)

Buchanan, G. *Memoirs of a Diplomat* (Moscow, 1991)

Catalogue Genéral Illustré des Editions de la Monnaie de Paris, vol. iii, 1983

Chernyshev, V. A. 'A History of Articles from Ceremonial Parades of the 18th and 19th Centuries'; *The History of the Hermitage and its Collections* (Leningrad, 1989)

Chernyshev, V. A. 'The Large French Carriage'; Exhibition Prospectus (St. Petersburg, 1993)

Chicherin, B. N. *Memoirs* (Moscow 1994)

Coronation Book, vol. i. (St. Petersburg, 1899)

Coronation of Alexander III, 1883 *In memory of the Holy Coronation of the Sovereign Emperor Alexander III and the Sovereign Empress Maria Feodorovna* (St. Petersburg, 1883)

Court Stables Museum (St. Petersburg, 1891)

Dietericks, M. K. *The Murder of the Tsar's Family and Members of the House of Romanov in the Urals* (Vladivostok, 1922)

Felkerzam, A. *Inventory of the Silver at the Court of His Imperial Highness*, vol. ii. (St. Petersburg, 1907)

Fenaille, M. *Etat General des Tapisseries de la Manufacture des Gobelins, 1600-1900* (Paris, 1923)

Feodorovsky Cathedral at Tsarskoe Selo (comp. Alexeev, Y. and Baranovsky, A.)

Fersman, A.E., Vlodavets, N. I. *The State Lapidary Factory at Peterhof: Past, Present and Future* (Petrograd, 1921)

Gilliard, P. *Emperor Nicholas II and his Family: Personal Reminiscences* (London, 1921)

Gippius, Z. *Little Anin House: Contemporary Notes* (Paris, 1923, vol. xvii)

Grimwade, A. G. *The Queen's Silver* (London, 1953)

Guiffrey, J. 'Les Gobelins'; *Le Figaro Illustré*, March 1911, No. 252

Guiffrey, J. *Les Gobelins et Beauvais* (Paris)

Harlow, G. E. The Nature of Diamonds *Hermitage: Western European Painting;* Cat., vol. ii (Leningrad, 1981)

Hayden, A. *Kopenhagener Porzelian* (Leipzig, 1913)

Hayward, J. F. *Huguenot Silver in England: 1688-1727* (London, 1959)

Hazelton, A. 'The Russian Orders'; *Numismatic Notes and Monograms*, No. 51 (New York, 1932)

Hermitage: Items of Russian Artistic Culture, 10th–early 20th Century (Moscow, 1979)

'Inventory of Medals, Coins and Tokens from the Collection of His Highness the Sovereign Emperor Nicholas Alexandrovich' (Manuscript in the Department of Numismatics of the State Hermitage)

Ivanova, E. N. 'Peculiarities of Glasswork by Craftsmen of the Nancy School in the Hermitage Collection'; *Western European and Russian Applied Art* (Leningrad, 1983)

Iroshnikov, M. P.; Protsai, L.A.; Shelaev, U.B. *Nicholas II — the Last Emperor of Russia* (St. Petersburg, 1992)

Jarry, M. *La tapisserie des origines à nos jours* (Paris, 1968)

Jones, E. A. *The Old English Plate of the Emperor of Russia* (London, 1909)

Kachalov, N. *Glass* (Moscow, 1959)

Kokovtsov, V. N. *From my Past: Memoirs, 1911-1919* (Moscow, 1991)

Komelova, G. N.; Printseva G. A. *Portrait Miniatures in Russia, 18th – Early 20th Century, from the Collections of the State Hermitage* (Leningrad, 1986)

Koni, A.F. *Selected Works* (Moscow, 1989)

Konstantin Romanov (Grand Duke Konstantin Konstantinovich), *Selected Works* (Moscow, 1991)

Korshunova, T. T. *Russian Costumes of the 18th–early 20th century from the collections of the State Hermitage* (Leningrad, 1979)

Kudriavtseva, T. V., 'Ceremonial Palace Services of the Imperial Porcelain Factory of the turn of the 20th century'; *State Hermitage Report*, 1982, No. 47

Kudriavtseva, T. V. 'Oriental Influence on Items from the Imperial Porcelain Factory'; *The Culture and Art of Russia of the 19th century* (Leningrad, 1985)

Kudriavtseva, T. V. 'National Traits in Russian Porcelain.' Russian and Western European Decorative and Applied Art (Leningrad, 1986)

Kuznetsov, A. A. *Orders and Medals* (Moscow, 1985)

Librovich, S. F. 'The Sculptor Bernstamm and his Son'; *Literature Herald*, 1913, No. 2

Liven, *Guide to the Study of Peter the Great and the Gallery of Treasures* (St. Petersburg, 1901)

Lopato, M. *Fresh Light on Carl Fabergé*; Apollo, No. 263 (London, 1984)

Maria of Russia, Grand Duchess, *Things I Remember* (London, 1930)

Marx, R. *Les Medailles Français Contemporains* (Paris, 1900)

Massie, R. K. *Nicholas and Alexandra* (London, 1996)

Maylunas, A.; Mironenko, S. *A Lifelong Passion: Nicholas and Alexandra* (London, 1996)

Melnik-Botkina, T. E. *Recollections of the Imperial Family, their Life before and after the Revolution* (Moscow, 1993)

Menshikova, M. L. 'Li Hun-Zhan and Nicholas II: The History of Various Chinese Articles in the Hermitage Collection'; *The Kunstkammer Collection* (St. Petersburg, 1995)

Mosolov A. A. *At the Court of the Last Emperor: Notes of the Head of the Chancellery at the Ministry of Court* (St. Petersburg, 1992)

Nicholas II, Diaries (Moscow, 1991)

Nicholas II. Memoirs, Diaries (St Petersburg, 1994)

Niva Magazine, 1915, No. 45

Notes of the Department of Numismatics of the Imperial Russian Archaeological Society, vol. i (St. Petersburg, 1909)

Oldenburg, S. S. *The Travels of their Imperial Highnesses in Russia and Abroad* (St. Petersburg, 1897)

Oldenburg, S. S. *The Reign of Emperor Nicholas II* (St. Petersburg, 1991)

Orlova, K. A. 'Articles of the Firm of P. A. Ovchinnikov in the Hermitage Collection'; *Russian and Western European Decorative and Applied Art of the late 18th - 19th Century* (Leningrad, 1986)

Paléologue, M. *Tsarist Russia on the Eve of the Revolution* (Moscow, 1991)

Penzer, N. M. 'English Plate at the Hermitage'; *The Connoisseur* (London, 1958)

Polovtsov, A. A. *The Diary of State Secretary A. A. Polovtsov*, vols. i-ii (Moscow, 1966)

Prakhov, A. V. 'Emperor Alexander III as a Figure of the Russian Artistic Enlightenment'; *Art Treasures of Russia*, vol. iii, pp. 121-181, 1903

Purishkevich, V. *Diary: How I killed Rasputin* (Moscow, 1990)

Rappe, T. V. 'Monuments of Franco-Russian Relations of the Last Decade of the 19th Century'; *State Hermitage Report*, 1991, No. 55

Red Archive, 1931 'Notes of Grand Duke Nikolai Mikhailovich'; *Red Archive*, 1931, No. 6

Russian Enamel of the 12th—early 20th Century from the Collections of the State Hermitage; Album compiled by Kaliazina, N.V. et al. (Leningrad, 1987)

Saltykov, A. B. 'Stone vases'; *Russian Decorative Art*, vol. ii (Moscow, 1963)

Savinkov, B. V. *Selected Works* (Moscow, 1990)

Sazonov, S. D. *Memoirs* (Moscow, 1991)

Schmid, M. Kunstgeschichte des XIX Jahrhunderts (Leipzig, 1906)

Severiukhin, D.Y. 'The Emperor's Favourite Sculptor'; *Nevsky Archive: The Historical Folk Collection* (St. Petersburg, 1993)

Semenov, V. B. *Malachite*, vols. i-ii (Sverdlovsk, 1987)

Shelkovnikov, B. A. *Decorative Glass* (Leningrad, 1962)

Shelkovnikov, B. A. *Russian Decorative Glass* (Leningrad, 1969)

Sheveleva, E. N. *A Catalogue of Russian Orders, Medals and Decorations* (Leningrad, 1962)

Sheveleva, E. N. *Russian Army Decorations* (St. Petersburg, 1993)

Shulgin, V. V. *Notes from 1920* (Moscow, 1989)

Miliukov, P. N. *Memoirs* (Moscow, 1991)

Smirnov, V. P. *A Description of Russian Medals* (St. Petersburg, 1908)

Sokolov, N. A. *The Murder of the Imperial Family* (Moscow, 1991)

Sokolova T. M.; Orlova K. A. *Ornamentation: the Signature of an Age* (Leningrad, 1972)

Sokolova T. M.; Orlova K. A. *Russian Furniture in the State Hermitage* (Leningrad, 1973)

Spassky, I. G. *Foreign and Russian Orders before 1917* (Leningrad, 1963)

Spiridovich, A. I. *The Great War and the February Revolution 1914-1917* (New York, 1962)

Surguchev, I. 'The Childhood of Emperor Nicholas II'; *Bezhin Lug*, 1992, No. 1

Svanholm, L. Laurits Tuxen. Europas sidste fyrstenmaier (1990)

Tarasiuk, L. *Antique Firearms in the Hermitage Collection* (Leningrad, 1971)

Tezi, A., Rothenstern, P. I. 'In the Workshop of the Sculptor Bernstamm'; *The World of Art*, 1909, No. 19.

Troinitsky, S. N. *English Silver* (Petrograd, 1923)

Tiunina, O. 'Count Nostitz, Amateur Photographer'; *Soviet Photo*, 1991, No. 6, pp. 35-8

Tiutcheva, A. F. *At the Court of Two Emperors* (Moscow, 1990)

Ukhanova, I. N. *Russian Lacquers in the Hermitage Collection* (Leningrad, 1963)

Ukhanova, I. N. 'Lacquers from Lukutin near Moscow'; *Works of the State Hermitage*, No. 23 (Leningrad, 1983)

Ukhanova, 1995 Ukhanova, I. N. *Lacquer Painting in Russia* (St. Petersburg, 1995)

Voikov, V. N. *With and Without the Tsar* (Helsingfors, 1933)

Volkov, A. A. *Around the Imperial Family* (Moscow, 1993)

Vorres, J. *The Last Grand Duchess* (London, 1985)

Vyrubova, A. A. *Diary and Memoirs* (Moscow, 1990)

Werlich, R. *Orders and Decorations of All Nations* (Washington, 1985)

Witte, S.Y. *Memoirs*, vols. i-iii (Moscow, 1960)

Wortman, R. *Scenarios of Power, Myth and Ceremony in the Russian Monarchy* (New Jersey, 1995, vol. i)

Yakovlev, V. I. *The Alexander Palace Museum at Detskoe Selo* (Leningrad, 1928)

Yusupov, F. F. *The End of Rasputin* (Paris, 1927)

Yusupov, F. F. *Before Exile, 1887-1919* (Moscow, 1993)

Zamyslovsky, E. E.; Petrov I. I., *Historical Record of Russian Orders and a Collection of Statutes of the Principal Orders* (St. Petersburg, 1891)

Zyrianov, P. N. *Piotr Stolypin: a Political Portrait* (Moscow, 1992)

Exhibitions

1894, St. Petersburg
Exhibition of articles brought back by Grand Duke
Tsesarevich Nikolai Alexandrovich from his travels in the
Far East, 1890-1.

1967, Leningrad
Decorative Glass: album of articles on display at the State
Hermitage.

1974, Leningrad
Costumes in Russia from the 18th to the early 20th
century from the Hermitage Collection. Exhibition
Catalogue. Compiled and introduced by T. T.
Korshunova.

1974, Leningrad
Applied Art from the late 19th to the early 20th century.
Exhibition Catalogue. Introductory Article by N. Y.
Biriukova.

1976, Leningrad
Russian Samovars from the 18th to the early 20th century.

1976, New York
History of Russian Costume from the 11th to the 20th
century. From the collections of the Arsenal Museum,
Leningrad, Historical Museum, Moscow, etc.

1978, Malbork
Bron Kaukazu i Azii Srodkovej. Katalog wystawky/
Ju. Miller.

1981, Leningrad
Russian Miniatures from the 18th to the early 20th
centuries from the Hermitage. Catalogue compiled by
G. N. Komelova, G. A. Printseva, L. P. Nikiforova.

1981, Moscow–Paris
Moscow–Paris, 1900–1930. Fine, Applied and Industrial
Art; Architecture and Town-planning. Exhibition
Catalogue, vols. i-ii.

1981, Leningrad
Metal in Art in Russia from the 18th to the early 20th
century. Catalogue compiled by Z. A. Berniakovich et al.
Introductory Article by N. V. Kaliazina.

1981–1982, Köln
Russische Schatzkunst aus dem Moskauer Kreml und
der Leningrader Eremitage. Ausstellung. Köln. 1981–2.
Katalog. Mainz am Rhein.

1984, Sofia
Russian Decorative and Applied Art from the 18th to
the early 20th century from the Hermitage collections.
Catalogue compiled by T. T. Korshunova and
L. A. Tarasova.

1984, Delhi
Russian Decorative Arts and Jewellery of 17th–19th
century from the State Hermitage. Catalogue: National
Museum, New Delhi.

1986, München
Habsburg, Geza von. Fabergé, Hafjuwelier der Zaren.

1986, Lugano
Ori e argenti dall Ermitage. Mostra. Catalogo:
Collezione Thyssen-Bornemisza, Villa Favorita,
Lugano / J. O.Kagan, O. G.Kostiuk, M. N.Lopato et al.

1987, London
Russian Style 1700–1920. Court and Country. Dress
from the Hermitage. T.Korshunova, J.Moiseenko.

1988, Limoges
Les emaux des Russes du 17 e au debut du 20 e siècle.
Tresors emaillés du Musée de l'Ermitage. Exposition
catalogue.

1989, Leningrad
Russian and Soviet Artistic Glass, 11th–20th century.
Exhibition catalogue. Introductory Article by
B. B. Piotrovsky; Contributors: Z. A. Lvova,
T. A. Malinina, L. V. Kazakova.

1989, Zürich
Barten, S., Carl Fabergé.

1989, Paris
Yves Saint Laurent presente les costumes historiques
russes du Musée de l'Ermitage de Leningrad. Catalogue.

1990, Essen
St. Petersburg um 1800. Ein goldenes Zeitalter
des russischen Zarenreichs.

1990, Leningrad
The Great Fabergé. Art of Jewellers to the Court.

1990, Leningrad
Kostsova, A. S., Pobedinskaya, A. G. Russian Icons from
the 16th–early 20th centuries with inscriptions, signatures
and dates. Exhibition Catalogue.

1990, Aarhus
Kunstskatte frå (Zarernes Hof. 1860–1917. Ermitagen.
Leningrad. Gaester. Aarhus. Kunstmuseum.

1990, Nagasaki
Tabikhaku. (in Japanese)

1991–92, Memphis
Treasures of Imperial Russia: Catharine the Great.
From the State Hermitage Museum, St. Petersburg.

1991, Leningrad
Miroliubova, G. A., Petrova, T. A. Russian Photography
1840–1910 from the Hermitage Collection.

1991, Riihimäki
Tsaarien Metsästysloistoa. Suomen, Riihimäki, 1991

1992, Moscow–Vienna
The World of Fabergé. 150 years of the Russian Jewellers
Firm. Exhibition Catalogue. Catalogue compiled and
introduced by T. N. Muntian.

1993, St. Petersburg
Russian Costume from the Silver Age, 1890-1914.
Exhibition Catalogue from the State Hermitage Funds.
Catalogue compiled and introduced by T. T. Korshunova.

1993, St. Petersburg
Chinese Snuff Boxes. Exhibition Catalogue. Author
and Compiler, T. B. Arapova.

1993, Berlin
Japan und Europa. 1543–1923. Eine Ausstellung der
"43 Berliner Festwochen im Martin-Gropius-Bau".
Bd. 1–2,

1993, Bonn
Sehsucht: Das Panorama als Massenunterhaltung des
19. Jahrhunderts. Aussellung und Katalog. Kunst und
Austellungshalle der Bundesrepublik, Deutschland.
Basel, Frankfurt-am-Main, 1993

1993, St. Petersburg
Fabergé, the Court Jeweller. Washington, 1993

1993, Paris
Fabergé - Orfèvre des Tsars. Washington, 1993

1994, London. Faberge
Faberge — Imperial Jeweller. Washington, 1993

1994, St. Petersburg
Chess-pieces in the Hermitage Collection.

1994, St. Petersburg
Nicholas and Alexandra: The Court of the Last
Russian Emperors.

1994, St. Petersburg
Oriental Porcelain from the 18th to the early 20th
centuries.

1995, Ekaterinburg
The Hermitage Saved. St. Petersburg, 1995

1995, Hamburg
Schiffart und Kunst aus Russland.

1995, St. Petersburg
Russian Lacquers. The 200th Anniversary of the
Lukutin Factory.

1996, Kaliningrad.
Glory to Sea-faring Vessels! St. Petersburg, 1996

1996, St. Petersburg
The Russian Historical Method. Style and Epoch
in Decorative Art, 1820–90.

1996, Hørsholm
Masterpieces of Russian Hunting Arms from the
Hermitage Museum, St. Petersburg. The Danish
Museum of Hunting and Forestry. Hørsholm

1996, Stockholm
Jewels and Silver for Tsars, Kings and Others.
B. A. Bolin — 200 years. St. Petersburg, Moscow,
Stockholm.

1997, Stockholm.
Carl Fabergé. Goldsmith to the Tsar.
Nationalmuseum, Stockholm.

1997, St. Petersburg
Siamese Art, 14th–19th century, in the State
Hermitage Collection.

1997, St. Petersburg
Emperor Alexander II.

STATE ARCHIVE OF THE RUSSIAN FEDERATION: SOURCES

Archive :

102: Police Department of the Ministry of Internal
Affairs.

109: Third Department of Her Imperial Majesty's
Office.

533: Private archive of P. K. Benckendorf.

601: Private archive of Emperor Nicholas II.

611: Private archive of P. V. Petrov, teacher to the
imperial children.

612: Private archive of G. E. Rasputin.

613: Private archive of Princess O. V. Paley.

640: Private archive of Empress Alexandra
Feodorovna.

642: Private archive of Empress Maria Feodorovna.

643: Private archive of Grand Duchess Olga
Alexandrovna.

644: Private archive of Grand Duke Pavel
Alexandrovich.

645: Private archive of Grand Duke Alexander
Mikhailovich.

646: Private archive of Grand Duke Nikolai
Nikolaevich (the elder).

648: Private archive of Grand Duke Sergei
Alexandrovich.

651: Private archive of Grand Duchess Tatiana
Nikolaevna.

659: Private archive of Grand Duke Ioann
Konstantinovich.

660: Private archive of Grand Duke Konstantin
Konstantinovich.

662: Private archive of Grand Duchess Xenia
Alexandrovna.

668: Private archive of Grand Duke Mikhail
Alexandrovich.

673: Private archive of Grand Duchess Olga
Nikolaevna.

677: Private archive of Emperor Alexander III.

678: Private archive of Emperor Alexander II.

681: Private archive of Grand Duke Alexei
Alexandrovich.

682: Private archive of Tsarevich Alexei Nikolaevich.

683: Private archive of Grand Duchess Anastasia
Nikolaevna.

685: Private archive of Grand Duchess Maria
Nikolaevna.

765: Private archive of Grand Duke Dmitry
Konstantinovich.

826: Private archive of Chancellor A. M. Gorchakov.

1486: Private archive of Presbyter G. I. Shavelsky.

1742: Collection of photo-portraits of people passing by
police institutions.

1779: Office of the Provisional Government, 1917.

10060: New acquisition from the family archive of Grand
Duke Andrei Vladimirovich.

1837: Collection of investigative material concerning the
murder of the imperial family and its circle.

R-130: Soviet of People's Commissars.

INDEX

WITHDRAWN

LONDON LIBRARY